D0882188

The Weber School
6751 Roswell Rd NE
Atlanta, GA 30328
(404) 917-2500

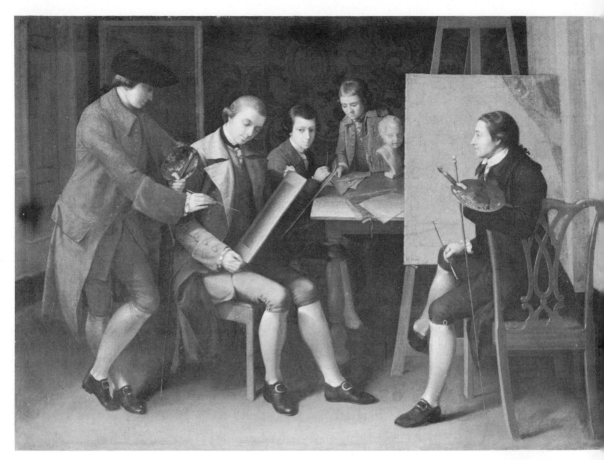

THE AMERICAN SCHOOL, 1765. Painting by Matthew Pratt. *Courtesy The Metropolitan Museum of Art, gift of Samuel P. Avery.*[The] "Last picture he exhibited was entitled 'American School': it consisted of small whole length portraits of himself, West, and other of his countrymen, whose names are unknown to the author." "Of the picture . . . , Sully says, [it] 'was so well executed that I had always thought it was a copy from West.'"

A HISTORY OF

THE RISE AND PROGRESS OF

The Arts of Design

in the United States

BY

WILLIAM DUNLAP

A REPRINT OF THE ORIGINAL 1834 EDITION
WITH A NEW INTRODUCTION BY
JAMES THOMAS FLEXNER

NEWLY EDITED BY RITA WEISS
WITH 394 ILLUSTRATIONS

IN TWO VOLUMES BOUND AS THREE
VOLUME 1

DOVER PUBLICATIONS, INC.
NEW YORK

Published in Canada by General Publishing Company, Ltd.,
30 Lesmill Road, Don Mills, Toronto, Ontario.
Published in the United Kingdom by Constable and Company, Ltd.,
10 Orange Street, London WC2.

This Dover edition, first published in 1969, is an unabridged re-publication of the first (1834) edition, as published by George P. Scott and Company. This edition also contains a new introduction by James Thomas Flexner, new biographical notes, new illustrations, and a new index prepared especially for this edition, and a preface by the editor.

Standard Book Number: 486-21695-0
Library of Congress Catalog Card Number: 69-16810

Manufactured in the United States of America
Dover Publications, Inc.
180 Varick Street
New York, N.Y. 10014

Editor's Preface

William Dunlap's *History of the Rise and Progress of the Arts of Design in the United States* has long been recognized as the first standard history of American painting, and for many years art historians and American art curators encouraged Dover Publications to undertake a republication of this classic work. When the decision to reprint was reached the question arose whether to reprint the original 1834 edition or the version revised and corrected in 1918 by Frank W. Bayley and Charles B. Goodspeed.

It was the opinion of the publisher's advisers that the reprint should be based upon the original text. The Bayley and Goodspeed version, although a creditable job for a work done in the early twentieth century, does display its age in the light of modern scholarship. It suffers from the fact that in 1918 few museums had large American art collections; moreover, several important collections of lithographs and engravings now available for public study were still in private hands (for instance, the extensive Phelps Stokes Collection of American Historical Prints was not given to the New York Public Library until 1930). Much additional biographical information is now available because of extensive research. A particularly valuable recent publication is George C. Groce and David H. Wallace's *The New-York Historical Society's Dictionary of Artists in America*, published in 1957. Another objection to the 1918 edition was that Bayley and Goodspeed had abridged the original text.

This Dover edition is thus an unabridged photographic reprint of the original 1834 text to which has been added new editorial apparatus. Alongside the main entry for each artist a marginal note has been added indicating the latest information on the correct spelling of the artist's name and dates of birth and death. Dunlap's brief alphabetical listing of names has been replaced by a new comprehensive and exhaustive index specially prepared for this edition.

Technical difficulties prevented Dunlap from illustrating his original volumes. Bayley and Goodspeed illustrated their edition with 174 illustrations, but many of these pictures are not mentioned by Dunlap and

some are by artists unknown to him. The present edition contains 394 illustrations representing the works of artists, engravers, illustrators and architects specifically mentioned by Dunlap, and, in fact, many of the pictures illustrate the very works described in the book. Dunlap discusses 289 artists in the main body of the book (161 artists are mentioned briefly in his appendix), and the works of 212 artists are illustrated herein. Most of the artists not represented are of minor significance.

The publisher wishes to thank the many scholars associated with museums and historical societies who took an active interest in the project and helped to track down the works of obscure painters. A credit line under each picture acknowledges its specific source. Many of the engravings in this edition come from eighteenth- and nineteenth-century books in the publisher's own collection and are marked "Dover archives." Special notes of thanks go to Mr. James Heslin of the New-York Historical Society, Miss Emily Papert of the Metropolitan Museum of Art, and Miss Louise Wallman of the Pennsylvania Academy of the Fine Arts.

Particular acknowledgement is due to James Thomas Flexner, the American art historian, who encouraged the reprinting of this work and who graciously consented to write an introduction.

RITA WEISS

New York, New York
May, 1969

Introduction to the Dover Edition

I can think of no more grateful task than preparing an introduction to a new edition of William Dunlap's *History of the Rise and Progress of the Arts of Design in the United States*. It has long been one of my favorite books.

If, as in neo-classical (or sentimental) moods I like to imagine, there exists an American Muse, surely that then very young young lady intervened actively in two opening events of American culture: the creation of the portrait *Mrs. Freake and Baby Mary*, and the writing of Dunlap's *History*. Limned by an anonymous hand in the first decade of known American painting—the 1660's—the Freake portrait set our art off with a brilliant beginning. It was a work of such touching beauty that almost a century was to pass before there appeared on these shores another picture of equivalent charm. And Dunlap's book, in 1834 the first published history of American art, demonstrated, for later generations to ponder, the many delights that can spring from a felicitous marriage between art history and literary skill.

Dunlap was himself a painter, who had shared in the excitements about which he wrote, and who was personally acquainted, often intimately, with many of the men whose careers he so evocatively described. However, his greater gift was as a writer. An author-producer, he composed some fifty plays, many of which found permanence in print. He had also completed a history of the American theater and various biographies when, at the age of sixty-six, he set to work on his history of the arts of design.

That he is sometimes styled "the American Vasari" is apposite enough, since Dunlap worked in the manner which was practiced by that sixteenth-century Italian chronicler and which was continued by many a subsequent writer. Dunlap identified himself most closely with an English "Vasari," George Vertue. An engraver by profession, Vertue had, for some twenty years before his death in 1756, gathered material for a history of English art. His notes were bought from his widow by the aristocratic dilettante and writer, Horace Walpole. During Dunlap's boyhood, there appeared *Anecdotes of Painting in England, with some Account of the Principal*

Artists and Incidental Notes on other Arts, Collected by the late George Vertue, and now Digested and Published from his Original Manuscript by Horace Walpole.

Dunlap was following Vasari and Walpole when he organized his book as a series of biographies, some long and some short, each independent of the others except insofar as the lives of the different characters had in actuality crossed. This traditional form slighted most of the shibboleths of twentieth-century academic art history. Far from regarding personal character and the happen-chances of his daily life as of secondary importance in the understanding of an artist's esthetic achievement, Dunlap was, like his predecessors, frankly and gleefully concerned with evoking personality. He recorded the minutia of a creator's life: how a painter made and spent his money, how much he ate and drank.

The influences of artists on each other are mentioned if they come naturally into the narrative—as in the case of teacher and pupil—but Dunlap did not seek out and emphasize chains of influence as a modern scholar would. Individual artifacts are named and brought into the story when and where the author considered them of importance, but are rarely given the attention and space reserved for anecdotes of the artists' lives. Criticism circles primarily around subject matter: what was the artist trying to show, was it worth depicting, and did the artist carry out his intention effectively? The "formal" considerations modern scholars analyze are, if mentioned at all, passed quickly over. Even the critical summaries of artists' careers are, however evocative, brief and general: what was a man's rank beside his fellows, what were his principal strengths and defects?

Dunlap was, indeed, within the modern, scholarly meaning of the term, not much of a "connoisseur," but this creates no serious lack in the usefulness of the book. Creations by the artists he discussed are, due to such modern conveniences as museums, cameras, and art libraries, more widely available to us than they were to him. We may make our own analyses of form and color, may juxtapose photographs and draw complicated lines of influence. But what Dunlap preserved—the characters and the careers and the environments of the creators—would, in many cases, but for him have vanished into the vagrant dust.

Even if out of key with modern scholarly practice (where lackluster writing is so admired and, alas, so often achieved), the sprightliness of Dunlap's style falls into a long and noble tradition. It dates back to the centuries before the invention of fiction, when what we today call "nonfiction" was the accepted vehicle of prose literature. Vasari wrote with exhilarating dash, and so did the best of his followers, including William Dunlap.

As every tyro in the field knows, Dunlap's history is crowded with facts valuable for today's students. Particularly as the publishers of this edition have added a comprehensive index, this information may be mined without bothering with any of the surrounding passages, as a prospector may dig for gold, even in the most beautiful landscape, with his face forever aimed at the ground. Although such restricted digging is often required by the exigencies of research, I should like to urge that the reader find enjoyment by using the book another way.

To begin with, you must get yourself quiet, for this is not a narrative that moves rapidly to any objective like a superhighway which burrows under all umbrageous country lanes. Put on your slippers, place a drink by your elbow, and resolve to ramble imaginatively with the author through vanished times. His avowed object is to make you acquainted with a great many people. He himself finds them all interesting because he is eternally amused and excited by the human race. With some men to whom he introduces you he is barely acquainted; after nods are exchanged, he will express curiosity to know more about them. Concerning others, he will pull you aside for a whisper of gossip. But if he meets one of his cronies or a man whom he greatly admires, then the session will be long, extending late into the night, and there will be much laughter. For this William Dunlap, when he has the right material and gets going, is a very funny man. Here is such an anecdote as he will tell:

In the early period of [Gilbert] Stuart's career as an independent portrait-painter, he had for his attendant a wild boy, the son of a poor widow, whose time was full as much taken up by play, with another of the painter's household, a fine Newfoundland dog, as by attendance upon his master. The boy and dog were inseparable; and when Tom went an errand Towzer must accompany him. Tom was a terrible truant, and played so many tricks that Stuart again and again threatened to turn him off, but as often Tom found some way to keep his hold on his eccentric master. One day, as story-tellers say, Tom staid when sent of an errand until Stuart, out of patience, posted off to the boy's mother, determined to dismiss him; but on his entering the old woman *began first.*

"Oh, Mr. Stuart, Tom has been here."

"So I supposed."

"Oh, Mr. Stuart, the dog!"

"He has been here, too: well, well, he shall not come again; but Tom must come home to you. I will not keep him!"

"Oh, Mr. Stuart, it was the dog did it."

"Did what?"

"Look, sir! look there! the dog overset my mutton pie—broke the dish—greased the floor, and eat the mutton!"

"I'm glad of it! you encourage the boy to come here, and here I will send him!"

"It was the dog, sir, eat the mutton!"

"Well, the boy may come and eat your mutton, I dismiss him! I'll have no more to do with him!"

The mother entreated—insisted that it was the dog's fault—told over and again the story of the pie, until Stuart, no longer hearing her, conceived the plan of a trick upon Tom, with a prospect of a joke, founded upon the dog's dinner of mutton-pie.

"Well, well, say no more: here's something for the pie, and to buy a dish. I will try Tom again, provided you never let him know that I came here to-day, or that I learned from you any thing of the dog and the pie."

The promise was given of course, and Stuart hastened home as full of his anticipated trick to try Tom, as any child with a new rattle. Tom found his master at his esel where he had left him, and was prepared with a story to account for his delay, in which neither his mother, nor Towzer, nor the mutton made parts.

"Very well, sir," said the painter, "bring in dinner; I shall know all about it by–and–by."

Stuart sat down to *his* mutton, and Towzer took his place by his side, as usual; while Tom, as usual, stood in attendance.

"Well, Towzer, your mouth don't water for your share. Where have you been? Whisper."

And he put his ear to Towzer's mouth, who wagged his tail in reply. "I thought so. With Tom to his mother's?"

"Bow-wow."

"And have you had your dinner?"

"Bow."

"I thought so. What have you been eating? Put your mouth nearer sir."

"Bow-wow!"

"Mutton-pie—very pretty—you and Tom have eat Mrs. Jenkins's mutton-pie, ha?"

"Bow-wow."

"He lies, sir, I didn't touch it; he broke mother's dish and eat all the mutton!"

From that moment Tom thought if he wished to deceive his master, he must leave Towzer at home, but rather on the whole concluded that what with the dog, the devil, and the painter, he had no chance for successful lying.

As we have seen, Walpole called his edition of Vertue *Anecdotes of Painting in England*: the anecdote always played an important role in the Vasari tradition of art history. The authors preferred not to prose out their points as would the writers of modern monographs, but to exemplify their conclusions in scenes. Here is an example of how Dunlap compares the styles of Benjamin West and Stuart:

> I will mention the following circumstance which took place about 1786, on occasion of a visit [by Stuart] to his old master's [West's] house and gallery, in Newman-street. Trumbull was painting on a portrait and the writer literally *lending him a hand*, by sitting for it. Stuart came in and his opinion was asked, as to the colouring, which he gave very much in these words, "Pretty well, pretty well; but more like our master's flesh than Nature's. When Benny teaches the boys, he says, 'yellow and white there,' and he makes a streak, 'red and white there,' another streak, 'blue-black and white there,' another streak, 'brown and red there, for a warm shadow,' another streak, 'red and yellow there,' another streak. But Nature does not colour in streaks. Look at my hand; see how the colours are mottled and mingled, yet all is clear as silver."

Unless charmed out of his critical sense by such passages, the modern reader will point with horror to the fact that Dunlap interlards non-fiction with conversations. In this practice, one feels strongly the influence of Boswell's *Life of Johnson*; neither Vasari nor Vertue went in for much dialogue. Boswell, as far as the modern reader is concerned, gets away with his endless quotations on the assumption that he is giving verbatim reports of what he has listened to—but, of course, stenographic notations would read very differently from the passages Boswell has shaped into parts of a work of art. Dunlap, too, usually claims to be quoting what he heard. Even the story of Stuart, the boy, and the dog, although much of it is in the third person, is presented in the way Stuart would have told it. That the wild portraitist's particular idiom was indeed accurately caught is revealed by the similarity in his talk as reported by Dunlap and his other friends.

To the little dramatizations that gleam on his pages, Dunlap brought skills he had developed in writing for the theater. He was a master in the

phrasing of dialogue. Having established succinctly the place and the characters, he ignited a flash of action which illuminated exactly the point he wished to convey. If an artist is quoted, we are almost always told to whom he made the statement and where. This contributes to our sense that we are not in a scholar's study but experiencing life as it was actually lived. And, almost by paradox, the technique contributes to those ends of scholarship which are most often served by that most unliterary of devices, the footnote. Seeking always artistic verisimilitude, Dunlap hooks every statement into the body of fact by embedding the source in the narrative.

Although his anecdotes crackle, Dunlap's chapters tend to wander. This can sometimes be an irritation—even the most charming and informed guide can, if garrulous, be a bore—but, on the whole, we are given a rich sense not only of artistic life but of the broad environments through which the artists moved. General historians would do well to read Dunlap. Where, for instance, is there a better picture of the English army as it appeared during the Revolution to the American inhabitants than in the following paragraph from the account of his own career that Dunlap included in his *History*?

The time is early 1777, shortly after Washington's victories at Trenton and Princeton had made the British draw their front line back. The place is Perth Amboy, now their principal remaining post in New Jersey:

> Here were centered, in addition to those cantoned at the place, all those drawn in from the Delaware, Princeton and Brunswick; and the flower and pick of the army, English, Scotch, and German, who had at this time been brought in from Rhode Island. Here was to be seen a party of the 42d Highlanders, in national costume, and there a regiment of Hessians, their dress and arms a perfect contrast to the first. The slaves of Anspach and Waldeck were there—the first sombre as night, the second gaudy as noon. Here dashed by a party of the 17th Dragoons, and there scampered a party of *Yagers*. The trim, neat and graceful English grenadier, the careless and half savage Highlander, with his flowing robes and naked knees, and the immovably stiff German, could hardly be taken for parts of one army.

As his published diaries* reveal, Dunlap started his active researches for his *History of the Arts of Design* on November 17, 1832, by writing Washington Allston and two other artists to ask their aid. More correspond-

* Dunlap, William, *Diary*, 3 vols., New York, printed for the New-York Historical Society, 1930.

ence followed, and also many interviews, as increasing information led him from one informant to another. The old gentleman must have operated with the most awe-inspiring energy since the manuscript was not only completed but the book printed within two years.

Although his definition of "the arts of design" included sculpture, architecture, and engraving, Dunlap's primary concern was with the art he himself practiced, with painting. An elderly man possessing a long memory, a file of diaries, much industry, and a wide acquaintance, he managed to grasp a wide chronological span: from artists who had worked in the second quarter of the eighteenth century to the emergence of the Hudson River School which was to remain active until late in the nineteenth.

Concerning what might be called the introductory period of American art, the some hundred years of activity before West and Copley bestrode the scene, Dunlap, it is true, was very sketchy. Quite good on Smibert, he had heard of Feke, Theus, and Blackburn, but was utterly ignorant of Bridges, Greenwood, Pelham, Badger. The earliest artist he discussed, John Watson, had come to his attention because Watson had worked at his own birthplace, Perth Amboy. Dunlap speculated that, although they had left "no traces that we can discover," many other painters had undoubtedly preceded Watson. It was both an indication of Dunlap's great influence and of how much more careful a scholar he was than his successors, that for years his passage was misread and Watson categorically described as the very first artist to have painted in America.

To deal with the great painting outburst that slightly preceded and for some time followed the Revolution, Dunlap was perfectly placed in space and time. Although twenty-eight years younger than Benjamin West and John Singleton Copley, eleven than Gilbert Stuart, and ten than John Trumbull, he had studied in London when these artists were converged there. He had been, like all the important American painters of the time—with the partial exception of Copley—a pupil of West's. His accounts of the painters he had known in West's studio, and of others of that generation whom he later met, are as fascinating as they are numerous, and add up to by far the most important source which exists on this very important school.

Dunlap concluded—an opinion shared by many in England and on the Continent as well as in America—that West was one of the greatest painters in the world. In that paragon's studio, he imbibed the conventional neo-classical esthetic of the time: Art should appeal to the rational rather than the sensuous faculties. The highest form of art was that depiction of the acts of religious or secular heroes which had been commonly practiced by the Old Masters and which was known as "historical painting." Subject

matter was of the first importance and should always be clearly presented. Since the object of art was to teach virtue, a good artist had to be a good man.

These conceptions Dunlap often stated in his *History* but his was not a theoretical mind. He was much more concerned with understanding and appreciating whatever he saw around him. His moralizing, for instance, did not go very deep. He could, it is true, be stuffy about the naked bodies of prostitutes presented to the public as embodiments of our common mother, Eve, but he was a frank and uncensorious biographer. Gleefully grasping the opportunities presented by Stuart's vagaries to create a dashing picture of a far from moral man, he nonetheless acknowledged the profligate's temendous artistic skill. As for younger artists who strayed away from the Westian esthetic: he complained, but gave them their due.

The early romantic, Allston, was thirteen years younger than Dunlap and forty-one than West. He responded to Dunlap's urgings with autobiographical letters, from which the chronicler quoted this description of Allston's first visit to the Louvre:

"Titian, Tintoret, and Paul Veronese, absolutely enchanted me, for they took away all sense of subject. . . . It was the poetry of colour which I felt; procreative in its nature, giving birth to a thousand things which the eye cannot see, and distinct from their cause. I did not, however stop to analyze my feelings. . . . But I now understand it, and *think* I understand *why* so many great colourists, especially Tintoret and Paul Veronese gave so little heed to the ostensible *stories* of their compositions. In some of them, the Marriage of Cana for instance, there is not the slightest clue given by which the spectator can guess at the subject. They addressed themselves not to the senses merely, as some have supposed, but rather through them to that region (if I may so speak) of the imagination which is supposed to be under the exclusive dominion of music, and which, by similar excitement, they caused to teem with visions that 'lap the soul in Elysium.' In other words, they leave the subject to be made by the spectator, provided he possesses the imaginative faculty—otherwise they will have little more meaning to him than a calico counterpane."

This denial of the primacy of subject matter, this insistence not on rational reactions to form but emotional reactions to color, was heresy within the neo-classical esthetic Dunlap had accepted in West's studio. But Dunlap does not denounce; he mediates:

The reader will perceive that Mr. Allston is far from being devoid of the imaginative faculty which he here speaks of, and that he saw objects with a poet's as well as a painter's eye—indeed they are the same. His own pictures are replete with this magic of colour, at the same time that he is strictly attentive to the story in all its parts, character, actions, and costume. It certainly is not fair to leave the spectator to make out the story of a picture, and to be puzzled by finding Pope Gregory alongside of Saint Peter, and both dressed in costume as far from truth as they were similarity of opinion. All the charm of colour may be attained without sacrificing truth.

Dunlap was even willing to put Allston on a par with West, "to whom, if inferior in facility of composition, he is superior in colour and equal in drawing."

Allston, who had been among West's pupils, represented no more than a turn, if a significant one, in the same esthetic flow. The true explosion in American art took place when Dunlap was almost sixty. Then Thomas Cole, thirty-five years his junior, led an entirely new beginning, initiating (among other styles) the Hudson River School which was dedicated to realistic painting of the American landscape. Dunlap helped discover Cole when the revolutionary was a complete unknown. In his *History*, he quoted the young man's wildly revolutionary arguments, the very antithesis of neo-classical theory:

"Will you allow me here to say a word or two on landscape? It is usual to rank it as a lower branch of the art, below the historical. Why so? Is there a better reason, than that the vanity of man makes him delight most in his own image? In its difficulty (though perhaps it may come ill from me, although I have dabbled a little in history) it is equal at least to the historical. There are certainly fewer good landscape pictures in the world, in proportion to their number, than of historical. In landscapes there is a greater variety of objects, textures, and phenomena to imitate. It has expression also; not of passion, to be sure, but of sentiment—whether it shall be tranquil or spirit-stirring. Its seasons—sun-rise, sun-set, the storm, the calm—various kinds of trees, herbage, waters, mountains, skies. And whatever scene is chosen, one spirit pervades the whole—light and darkness tremble in the atmosphere, and each change transmutes. . . .

"I mean to say, that if the talent of Raphael had been applied to landscape, his productions would have been as great as those he really did produce."

Dunlap soothed his conscience by demurring politely, and then showered Cole (as we still do today) with praise.

In giving all artists, as best he could, their due, Dunlap allowed them, whenever he could, to speak for themselves, quoting page after page from the autobiographical letters they had written him. This adds to the authenticity and also the variety of a book which, I hope, will afford new readers not only instruction but also the pleasure it has consistently given me since I first made its acquaintance more than thirty years ago.

JAMES THOMAS FLEXNER

New York City
May, 1969

List of Plates

HISTORY

OF THE

RISE AND PROGRESS

OF THE

ARTS OF DESIGN

IN THE UNITED STATES.

———

BY WILLIAM DUNLAP,

Vice President of the National Academy of Design, Author of the History of the
American Theatre,—Biography of G. F. Cooke,—&c.

———

IN TWO VOLUMES.

VOL. I.

━━━━

NEW-YORK:

GEORGE P. SCOTT AND CO. PRINTERS, 33 ANN STREET.

1834.

PREFACE.

A HISTORY of the Arts of Design in the United States, given by a series of biographical notices, which should show not only the progress of improvement in those arts, but their present state, necessarily includes the biography of many living artists.

To publish the biography of the living is objected to by some. They say, if truth is told, the feelings may be wounded ; and if mere eulogium is aimed at, truth will be wounded, the public deceived, and that which pretends to be history, will become a tissue of adulatory falsehood. But of public men—and every artist is a public man—the public have a right to demand the truth. The most interesting portion of my work is the biographies of living artists; and it throws a light upon the lives and actions of those who have departed, which could not be obtained in any other way. Every artist wishes, and ought to wish, that public attention should be called to him. It is for him so to conduct himself, both as an artist and a man, that his works and his actions may defy scrutiny, and his reputation may be increased by a knowledge of the truth.

The artist, the author, and every other public man may rely upon it, that their lives will be scrutinized in proportion as they attain the celebrity which they desire. They may likewise expect that the world will be curious, and wish to be made acquainted with them after their decease, and that some one will be found whose interest it is to gratify this curiosity. If the biographer should do them injustice, the time is past in which they might defend themselves ; but if the living find themselves misrepresented, they can rectify errors or rebut slander.

"Nothing extenuate, nor set down aught in malice," like most of the precepts of our unrivalled poet, is a part of our moral law. The artist ought to wish it to be the guide of his biographer. The biographer may in pity, or in mercy, deviate from the first part of the precept, but never from the last. If, by obeying the whole, the good of those for whom he writes is to be attained, let him obey the precept in its utmost extent. With these views of the subject I have written this work.

When I undertook the task I had no notion of the importance or magnitude of what I had undertaken. It has grown upon me ; and but for the interest which has been taken in the subject by the most enlightened men of our country, I could not have accomplished as much as I now place before the public. To name those who have assisted me, would be to name the best of our artists and of our authors.

I publish by subscription, because I need the immediate return of the cost of publication. I am my own publisher, because I wish to have the sole control of the work. I know that my intentions are good, and that I have done the best in my power to fulfil them.

To those who have assisted me in the work I dedicate it with thanks.

WILLIAM DUNLAP.

New-York, Oct. 1834.

CONTENTS OF VOLUME I.

CHAPTER VII.

CHAPTER VIII.

CHAPTER IX.

CHAPTER X.

CHAPTER XI.

CHAPTER XII.

CHAPTER XIII.

CHAPTER XIX.

CHAPTER XX.

CHAPTER XXI.

CHAPTER XXII.

CHAPTER XXIII.

CHAPTER XXIV.

A HISTORY

OF THE

RISE AND PROGRESS OF THE ARTS OF DESIGN

IN AMERICA.

CHAPTER I.

Arts of Design, what—General Progress of these Arts—Their state in Europe at the time of colonizing America—Patronage of the Arts in England, in the eighteenth century—Biography of John Watson.

THE author calls this work a history, without presuming to place himself in the rank of professed historians. His history shall be given by a chain of biographical notices, with all the discursiveness and license of biography; but, in the first place, he solicits the attention of the reader to some general remarks on the subjects of which he treats,—the arts of design and their professors.

The fine arts are all of one family; but it is only a part of this family that falls within our limits. "The Arts of Design" form of themselves a field sufficiently wide for us to travel over, nay, too wide, and it will be found that we shall, from necessity, neglect much that would come with propriety under the title. Sculpture, Painting, Engraving, Architecture, and their professors, will occupy us almost exclusively; and the second in the order above given must fill the greater number of our pages.

Poetry, as we are told, excites images and sensations through the medium of *successive action*, communicated by sounds and *time*. The same may be said of music; but painting and her sister *arts of design* rely upon *form* displayed in *space*.

Design, in its broadest signification, is the plan of the whole, whether applied to building, modelling, painting, engraving, or landscape gardening; in its limited sense it denotes merely drawing; the art of representing *form*. Man has fully con-

vinced himself that the human is the most perfect of all forms, and has found that its representation is the most difficult achievement of design. The sculptors of ancient Greece alone attained the knowledge of this form in its perfection, and the power to represent it. Happily for us their works were executed in such materials as have defied time, the elements, and even ignorance, more destructive than either: happily the architecture and sculpture of Greece have come down to us, for we have no standard of beauty, but that which is derived from the country of Homer and Phidias. The sculptors and architects of Greece are our teachers to this day, in *form;* and he most excels who most assiduously studies the models they have left us. This seems to contradict the precept that bids the artist study nature alone. But it must be remembered that we speak only of that form, the perfection of which the ancients saw in nature, and embodied in their religion. *That* natural perfection which they saw under *their* bright skies, at the games instituted in honour of *their* gods, they combined in the statues of those gods; diversified according to their several attributes. The contemplation of these attributes added action and expression to individual form. This appears to be the source from which the wonders of Praxiteles and Phidias sprung—the Jupiter, the Minerva, the Hercules, the Venus, the Apollo. The contemplation of these forms led to the improvement of Egyptian architecture by the Greek colonists of Asia Minor. Slegel has said, that by contemplating the Belvidere Apollo, we learn to appreciate the tragedies of Sophocles. Such is the alliance of poetry and the arts of design.

The arts of design are usually considered as commentators upon history and poetry. Truly they are the most impressive of all commentators. But to consider them only as such, is to degrade them. To invent, belongs to the artist as well as to the poet; and a Sophocles may catch inspiration from a Phidias, as an Apelles may be inspired by an Euripides. The poet is never more a poet than when describing the works of art, and the poetic artist delights to seize the evanescent forms of the poet, to fix them immovably in motion—palpable—in all their beauty brought before the physical eye; but it is no less his to invent the fable than to illustrate it.

The progress of the arts of design is from those that are necessary to those that delight, ennoble, refine. Man first seeks shelter from the elements, and defence from savages of his own, or the brute kind. In his progress to that perfection destined for him, by his bountiful Creator, he feels the necessity of refinement and beauty. In this progress architecture is first in

order, sculpture second, painting third, and engraving follows to perpetuate by diffusing the forms invented by her sisters.

The mechanic arts have accompanied and assisted the fine arts in every step of their progress. To the sciences they have been indispensable handmaids. In all the ameliorations of man's earthly sojourn, the mechanic and fine arts have gone hand in hand. The painter, the sculptor, the engraver, and the architect, will all acknowledge their obligations to the mechanic arts, and the mechanic will be pleased by the consciousness that he has aided the arts of design in arriving at their present state of perfection.

Of the four arts of design, to which our attention is directed, architecture alone is the offspring of necessity; but before it became one of the fine arts, sculpture, and perhaps, painting, had existence. The first effort of man, in the imitative arts, is probably to model in clay, the second to cut in wood, and then in ivory or stone. The rude efforts of the aborigines of our country may be adduced to prove this. We find specimens of their modelling in baked clay, the *terra cotta* of Italy, and sculptured figures in wood and stone; but no attempt to represent round objects on a flat surface by lights and shadows. The late travellers, who have penetrated the terra incognita of Africa, tell us of figures sculptured as ornaments to the rude architecture of the negroes, but they saw no painting.

In that extremely interesting portion of the globe, Polynesia, we find sculpture existing in the rude forms of their idols, the elegant ornaments of naval architecture, and on the weapons of destruction; but no attempt at drawing, unless tattooing figures by lines and dots on their own bodies—engraving in flesh—may be so called. The graphic art was unknown, as much in its connection with pictorial form, as it was in that more common and still more precious form to mankind—letters.

In central America, near the village of Palenque, ruins and monuments are found, proving, as is supposed, the existence of a nation or people in a remote age, far surpassing in civilization the Mexicans or Peruvians, when visited by the Spaniards. Statues, and works in high and low relief, ornamented their buildings—but no paintings. The pictures formed by feathers, or otherwise, which were found among the Mexicans, at the time when treachery, bigotry, murder, and rapine put a stop to their progress towards civilization, were not designs representing the round on the flat, but a species of hieroglyphic writing; undoubtedly having a near affinity to the graphic art, and approaching it in the same degree that the people approached the blessings of civilized life. It was not drawing or writing, but was leading to both. At what period the nations

of the East attempted painting, we know not, but doubtless they carved their idols, and daubed them with colours, before they made any pictorial representations of the monsters. To this moment they neither invent nor imitate any thing in painting. They copy. There is nothing in which their barbarism is more apparent than in the deficiency of the arts of design. If the progress of the arts was from Egypt to India, and thence to Greece, they, on their arrival at the latter country, were a chaos without *form* and void. It required a more perfect state of the human mind to extract *form* from the chaotic mass. The Grecian sculptors discovered form, and perfected the mode of representing historical events by high and low relief; their painters followed; and although *they* arrived at the perfection of form, as well as their masters, we believe that they never went much beyond them in that which, in modern times, is the glory of the arts of design—composition. They told their stories as their masters had done, by a line of figures. The Greeks taught us beauty and expression; modern art has added colour, chiara scuro, perspective, composition— all by which distance, space, air, light, colour, transparency, solidity—may be brought before the eye on a flat surface. The painter knows no limits but time and place, and even the last has been burst by Raphael and by Tintoret; but it is only the author of the *Transfiguration*, and the *Adoration of the Golden Calf*, or men like them, that may break through the limit of locality.

Of the many elements of art and science, which must combine to produce these almost miraculous effects, it is not our immediate province to speak; neither to give the history of the progress of painting and her sister arts in Europe. The writers before the public are many and good. We will mention a few, as the names are suggested to memory—Visari, De Piles, Leonardo da Vinci, Albert Durer, Du Fresnoy, (with notes by Reynolds,) Winkleman, Mengs, Reynolds, Opie, Fuseli, Pilkington's Dictionary, (with additions by Fuseli, who has, in all his works, immense learning on the subjects of which he treats, though sometimes displayed rather than used,) and we must not forget Shee and Burnet. The remarks of Sir Martin Archer Shee, touching the writings and writers on the subject of the arts, appear to us so just and so essential to the correction of error and prejudice, that we insert them, notwithstanding that there may be an appearance of assumption in so doing. They are addressed to the students of the Royal Academy of England.

" There is, perhaps, no subject so unmanageable as that of the arts, in the hands of those who bring to its discussion only

the superficial acquirements of amateur taste and mere literary talent. As it is an alluring theme, however, to all who are disposed to wander in the regions of *virtu*, more flimsy and unsubstantial speculation has been hazarded on topics connected with the fine arts, than is found to encumber the path of the student in any other profession. The tracts of science, of law, and of physic, are too rough and thorny to be frequented by those who would traverse them as an amusement, rather than as an occupation : but the flowery domains of taste invite the approach of the idlest loungers of literature ; they are considered as common ground, where all may claim free manor, and range at large, without any apprehension of exposure or punishment, either as pretenders or trespassers. The fine arts appear to be the only pursuit in which the authority of the professor is undervalued by those who derive all their knowledge from his works. But you must not allow yourselves, gentlemen, to be influenced by prejudices of this kind. To the writings of artists alone can you look with any confident hope of obtaining valuable instruction or useful knowledge in your profession."

In our mode of giving the history of the progress of art in this country, principally by a chronological series of biographical notices, we shall undoubtedly speak of men who in no wise aided that progress ; but, we hope, by giving as complete a view of the subject as can now be obtained, to place in the hands of the future historian, many valuable facts, which would otherwise have been lost ; and to leave information respecting those professors of the arts who have failed, as well as those who have attained to honourable distinction—information which may guide the present and future student on his way to the wished-for goal.

Horace Walpole gives, as the reason for calling his work " Anecdotes of Painting in England," instead of the " Lives of English Painters," that the greatest men England could boast, as professors of the art in that country, were foreigners. Not so with us. In the commencement of our history as colonies, every painter was from beyond sea; but no sooner did native artists appear than their works exceeded in value immeasurably, the visiters who had preceded them. Although this is strictly true in regard to our painters, it will not yet fully apply to the professors of all the sister arts. We are happy to record foreign artists in our work, and acknowledge their influence on the progress of the arts ; but while England claims our artists as her own, because thrown on her shores, or invited by her liberality, we are content to call those only

American, exclusively, who were born or educated as artists within our boundaries.

It is matter of surprise to many, that the land of our forefathers should have been behind the rest of the civilized world in the conveniences and decorations which attend the expansion of mind and the progress of science. It will be explained by the consideration, that, although of late the freest and best governed country in Europe, and brilliant with art and science, it was the seat of barbarism with episcopal and military aristocracy to a later period than those lands which have since fallen behind her in the march towards perfection. While the artist was honoured on the continent, he was in the island of Great Britain considered as an appendage to my lord's tailor.

The curious may see in Walpole's Anecdotes of Painting in England, that my lord of Warwick in Henry VI.'s time "contracted with his tailor for the painter's work that was to be displayed" on his clothing, and the pageantry thought necessary, at that period, when going abroad. Walpole says, " the art was engrossed by, and confined to, the vanity or devotion of the nobility. The arms they bore and quartered, their missals, their church windows, and the images of their idols were the only circumstances in which they had any employment for a painter." The more esteemed painters were called limners, and were those who limned or illuminated missals, books or manuscripts, with miniatures ; that is, small pictures done in minium or red lead, from which the word now appropriated principally to small pictures on ivory, is derived. Such was the state of painting in the land of our fathers—*when Raphael flourished in Italy.*

It will hardly be credited in times to come—nay, it can hardly be credited now—only that we have English books of high authority to bear us out in the assertion, that in the eighteenth century the fine arts, and their professors, depended in that country upon patrons and patronage for subsistence—that the descendants of the military robbers who conquered the land ; or the minions, mistresses, or spurious offspring of their kings, revelling in the hereditary spoils of the people, should be sought and acknowledged as the necessary protectors of those whose knowledge or skill is now the boast of England. We will give a few extracts, or our readers, who are not conversant with the subject, may not believe what appears so monstrous.

A noble author, speaking of an artist who died so late as 1756, after Benjamin West began his career by painting portraits in this country, Walpole, in the last edition of his work, published in the nineteenth century, gives this character of

Vertue, an eminent artist and exemplary man. Speaking of his modesty, he says, "the highest praise he ventured to assume is founded on his industry"—"if vanity had entered into his composition, he might have boasted the antiquity of his race." By that industry which was never intermitted, he solaced the age of his parents; and, at his father's death, was the support of his widowed mother and many children. When not occupied by his professional labours, he practised music, and acquired foreign languages. His works were admired and *sought after*. "Many persons," says Walpole, "were desirous of having a complete collection." He gratified them by making up sets, which, after his death, sold for more than double the price he received for them. He was one of the first members of the first Academy of Painting known in his country. He was a learned antiquary. He was indefatigable in his researches after that knowledge which enabled him to compose his great work—"the History of the Arts in England." "His scrupulous veracity" is eulogized justly. "His merit and modesty still raised him friends." "He lost his friends, (by death,) but his piety, mildness, and ingenuity never forsook him." "He died July 24th, 1756, and was buried in the cloisters of Westminster Abbey,"

"With manners gentle, and a grateful heart,
And all the genius of the graphic art,
His fame shall each succeeding artist own,
Longer by far than monuments of stone."

This man so gifted, so pure, whose company and conversation conferred instruction on the wise, and honour on the dignified, is spoken of in the latter part of the eighteenth century, by Walpole, who acknowledged his virtues and admired his talents, in terms, when his name is connected with the rich and titled, that would in this country, at this time, be thought degrading to any—the lowest and most ignorant member of our happy republican society. The earl of Oxford saw the merits of the artist, purchased his works, and gave them their due praise. This is called the " bounty of the patron." "Another patron was the earl of Winchelsea." How did he protect him, and from whom or what? The artist " painted and engraved" his picture. He gratified the earl's wishes, perhaps his vanity, and rescued his effigies from oblivion. Thus the artist conferred the favour, but the lord is called and acknowledged as the protector of the man whose knowledge and skill he sought, for his own gratification and improvement. " Lord Coleraine," says Walpole, " is enumerated by Vertue, among his protectors." He is represented as travelling with Lord Oxford—as making the journeys he took with

him and others, "more delightful, by explaining, taking
draughts, and keeping a register of what they saw ;" and then,
drawing up " an account of this progress and presenting it to
his patron." He is represented as " humble before his supe-
riors." Who were they ? The men who possessed castles and
palaces, and looked to him for an explanation of the treasures
their libraries, cabinets, and galleries contained. The earl of
Oxford died. He and the artist had been friends ; and the
artist, according to the custom of the time, felt that the earl
was his superior, and lamented the loss as if he had been left
without " support, cherisher," or "comfort." "He was a
little revived," says Walpole, "by acquiring the honour of
the Duke of Norfolk's *notice.*" " The Duke of Richmond
and Lord Burlington did not forget him among the artists
they *patronized.*" But in 1749 he found a yet more exalted
protector. " The prince of Wales sent for him, and finding
him capable of the task of explaining to his ignorance, the his-
tory of those treasures of art his hereditary fortune had put in
his possession ; and of pointing out the mode of making his
collection more valuable"—What followed ? " The artist,"
says Walpole, " often had the honour of attending the prince ;
was shown his pictures by himself, and accompanied him to
the royal palaces." And he had the further honour of being
" employed" by his protector, "in collecting prints for him,
and taking catalogues, and sold him many of his own minia-
tures and prints."

Such was the manner of thinking and speaking in Great
Britain in the eighteenth century. There are individuals
in America who, without due reflection, or, from residing too
long in England, or, perhaps, being foreigners, and not under-
standing the nature of our institutions, and the manner of
thinking which those institutions induce, sometimes talk of
patronage and protection ; but from the very first settlement
of this country, the germs of republican equality were planted
in our soil ; they grew with the growth of the colonies, and
were nursed into maturity by the blood of our fathers. The
laws are here the only protectors. Industry, virtue, and
talents, the only patrons. The ignorant, the afflicted, the
weak, the unfortunate may want aid, instruction, protection,
from the strong, and the rich, and the wise ; but the artist—the
man who possesses the genius, skill, and knowledge which en-
titles him to that name—will look to be honoured and esteem-
ed by his fellow-citizens ; not seeking protection, from them ;
or acknowledging superiority, except in superior worth.

Happy ! thrice happy country ! where the lord, the prince,
or the king, on touching youı shores, becomes a man, if he

possesses the requisites for one : or, if not, falls below the level of the men who surround him ;—where the man of virtue and talents is the only acknowledged superior, and where the man possessing those requisites of an artist, needs no protector and acknowledges no patron. The artist who feels the necessity of patronage, must do one of two things—abandon his high and responsible character, bow to the golden calf that he may partake of the bread and wine set before the idol, or abandon his profession—grasp the axe and the plough, instead of the crayon and pencil. The agriculturist, the mechanic, the sailor, the cartman, the sawyer, the chimney-sweeper, need no protectors. When they are wanted they are sought for—so should it be with the artist ; at least let him be as independent as the last.

The artists who visited the colonies found friends and employers ; they did not need protectors. They exchanged the product of their skill and labour for the money of the rich, and received kindness and hospitality " in the bargain." Our first visiters were probably all from Great Britain ; and none staid long. The pilgrims who sought refuge from oppression, and the other pioneers of colonization, had their thoughts sufficiently employed on the arts of necessity, and the means of subsistence or defence. Their followers brought wealth and pictures, and imported from *home* the articles of luxury, and the materials for ornamental architecture. As wealth increased, art and artists followed ; and as the effects of that freedom which the colonists enjoyed was felt, native artists sprung up, and excelled the visiters from the father land.

As the work of Vertue, the historian of the arts in England, has been made perfect by Walpole and Dalaway, so we may hope that in process of time, this work will have additions made to it by those who may discover more than has been yielded to our researches. We have rescued many facts from oblivion which would otherwise have been lost, and perhaps opened the way for the discovery of more. Many of the artists who first visited the colonies, have left no traces that we can as yet discover. We, therefore, begin our history of the arts of design as introduced into the country now called the United States of America, with the name of a man who chose for his place of residence the native town of the writer. Probably many of the pioneers who led the way, and opened a path for the arts in our country, had little merit as artists, but they are objects of curious inquiry to us of the present day ; for as we earnestly desire to know every particular relative to the first settlers who raised the standard of civilization

in the wilderness; so the same rational desire is felt, especially by artists, to learn who were their predecessors; who raised and who supported the standard of taste, and decorated the social column with its corinthian capital.

<div style="text-align:right">John Watson, 1685–1768.</div>

JOHN WATSON—1715,

came to the colonies in 1715, and set up his esel* in the capital of New-Jersey, Perth Amboy. This gentleman was a native of Scotland. The precise place of his birth we do not know; the year in which he was born is found by the date of his death engraved on his tombstone, and the age at which he died. He was born in 1685.

The commanding and beautiful point on which the settlers and proprietors of New-Jersey fixed for the site of their capital, has a fine harbour, sheltered by Staten Island on one side, and the hills of Monmouth on the other, and receiving the waters of the Raritan from the west, and those of the Pesaic and Hackensack through Arthurkull Sound, from the north. In the eyes of the colonists of that day, it was viewed as the seat designed by nature for the great commercial metropolis of the middle colonies. Time has shown how baseless were their hopes. Commerce has centered at the meeting of a greater river, with a more extensive arm of the sea; but the capital of New-Jersey, notwithstanding the vicinity of New-York, was in 1715, and long after, a place of commercial and political consequence; it will ever be in situation and capabilities one of the pleasantest and most healthy places on the sea-board.

Mr. Watson fixed upon this city as the place of his sojourn, purchased land, and built houses. He was a Scotchman, and by profession a portrait painter. He lived long in the land of his choice, and died in extreme old age.

The writer remembers well the child's wonder that was caused in his early life, by the appearance of the house this artist once owned, (for he was then dead,) and the tales that were told of the *limner* in answer to the questions asked. His dwelling-house had been pulled down by his heir, but a smaller building which adjoined it, and which had been his painting and picture house, remained and attracted admiration by the

* The Esel is a frame on which the artist places his picture when he paints. The name is German, and has been adopted by the English painters from the Germans and Flemings, who introduced the art into England. The word means a beast of burthen—an ass—as we call that frame a horse on which boards for scaffolding are placed. The painter's maul-stick has the same origin, from the German *malen* to paint, and *maler* a painter.

1 GOVERNOR WILLIAM BURNET. Drawing by John Watson. *Courtesy The New-York Historical Society*.

2 DANIEL HENDRICKSON. Drawing by John Watson. *Courtesy The New-York Historical Society*.

heads of sages, heroes, and kings. The window-shutters were divided into squares, and each square presented the head of a man or woman, which, if memory can be trusted at this distant period, after an interval of more than sixty years, represented personages in antique costume, and the men with beards and helmets, or crowns. In answer to the questions elicited by this display of art, the inquirer was told that the painter had been considered in the neighbourhood, and was handed down traditionally as a miser and an usurer—words of dire portent—probably meaning that he was a prudent, perhaps a wise man, who lived without ostentation or superfluous expense, and lent the excess of his revenue to those who wanted it, and who could give security for principal and interest, instead of locking it up as a useless idol in his strong box, or risking it on the fluctuating waves of commercial enterprise. " The story ran" that old Mr. Watson painted many portraits and lent his money to those who employed him, thus procuring employment from those who could secure payment, and, according to English phraseology, patronizing his patrons. At all events, like Jacob's flocks and Shylock's ducats, his riches had increase.

> " This was a way to thrive, and he was blest,
> And thrift is blessing, if men steal it not."

Mr. Watson never was married, and having no children he prevailed upon several relatives, notwithstanding that attachment to their soil which distinguishes his countrymen, to leave Scotland, and settle in Perth Amboy, made dear to them by one of its names, and the report of the painter's riches. He had a nephew who was a midshipman in the British navy, but even that comparatively eligible home was abandoned, on promise of inheriting his uncle's wealth. Mr. Alexander Watson, the son of the painter's brother, accordingly became a resident with his uncle, superintended his business when he became too infirm to paint or even to examine bonds and mortgages, and shared his frugal fare with the cheering hope of a blessed change when the old man should " shuffle off this mortal coil."

But " hope deferred maketh the heart sick." The painter became blind, and deaf, and bed-rid, but still he lived. In this condition the old man remained several years. The nephew, anticipating the hour in which he was to become lord of money and houses, and lands, used to speak of this as *that* which must soon come " in the course of nature, you know," but in the meanwhile had no power over the revenue. During this period, which is called proverbially the time of " waiting for

dead-men's shoes," the house wanted repairing ; but the bed-rid man turned his deafest ear to any proposal involving the expenditure of money, for that or any other purpose. The hand grasped the world's idol with the greater intenseness as the hour approached on which its hold must be relaxed forever. The nephew, *trusting* to the uncle's incapability of moving or hearing, and finding tradesmen willing to *trust* to the kind course of nature, determined to prevent the decay of the property he felt an heir's affection for, and concluded his bar-gain with the carpenters for a new roof, to be paid for " in the course of nature, you know." Accordingly the house was unroofed, and re-roofed, while the owner was living in it, per-fectly unconscious of the important operation which was in progress over his head. The strokes of hammers, however, occasionally reached his ear, and penetrated through the ob-stacles interposed by art and nature, and the heir was startled by the question, " What is the meaning of that pecking and knocking that I hear every day ?" The nephew taken by sur-prise, answered, " pecking !—pecking ?—oh, ay !—it's the woodpeckers—they are in amazing quantities this year—leave the trees, and attack the roofs of the houses. There is no driving them off." The roof was finished, and the saucy birds ceased pecking.

"In the course of nature" the old man at length died, but not until between eighty and ninety years of age. After his first visit to America, in 1715, the painter had returned to Eu-rope, and had brought from thence to his adopted country, many pictures, which, with those of his own composition, formed no inconsiderable collection in point of number; of their value we are ignorant. It is, however, a curious fact, that the first painter, and the first collection of paintings of which we have any knowledge, were planted at the place of the writer's nativity—Perth Amboy.

We have been told that many of Mr. Watson's pictures were portraits, real or imaginary, of the kings of England and Scotland ; and this agrees with the awe-inspiring, inveterate heroes we remember to have seen on his window-shutters. The painter's heir very naturally took part with the loyal ad-herents of his former master, and fled from the storm which gathered in New-Jersey threatening the invader, who came with fire and sword to keep the " king's peace," in 1776. The rebels, a motley mass of half-armed militia, under General Mercer, (soon after killed at the battle of Princeton,) made a show of opposition to the *regulars* of Britain, who were divid-ed from them by the waters of Arthurkull Sound. Of course

the deserted house and collection of paintings were left at the mercy of the undisciplined yeomanry, and this first cabinet of the fine arts was broken up, and the treasures dispersed by those who probably took delight in executing summary justice on the effigies of the Nimrods of the father-land.

An excavation, the remains of a cellar, marks the site of Watson's house, and proves that his taste for the picturesque was not despicable. On an elevation which gradually sloped to the verge of the bank, the painter had seated himself; the beautiful point of Staten Island in front, over which he looked to the sea and to the highlands of Navesink, so dear to the mariner; to the right the spacious bay is bounded by the undulating hills of Monmouth, and the rich lowlands of Middletown. Such in life was the artist's situation—his remains lie in the cemetery of the venerable brick episcopal church, a little south of his chosen residence.

His grave is near the south-east corner of the church-yard, and has a tombstone with the following inscription:

" Here lies interred the body of Mr. John Watson, who departed this life August 22d, 1768, aged 83 years."

None of the pictures brought into this country or painted by him can now be found; yet that he had and continues to have an influence on the progress of the arts in the United States, will not be doubted by any who have duly considered the subject of cause and effect. It perhaps would not be too much to attribute the writing of this book to the emigration of Mr. John Watson; it is to be seen whether our efforts will forward the progress of the arts it treats of.

Of the next painter who visited America, we have many interesting particulars.

CHAPTER II.

John Smybert—Dean Berkeley—Nathaniel Smybert—Blackburn—Williams—R. Feke—Theus.

JOHN SMYBERT—1728,

John Smibert, 1688–1751.

(For so he has spelled his name on the picture of Dean Berkeley and family, now at Yale College,) had a powerful and lasting effect on the arts of design in this country. We see the influence of Smybert and his works upon Copley, Trumbull,

and Allston. Copley was a youth of thirteen years of age at the time of Smybert's death, and probably had instructions from him—certainly from his pictures. Trumbull, having retired from the army in the winter of 1776 or spring of 1777, because his commission as deputy-adjutant-general, was dated in September, instead (as he thought it ought to be) in June, resumed his study of painting in Boston in 1777, amidst the works of Copley, and in the room "which had been built by Smybert, in which remained many of his works." And Allston says, in a letter to a friend, after speaking of the pictures of Pine, " But I had a higher master in the head of Cardinal Bentevoglio, from Vandyke, in the College library, (Cambridge,) which I obtained permission to copy, one winter vacation. This copy from Vandyke was by Smybert, an English painter, who came to this country with Dean, afterwards Bishop Berkeley. At that time it seemed to me perfection, but when I saw the original, some years afterwards, I had to alter my notions of perfection ; however, I am grateful to Smybert for the instruction he gave me—his work rather."

It is thus that science, literature and art is propagated ; and it is thus that we owe, perhaps, the colouring of Allston to the faint reflection of Vandyke in Smybert. West, as we shall see, was out of the sphere of Smybert's influence.

We owe the introduction of Smybert to one of the best of men—Dean Berkeley. Gratitude requires that we should not in this work pass by his name with slight notice, and we cannot better pay the debt than by quotations from the "historical discourse" of our distinguished fellow-citizen, Gulian C. Verplanck :—

"With all this metaphysical subtility, Berkeley was equally distinguished for the depth and variety of his knowledge, the exuberance and gracefulness of his imagination, the elegance of his conversation and manners, and the purity of his life. It was about the fortieth year of his age, that, wearied out by these fruitless speculations, in which the most vigorous mind "can find no end, in wandering mazes lost," he conceived the project of founding a University in the island of Bermuda on so liberal a scale as to afford the amplest means of diffusing scientific and religious instruction over the whole of the British possessions in America. Dr. Berkeley, at that time, held the richest church preferment in Ireland, and had the fairest prospects of advancement to the first literary and ecclesiastical dignities of that country, or even of England. All these, with a disinterestedness which excited the astonishment and sneers of Swift and his literary friends, he proposed to resign for a bare

maintenance as principal of the projected American University. His personal character and influence, and the warmth of his benevolent eloquence, soon subdued or silenced open opposition. He obtained a charter from the crown, and the grant of a large sum of money, to be raised from the sale of certain lands in the island of St. Christopher, which had been ceded by the treaty of Utrecht to the British government, but had afterwards been totally forgotten or neglected, and of the real value of which he had with great industry acquired an accurate knowledge.

" To describe Berkeley's confident anticipations of the future glories of America, we must have recourse to his own words.

> The Muse, disgusted at an age and clime
> Barren of every glorious theme,
> In distant lands now waits a better time,
> Producing subjects worthy fame.
>
> In happy climes where from the genial sun
> And virgin earth such scenes ensue,
> The force of art by nature seems outdone,
> And fancied beauties by the true :
>
> In happy climes, the seat of innocence,
> Where nature guides and virtue rules ;
> Where men shall not impose for truth and sense
> The pedantry of courts and schools :
>
> There shall be sung another golden age,
> The rise of empires and of arts,
> The good and great, inspiring epic rage,
> The wisest heads and noblest hearts.
>
> Not such as Europe breeds in her decay,
> Such as she bred when fresh and young,
> When heavenly flame did animate her clay,
> By future poets shall be sung.
>
> Westward the course of empire takes its way ;
> The four first acts already past,
> A fifth shall close the drama with the day—
> Time's noblest offspring is the last.

" I have quoted these fine lines at length because I do not recollect to have seen or heard them referred to in this country. They were written fifty years before the declaration of independence; and to the patriot who may now exult with undoubting hope, in the great and sure destinies of our nation, they may well seem to revive the old connexion between the prophetic character and that of the poet :

For, in a Roman mouth, the graceful name
Of poet and of prophet were the same.*

" Confiding in these glorious auguries, and animated by the
pure ambition of contributing to hasten forward this " rise of
empire and of arts," he sailed from England in 1728. He
came first to Rhode-Island, where he determined to remain for
a short time, for the purpose of purchasing lands on this con-
tinent as estates for the support of his college, as well as in
order to gain a more intimate knowledge of the northern colo-
nies. Here he soon became convinced that he had erred alto-
gether in his choice of Bermuda ; and he applied for an alter-
ation of his charter, empowering him to select some place on
the American continent for the site of the University, which
would, probably, have been fixed in the city of New-York or in
its vicinity.† But in the succeeding year all his sanguine
hopes were at once extinguished by an unexpected court in-
trigue ; and a large sum, (90,000*l.* sterling in all,) that had
been paid into the treasury from the funds pointed out by
Berkeley, and part of which had been solemnly appropriated
to the projected institution, by a vote of parliament, was seized
by Sir Robert Walpole to pay the marriage portion of the
Princess Royal ; an additional proof, if proof were needed, of
the truth of the old republican adage, that the very trappings
of a monarchy are sufficient to support a moderate common-
wealth.

" The two years and a half of Berkeley's residence in Rhode-
Island, had not been idly spent. It was there that he composed
his Minute Philosopher, a work written on the model of the
Philosophical Dialogues of his favourite, Plato, and, like them,
to be admired for the graces which a rich imagination has
carelessly and profusely scattered over its pages, as well as for
novelty of thought and ingenuity of argument. The rural
descriptions which frequently occur in it, are, it is said, exqui-
site pictures of some of those delightful landscapes which pre-
sented themselves to his eye at the time he was writing.

" Berkeley returned to Europe, mortified and disappointed ;
but as there was nothing selfish or peevish in his nature, the
failure of this long cherished and darling project could not
abate the ardour of his philanthropy.

* Cowper.
† This is the opinion of Dr. Chandler, Life of President Johnson. Others
have said that it would have been transferred to Rhode-Island.

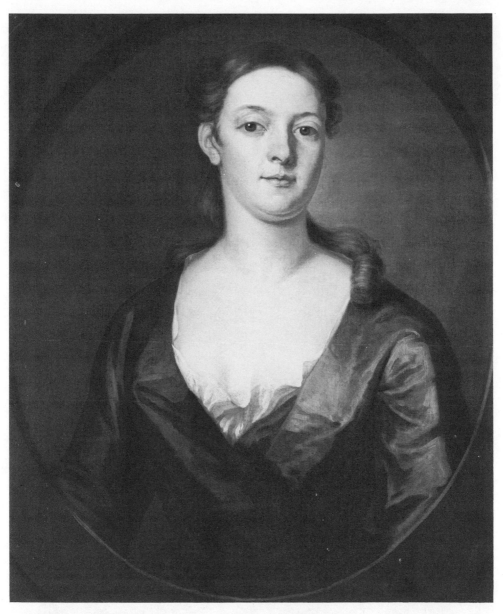

3 Mrs. Thomas Bulfinch. Painting by John Smibert. *Courtesy The Cleveland Museum Of Art, Hinman B. Hurlbut Collection.*

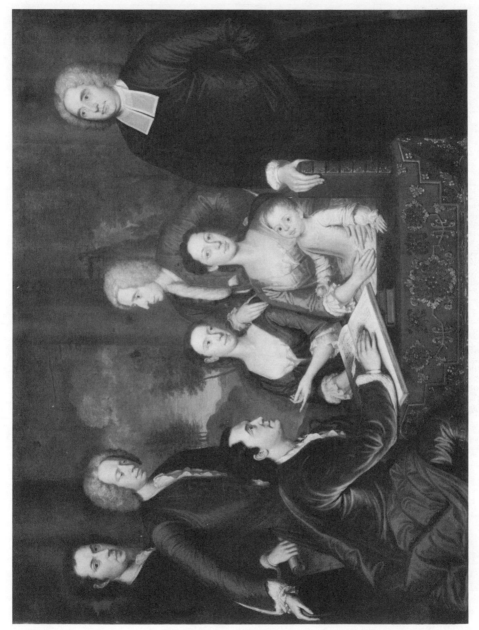

4 THE BERMUDA GROUP, 1729. Painting by John Smibert. *Courtesy Yale University Art Gallery.*

" The rest of his history belongs more to Ireland than to America. Never had that ill-governed and injured country a purer or more devoted patriot. His Querist, his Letters to the Roman Catholic clergy, and his other tracts on Irish politics, are full of practical good sense, unbounded charity, and the warmest affection for his country.

" Such was the strong and general sense of the usefulness of these labours, that, in 1749, the body of the Irish Roman Catholic clergy, in a formal address to Dr. Berkeley, who was then Protestant Bishop of Cloyne, returned him " their sincere and hearty thanks," for certain of these publications, assuring him that " they were determined to comply with his advice in all particulars ;" they add, " that every page contains a proof of the author's extensive charity, his views are only towards the public good, and his manner of treating persons, in their circumstances, so very uncommon, that it plainly shows the good man, the polite gentleman, and the true patriot."

He died at Oxford, in 1763, in his seventy-third year. His epitaph in the cathedral church of that city, deserves to be cited for the dignified and concise elegance with which it records his praise.

On a stone, over his grave, is the often quoted line of Pope,

" To Berkeley every virtue under heaven ;"

and above it, after his name and titles,

> Viro
> Seu ingenii et eruditionis laudem
> Seu probitatis et beneficentiæ spectemus,
> Inter primus omnium ætatum numerando.
> Si Christianus fueris
> Si amans patriæ
> Utroque nomine gaudere potes
> BERKELEIUM VIXISSE.

Swift, in a letter to Lord Carteret, says—

" There is a gentleman of this kingdom just gone for England; it is Dr. George Berkeley, Dean of Derry, the best preferment among us, being worth eleven hundred pounds a year. And because I believe you will choose out some very idle minutes to read this letter, perhaps you may not be ill entertained with some account of the man and his errand. He was a fellow of the university here, and going to England very young, about thirteen years ago, he became the founder of a sect there, called the *Immaterialists,* by the force of a very curious book upon that subject. Dr. Smallridge and many other eminent persons were his proselytes. I sent him secre-

tary and chaplain to Sicily, with my Lord Peterborough; and upon his lordship's return, Dr. Berkeley spent above seven years in travelling over most parts of Europe, but chiefly through every corner of Italy, Sicily, and other islands. When he came back to Ireland. he found so many friends that he was effectually recommended to the Duke of Grafton, by whom he was made Dean of Derry. Your excellency will be frightened when I tell you all this is but an introduction; for I am now to mention his errand. He is an absolute philosopher with regard to money, titles, and power; and, for three years past, has been struck with a notion of founding a university at Bermudas, by a charter from the crown. He has seduced several of the hopefullest young clergymen and others here, many of them well provided for, and all of them in the finest way of preferment; but in England his conquests are greater, and I doubt will spread very far this winter. He showed me a small tract which he designs to publish; and there your excellency will see his whole scheme of a life academico-philosophical (I shall make you remember what you were) of a college founded for Indian scholars and missionaries; wherein he most exorbitantly proposes a whole hundred pounds a year for himself, forty pounds for a fellow, and ten for a student. His heart will break if his deanery be not taken from him and left to your excellency's disposal. I discouraged him by the coldness of courts and ministers, who will interpret all this as impossible, and a vision; but nothing will do. And, therefore, I humbly entreat your excellency either to use such persuasions as will keep one of the first men in this kingdom, for virtue and learning, quiet at home; or to assist him by your credit to compass his romantic design; which, however, is very noble and generous, and proper for a great person of your excellent education to encourage."

And Dr. Blackwall thus speaks of the wonderful variety and extent of Berkeley's knowledge:

" I would with pleasure do justice to the memory of a very great, though singular sort of man, Dr. Berkeley, better known as a philosopher and intended founder of a university in the Bermudas than as Bishop of Cloyne, in Ireland. An inclination to carry me out on that expedition as one of the young professors, on his new foundation, having brought us often together, I scarce remember to have conversed with him on that art, liberal or mechanic, of which he knew not more than ordinary practitioners. He travelled through a great part of Sicily on foot, clambered over the mountains, and crept into the caverns to investigate its natural history and

discover the causes of its volcanoes; and I have known him sit for hours in forgeries and founderies, to inspect their successive operations. I enter not into his peculiarities, either religious or personal, but admire the extensive genius of the man, and think it a loss to the western world, that his noble and exalted plan of an American university was not carried into execution."

The reader will not think that too many pages devoted to the arts have been appropriated to a man so singular, and to whom America owes so much, both in her arts and her literature; for Berkeley, in his benevolent project for spreading knowledge in America, did not neglect the important agency of the arts of design, and having experience of the character and talents of Smybert, who had been his fellow-traveller in Italy, chose him as the professor of drawing, painting, and architecture for his intended institution.

" Smybert," as Mr. Verplanck justly observes, "was an artist of the first rank, for the arts were then at a very low ebb in England; but the best portraits which we have of the eminent magistrates and divines of New-England and New-York, who lived between 1725 and 1751, are from his pencil.

"Horace Walpole, in his 'Anecdotes of Painting, in England,' gives some account of him. Walpole was a man of fashion and pleasure, of wit and taste, and withal a most expert hunter of antiquarian small game; but he had no heart for any thing generous or great, and he speaks of Berkeley's plans as might be expected from such a man; though he may be pardoned, for slurring over, as he does, his own father's conduct in the business.

"' John Smybert, of Edinburgh, was born about 1684, and served his time with a common house painter; but eager to handle a pencil in a more elevated style, he came to London, where, however, for subsistence, he was forced to content himself, at first, with working for coach-painters. It was a little rise to be employed in copying for dealers, and from thence he obtained admittance into the academy. His efforts and ardor at last carried him to Italy, where he spent three years in copying Raphael, Titian, Vandyck, and Reubens, and improved enough to meet with much business at his return. When his industry and abilities had thus surmounted the asperities of his fortune, he was tempted, against the persuasions of his friends, to embark in the uncertain, but amusing, scheme of the famous Dean Berkeley, afterwards Bishop of Cloyne, whose benevolent heart was then warmly set on the erection of a universal college of science and arts, for the instruction of

heathen children in christian duties and civil knowledge. Smybert, a silent, modest man, who abhorred the finesse of some of his profession, was enchanted with a plan that, he thought, promised him tranquillity and honest subsistence in a healthful elysian climate, and in spite of remonstrances, engaged with the Dean, whose zeal had ranged the favour of the court on his side. *The king's death dispelled the vision.* Smybert, however, who had set sail, found it convenient, or had resolution enough, to proceed, but settled at Boston, in New-England, where he succeeded to his wish, and married a woman with considerable fortune, whom he left a widow with two children, in 1751.'

" Walpole adds, ' We may conceive how a man, so devoted to his art, must have been animated, when the Dean's enthusiasm and eloquence painted to his imagination a new theatre of prospects, rich, warm, and glowing with scenery which no pencil had yet made cheap and common by a sameness of thinking and imagination. As our disputes and politics have travelled to America, is it not probable that poetry and painting, too, will revive amidst those extensive tracts as they increase in opulence and empire, and where the stores of nature are so various, so magnificent, and so new?" This was written in 1762.'

There is at Yale College a large picture, and, from its subject, an interesting one, representing Berkeley and some of his family, together with the artist himself, on their first landing in America. I presume that it is the first picture of more than a single figure ever painted in the United States."

We find the following passage in a letter from Ramsay, the author of the " Gentle Shepherd," to Smybert, dated 1736.

" My son Allan has been pursuing his science since he was a dozen years auld; was with Mr. Hiffdig in London for some time, about two years ago; he has since been painting here like a Raphael; sets out for the seat of the beast beyond the Alps within a month hence, to be away two years. I'm sweer to part with him, but canna stem the current which flows from the advice of his patrons, and his own inclination."

Even this scrap has become interesting. But the following letter from Professor Goodrich, of Yale College, with the extract from President Styles, are incomparably more so.

Yale College, April 20, 1834.

Sir—I embrace the earliest opportunity in my power to answer your inquiries respecting Smybert's painting of Bishop

Berkeley and family, which forms a part of the gallery belonging to this college.

This institution had a peculiar interest in possessing some memorial of that distinguished man, because he was among our early benefactors. He came to this country in the year 1728, to carry into effect a project which he had long entertained, of founding a college in Bermuda, " for converting the *savage* Americans to christianity." A large grant was promised him for this purpose, by the British government; and while waiting for its arrival, he resided, about two years, at Newport, R. I. where he had purchased a farm. Here the painting in question was executed by Smybert, who had attended Bishop Berkeley to this country as a member of his family, which likewise embraced a young lady of the name of Handcock, and two gentlemen of fortune, Mr. James and Mr. Dalton. Being disappointed in receiving the money promised by the government, he abandoned the project, but before his return to England, being made acquainted with the condition and wants of this college, he presented it with some valuable books, to which he added after his return, a donation of a thousand volumes, " the finest collection of books," President Clapp says, in his History, " that ever came together at one time to America." He sent also a deed of his farm on Rhode-Island, which he directed to be held in trust for " the maintenance, during the time between their first and second degree," of three students of the college, who should be found on examination to be most distinguished for their attainments in the Latin and Greek languages; and in default of applicants at any time, to the purchase of Latin or Greek books, as premiums for Latin compositions in the several classes. This farm now produces about one hundred and fifty dollars a year, and the proceeds are regularly applied to the objects designated by the donor.

About the year 1800, the late President Dwight, being on a tour to the south-eastern part of Massachusetts, met with Smybert's picture of the Berkeley family—in what place I cannot exactly learn. It was but little prized, however, by its possessor; and had been thrust aside and neglected until it had suffered considerable injury, though not in any important part. I have never heard how a painting of so much value came into such a situation. Dr. Dwight was naturally desirous to obtain it for the college; and through the intervention of Dr. Waterhouse, of Cambridge, succeeded in his object. It is to this gentleman chiefly that we are indebted for our knowledge of the details of this picture. It is nine feet

long, and six wide, and represents Bishop Berkeley as standing at one end of a table, which is surrounded by the other members of his family. He appears to be in deep thought, his eyes slightly raised ; one hand resting on a folio volume (a copy of Plato, his favourite author) which stands on the table before him ; and is engaged in dictating to his Amanuensis (who is seated at the other end of the table) part of the Minute Philosopher, which is said to have been commenced during his residence at Newport. The figure of the Amanuensis, which is an uncommonly fine one, represents Sir James Dalton. Miss Handcock, and Mrs. Berkeley, with an infant in her arms, are seated on one side the table, whose two ends are occupied in the manner just described, while Mr. James, and a gentleman of Newport, named John Moffat, stand behind the ladies. The painter has placed himself in the rear, standing by a pillar, with a scroll in his hand ; and beyond him opens a very beautiful water scene, with woods and headlands, the original of which probably once existed on the shores of the Narragansett bay. Dr. Dwight used to state though I know not his authority, that the sketch of this picture was originally made at sea ; and was enlarged and finished at a subsequent period after his residence at Newport. The Mr. Moffat mentioned above, is said, by Dr. Waterhouse, to have been a dealer in paints, a Scotchman, brother to Dr. Thomas Moffat, who was well known at Newport, and afterwards at New-London.

Of Smybert I know nothing. Dr. Waterhouse mentions that he married a daughter of Dr. Williams, who was the Latin schoolmaster of the town of Boston for fifty years.

I enclose an extract from a sermon of President Stiles, respecting Smybert.

The name on the painting is spelled with a *y*.

I am, sir, with much respect, yours, &c.

C. A. GOODRICH.

"Mr. Smybert, the portrait painter, who in 1728 accompanied Dr. Berkeley, then Dean of Derry, and afterwards Bishop of Cloyne, from Italy to America, was employed, while at Florence, by the Grand Duke of Tuscany, to paint two or three Siberian Tartars, presented to the duke by the Czar of Russia. This Mr. Smybert, upon his landing with Dr. Berkeley at Narragansett bay, instantly recognised the Indians here to be the same people as the Siberian Tartars, whose pictures he had taken."

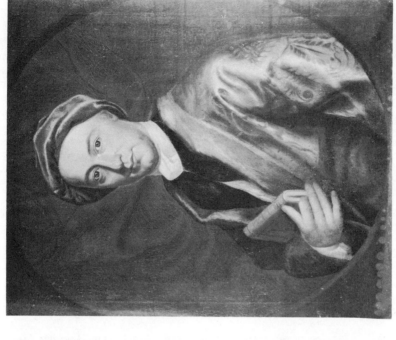

5B Ezra Stiles, 1756. Painting by Nathaniel Smibert. *Courtesy Yale University Art Gallery, gift of a number of subscribers through Anson Phelps Stokes.*

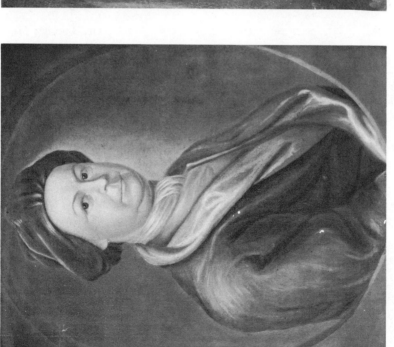

5A John Lovell. Painting by Nathaniel Smibert. *Courtesy Fogg Art Museum, Harvard University.*

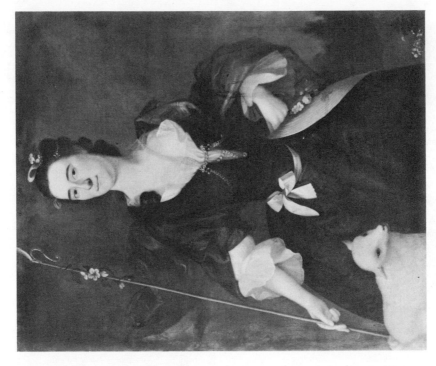

6A MRS. JAMES PITTS. Painting by Joseph Blackburn. *Courtesy The Detroit Institute of Arts.*

6B MARY SYLVESTER, 1754. Painting by Joseph Black- burn. *Courtesy The Metropolitan Museum of Art.*

Thus we see that Smybert married respectably, and we know that he lived in Boston in high estimation until the year 1751, leaving two children. One of the children of John Smybert, was a son of the name of Nathaniel, who was born and died in America. We have the following notice of him from our valued correspondent, Judge Cranch, of Washington, district of Columbia.

NATHANIEL SMYBERT.

Nathaniel Smibert, 1735–1756.

"There was a young painter in Boston, the particular friend of my father, about the year 1755, whose name should not be omitted in the list of American artists ; as he bade fair to be one of the first of the age. His name was Nathaniel Smybert. I have an original letter of friendship from him to my father, (the late Judge Cranch of Quincy, in Mass.) dated ' Boston, August 5, 1755,' and a copy of my father's answer, in which he says, ' When I consider the ease with which your hand improves the beauty of the fairest form, and adds new charms to the most angelic face, I do not wonder that your riper imagination should fly beyond your pencil, and draw the internal picture of your friend so much fairer than the original.'

"In a letter from my father to the late Dr. John Eliot, of Boston, dated ' Quincy, July 20th, 1809,' he says ' Mr. Nathaniel Smybert, whom you mention, was one of the most amiable youths that I ever was acquainted with ; *but he came forth as a flower and was cut down.* I cannot now, after an interval of more than fifty years, recollect the time of his birth or his death. I remember that Mr. Peter Chardrou, who took his degree in 1757, was then one of our acquaintance ; and I think that Mr. Smybert died about that time. I do not recollect that he left any writings. He received his grammar instruction under the famous master John Lovell, but did not proceed to a collegiate education. He engaged in his father's profession of painting, in which he emulated the excellencies of the best masters ; and had his life been spared he would probably have been, in his day, what Copley and West have since been, *the honour of America in the imitative art.* I remember that one of his first portraits was the picture of his old master Lovell, drawn while the terrific impressions of the pedagogue were yet vibrating upon his nerves. I found it so perfect a likeness of my old neighbour, that I did not wonder, when my young friend told me that a sudden, undesigned glance at it had often made him shudder.' " Of

Joseph Blackburn,
fl. c. 1754–*c.* 1760.

BLACKBURN

all we know is, that he was nearly contemporary with John
Smybert, and painted very respectable portraits in Boston. Of

William Williams,
fl. c. 1747–*c.* 1770;
died *c.* 1790.

WILLIAMS,

who painted in Philadelphia at the time Smybert flourished in
Boston, we know little more than of Blackburn. This gentle-
man would have escaped our notice, but that Benjamin West
remembered him with gratitude, as the man who put into his
hands, when a boy, the first books he had ever read on the
subject of painting, and showed him, in specimens from his
own pencil, the first oil pictures he had ever seen.

Mr. Williams was an Englishman, and was employed by
the inhabitants of Penn's city, in 1746–7, and perhaps after.
That he sought knowledge in his art we know, or he could
not have lent to the boy, West, the works of Fresnoy (of
course the translation) and of Richardson ; of his attainments
as exemplified in his pictures, we know nothing. The instruc-
tion that Benjamin West received from his conversation, his
books, and his paintings, entitles him to a place among those
who assisted in forwarding the progress of the arts of design
in our country.

Robert Feke, *c.* 1705–*c.* 1750.

R. FEKE

is the name of a painter inscribed on a portrait of Mrs. Welling,
with the date of 1746, of course was contemporary with Wil-
liams.

John Green, ?–1802.

GREEN

is the name of a portrait painter, who visited the colonies
nearly about the same time.*

The next name we can record is that of

Jeremiah Theus, *c.* 1719–1774.

THEUS.

A gentleman of this name painted portraits in South Caro-

* Our friend John F. Watson, to whom the public is indebted for researches
into the antiquities of our recent country, informs us that he has seen a portrait
of Samuel Carpenter, a primitive settler of Philadelphia, a leader, and one of its
ablest improvers. The portrait, he says, is well painted. This Samuel Carpen-
ter was the original owner of the house in which William Penn lived in 1700, and
in which John Penn, the only one of the race born in America, first saw the light.
Carpenter's portrait is a little under the size of life, and is now (1833) with a
descendant, Isaac C. Jones, Eighth-street, Philadelphia. This portrait may have
been painted before Carpenter left England.

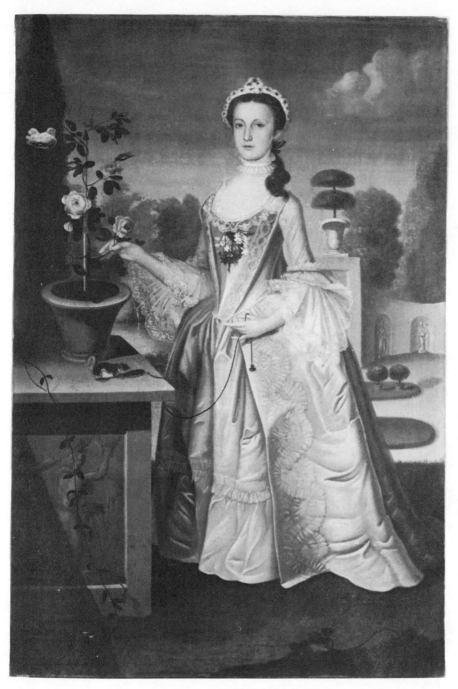

7　Deborah Hall, 1776. Painting by William Williams. *Courtesy The Brooklyn Museum.*

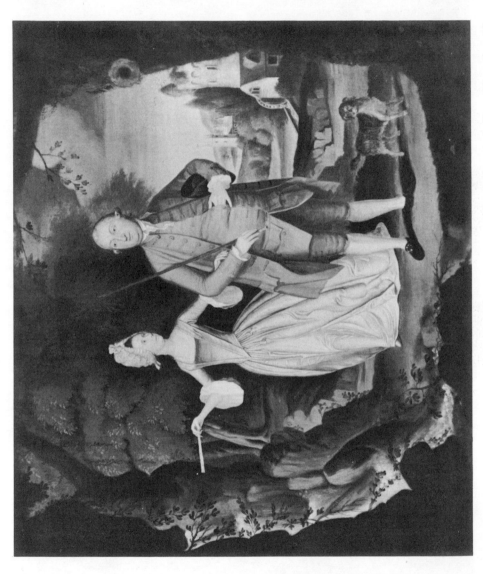

8 CONVERSATION PIECE, 1775. Painting by William Williams. Courtesy Henry Francis du Pont Winterthur Museum.

lina, certainly as early as 1750. The faces (as we are inform-
ed) were generally painted with great care. Our correspond-
ent's expression is, " beautifully painted ;" but he had not the
art to give grace and picturesque effect to the stiff brocades,
enormous ruffles, and outré stays and stomachers of our grand-
mothers ; or the wigs, velvet coats, and waistcoats, with buck-
ram skirts and flaps, and other courtly appendages to the dig-
nity of our grandfathers. His pictures were as stiff and formal
as the originals, when dressed for the purpose and sitting for
them. Our valuable correspondent, Charles Fraser, Esq. of
Charleston, says, " I own one of his pictures, which independ-
ently of its claims as a family portrait of 1750, I value for its
excellence."

CHAPTER III.

The first portrait West painted, 1753—Galt's life of West—West " well born"—
Birth and early education—Ambition—Encouraged by Pennington and Williams
—By Henry the gunsmith—Doctor Smith—Prices for which West painted—
He is assisted by Mr. Allen and other liberal admirers, and embarks for Italy
—Studies and adventures in Italy—Splendour and misery of modern Italy at
that time—Further encouragement to West from his American friends.

THE next painter, in chronological order, is indigenous.
We no longer seek darkling for any of the events we wish to
record. His virtues and his talents have shed a lustre around
his name, and we view him by a light radiating from himself.
His influence on the art he professed will never cease.

BENJAMIN WEST

Benjamin West, 1738–1820.

commenced portrait-painting in the year 1753, and is there-
fore the next subject for the reader's consideration. We shall
show his early efforts in his native country, and accompany
him to the land which old Allan Ramsay called " the seat of
the beast," but which West found a pure fountain of instruc-
tion—for to the pure all is pure—the land of Buonorotti and
Raphael—the land of colour and form, and of all those asso-
ciations which make and delight the poet and the painter.
From thence we shall follow him to the land of his fathers, and
show the effects of his unsullied life as a man, and unrivalled
skill in historical composition, upon the arts of both hemi-
spheres. The picture copied from Vandyke by Smybert pro-

duced effects on the progress of art in America, of which it is difficult to ascertain the limits; but the effects of the fame and the instructions of West are literally incalculable.

In the year 1753, and at the age of fifteen, Benjamin West commenced portrait and historical painter. The first portrait, regularly undertaken as such from a sitter, was that of Mrs. Ross, of Lancaster, Pennsylvania. But it is our duty to go back to an earlier period, and to seek from every source the facts appertaining to his family and early life.

Honest Allan Cunningham gives us the following account of the painter's ancestors:

" John West, the father of Benjamin, was of that family settled at Long Crendon, in Buckinghamshire, which produced Colonel James West, the friend and companion in arms of John Hampden. Upon one occasion, in the course of a conversation in Buckingham Palace, respecting his picture of the Institution of the Garter, West happened to make some allusion to his English descent; when the Marquis of Buckingham, to the manifest pleasure of the late king, (George III.,) declared that the Wests of Long Crendon were undoubted descendants of the Lord Delaware, renowned in the wars of Edward the Third and the Black Prince, and that the artist's likeness had therefore a right to a place among those of the nobles and warriors in his own piece."

Benjamin West has found a most injudicious biographer in John Galt, but still we may rely upon certain portions of his book, although we dismiss the puerilities of the performance, and the absurd tales and speeches of general officers, Quaker preachers, Indian actors, and Italian improvisatori, which we find in it, as altogether unworthy. West never could have given Mr. Galt a long harangue as Washington's, addressed to a woman who brought him a letter from parson Duché to persuade him to renounce the cause of his country and join the arms of England. A letter which agitated the general much, as Galt writes, and, as is intimated, caused indecision as to the course he should pursue; for the writer says, " Having decided with himself, he stopped" from walking " backwards and forwards," " and addressed her in nearly the following words." Among other absurdities, he is made to say, " I am here intrusted by the people of America with sovereign authority," and continues to justify his conduct in a strain of stupid bombast that would disgrace a schoolboy. Neither is it to be believed that Mr. West furnished his biographer with the speeches of the quaker preachers, or of the Mohawk Indian who found another Mohawk Indian an actor on the stage at

New-York. Such passages are almost enough to make us disbelieve the whole of Mr. Galt's book; but as I hope I can separate the poetry from the facts, I will make use of the work in combination with such truth as I can collect from other sources, or possess of my own knowledge.*

* Since writing the above, my attention has been called to a notice of John Galt's book, in a publication called "The Friend," which so perfectly agrees with my previous decision on the subject, and is so conclusive, from facts brought forward by the writer, which did not come within the compass of my knowledge, that I insert some extracts as being connected essentially with my work, and showing the gross falsehoods and misapprehensions which are thrust upon us as historical truth.

"The extreme improbability of the narrative here given of some of the principal events of the early life of our celebrated painter, induced the writer of this notice, soon after its publication, to investigate its claims to authenticity. The result of that examination was published in one of the daily journals, and was long since forgotten by him, until revived by seeing the same erroneous narrative copied into several recent notices of Benjamin West, particularly that contained in Allan Cunningham's Lives of Celebrated Painters, which forms part of the series of Harpers' Family Library, and that in the American edition of the Edinburgh Encyclopedia."

Of the story of Peckover and of the effect of his sermon on West's mother, the writer says:

"Now this is truly a wonderful story, and if it were but true, would be delightful to many a lover of the marvellous. Unfortunately, however, it is utterly destitute of this essential quality. The birth of West is fixed in the autumn of 1738. Edmund Peckover did not visit America till the year 1743—*five years* after this pretended prophecy. He was a popular and fervid preacher; but the question whether he was likely to have made the foolish speech about the wonderful boy, need not hereafter be discussed."

Of the story of the meeting of Friends to decide on West's being allowed to become a painter, and the harangue of John Williamson, with the effect, is thus given by Galt:

"At the conclusion of this address, the women rose and kissed the young artist, and the men, one by one, laid their hands on his head, and prayed that the Lord might verify in his life the value of the gift which had induced them, in despite of their religious tenets, to allow him to cultivate the faculties of his genius."

The writer in "The Friend" justly observes.

"Well might the author exclaim, the history of no other individual affords an incident so extraordinary! The whole story bears intrinsic marks of fiction: and we do not hesitate to say, that no such incidents ever occurred to West. That his father, hesitating when his resolution was shaken by the boy's pertinacity, may have consulted a few of his friends, is by no means improbable; neither is it at all unlikely that some of the old gentlemen may have patted him on the head, and warned him of the dangers to which he was about to expose himself. But how strangely would the polished and artificial oration of John Galt have sounded from the lips of honest John Williamson! It is a gross and palpable fiction, and has not the merit of probability, or of what in painting is called *keeping*. That a meeting of the religious Society of Friends was convened at the meeting-house in Springfield to decide on the destiny of the boy, is scarcely possible. That a private meeting was held in order to bestow upon him *in form* the assent and blessing of the Society is a circumstance which *could not* happen under any organization of our society which has ever existed. That at the conclusion of the *service*, the women all kissed the boy, and that the men, *one by one, laid their hands on his head*, and *prayed*, is sufficient of itself to destroy the credibility of the whole memoir, unless in parts where its truth is confirmed from

Benjamin West, the youngest son of John West and Sarah Pearson, was born near Springfield, in Chester county, in the province of Pennsylvania, on the 10th of October, 1738. Ten years after Smybert, as before stated, visited America in company with Dean Berkeley.

The town of Springfield owes its name to the farm on which the painter was born, which was the original settlement of his maternal grandfather; and in clearing the first field a spring of fine water was discovered, which gave name to the farm, and subsequently to the township. Thus is the name of the town associated with West, and derived from one of his ancestors.

The family of West were quakers, and emigrated to America from England in the year 1699, but left John, the father of Benjamin, at school in the land of his nativity. He did not join his relations until 1714.

After having taken unto himself a wife, he found it convenient to leave her with her relatives, while he explored the land of promise. During this visit of pioneering, his wife died in childbed. The child lived, and was adopted by its mother's relations, all quakers. The father determined to settle in Pennsylvania, and wrote to have the child sent to him. Those who had charge of the boy had become attached to him, and John at length consented that his first born should remain in England. As we shall never again, probably, mention this brother of the painter, we shall refer the reader to his portrait in the West family picture, which has been engraved, where he is represented sitting by the side of his venerable father, both in quaker costume.

Of this family picture Mr. Leslie in a letter to us says:

"When John West, the father of Benjamin, accompanied Miss Sewell to England, as the affianced bride of the painter, the old gentleman met his eldest son, who was a watchmaker settled at Reading, and at that time forty years of age."

Benjamin West, although born in humble life, was essentially *well-born;* though not of parents who by riches or station could insure, or even promote his views of ambition. His father a man of sense, his mother affectionate and exemplary. He was not spoiled by indulgence or soured by thwartings.

other sources. Of John Williamson himself, who is here endowed with super-natural eloquence, I have been able to learn but little, and that little only from tradition. The amount of my gleaning is, that he was a man far from remarkable for any gift of eloquence, and one of the last men in the society to act the part assigned him in this curious *masquerade* of quakerism."

His natural inclinations were good; and they were not poison-
ed by bad education or evil example. The most precious
part of his education was not intrusted to ignorant and vicious
menials; and all who surrounded him were temperate, pure,
and happy. The sordid sufferings of poverty were unknown
to him, neither was he pampered in the lap of luxury. As the
youngest child of the family, he was the favourite of his
parents, and equally so of his brothers and sisters. His phy-
sical advantages were great from nature, and the occupations
of rural life in childhood tended to strengthen and perfect
them. He was taught in the school of realities. He became
acquainted with things as they are. The knowledge which he
gained in the school of experience was not blasted by any
untoward circumstances. His genius was developed by the
friends his manners and his virtues gained him. West may be
said to have been the favoured of fortune as well as nature,
and to have been so led to the height he attained, that men
might say " we know not whether genius or virtue placed him
there." This we know; vice or folly did not counteract
genius.

It is stated that before the age of seven, Benjamin, being
left in charge of a child sleeping in a cradle, made his first
essay at drawing by attempting to represent the infant on a
piece of paper with pen and ink. However imperfect such
an attempt must have been, it is a remarkable fact, if taken in
connexion with the state of society among quakers in a vil-
lage of the new world; for it may be supposed that those pic-
tures which ornament books, and are so attractive to children,
often stimulating to imitation, would be unknown among the
followers of Penn in the year 1745, and it is almost a certainty
that other pictures did not exist in the houses of these primi-
tive people, although many and good were in various parts of
the country. It would seem, then, that there was an intuitive
desire in the individual to express by lines the images of things
as they appeared in his eyes. If the child had not seen any
prints or pictures, the circumstance above noticed must be
considered very extraordinary; and even if he had, the attempt
to draw from nature, at six or seven years of age, is an indi-
cation of an uncommon observation of forms, and still more
uncommon quickness, that could lead to attempt their resem-
blance on a flat surface.

The success of the child's efforts excited the admiration of
his fond parents; and their admiration encouraged his
attempts. The consequences were that in the quaker habita-
tion, rude images of flowers and birds and other things which

struck the boy's fancy were stuck upon the walls and exhibited
to the neighbours. We all know that engravings and paint-
ings had been brought into the colonies long before this time,
and that painters had visited the cities and plantations, exer-
cising their art ; still Springfield probably had seen none of
these wonders or wonder-workers, and those of its inhabitants
who were natives of Europe had probably as little knowledge
of the fine arts as the aborigines. Among such a population
the scratchings of little Ben would produce the exciting effect
which even the admiration of ignorance causes in men as well
as children at this day.

"I find," says a friend, "on a page of Pilkington's Dic-
tionary of Painters, this note, in the handwriting of Mr. Ha-
milton, viz. ' General Wayne's father, who lived in Springfield,
Chester county, when B. West was a lad, took a liking to six
heads in chalk drawn by him, and presented him with six dol-
lars for them. These chalk productions were among Mr.
West's first performances, and he was so much pleased with
their producing so large a price, as to be thereby chiefly
induced to adopt for his means of support the profession of a
painter. This anecdote Mr. West told me in London in 1785,
and said also, that he believed that Mr. Wayne the elder had
given the heads to one of the Penrose family (in Philadelphia)
into which a son of Mr. Wayne had married.' "

Such was the commencement of Benjamin West's drawing.
Of colouring he could know nothing ; and however much the
tints of the birds, the flowers, the fields and the skies, might
delight him, neither colour nor colouring material were found
in the houses of his father or his neighbours, excepting pro-
fane indigo to tinge the starch of the women's caps and ker-
chiefs—all else was holy drab.

Mr. Lewis, the American biographer of West, says, that the
" colours he used were charcoal and chalk, mixed with the
juice of berries ;" and further, that "with such colours *laid on*
with the hair of a cat drawn through a goose quill, when about
nine years of age he drew on a sheet of paper the portraits of
a neighbouring family, in which the delineation of each indivi-
dual was sufficiently accurate to be immediately recognised by
his father, when the picture was first shown to him. When
about twelve years old he drew a portrait of himself, with his
hair hanging loosely about his shoulders."

Fortunately for little Ben the children of the forest who saw
no crime in decorating themselves in the colours which decora-
ted all around them, were yet in the habit of visiting the pur-
chasers of their land, and from the Mohawk or the Delaware

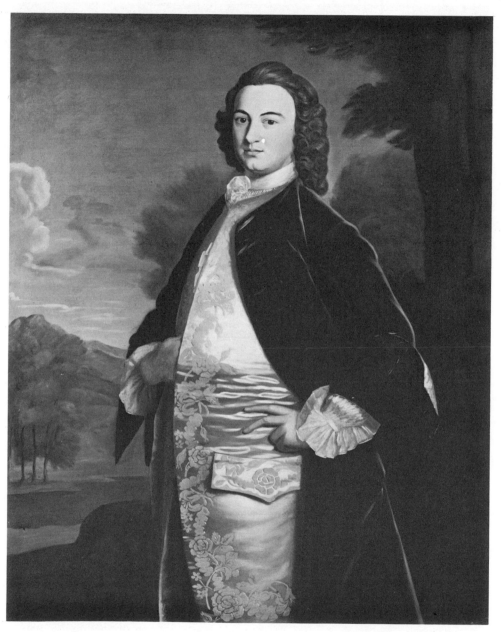

9 JAMES BOWDOIN, 1748. Painting by Robert Feke. *Courtesy Bowdoin College Museum of Art.*

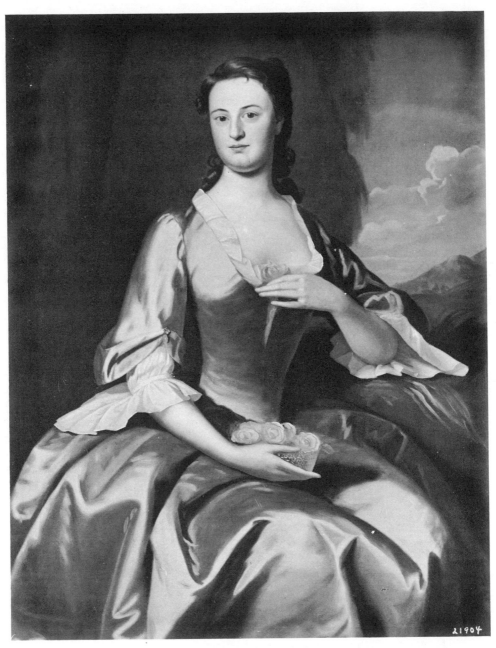

10 Mrs. James Bowdoin (Elizabeth Erving). Painting by Robert Feke. *Courtesy Bowdoin College Museum of Art. Photograph Frick Art Reference Library.*

the boy procured the red and yellow earths used by them at their toilets. Mrs. West's indigo pot supplied blue, and the urchin thus gained possession of those primitive colours which he afterwards knew to be the materials whose combined minglings, in their various gradations, give all the tints of the rainbow.

Drawing and painting were thus introduced to the being who never ceased to cultivate their acquaintance; but still he had no brushes, and on being told that they could be made by inserting hair into a quill, West manufactured his first pencils from the geese and the cat of the establishment.

As West's English and Scotch biographers have an anecdote related by him, marking his early ambition, we must not omit it.

"One of his school-fellows allured him on a half-holiday from trap and ball, by promising him a ride to a neighbouring plantation. 'Here is the horse, bridled and saddled,' said his friend, 'so come, get up behind me.' 'Behind you!' said Benjamin; 'I will ride behind nobody.' 'Oh, very well,' replied the other, 'I will ride behind you, so mount.' He mounted accordingly, and away they rode. 'This is the last ride I shall have,' said his companion, 'for some time. To-morrow I am to be apprenticed to a tailor.' 'A tailor!' exclaimed West; 'you will surely never be a tailor?' 'Indeed, but I shall,' replied the other; 'it is a good trade. What do do you intend to be, Benjamin?'—'A painter.' 'A painter! what sort of a trade is a painter? I never heard of it before.' 'A painter,' said this humble son of a Philadelphia quaker, 'is the companion of kings and emperors.' 'You are surely mad,' said the embryo tailor; 'there are neither kings nor emperors in America.'—'Ay, but there are plenty in other parts of the world. And do you really intend to be a tailor?' —'Indeed I do; there is nothing surer.' 'Then you may ride alone,' said the future companion of kings and emperors, leaping down; 'I will not ride with one willing to be a tailor.'"

When directing our friend Sully how to find the house in which he was born, the old gentleman, in describing the road, pointed out the spot where he abandoned the intended tailor.

The arrival of a merchant from Philadelphia, on a visit to the family, added another link to the chain which united the boy to the fine arts. Mr. Pennington, seeing the effects of little Benjamin's persevering efforts, promised him a box of paints and brushes; and, on his return to Philadelphia, not only performed his promise, but accompanied the materials for

painting with several pieces of canvas prepared for their reception, and " six engravings by Grevling."

The delight which such a child would feel at the reception of such a present, can be better imagined than described. The consequence was imitation of the engravings in colours on the canvas, with such success as delighted his parents, and astonished their neighbours. The result of this boyish effort to combine figures from engravings, and invent a system of colouring, was exhibited sixty-seven years afterwards, in the same room with the " Christ Rejected."

In the building erected to receive "The Healing in the Temple," presented by West to the Pennsylvania Hospital, may now (1833) be seen two of those juvenile performances painted on pannel. The largest is his own composition, and consists of a white cow, who is the *hero* of the piece, and sundry trees, houses, men, and ships, combined in a manner perfectly childish: the other is a sea-piece, copied from a print, with a perfect lack of skill, as might be expected.

Shortly after these first attempts to paint with painters' materials and tools, the boy was permitted to accompany the donor of the treasures to the metropolis of Pennsylvania. With Mr. Pennington the youth resided; and after the novelty of a city had ceased to distract his attention, he commenced his second picture in oil colouring, for his friend and relative. At this time Mr. Samuel Shoemaker, who, though a quaker, had employed Mr. Williams, an artist then residing in the city, to paint a picture for him, desired the painter to carry it to Mr. Pennington's, that young West might see it. This is the first notice we have of any oil painting being seen by Benjamin, save his own; and his admiration of Williams's work was similar to that which his own produced at Springfield. Mr. Williams was interested in the lad, and finding that his reading did not extend beyond the Bible, lent him the works of Fresnoy and Richardson, invited him to see his pictures and drawings, and may be called the first instructor of West.

These books West was permitted to carry home when he left the city; and Fresnoy and Richardson not only confirmed the boy's ambition to become a painter, but to aspire to the fellowship of kings and emperors. We have seen that he would not ride on the same horse with a schoolmate who was content with the prospect of becoming a tailor.

The first money received by West for his works *as an artist,* was from Mr. Wayne, in exchange for drawings made on poplar boards; and Dr. Jonathan Morris made him a present of " a few dollars to buy materials to paint with." At the house of

Mr. Flower, the boy first became acquainted with books of profane history, and from an English lady, the governess of Mr. Flower's children, he received instruction from the historians and poets of his friend's library.

At Lancaster he made his first essay as a painter of portraits, and, as may be supposed, gained admiration and custom. A gunsmith, of the name of Henry, employed him to paint the death of Socrates, an event he had not at the time heard of. The gunsmith read the story to him, and left him the book, and one of the workmen stood as a model for one of the figures. This led to the study of the human form, and showed the youth the importance of anatomy as connected with the arts of design.

While West was at Lancaster, Dr. Smith, provost of the college at Philadelphia, visited the place, and seeing the result of the boy's efforts, warmly interested himself in his welfare. He proposed to the elder West to send his son to the capital, and offered to instruct him in English classical literature. This liberal offer was gladly accepted, and Benjamin sent to reside with his brother-in-law, Mr. Clarkson, where he pursued his studies and became an associate of Francis Hopkinson, Thomas Godfrey, Jacob Duché, and Joseph Reid, then, like himself, unknown to fame. Of these school days West makes incidental mention in a letter, when speaking of the long-venerated tree under which Penn concluded his treaty with the Indians,—a tree which the painter introduced into his picture on the subject. He says, " This tree, which was held in the highest veneration by the original inhabitants of my native country—by the first settlers and by their descendants—and which I well remember about the year 1755, when a boy, often resorting to it with my schoolfellows, (the spot being a favourite one for assembling in the hours of leisure,) was in some danger during the American war of 1775, when the British possessed the country, from the parties sent out in search of wood for firing ; but the late General Simcoe, who had the command of the district where it grew, from a regard for the character of William Penn, and the interest which he took in the history connected with the tree, ordered a guard of British soldiers to protect it from the axe. This circumstance the General related to me, in answer to my inquiries concerning it, (the tree,) after he returned to England." See for this letter of West's the Memoirs of the Historical Society of Pennsylvania, 1825, p. 97.

Provost Smith directed West's studies with a view to the profession he had chosen; and his reading of history conduced

most to the attaining that knowledge which would be more serviceable to the painter than to the politician or man of the world. It is said, that while the son was preparing himself for the brilliant career destined for him, the father had some quaker-qualms on the subject, and held a consultation with the wise men of the *Meeting of Friends*, which resulted in a permission given contrary to the principles of the sect, for the youth to pursue the bent of his inclination, and to administer to those vanities their religious tenets told them to eschew as the snares of the evil one. We must not doubt this incident, given on such authority, but the argumentative speeches which led to this curious anti-religious conclusion we may consider in the light of *such as might have been suggested to the mind of John Galt*, rather than such as were actually delivered.

Mr. Galt relates an adventurous enterprise of an elder brother of Benjamin West, and Cunningham transcribes it from Galt, and substitutes Benjamin for his brother as the military hero of the story. He says,

" Being now left more to the freedom of his own will, West deviated into a course not at all professional, but for which the accommodating eloquence of a John Williamson might have conceived a ready apology. He became a soldier. The Friends had not included this among those pure and pious pursuits which they ascribed to the future painter of history ; they expressed, however, neither surprise nor sorrow for this backsliding in Benjamin, nor did they either admonish or remonstrate. He took up a musket—inspired with his enthusiasm young Wayne, afterward a distinguished officer—and joining the troops of General Forbes, proceeded in search of the relics of that gallant army lost in the desert by the unfortunate General Braddock.

" To West and his companions were added a select body of Indians ; these again were accompanied by several officers of the Old Highland Watch—the well-known forty-second, commanded by the most anxious person of the whole detachment, Major Sir Peter Halket, who had lost his father and brother in that unhappy expedition. Though many months had elapsed since the battle, and though time, the fowls of the air, the beasts of the field, and wild men more savage than they, had done their worst, Halket was not without hopes of finding the remains of his father and his brother, as an Indian warrior assured him that he had seen an elderly officer drop dead beneath a large and remarkable tree, and a young subaltern, who hastened to his aid, fall mortally wounded across the body. After a long march through the woods, they approached the

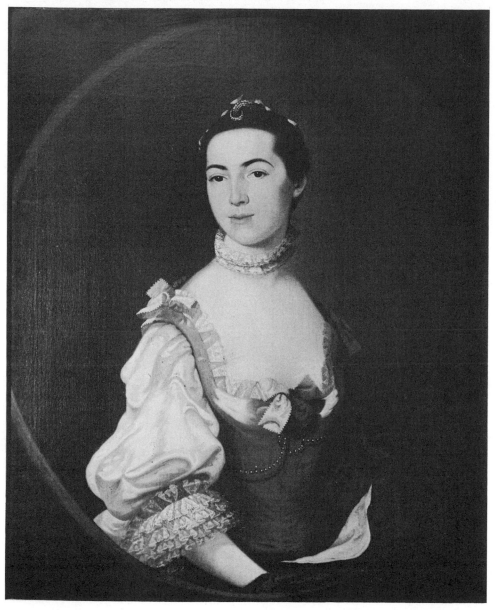

11 Mrs. John Green (Polly Smith, The Artist's Wife). Painting by John Green. *Courtesy Bermuda Historical Monuments Trust.*

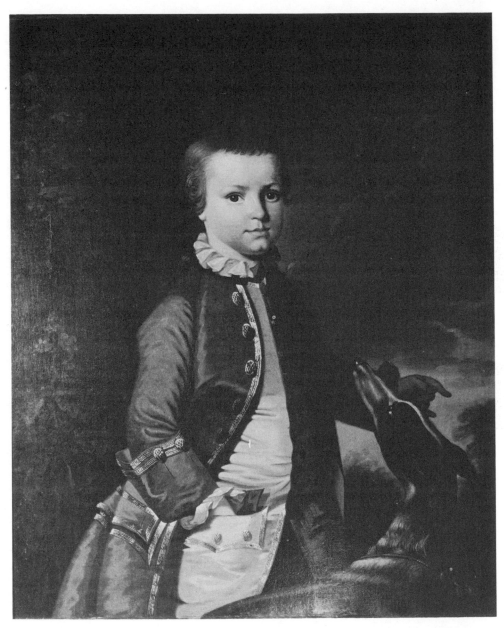

12 MASTER PACKWOOD AND DOG. Painting by John Green. *Courtesy Bermuda Historical Monuments Trust.*

fatal valley. They were affected at seeing the bones of men, who, escaping wounded from invisible enemies, had sunk down and expired as they leaned against the trees, and they were shocked to see in other places the relics of their countrymen mingled with the ashes of the savage bivouacs.

" When they reached the principal scene of destruction, the Indian guide looked anxiously round, darted into the wood, and in a few seconds raised a shrill cry. Halket and West hastened to the place—the Indian pointed out the tree—a circle of soldiers were drawn round it, while others removed the leaves of the forest which had fallen since the fight. They found two skeletons—one lying across the other—Halket looked at the skulls, said, faintly, ' It is my father !' and dropped senseless in the arms of his companions. On recovering, he said, "I know who it is by that artificial tooth." They dug a grave in the desert, covered the bones with a Highland plaid, and interred them reverently. This scene, at once picturesque and pious, made a lasting impression on the artist's mind. After he had painted the Death of Wolfe, he proposed the finding of the bones of the Halkets, as an historical subject; and, describing to Lord Grosvenor the gloomy wood, the wild Indians, the passionate grief of the son, and the sympathy of his campanions, said, he conceived it would form a picture full of dignity and sentiment. His lordship thought otherwise. The subject which genius chooses for itself is, however, in most cases, the best. The sober imagination of West had here a twofold excitement—he had witnessed the scene, and it was American—and had Lord Grosvenor encouraged him to embody his conception, the result would, I doubt not, have been a worthy companion to the Death of Wolfe."

Now, as far as the painter is concerned, the story is pure fiction. And as a subject, for historical composition, it is utterly unworthy of being classed with the Battle of Quebec, on the Plains of Abraham. The one, though picturesque and pathetic, is a private event, and without consequences; the other, one of the most influential causes of mighty effects which the world has known. The victory gained by Wolfe, annihilated the power of France on this continent, and established reformed religion, English language arts and literature, and more than English liberty from Mexico to the North pole, and from the Atlantic to the Pacific.

In the year 1756 the mother of the young painter died, and in August of that year he took his leave of Springfield, and went again to reside in Philadelphia, under the roof of his bro-

ther-in-law. He now had full employment as a portrait-
painter, and gained a portion of that facility of execution
which was remarkable in his after life. He enjoyed still the
instruction of Dr. Smith, and while his days were devoted to
his esel, his evenings were probably employed in listening to
his preceptor, or reading the books he pointed out for his pe-
rusal. As his mind strengthened, and the powers of discrimi-
nation increased—as his eyes became open to the beauties of
nature, and his power of imitating those beauties increased, the
perception of his deficiencies likewise increased, with the ardent
desire to examine the wonders of art which could at that time
only be seen by visiting Italy. This desire stimulated the in-
dustry, and added to the self-denying frugality of the virtuous
and gifted youth. He looked forward to the time when the
product of his industry would enable him to transport himself
to the land of his wishes, the land of the fine arts. Such pic-
tures as had been brought to the provinces, and fell within the
limited range of the boy's observation, while they added to
his knowledge of the art, added tenfold to his anxiety for the
time to arrive when he could drink at the fountain from which
these scanty streams were derived. Governor Hamilton had a
collection of pictures which were placed at West's disposal as
objects of study, and among them a Murillo which had been
captured in a Spanish prize. This picture, a St. Ignatius, was
copied by the youth, and added to his reputation and his skill.
Dr. Smith suggested the idea of combining historical and por-
trait painting, and West painted the provost in the attitude
and style of St. Ignatius. This is a false taste. Every por-
trait ought to convey a portion of the history of its own times.
The value of the portraits of Vandyke and Reynolds, is in-
creased by the knowledge they convey of the costume and
manners of the time at which they were painted ; and a grocer
of Thames-street as a Cæsar or Hector—or a doctor of divi-
nity as a martyr or saint, may cause the admiration and con-
found the ideas of the ignorant, but can only excite the ridicule
of the well-informed beholder. All this practice tended to im-
prove the young artist and extend his fame. Mr. Cox em-
ployed him to paint an historical picture. The Trial of Susan-
nah was the subject chosen and executed. Mr. Galt says, " it
is not known what has become of this picture." It is, how-
ever, known to us, and although the artist in his old age had
forgotten the circumstances attending the composition, and the
assistance he received therein, it appears that he made ample
use of a print on the subject, which had fallen in his way.

At this time the remuneration of West for his portraits was two guineas and a half for a head, and five for a half-length. He visited New-York with a view to the increase of his prices, that the object for which he desired money might the sooner be placed within his grasp—*improvement.* In New-York he painted many portraits, but few have been preserved from those tombs of the Capulets destined for the works of the mass of painters—the nursery, where urchins set them up as marks for their puny archery; or the garret, where cats litter among the satins of our grandmothers, or mice feast on the well powdered wigs of our grandsires. Some three or four of West's immortal works of this date, may be found in America, by industry, perseverance, and much labour, and when found can scarcely be seen through a mass of dinginess, or will be found defaced by careful scouring, with here and there a hole, patched or unpatched, received in a May-day moving, or while exposed to the incidents of the cock-loft.

In our researches we were directed, by the honourable Edmund Pendleton, to a portrait of one of his maternal ancestors, Mrs. Dinah Bard, (born Marmion,) which we found at Trenton, New-Jersey, at the residence of one of her descendents, Mr. Charles Fraser. This picture was painted in a style which justifies in part the eulogiums recorded by Galt, as bestowed upon West's first head finished in Rome. It had been firmly painted and well drawn, and the drapery carefully made out; but it is injured by time, and had received two bullets or bayonet wounds during the war of the revolution, which had never been cured, though patched up. Her husband's portrait (Peter Bard, Esq.) is *returned* " missing." There are older portraits in Mr. Fraser's house by other hands,—no trace of the artist's name remaining, and nothing in the work indicating a name worth preserving.

We found at Germantown a portrait painted in West's youth, of a gentleman of the Morris family. This was in better preservation than the above, and a still better picture. Judicious cleaning and lining would preserve it, and it is well worth preserving.

The young painter pursued his professional labours eleven months in New-York, at prices double those he received in Philadelphia, and had accumulated nearly enough, by his industry, to waft him to the " land where the orange trees bloom," and where the fine arts have left a lasting impression of the time they *did* flourish, when he heard that a ship was about to sail from his own homely country to carry food to the inhabitants of Italy, who have in modern as well as ancient

times been more abounding in marbles than bread. Mr. Allen, of Philadelphia, was loading a ship with flour for Leghorn, and West, who was painting the picture of Mr. Kelly, of New-York, when he heard the news, mentioned it to his sitter, with his intention to take advantage of this extraordinary occurrence. Kelly's portrait being finished, and the ten guineas paid for it, he gave a letter in charge to the painter for his agents in Philadelphia, which, on delivery, proved an order for fifty guineas, to assist the youth in his projected journey and intended studies abroad. In the meantime Mr. Allen had determined that his son should have the benefit of travel, by accompanying the flour; and West's invaluable friend, Provost Smith, had obtained permission for the young painter to accompany the young merchant. Thus every thing seemed to conspire for the furtherance of the youth's advancement in the road to wealth and honour. He found friends eager to assist him at every step. Was it not because it was seen by all that every step was in the right path—that his mind was as deeply imbued with the love of virtue as with the love of his art? Such was the character of West through life ; and through life his success was uniform. He met in his way false friends, detractors and libellers, but he never turned aside ; and as he approached that height at which he aimed from childhood, the hands of those who had attained or had been seated on the high places in his upward way, were stretched forth to welcome him. We see the undeviating tribute paid to worth and genius in its ascending progress, whether in the homely encouragement given by Henry the gunsmith, of Lancaster, the refined and well directed friendship of Provost Smith, the frank liberality of the merchants Kelly and Allen, the enlightened admiration of the men of fortune who received him with open arms at Rome, as we have yet to mention, and finally in the smiles of the nobles and the sovereign of England, who hailed his arrival with joy in the land of his fathers.

Mr. West, in the reminiscences communicated to his biographer, mentions, that while he was waiting for the sailing of the ship, which was to bear him to the land he longed to see, he again met his friend Henry the gunsmith, and the artist's grateful recollections of this man is in common with his pure and virtuous character. Henry had introduced him to his first knowledge of history, by lending him Plutarch, and excited him to attempt his first historical picture by employing him, and aiding him to paint the death of Socrates, in the year 1759.

At the age of twenty-one, Benjamin West embarked with

young Allen, and soon arrived at Gibraltar, where the ship stopped for convoy. Captain Kearny, commanding the ships of war on the station, was a friend of young Allen's father, and the young man, with his companion, being invited to dine on board his ship, West was introduced favourably to the officers, with whom he proceeded up the Mediterranean. Messrs. Rutherford and Jackson were the correspondents of Mr. Allen, and the young painter, having delivered his credentials to them at Leghorn, was furnished with letters to Cardinal Albani and other distinguished characters at Rome. Under these favourable auspices the quaker painter proceeded on his journey in charge of a French courier, who had been engaged by his Leghorn friends as his guide and interpreter, and gained his first view of the immortal city from a height at eight miles distance. It is easy to imagine the impression such a prospect, and its attendant anticipations, would make upon an American youth of that day, and it is much safer to leave the subject to the imagination of the reader than to obtrude upon him the surmises of the writer. Suffice it to say, that the unsophisticated Yankee arrived safe at the great metropolis, and was introduced to the remains of her ancient taste and splendour, scarcely more the object of his admiration, than he was of attention to the nobles of Italy, and the illustrious strangers with whom the city swarmed. An American had come to study painting, and that American a quaker! This was a matter of astonishment, and when it was found that the young man was neither black nor a savage, but fair, intelligent, and already a painter, West became emphatically the lion of the day in Rome.

It was on the 10th of July, 1760, that the French courier deposited the youth at an hotel in the great city, and spread the strange story abroad that a quaker and an American had come to study the fine arts in Italy; this appeared so extraordinary to an English gentleman, Mr. Robinson, that he immediately sought him, and insisted on his dining with him. The letters brought by West proved to be for Mr. Robinson's friends, and the artist had the advantage of an immediate introduction to the best society of Rome.

At the house of Mr. Crespigne he was presented to Cardinal Albani, who although blind, " had acquired, by the exquisite delicacy of his touch, and the combining powers of his mind," we quote Mr. Galt, "such a sense of ancient beauty, that he excelled all the virtuosi of Rome in the correctness of his knowledge of the verity and peculiarities of the smallest medals and intaglios." To this virtuosi Mr. Robinson intro-

duced the quaker as " a young American, who had come to Italy for the purpose of studying the fine arts;" and the query of the cardinal was, " Is he black or white ?"

West, among the many advantages derived from nature, possessed a fine form, and a face as fair as artists paint angels, or lovers their mistresses. At the age of fifty he was remarkable for comeliness; and it is presumed that at the period of which we treat, his appearance must have been very prepossessing, and not the less for the flowing locks and simple attire of his sect. The cardinal being satisfied that the painter was as white *as himself*, (that being his next inquiry,) received him graciously, examined his face and head, with his fingers, expressed his admiration, and made up a party to witness the impression which the sight of the chef d'œuvres of antiquity, would make upon a native of the new world. The Apollo was first shown him, and his exclamation was, " How like a young Mohawk warrior !"

The Italians, on having the words translated by Mr. Robinson, were mortified, but when West, at that gentleman's request, described the Mohawk in his state of native freedom, as seen in those days, his speed, his vigour, his exercise with the bow,—when Mr. Robinson interpreted the words, " I have seen a Mohawk standing in that very attitude, intensely pursuing with his eye the flight of the arrow just discharged from the bow," his auditory were delighted by the criticism of the stranger, and applauded his untutored acumen.

Galt tells a story very seriously of an Italian improvisatore and his rhodomontade about America and West, which Cunningham treats as a quiz upon the young quaker painter. We had the story from another source many years ago, and published it in a short-lived periodical which we then called " The Monthly Recorder." (See No. 3, p. 172.)

The following anecdote is related by an American traveller who, calling to see Mr. West, found him in conversation with an Italian gentleman on the subject of the improvisatori, and is one among the many thousand instances of the profound ignorance in which Europeans generally remain respecting this country. While we, as descendants from one of the proudest and most enlightened nations of the world, enjoying their institutions, and improving upon their improvements, know and feel our high standing in society ; we see a vagabond Italian rhymster treating us as savages, and looking forward to our future illumination as the effects of a ray from the sun of science blazing in modern Rome. We give it in the words of the writer, in a letter to his friends.

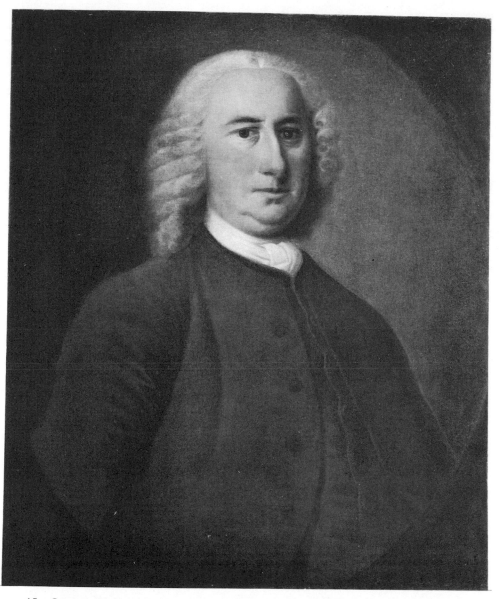

13 GABRIEL MANIGAULT, 1757. Painting by Jeremiah Theüs. *Courtesy The Metropolitan Museum of Art, Fletcher Fund.*

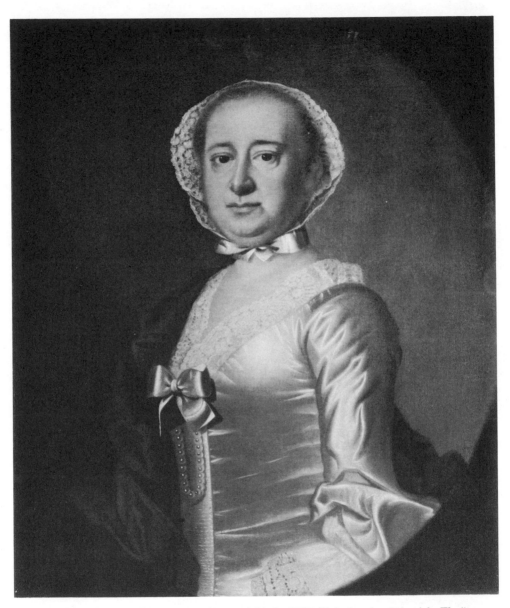

14 MRS GABRIEL MANIGAULT (Anne Ashby), 1757. Painting by Jeremiah Theüs. *Courtesy The Metropolitan Museum of Art, Fletcher Fund.*

" There was an Italian gentleman with him, to whom he was talking about the improvisatori, or itinerant poets, who recite verses extempore. Mr. West said that soon after his arrival in Rome, while he was sitting in the English coffee-house, with an American gentleman, one of these poets, who was very celebrated at that time, and went by the name of Homer, came in, and walking up to Mr. West's friend, who knew him, requested him to give him a subject, as was customary. The gentleman said he had a new subject for him—there, said he, is a young American, arrived in Rome to study the fine arts, (for Mr. West was the first of our countrymen who had gone there for such a purpose.) The improvisatore proceeded to prepare himself for his task, and sitting directly opposite to Mr. West, began tuning his guitar, which was an enormous one, bending his body from side to side until he worked himself (as Mr. West said) in perfect tune with the instrument; he then began his poem, and described the Almighty as having determined to enlighten those nations of the world that were yet in darkness. For this purpose he had sent out an Italian (Americus Vespucius) to civilize the inhabitants, and establish manufactures, useful arts, &c., on the vast continent of America. That when civilization had considerably advanced through succeeding ages, God shed a ray of divine light upon *genius,* which before was but a dormant material there; it instantly kindled and lighted up a flame in the breast of this young savage (Mr. West) while a guiding star appeared to direct his steps to Italy, to seek for improvement—he had followed it until it had led him to Rome. Here the poet entered into a warm eulogium on his native country, and the treasures of art it possessed; and concluded by prophesying that the young savage should be the first to transplant the arts to America, and that in time she would become the greatest nation on earth."

We presume this is no uncommon way for the pauper-poet to put a little coin in his pocket. West, of course, could not understand him, and West's companion gave him a trifle as a compensation for his flattery. Mr. Leslie, in one of his letters to us, gives the story of the blind cardinal immediately from West. "You recollect that Mr. West's complexion was remarkably fair; even in extreme old age it was so. He was a very handsome old man. He told me that soon after his arrival in Italy, he was introduced to a cardinal who was blind. His reverence was accustomed to pass his hand over the faces of strangers who were presented to him, in order to judge of their countenances. On doing so to Mr. West, he said, " This

young savage has very good features, but what is his complexion?" The reply was that it was *fair*. " What," said the cardinal, with astonishment, " as fair as I am?" Mr. West had the greatest difficulty to refrain from laughing, for the cardinal's complexion was of the darkest brown of Italy, and possibly some shades darker than many of the American Indians."

The effect produced by the works of art in pictures or statues, by the palaces and churches, by the splendour of social intercourse or of religious ceremonies, upon a youth from our country at that time, can hardly be conceived by us at this day. We have our galleries of paintings and statues, our marble domes and column-faced temples, erected to luxury, wealth and religion; and the quaker boy who now leaves America may be familiar with the pomp of papal ceremonies, and the overpowering excellence of Italian music, so far as not to be astounded by the novelty of the objects which will meet his view in Europe. Upon such a youth as Benjamin West, new from such a country as this then was, the effect of such objects must be left to the imagination of the reader. " But neither the Apollo, the Vatican, or the pomp of the Catholic ritual" made such an impression on the American youth, or excited his feelings to so great a degree, as the spectacle of poverty, nakedness, filth and disease, which met his eye at every turn, and the cries for relief urged in the names he had in his own happy country only heard in the prayers of the sanctuary. The contrast which such scenes present between American and European society, happily, for one party, may appear as striking now as in the time of the first visit of a painter from the new to the old world.

It is related by Mr. Galt that West's first specimen of painting in Europe, a portrait of Mr. Robinson, was said to be better coloured than the works of Mengs, at that time the greatest painter in Rome, and that the young American was pronounced the second in rank in that Capital. This assertion does not accord with the fact that few of West's pictures previous to that time appear to have merited preservation. Many of Copley's works painted before he left his country are yet to be seen and admired. We have been obliged to search diligently for any specimen of West's portrait painting before he left America, and when we have found it, it has hardly been worth the search. This, however, we can say, that we have found none better among the works of his predecessors. They are not such as we should expect would rival Mengs in colouring or any thing else; we have previously mentioned those of Mr.

Bard and Mr. Morris, and we may not have seen the best he painted at that early period. On the other hand, we know that West during the four years he passed in Italy, painted pictures which gained him academical honours, and the applause of the public; we know that his copy of Corregio's St. Jerome, executed at Parma, is a perfect specimen of colouring; and we know that on his arrival in England he took his stand immediately as the first historical painter in the kingdom.

Mengs and Pompeo Battoni were at this period the great painters of Rome. Of the latter, in connection with our subject we have been favoured with the following from Mr. Allston, as related to him by Mr. West. "Battoni was at that time 'in full flower,' dividing the empire of art with Mengs. He received Mr. West very graciously in his painting room, and after some questions respecting his country, concerning which he seemed to have had no very distinct notion,—said "And so, young man, you have come—how far is it?" "Three thousand miles." "Ay, three thousand miles from the woods of America to become a painter! You are very fortunate in coming to Rome at this time, for now you shall see Battoni paint." He thereupon proceeded with his work then in hand, a picture of the Madonna; occasionally exclaiming, as he stept back, to see the effect, "e viva Battoni!"

Mengs very liberally applauded the effort of the young artist, which had been compared to his own masterly productions, and traced out a plan for his studies and travel. "See and examine every thing deserving of your attention here, and after making a few drawings of about half a dozen of the best statues, go to Florence, and observe what has been done for art in the collections there. Then proceed to Bologna, and study the works of the Caracci; afterwards visit Parma, and examine attentively the pictures of Corregio; and then go to Venice, and view the productions of Tintoretto, Titian, and Paul Veronese. When you have made this tour, come back to Rome, and paint an historical composition to be exhibited to the Roman public."

The excitements of Rome produced fever, and before West could avail himself of this judicious advice, his friends and physicians advised a return to Leghorn for the restoration of health. Here he was received into the hospitable mansion of Messrs. Rutherford and Jackson, and by their care, recovered so far as to return to his studies in Rome, but was soon again forced by a relapse to fly once more to Leghorn, when the fever left him with an affection of the ancle, which threatened

the loss of the limb. His constant friends Jackson and Ruther-
ford sent him to Florence, and placed him under the care of a
celebrated surgeon, who produced a radical cure, after a con-
finement of eleven months.

Even during this season of pain and disease, the artist pur-
sued his studies, and was encouraged by the attentions of men
of taste and influence, both natives and travellers. When
recovered so as to bear the fatigues of travelling, he had the
good fortune to obtain as a companion on the tour recom-
mended by Mengs, a man of extraordinary accomplishments
and acquirements. A gentleman of the name of Matthews,
connected with Messrs. Rutherford and Jackson, visited Flo-
rence and agreed to accompany the young painter in his visit
to the most celebrated repositories of Italian art.

In the mean time, that good fortune which attended West's
conduct throughout life, was operating in his favour on
the shores of the western world. The applause bestowed on
the portrait of Mr. Robinson, was mentioned in a letter from
Rutherford and Jackson to Mr. Allen, of Philadelphia, and
the letter read by him to an assemblage of gentlemen at his
dinner table, among whom was Governor Hamilton. Allen
mentioned the sum deposited with him, by West before his
departure, adding, "as it must be much reduced, he shall not
be frustrated in his studies for want of money : I will write to
my correspondents to furnish him with whatever he may re-
quire." This generous declaration produced a demand from
the Governor, that "he should be considered as joining in the
responsibility of the credit." The consequence was, that
while West was waiting at Florence for the sum of ten pounds
for which he had written to his friends at Leghorn, he received
notice from their bankers that they were instructed to give him
unlimited credit.

It is not always that talents, when backed by good conduct,
produce such effects upon mankind ; and some may perhaps
exclaim, "surely mankind are less inclined to obey the gene-
rous impulses of nature now, than they were a century ago."
But it is not so. Talents ever command admiration, and
good conduct solicits good will. But both or either may be
obscured by circumstances. They may exist separately, and
not be deserving of friendship. They may be united, and
their effect destroyed by personal defect in the possessor, timi-
dity, false shame, false pride or excessive sensitiveness—and
as far as these defects have influence, the effects of good con-
duct are weakened, obscured or destroyed. West had talents,
virtue, youth, beauty, and prudence. He appears to have

possessed no quality to counteract their influence, and circumstances independent of his own good qualities seemed uniformly to favour his progress.

From Florence Mr. West proceeded to Bologna, and after inspecting the works of art, he went on to Venice. Here the style and colouring of Titian were his principal study. After completing the tour recommended by Mengs, he returned to Rome, and pursued his studies again in that great center of taste. He at this time painted his pictures of Cimon and Iphigenia, and Angelica and Medora. These established his reputation as an historical painter, and obtained him the academical honours of Rome.

By the advice of his father he determined to visit England before returning home, and again he had the advantage of travelling with a man of taste and refinement, Dr. Patoune, who was returning to Great Britain. The doctor proceeded to Florence, while the painter went to take leave of his friends at Leghorn. The travellers afterwards stopped at Parma, while West finished his copy of St. Jerome. This beautiful picture is in the possession of the family of Mr. Allen, one of the painter's earliest friends, and in America. Here again the novelty of an American quaker painter procured him the attention of the great; and the *friend* kept on his broad brim when introduced to the court of Parma, very much to the astonishment of the prince and his courtiers—perhaps not a little to their amusement.

Genoa and Turin were taken in the route to France, and the peace of 1763 having been but lately concluded, the travellers as Englishmen, were only protected by a magistrate from a mob, who had not yet ratified the treaty. In Paris, West visited, as every where else, the collections of paintings and sculptures, but the inferiority of France to Italy was at that time more apparent than at this, and the American had little to learn in Paris, who had studied in, and gained the approbation of the academies of Italy.

CHAPTER IV.

West in England, 1763—Cunningham's life of West—Costume of an Indian Warrior—West's great success, and the friendship of George the Third—West at his esel—His pupils—Not a quaker in dress or manner—Declines the title and supposed honours of knighthood—General impression that he had been knighted—Envy and jealousy manifested towards him—Allston's feeling towards him—He visits France.

On the 20th of June, 1763, West arrived in London. He had while in Rome, painted his pictures of Cimon and Iphigenia, and Angelica and Medora, and proved that he needed no longer the instruction of modern Italy. Raphael he would willingly have studied all his life, if Raphael could have been transported by him to the land in which he was to abide. He says, " Michael Angelo has not succeeded in giving a probable character to any of his works, the Moses, perhaps, excepted. The works of Raphael grow daily more interesting, natural and noble."

Wherever West went, circumstances combined for his advantage. His friends, Allen, Hamilton, and Smith had arrived before him in London, and received him with joy and triumph. The portrait of Governor Hamilton, painted at this time, is in Philadelphia now. Thus he found warm friends ready to introduce him to the best and most powerful of the land of his fathers. His merit insured him a favourable reception, and he was soon induced to determine upon taking rooms, and trying to establish himself as an historical painter in the metropolis of England.

The state of the art of painting in that country, is thus described by Mr. Cunningham : " Reynolds was devoted to portraits. Hogarth was on the brink of the grave ; Barry engaged in controversaries in Rome ; Wilson neglected ; Gainsborough's excellence lay in landscape ;—" Wilson mentioned above only painted landscape ; Hogarth's genius led him into another path : the heroic had no charms for him, and the *beau ideal* was probably unknown and unfelt—simple everyday nature satisfied him, he worshipped her, and the goddess smiled upon him. In fact England had no distinguished historical painter, and circumstances again placed West where he was formed best to thrive.

In a work called " The Percy Anecdotes," it is said, that on the arrival of Mr. West in England, he " soon displayed his powers in historical painting, in a most excellent picture ; the subject was that of Pylades and Orestes, one of his very best works." The author dilates on the curiosity excited and the admiration elicited by the work, and proceeds, "but the most wonderful part of the story is, that notwithstanding all this vast bustle and commendation bestowed upon this justly admired picture, by which, Mr. West's servant gained upwards of thirty pounds for showing it, no mortal ever asked the price of the work, or so much as offered to give him a commission to paint any other subject. Indeed there was one gentleman, who was so highly delighted with the picture, and spoke of it with such great praise to his father, that the latter immediately asked him the reason he did not purchase what he so much admired ; when he answered, " What could I do, if I had it ? You would not surely have me hang up a modern English picture in my house, unless it was a portrait ?"

This is a good satire upon those who buy up old pictures, and despise the efforts of artists who are producing excellent works in their presence.

We will here quote a passage from a letter of Mr. Leslie's : " The following account of the commencement of Mr. West's career in London I had from Sir George Beaumont ; as I have not either Galt's or Allen Cunningham's life of West by me, I do not know whether or not they have related it in the same way. When Mr. West arrived in London, the general opinion was so unfavourable to modern art, that it was scarcely thought possible for an artist to paint an historical or fancy picture worthy to hang up beside the old masters. Hogarth had produced his matchless pictures in vain. The connoisseur who would have ventured to place the inimitable scenes of the " Marriage a la mode," on his walls, (I mean the pictures, the prints were in great request,) would have hazarded most fearfully his reputation for taste. This prejudice against living genius continued until the arrival of West, and it must have required some courage in a young man at that time to make his appearance in England, in the character of an historical painter. One of the first pictures, if not the very first he produced, was from the story of Pylades and Orestes, (there is an admirable copy of it in this country, painted by Mr. Sully.) This picture attracted so much attention, that Mr. West's servant was employed from morning till night in opening the door to visiters, and the man received a considerable sum of money by showing it, while the master was obliged to content

himself with empty praise. All admired, but no one dared to
buy it. It was curious enough, however, that the reputation
of this picture raised him into high favour as a portrait painter,
for portrait painters *were* employed. I know not how long
the picture remained on the artist's hands, but when I first
saw it, it was in the collection of Sir George Beaumont. He
gave it with nearly all his pictures to the government, who
were induced by so magnificent a present to purchase the
Angerstein collection, and united the two, to form a National
Gallery. Hogarth's merit as a painter is now acknowledged,
and the six pictures of the " Marriage a la mode," were hang-
ing in the same room with the " Pylades and Orestes" when
I left London."

Those who have read Cunningham's Lives of Painters, (and
that is all readers of taste,) will know something of Sir George
Beaumont ; for he was not only a man of the highest stand-
ing in fortune and fashion, but he was a painter. He was
truly a patron, not only of the art, but of individuals who had
merit and wanted assistance ; he was the protector, supporter,
adviser, of the poor youth who evinced genius, but had not
the means of procuring the instruction necessary to his well-
doing. Jackson, one of the greatest portrait painters England
boasts, was an apprentice to a tailor. His talent for drawing
gained him the attention of Lord Mulgrave, who happened to
reside near him in Yorkshire ; his Lordship and Sir George
Beaumont purchased the lad's freedom from the shop-board
and the goose, and he immediately presented himself as if by
instinct, before Beaumont in London, and expressed his wish
to study in the Royal Academy : " You have done wisely,"
said Sir George, " London is the place for talents such as
yours." He then gave him a plan of study and concluded,
" To enable you to do all this, you shall have fifty pounds a
year while you are a student, and live in my house ; you will
soon require no aid." This is the patronage of friendship,
the protection of the rich, the good, and the wise, afforded to
the meritorious poor, seeking support and instruction.

Mr. West sent his pictures of Angelica and Medora, Cimon
and Iphigenia and others finished since his arrival, to the
public exhibition room, at that time, in Spring Garden. His
success was complete, and he attracted the notice " of some of
the dignitaries of the church. He painted for Dr. Newton the
parting of Hector and Andromache,—and for the bishop of
Worcester, the Return of the Prodigal Son. His reputation
rose so much with these productions, that Lord Rockingham
tempted him with the offer of a permanent engagement, and a

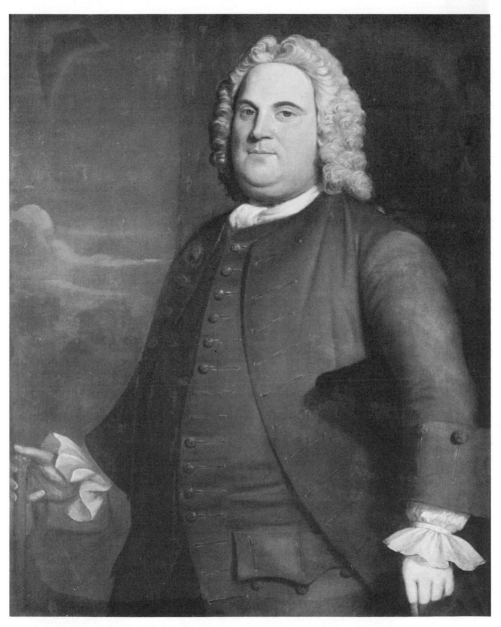

15 WILLIAM ALLEN, *c.* 1760. Painting by Benjamin West. *Courtesy Independence National Historical Park.*

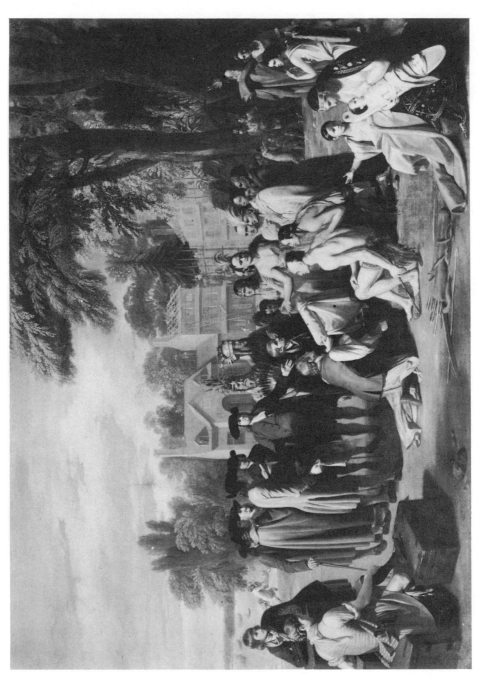

16 PENN'S TREATY WITH THE INDIANS, c. 1771. Painting by Benjamin West. Courtesy the Pennsylvania Academy of the Fine Arts.

salary of seven hundred pounds a year, to embellish with historical paintings his mansion in Yorkshire. West consulted his friends concerning this alluring offer—they were sensible men—they advised him to confide in the *public:* and he followed, for a time, their salutary counsel.

"This successful beginning, and the promise of full employment, induced him to resolve on remaining in the Old Country. But he was attached to a young lady in his native land— absence had augmented his regard, and he wished to return to Philadelphia, marry her, and bring her to England. He disclosed the state of his affections to his friends, Smith and Allen; those gentlemen took a less romantic view of the matter, advised the artist to stick to his esel, and arranged the whole so prudently, that the lady came to London accompanied by a relation whose time was not so valuable as West's—and they were married on the 2d of September, 1765, in the church of St. Martin's in the Fields."

This relation was West's father, Miss Shewell having agreed to leave America on that condition. "The venerable figure of the old quaker is conspicuous in Penn's treaty, in the family picture of West, and in a large allegorical painting in St. George's Hospital, London. The reasons given by West for not crossing the Atlantic, appeared sufficient in the eyes of his betrothed and her friends, and unlike the bride of a king, she came to the youth who had gained her heart, accompanied by his father, and was united to the man who in her last stage of life, she declared to have been all his days without fault. On receiving from Mr. Leslie the anecdote of Benjamin West's oldest brother, left in England as above related, and first seen by his father at the age of forty, I inquired of my excellent correspondent for his authority, he answered, "The information respecting Mr. West's elder brother, I had from a quarter I can thoroughly rely on. It was given me by my venerable friend William Dillwyer, a quaker gentleman and a native of Philadelphia. He had known Mr. West from his youth, and indeed I think their acquaintance commenced before either of them left America. Raphael West remembers his grandfather and uncle, and confirms Mr. Dillwyer's account of the latter being a watch-maker and settled at Reading. Mr. Dillwyer was intimate with Wilberforce and Clarkson, and took an active part with them in their great work of the abolition of the slave trade. He told me that Mr. West accommodated the committees with the use of his large rooms in Newman-street. Raphael West remembers his grandfather as being very neat in his dress. Mr. West told me that on

asking the old gentleman how he was struck with the appear-
ance of London after his long absence, he replied, ' The
streets and houses look very much as they did, but can *thee*
tell me, my son, *what has become of all the Englishmen?* When
I left England forty years since, the men were generally a
portly, comely race, with ample garments, and large flowing
wigs; rather slow in their movements, and grave and digni-
fied in their deportment:—but now, they are docked and
cropped, and skipping about in scanty clothes, like so many
monkeys.' " " I believe," continues Mr. Leslie, " Mr. West
has introduced the portraits of his father, and half brother in
his picture of Penn's treaty. This picture is in the possession
of John Penn, Esq. of Stike, the lineal descendant of William
Penn. Mr. West told me that he introduced his father and
some other quakers from Philadelphia to a private audience
with George the Third at the request of the king. On this
occasion, the Prince of Wales remarked, rather irreverently
that ' the king had always been fond of quakers ever since he
kept that little quaker w———.' "

This is a specimen of the " finest gentleman in England"—
We give another, connected with West, when this fine gentle-
man was George the Fourth. " An anecdote connected with
Benjamin West has just occurred to my memory," says Les-
lie, " I cannot *vouch for its truth*, but it was current among
the artists, and I think it highly probable that it is true. You
most likely know that one room in Windsor Castle is entirely
filled with his pictures, consisting of a series of subjects from
the history of Edward the Third ; the surrender of Calais ;
the battles of Cressy and Poictiers, the Installation of the
knights of the garter, &c. &c. George the Fourth, who
amused himself during the last years of his life in making al-
terations in the castle, took it into his head to consign all these
pictures to the lumber-room. Fortunately, however, he con-
sulted Sir Thomas Lawrence on the subject. Lawrence who
was considered in general to be sufficiently complaisant to his
majesty, had the courage on this occasion to differ from him,
and told him he thought these pictures formed a most appro-
priate ornament to the castle, and that if they were removed,
there was no living artist capable of supplying their place
with similar subjects ! His opinion saved the pictures."

" In portraits," says an English author, " we saw Reynolds
rise eminently superior, while West chose for the exercise of
his pencil the heroes and heroines of antiquity." " Struck
with the superior merits of an historical design by Mr. West,
then a very young man, his majesty commissioned him to

paint a composition for the royal collection, and with that delicate consideration, that unites the true gentleman with the patron, left the subject to the painter's choice. Mr. West selected one of the most interesting events in ancient history, and produced a picture which, added to a knowledge of all the executive properties of painting, exhibited a pathos worthy of the awful dignity of the story. Regulus, a Roman general, prisoner to the Carthaginians, and then on his parole at Rome had patriotically determined to return to captivity, and sacrifice his life for the benefit of his country. The moment chosen is, when surrounded by his supplicating friends, and rejecting their entreaties, he is resigning himself to the ambassadors of Carthage. The excellence of the picture, for which his majesty gave the artist one thousand guineas, is the best comment on the judgment of his royal employer. One apartment in Buckingham House was afterwards entirely appropriated to productions from the pencil of Mr. West. Among these are the death of General Wolfe; the death of Chevalier Bayard; and perhaps the finest of all, Hamilcar swearing the infant Hannibal at the altar."

" Dr. Drummond, the Archbishop of York, a dignified and liberal prelate, and an admirer of painting, invited West to his table, conversed with him on the influence of art, and on the honour which the patronage of genius reflected on the rich, and opening Tacitus, pointed out that fine passage where Agrippina lands with the ashes of Germanicus. He caused his son to read it again and again, commented upon it with taste and feeling, and requested West to make him a painting of that subject. The artist went home, it was then late, but before closing his eyes he formed a sketch, and carried it early next morning to his patron, who, glad to see that his own notions were likely to be embodied in lasting colours, requested that the full size work might be proceeded with. Nor was this all—that munificent prelate proposed to raise three thousand pounds by subscription, to enable West to relinquish likenesses, and give his whole time and talents to historical painting. Fifteen hundred pounds were accordingly subscribed by himself and his friends; but the public refused to co-operate, and the scheme was abandoned.

" The archbishop regarded the failure of this plan as a stigma on the country; his self-love too was offended. He disregarded alike the coldness of the duke of Portland and the evasions of Lord Rockingham, to whom he communicated his scheme—sought and obtained an audience of his majesty, then young and unacquainted with cares—informed him that a de-

vout American and quaker had painted, at his request, such a noble picture that he was desirous to secure his talents for the throne and the country. The king was much interested with the story, and said, ' Let me see this young painter of yours with his Agrippina as soon as you please.' The prelate retired to communicate his success to West." A gentleman came from the palace to request West's attendance with the picture of Agrippina. ' His majesty,' said the messenger, 'is a young man of great simplicity and candour ; sedate in his affections, scrupulous in forming private friendships, good from principle, and pure from a sense of the beauty of virtue.' Forty years intercourse, we might almost say friendship, confirmed to the painter the accuracy of these words.

" The king received West with easy frankness, assisted him to place the Agrippina in a favourable light, removed the attendants, and brought in the queen, to whom he presented our quaker. He related to her majesty the history of the picture, and bade her notice the simplicity of the design and the beauty of the colouring. ' There is another noble Roman subject,' observed his Majesty, ' the departure of Regulus from Rome— would it not make a fine picture ?' ' It is a magnificent subject,' said the painter. ' Then,' said the king, ' you shall paint it for me.' He turned with a smile to the queen, and said, ' The archbishop made one of his sons read Tacitus to Mr. West, but I will read Livy to him myself—that part where he describes the departure of Regulus.' So saying, he read the passage very gracefully, and then repeated his command that the picture should be painted.

" West was too prudent not to wish to retain the sovereign's good opinion—and his modesty and his merit deserved it. The palace-doors now seemed to open of their own accord, and the domestics attended with an obedient start to the wishes of him whom the king delighted to honour. There are minor matters which sometimes help a man on to fame ; and in these too he had his share. West was a skilful skater, and in America had formed an acquaintance on the ice with Colonel, afterward too well known in the colonial war as General Howe ; this friendship had dissolved with the thaw, and was forgotten, till one day the painter, having tied on his skates at the Serpentine, was astonishing the timid practitioners of London by the rapidity of his motions and the graceful figure which he cut. Some one cried ' West! West !' it was Colonel Howe. ' I am glad to see you,' said he, ' and not the less so that you come in good time to vindicate my praises of American skating.' He called to him Lord Spencer Hamilton and

some of the Cavendishes, to whom he introduced West as one of the Philadelphia prodigies, and requested him to show them what was called 'The Salute.' He performed his feat so much to their satisfaction, that they went away spreading the praises of the American skater over London. Nor was the considerate quaker insensible to the value of such commendations; he continued to frequent the Serpentine and to gratify large crowds by cutting the Philadelphia Salute. Many to their praise of his skating added panegyrics on his professional skill, and not a few, to vindicate their applause, followed him to his esel, and sat for their portraits."

More than twenty years after, the writer skated with the great painter and his oldest son on the Serpentine, and West was the best, though not the most active then on the ice.

The 'Departure of Regulus' placed Benjamin West on the throne of English art. Thus a youth, by the force of talent, guided by prudence, found himself at the pinnacle he aimed at, when, as a child, he read in Richardson and Du Fresnoy of painters who were cherished and honoured by kings.

In a late publication, The Cabinet of Natural History, published 1830, by Doughty, Philadelphia, West has been represented to his country, by one of his most favoured pupils, as a man of moderate genius, arriving at excellence by perseverance and industry. Perseverance and industry in well-doing cannot be too much praised. West was industrious and persevering. But God had endowed him with uncommon physical and mental powers; and those powers were not only fitted for the art he loved, but circumstances of a peculiar nature turned the course of his genius into the track leading to brilliant excellence. It would appear from this publication, that West's success was only derived from persevering industry; but the fact of West's complete success at the age of twenty-five, when perseverance and industry had not had time to do more for him than for hundreds of his pupils, contradicts this assertion.

" While West was painting the 'Departure of Regulus,' the present Royal Academy was planned. The Society of Incorporated Artists, of which he was a member, had grown rich by yearly exhibitions, and how to lay out this money became the subject of vehement debate. The architects were for a house, the sculptors for statues, and the painters proposed a large gallery for historical works, while a mean and sordid member or two voted to let it lie and grow more, for it was pleasant to see riches accumulate. West, who happened to be a director, approved of none of these notions, and with

Reynolds withdrew from the association. The newspapers of the day noticed these indecent bickerings; and the king, learning the cause from the lips of West, declared that he was ready to patronize any association formed on principles calculated to advance the interests of art. A plan was proposed by some of the dissenters, and submitted to his majesty, who corrected it, and drew up some additional articles with his own hand.

" Meanwhile the incorporated artists continued their debates, in total ignorance that their dissenting brethren were laying the foundation of a surer structure than their own. Kirby, teacher of perspective to the king, had been chosen president: but so secretly was all managed, that he had never heard a whisper in the palace concerning the new academy, and in his inaugural address from the chair, he assured his companions that his majesty would not countenance the schismatics. While West was one day busy with his Regulus, the king and queen looking on, Kirby was announced, and his majesty having consulted his consort in German, admitted him, and introduced him to West, to whose person he was a stranger. He looked at the picture, praised it warmly, and congratulated the artist; then, turning to the king, said, ' Your majesty never mentioned any thing of this work to me; who made the frame? it is not made by one of your majesty's workmen; it ought to have been made by the royal carver and gilder.' To this impertinence the king answered, with great calmness, 'Kirby, whenever you are able to paint me such a picture as this, your friend shall make the frame.' 'I hope, Mr. West,' said Kirby, ' that you intend to exhibit this picture?' ' It is painted for the palace,' said West, ' and its exhibition must depend upon his majesty's pleasure.' ' Assuredly,' said the king, ' I shall be very happy to let the work be shown to the public.' ' Then, Mr. West,' said Kirby, ' you will send it to my exhibition.' ' No!' interrupted his majesty, ' it must go to *my* exhibition—to that of the Royal Academy.' The president of the associated artists bowed with much humility and retired. He did not long survive this mortification, and his death was imputed by the founders of the new academy to jealousy of their rising establishment, but by those who knew him well, to a more ordinary cause, the decay of nature. The Royal Academy was founded, and in its first exhibition appeared the Regulus.

"A change was now to be effected in the character of British art; hitherto historical painting had appeared in a masking habit: the actions of Englishmen seemed all to have been per-

formed, if costume were to be believed, by Greeks or by Romans. West dismissed at once this pedantry, and restored nature and propriety in his noble work of 'The Death of Wolfe.' The multitude acknowledged its excellence at once. The lovers of old art, the manufacturers of compositions called by courtesy classical, complained of the barbarism of boots, buttons, and blunderbuses, and cried out for naked warriors, with bows, bucklers, and battering rams. Lord Grosvenor, disregarding the frowns of the amateurs, and the, at best, cold approbation of the Academy, purchased this work, which, in spite of laced coats and cocked hats, is one of the best of our historical pictures. The Indian warrior, watching the dying hero, to see if he equalled in fortitude the children of the deserts, is a fine stroke of nature and poetry.

"The king questioned West concerning the picture, and put him on his defence of this new heresy in art. To the curiosity of Galt we owe the sensible answer of West :—' When it was understood,' said the artist, ' that I intended to paint the characters as they had actually appeared on the scene, the Archbishop of York called on Reynolds, and asked his opinion ; they both came to my house to dissuade me from running so great a risk. Reynolds began a very ingenious and elegant dissertation on the state of the public taste in this country, and the danger which every innovation incurred of contempt and ridicule, and concluded by urging me earnestly to adopt the costume of antiquity, as more becoming the greatness of my subject than the modern garb of European warriors. I answered, that the event to be commemorated happened in the year 1758, in a region of the world unknown to Greeks and Romans, and at a period of time when no warriors who wore such costume existed. The subject I have to represent is a great battle fought and won, and the same truth which gives law to the historian should rule the painter. If instead of the facts of the action I introduce fictions, how shall I be understood by posterity ? The classic dress is certainly picturesque, but by using it I shall lose in sentiment what I gain in external grace. I want to mark the place, the time, and the people, and to do this I must abide by truth. They went away then, and returned again when I had the painting finished. Reynolds seated himself before the picture, examined it with deep and minute attention for half an hour ; then rising, said to Drummond, ' West has conquered ; he has treated his subject as it ought to be treated ; I retract my objections. I foresee that this picture will not only become one of the most popular, but will occasion a revolution in art.' ' I wish,' said the king, ' that I had known

all this before, for the objection has been the means of Lord Grosvenor's getting the picture, but you shall make a copy for me.' "

From the following anecdote, communicated by my friend Charles Fraser, Esq., it will appear that West, notwithstanding his acquaintance with the savages of Pennsylvania, who first made him master of red and yellow pigments to combine with the contents of his mother's indigo-bag—notwithstanding his familiarity with the Indians, who visited the early settlers, and brought their baskets to exchange for the European wares of their quaker neighbours, notwithstanding all this intercourse with American savages, he was unacquainted with the peculiar toilette of the warrior, when arrayed for the exercise of the tomahawk and the scalping-knife. West not having seen an Indian in his war-dress, (although Mr. Cunningham has made him lead a " select body of Indians" on a war expedition into the wilderness, as we have seen above,) notwithstanding his desire to represent the true costume of the figures introduced as present at the Death of Wolfe, erred through ignorance of the Indian warrior's appearance on the field of battle. " When Col. Henry Laurens," says Mr. Fraser, " was in London during the American war of the revolution, Mr. West showed him the picture of the Death of General Wolfe. After admiring it, he asked the artist's permission to make one criticism on it, which, however, was not connected with its merits as a work of art. He then observed that the Indian on the front ground was represented with naked feet; whereas an Indian warrior was never known to go into battle without his moccasins, they being considered a necessary part of his military equipment. This information came with authority from one who had himself served against the American Indians. Mr. West expressed much regret at his ignorance of the fact, but it was too late to make any alteration in the picture.

"West had now obtained the personal confidence of the king and the favour of the public; his commissions were numerous, but of course the works for the palace had precedence. His majesty employed him to paint the death of Epaminondas, as a companion to that of Wolfe, the death of the Chevalier Bayard, Cyrus liberating the family of the king of Armenia, and Segestes and his daughter brought before Germanicus."

Established as the favourite painter of the king of Great Britain, Mr. West suggested to the king a series of pictures on the progress of revealed religion: a splendid oratory was projected for their reception, and half-a-dozen dignitaries of the

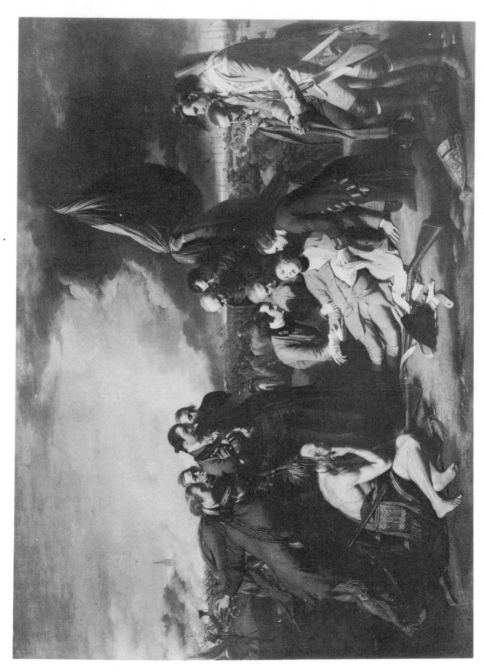

17 The Death of Wolfe, 1770. Painting by Benjamin West. *Courtesy The National Gallery of Canada, Ottawa.*

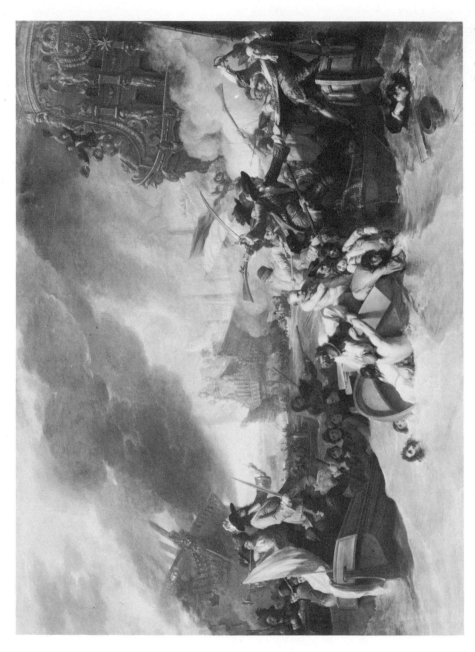

18 BATTLE OF LA HOGUE, 1778. Painting by Benjamin West. *Courtesy National Gallery of Art, Washington, D.C., Andrew W. Mellon Fund.*

church were summoned to consider the propriety of introducing paintings into a place of worship. ' When I reflect,' said the king, ' that the Reformation condemned religious paintings in churches, and that the parliament in the unhappy days of Charles the First did the same, I am fearful of introducing any thing which my people might think popish. Will you give me your opinions on the subject?' After some deliberation Bishop Hurd delivered in the name of his brethren and himself their unanimous opinion, that the introduction of religious paintings into *his Majesty's Chapel* would in no respect violate the laws or the usages of the Church of England."

The painter, with his usual assiduity and love for his art, devoted himself to this great study. He divided his subject " into Four Dispensations—the Antediluvian, the Patriarchal, the Mosaical, and the Prophetical. They contained in all thirty-six subjects, eighteen of which belonged to the Old Testament, the rest to the New. They were all sketched, and twenty-eight were executed, for which West received in all twenty-one thousand seven hundred and five pounds. A work so varied, so extensive, and so noble in its nature, was never before undertaken by any painter."

During the progress of this work, he painted many other pictures, some of them for his royal friend. The king, queen, princes, and princesses, sat for their portraits, sometimes singly and sometimes in groups, and he received for nine pictures of this description, two thousand guineas. These portraits are far inferior to the works in that branch of the art, of Reynolds or Copley, or many others. One of the finest pictures of West is the Battle of La Hogue. It is said that when he was painting this picture, an admiral took him to Spithead, and to give him a lesson on the effect of smoke in a naval engagement, ordered several ships of the fleet to manœuvre as in action, and fire broadsides, while the painter made notes. It was a maxim with West to paint nothing without studying the object, if it was to be obtained. The originality of this great picture cannot be questioned, yet we have a print before us (of the same size with Woollet's print from La Hogue) which has points of similarity that make us think West must have seen it. It is from a picture by Langendyk, a Dutch painter, and represents the destruction of the English fleet in the Thames by De Ruyter and De Witt, in the year 1667. The Royal Charles is strikingly like the nearest French ship in West's picture; and indeed the treatment of the whole subject is in a manner analogous.

To paint great pictures, and to live, even with prudence and without ostentation as befitting the friend of royalty, required many thousand guineas. Benjamin West, when he began his career in London, had no fortune, and had to rely on the product of his individual exertion; for it was only after his establishment, that he could employ pupils and inferior artists, to assist in the mechanical part of the labour. He had debts to pay. He had a house to build for his family, and galleries and work-shops, spacious and lofty for pictures designed for royal chapels. To purchase ground in the west part of the metropolis and erect such buildings as the painter boldly, yet wisely, constructed in Newman-street, necessarily incurred a great debt. " When," said Gilbert Stuart, " I had finished a copy of a portrait for my old master, that I knew he was to have a good price for, and he gave me a guinea, I used to think it hard—but when I looked on the establishment around me, which with his instruction I enjoyed, and knew it was yet to be paid for, I fully exonerated West from the charge of niggardliness, and cheerfully contributed my labour in return for his kindness."

The following painter's gossip was communicated by Mr. West to Allston, and by him to us. " Before the Royal Academy was formed, the Society of Painters (as I think they were then called) held their annual exhibition in Spring Gardens. On a certain year Mr. West and Mr. Wilson happened to be appointed joint *hangers*. It was a memorable year for the crudeness of the performances, in consequence, I suppose, of an unusual number of new adventurers. When the pictures were all up, Wilson, with an expressive grin, began to rub his eyes, as if to clear them of something painful. ' I'll tell you what, West,' said he after a while, ' this will never do; we shall lose the little credit we have : the public can never stand such a shower of chalk and brick-bats.'—' Well, what's to be done ? We can't reject any pictures now.' ' Since that's the case then, we must mend their manners.' ' What do you mean to do ?' ' You shall see,' said Wilson after a pause, ' what Indian ink and Spanish liquorice can do.' He accordingly despatched the porter to the colourman and druggist for these reformers, and dissolving them in water, actually washed nearly half the pictures in the exhibition with this original glaze. ' There,' said he ' 'tis as good as asphaltum— with this advantage : that if the artists don't like it, they can wash it off when they get the pictures home.' " And Mr. West acknowledged that they were all the better for it.

West proceeded steadily in the execution of the great work from the scriptures, (occasionally painting other historical

subjects,) to the increase of his reputation, and the satisfaction of his royal friend.

In the month of June, 1784, the writer of this memoir arrived in England, for the purpose of studying the art of painting, having assurances of the aid of Mr. West, before leaving New-York. When introduced to the painter, he was working on an esel-picture for the Empress Catharine of Russia. It was Lear and Cordelia.

The impression made upon an American youth of eighteen by the long gallery leading from the dwelling-house, to the lofty suite of painting-rooms—a gallery filled with sketches and designs for large paintings—the spacious room through which I passed to the more retired attelier—the works of his pencil surrounding me on every side—his own figure seated at his esel, and the beautiful composition at which he was employed, as if in sport, not labour ;—all are recalled to my mind's eye at this distance of half a century, with a vividness which doubtless proceeds in part, from the repeated visits to, and examination of, many of the same objects, during a residence of more than three years in London. But the painter, as he then appeared, and received me and my conductor, (Mr. Effingham Lawrence, an American, like himself of a quaker family, and no longer a quaker in habits and appearance,) the palette, pencil, esel, figure of Cordelia, all are now before me as though seen yesterday.

Many of the pictures for the Royal Chapel of Windsor were then in the apartments, particularly I call to view the Moses receiving the Law.

The pictures mentioned below by Mr. Cunningham, were not painted for some years after ; although recorded by him as preceding the works on Revelation.

" The painter expressed his regret that the Italians had dipped their pencils in the monkish miracles and incredible legends of the church, to the almost total neglect of their national history; the king instantly bethought him of the victorious reign of our third Edward, and of St. George's Hall in Windsor Castle. West had a ready hand; he sketched out the following subjects, seven of which are from real and one from fabulous history :

' 1. Edward the Third embracing the Black Prince, after the Battle of Cressy. 2. The Installation of the order of the Garter. 3. The Black Prince receiving the king of France and his son prisoners, at Poictiers. 4. St. George vanquishing the Dragon. 5. Queen Phillipa defeating David of Scotland, in the Battle of Neville's Cross. 6. Queen Phillipa interceding with Edward for the Burgesses of Calais. 7. King

Edward forcing the passage of the Somme. 8. King Edward crowning Sir Eustace de Ribaumont at Calais. These works are very large. They were the fruit of long study and much labour, and with the exception of the Death of Wolfe and the Battle of La Hogue, they are the best of all the numerous works of this artist." Yet these are the pictures George IV. consigned to the lumber-room.

Previous to the writer's visit to Europe, Mr. West had afforded instruction and the most paternal encouragement to many pupils, American and English. Those of this country will frequently be brought before the reader of this work. Charles Wilson Peale, Gilbert Stuart, Joseph Wright and John Trumbull, were among the American students. Peale was under his guidance from 1771 to 1774; Stuart, Wright and Trumbull, during portions of the American revolutionary war, and the last mentioned was established with him at the time of the visit above noticed, as a pupil, and remained such for some years after.

It has been a subject of speculation with many, to determine how West managed to keep the favour of his friend George the Third, during the contest his ministers and armies were carrying on against the native land of the artist, and at the same time preserve the love of country, and declare his attachment to the cause of liberty.

Cunningham says, " He was not, according to his own account, silent; he was too much in the palace and alone with his majesty to avoid some allusion to the strife ; the King inquired anxiously respecting the resources of his foes and the talents of their chiefs, and the artist gave, or imagined he gave, more correct information concerning the American leaders and their objects than could be acquired through official channels. How he contrived both to keep his place in the king's opinion, and the respect of the spirits who stirred in the American revolution, he has not told us, but it is not difficult to guess."

As we are yankees, we may perhaps guess as well as a Scotchman. West had been many years from his native land before the contest took place. He had no connexion with, or knowledge of, most of the leaders in his country's cause. He was prudent and known to be an honest man. George the Third was an honest man, and perfectly relied upon the painter's sincerity. Why should he quarrel with him for honest opinions, which did not interfere with his attachment to the sovereign who was his friend, or influence any of his actions ?

One of our best and most intelligent artists, Samuel F. B. Morse, president of the National Academy, has mentioned to

the writer an anecdote connected with this subject. He says, that on one occasion, when he entered Mr. West's painting room, long after the death of George the Third, he found the artist engaged in copying a portrait of that king, and as he sat at his work, and talked according to his custom, "this picture" said he, "is remarkable for one circumstance; the king was sitting to me for it, when a messenger brought him the declaration of American Independence." It may be supposed, that the question "how did he receive the news?" was asked. "He was agitated at first," said West, "then sat silent and thoughtful, at length, he said, "Well if they cannot be happy under my government, I hope they may not change it for a worse. I wish them no ill." If such was George the Third, we find no difficulty in reconciling his attachment to Benjamin West, with the American's honest love of his native land.

It is recorded of West, that he used to say, "you could always tell the highest nobility at court, from their profound humility to the king. The others kept at a distance, and did not seem to care about it. The first thought the higher they raised the prince, the higher they raised themselves." This is not only a proof of the painter's keen eye for observation of manners, as well as forms among mankind, but of a philosophical spirit and a happy power, by which to communicate his thoughts by words.

On the death of Reynolds, the choice of the Academy fell on West for their president, and the king gave his ready assent. The Royal Academy consists solely of artists, who elect their own members and officers, and manage their own affairs. The king from its establishment gave it his patronage and conferred such titles on its presidents or members, as are considered honours in a monarchy. This circumstance has been used as an argument in support of the patronage of a body of merchants, lawyers and physicians, and of such patrons having control over an Academy of Fine Arts in this country, directing its measures, and guiding its elections. Such absurdities can be advocated by men otherwise rational! and in a republic! In monarchies men need the patronage of those who lord it over them, and are supported by their labours. In republics there is no protector but the law. That spirit of benevolence with which our bountiful Creator has endowed us, and which, breaking through the sordid crust of worldliness with which we surround it, shines forth in acts of kindness, encouragement, liberality, and philanthropy, is not what is meant by *patronage* in the common acceptation of the word ;

it is the opposite of that patronage which the supercilious presume they are affording to those they employ—but it is the real patronage, which protects the weak and encourages the meritorious by support and advice; it is *that* love of our neighbour which is the essence of religion; it is the love of *good*, which is the essence of morality.

On the 24th of March, 1792, Mr. West delivered his inaugural discourse. His discourses were distinguished for practical good sense. He advised the students "to give heart and soul wholly to art, to turn aside neither to the right nor to the left, but consider that hour lost in which a line had not been drawn, nor a masterpiece studied. 'Observe,' he said, ' with the same contemplative eye the landscape, the appearance of trees, figures dispersed around, and their aerial distance as well as lineal forms. Omit not to observe the light and shade in consequence of the sun's rays being intercepted by clouds or other accidents. Let your mind be familiar with the characteristics of the ocean; mark its calm dignity when undisturbed by the winds, and all its various states between that and its terrible sublimity when agitated by the tempest. Sketch with attention its foaming and winding coasts, and that awful line which separates it from the heavens. Replenished with these stores, your imagination will then come forth as a river collected from little springs spreads into might and majesty. If you aspire to excellence in your profession, you must, like the industrious bee, survey the whole face of nature and sip the sweet from every flower. When thus enriched, lay up your acquisitions for future use, and examine the great works of art to animate your feelings and to excite your emulation. When you are thus mentally enriched, and your hand practised to obey the powers of your will, you will then find your pencils or your chisels as magic wands, calling into view creations of your own to adorn your name and country.'

Mr. West's advice was always replete with practical good sense. " Don't shut yourself up from visiters when engaged on any great work. Hear their remarks and encourage their criticisms. From the various opinions something useful may be gathered to improve your picture." His practice corresponded with his advice. He would continue his work though surrounded by company. When Trumbull was painting under his roof and direction, he consulted him as to expunging a part of a picture he was composing, in order to substitute other figures, but the master advised him rather to take a fresh canvass and paint the whole anew. He said he had

found this the shortest and least troublesome way of proceeding to alter a picture.

One of Mr. West's discourses has been illustrated by the pencil of his successor in the presidency. A subscription having been raised in New-York to pay Lawrence for a full length of West, the portrait painter judiciously chose to exhibit the president in the act of delivering a discourse on colour to the students of the academy. Of this discourse, and of Lawrence's picture, Mr. Leslie says: "Your mention of the rainbow in Lawrence's picture, reminds me that Sir Thomas intended that picture to represent Mr. West in the act of delivering a lecture, which he once did at Somerset-house to the academicians and students, for the purpose of explaining to them his theory of colour. It was not one of the discourses read by him as president, on the occasion of delivering the medals, but it was given by his own appointment in the middle of the day, and was extemporaneous. I was present as a student, and I remember he exhibited a board, on which was painted a *globe* and a *rainbow*. From these he illustrated what he conceived to be the principle on which the composition of the colours in Raphael's Cartoons was conducted, large copies of which, by Thornhill, were hanging round the room. Lawrence has dressed Mr. West in a gown he only wore in his painting room, as more picturesque than a coat and waistcoat. I think you will observe that besides the rainbow, he has introduced a part of the cartoon of the "Death of Ananias." It is a pity that Sir Thomas in this fine portrait has exaggerated the proportions of Mr. West's figure. Sir J. Reynolds would not have done so. He painted men as they were, and gave dignity without making them taller. The head, however, is very like, and in Lawrence's best style."

We fully concur in opinion with this eminent artist and able critic. Lawrence's biographer, Williams, has roundly asserted, and Cunningham has repeated the falsehood, that this portrait of West was presented by Sir Thomas to the American Academy of Fine Arts upon being made a member. Now the knight made no present whatever. He was employed by a number of subscribers, and paid $2000. The originator of the subscription was Mr. Waldo. The picture was placed under the care of the directors of the American Academy, and they gave public notice that no one should copy it!! This was their way of encouraging the progress of art.

It is remarkable that Mr. Cunningham, when speaking of West, always represents him as a quaker, although he has with most poetical liberty made him a soldier, and a captain leading

soldiers, in an enterprise of danger. We are told, that " he went from his gallery in Newman-street to Windsor, and back again, with the staid looks of one of the brethren going to, and returning from, chapel." Now this is as purely fiction as his captain's commission, and his military achievements. In Newman-street, or at Court, West looked and dressed like other gentlemen of the time.

Cunningham says, that the father of West was of that family settled at Long Crendon, in Buckinghamshire, which produced Colonel James West, the friend and companion in arms of John Hampden. This family were undoubted descendants of the Lord Delaware, renowned in the wars of Edward the Third, and the Black Prince.

When in consequence of West's being elected to the presidency of the academy, the king offered him the honour of knighthood, he respectfully declined the empty title, yet to this day we hear him called Sir Benjamin.—Surely every American will rejoice that he rejected the nick-name. " West" is all-sufficient for his fame—any addition would be deformity.

In an address delivered to the students of the National Academy of Design, New York, in 1831, it was said,

" When Holbein visited England, Henry the Eighth was probably as accomplished a gentleman, compared with his subjects, as George the Fourth was in comparison with the Englishmen of the present day. Holbein received no mark of honour, and the beastly tyrant in the all-sufficiency of right-divine, power and patronage, prescribed to the artist the mode in which he should design the portrait of his patron. The painter probably fearing for his life, submitted to be dictated to by the barbarian, and represented the burly murderer with face and body full in front, as may be still seen on the covers of the Harry-the-Eighth playing cards. The cotemporary of this Harry, Francis the First of France, proved his superiority, by the memorable speech to his murmuring nobles, who were dissatisfied that he preferred the society of a painter to that of his courtiers : 'I can make a thousand nobles with a word,' said the heroic monarch, 'but only God can make a Da Vinci.' Francis, though perhaps unknown to himself, felt an undefined conviction of the folly, if not blasphemy, of the flattery which tells kings that they are the fountains of honour. He felt, perhaps, as we feel, that God alone is the fountain of honour, as of all good. While contemplating this reproof to the nobles of France, so glorious to Francis, let us

remember that Da Vinci was not only an artist, but an accomplished and learned man. The progress of civilization in England is marked by the attentions and honours paid to Rubens by Charles the First, who, though not as far advanced as his subjects in the science of political justice, was one of the most accomplished men of his time. He made the painter, Sir Peter Paul. But the painter was, and still remains, Rubens. From that time, it appears to have been a matter of course, to confer the title of knight on the most distinguished painter in England, and I am proud that I can say that Benjamin West was the only man who refused the supposed honour. When a child, he aspired to such distinction, as he then childishly thought it; as a man, he firmly, though respectfully, declined the honour which his friend, for such George the Third was, intended him. He knew that the name of West could receive no lustre from a title."

This assertion respecting West, is thus noticed by the editor of a very respectable Journal, devoted to the Fine Arts, published in London, in which the address is copied, "We honour the principles of the republican professor, but he is mistaken in giving West credit for contemning honours. The knighthood was probably declined from religious scruples, but he evidently had no disinclination to a baronetage, and had the vanity to boast of his descent." We have reason to believe that George the Third intended to create West a baronet, and to add the means of supporting the distinction; and the painter had no objection to such distinction for his family. Is it vanity to be proud of descent from the companion in arms of Hampden?—of descent from a leader of patriots, armed and bleeding in defence of their country's rights and liberty?—of a man who risked fortune and life to repel tyranny? But where is the proof of West's boasting? Certainly not in the incident relative to his picture of the " order of the garter." As to the religious scruples, the editor no doubt, like many others, views West as a quaker. But the writer knows that the painter had no religious scruples of the kind. He was not a quaker in manner, dress, conversation, or conduct after his arrival in England, at least we can speak of our own knowledge after the year 1783, and was as unquaker-like in his appearance as any man in Great Britain.

Cunningham says, " The grave simplicity of the quaker continued to the last in the looks and manners of the artist." This might induce any one to picture West to himself as a broad-brimmed, drabbed-coloured sectarian—but he was nothing like it. His countenance was surrounded by the powder and

the curls, considered decorations at the time, and his well-
formed limbs covered by garments of texture and colour such
as were worn by other gentlemen. His liberal mind did not
even prohibit the study or practice of his liberal profession on
the day set apart for the cessation of labour. To study or
exercise his high calling was no labour to him. It was the
pleasant exertion of powers given by his Creator, to lift his
fellow creatures from the pits and quagmires of ignorance.

We have said that when West was elected president of the
Royal Academy, George the Third wished to confer the title
upon him which his predecessor had borne. The Duke of
Gloucester " called on West from the king to inquire if this
honour would be acceptable. ' No man,' said Benjamin, ' en-
tertains a higher respect for political honours and distinctions
than myself, but I really think I have earned greater eminence
by my pencil already than knighthood could confer on me.
The chief value of titles is to preserve in families a respect for
those principles by which such distinctions were originally ob-
tained—but simple knighthood to a man who is at least as
well known as he could ever hope to be from that honour, is
not a legitimate object of ambition. To myself then your
royal highness must perceive the title could add no dignity,
and as it would perish with myself, it could add none to my
family. But were I possessed of fortune, independent of my
profession, sufficient to enable my posterity to maintain the
rank, I think that, with my hereditary descent and the station
I occupy among artists, a more permanent title might become
a desirable object. As it is, however, that cannot be; and I
have been thus explicit with your royal highness that no mis-
conception may exist on the subject.' The duke took West
by the hand, and said, ' You have justified the opinion which
the king has of you; he will be delighted with your answer.' "

From this we are justified in saying, as in the address to
the students, that " he firmly, though respectfully, declined
the honour, which his friend, for such George the Third was,
intended him. He knew the name of West could receive no
lustre from a title." The words, " I really think I have earn-
ed greater eminence by my pencil already, than knighthood
could confer upon me," appear very plainly to indicate the
painter's sense of the relative value of his art, and the honours
it is supposed princes can bestow by a title not hereditary and
unaccompanied by wealth. He seems to have said, " If my
posterity could be distinguished among men by a mark or title
derived from me, and wealth to support that rank among their
countrymen to which wealth is supposed essential, I might

wish that the remembrance of *that* by which the distinction was obtained might be so perpetuated. But for myself a title is not a legitimate object of ambition."

Mr. Leslie, in one of his letters, says, " Raphael West told me that his father was led to expect a baronetcy as soon as the great works he was engaged on for the chapel of Windsor Castle were completed ; but these works were all stopped when the king lost his senses."

" Mr. West was, as you know, at all times delighted to receive Americans, and no subject of conversation interested him more than the present greatness and future prospects of the United States. His political opinions were known to be too liberal for the party who governed England during the regency and the reign of George IV. Whether owing to this cause or not, he was certainly out of favour with the court during all the time of George III.'s long seclusion from the world. It was to the credit of that monarch, that he never allowed the political opinions of Mr. West to interfere with his admiration of him as an artist, and his friendship for him as a man. The king died while Mr. West was confined to his bed with his last illness. Raphael West endeavoured to keep the newspaper from him, but he guessed the reason, and said, " I am sure the king is dead, and I have lost the best friend I ever had in my life."

The feeling that West ought to receive that title which the vulgar consider as bestowing honour, was and is so prevalent both in England and America, that in both countries he is occasionally called Sir Benjamin to this day. Memes, in a recent English publication on the fine arts, calls him Sir Benjamin; and Hazlitt, in his book called " Conversations of James Northcote," has this passage in relating circumstances attending a trial in which West was subpœnaed as a witness. " West was then called upon to give his evidence, and there was immediately a lane made for him to come forward, and a stillness that you could hear a pin drop. The judge (Lord Kenyon) then addressed him: " Sir Benjamin, we shall be glad to hear your opinion." Mr. West answered, " He had never received the honour of a title from his majesty;" and proceeded to explain the difference between the two engravings which were charged with being copies the one of the other, with such clearness and knowledge of the art, though in general he was a bad speaker, that Lord Kenyon said, when he had done, " I suppose, gentlemen, you are perfectly satisfied—I perceive that there is much more in this than I

had any idea of, and I am sorry I did not make it more my study when I was young !"

The reader will please to remark that it is Mr. Hazlitt who speaks of " two engravings which were charged with being copies the one of the other," which is phraseology not sufficiently clear for our yankee comprehension, though we are bound to believe it good English, on the authority of a popular writer, and a beautiful London edition from the hands of Colburn & Bentley.

I find, and my readers may be pleased to know, that the ancient crest of the Wests, Lords Delaware, was a bird's head argent, charged with a foss dancette sable.

In the answer West gave to the offer of knighthood, Cunningham observes, " there was certainly very little of the quaker. Possibly he was not without hope that the king would confer a baronetcy, and an income to support it, on one who, to the descent from the lords of Delaware, could add such claims of personal importance. No further notice, however, was taken of the matter ; he went to the palace as usual, and as usual his reception was warm and friendly.

" From 1769 till 1801 West had uniformly received all orders for pictures from his majesty in person. They had settled the subject and price between them without the intervention of others, and, in addition to his one thousand pounds a year paid on account, he had received whatever more, and it was not much, might be due upon the pictures actually painted. A great change was near. A mental cloud fell upon the king, and the artist was the first to be made sensible that the sceptre was departed from his hand. The doors of the palace, which heretofore had opened spontaneously like those of Milton's Paradise, no longer flew wide at his approach, but turned on their hinges grating and reluctantly. What this might mean he was informed by Mr. Wyatt, the royal architect, who called and said he was authorized to inform him that the pictures painting for the chapel at Windsor must be suspended till further orders. 'This extraordinary proceeding,' says Galt, 'rendered the studies of the best part of the artist's life useless, and deprived him of that honourable provision, the fruit of his talents and industry, on which he had counted for the repose of his declining years. For some time it affected him deeply, and he was at a loss what steps to take. At last, however, on reflecting on the marked friendship and favour which the king had always shown him, he addressed his majesty a letter, of which the following is a copy of the rough

draft, being the only one preserved.' After mentioning the
message to suspend the paintings for the chapel, it proceeds:

" ' Since 1797 I have finished three pictures, begun several
others, and composed the remainder of the subjects for the cha-
pel, on the progress of Revealed Religion. Those are subjects
so replete with dignity of character and expression, as demanded
the historian, the commentator, and the accomplished painter,
to bring them into view. Your majesty's gracious commands
for my pencil on that extensive subject stimulated my humble
abilities, and I commenced the work with zeal and enthusiasm.
Animated by your commands, I burned my midnight lamp to
attain that polish which marks my scriptural pictures. Your
majesty's zeal for religion and love of the elegant arts are
known over the civilized world, and your protection of my
pencil had given it celebrity, and made mankind anxiously
look for the completion of the great work on Revealed Reli-
gion. In the station which I fill in the Academy I have been
zealous in promoting merit; ingenious artists have received
my ready aid, and my galleries and my purse have been
opened to their studies and their distresses. The breath of
envy or the whisper of detraction never defiled my lips, nor
the want of morality my character; and your majesty's vir-
tues and those of her majesty have been the theme of my admi-
ration for many years.

" ' I feel with great concern the suspension of the work on
Revealed Religion—if it is meant to be permanent, myself
and the fine arts have much to lament. To me it will be ruin-
ous, and it will damp the hope of patronage in the more re-
fined departments of painting. I have this consolation, that
in the thirty-five years during which my pencil has been
honoured with your commands, a great body of historical and
scriptural works have been placed in the churches and palaces
of the kingdom. Their professional claims may be humble,
but similar works have not been executed before by any of
your majesty's subjects. And this I will assert, that your
commands and patronage were not laid on a lazy or an un-
grateful man, or an undutiful subject.'

" To this letter, written on the 26th of September, 1801,
and carried to the court by Wyatt, West received no answer.
On his majesty's recovery, he sought and obtained a private
audience. The king had not been made acquainted with the
order for suspending the works, nor had he received the letter.
' Go on with your work, West,' said the king, kindly, ' go on
with the pictures, and I will take care of you.' He shook him
by the hand and dismissed him. ' And this,' says Galt, ' was

the last interview he was permitted to have with his early and constant, and to him truly royal, patron. But he continued to execute the pictures, and, in the usual quarterly payments, received his £1000 per annum till his majesty's final superannuation; when, without any intimation whatever, on calling to receive it, he was told that it had been stopped, and that the paintings for the chapel, of Revealed Religion, had been suspended. He submitted in silence—he neither remonstrated nor complained.'

" The story of his dismissal from court was spread with many aggravations; and the malevolence of enemies which his success had created—there are always such reptiles—was gratified by the circulation of papers detailing an account of the prices which the fortunate painter had received for his works from the king. The hand which had drawn up this injurious document neglected to state that the sum of thirty-four thousand one hundred and eighty-seven pounds was earned in the course of thirty-three laborious years: and the public, looking only to the sum at the bottom of the page, imagined that West must have amassed a fortune. This notion was dispelled by an accurate statement of work done and money received, with day and date, signed with the artist's name, and accompanied by a formal declaration of its truth; a needless addition, for all who knew any thing of West knew him to be one of the most honourable of men."

This disgraceful spirit, originating in disappointment, envy, and all the base feelings which ignorance of our true interests, and the imperfections of our social systems engender in the bosoms of men, may be traced in the publications of the days in which West lived; and unfortunately some of the slanders are embalmed in the works of genius, and will descend to posterity. Wolcott strove to pull down West, that Opie might be exalted on his ruins; and the talents of the poet may preserve the falsehoods which were harmless at the time, notwithstanding the popularity of Peter Pindar. The infamous Williams, as Anthony Pasquin, shot his feeble arrows against West, and against all who were distinguished for talents or virtue. Fuseli, the caricaturist of nature, was the caricaturist of West. Hazlitt relates the sarcasms of Northcote, a pupil of Reynolds —in short, it is painful to observe, that (notwithstanding West's acknowledged purity of moral character, active benevolence, simplicity of manner, great kindness to all artists who sought his instruction, unwearied readiness to assist and advise, equability of temper that dulness could not disturb, or

impertinence ruffle) such a man was a butt for the shafts of
envy, malice, and uncharitableness, pointed by men of learn-
ing, wit, and genius.

Of the very many artists with whom we have associated, who
had known Mr. West personally, we never heard but one
speak otherwise of him, except as of a benefactor and friend,
and that one acknowledged that he had been more than a
father to him for thirty years.　Mr. Allston, in a letter before
us, says, he " received me with the greatest kindness.　I shall
never forget his benevolent smile when he took me by the
hand; it is still fresh in my memory, linked with the last of
like kind which accompanied the farewell shake of the hand
when I took leave of him in 1818.　His gallery was open to
me at all times, and his advice always ready and kindly given.
He was a man overflowing with the milk of human kindness.
If he had enemies, I doubt if he owed them to any other cause
than this rare virtue, which (alas for human nature!) is too
often deemed cause sufficient."

" Whenever," says the eloquent and judicious Verplanck,
" the historical inquirer can thus efface the stains left by time
or malice upon the fame of the wise and good, he effects many
of the grandest objects of history."

Fuseli writes to Roscoe: " ' There are,' says Mr. West, ' but
two ways of working successfully, that is, lastingly, in this
country, for an artist—the one is to paint for the king; the
other, to meditate a scheme of your own.'　The first he has
monopolized; in the second he is not idle: witness the prints
from English history, and the late advertisement of allegorical
prints to be published from his designs by Bartolozzi.　In imi-
tation of *so great a man*, I am determined to lay, hatch, and
crack an egg for myself too, if I can."　By marking the words
" so great a man" in italics, the envious Swiss has only marked
his own irritation at seeing the prosperity and popularity of the
amiable American.　It reminds us of his single vote against the
otherwise unanimous election for West as president of the Aca-
demy.　Fuseli did " lay, hatch, and crack an egg" for him-
self: he produced his splendid Milton Gallery, which totally
failed, notwithstanding the efforts of the Academy to support
it, who not only gave it the high encomiums it deserved, but
got up a dinner in the gallery at fifteen shillings a head for
the painter's benefit.　The pictures were principally pur-
chased by the painter's private friends, to help him out of
the undeserved difficulties his project had generated.　The
reader will see more on this subject in our biography of

Allston, a man who loved and was loved by West, and found ample encouragement for his pencil in London, although he did not paint for a king or bespatter the king's painter with scurrilous abuse, mis-called wit. By no means meaning to deny that Fuseli had *wit;* but when wit is prompted by envy and jealousy, it loses its character, and takes the ugly features of the demons who incite it. *Real wit* is always accompanied by truth, if not by good nature. Fuseli had extraordinary talents as a man independent of his art, and was perhaps the most learned of modern painters. But the enmity of Fuseli and Barry towards each other, though both eminently high in their profession, the hostility of both against West, and of Barry towards Reynolds, with the jealousy and envy at one time displayed generally against West—form a disgusting portion of the history of English art.

That armistice which was denominated the peace of Amiens, took place in 1802, when West was dismissed from employment by the unworthy successor of George the Third. The continent of Europe had been virtually shut against the English for ten years, and all ranks rushed to Paris, with curiosity on tiptoe to see the wonders there accumulated by the great military robber, and the no less wonder, the robber himself. That the president of the Royal Academy should seize this opportunity to view in one great collection those gems, which in his youth he had studied in their peaceful homes, from whence the spoiler had dragged them, was to be expected. He visited Paris, and took with him his sublime composition, on a small scale, of " Death on the Pale Horse." His reception was cordial, and the admiration of his work enthusiastic. Mr. Cunningham says, " Minister after minister, and artist after artist, from the accomplished Talleyrand, and the subtle Fouché, to the enthusiastic Dénon, and the ferocious David gathered around him, and talked with unbounded love of historical painting and its influence on mankind." All this is attributed by the Scottish biographer to "wily" politics, hypocrisy and flattery. We believe men of all civilized nations at present pretty much the same, and the professions of a Frenchman worth as much as those of a Briton, south or north. That West was pleased with his reception among a gallant and polished people, is certain. He had two or more interviews, as we are informed, with the First Consul ; and it must be remembered that at this time, Bonaparte had restored prosperity to distracted France, and peace to Europe. That although a military robber, he was only more successful, not more atro-

cious than other military robbers who have been glorified by
deluded mankind. That he had not divorced a faithful wife.
That he had not developed the enormous plans of self-idolatry,
which overthrew the hopes of the friends of man, and
deluged the world in blood. West saw in him a great man,
and an interesting gentleman, who had taste for, and know-
ledge of the arts, in which the painter delighted and excelled.
He saw him, and was pleased. It is said, that he ventured to
recommend to Napolean, the example of Washington, if he did
so, it is a greater proof of his simplicity than any Galt or Cun-
ningham have recorded.

Among the distinguished visiters of Paris, were Charles
Fox and Sir Francis Baring. West met them in the Louvre,
and expatiated upon the advantages which the arts would derive
from the circumstance of the chefs d'œuvres of the world being
collected in one place.

"He concluded by pointing out the propriety, even in a
mercantile point of view, of encouraging to a sevenfold extent
the higher departments of art in England. The prospect of
commercial advantages pleased Baring, and Fox said, with
much frankness, and with that sincerity which lasts at least for
the moment, ' I have been rocked in the cradle of politics, and
never before was so much struck with the advantages, even in
a political bearing, of the fine arts, to the prosperity as well
as to the renown of a kingdom; and I do assure you, Mr.
West, if ever I have it in my power to influence our government
to promote the arts, the conversation which we have had to-
day shall not be forgotten.' They parted, and West returned
to England.

"Old age was now coming on him; but his gray hairs were
denied the repose which a life of virtue and labour deserved."
So says his biographer, Cunningham.

The academicians who had bowed to the president, while
he was the favoured of the court, now assailed him in his de-
clining and unprotected age. West retired from the presi-
dent's chair, and Wyatt was elected in his stead. "This dis-
tinction!" says Cunningham, "the *court architect* had merit-
ed by no works which could be weighed in the balance with
the worst of his predecessor's; and West persuaded himself
that his own splendid reception in France had been at the
root of all the evil."

Mr. Cunningham goes on to say, "In a short time, how-
ever, the academy became weary of Wyatt, displaced him, and
restored the painter, by a vote which may be called unani
mous; since there was only one dissenting member—supposed

to be Fuseli*—who put in the name of Mrs. Moser for president. Ladies were at that period permitted to be members, and the jester no doubt meant to insinuate that a shrewd old woman was a fit rival for West."

So much for Mr. Fuseli. West, though he had been deserted by the court of Great Britain, and the artists of the *Royal* Academy, never deserted himself. Those who had driven him from the president's chair, we hope, were ashamed of their dirty work. The venerable artist regained his place at the head of the academy, (he was always at the head of all its artists,) and as president exerted himself for the benefit of the arts, until death closed his virtuous and useful career.

Martin Archer Shee, Esq. in his excellent work, " Elements of Art," thus speaks of West:

" The claims of the present president of the academy are not more generally understood than those of his predecessor, and his merits have been as inadequately appreciated as they have been rewarded by the public. Notwithstanding the large space which he fills in his art, and although his brethren have justly and honourably placed him at their head, he has good ground of complaint, against the undiscriminating criticism of his day, and may be said to be, in a great degree, ' defrauded of his fame.' Posterity will see him in his merits as well as his defects ; will regard him as a great artist, whose powers place him high in the scale of elevated art ; whose pencil has maintained with dignity the historic pretensions of his age, and whose best compositions would do honour to any school or country."

The same artist and author thus speaks of the encouragement afforded by the public to this great painter:

" What will be thought of the protection and encouragement afforded to genius in this great and wealthy empire, when it is stated, that the unremitting exertions of this distinguished artist, in the higher department of painting, during the period of forty-eight years, (almost half a century,) have not, exclusive of his majesty's patronage, produced to him the sum of six thousand pounds ! ! !"

He endeavoured " to form a national association for the encouragement of works of dignity and importance, and was cheered with the assurance of ministerial, if not royal, patronage. But many of those who countenanced the design were cautious and timid men, deficient in that lofty enthusiam necessary for success in grand undertakings, and whose souls

* Fuseli avowed that the vote was his : saying " one old woman is as good as another."

were not large enough to conceive and consummate a plan worthy of the rank and genius of the nation. The times, too, were unfavourable: Englishmen had in those days need enough to think of other matters than paintings and statues. Mr. Pitt, who had really seemed disposed to lend his aid to this new association, soon died. Mr. Fox, who succeeded him, declared, " As soon as I am firmly seated in the saddle, I shall redeem the promise I made in the Louvre"—but he also was soon lost to his country. The pistol of an assassin prevented Percival from taking into consideration a third memorial, which West had drawn up, and the president at last relinquished the project in despair." Yet his efforts were not unavailing as the British Institution was formed out of the wreck of his magnificent plan.

In the year 1809, Mr. West, in a letter to one of his early pupils, (Charles Wilson Peale,) thus expresses himself:

" When I was in Italy in the year 1760, the stupendous productions in the fine arts which are in that country, rushed on my feelings with their impetuous novelty and grandeur ; and their progress through the world from the earliest period, arrested my attention when I discovered they had accompanied empire, as shade does the body when it is most illuminated, and that they had declined both in Greece and Italy, as the ancient splendour of those countries passed away.

" In England I found the fine arts, as connected with painting and sculpture, had not taken root ; but that there were great exertions making by the artists to prepare the soil, and sow the seeds. It was those artists who invited me to appear among them, with a few essays of my historical compositions in their annual exhibitions of painting, sculpture and architecture. Those exhibitions became an object of attraction to men of taste in the fine arts; the young sovereign was interested in their prosperity ; and the artists were by his royal charter raised into the dignity, the independence, and, as it were, the municipal permanency of a body corporate ; in which body I found myself a member, and a director ; but party and jealousy in two or three years interrupted the harmony and finally dissolved that society. At this period his majesty was graciously pleased to signify his commands to four artists, to form a plan for a royal academy, in which number I had the honour to be included. His majesty was graciously pleased to approve the plan, and commanded it to be carried into effect. Thus commenced the institution of the Royal Academy of Arts in London. An institution of proud importance to the sovereign ; and to this, as a manufacturing country, of more real

and solid advantage than would have been the discovery of
gold and silver mines within her earth ; as it taught delinea-
tion to her ingenious men, by which they were instructed to
give taste to every species of manufactories, to polish rudeness
into elegance, and soften massiveness into grace ; and which
raised the demand for them to an eminence unknown before in
all the markets of civilized nations throughout the world.

" At that time the breast of every professional man glowed
with the warmth and energy of genius, at the establishment of
the royal academy, and at the pleasing prospect it held out in
the higher department of art—historical painting. The expe-
riment was then to be made, whether there was genius in the
country for that department of art, and patronage to nourish
and stimulate it. The sovereign, the artist, and a few gentle-
men of distinguished taste were solicitous for its success. With
respect to genius, I have to speak from observation, that the
distinguished youths who have passed in review before me
since the establishment of the academy, in the three depart-
ments of art which constitute its views, would have been found
equal to attain unrivalled eminence in them : and I know of
no people since the Greeks so likely to attain excellence in
the arts as the people of England ; if the same spirit and love
for them were diffused and cherished among them, as it was
among the subjects in the Grecian states.

" Your communication respecting your son being about to
embark again for France, and to study painting, and collect
the portraits of eminent men in that country as well as in
other parts of Europe, gives me sincere pleasure ; I honour his
enterprise ; but I hope he will, when surrounded by the great
examples which are now at Paris, of Grecian and Italian art,
I hope he will direct his mind to what are their real, and im-
mutable excellencies, and reflect upon the dignity which they
give to man, and to the countries where they were produced.
Although I am friendly to portraying eminent men, I am not
friendly to the indiscriminate waste of genius in portrait paint-
ing ; and I do hope that your son will ever bear in his mind,
that the art of painting has powers to dignify man, by trans-
mitting to posterity his noble actions, and his mental powers,
to be viewed in those invaluable lessons of religion, love of
country, and morality ; such subjects are worthy of the pencil,
they are worthy of being placed in view as the most instructive
records to a rising generation. And as an artist, I hope he
will bear in his mind, that correctness of outline, and the just-
ness of character in the human figure are eternal ; all other
points are variable, all other points are in a degree subordi-

nate and indifferent—such as colour, manners and costume: they are the marks of various nations: but the form of man has been fixed by eternal laws, and must therefore be immutable. It was to those points that the philosophical taste of the Greek artists was directed; and their figures produced on those principles leave no room for improvement, their excellencies are eternal."

CHAPTER V.

The great picture presented by West to the Pennsylvania Hospital—His great pictures for exhibition—Death—Miscellaneous notices—The subjects chosen for his pictures—His character by Sir Martin Archer Shee.

The undaunted painter now between sixty and seventy years of age, commenced a series of great works solely relying upon himself for their success. The first he exhibited to the public was his "Christ healing the sick," designed as a present to the hospital of the metropolis of Pennsylvania, his native state. A noble memorial of his love to the country of his birth, and her institutions. Not given to "aid in creating a hospital for the sick in his native town," as his biographer has said, for Philadelphia was not his native town, and the Pennsylvania Hospital in that city, had been built and in operation for half a century.

When the "Healing of the Sick" was exhibited in London, the rush to see it was very great, and the praise it obtained very high. "The British Institution," says his English biographer, "offered him three thousand guineas for the work: West accepted the offer, for he was far from being rich,—but on condition that he should be allowed to make a copy, with alterations." This copy, with not only alterations, but an additional group, was received by the trustees of the hospital, and placed in a building erected according to a plan transmitted by the donor, in which it stands a monument to his honour as a man and an artist. The receipts from the exhibition in the first year after its arrival were four thousand dollars.

We are sorry to record any thing discreditable, relative to any man or body of men, but we will not hide any transaction connected with the arts or artists of our country which appears to us necessary or belonging to the historical memoirs we have undertaken. We know that Mr. West, when he made this noble present to the Pennsylvania Hospital, intended that it should be free to students and artists, for he justly thought

that as a model, it would promote the progress of painting in his native country. He expressed this wish and intention to the managers of the hospital, but it has not been complied with. It is the only exhibition of painting in the United States where money is received from the artist or the student. Yet this is the free gift of an American artist, who delighted in pointing the way to excellence in the arts. We, while on the subject, will object to these managers, that they do not give due credit to the picture presented to them, by their statements of receipts and expenditures in its exhibition. They charge against the receipts from the picture $14,000 for the building in which it is placed, as if that building was appropriated to that use alone, whereas it is used for other purposes in such manner and proportion, as ought to reduce the sum to one half. We hope these gentlemen will in both these respects do justice to their benefactor.

"It ought to be known, if it is not," says Mr. Leslie, in one of his letters to us from West Point, "that at the time Mr. West made his noble present to the Pennsylvania Hospital, his pecuniary affairs were by no means in a prosperous condition. He was blamed by those who did not know this, for selling the first picture he painted for them; but he redeemed his pledge to them, and I can bear witness of his great satisfaction, when he heard that the exhibition of it had so much benefited the institution. He had begun his own portrait to present to the hospital. It was a whole length on a mahogany pannel; he employed me to dead colour it for him. He had also made a small sketch of a picture of Dr. Franklin, to present with it. The doctor was seated on the clouds, surrounded by naked boys, and the experiment of proving lightning and electricity to be the same was alluded to."

The success of the Healing in the Temple, encouraged the painter, and he produced in rapid succession, "'the Descent of the Holy Ghost on Christ at the Jordan,' ten feet by fourteen—' The Crucifixion,' sixteen feet by twenty-eight— ' The Ascension,' twelve feet by eighteen—and ' The Inspiration of St. Peter,' of corresponding extent.'" The great painting of " Christ rejected," and the still more sublime " Death on the Pale Horse," enlarged and altered from the picture, which he had carried to Paris in 1802.

"Domestic sorrow mingled with professional disappointment. Elizabeth Shewell—for more than fifty years his kind and tender companion—died on the 6th of December, 1817, and West, seventy-nine years old, felt that he was soon to follow. His wife and he had loved each other some sixty years

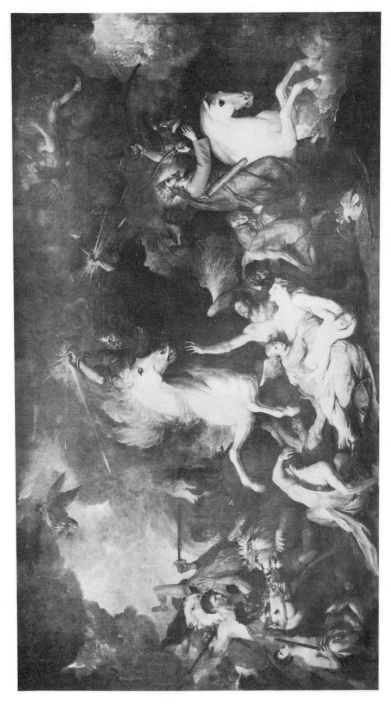

19 DEATH ON A PALE HORSE, 1802. Painting by Benjamin West. Courtesy The Pennsylvania Academy of the Fine Arts.

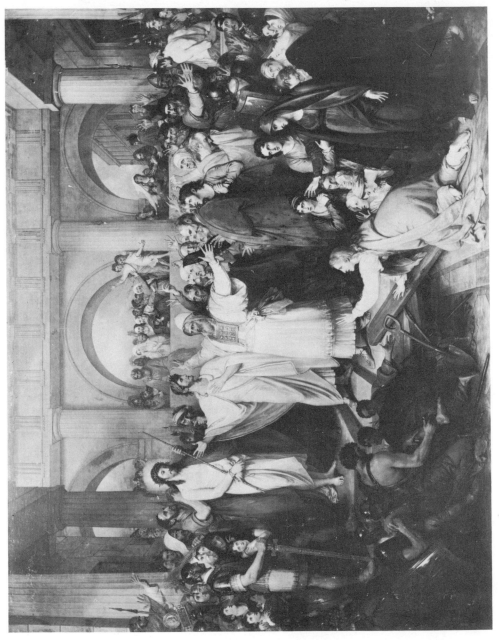

20 CHRIST REJECTED, 1815. Painting by Benjamin West. *Courtesy The Pennsylvania Academy of the Fine Arts.*

—had seen their children's children—and the world had no compensation to offer. He began to sink, and though still to be found at his esel, his hand had lost its early alacrity. It was evident that all this was to cease soon; that he was suffering a slow, and a general, and easy decay. The venerable old man sat in his study among his favourite pictures, a breathing image of piety and contentment, awaiting calmly the hour of his dissolution. Without any fixed complaint, his mental faculties unimpaired, his cheerfulness uneclipsed, and with looks serene and benevolent, he expired 11th March, 1820, in the eighty-second year of his age. He was buried beside Reynolds, Opie, and Barry, in St. Paul's Cathedral. The pall was borne by noblemen, ambassadors, and academicians; his two sons and grandson were chief mourners; and sixty coaches brought up the splendid procession."

West was buried in St. Pauls Cathedral, following Barry, Reynolds and Vandyke to that abode of the illustrious dead.

Benjamin West was not, (as his biographer has asserted,) above the middle size. He was about five feet eight inches in height. Well made and athletic. His complexion was remarkably fair. His eye was piercing. Of his manners and disposition we have already spoken, but may be allowed to relate an anecdote from one of his pupils. He had frequently a levee of young artists asking advice on their productions, and it was given always with encouraging amenity. On one occasion a Camera Lucida, then a new thing, had been left with him for inspection: it was the first he had ever seen, and Stuart coming in, West showed it to him, and explained its use. Stuart's hand was always tremulous. He took the delicate machine for examination, let it fall, and it was dashed to fragments on the hearth. Stuart stood with his back to West, looking at the wreck in despair. After a short silence, the benevolent man said, "Well, Stuart, you may as well pick up the pieces." This was of course in early life, but old age made no change in him. Mr. Leslie says, " Mr. West's readiness to give advice and assistance to artists is well known. Every morning before he began to work he received all who wished to see him. A friend of mine called at his house the day after his death. His old and faithful servant, Robert, opened the door, and said, with a melancholy shake of the head, " Ah, sir! where will they go now?" And well might he say so; for although I can affirm with truth, that I know of no eminent artist in London, who is not ready to communicate instruction to any of his brethren who need it, yet at that time there was certainly no one so accessible as Mr. West, and I think I may

say so admirably qualified to give advice in every branch of the art.

Ninety-eight of his pictures were exhibited in a gallery designed by himself, and erected by his heirs.

Cunningham says, " In his ' Death on the Pale Horse,' and more particularly in the sketch of that picture, he has more than approached the masters and princes of the calling. It is, indeed, irresistibly fearful to see the triumphant march of the terrific phantom, and the dissolution of all that earth is proud of beneath his tread. War and peace, sorrow and joy, youth and age, all who love and all who hate, seem planet-struck. The ' Death of Wolfe,' too is natural and noble, and the ' Indian chief,' like the Oneida warrior of Campbell,

A stoic of the woods, a man without a tear,

was a happy thought. The ' Battle of La Hogue' I have heard praised as *the best* historic picture of the British school, by one not likely to be mistaken, and who would not say what he did not feel. Many of his single figures, also, are of a high order. There is a natural grace in the looks of some of his women which few painters have ever excelled."

This is high and just praise, and if all his pictures do not deserve equal, it by no means lessens the claim of the master. If he had only painted his earliest and his latest works, they would entitle him to immortality, and a place higher than any successor has yet reached.

West was generally happy, that is to say judicious, in his choice of subject.

Few painters selected subjects with so much judgment as Benjamin West. The number of his works create almost as much admiration as their excellence. The Old and the New Testament employed his pencil, in a series of pictures embracing almost every prominent event, from the reception of the law by Moses to the opening of the seals—besides many subjects not strictly in the series, from the history of the patriarchs. The Healing in the Temple, his magnificent present to the Pennsylvania hospital, will remain among us a monument of his patriotism and of his genius. His paintings from Grecian and Roman history are exceedingly numerous, and would alone immortalize him. Of modern history he has left us almost an equal number. I will mention a few, the subjects of which answer to the talent displayed in their execution. The triumph of Rooke over James II., a victory which secured the revolution of 1688, and that liberty which England has

since enjoyed. The Battle of La Hogue is one of West's best pictures. There is a remarkable coincidence in the general aspect of this very fine painting, with a Dutch picture of the triumph of De Ruyter in the Thames, when he took possession of the Royal Charles, burnt several ships of war, and threw the kingdom into consternation. The engraving (of the same size of West's and Woollet's print) is entitled "De Beroemde Enderneming op de Rivieren van London en Rochester," and it is marked where in English prints the painter's name is given "Getekend door Dk. Langendyk, 1782," and where the engraver's name is given " Gesneiden door M. de Sallieth te Rotterdam ;" and in the midway between these inscriptions is " urt gegeven by D. Langendyk, M. de Sallieth en Dirk de Yong te Rotterdam." West's and Woollet's print was published the 18th of October, 1781—probably the painting made five or more years before. If " getekend door Dk. Langendyk, 1782," means painted by Langendyk, at *that* date, we must think that he has taken a hint from West; but although there is a similarity of aspect, and somewhat of incident, the figures are dissimilar. The dispositions of the ships and figures are reversed, as is done in engraving; the French admiral's ship in West is to the right of the spectator, and the " Royal Charles" to the left in the Dutch picture— Sir George Rooke and de Ruyter change sides, and so of the prominent groups. It is needless to say that West's picture is incomparably the best ; still the picture of Mynheer Dk. Langendyk, if he be the painter, is a fine, spirited composition, with very little of the *beau ideal*, and much of nature. It is suggested that the Dutch picture was painted shortly after the affair represented, and the print perhaps engraved, but the publication suspended (as a peace-offering to England) when peace took place ; but after the declaration of war and during our revolutionary struggle, the print was published. According to this hypothesis, West may have seen a proof of the Dutch print, or had a sight of the painting, before making his great picture of La Hogue. It will be remembered, that during the war between England and Holland, in 1667, De Ruyter and De Witt entered the Thames, burned a number of ships of war, at least six, gained possession of the Royal Charles, and inflicted disgrace upon the navy of England, and terror upon the people. The peace of Breda followed soon after ; but in the year 1669, the infamous Charles being purchased by Louis XIV., and acting under his orders as his pensioner, prepared for a declaration of war against Holland, by ordering his admiral, Holmes, to attack the Dutch Smyrna

fleet, sailing under the faith of treaties in time of peace with England. When the English admiral, who had been ordered on this piratical expedition, fell in with the Dutch fleet, he, with every appearance of friendship, invited Admiral Van Ness to come on board, and with the same insidious show of friendship, the Dutch rear admiral was complimented with an invitation by another officer of the British squadron. The wary Hollanders were not so to be caught by the satellites of a faithless monarch. They declined the honour, and Holmes, failing in the attempt as a hypocrite, threw off the mask, and in his character of pirate attacked the gallant and wary Van Ness. Twice the Dutchman valiantly beat off the pirates; but in a third attack lost one ship of war and three inconsiderable merchantmen, out of a fleet of seventy; the remainder, under the protection of their brave admiral, were convoyed safe into port. The vile Charles, in obedience to his master, immediately issued a declaration of war; "and surely," says Hume, the apologist of the Stuarts, " surely reasons more false and frivolous never where employed to justify a flagrant violation of treaty." Among " the pretensions, some abusive pictures are mentioned, and represented as a ground of quarrel. The Dutch were long at a loss what to make of this article, till it was discovered that a portrait of Cornelius De Witt, brother to the pensioner, painted by the order of certain magistrates of Dort, and hung up in a chamber of the townhouse, had given occasion to the complaint. In the perspective of this portrait the painter had drawn some ships on fire in a harbour. This was construed to be Chatham, where De Witt had signally distinguished himself, and had acquired honour; but little did he imagine, that while the insult itself, committed in open war, had so long been forgiven, the picture of it should draw such severe vengeance upon his country." Thus far Hume; but it appears to us that the philosopher might with more justice have said, "Little did he think, that a gallant nation would suffer a mean and licentious tyrant to lead them into an unjust war, on pretences so utterly unfounded;" for surely it was not vengeance, poor as that motive is, which actuated the British monarch and his base ministry, but the desire to promote the views of a master whose treasures furnished the means of gratifying appetite. The consequence of this war, begun in piracy and justified by falsehood, was not only the destruction of brave men of both nations, but the triumph of the injured Hollanders, who again and again defeated the fleets of France and England, combined against them. Charles, in 1674, graciously condescended to hear the

voice of the English people, and give them peace with Holland, having no resources wherewith to carry on the war.

It is only as connected with these pictures, the " La Hogue" of West and the " Beroemde Enderneming op de Rivieren van London" of Dirk Langendyk, that we recall this portion of history. From the year 1674 to 1780, England and Holland continued in peace ; and as pictures could be made pretences for a war, the strict police of the Dutch would doubtless prohibit such a print as that published by Langendyk, Sallieth, and Yong, during this century of quiet, and especially as the power of England and her jealousy of her naval honour were daily increasing ; but when the Dutch again became the opponents of Britain, and displayed the flag of defiance, it was natural for the painters and engravers to take advantage of these hostile feelings, and to animate the courage of their countrymen by reminding them of the triumph of De Ruyter and De Witt on the Thames, when the Dutch flag not only floated the narrow seas, but floated in triumph over the hull of the Royal Charles. West had painted, probably in 1774 or 5, his Battle of La Hogue, and Woollet had engraved it in time to be published in 1781. Proofs before the publication of the engraving might have been seen by Langendyk, or even West's painting at an earlier period ; and to compose his picture on the plan of the Battle of La Hogue would readily be suggested. De Witt's portrait at Dort furnished part of the material, and he is placed by the side of De Ruyter ; these two heroes corresponding to West's Sir George Rooke. Instead of the French admiral's ship, we have the Royal Charles, and in the spirit of Hogarth we see a Dutch cabin-boy waving the flag of his country over the image of the king which decorates the stern. We repeat, both pictures are original, and West's far the best ; but Langendyk is full of spirit and truth, the tamest part being the portraits of the two heroes, De Ruyter and De Witt : while on the other hand West's hero is clothed in grandeur and dignity, becoming the leader whose valour confirmed the constitutional freedom of his country by destroying the power and almost the hopes of the Stuarts.

Penn's Treaty with the Indians is another of his happy subjects. William Penn rested his empire on justice and liberty of conscience. Brute force had no agency in its foundation, neither was it cemented by the blood of his fellow-creatures. West's pictures from Shakspeare and other poets are well known. I will mention a picture by him connected with *this country*, of more importance to civil and religious liberty, than even the victory of La Hogue, or the benevolent Treaty

of Penn—the Death of Wolfe. This is not only one of the best historical compositions of a great master, but it is one of the very best subjects for the historical painter, according to my view of the utility of the art. It records one of those events which has produced incalculable good to the human race. It would not be too much to ascribe to the victory of the plains of Abraham, the blessings we enjoy under our unparalleled constitution, the effects of example upon the *existing* civilized world, and upon millions on millions *yet unborn*. It may appear, at first sight, wild to attribute such mighty consequences to a battle gained in Canada by a few English over a few French soldiers; but when we recollect that the power of France, under a despotic government, had been exerted successfully to extend her armies and her fortresses, from Hudson's bay and the St. Lawrence to the Mississippi and the Gulf of Mexico; that an enslaving and soul-debasing government was extending, link after link, a chain, made stronger day after day with systematic perseverance and admirable skill, and was inclosing, as in a net of steel, all the descendants of the English republicans who had sought refuge on the shores of this continent; a net which would have made all this fair territory a province of a despotic monarchy, instead of what it now is—the greatest republic the world ever saw; when we remember that all the struggles of the provincials, aided by the armies of England, had been for years rendered vain by the military skill and power of France; when we call to mind the bloody and disastrous battles fought on the banks of Lake Champlain and Lake George, the defeat of Braddock, and the unceasing encroachments of the triumphant enemy—and rememberthat the victory of Wolfe, by breaking the charm and the chain, made of all America a land of freedom—we may be justified, perhaps, in attributing such consequences to Wolfe's victory.

By a curious calculation, it was ascertained that to contain all West's pictures, a gallery would be necessary four hundred feet long, fifty broad, and forty high.

Bell's Weekly Messenger gives an account of the third and final day's sale of the gallery of West's pictures. The grand total of the sale, amounted to £25,040 12*s*. Among those sold were the following : " Christ Rejected ;" it was bought by Mr. Smith for 3,000 guineas, on account, as was whispered in the room, of the Duke of Orleans. " Death on the Pale Horse," painted when Mr. West had nearly accomplished his eightieth year, was bought by a gentleman by the name of Kirshaw, for 2,000 guineas. " The Death of Lord Nelson," 850 guineas.

" The Death of General Wolfe," 500 guineas, bought by J. Monkton, Esq., of Portman square. (Is this a descendant of the general, who is one of the principal figures?) " Battle of La Hogue," 370 guineas. (These last two must have been copies.) " Moses receiving the Laws," 500 guineas. " The Ascension of our Saviour," 200 guineas: and a number of others, which sold for from 200 down to 17 guineas. Lords Egremont and Amherst bought several.*

We will subjoin the following respecting this excellent painter. In a letter to us from Mr. Allston, he says: " To Mr. West's character as a man, I will add the following affecting testimony of his wife, a few years before her death. Speaking of him to a lady, a particular friend of mine, she said, ' Ah, he is a *good man;* he never had a vice.' Mrs. West was then suffering under a paralysis, and could scarcely articulate. Such testimony, from one who had been for more than half a century his most intimate companion, is worth more than a volume of eulogy."

It remained for us to conclude the biography of Benjamin West, by a review of his character as a painter and a man. It was an imperative duty in the author of this work, as an artist, a man, and an American; but he is pleased to have been anticipated by an artist of higher authority, and a writer of more celebrity; and still more gratified that justice has been done to our great countryman by an Englishman. Instead of our remarks, we will substitute those of Sir Martin Archer Shee, now the president of the Royal Academy of England:

" The example set by Reynolds was not lost upon his eminent successors; and the distinguished artist, who was next appointed to this chair, hesitated not to co-operate, in like manner, with the able professors of the Academy, in the office of instruction. The discourses of President West bear ample testimony to the zeal and knowledge which he brought to the performance of a task, rendered as arduous as it was honourable, by the extraordinary ability with which it had been previously executed.

" Well grounded in the elementary principles of his profession, he was as conversant with the theory, as he was dexterous in the practice of his art. It is no exaggeration to say of him, that in the exercise of those powers of the pencil, to the attainment of which his ambition more particularly directed him, he was unrivalled in his day. Such, indeed, was the facility of his hand, and with so much certainty did he proceed in his

* The Christ Rejected and Death on the Pale Horse were bought in for West's sons.

operations, that he rarely failed to achieve whatever he proposed to accomplish, and within the time which he had allotted for its performance.

"Indefatigable application and irrepressible ardour in his pursuit, succeeded in obtaining for him that general knowledge of his subject, which seldom fails to reward the toils of resolute and well-directed study. No artist of his time, perhaps, was better acquainted with the powers and the expedients, the exigencies and the resources of his art. No man could more sagaciously estimate the qualities of a fine picture, or more skilfully analyze the merits combined in its production. If you found yourself embarrassed in the conduct of your work, and you consulted him, he would at once show you where it failed, and why it failed. Like a skilful physician, he announced with precision the nature of the disease, and could suggest the remedy, even where he was not himself qualified to administer it.

"The qualities which distinguished him, both as a man and as an artist, were, perhaps, not a little influenced by the peculiar religious impressions which he had early received. Order, calmness, and regularity characterized him through all the relations of life. In his habits of investigation, there was nothing loose, desultory, or digressive. The stores of knowledge which study and experience enabled him to lay up, were immediately classed and ticketed for use; and the results of his observations he diligently endeavoured to compress into principles, whenever they would admit of so advantageous a reduction; the natural turn of his mind leading him to repress, within the strict limits of system and science, the arbitrary, irregular, and eccentric movements of genius and taste.

"No man could be more liberally desirous than West to impart to others the knowledge which he possessed. He never, indeed, appeared to be more gratified than when engaged in enlightening the minds of those who looked up to him for instruction; and though, in following the path of precept marked out by his great predecessor, and communicating the lessons of his experience in a similar way, he does not approach to a rivalry with Reynolds as a teacher of his art; though his pen was not so ready as his pencil, and cannot be said to display the graces of language and style which distinguish the compositions of that eminent writer, yet the discourses of President West, delivered from this place, must be acknowledged to contain many ingenious remarks and much useful information. They evince an ardent enthusiasm for the honour and interests of his profession, and a laudable zeal to recommend the just

claims of the arts to the respect and protection of our country.

" It is impossible to review the character and professional powers of this able artist, without the strongest sense of regret that they are so inadequately understood and appreciated in this country, even at this day. The spirit of criticism prevalent among us, which, it must be confessed, is not generally too indulgent to the imperfections of modern art, has shown itself, in his case, more than usually fastidious and severe. The high aims of his pencil, which might reasonably be expected to propitiate the community of taste, have procured for him no favour. He is unsparingly censured where he fails, and is allowed little credit where he has succeeded. He is tried, not by his merits, but by his defects, and judged before a tribunal which admits only the evidence against him. His profession, indeed, have always done him justice; and they manifested their sense of his claims by the station in which they placed him. But few artists have been less favoured by fortune, or more ungenerously defrauded of their fame. It has been unreservedly stated on his own authority, that the remuneration of his labours, from the patronage of *the public*, during the space of forty-five years, was so inadequate to his very moderate wants, as to leave him dependent on the income allowed him as historical painter to his royal patron George the Third, for the means of living in this country.

" It is melancholy to reflect, that in consequence of this resource having been unexpectedly withdrawn from him, very late in life, and at a period when his royal protector must have been unconscious of such a proceeding, the close of his long and laborious career was embittered by pecuniary embarrassment. But his enthusiasm for his art never for a moment failed under his disappointments. The spring of his mind never once gave way; and nearly to the latest hour of an existence prolonged beyond the period usually assigned to the age of man, he was occupied in projecting works sufficiently extensive to startle the enterprise of youth, and demand the exertion of the most vigorous manhood.

" Unfortunately, however, West did not possess, in a sufficient degree, those qualities of art which are the most popular amongst us. The captivations of colour, *chiar' oscuro*, and execution, which the English school displays in such perfection, were wanting to set off his productions; and the merits of a higher order which they contained, appealed to, and required the exercise of a better informed and more comprehensive judgment than the taste of his time could in general supply.

" So little impression, indeed, had his various powers left upon the public mind, after the toils of more than half a century, that a collection of his pictures, formed after his death by his family, containing many of his finest works, and arranged with peculiar judgment and taste, had scarcely sufficient attraction for the admirers of art in this great metropolis, to defray the expenses attending their exhibition.

" The defects of West were obvious to the most common observer of his works. Every small critic could talk of the hardness of his outline, the dryness of his manner, and the absence of what may be called those *surface sweets* which are so highly prized, under the name of execution, by that class of artists and connoisseurs who think more of the means than of the end, in contemplating a work of art. But it demanded greater knowledge of the subject than is commonly found amongst the ordinary dispensers of fame in this country, to appreciate his various acquirements ;—his powers of composition ;—his general facility of design ;—his masterly treatment of extensive subjects, where, in pouring a population on his canvass, the resources of an artist's imagination are put to the test ;—the scientific construction and arrangement of his groupes, and the appropriate action and occupation of the different figures of which they are composed. Yet all these are qualities which rank high in the scale by which it is usual to estimate the comparative claims of a painter. We must take care not to lose sight of the standard by which the relative merits of our art are to be measured. In proportion as the intellectual is combined with the mechanical, do we value those productions of man which are not appropriated to the purposes of manufacture, or the ordinary accommodations of life.

" Invention, composition, design, character, and expression have always taken precedence of colouring, *chiar' oscuro*, and execution, in the estimation of the judicious critic ; though excellence in the latter qualities may be justly preferred to mediocrity in the former. We may, from local prejudice, or personal peculiarity, prefer silver to gold, or a pebble to a diamond ; but if we reverse in our notions the relative value, which, by common consent, has been assigned to these objects, our judgment will be considered not only erroneous, but diseased.

" The ambition of West directed him to the highest department of his art. In *his* hands the pencil was always employed for the noblest purposes,—on subjects the moral interest of which outweighs their mechanical execution. He delighted

to commemorate heroic deeds, to illustrate the annals of sacred history, and perpetuate the triumphs of patriotism and public virtue.

"If we applaud the exalted spirit which prompted him to devote his talents to such praiseworthy objects, shall we not also offer the just tribute of our admiration to the enlightened monarch who encouraged and sustained his labours; who, by liberally endeavouring to reopen the church to the arts, sought to procure for them a new source of employment in this country, and who, as far as in him lay, set an example of generous patronage of the arts to the great and powerful of his day, which, if it had been followed with corresponding zeal and patriotism, could not have failed to obtain for Great Britain all the glory which pre-eminence in arts can shed upon a state?

"The degree of success with which the honourable exertions of West were attended, may, I conceive, be fairly determined by this test: let the most prejudiced of those who are inclined to question his claims to the rank of a great artist examine the series of prints engraved from his works. I would, in particular, entreat them to view with some attention, the Death of General Wolfe.—the Battles of La Hogue and the Boyne,—the Return of Regulus to Carthage,—Agrippina bearing the ashes of Germanicus,—the young Hannibal swearing eternal enmity to the Romans,—the Death of Epaminondas,—the Death of the Chevalier Bayard,—Pyrrhus, when a boy, brought to Glaucus, king of Illyria, for protection,—and Penn's treaty with the Indians; not to mention many others, perhaps equally deserving of enumeration. Let these well-known examples of his ability be candidly considered, and where is the artist, whose mind is enlarged beyond the narrow sphere of his own peculiar practice,—where is the connoisseur, whose taste has not been formed by a catalogue raisonné, or in the atmosphere of an auction-room,—who will hesitate to acknowledge that the author of such noble compositions may justly claim a higher station in his profession than has been hitherto assigned to him, and well merits to be considered, in his peculiar department, the most distinguished artist of the age in which he lived?"*

* "In support of the humble attempt here made to render justice to the professional character and talents of West, it is a gratification to the author to be able to adduce the corroborative testimony of the highest artist and amateur authorities of our day:

"'His (West's) power at his advanced age is beyond all example; and my visit to the continent has given me a still higher opinion of his great talents and

CHAPTER VI.

Edward Duffield—Matthew Pratt—Pratt the schoolmate and friend of West—
Accompanies Miss Shewell to England—Studies with West—Generosity of
Pratt to a stranger in distress—Merit as a painter—His sign-painting—Copley,
his origin—Not self-taught—Great excellence before going to Europe—Cun-
ningham's memoir of him—Communication from G. C. Verplanck, Esq.—Cop-
ley established in London—His historical pictures.

Edward Duffield, 1730–1805.

EDWARD DUFFIELD—1775,

is brought to our knowledge by our friend John F. Watson,
author of Annals of Philadelphia, &c. Mr. Duffield designed
and executed several medals in 1756–7.

James Claypoole,
c. 1720–c. 1796.

JAMES CLAYPOOLE—1756,

I only know as the teacher of

Matthew Pratt, 1734–1805.

MATTHEW PRATT—1758.

Matthew Pratt, the subject of this notice, was born in Phi-
ladelphia, on the 23d September, 1734; and though he could
not boast a noble line of ancestry, he was aware that his an-
cestors, for near a century, had been honest and reputable
householders. His father was a goldsmith, and served his
time with Philip Syng, jr., the grandfather of the present
Dr. P. S. Physick. At this time a company of associates was
formed, of which Dr. Franklin was the head, and from them
emanated the Philadelphia Library, for which they procured
a charter. Apartments were provided for it in the state-house.
Matthew Pratt received such an education as the common
schools in the city afforded, and at the age of fifteen was
placed an apprentice to his uncle, James Claypoole, from whom
(to use his own words) he learned all the different branches
of the painting business, particularly portrait-painting, which
was his favourite study from ten years of age. This allusion
to the different branches of the painting business, shows plainly
the degraded state in which the arts were at that time in this
country.

Passing over the period of his apprenticeship, and two
years during which he followed his profession in Philadelphia,
we find him, in October, 1757, embarking on board a small

knowledge of his art than I before had, and *this, from comparison with the works
of the great masters.'—Sir Thomas Lawrence's letter to Mr. Lysons, from Rome.*
"'When we consider the determined perseverance he (West) showed to per-
sist in the high walk he had at first chosen, though there was not a grain of taste for
it in the country at that time, it does him the highest honour, and *I am ashamed of
the recent ungrateful neglect of my countrymen,—it surprised and grieved me.'—
Letter of Sir George Beaumont to Sir Thomas Lawrence.*"

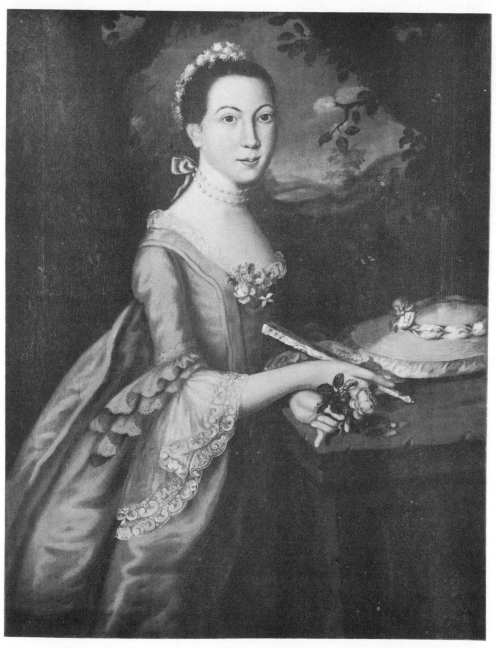

21 MARTHA DOZ, c. 1768–1770. Painting attributed to James Claypoole. *Courtesy Independence National Historical Park.*

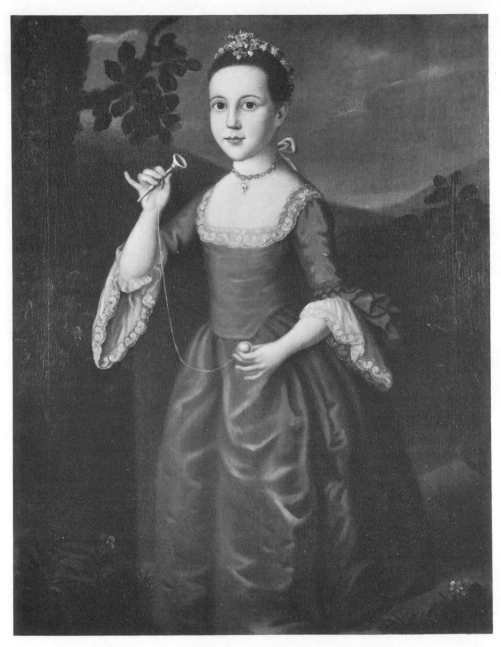

22 REBECCA DOZ, c. 1768–1770. Painting attributed to James Claypoole. *Courtesy Independence National Historical Park.*

vessel for the island of Jamaica, having ventured a great part of his property in a mercantile speculation. Of the vessel in which he sailed, Enoch Hobart, who married his sister, was commander, and who was father to the late Right Reverend Bishop Hobart, of New-York. His abandoning the arts at this time is not to be looked upon as an evidence of his want of encouragement, but as a disposition to see the world. The voyage to Jamaica, however, in a pecuniary point of view, was not very successful. They were captured and plundered near St. Lucia, by a French privateer, and after a week's detention were retaken by a British ship. The result of this adventure was an agreeable residence of six months in Jamaica; and he did not reach home until late in 1758. He now, for the first time, regularly pursued portrait-painting, and met with the most perfect success, giving general satisfaction to his employers, and receiving an ample reward.

In 1760 he married Elizabeth, the daughter of Mr. Charles Moore, merchant, of Philadelphia, and four years after he prepared for his departure for England.

It is now for the first time that the manuscript from which I compiled this sketch speaks of Benjamin West. When or how the friendship between them commenced, I am unable to determine; but from his journal it appears that Mr. West had entered into a matrimonial engagement, three years previous, with Miss Betsey Shewell, a relation of Mr. Pratt's father, and the present voyage was made in company with Miss Shewell and Mr. West's father, for the purpose of terminating that engagement by marriage. The passage out was speedy and pleasant—twenty-eight days from the Capes to London; and in three weeks after their arrival, the marriage ceremony was performed at St. Martin's church in the Strand; Mr. Pratt officiating as father and giving away the bride. The whole party then made an excursion to Mr. West's aunt's in Oxfordshire, and to his brother's in Berkshire, and returned to London after a delightful tour of several weeks.

Mr. Pratt was now located as a member in Mr. West's family, and studied his art under him with close application, and received from him at all times (to use his own words) "the attentions of a friend and brother."* He continued in England four years—eighteen months of that time being spent

* Mr. Pratt was the first of the many who received gratuitous instruction from Benjamin West. It is curious to observe how uniformly his American pupils speak of him as a friend, a brother, or a father to them.

in the practice of his profession in the city of Bristol; and it is to his studies and improvement during this period that we are to look, as the cause of his attaining a professional stand of high respectability. In 1768 he returned to Philadelphia, and recommenced his business at the corner of Front and Pine streets. His situation and the nature of his business may be in some degree elucidated by referring again to his manuscript. " I now met with my old friend, the Rev. Thomas Barton, who came purposely to introduce me to Governor Hamilton, Governor John Penn, Mr. John Dickenson, Mr. Samuel Powel, the Willing family, the clergy of Philadelphia, &c. &c.; among whom I met with full employ for two years." This pleasing and successful career was interrupted by some family concerns of importance, which rendered his presence in Ireland indispensable. Accordingly, in March, 1770, he sailed for Newry, a fellow-passenger with Mr. Joseph Reed, (afterwards governor of Pennsylvania,) and had an agreeable passage out, and soon after reached Dublin. Among others with whom Mr. Pratt formed an intimacy in this place, was the Rev. Archdeacon Mann, from whose family, during his stay, he received every species of polite attention. By way of acknowledgment for so many favours, he painted a full-length portrait of the Rev. Doctor, in his canonical robes. This picture was placed in an exhibition by the Dublin Society of Artists, and its author received no inconsiderable share of praise and commendation. In the latter part of his time, he proceeded to England; and during two weeks that he remained in Liverpool, was assiduously occupied in painting portraits. From Liverpool he went to Cork, and soon after sailed to Philadelphia.

Previous to their sailing, as the last boat was about leaving the shore, a young woman applied for a passage to Philadelphia, where she said her family held a respectable situation in society. An unfortunate marriage had been the cause of her following the fortunes of a worthless husband to Ireland, where she was now deserted. To others in the boat her appeal was made in vain; but the characteristic generosity of an artist was at once excited. Mr. Pratt became responsible for her passage-money, and a share of the few guineas remaining in his pocket was appropriated to her immediate wants; and through his means she was rescued from want and misery. The person here spoken of was conducted by Mr. Pratt to her friends in safety in Philadelphia, whose gratitude was great and lasting.

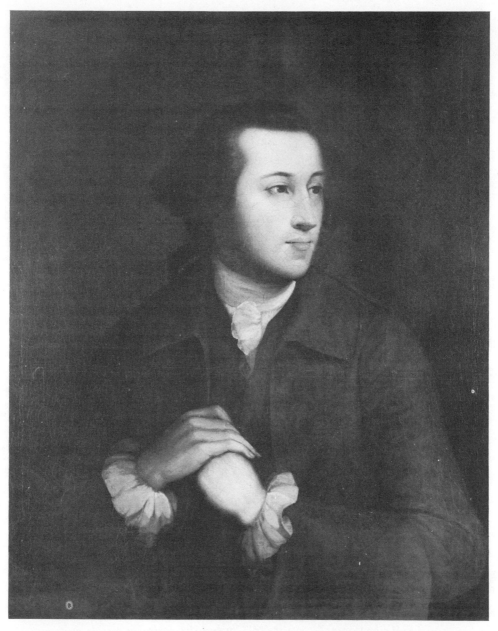

23 BENJAMIN WEST. Painting by Matthew Pratt. *Courtesy The Pennsylvania Academy of the Fine Arts.*

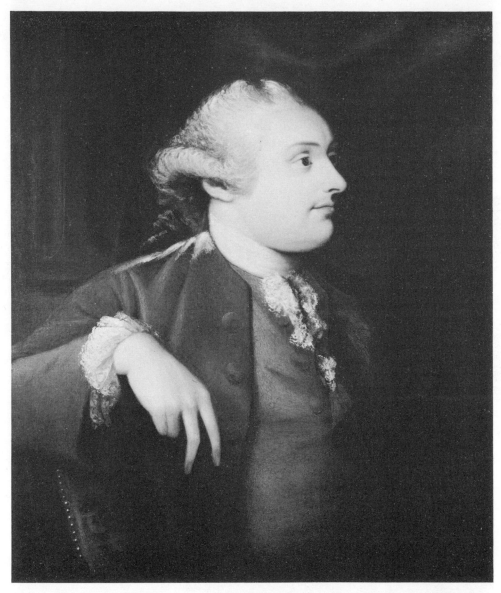

24 THE DUKE OF PORTLAND. Painting by Matthew Pratt. *Courtesy National Gallery of Art, Washington, D.C., gift of Mr. Clarence Van Dyke Tiers.*

Having returned to Philadelphia, Mr. Pratt never left it again, but pursued his profession with unabated zeal and industry. Many of his portraits extant prove him to have been an artist of talent and capacity. Among these I would notice, as works praised by competent judges, a portrait of the duke of Portland, and one of the duchess of Manchester; also a scripture piece, and the London School of Artists, and a full-length portrait of Gov. Hamilton, now in the possession of his family; the colouring and effect are highly creditable to the infant arts of our country.

Devotedly attached to his profession, and governed by the spirit of the times, and feeling that the legitimate path of the limner could not support an increasing family, Mr. Pratt painted at intervals a number of signs, some of which, until within a few years, have been hanging in this city. Amongst these, perhaps the best was a representation of a cock in a barn-yard, which for many years graced a beer-house in Spruce-street; the execution of this was so fine, and the expression of nature so exactly copied, that it was evident to the most casual observer that it was painted by the hand of a master. Most of our old citizens recollect the sign of the grand convention of 1788, which was first raised at the corner of Fourth and Chesnut streets. On this piece Mr. Pratt gave portraits of most of the distinguished men assembled on that occasion, and for some time the streets were filled with crowds occupied in identifying likenesses.

After spending a life principally in the cultivation of the arts, of which he was in this country a most effective pioneer, he was attacked by the gout in the head and stomach, and died on the 9th day of January, 1805, aged seventy years three months and nineteen days.

Of the picture of " The London School of Artists," painted by Mr. Pratt, my friend Thomas Sully says, " This picture was exhibited in our academy some years ago, and was so well executed that I had always thought it was a copy from West. The whole-length of Governor Hamilton I have often seen at the Woodlands, near Philadelphia, and considered it a very excellent picture, and worthy to pass for one of West's."

Between the years 1760 and 1764, Mr. Pratt painted portraits occasionally in New-York. I have seen a full-length portrait of Governor Colden by him, and there are in the Walton family several of his pictures. Tradition says of him at this time that he was a gentleman of pleasing manners, and a great favourite with the first citizens in point of wealth and intelligence.

From the venerable Mr. Thackara, we learn that Pratt, when a boy, "was a schoolmate of Charles W. Peale and B. West, at Videl's school, up the alley, back of Holland's hatter's shop, Second-street, below Chesnut. At ten years of age he wrote twelve different handwritings, and painted a number of marine pieces, which are now in the family. He assisted C. W. Peale to form the first museum in Philadelphia, southwest corner of Third and Lombard streets. When in England, he assisted West in painting the whole royal family." I give this as received from my respectable friend Mr. Thackara; but it seems at variance with the memoirs of C. W. Peale, in respect to Pratt, West, and Peale being schoolmates in Philadelphia. Mr. Peale was seven years younger than Pratt, and was born at Chesterton, eastern shore of Maryland, and did not visit Philadelphia until he was a married man and a saddler; according to his son's biography of him.

It is well known that many a good painter has condescended, and many a one been glad, to paint a sign. I have been told that it is very common in Paris. In Philadelphia the signs have been remarkable for the skill with which they are designed and executed. Beside the signs mentioned above as painted by Mr. Pratt, a Neptune and a Fox-chase, with many others, came from his work-shop. One of the signs mentioned above is thus noticed in a letter from M. M. Noah, Esq., to me, and published in my History of the American Theatre. He says a prologue he wrote when a boy "was probably suggested by the sign of the Federal Convention at the tavern opposite the theatre (the old theatre in South-street). You no doubt remember the picture and the motto: an excellent piece of painting of the kind, representing a group of venerable personages engaged in public discussions. The sign must have been painted soon after the adoption of the federal constitution; and I remember to have stood 'many a time and oft' gazing, when a boy, at the assembled patriots, particularly the venerable head and spectacles of Dr. Franklin, always in conspicuous relief."

I insert with pleasure Mr. Neagle's testimony to the merit of Pratt, and it is the testimony of an excellent artist and judicious man.

"I have seen the works of Pratt—portraits and other subjects. I remember many signs for public houses (now all gone) painted by his hand, and I assure you they were by far the best signs I ever saw. They were of a higher character than signs generally, well coloured, and well composed. They

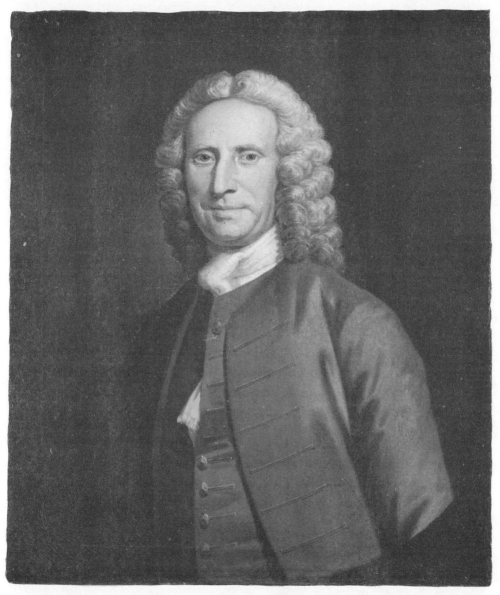

25　Cadwallader Colden, *c.* 1749–1752. Painting by John Wollaston. *Courtesy The Metropolitan Museum of Art, bequest of Grace Wilkes.*

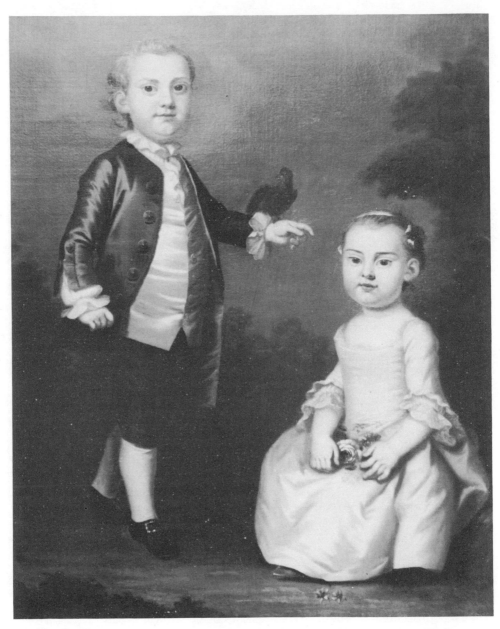

26 JOHN PARKE AND MARTHA CUSTIS. Painting by John Wollaston. *Courtesy Washington and Lee University.*

were like the works of an artist descended from a much higher department. One of a game-cock, admirably painted, which was afterwards retouched or repainted by Woodside. It was called the 'Cock revived,' but with all Woodside's skill, it was ruined, and I have heard he confesses it. One of the Continental Convention, with they say good likenesses. One of Neptune, &c., for Lebanon gardens in South-street. One admirably executed Hunting Scene, with sun-rise, in Arch-street. A Drovers' Scene, and others, most of them with verses at bottom composed by himself.

"Pratt's signs, or at least those attributed to him by his son Thomas, were broad in effect and loaded with colour. There is no niggling in his style or touch. I remember them well; for it was in a great measure his signs that stirred a spirit within me for the art, whenever I saw them, which was frequent."

WOOLASTON—1758.

John Wollaston,
fl. c. 1736–*c.* 1767.

A gentleman of this name painted portraits in Philadelphia in 1758, and in Maryland as early as 1759–60. I know nothing more of him, but that Francis Hopkinson published verses in his praise in the American Magazine for September, 1758.

JOHN SINGLETON COPLEY—1760,

John Singleton Copley,
1738–1815.

probably painted portraits as early as 1760; and therefere is next in point of time. Copley, another American, after enjoying greater advantages for the study of his art, than had been afforded to his countryman West, and after painting better pictures, in the new world, than the Pennsylvanian, followed him to Europe; and with admirable industry and perseverance raised himself nearly to a level with the best portrait-painters of England, where portrait-painting was at the period of his making that country his permanent place of residence, taking that stand which has rendered England the school for all artists, who desire to excel in a branch of the fine arts, more lucrative, (though not so honourable,) than history painting. West, as we have seen, chose the more difficult, complicated, and brilliant department, and was acknowledged as its head. Copley only took up the historic pencil at intervals, and was even when so employed, still a portrait-painter.

Knowing that Samuel F. B. Morse, Esq., with a wish to honour his countryman, had applied to Copley's son, Lord Lyndhurst, for information respecting his father, I requested

the noble lord's answer, which being communicated to me, is here given:

" George-street, 27th December, 1827.

" Dear Sir :—I beg you will accept my best thanks for your discourse delivered before the National Academy at New-York, which has been handed to me by Mr. Ward. The tenor of my father's life was so uniform as to afford little materials for a biographer. He was entirely devoted to his art, which he pursued with unremitting assiduity to the last year of his life. The result is before the public in his works, which must speak for themselves; and considering that he was entirely self-taught, and never saw a decent picture, with the exception of his own, until he was nearly thirty years of age, the circumstance is, I think, worthy of admiration, and affords a striking proof of what natural genius, aided by determined perseverance can, under almost any circumstances, accomplish.

" I remain, dear sir,

" Your faithful servant,

" LYNDHURST."

Now this is very civil, but sufficiently meagre and unsatisfactory. That Mr. Copley was a prudent, assiduous, persevering man, we know, and that he was a good painter before he left his country; but the " entirely self-taught," I reject altogether. Neither can I admit that he had not seen a " decent picture. with the exception of his own," before he saw the treasures of European art. Smybert and Blackburn painted in Boston; and even if the young man did not receive their instruction as a pupil, he saw their pictures, which were more than decent, and received the instruction which is conveyed by studying the works of others. We shall see that Allston gained his first notion of colouring from a picture by Smybert in the neighbourhood of Boston. Copley painted in New-York, and saw the portraits executed by West in that city, and, as we have seen, West painted a portrait on his arrival at Rome, which stood a comparison with the works of Mengs. We have no testimony that Copley visited Philadelphia; if he did not, it was from a lack of curiosity, and not of means, for he had long been in lucrative employment, and lived in comparative splendour. If he saw only the collection of pictures belonging to Governor Hamilton, he saw many that were more than decent. The Murillo of this collection was probably a first-rate picture.

But if he only saw the pictures of Smybert, we know that he was no mean artist ; and that he brought to Boston, casts, drawings, prints, and many copies from old masters, besides the Cardinal Bentivoglio, above alluded to. It is further, very probable, that Copley was the companion, the friend, or the fellow-student of the younger Smybert, under the tuition of his father. Copley, born in 1738, was at the period of Smybert's death, (1751) thirteen years of age, and though we find no direct evidence of the fact, was probably a pupil, directly or indirectly, of the friend of Dean Berkeley.

Not satisfied with the information afforded by Lord Lynd- hurst in his letter above quoted, we, in the democratic simpli- city of our hearts, endeavoured to elicit something more defi- nite from the painter's son respecting his father. We wrote to the noble lord, but having waited many months, we despair of information from that source. It has been observed, that in England, *as well as in America*, any man, however low in the scale of society, if he has talents, may be lifted to high rank and official power. But with *us* he is so lifted by the people, and remains one of them ; whereas in England, he is exalted by the aristocracy, and is evermore lost to the mass from which he is taken. It is understood, that he is to become, when he is admitted to breathe the air of the upper region, a being of a superior nature from those with whom he once associated.

Thus disappointed, we have, through the medium of a friend, applied to another of Mr. Copley's children, endeavouring to find the date of his birth, and other circumstances relative to his early life which might be remembered in the family with pleasure, and recorded to his credit. We are referred to an article in the Encyclopedia Americana for information, which was communicated to Doctor Leiber by Mrs. Elizabeth Clark Green. We give the whole.

"John Singleton Copley, a self-taught* and distinguished painter, was born in 1738, in Boston, Mass., and died in Lon- don, in 1815. Copley began to paint at a very early age ; and pieces executed by him in Boston, before (to use his own words) he had seen any tolerable picture, and certainly before he could have received any instruction, in the art of painting, from the lips of a master,† show his natural talent, and, in fact, were unsurpassed by his later productions. He did not visit Italy till 1774. In 1776 he went to England, where he met his wife and children, whom he left in Boston. As the

* We have given our opinion on this subject already.

† This is a subject on which we have also given an opinion.

struggle between England and America had begun in 1775, there was neither a good opportunity for Mr. Copley to return to his native land, which he always seems to have had in view, nor was there much hope of success for an artist in the convulsed state of the country. He therefore devoted himself to portrait painting in London, and was chosen a member of the Royal Academy. His first picture which may be called historical, was the youth rescued from a shark; but the picture styled the death of Lord Chatham, which represents the great orator fainting in the house of lords, after the memorable speech in favour of America,* and contains, at the same time, the portraits of all the leading men of that house, at once established his fame. In 1790, Copley was sent by the city of London, to Hanover, to take the portraits of four Hanoverian officers, commanders of regiments associated with the British troops under General Eliot, (afterwards Lord Heathfield,) at the defence of Gibraltar, in order to introduce them in the large picture, which he was about making for the city, of the siege and relief of Gibraltar, which was afterwards placed in the council-chamber of Guildhall. Mr. Copley pursued his profession with unabated ardour, until his sudden death, in 1815. Beside the pictures already mentioned, and a number of portraits, including those of members of the royal family, the most distinguished of his productions, are Major Pierson's death on the Island of Jersey; Charles the First in the house of commons, demanding of the speaker, Lenthall, the five impeached members, containing the portraits of the most distinguished members of that house : the surrender of Admiral De Winter to Lord Duncan, on board the Venerable, off Camperdown; Samuel and Eli, &c.; of all of which engravings exist, though of some, (for instance the last-mentioned piece,) they are extremely rare. His eldest and only surviving son, John Singleton Copley, Lord Lyndhurst, high chancellor of England, was born in Boston, May 21, 1772.''

We will now proceed to our task with some degree of regularity. John Singleton Copley was born at Boston, Massachusetts, in the year 1738; thirteen years before the death of

* This memorable speech, so far from being " in favour of America," was an exertion of his eloquence to rouse his countrymen to continue hostilities, and to make redoubled efforts against American independence. The last effort of Chatham's mental and physical powers was made to excite England to risk all rather than succumb to America. " Let us fall like men, if we must fall,'' said the orator; "if we must fall, we will fall in the effort to preserve the lustre of this nation.''

Boston) M.rs Elizabeth Cummings to In: S: Copley D.r

1769

To her own portrait 3/4 Cloth at 7 Guis — £ 9.,16.,0.

To M.rs Magnatters D.o — — — — 9.,16.0

To M.r Magnatters D.o — — — — 9.,16.0

1770 — To two black frames a 24/. — — — — £ 2.,8.,0

£ 31.,16.0

Rec. the contents in full

M.r John Singleton Copley

John Smybert. He was son of John Copley and Mary Single-
ton his wife, who emigrated to America from Ireland.

Mr. Copley soon evinced such excellence as a portrait-pain-
ter that he commanded the time and purses of the rich. In
1768, we find Charles Wilson Peale journeying from Anna-
polis to Boston, to seek his instruction.

By the favour of Judge Bacon of Utica, we have an oppor-
tunity of presenting the reader with the fac-simile of an auto-
graph bill of sale, or due-bill by Copley, which shows what
his Boston prices were in 1769 and 70. One of the portraits
here mentioned we have seen, the mother of Judge Bacon, the
accuracy and finish of which is admirable.

In 1771, Mr. Trumbull says, he being then at Cambridge
College, visited Mr. Copley at the time of his marriage. He
was dressed on the occasion in a suit of crimson velvet, with
gold buttons, and the elegance displayed by Copley in his
style of living, added to his high repute as an artist, made a
permanent impression on Trumbull in favour of the life of a
painter.

Copley married, in 1771, Miss Clarke, the daughter of a
merchant of Boston, who was afterward the agent of the Eng-
lish East India Company for the sale of their teas.

In 1773 Copley resided some time in New-York, painting
for the rich and fashionable. We remember particularly the
portrait of the Rev. Doctor Ogilvie, as of this period. The
painter's esel was in Broadway, on the west side, in a house
which was burnt in the great conflagration on the night the
British army entered the city as enemies.

In 1774 Mr. Copley proceeded to England, and thence to
Italy, leaving his wife and family in Boston. On his return to
London he found his family there; they having left America
in 1776.

From this period we find little to aid us in our notice of John
Singleton Copley, except Cunningham's Lives of Painters.
From an English memoir of his son now before us, we copy
the following : "Soon after the father of the present chancellor
settled in London, he became a member of the academy of
painters, and attracted considerable notice by several works of
superior merit, and among others, the death of Lord Chatham,
and the defence of Gibraltar. Mr. Copley, however, soon
discovered that portrait painting, which recommends itself to
the personal vanity and the household affections of all man-
kind, was likely to be a more lucrative avocation than the
severer style of historical painting, and to the former he suc-

cessfully dedicated himself, and gradually rose to fortune and reputation."

The few ideas conveyed by this are essentially false. Mr. Copley never adopted the severer style of historical painting. He was always a portrait-painter. His historical compositions were laboured, polished, and finished from the ermine and feather, to the glossy shoe and boot, or glittering star and buckle. The picture called the Death of Chatham, is a collection of portraits. It is a splendid picture, and the subject was well chosen for the advancement of the painter's interest. The exhibition of it was lucrative. Neither did Mr. Copley relinquish historical painting, but resorted to historical composition after practising portrait, and when at times the tide of fashion ebbed, and left him leisure to exercise his pencil in the more arduous branch of the art.

We shall borrow from Mr. Cunningham's work, and add such knowledge as we possess or can obtain. It appears that it was not Copley's loyalty or attachment to Great Britain, which occasioned his residence there. In a letter from John Scolley of Boston, to the painter in 1782, he says, "I trust amidst this blaze of prosperity that you don't forget your dear native country, and the cause it is engaged in, which I know lay once near your heart, and I trust does so still."

"It is note-worthy," says Mr. Cunningham, "that almost at the same hour, America produced amid her deserts and her trading villages two distinguished painters, West and Copley, who unknown to each other were schooling themselves in the rudiments of the art, attempting portraits of their friends one day, and historical compositions the other; studying nature from the naked Apollos of the wilderness, as some one called the native warriors; and making experiments on all manner of colours, primitive and compound; in short, groping through inspiration, the right way to eminence and fame."

We must strip this of its romance. That these two young men found the way to eminence and fame is true, but not in the desert or the wilderness. Colours were to be found at the colour-shops, and inspiration—heaven knows where! It was by exerting their talents perseveringly in pursuit of the art they loved, seeking and obtaining information from those who preceded them, and never deviating from the path which wisdom and virtue pointed out, that they succeeded and obtained their reward, " eminence and fame."

We copy the following from Mr. Cunningham. " I once heard an artist say that the fame of a fine painter found its way

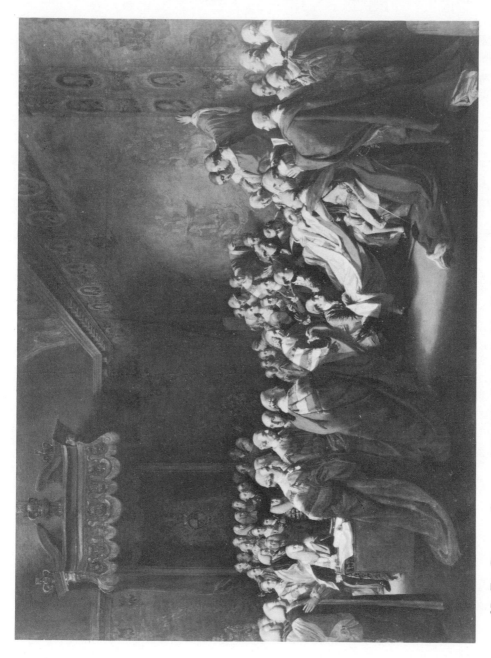

27 THE DEATH OF CHATHAM, 1779–1781. Painting by John Singleton Copley. *Courtesy Tate Gallery, London.*

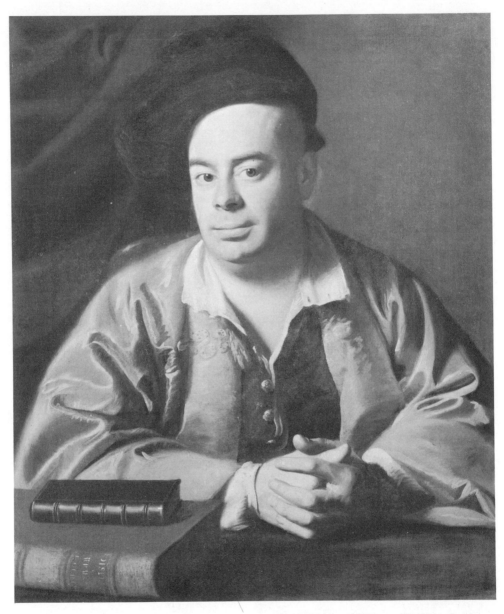

28　NATHANIEL HURD. Painting by John Singleton Copley. *Courtesy The Cleveland Museum of Art, John Huntington Collection.*

to England as early as the year 1760. No name was men-
tioned. And this, he said, was the more impressed upon his
mind, because of a painting of ' a boy and a tame squirrel,'
which came without any letter or artist's name to one of the
exhibitions of the Royal Academy; and when its natural
action, and deep vivid colouring made the academicians
anxious to give it a good place, they were at a loss what to say
about it in the catalogue, but from the frame on which it was
stretched, being American pine, they called the work American.
The surmise was just; it was a portrait by Copley of his half-
brother Harry Pelham, and of such excellence as naturally
raised high expectations." *The Royal Academy* was not
established until 1769.

The Hon. Gulian C. Verplanck in a letter to us says, " In
the lives of Copley I see that he gained his just celebrity in
England by a picture of a boy and squirrel. The introduction
of a squirrel which he painted beautifully, and whose habits he
seems to have studied, was a favourite idea with him. I have
a large full length of my father when a child, playing with a
squirrel.' This picture of the Hon. Cromeline Verplanck was
probably painted in 1773, when Copley resided in New-
York.

Mr. Cunningham proceeds: "In 1767, when Copley was thirty
years old we find him well known to the admirers of art on both
sides of the Atlantic: he was then a constant exhibiter in the
British Royal Academy; was earning a decent subsistence by
his art among the citizens of Boston; had proved, too, that
praise was sweet and censure bitter; and was, moreover, sighing
for a sight of the Sistine chapel, and talking of the great
masters."

As before noticed, in 1768 the British Royal Academy was
not in existence, still the American painter may have exhibited
his pictures at the artist's exhibition-room, Spring Garden,
and that his merit was well known, and acknowledged by his
countryman West, before Copley left Boston, is proved by
the first of the following extracts, from the letters of a distin-
guished American gentleman, sent to us enclosed in this
note :

" Wednesday, May 14, 1834.

" Dear Sir :—In looking over some letters to my grandfather
from his brother, I found the enclosed passages, which may
be of service to your history of the arts. The letters are from
the late Gulian Verplanck, whom you doubtless recollect as

for many years, speaker of our assembly, president of the bank of New-York, &c. &c., a gentleman of much taste and cultivation.

"Very truly yours,
"G. C. VERPLANCK."

First, "London, Feb. 26, 1773.—I may tell you that I have been introduced to Mr. West, and have made some acquaintance with him. He is of very genteel behaviour, and seems greatly partial to Americans; at least he is much pleased with visits from them. He speaks very highly of Mr. Copley's merit, and declared to me, that in his opinion, he only wanted the advantage of studying proper masters to be one of the first painters of the age. I have an opportunity of seeing the greater part of Mr. West's capital paintings, and think the Death of General Wolfe decidedly the best production of his pencil. It will be a long time before you will have an opportunity of judging of its merit in America, as it has lately been delivered to the engraver, who will require at least two years to complete a plate."

Second, "Rome, March 12, 1775.—I have the satisfaction of finding Mr. Copley in Italy, whom I persuaded to go to Naples with me. He has just finished two excellent portraits of Mr. and Mrs. Izard of S. C., who are likewise here; from the improvement he has already made in his manner, and will continue to make from studying the works of the greatest masters, I have no doubt but that he will soon rank with the first artists of the age." We recur to Cunningham:—

"He thus sets forth his feelings in a letter to Captain Bruce, a gentleman of some taste, who seems to have been an admirer of the works of Copley—'I would gladly exchange my situation for the serene climate of Italy, or even that of England; but what would be the advantage of seeking improvement at such an outlay of time and money? I am now in as good business as the poverty of this place will admit. I make as much as if I were a Raphael or a Correggio; and three hundred guineas a year, my present income, is equal to nine hundred a year in London. With regard to reputation, you are sensible that fame cannot be durable where pictures are confined to sitting rooms, and regarded only for the resemblance they bear to their originals. Were I sure of doing as well in Europe as here, I would not hesitate a moment in my choice; but I might in the experiment waste a thousand pounds and two years of my time, and have to return baffled to America. Then I should have to take my mother with me, who is ailing:

she does not, however, seem averse to cross the salt water once more; but my failure would oblige me to recross the sea again. My ambition whispers me to run this risk; and I think the time draws nigh that must determine my future fortune.' In something of the same strain and nearly at the same time Copley wrote to his countryman West, then in high favour at the British court. 'You will see by the two pictures I have lately sent to your exhibition, what improvement I may still make, and what encouragement I may reasonably expect. I must beg, however, that you will not suffer your benevolent wishes for my welfare to induce you to think more favourably of my works than they deserve. To give you a further opportunity of judging, I shall send over to your care for the exhibition the portrait of a gentleman, now nearly finished: the owner will be in London at the same time. If your answer should be in favour of my visit to Europe, I must beg of you to send it as soon as you can, otherwise I must abide here another year, when my mother might be so infirm as to be unable to accompany me; and I cannot think of leaving her. Your friendly invitation to your house, and your offer to propose me as a member of the society, are matters which I shall long remember.'

"What the answers of Bruce and West were, I have not been able to learn: but it is to be supposed they still left it a matter of uncertainty, whether it would be more profitable to go to London or remain in Boston. Success the wisest head cannot ensure; sensible and prudent mediocrity frequently wins what true genius cannot obtain—the race of reputation is, in short, the most slippery and uncertain of all races. As seven years elapsed from this time till he finally set sail for Italy, we must suppose that Copley was busy extending his fame with his pencil, and hoarding his earnings for the outlay of travel and study. He had, as he acknowledged to West, as many commissions in Boston as he could execute. The price for his half lengths was fourteen guineas; and he also executed many likenesses in crayons; he was, therefore, waxing comparatively rich. He was not one of those inconsiderate enthusiasts, who rashly run into undertakings which promise no certain return. He had laboured as students seldom labour now for his knowledge, and for the remuneration which it brought; and he was wise not to commit his all to the waters of the Atlantic. He had continued a bachelor, according to the precept of Reynolds, that he might be able to pursue his studies without offering up his time and money at the altar of that expensive idol, a wife; and he had sent over various pic-

tures, chiefly portraits in fancy postures and employments, with
the hope of finding customers for them in the English market.
He thus writes to captain Bruce: "Both my brother's por-
trait and the little girl's, or either of them, I am quite willing
to part with, should any one incline to purchase them, at such
a price as you may think proper.' I have not heard that he
held any further consultations with captains or academicians,
respecting his studies in Europe : the growing discord in Ame-
rica was a sharp sword that urged him onward; so in 1774,
having arranged his affairs, left a number of paintings in the
custody of his mother, and put in his pocket enough of his
winnings for a three years' campaign in the old world, he set
sail for Italy, by the way of England."

We have seen many of his portraits in New-York and Bos-
ton, painted before he left America. They are in some respects
better than his London portraits. One picture, the likeness
of Judge Bacon's mother, we found in a city now as populous as
Boston was when the portrait was painted, the site of which was
literally a wilderness for fifteen years after Copley left Ame-
rica. Utica, in the state of New-York, is surrounded in every
direction by a dense and happy population. The picture al-
luded to is a fine specimen of the artist's drawing and colour-
ing, and still more of elaborate finishing.

After reminding the reader that Mr. Copley was a married
man, and a father before he left home, we recur to Cunningham:

"In London he found few friends, and many counsellors;
and left it for Rome, August 26th, 1774. It was his misfor-
tune to choose for his companion an artist of the name of Car-
ter ; a captious, cross-grained, and self-conceited person, who
kept a regular journal of his tour, in which he remorselessly
set down the smallest trifle that could bear a construction un-
favourable to the American's character. A few specimens may
amuse the reader, *e. g.*—' This companion of mine is rather a
singular character; he seems happy at taking things at the
wrong end; and laboured near an hour to-day to prove that a
huckabuck towel was softer than a Barcelona silk handker-
chief.' ' My agreeable companion suspects he has got a
cold upon his lungs. He is now sitting by a fire, the heat of
which makes me very faint; a silk handkerchief about his head,
and a white pocket one about his neck, applying fresh fuel, and
complaining that the wood of this country don't give half the
heat that the wood of America does; and has just finished a
a long-winded discourse upon the merits of an American wood-
fire, in preference to one of our coal. He has never asked me
yet, and we have been up an hour, how I do, or how I have

passed the night : 'tis an engaging creature.' Upon another occasion one traveller wishes to walk, the other is determined to ride, and they stop in a shower to debate it. "We had a very warm altercation, and I was constrained to tell him, 'Sir, we are now more than eight hundred miles from home, through all which way you have not had a single care that I could alleviate ; I have taken as much pains as to the mode of conveying you, as if you had been my wife ; and I cannot help telling you, that she, though a delicate little woman, accommodated her feelings to her situation with much more temper than you have done.' " 'There is nothing that he is not master of. On asking him to-day what they called that weed in America, pointing to some fern; he said he knew it very well; there was a deal of it in America, but he had never heard its name.' 'My companion is solacing himself, that if they go on in America for a hundred years to come, as they have for a hundred and fifty years past, they shall have an independent government : the woods will be cleared, and, lying in the same latitude, they shall have the same air as in the south of France ; art would then be encouraged there, and great artists would arise.' These ill-matched fellow-voyagers, soon after their arrival in Rome, separated; and Carter closes with the following kind description of Copley, as he appeared on the road in his travelling trim :—'He had on one of those white French bonnets, which, turned on one side, admit of being pulled over the ears : under this was a yellow and red silk handkerchief, with a large Catharine wheel flambeaued upon it, such as may be seen upon the necks of those delicate ladies who cry Malton oysters : this flowed half way down his back. He wore a red-brown, or rather cinnamon, great coat, with a friar's cape, and worsted binding of a yellowish white ; it hung near his heels, out of which peeped his boots: under his arm he carried the sword which he bought in Paris, and a hickory stick with an ivory head. Joined to this dress, he was very thin, pale, a little pock-marked, prominent eye-brows, small eyes, which, after fatigue, seemed a day's march in his head.'

"Copley was, no doubt, glad to be relieved from the company of a man who was peevish without ill health ; who, with his smattering of Italian, continually crowed over one who could only speak English ; who constantly contradicted him in company ; and, finally caricatured him when they parted. Our painter, in speaking afterward of his *bore*, said 'he was a sort of snail which crawled over a man in his sleep, and left its slime and no more.'

" Of Copley's proceedings in Rome we have no account; but we find him writing thus by May, 1775.—' Having seen the Roman school, and the wonderful efforts of genius exhibited by Grecian artists, I now wish to see the Venetian and Flemish schools : there is a kind of luxury in seeing, as well as there is in eating and drinking ; the more we indulge, the less are we to be restrained ; and indulgence in art I think innocent and laudable. I have not one letter to any person in all my intended route, and I may miss the most beautiful things ; I beg you therefore, to assist and advise me. I propose to leave Rome about the 20th of May ; go to Florence, Parma, Mantua, Venice, Inspruck, Augsburg, Stuttgardt, Manheim, Coblentz, Cologne, Dusseldorf, Utrecht, Amsterdam, Leyden, Rotterdam, Antwerp, Brussels, Ghent, Bruges, Lille, Paris, London. The only considerable stay which I intend to make will be at Parma, to copy the fine Correggio. Art is in its utmost perfection here ; a mind susceptible of the fine feelings which art is calculated to excite, will find abundance of pleasure in this country. The Apollo, the Laocoon, &c., leave nothing for the human mind to wish for ; more cannot be effected by the genius of man than what is happily combined in those miracles of the chisel.'

" No memorial remains of what he said or did in the route marked out in this letter, save the copy of the Parma Correggio. His imitation is in England, and may be compared, without injury to his name, with any copies made by his brethren of the British school.

" In the latter end of the year 1775, Copley reached London ; and set up his esel, 25 George-street, Hanover-square. West was as good as his word : he introduced him to the academy ; in 1777 he became an associate ; and in February, 1783, we find the king sanctioning his election as a royal academician.

" By this time Copley's name had been established by works of eminent merit ; among the first of which was ' The Death of Chatham.' The chief excellence of this picture is the accurate delineation of that impressive event, and the vast number of noble heads, all portraits, with which the house of lords is thronged ; its chief fault is an air of formality, and a deficiency of deep feeling : yet, it must be owned that those who are near the dying statesman are sufficiently moved. All lords could not feel alike ;—some seem standing for their portraits ; some seem anxious about their places ; and others, from their looks, may be supposed inwardly rejoicing that death, having struck the head of the administration, seems satisfied with his prey. Praise poured in upon the successful painter from all quarters ;

no people were more pleased than his old companions in America; and many letters were addressed to him from grave and aged persons.—' I delight,' said the venerable Matthew Byles, of Boston, ' in the fame you have acquired; and I delight in being ranked among your earliest friends.' No one, it may be believed, rejoiced more than his mother. She was now very old, feeble in body, sinking silently into the grave ; had suffered in peace of mind, and in property, during the war of separation ; but what she lamented most were the interruptions which took place in a correspondence with her son : private letters were sometimes detained by the government, and she was months without the solace of his handwriting. It appears, too, that her circumstances were far from affluent ; and it must be related to the honour of all concerned, that she made no complaint, and that her son did not forget her, or any of his relatives, amid all his prosperity.

" The fame which Copley acquired, and the value which he put upon this noble picture, brought him, along with many friends, a few detractors. To have refused 1500 guineas, was, in the sight of some, offence enough ; nor was this forgotten, when some time afterward the fame of the painting was revived by a splendid engraving of large size, of which no less than five-and-twenty hundred impressions were sold in a very few weeks. He was advised to exhibit the picture ; and naturally preferring the time when the town is fullest, hired a room, and announced his intention, without reflecting that the Royal Academy Exhibition was about to open. He met with unexpected opposition. Sir William Chambers remonstrated :— the room which was chosen belonged to the king ; it was his duty, he said, to protect the interests of the Royal Academy, which were sure to suffer from such partial exhibitions ; and he interposed, lest the world should think that the king, who had aided and protected the academy, now countenanced an exhibition injurious to its welfare, and contrary to the spirit and rules of the institution. This, Copley thought a little too autocratic in the architect, who, moreover, had not hesitated to imbitter his opposition by most gratuitous incivilities. Those who desire to know how men of eminence in art addressed each other in the year 1781, may consult the conclusion of Sir William's epistle :—' No one wishes Mr. Copley greater success, or is more sensible of his merit, than his humble servant ; who, if he may be allowed to give his opinion, thinks no place so proper as the royal exhibition to promote either the sale of prints, or the raffle for the picture, which he understands are Mr. Copley's motives : or, if that should be objected to, he

thinks no place so proper as Mr. Copley's own house, where the idea of a raree-show will not be quite so striking as in any other place, and where his own presence will not fail to be of service to his views.' The painter was much incensed by this language, and had some intention, when he moved his picture to another place, of stating publicly the cause of this vexatious change: he did, however, what many wise men do—having vented his wrath and sarcasm on paper in the morning, he sweetened the bitterness of the invective a little at mid-day, laughed at the whole affair in the evening, and threw the satire into the fire before he went to bed. The picture was so much admired, that the artist was emboldened to have an engraving made from it of unusual size, viz. thirty inches long and twenty-two inches and a half high, by the hand of Bartolozzi.

" When this great plate was finished, he was remembered by all those to whom he had happened to give offence; more particularly by those who were envious of his success. They spread a report every where that he had fraudulently withheld from his subscribers the early impressions to which the order of signatures entitled them. This audacious calumny was promptly refuted; four gentlemen of taste and talent, one of them Edmund Malone, took up the cause of their injured friend, and proved to the satisfaction of the public—first, that Bartolozzi received 2000*l.* for the plate; secondly, that the number of subscribers, from April 1780, to August 1782, amounted to 1750; thirdly, that 2438 impressions were taken in all; fourthly, that 320 proofs were struck from the plate; and, finally, that the impressions were delivered to the subscribers according to the order of subscription. The approbation of many good judges compensated for the pain which this rumour occasioned: he could not but feel gratified with the united thanks of Washington and Adams, to whom he had presented two of the prints:—' This work,' says the former, ' highly valuable in itself, is rendered more estimable in my eye, when I remember that America gave birth to the celebrated artist who produced it.'—' I shall preserve my copy,' said the latter, ' both as a token of your friendship, and as an indubitable proof of American genius.' "

In the year 1784, the writer carried letters to Mr. Copley from his wife's relatives in New-York. In the summer of that year were on exhibition the great historical pictures of the " Death of Chatham," " The Youth rescued from a Shark," and " The Death of Major Pierson."

The history of England is the history of our fathers. It is *our history* to the time of separation by the Declaration of

Independence of 1776. The good and the bad of English history are ours up to that time, and as much belonging to us as to those who now inhabit the island of Great Britain. We inherit the blessings proceeding from her patriots and heroes—her poets and sages; and the curses entailed upon us by her mistaken statesmen and avaricious merchants. Shakspeare and Milton—Bacon, Locke, and Newton, are ours, and their minds are mingled with our intellectual being. So the deeds of Hampden and Sidney, and all the men who thought and fought, and bled for liberty of mind and body, are subjects for the pencils of American painters. Mr. Copley chose and finely executed one great picture from this period of English history, "The Arrest of the Five Members of the Commons, by Charles the First." But Copley was, when removed to England, no longer an American painter in feeling; and his choice of subjects for historical composition, was decided by the circumstances of the time, or by employers. The picture called the Death of Lord Chatham, is connected with the history of America. He received the dart of death (for he never recovered from the fainting of that day,) exerting himself in opposition to that independence which is our glory, and which with its offspring, our union under the federal constitution, is the source of all our political happiness. The subject was worthy of the historical painter. It is the last scene in the public life of a great man. The last exertion of his transcendant powers for what he thought the honour and interest of his country. He died exerting his eloquence to rouse his countrymen to redouble their efforts for the destruction of our liberties.

The second picture that we have mentioned above, represents the rescuing of Brook Watson (an American adventurer from one of the New-England provinces, who was afterwards commissary general of the English armies in America, lord mayor " of great London," and a member of the parliament of Great Britain,) from the jaws of a shark, in the harbour of the Havana. This individual is memorable as arrayed with our enemies in opposition to our independence, and with the enemies of God and man in opposition to the abolitionists of the slave-trade in the English house of commons. Before he avowedly joined the standard of Britain, the traitor ingratiated himself with many leading Americans, obtained as much information of their designs as he could, and transmitted it to his chosen masters. In the character of legislator, his argument in support of the trade in human flesh was that it would injure the market for the refuse-fish of the English fisheries to abolish it—these refuse-fish being purchased by the West India

planters for their slaves. To immortalize such a man was the pencil of Copley employed. The picture may be seen in " Christ's Hospital School," and the debate in which this argument is urged may be read in the records of " St. Stephen's Chapel." Both holy places.

The third picture above mentioned, and a very fine one it is, represents the death of a Major Pierson, in a skirmish on the island of Jersey.

West, as we have seen, produced, in his " Death of Wolfe," the first historical picture of this species. It is a curious fact, that three Americans in succession painted successfully in this style, and led the way to Europeans. West, the founder, the inventor, the original, the master ; Copley, the second, his immediate follower ; and Trumbull, painting under West's eye, the third. West's Wolfe is not only the first in point of time, but the first in excellence; Copley's the second; and Trumbull's "Bunker Hill" the third. Copley, in the years 1786–7, painted another picture of this class, his Elliot at Gibraltar, (if his daughter is correct, as quoted above, this picture was not finished in 1790 ; I saw it in progress as early as 1787,) and Trumbull followed with a picture on a similar subject, Elliot's triumph over the French and Spanish combined forces at Gibraltar. Of these three Americans, West painted the triumph of the colonists of Great Britain and her European soldiers over France, and the establishment thereby of the protestant religion and the liberties of the colonies ; he composed the first picture of the heroic class in which modern costume was introduced, and has all the merit of original daring with perfect success ; Copley followed in his track, second in all, though displaying great talents : Trumbull followed, with both before him, in every sense.

I will now recur to Mr. Cunningham, and the reader will find just opinions and descriptions of the above pictures of Mr. Copley's, as well as others:

" At this time historical painting seemed to have a chance of taking a hold on public affection ; the king patronized it openly ; several dignitaries of the church, and sundry noblemen, obeyed their own taste, or the example of the throne, and ordered pictures ; and finally, Alderman Boydell entered into a covenant with a number of the academicians to unite their talents, and form a gallery of English works in the manner of some of those in foreign lands ; we have stated this more fully elsewhere ; at present it is sufficient to say that Copley was one of the select, and that various subjects presented themselves to his fancy: 1. The Assassination of Buckingham ;

2. Charles signing Strafford's Death-warrant; 3. Charles addressing the Citizens of London; 4. The Five impeached Members brought in Triumph to Westminster; 5. The Speaker of the Commons thanks the City Sheriffs for protecting the Five impeached Members; 6. The Members of the House of Commons appear before the Army on Hounslow; 7. London sends six Aldermen to General Monk, and submits; 8. The Lord-mayor presenting a Gold Cup to Monk; 9. The General conducts the Members back to Westminster Hall; 10. The King's Escape from Hampton Court. It must be confessed that some of these themes smack of Bow bells and Cheapside; they were probably suggested to Copley by the worthy alderman, who was anxious to honour his predecessors, in the hope of not being forgotten himself. While this list was under consideration, an event happened, in the course of the war, which furnished a subject of more immediate interest.

"The French invaded Jersey; stormed St. Hellier's; took the commander prisoner, and compelled him to sign the surrender of the island. Major Pierson, a youth of twenty-four, refused to yield—collected some troops—charged the invaders with equal courage and skill—defeated them with much effusion of blood, but fell himself in the moment of victory, not by a random shot, but by a ball aimed deliberately at him by a French officer, who fell in his turn, shot through the heart by the African servant of the dying victor. It is enough to say in praise of any work, that it is worthy of such a scene. The first print I ever saw was from this picture: it was engraved by Heath; and equals in dimensions that of "The Death of Chatham." I was very young, not ten years old; but the scene has ever since been present to my fancy. I thought then, what I think still, on looking at the original— that it is stamped with true life and heroism: there is nothing mean, nothing little,—the fierce fight, the affrighted women, the falling warrior, and the avenging of his death, are all there: this story is finely told. The picture was painted for Boydell: long afterward, when his gallery was dispersed, it was purchased back by Copley, and is now in the keeping of his distinguished son, Lord Lyndhurst.

"His next subject was a much more magnificent one, but too vast and varied perhaps—the repulse and defeat of the Spanish floating batteries at Gibraltar. The common council of London commissioned this picture for their hall; and they gave ample space and verge enough, wherein to trace the beleaguered rock and its fiery assailants; viz. a panel twenty-five feet long and twenty-two feet and a half high. In this great

picture, as in others, he introduced many portraits; the gallant Lord Heathfield himself is foremost in the scene of death; and near him appear Sir Robert Boyd, Sir William Green, chief engineer, and others, to the amount of a dozen or fifteen. The fire of the artillery has slackened; the floating-batteries, on whose roofs thirteen-inch shells and showers of thirty-two pound balls had fallen harmless, at ten o'clock in the forenoon, are now sending up flames on all sides; while their mariners are leaping in scores into the sea. The scene of desolation is certainly grand. There is, however, a want of true perspective : the defenders of the rock are like the children of Anak; the perishing mariners, at the very line where the sea washes the defences of stone, are less than ordinary mortals. The figures have been charged with looking more formal and stiff than nature. This may be too severe—but on the whole I cannot class the piece with his happiest works. I may mention here a work bequeathed by Copley to that noble institution, Christ's Hospital School, painted early in his career, and representing the escape of Brook Watson, when a sea-boy, from a shark. He was bathing at Havana; a shark seized his foot and snapped it off, and was about to devour him, when a seaman struck the monster between the eyes with a heavy boat-hook, and saved his companion. The terror of the boy —the fury of the fish—and the resolution of the mariner, are well represented ; while the agitated water in which the scene is laid seems bloody."

In addition to what I have said of Brook Watson, I will add that he was at Montreal when the patriotic Colonel Allen made his rash attempt to take that place in October 1775. He accompanied Allen, who was taken prisoner and kept in irons, to England; and treated him with cruelty and abuse.

We saw, when in London, a full-length by Copley, representing John Adams as the first ambassador of the United States to the court of St. James's. To that king whose subject he had been born, and from whom he had been a most efficient instrument in rescuing millions who would otherwise have been ruled by the laws framed by the British parliament, and by the bayonets of British mercenaries, equally interested in plundering and trampling on them. Cunningham says:

" Subjects from British history and British poetry were what Copley chiefly found pleasure in. The first installation of the order of St. Patrick seemed to him a subject worthy of the pencil ; and Edmund Malone readily aided him with his knowledge ; and the Irish nobility, with but one exception or so, offered to give him the advantage of their faces, so that the whole might bear the true image of the green isle. Of this

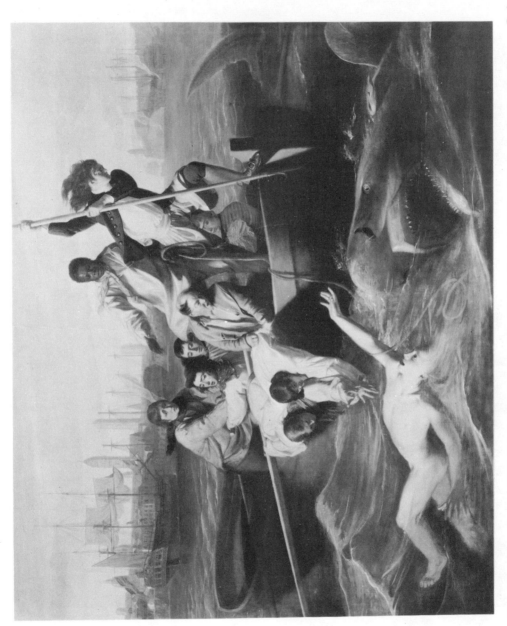

29 WATSON AND THE SHARK, 1778. Painting by John Singleton Copley. *Courtesy National Gallery of Art, Washington, D.C., Ferdinand Lamont Berlin Fund.*

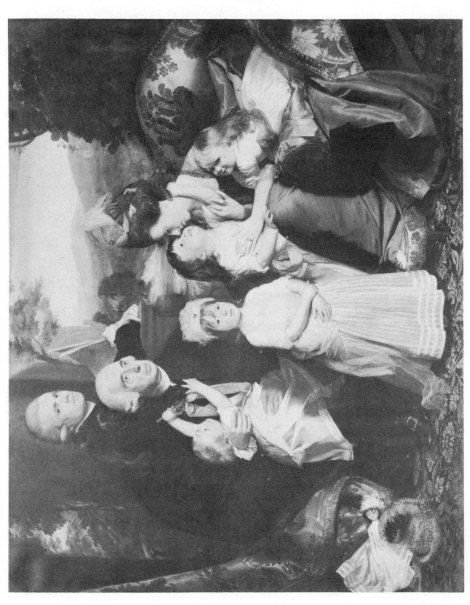

30 The Copley Family, 1776-1777. Painting by John Singleton Copley. *Courtesy National Gallery of Art, Washington D.C.*

projected work the painter thus speaks : ' I think it a magnificent subject for painting; and my desire is to treat it in an historic style, and make it a companion to the picture of Lord Chatham : filling the whole with the portraits of the knights and other great characters. The idea originated with myself; and I mean to paint it on my own account, and publish a print from it of the same size as that of Chatham.' This was a vain imagination—the king approved of the work; the nobility of Ireland promised to sit for their portraits, though one of them, Lord Inchiquin, I think, declared sitting for one's portrait to be a punishment almost unendurable; but somehow, here the matter stopped, and the first installation of the order of St. Patrick is yet to be painted.

" It ought to be mentioned that Copley, amid all his historical works, continued to paint portraits, and had in that way considerable employment. Among others he took the likeness of Lord Mansfield; and has left us a very fine family group of himself, his wife, and his children : the hands are well proportioned; there is much nature in the looks of the whole, and some very fine colouring.

" A portrait painter in large practice might write a pretty book on the vanity and singularity of his sitters. A certain man came to Copley, and had himself, his wife, and seven children, all included in a family piece. ' It wants but one thing,' said he, ' and that is the portrait of my first wife—for this one is my second.'—' But,' said the artist, ' she is dead, you know, sir : what can I do? she is only to be admitted as an angel.'—' Oh, no ! not at all,' answered the other; ' she must come in as a woman—no angels for me.' The portrait was added, but some time elapsed before the person came back : when he returned, he had a stranger lady on his arm. ' I must have another cast of your hand, Copley,' he said : ' an accident befell my second wife : this lady is my third, and she is come to have her likeness included in the family picture.' The painter complied—the likeness was introduced—and the husband looked with a glance of satisfaction on his three spouses : not so the lady; she remonstrated; never was such a thing heard of—out her predecessors must go. The artist painted them out accordingly; and had to bring an action at law to obtain payment for the portraits which he had obliterated.

" The mind of Copley teemed with large pictures : he had hardly failed in his Irish subject before he resolved to try an English one, viz. the Arrest of the Five Members of the Commons by Charles the First. Malone, an indefatigable friend,

supplied the historical information, and gave a list of the chief men whose faces ought to be introduced. It was the good fortune of the eminent men of those days, both cavaliers and roundheads, that their portraits had chiefly been taken by the inimitable Vandyke : all that had to be done, therefore, was to collect these heads, and paint his picture from them. They were, it is true, scattered east, west, north, and south : but no sooner was Copley's undertaking publicly announced, than pictures came from all quarters ; and it is a proof of his name and fame that such treasures were placed in his hands with the most unlimited confidence. The labour which this picture required must have been immense, besides the grouping, the proper distribution of parts, and the passion and varied feelings of the scene, he had some fifty-eight likenesses to make of a size corresponding with his design. The point of time chosen is when the king having demanded if Hampden, Pym, Hollis, Hazelrig, and Strode were present, Lenthall the speaker replies,—" I have, sir, neither eyes to see, nor tongue to speak, in this place, but as the House is pleased to direct me." The scene is one of deep interest, and the artist has handled it with considerable skill and knowledge. The head I like best is the dark and enthusiastic Sir Harry Vane : the Cromwell is comparatively a failure. Many have left their seats dismayed; while fear, and anger, and indignation have thrown the whole into natural groupings : the picture was much talked of when it appeared, and deserves to be remembered still.

"There has always been a difficulty in disposing of historical pictures in this country ; and no one was doomed to experience it more than Copley : no customer made his appearance for Charles and the impeached members. I know not whether the following remarkable letter, from a wealthy peer, arose from his own inquiries, or from an offer made by the artist ; the letter, however, is genuine, and proves that they err, who imagine that the spirit of bargaining is confined to mercantile men :—

" ' Lord Ferrers' compliments to Mr. Copley ; he cannot form any judgment of the picture ; but, as money is scarce, and any one may make eight per cent. of their money in the funds, and particularly in navy bills, and there is so much gaming, he hopes he'll excuse his valuing his picture in conformity to the times, and not think he depreciates in the least from Mr. Copley's just merit ; but if he reckons fifty-seven figures, there are not above one-third that are capital, but are only heads or a little more ; and therefore he thinks, according to the present times, if he gets nine hundred pounds for the picture with the frame, after the three other figures are put in, and it is com-

pletely finished, and he has the power of taking a copy, it is pretty near the value : that is what very few people can afford to give for a picture. However, if Mr. Copley would undertake to do a family piece for him with about six figures, about the size of the picture he has of Mr. Wright's, with frame and all, he would agree to give him a thousand guineas for the two pictures. But he imagines the emperor or some of the royal family may give him more, perhaps a great deal more, which he wishes they may, and thinks he well deserves; but if he can't make a better bargain, Lord Ferrers will stand to what he says, and give him six months to consider of it, and will not take it amiss if he sells it for ever so little more than he has mentioned, as he has stretched to the utmost of his purse, though he does not think he has come near up to Mr. Copley's merit.

" ' Upper Seymour-street, 5th June, 1791.'

" Copley felt himself so much obliged to Malone for historical help, that he made a public acknowledgment of it ; but he seemed not to be aware that he had received invisible help before, both in America and England. The person who had done this good deed was Lord Buchan ; and, lest the painter should go to the grave in ignorance of the name of his benefactor, he addressed this characteristic note from Dryburgh :— ' You are now the father of my list in the charming art of perpetuating or greatly extending the impressions received by the most spiritual of our external senses from living forms. I take pride to myself in having been the first, with your ' Boy and Squirrel,' and your excellent character from the other side of the Atlantic, to make you properly known to the illustrious Pitt, to whom in this particular department there has been found no equal.' This northern lord lived, and, I hear, died, in the belief that he was the great support of literature and patron of art. But, though the elder brother of two men of wit and genius, he was, in fact, in every possible respect, saving his coronet, a *nobody*.

" No artist was ever more ready than Copley to lend his pencil to celebrate passing events; the defeat of De Winter by Duncan was now celebrated in a picture, exhibiting considerable skill in depicting maritime movements, and containing in all twelve portraits. He is not, however, so happy at sea as on land; indeed, a naval battle is conducted on such mathematical principles, that no human ingenuity seems capable of infusing poetic beauty into the scene. When we have seen the sides, and the prow, and the stern, of a ship, we have seen all ;

their tiers of guns, their masts, their rigging, and their mode of fighting, are all alike. The battle of La Hogue is the best of all the pieces of this class; yet a distinguished officer once called it, in my hearing, a splendid confusion; and declared if the painter had commanded the fleet, and conducted it so, he would have been soundly thrashed. When Nelson fell at Trafalgar, West dipped his brush in historic paint. Copley did the same; the former finished his picture, the latter but planned his. The tide of taste had set in against compositions of that extent and character: more youthful adventurers were making their appearance. Lawrence, Beechey, and Shee, with their splendid portraitures—Stothard, with his poetic pictures—and Turner, with his magical landscape, began to appear in the van; and, at seventy years of age, nature admonished Copley to cease thinking of the public, and prepare for a higher tribunal. He had still, however, energy sufficient to send works from his easel to the exhibition; among which were portraits of the Earl of Northampton, Baron Graham, Viscount Dudley and Ward, Lord Sidmouth, the Prince of Wales at a review, attended by Lord Heathfield, and other military worthies. His last work was 'The Resurrection;' and with this his labours closed, unless we except a portrait of his son, Lord Lyndhurst, painted in 1814. An American gentleman applied to him for information and materials to compose a narrative of his life; he felt a reluctance, which all must feel, about complying with such a request; and while he was hesitating, death interposed. He died 9th September 1815, aged seventy-eight years.

"Those who desire to know the modes of study, the peculiar habits, the feelings and opinions, likings and dislikings, of Copley, cannot, I fear, be gratified. No one lives now who could tell us of his early days, when the boy, on the wild shores of America, achieved works of surpassing beauty; he is but remembered in his declining years, when the world had sobered down his mood, and the ecstasy of the blood was departed. He has been represented to me by some as a peevish and peremptory man, while others describe him as mild and unassuming. Man has many moods, and they have all, I doubt not, spoken the truth of their impressions. I can depend more upon the authority which says, he was fond of books, a lover of history, and well acquainted with poetry, especially the divine works of Milton. These he preferred to exercise either on foot or on horseback, when labour at the easel was over—and his bookish turn has been talked of as injurious to his

health; but no one has much right to complain of shortness of years, who lives to see out threescore and eighteen.

"He sometimes made experiments in colours; the methods of the Greeks, the elder Italians, and the schools of Florence and Venice, he was long in quest of; and he wrote out receipts for composing those lustrous hues in which Titian and Correggio excelled. For the worth of his discoveries, read not his receipts, but look at his works; of all that he ever painted, nothing surpasses his 'Boy and Squirrel' for fine depth and beauty of colour; and this was done, I presume, before he heard the name of Titian pronounced. His 'Samuel reproving Saul for sparing the People of Amalek,' is likewise a fine bit of colouring, with good feeling and good drawing too. I have only this to add to what has been already said of his works; he shares with West the reproach of want of natural warmth—and uniting much stateliness with little passion. As to his personal character, it seems to have been in all essential respects, that of an honourable and accomplished gentleman.

"Copley's eminent son still inhabits the artist's house in George-street, Hanover-square; and all must consider it as honourable to this noble person, that he has made it his object to collect works of his father's pencil wherewith to adorn the apartments in which they were conceived and produced."

We have given our opinion of the merits of Mr. Copley as a painter, and will add that of a higher authority. In a note which we are permitted to copy, Mr. Thomas Sully says,—"Copley was in all respects but one equal to West; he had not so great dispatch: but then he was more correct, and did not so often repeat himself. His early portraits, which I saw at Boston, show the same style, only less finished, that he kept to the last. He had great force and breadth. He was crude in colouring, and used hard terminations." Highly as we respect this authority, we must still think that Copley, as an historical painter, was inferior to West in very many points; in portraits he was his superior. It appears to us strange that any one who has seen the appropriate variation of style from the scripture subjects for Windsor, to the Roman pictures—the representations of English history from Edward III. to Cromwell—from the battles of the Boyne, La Hogue, and Quebec, to Telemachus, Mentor, and Calypso—can place Mr. Copley near his great countryman.

We will give some anecdotes elucidating Copley's elaborate mode of working: and first, from Mr. Sargent:

"Stuart used to tell me, that no man ever knew how to *manage paint* better than Copley. I suppose he meant that

firm, artist-like manner in which it was applied to the canvas; but he said he was very tedious in his practice. He once visited Copley in his painting-room, and being a good deal of a beau!!" (by these notes of admiration we suppose Mr. Sargent to allude to Stuart's slovenly, snuffy appearance when he knew him,) "Copley asked him to stand for him, that he might paint a bit of a ruffle-shirt that stuck out of his bosom. Not thinking that it would take more than a few minutes, he complied. But after standing a long time, and growing uneasy, Copley began to apologize. "No consequence at all," said Stuart, "I beg you would finish—do all you can do to it now, for this is the last time you ever get me into such a scrape."

"Copley's manner," continues Mr. Sargent, "though his pictures have great merit, was very mechanical. He painted a very beautiful head of my mother, who told me that she sat to him fifteen or sixteen times! six hours at a time!! and that once she had been sitting to him for many hours, when he left the room for a few minutes, but requested that she would not move from her seat during his absence. She had the curiosity, however, to peep at the picture, and, to her astonishment, she found it all rubbed out."

On this same subject we quote from letters in answer to our inquiries, addressed to that very distinguished artist, C. R. Leslie, Esq. R. A.

"Of Copley I can tell you very little. I saw him once in Mr. West's gallery, but he died very soon after my arrival in London. Mr. West told me he was the most tedious of all painters. When painting a portrait, he used to match with his palette-knife a tint for every part of the face, whether in light, shadow, or reflection. This occupied himself and the sitter a long time before he touched the canvas. One of the most beautiful of his portrait compositions is at Windsor Castle, and represents a group of the royal children playing in a garden with dogs and parrots. It was painted at Windsor, and during the operation, the children, the dogs, and the parrots became equally wearied. The persons who were obliged to attend them while sitting complained to the queen; the queen complained to the king; and the king complained to Mr. West, who had obtained the commission for Copley. Mr. West satisfied his majesty that Copley must be allowed to proceed in his own way, and that any attempt to hurry him might be injurious to the picture, which would be a very fine one when done."

The prediction of West was fully accomplished; and this graceful, splendid, and beautiful composition was seen by the

writer at Somerset House, in the year 1786 or '7, and is remembered with pleasure to this day.

On the subject of Copley, we must give our readers some further valuable and entertaining matter from the pen of Mr. Leslie. He says:

"As you ask my opinion of Copley, you shall have it, such as it is. His merits and defects resemble those of West. I know not that he was ever a regular pupil of the president, but he was certainly of his school. Correct in drawing, with a fine manner of composition, and a true eye for light and shadow, he was defective in colouring. With him it wants brilliancy and transparency. His Death of Major Pierson, I think his finest historical work—you have perhaps seen it—at any rate you know the fine engraving of it, by James Heath. Copley's largest picture is in Guildhall; the destruction of the floating batteries off Gibraltar, by General Elliot. The foreground figures are as large as life, but those in the middle distance, are either too small or deficient in aerial perspective. Instead of looking like men diminished by distance, they look less than life. With the exception of this defect the picture is a fine one. His Death of Lord Chatham is now in the National Gallery. It is the best coloured picture I have seen by him, but it has a defect frequent in large compositions made up of a number of portraits. There are too many *figures to let.* Too many unoccupied, and merely introduced to show the faces. His picture of Brooke Watson and the Shark, is in the large hall of the Blue Coat School. It is a good picture, but dry and bad in colour. He painted, I believe, a great many portraits, but I have seen none of any consequence excepting the group of the King's Children I described to you in my last. It is a beautiful picture. I have heard Allston say, he has seen very fine portraits, painted by Copley before he left America. I would advise you to write to Allston about it." In another of Mr. Leslie's valuable letters we have the following:—"I know not if Allan Cunningham in his life of Copley, has told the following story of his tediousness as a painter. It is said, a gentleman employed him to paint his family in one large picture, but during its progress, the gentleman's wife died, and he married again. Copley was now obliged to obliterate all that was painted of the first wife, and place her in the clouds in the character of an angel, while her successor occupied her place on earth. But lo! she died also, and the picture proceeded so slowly as to allow the husband time enough to console himself with a third wife. When the picture was completed, therefore, the gentleman had two wives

in heaven, and one on earth, with a sufficient quantity of children. The price, which was proportioned to the labour bestowed on the picture, was disputed by the employer, who alleged that the picture ought to have been completed before his domestic changes had rendered the alterations and additions necessary. Copley went to law with him; and his son, (now Lord Lyndhurst,) who was just admitted to the bar, gained his father's cause. The story was told me by a gentleman, who was old enough to remember Copley, but he did not give me his anthority for it, and I fear it is too good to be true.* I remember one or two of Copley's last pictures in the exhibition, but they were very poor; he had outlived his powers as an artist."

It has been said that Mr. Copley's death was accelerated by two concurrent circumstances, both affecting his purse. The one was the dilatoriness of Bartolozzi in finishing the print of the Death of Chatham, by which he lost many subscribers, and experienced a diminished sale. The other is thus related. Some American speculator who was acquainted with the superb situation of Copley's house in Boston, (overlooking the beautiful green and parade ground called the Common, with the Mall, and its venerable trees,) and who knew the rapid increase in value, which such property had experienced, and was daily experiencing, made an offer to the painter for the purchase, which, compared to the value of property in the town of Boston in former days, seemed enormous. Copley eagerly closed with him, and sold the property for a song, compared to its real value. Shortly after the irrevocable deed was done, he heard that it was worth ten—perhaps twenty times the money he had received—in short, that he had lost a fortune. He, it is said, tried to undo the bargain, and even sent his lawyer-son to Boston for the purpose, but his travelling countryman had left no loop-hole for the future peer of the realm of Great Britain to peer into. All was irrevocably fast, and these losses are said to have shortened his days. All this may be mere gossip. It is more than gossip, that John Singleton Copley was a great painter, and a good man. It is undoubtedly true that he experienced disappointment and loss from another engraving of his " Chatham."

This was by the decision of a stupid jury against him, July 2, 1801. The circumstances are thus well told:—

" Law Intelligence. Delatre v. Copley. This cause occupied the attention of the ' Court of King's Bench,' the whole

* Cunningham tells this story with such variations as such stories are liable to ; the reader has seen it, and will judge which is best

day, and excited a considerable degree of interest. The question was concerning the execution of an engraving from the celebrated picture of the death of Lord Chatham. This was originally painted by the defendant. As soon as it was finished he put it in the hands of Bartolozzi, who undertook to engrave it for 2000 guineas. This print was admirably done, but the price being high, he wished to publish another which he could afford to sell at a more moderate rate. He therefore contracted with the plaintiff, for an engraving about half the size, for which he was to give him about £800. After working on the plate three years, Mr. Delatre thought he had brought it to perfection, and sent a proof to Mr. Copley. The latter, however, was dissatisfied with the performance, and refused to pay the stipulated sum; when the action was brought to recover £650, as the balance due the plaintiff, he having received £150, during the course of the work.

"The first witness called was M. Bartolozzi, who spoke very much in favour of the engraving. Copies of it were produced, as well as of Bartolozzi's. Mr. Erskine in cross-examining the witness, desired him to compare minutely the two prints together. 'Do you see, sir,' said he, 'in your own, the youngest son of Lord Chatham, in a naval uniform, bending forward with a tear in his eye, and a countenance displaying the agony of an affectionate son, on beholding a dying father; and do you not see in the other, an assassin, with a scar upon his cheek, exulting over the body of an old man whom he has murdered? In the one you observe the late minister, a thin, fair complexioned, genteel-looking young man; in the other, a fat, round-faced, grim-visaged negro. In the one, the Archbishop ot York appears in his true colours, as a dignified and venerable prelate; in the other, his place is usurped by the drunken parson in Hogarth's Harlot's Progress. In the one, the Earl of Chatham is supported by his son-in-law, Lord Stanhope, a figure tall, slender and elegant; and does not the other offer to view a short, sturdy porter of a bagnio, lugging home an old letcher, who had got mortal drunk?' M. Bartolozzi allowed that some of the portraits were not exactly alike, but maintained that the piece was well executed upon the whole. Mr. Pitt's looks, he said, had altered much of late years, and this accounted for the dissimilarity of his appearance in the two prints. This remark caused a loud and general laugh.

"M. Bartolozzi was followed by an immense number of other engravers, who all coincided in opinion with him.

"After a very elegant speech for the defendant, from Mr.

Erskine, as many eminent painters were called, whose opinion was diametrically opposite. Among these were Sir William Beechy, Mr. Opie, Mr. Cosway, Mr. President West, and Mr. Hopner; they, together with several engravers, unanimously pronounced the engraving extremely ill executed, and declared that the defendant could not publish it without materially injuring his reputation.

"Lord Kenyon professed total ignorance upon this subject; the knowledge of the fine arts, he said, doubtless added to the value of human life; but this source of enjoyment had unfortunately never been open to him. He found himself in a wilderness, and at a loss what path to take to arrive at justice; he found fourteen persons who advised him to go one way, and other fourteen who insisted upon his going another. He would not even talk upon this subject, lest he should appear a fool and a babbler, like the man who discoursed upon the art of war before Hannibal. In the course of his charge, however, the noble lord laid great stress upon the evidence of Mr. West, and though he gave no direction to the jury, seemed inclined to think that the defendant was entitled to a verdict. The jury nevertheless after withdrawing for about ten minutes, found a verdict for the plaintiff. Damages £650."

It was on this occasion that the judge showed his conviction that West ought to be decorated with a title, and called upon him as *Sir Benjamin,* and the audience paid him such peculiar respect in making way for him. See Hazlitt's conversations of Northcote as quoted in the biography of Mr. West, in this work.

TAYLOR—1760

? Taylor. No further information available.

A gentleman of this name painted miniatures in Philadelphia, in the year 1760. A copy of a miniature of Oliver Cromwell is in the museum of that city, as I am informed. At the same time a painter of the name of

CAIN—1760

Justus Englehardt Kühn, ?–1717.

exercised his profession in Maryland.

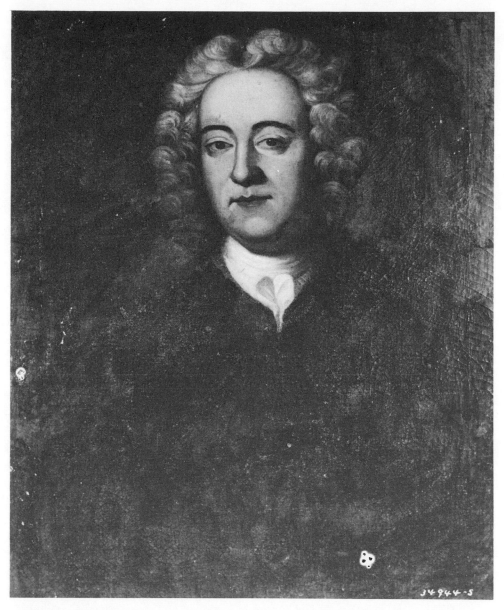

31 DANIEL DULANY THE ELDER. Painting by Justus Englehardt Kühn. *Courtesy Trustees of the Peabody Institute of the City of Baltimore. Photograph Frick Art Reference Library.*

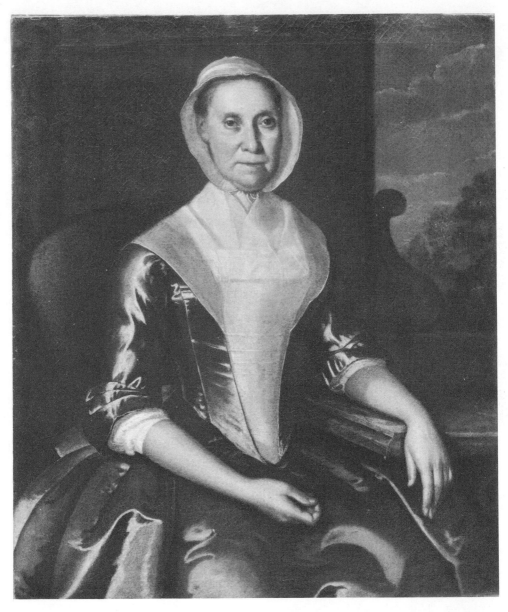

32 MRS. RICHARD GALLOWAY, JR. OF CEDAR PARK, MARYLAND (Sophia Richardson), 1764. Painting by John Hesselius. *Courtesy The Metropolitan Museum of Art, Maria De Witt Jesup Fund.*

CHAPTER VII.

Hesselius—Frazier—Patience Wright—Charles Wilson Peale—Peale visits England, and is received kindly by West—Returns in 1774—Curious error respecting the surrender of Cornwallis—Peale's Museum*—Mammoth—Pennsylvania Academy of Fine Arts—Mr. Peale's death—His many trades and professions.

HESSELIUS—1763.

John Hesselius, 1728–1778.

An English painter of this name, married and settled in Annapolis in 1763. Our highly esteemed correspondent, Robert Gilmor, Esq. of Baltimore, an enlightened patron of art, and friend to artists, speaks of him thus:—

"Hesselius, by whom the greater part of the family portraits in the old mansions of Maryland was painted, and that in a respectable manner." He was an early instructor of Charles Wilson Peale, whose son Rembrandt in the memoir of his father, published in the Encyclopedia Americana, calls him 'a portrait painter, from the school of Sir Godfrey Kneller.' About this same period a gentleman of the name of

FRAZIER—1763,

? Frazier, *fl. c.* 1763.

was painting at Norfolk in Virginia.

PATIENCE WRIGHT—1768.

Patience Lovell Wright, 1725–1786.

It is not our intention to notice as artists every modeller in clay or wax, or carver in wood or even stone, that may have attempted the likeness of the human face or form; but the earlier aspirants, we think, entitled to a page in the history of

* Since printing the biography of Pratt, I find in a work entitled "Anecdotes of Painters, who have resided or been born in England," by Edward Edwards, teacher of perspective, &c. at the Royal Academy:—

"Matthew Pratt, a native of Philadelphia, where he practised as portrait-painter. Came to London, 1764. Staid two years, residing with B. West. 1765 was an exhibiter at Spring-Garden, and again in the following year. Last picture he exhibited was entitled the 'American School:' it consisted of small whole length portraits of himself, West, and other of his countrymen, whose names are unknown to the author. Soon after he returned to his native city, where he practised, and was well employed." He assisted Peale in founding his museum.

American art. We have endeavoured to rescue from oblivion the name of Patience Wright a lady of uncommon talent. Mrs. Wright must have made her earliest attempts before she had seen any works of art, in modeling or otherwise. From childhood the dough intended for the oven, or the clay found near the house assumed in her hands somewhat of the semblance of man; and soon, the likeness of the individuals she associated with.

This extraordinary woman was born, like West, among people who eschewed images or pictures. Her parents were quakers, residing at Bordentown, New Jersey;—1725 was the year of her birth;—March 20th, 1748, the date of her marriage with Joseph Wright, of Bordentown, New Jersey, who died in 1769. Her maiden name was Lovell. Before the year 1772, she had made herself famous for likenesses in wax, in the cities of her native country, and when a widow with three children, was enabled to seek more extensive fame, and more splendid fortune in the metropolis of Great Britain. There is ample testimony in the English periodicals of the time, that her work was considered of an extraordinary kind; and her talent for observation and conversation—for gaining knowledge and eliciting information, and for communicating her stores, whether original or acquired, gained her the attention and friendship of many distinguished men of the day. As she retained an ardent love for her country, and entered into the feelings of her injured countrymen during the war of the revolution, she used the information she obtained by giving warning of the intentions of their enemies, and especially corresponding with Benjamin Franklin, when he resided in Paris, having become intimate with him in London.

In the sixth volume of Franklin's letters, published by William T. Franklin, in London, and republished by William Duane, in Philadelphia, is the following:—

" To Mrs. Wright, London.

"Passy, May 4, 1779.

" DEAR MADAM :—I received your favour of the 14th of March past, and if you should continue in your resolution of returning to America, through France, I shall certainly render you any of the little services in my power: but there are so many difficulties at present in getting passages hence, particularly safe ones for women, that methinks I should advise your stay till more settled times, and, till a more frequent intercourse is established.

" As to the exercise of your art here, I am in doubt whether it would answer your expectations. Here are two or three who profess it, and make a show of their works on the Boulevards ; but it is not the taste for persons of fashion to sit to these artists for their portraits : and both house-rent and living at Paris are very expensive.

" I thought that friendship required I should acquaint you with these circumstances ; after which you will use your discretion.

"I am, &c.

"B. Franklin."

[Written in the envelope of the above.)

"P. S. My grandson, whom you may remember when a little saucy boy at school, being my amanuensis in writing the within letter, has been diverting me with his remarks. He conceives that your figures cannot be packed up, without damage from any thing you could fill the boxes with to keep them steady. He supposes, therefore, that you must put them into post-chaises, two and two, which will make a long train upon the road, and be a very expensive conveyance ; but as they will eat nothing at the inns, you may the better afford it. When they come to Dover, he is sure they are so like life and nature, that the master of the packet will not receive them on board without passes ; which you will do well therefore to take out from the secretary's office, before you leave London ; where they will cost you *only* the modest price of two guineas and sixpence each, which you will pay without grumbling, because you are sure the money will never be employed against your country. It will require, he says, five or six of the long wicker French stage coaches to carry them as passengers from Calais to Paris, and a ship with good accommodations to convey them to America ; where all the world will wonder at your clemency to Lord N———— ; that having it in your power to hang, or send him to the lighters, you had generously reprieved him for transportation."

The Editor in the following note has called this lady, Mrs. Mehetabel Wright. I write with her letters to her children before me, signed " Patience Wright." She is further said to be the niece of John Wesley, and born in Philadelphia, where her parents had setttled, all which is as false as a great deal of biography I meet with. She has likewise been called Sybilla, for which there was some foundation, as she professed

sometimes to foretell political events, and was called the Sybill.*

I have before me an engraving published in 1775, representing Mrs. Wright at full length in the act of modelling a bust of a gentleman. In the London Magazine of that year, she is styled the Promethean modeller. In that work it is said, " In her very infancy she discovered a striking genius, and began with making faces with new bread and putty, to such excellence that she was advised to try her skill in wax." Her likenesses of the King, Queen, Lords Chatham and Temple, Messrs. Barre, Wilkes and others, attracted universal admiration." The above writer says, " Her natural abilities are surpassing, and had a liberal and extensive education been added to her innate qualities, she had been a prodigy. She has an eye of that quick and brilliant water, that it penetrates and darts through the person it looks on ; and practice has made her capable of distinguishing the character and dispositions of her visiters, that she is very rarely mistaken, even in the minute point of manners ; much more so in the general cast of character."

Nine years after the above was written, I was introduced to Mrs. Wright, but too young and careless to observe her character minutely. The expression of her eye is remembered, and an energetic wildness in her manner. While conversing she was busily employed modelling, both hands being under her apron. She had three children; two daughters and a son. The son will occupy another page of this work. The elder daughter married an American of the name of Platt, and inheriting some of her mother's works and talent, returned to this country and died here. Mrs. Platt made herself well known in New-York, about the year 1787, by her modelling in wax.

* " Mrs. Mehetabel Wright was altogether a very extraordinary woman. She was the niece of the celebrated John Wesley, but was born at Philadelphia, in which city her parents settled at an early period. Mrs. Wright was greatly distinguished as a modeller in wax ; which art she turned to a remarkable account in the American war, by coming to England, and exhibiting her performances. This enabled her to procure much intelligence of importance, which she communicated to Dr. Franklin and others, with whom she corresponded during the whole war. As soon as a general was appointed, or a squadron begun to be fitted out, the old lady found means of access to some family where she could gain information, and thus without being at all suspected, she contrived to transmit an account of the number of the troops, and the place of their destination to her political friends abroad. She at one time had frequent access to Buckingham house ; and used, it is said to speak her sentiments very freely to their majesties, who were amused with her originality. The great lord Chatham honoured her with his visits, and she took his likeness which appears in Westminster Abbey. Mrs. Wright died very old in February, 1785.

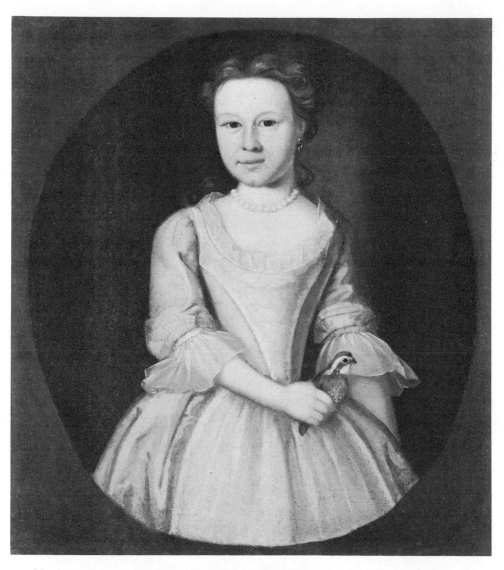

33　MARGARET ROBBINS. Painting by John Hesselius. *Courtesy National Gallery of Art, Washington, D.C., collection of Edgar William and Bernice Chrysler Garbisch.*

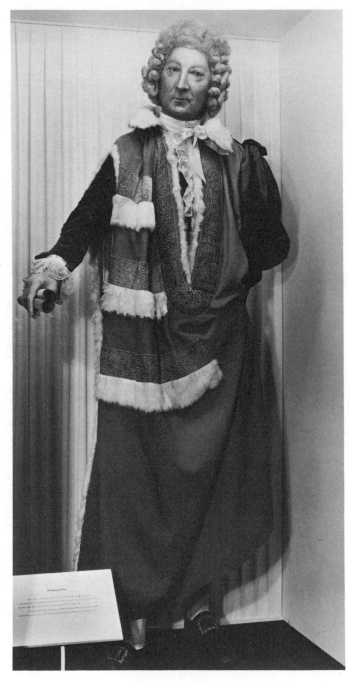

34 MEMORIAL TO THE EARL OF CHATHAM. Wax figure by Patience Lovell Wright. *Reproduced by kind permission of the Dean and Chapter of Westminster Abbey, London.*

The younger daughter married Hopner, the rival of Stuart and Lawrence as a portrait painter.

The only work that I distinctly remember of Mrs. Wright's is a full length of the great Lord Chatham, as it stood in Westminster Abbey, in 1784, enclosed in a glass case.

Anecdotes are related of the eccentricities of Mrs. Wright. Her manners were not those of a courtier. She once had the ear and favour of George the Third, but lost it by scolding him for sanctioning the American war. She was intimate with Mr. West and his family; and the beautiful form and face of her younger daughter is frequently to be found in his historical compositions: the English Consul at Venice, mentioned by Moore in his life of Byron, is son to this lady, and of course grandson to Mrs. Wright.

In 1781, Mrs. Wright went to Paris. The son, Joseph Wright, followed in 1782, and remained in France during part of the year; and I have before me several of Mrs. Wright's letters to him, replete with affection and good sense, written after her return to London; and likewise letters to him in 1783, written to meet him in America.

In 1785, Mrs. Wright sent the following characteristic letter to Mr. Jefferson, then in Paris.

"London, at the wax-work, Aug. 14, 1785.

"Honoured sir :—I had the pleasure to hear that my son Joseph Wright had painted the best likeness of our HERO Washington, of any painter in America; and my friends are anxious that I should make a likeness, a bust in wax, to be placed in the state-house, or some new public building that may be erected by congress. The flattering letters from gentlemen of distinguished virtues and rank, and one from that general himself, wherein he says, 'He shall think himself happy to have his bust done by Mrs. Wright, whose *uncommon talents, &c. &c.*' make me happy in the prospect of seeing him in my own country.

"I most sincerely wish not only to make the likeness of Washington, but of those *five* gentlemen, who assisted at the signing the treaty of peace, that put an end to so bloody and dreadful a war. The more public the honours bestowed on such men by their country, the better. To shame the English king, I would go to any trouble and expense to add my mite in the stock of honour due to Adams, Jefferson, and others, to send to America; and I will, if it is thought proper to pay my expense of travelling to Paris, come myself and model the likeness of Mr. Jefferson; and at the same time see the picture,

and if possible by this painting, which is said to be so like him, make a likeness of the General. I wish likewise to consult with you, how best we may honour our country, by holding up the likenesses of her eminent men, either in painting or wax-work. A statue in marble is already ordered, and an artist gone to Philadelphia to begin the work. *(Houdon)* This is as I wished and hoped."

The letter concludes by hinting the danger of sending Washington's picture to London, from the enmity of the government, and the *espionage* of the police; which she says has all the "folly, without the abilities of the French." She subscribes herself "Patience Wright." In the same year, this extraordinary woman died.

Charles Willson Peale, 1741–1827.

CHARLES WILSON PEALE—1769.

Succeeds in chronological order. His son Rembrandt has published two memoirs of him, which I shall use. Charles Wilson Peale was born at Chesterton, on the eastern shore of Maryland, April 16, 1741, consequently he was three years younger than West and Copley, who were born in 1738. He was bound apprentice to a saddler in Annapolis, then the metropolis of Maryland. He married before he was twenty-one, and after the term of apprenticeship, pursued his trade, and as appears several others, for he attempted coach-making, and soon added clock and watch-making, besides working as a silver-smith, and beginning to try his hand as a painter. Going to Norfolk to buy leather, he saw the paintings of Mr. Frazier, above mentioned, and he thought he could do as well if *he tried.* Accordingly on returning home, he *did try,* by painting a portrait of himself, which drew him into notice, and determined him henceforward to make faces instead of saddles. This work, the portrait of himself was long lost to the world, but forty years after it had "procured him employment" as a painter, it was found "tied up as a bag, and containing a pound or two of whiting."

Peale visited Philadelphia; and brought home materials for portrait painting, and a book to instruct him, "the handmaid of the arts." He found another instructor on his return to Annapolis, in Mr. Hesselius, an English artist, who like others had made a circuit of the provinces, but had been arrested by the charms of a young lady, became a married man, and settled at Annapolis. Mr. Peale having an opportunity to make a voyage, *passage free,* to Boston, in a schooner belonging to his brother-in-law, visited that famous town, then the

most conspicuous place in America, and he there found Copley established as a portrait-painter. Mr. Copley received the aspiring saddler kindly, and lent him a picture to copy. "The sight of Mr. Copley's picture-room," says his son Rembrandt, in the Cabinet of Natural History, published 1830 by Doughty, Philadelphia, "afforded him great enjoyment and instruction." From this we infer, that although called by his son "a pupil of Hesselius," Peale had no permanent connexion with that gentleman.

The voyage to Boston took place in 1768–9, and on Mr. Peale's returning to Annapolis, he decided upon a voyage to England as soon as practicable. His wishes were seconded by several gentlemen of that city, and a subscription made to forward his enterprise, he engaging to repay the loan with pictures on his return. Accordingly he proceeded to London bearing letters to Mr. West, and arrived in the year 1770. West received his ingenious and enterprising countryman frankly, and imparted instructions for his conduct and study. The scanty funds of Peale being soon exhausted, the benevolent West received him into his house, that he might not lose the opportunity of improvement anticipated from his voyage.

Peale remained in London from 1770 to 1774. "At this time," says his biographer, "Stuart and Trumbull were likewise students with Mr. West." Not so. Stuart went to London in 1775, and remained in that city unknown to West until 1778, and Trumbull did not reach London until after he had studied painting in Boston, during parts of the years 1777–78 and 79. He sailed for Europe in the spring of 1780. These dates prove that the following anecdote, although stated by Mr. Rembrandt Peale in the memoir of his father, published in Leiber's Encyclopedia Americana, cannot be true:— "The writer of this article was informed by Colonel Trumbull, that one day when he was in Mr. West's painting-room, some hammering arrested his attention, 'Oh,' said Mr. West, 'that is only that ingenious young Mr. Peale, repairing some of my bells and locks.'" Though we dismiss the above proof of Mr. Peale's mechanical propensities, we insert another instance with pleasure. It is a more pleasing duty to display truth, than to detect and expose error, but we shall not shrink from the latter duty, cost what it may. Mr. Leslie, in one of his letters from West Point, says, "Charles Wilson Peale, Rembrandt's father, was a pupil of West's. Mr. West painted to the last with a palette, which Peale had most ingeniously mended for him, after he (West) had broken and thrown it aside as useless. It was a small palette ; but he never used any

other for his largest pictures." This is an anecdote showing the gratitude of the pupil, and the regard which his illustrious master had for his memory.

Mr. Peale, who seems to have wished to play every part in life's drama, not content with being a saddler, a coach-maker, a clock and watch-maker, a silver-smith, and a portrait-painter, studied while in London modelling in wax, moulding and casting in plaster, painting in miniature, and engraving in mezzotinto. These were studies allied to painting.

On his return to Annapolis in 1774, he found constant employment at portrait-painting. He was now probably the only portrait-painter in that region. Mr. Peale, having brothers and sisters, made them all painters. His brother James became a respectable miniature painter.

In the year 1776, Charles Wilson Peale established himself in Philadelphia, and as a captain of volunteers, he joined Washington, and was present at the battles of Trenton and Germantown. He found time while in camp to exercise his pencil, and painted the likenesses of many officers.

In 1779, his biographer says, he represented Philadelphia in the Pennsylvanian legislature. Thus we see the two additional avocations of soldier and statesman engrafted on the already overloaded stock. It was a sturdy stem; but no stem can bring to maturity the best fruit of so many different kinds, if, as is the case with man, its life is too short to bring any one to perfection.

Mr. Rembrandt Peale asserts that his father was employed in painting a miniature of General Washington at a farm-house in New-Jersey, and while he was sitting for the picture, the general received "a letter announcing the surrender of Cornwallis." This is related as occurring while Mr. Peale was in the army, as a captain of volunteers. "Mr. Peale had his table and chair near the window, and Washington was sitting on the side of a bed, the room being too small for another chair. His aid de camp, Colonel Tilghman was present. It was an interesting moment, but the sitting was continued, as the miniature was intended for Mrs. Washington." The surrender of Cornwallis was a stupendous event, and the moment the news was received was an interesting moment to all Americans; but the surrender took place the 19th of October, 1781, and Washington was at Yorktown, Virginia, commanding the army to which the Briton surrendered, and on the field to receive the earl, and his invading army. He received the army and his lordship's sword; but his lordship excused himself on the plea of indisposition from attending in person on the humi-

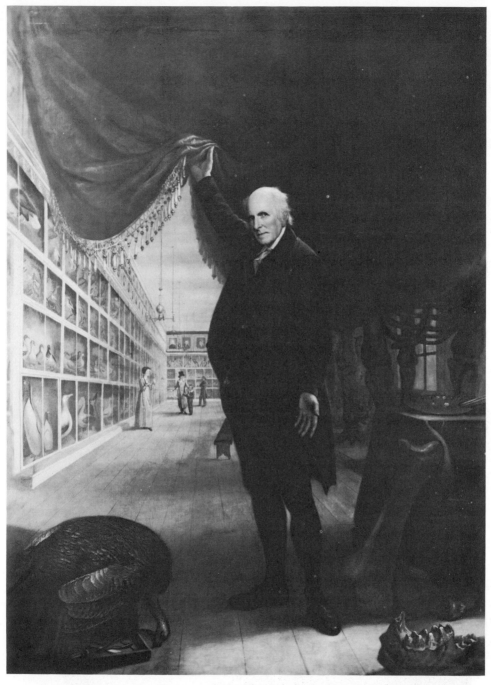

35 THE ARTIST IN HIS MUSEUM, 1822. Painting by Charles Willson Peale. *Courtesy The Pennsylvania Academy of the Fine Arts.*

36B JOHN PAUL JONES, 1781. Painting by Charles Willson Peale. *Courtesy Independence National Historical Park.*

36A MARTHA WASHINGTON, 1795. Painting by Charles Willson Peale. *Courtesy Independence National Historical Park.*

liating ceremony. We presume that the incident Mr. Rembrandt Peale meant to record of his father and General Washington, belonged to an earlier portion of American history, and by substituting the name of Burgoyne for Cornwallis, we have an interesting anecdote.

From 1779 to 1785, Mr. Peale applied himself assiduously to painting; but about that time some bones of a mammoth having been brought to him, the idea of forming a museum, occurred to his active mind, " and this new pursuit engaged all his thoughts." He now became a collector, and preserver of birds and beasts, fishes and insects—of all that fly, leap, creep, or swim, and all things else. Strangers and citizens contributed to enlarge his collection, and in a few years his picture gallery at the corner of Lombard and Third streets, after several enlargements was found too small for his museum. It was then removed to the Philosophical Hall, and there it was greatly enlarged, especially by the skeleton, which was found in Ulster county, New-York, and disinterred at great expense and labour. This skeleton, or a similar one, was sent by Mr. Peale to London, accompanied by his sons Rembrandt and Rubens.

Mr. Peale now became a lecturer on Natural History, and "his lectures were attended by the most distinguished citizens," but finding that the loss of his front teeth interfered with his oratory, he became a dentist to supply the deficiency; first working in ivory, and then making porcelain teeth for himself and others.

In the year 1791 Mr. Peale attempted to form an association as an Academy of Fine Arts, in Philadelphia. The only artists named by his biographer as joining in the scheme are Ceracchi, the celebrated sculptor, and Mr. Rush, who, though by trade a carver of ships'-heads, was, by talent and study, an artist. There were others, natives and foreigners; probably Joseph Wright was among them. They did not agree in forming a plan, and separated. Three years after the indefatigable Peale made another effort for the promotion of the Art of Designing; collected some plaster-casts, and even attempted a life school. Finding no persons willing to exhibit themselves for hire in this school, his zeal induced him to stand as the model. An exhibition of paintings was opened in the chamber in which the Declaration of Independence had been signed, and pictures lent by the citizens for the purpose. This second attempt of Peale's failed likewise.

Mr. Peale in the meantime continued prosperously to push his own fortunes, and the fortunes of his numerous progeny.

He had a succession of wives, and children by all; his last consort was Miss Elizabeth De Peyster of New-York. In the year 1809, Mr. Peale actively promoted the measures which resulted in an association of gentlemen of influence and fortune, (of course not artists,) who erected the building, called "The Pennsylvania Academy of the Fine Arts," imported casts, and purchased pictures. "Mr. Peale," says his biographer, "lived to see, and contribute to seventeen annual exhibitions," in the galleries of this institution. The establishment of this nominal academy, called forth a letter from Mr. West to Mr. Peale, dated September 19, 1809, (which is published in the Port Folio of 1810, with the vulgar error of making the writer "Sir Benjamin.") West expresses his gratification at the establishment of an academy in Philadelphia, "for cultivating the art of delineation." He argues from the flourishing state of the Fine Arts in Greece and Rome, when they were flourishing, and their degradation, with the degradation of the state, that as America is rising in greatness to political supremacy, she will rise proportionably in civilization and the arts.

In all these attempts to introduce the arts of design, and the cultivation of science, Charles Wilson Peale did his part, as far as circumstances permitted, and honourably under *every circumstance*. In the year 1827, he closed his long and busy life, at the age of eighty-five. In height, he was rather below the middle size, but compactly formed and athletic. He had not experienced the usual infirmities, "which flesh is heir to" through life, nor that decay attending age in others; and talked confidently of enjoying life for many years to come: nay sometimes, as if death was not the legitimate heir of all of earthly mould. He injured himself by exertions of his strength and activity. A disease of the heart ensued; and after some partial amendments and relapses, death claimed his own.

Mr. Peale, among his many whims, had that of naming his numerous family after illustrious characters of by-gone ages, particularly painters. A dangerous and sometimes ludicrous experiment. Raphael, Angelica Kauffman, Rembrandt, Rubens, and Titian, and many other great folks, were all his children.

We shall sum up the trades, employments, and professions of Mr. Peale, somewhat as his biographer in the Cabinet of Natural History has done. He was a saddler; harness-maker; clock and watch-maker; silver-smith; painter in oil, crayons, and miniature; modeler in clay, wax, and plaister: he sawed his own ivory for his miniatures, moulded the glasses, and

made the shagreen cases; he was a soldier; a legislator; a lecturer; a preserver of animals,—whose deficiencies he supplied by means of glass eyes and artificial limbs; he was a dentist—and he was, as his biographer truly says, " a mild, benevolent, and good man."

At the close of the biographical sketch given in the Cabinet of Natural History, a passage occurs which we cannot pass over unnoticed. It is an observation given by the biographer, Mr. Rembrandt Peale, as from Mr. John Trumbull, for many years a pupil and protégé of Mr. West. It is in these words, published in 1830, in Philadelphia, and republished in New-York, where Mr. Trumbull resided at the time, and after. " That an interesting comparison might be drawn between Mr. Peale and his countryman Mr. West, who was a striking instance how much could be accomplished with *moderate genius,* by a steady and undeviating course directed to a single object, to become the first historical painter of his age; whilst the other with a *more lively genius,* was able to acquire an extraordinary excellence in many arts, between which his attention was too much divided; for had he confined his operations to one pursuit, he probably would have attained the highest excellence in the fine arts."

Mr. Peale's son is justified in publishing the above observations; but nothing can justify the man who made them. A comparison between Peale and West, to those who knew them and know their works, is absolutely ridiculous. Where is the evidence of Mr. Peale's genius? Perseverance and industry, in well doing, cannot be too much praised. West was industrious and persevering; and his works show that he was a man of *sublime* genius. He had scarcely attained the age of puberty when he rivalled the best painter in Rome, and gained academical honours throughout Italy. His perseverance and industry had not had time to do any thing for him, *when* on his arrival in London, young and unknown, he produced works, by his potent genius, which placed him before all who had preceded him in England. He was immediately acknowledged the first historical painter of the age.

Now Mr. Peale appears rather to have delighted in mechanical employments; and his *genius* was devoted to making money. There have been men, truly of a *lively genius,* who might almost be compared to Mr. Peale, for the variety of their pursuits, and yet excelled both as artists and men. We will instance Albert Durer. He only lived 57 years, and that in the 15th and 16th century, yet he is in the 19th, the pride of Germany as a painter. He was a goldsmith; a great en-

graver on copper ; he engraved in wood with a skill that long remained unrivalled ; he was a carver in wood and ivory; he wrote treatises in his native tongue, on perspective, anatomy, geometry, architecture, fortification, painting, and the scriptures ; and translated them into Latin, French and Italian. Nor must it be forgotten that Albert Durer was a member of the legislature of a free and self-governed republic. The works of West and Durer will go down to posterity ; those of Charles Wilson Peale will soon be forgotten, although several portraits painted by him in his old age, deserve preservation, and call forth admiration.

WINSTANLEY—1769,

is known about this time to have painted in the colonies. But of·

HENRY BEMBRIDGE—1770,

although we cannot give so full an account as we wish, we have rescued something from oblivion. At a very early period we heard of this gentleman, as one who had gone to Rome to study painting. Mr. Bembridge was born in Philadelphia about the year 1750. Being left at liberty to pursue the bent of his inclination by the death of parents, he devoted his patrimony in aid of his desire to become a painter, no doubt stimulated by the success of West ; and he was the second American who studied the fine arts at Rome. Mr. Bembridge was a gentleman by birth, and had received a liberal education ; the time of his visiting Italy we must suppose to be 1770 : and before he left Philadelphia he had shown his love of the arts by painting the pannels of a room in his paternal dwelling with designs from history. In Rome he became the pupil of Pompeio Battoni, and received instruction from Mengs. We have reason to believe that he returned to America in 1774, and commenced painting in Charleston, South Carolina, where he was the instructor of Thomas Coram. Sometime after the war of the revolution, Mr. Bembridge painted in Philadelphia. He is thus mentioned by James Peller Malcolm: "Mr. Bembridge, a relation and brother-student of Mr. West, who had spent several years at Rome, flattered me with his approbation, and advised an immediate voyage to Great Britain." He was neither a relation, nor brother-student of West.

He married Miss Sage of Philadelphia, and I met a son of his in Perth Amboy, in 1800, whose residence was Philadelphia, and who was at the time married to the eldest daughter of Commodore Truxton. I at this time saw several por-

Winstanley. Cannot be identified unless this is a confused mention of the William Winstanley discussed on pp. 394–395.

Henry Benbridge, 1743–1812.

37A MRS. BENJAMIN SIMONS II OF CHARLESTON, SOUTH CAROLINA, 1771–1773.
Painting by Henry Benbridge. *Courtesy The Metropolitan Museum of Art,
Fletcher Fund.*

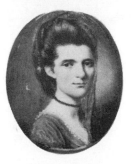

37B ELIZABETH ANN TIMOTHÉE (Mrs. John Williamson of Savannah, Georgia).
Miniature by Henry Benbridge. *Courtesy The Metropolitan Museum of Art,
Rogers Fund.*

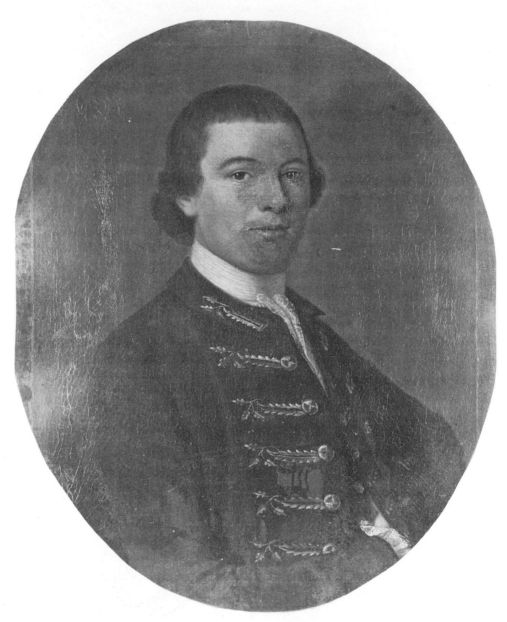

38 CHARLES DUDLEY. Painting by Cosmo Alexander. *Courtesy George Dudley Tibbits. Photograph Frick Art Reference Library.*

traits in small full-length, of the Truxton family, by the artist, and they are the only specimens I ever saw of his skill. I remember them as being solidly painted, well drawn, like the personages, but hard and without any distinguishing mark of taste; still they were better than those of Charles Wilson Peale of the same date.

Mr. Bembridge was a gentleman of good classical education, great devotion to the art, and persevering industry. He had the same advantages in Italy that West had had; and yet, notwithstanding Reynolds's remark that nothing is denied to perseverance and industry well directed, he acquired all his nature was seemingly capable of, in three or four years study. In the year 1799, Mr. Thomas Sully, then a youth, found Mr. Bembridge settled in high estimation at Norfolk, Virginia. His works excited Sully to attempt oil-painting, and to introduce himself to the veteran painter, Sully sat to him for his picture, and was "well repaid," as he has said, "by his useful and kind instruction."

After living in high estimation as a man and artist many years in the Carolinas and Virginia, Mr. Bembridge returned to his native city, Philadelphia, and died in obscurity and poverty.

We will conclude our brief memoir by quoting from our correspondents who have answered our queries on the subject of Mr. Bembridge.

Mr. Allston says Bembridge left many portraits of his painting in South Carolina, but he does not remember them sufficiently to speak of their merits.

Mr. McMurtrie says, "He was a promising young man, but did not realize much. His portraits are stiff and formal. He painted drapery well, particularly silks and satins."

Mr. Charles Fraser says: "Bembridge painted a good deal in Charleston: he had had great advantages, having studied in Rome under Mengs and Pompeio Battoni." Of Battoni the reader will find in these pages an anecdote that will not exalt him in his opinion. It is certain that the portraits by Bembridge were sought after eagerly on his return, and he was held in high estimation by his cotemporaries. Mr. Fraser adds: "The generation with whom he lived is passed away, and all means of information are gone with it. I cannot say that I admire his portraits. They bear evident marks of a skilful hand, but want that taste which gives to portrait one of its greatest charms. His shadows were dark and opaque, and more suitable to the historical style. I have however seen one or two of his pictures, which I thought displayed great know-

ledge of the art." We must remark that dark and opaque shadows, though they may be more tolerable in the historic (in certain subjects) than in the portrait style, are faults in any style. Nature disclaims them, and she is the only teacher of true art.

Mr. Sully describes Mr. Bembridge as a portly man, of good address—gentlemanly in his deportment. He told a good story, and was in other respects not unlike Gilbert Stuart.

The next person who calls for our attention is a Scotch gentleman of the name of

Cosmo (or Cosmo John or Cosmus) Alexander, c. 1724–1772.

COSMO ALEXANDER—1772,

who painted portraits in Newport, Rhode-Island in 1772. As all we know of this gentleman is from Doctor Waterhouse, and is incorporated with the memoir soon to follow, that of Gilbert C. Stuart, we here merely notice, that at the time of his arrival Mr. Alexander was between fifty and sixty—that he painted all the Scotch gentlemen of the place, and finding Stuart a promising boy, he gave him lessons, and finally took the youth with him to South Carolina, and thence to Edinburgh. Shortly after his arrival in his native country, he died.

John Wollaston, fl. c. 1736– c. 1767. This is clearly a repetition. See page 103.

WOOLASTON—1772.

This English gentleman visited the colonies about the year 1772, and painted a great many pictures in Virginia and Maryland. Many of his portraits are yet to be seen in Petersburg. Mr. Robert Sully, who has kindly exerted himself in making researches into the antiquities of art in Virginia to assist the writer, says, " The only artists that are remembered by the oldest inhabitants, are DURAND, MANLY, and Woolaston—the first tolerable, the second execrable, and the third *very good*. His portraits possess unquestionable merit. Among those in Petersburg, is the grandmother of the late John Randolph of Roanoke, an excellent portrait. The pictures of Woolaston are very much in the *Kneller style;* more feeble than the style of Reynolds, but with a very pretty taste."

John Durand, fl. c. 1766–c. 1782.

DURAND—1772,

I place at this date, but with uncertainty. My only knowledge of him is from Mr. R. Sully, who says, " He painted an immense number of portraits in Virginia ; his works are hard and dry, but appear to have been strong likenesses, with less vulgarity of style than artists of his *calibre* generally possess."

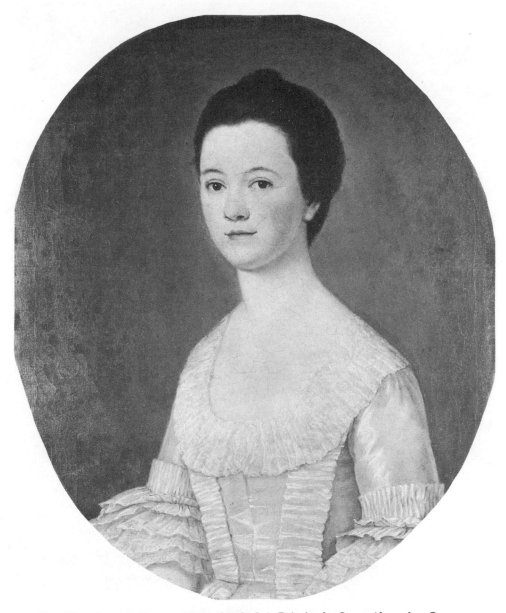

39 MRS. CHARLES DUDLEY (Catherine Cooke). Painting by Cosmo Alexander. *Courtesy George Dudley Tibbits. Photograph Frick Art Reference Library.*

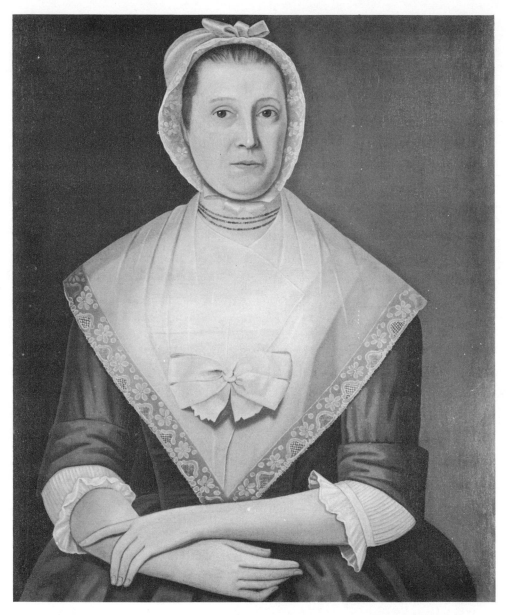

40 SARAH WHITEHEAD HUBBARD, c. 1768. Painting by John Durand. *Courtesy Philadelphia Museum of Art, the Edgar William and Bernice Chrysler Garbisch Collection.*

Of the pictures brought or sent to Virginia, Mr. Sully says, " There are certainly a few pictures in some of the old family mansions, of considerable merit, sent to this country from England during the existence of the colonies, but it is impossible to conjecture who the artists were, as no record is attached to them, and they are remembered by the possessors as old *fixtures*.

MANLY—1772,

A very bad portrait-painter, and only mentioned as one of the pioneers of the arts.　He painted in Virginia.

? Manly. No further information available.

SMITH—1772.

? Smith, *c.* 1747–after 1834.

This gentleman is known among American travellers, particularly artists who visit Italy, as old Mr. Smith.　He is said to have been 116 years of age in 1834.　If so, he was born in the year 1718.　He is a native of Long-Island, state of New-York, brother to the well-remembered Doctor Smith, (whose eccentric character and verses afforded more amusement than instruction,) and uncle to Col. William Smith, an aid to Washington, and son-in-law to John Adams.　Mr. Smith devoted himself to painting, and was probably the third American who pursued the coy art to Italy, West being the first and Bembridge the second.　Smith never became a distinguished artist, and fell into the trade of picture-dealer, by which it is believed that he acquired a competency for old age. He lives near Florence.

CHAPTER VIII.

Sketch of the history of engraving—Implements used—Early engravers in America.

The earliest specimens of engraving are of the fifteenth century, and the first artist on record is Martin Schoen, of Culmbach, who died in 1486.　The Italians claim the invention ; but it is remarkable that the first book printed at Rome had the first engravings executed there, and they were done by two Germans—the date 1478.　The names of Lucas Jacobs and Albert Durer are too well known to require notice here. We shall mention both in our history of wood engraving, which, though preceding that on copper, was not so soon practised with us.

In the sixteenth century the Italian painters etched and en-

graved on copper. Other artists devoted themselves to engraving alone, and worked from the designs of Raffaelle and the great men who reared the fabric of art at that period. Still the German and Dutch artists led the way, and Cort was the first engraver on large plates, and the instructor of many Italians.

In the seventeenth century the art began to flourish in France, and encouraged by Colbert, attained high perfection. But the most distinguished artist of the time was Edelinck of Antwerp. The history of the art in France in the next century is the same—a German, Wille, being the best engraver.

The Flemish and Dutch painters etched and engraved. Vandyke, Bol, Ruysdael, and many others, practised the art with taste and success.

The true mode of giving a history of engraving would be by a series of prints illustrative of its progress. This forms no part of our plan, and is far beyond our power. Our sketch of the history of the art is merely to illustrate what we may hereafter say of the progress of the arts in America.

In England both painting and engraving were indebted to foreigners, generally Flemish, Dutch and German, for existence, until the middle of the seventeenth century. Of early English artists one of the most eminent is George Vertue, who died in 1756.

The founder of the school of English landscape engraving, is Francis Vivares, a Frenchman. But the greatest of the school is a native of England, Woollett. They both carried the plates a great way towards the completion by etching, and finished with the graver—the usual mode now practised.—Woollett was not confined to landscape, as his great work, after West's Death of Wolfe, sufficiently proves. England now stands, and has for many years stood, pre-eminent in engravers and engraving.

The works of Hogarth must not be passed over unnoticed, even in this brief sketch. To mention them is to praise them, both as productions of the engraver and the painter. In the latter character he is now acknowledged as among the glories of the art; in point of time, the first great English painter; in merit, equal to the best.

Engraving, or working with the graver, was the first or oldest practice; etching followed, and became an auxiliary to the graver—this is working the lines through wax, or a preparation of it, and biting them in the metal by acids. Mezzotinto is produced by making the copper a mass of roughness, which, if printed, would be one black spot; and then scraping out

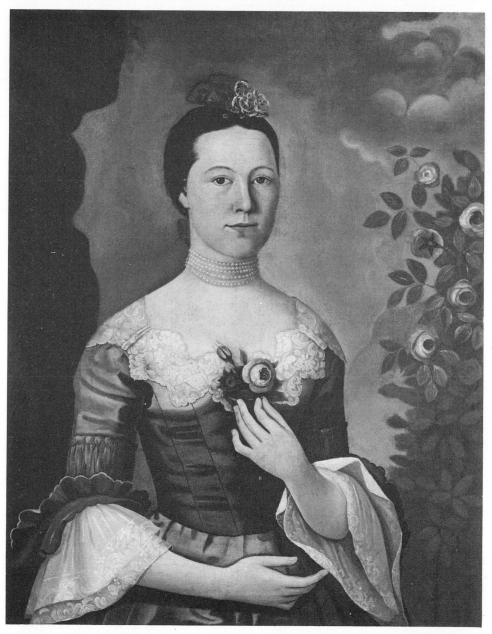

41 MARY BONTECOU LATHROP, c. 1770. Painting by John Durand. *Courtesy The Metro-politan Museum of Art, gift of Edgar William and Bernice Chrysler Garbisch.*

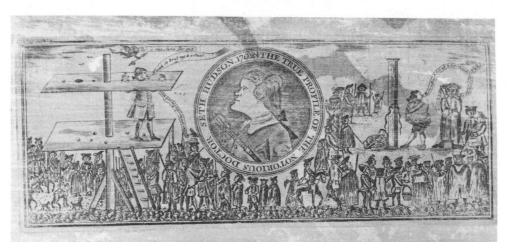

H-dſ-n's SPEECH from the Pillory.

WHAT mean theſe Crouds, this Noiſe and Roar!
Did ye ne'er ſee a *Rogue* before?
Are *Villains* then a Sight ſo rare,
To make you preſs and gape and ſtare?
Come forward all who look ſo fine,
With Gain as illy got as mine:
Step up——you'l ſoon reverſe the Show;
The *Croud* above, and *few* below.

Well—for my Roguery here I ſtand,
A Spectacle to all the Land:
High elevated on this Stage,
The *greateſt Villain* of the Age.
My Crimes have been both great and many,
Equal'd by very few, if any:
And for the Miſchief I have done
I put this *wooden Neckcloth* on.

There *HOW* his brawny Back is ſtripping,
Quite callous grown with often whipping.
In vain you wear your *Whip-Cord* out,
You'l ne'er reclaim that *Rogue ſo ſtout*.
To make him honeſt, take my Word,
You muſt apply a *bigger Cord*.

Now all ye who behold this Sight,
That ye may get ſome profit by't,
Keep always in your Mind, I pray,
Theſe few Words that I have to ſay.
Follow my Steps and you may be
In Time, perhaps, advanc'd like me;
Or, like my fellow Lab'rer *HOW*,
You'l get at leaſt a *Poſt* below.

Sold by N. HURD, near the Exchange, and at the *Heart* and *Crown* in Cornhill, *Boſton.*

42 H-DS-N'S SPEECH FROM THE PILLORY, 1762. Engraving by Nathaniel Hurd. *Courtesy Worcester Art Museum.*

the various degrees of tint and light. This was a Dutch invention likewise, and has been attributed to Prince Rupert. Stippling is another mode of engraving.

The ruling machine, invented by Wilson Lowry, of London, has given great facility to the engraving of skies, and all subjects which require parallel lines.

The instruments used by engravers are the burin or graver; this makes an incision in the plate as it is guided by the hand. The burnisher is used to soften lines if cut too deep. The scraper is a steel instrument whose use is to take off the *barb* formed by the action of the graver. Needles of various diameters are used to form the lines through the hard or soft grounds in etching, and sometimes in dry etching—that is, when the plate is touched without being covered with a ground. The tools used in mezzotinto work are for making the plate uniformly rough, and for scraping out the lights; and the ruling machine is used, as before mentioned, in etching. Engraving on wood we notice in other parts of our work.

As this introductory sketch is not intended to instruct artists, but merely to illustrate what shall be said of the progress of engraving in the United States, we refer the reader for further information to Sturt, Landseer, and the very many books treating on the subject.

The first engraver in our country, in point of time, that comes within our knowledge, is

NATHANIEL HURD—1764,

Nathaniel Hurd, 1729–1777.

who, according to a writer in Buckingham's New-England Magazine, (a work to which we are indebted for all we know of Hurd,) engraved "a miniature likeness of the Rev. Dr. Sewall, minister of the old South church in Boston," " in the linear style, in 1764. In this art he was his own instructor. There are still extant a few pictures of a different character, done on copper, by Hurd, about the same period." " Hurd," says the same writer, " was a real genius. To a superior mode of execution, he added a Hogarthian talent of character and humour. Among other things of his" of course designed by himself, " he engraved a descriptive representation of a certain swindler and forger of bills, named Hudson, a foreigner, standing in the pillory. In the crowd of spectators, he introduced the likenesses of some well known characters.

" In the year 1762, there appeared in Boston a curious character who called himself Dr. Hudson," who, and an agent employed by him of the name of Howe, were convicted of for-

gery and uttering "province notes." "Hudson was ordered to the pillory, and Howe to the whipping-post." "Hurd immediately put out a caricature print of the exhibition." The Doctor was in the pillory, and Howe preparing to undergo his degrading punishment. "The devil is represented flying towards the Doctor, exclaiming, *This is the man for me.* In front of the print is the representation of a medallion, on which is a profile of Hudson, dressed in a bag wig, with a sword under his arm, (as he generally appeared before his detection,) partly drawn from the scabbard, with the words *Dutch Tuck* on the exposed part of the blade. Round the edge is, THE TRUE PROFILE OF THE NOTORIOUS DOCTOR SETH HUDSON, 1762. The Doctor is made to speak as well as the devil, but he speaks in verse. The print is marked ' Sold by N. Hurd, near the Exchange, at the Heart and Crown, in Cornhill, Boston.' "

In our days of childhood we remember seeing caricature prints executed in Philadelphia, generally political, one in particular, in which the devil and Doctor Franklin were introduced, his majesty with a label from his mouth, saying, "Never mind, Ben! you shall be my agent yet." Judge Hopkinson told us that he saw rude prints of this description in a journey through Lancaster, Pennsylvania, and wished to purchase them, but the possessors conceiving that what the judge wished must be of great value, demanded a price so far beyond reason, that he relinquished all thought of buying.

The writer above quoted from says further of Mr. Hurd, " He was born in Boston, February 13th, 1730, and died December 17th, 1777, before he had attained the age of forty-eight. There is an original picture of him, painted by Copley, in the possession of one of his relatives at Medford, Mass. From that picture a man by the name of Jennings (of whom we can learn little else) engraved a likeness in mezzotinto."

Paul Revere, 1735–1818.

PAUL REVERE—1770,

is the next artist, in point of time, that handled the graver in our country, as far as we know, and our knowledge of him is derived from the same fountain of useful information, Buckingham's New-England Magazine. Mr. Revere's grandfather was a French Hugonot, who emigrated to Guernsey, and his father married and settled as a goldsmith in Boston. Paul was brought up by his father as a goldsmith, but having a natural taste for drawing, he designed and engraved the ornaments on the plates wrought at the shop.

In 1756 he received the appointment of lieutenant of artillery, and served in the expedition against Crownpoint. Returning to Boston he married, and carried on the business of goldsmith, which, with engraving, and the study of mechanics as a science, occupied him during a long and active life.

The caricatures of Hurd and Revere not only mark the state of the art at the time, but of society; and the political temper of the colonies, particularly Massachusetts.

" Engraving on copper was an art in which, as in some others, he was self-instructed. One of his earliest engravings of this description was a portrait of his friend, Dr. Mayhew. In 1766, he engraved on copper a picture, emblematical of the repeal of the Stamp Act. He also executed a very popular caricature, of the 'Seventeen Rescinders.' As there are not extant many copies of this print, some account of it may be interesting. In the beginning of the year 1768, when the measures of the British government were assuming more and more of a threatening appearance, the house of representatives of Massachusetts, voted to send a circular letter to the legislatures of the several Provinces, upon the alarming state of affairs with the mother country. This measure gave so much umbrage to the King, that he sent out orders to Governor Bernard, peremptorily to demand that the said vote should be rescinded and obliterated. This demand being judged unreasonable, after debate, a vote was passed *not* to conform to it. *Seventeen* members only voting *for it*, and *ninety-two against it*. These numbers became notorious in a political sense. *Seventeen* being called the Tory number, and the *glorious ninety-two*, as it was called, was denominated that of the Whigs. The seventeen members were branded with the name of *rescinders*, and were treated in the most contemptuous manner. Mr. Revere's caricature helped to increase the odium. It was entitled, "A WARM PLACE—HELL!" The delineation was a pair of monstrous open jaws, resembling those of a shark, with flames issuing from them, and the devil, with a large pitch-fork, driving the seventeen rescinders into the flames, exclaiming, "*Now I've got you,—a fine haul, by Jove.*" As a reluctance is shown by the foremost man, at entering, who is supposed to represent the Hon. Timothy Ruggles, of Worcester county, another devil is drawn, with a fork, flying towards him, and crying out, " Push on, Tim." Over the upper jaw is seen, in the back ground, the cupola of the Province House, with the Indian and bow and arrow, (the

arms of the Province,) which house was the governor's residence.

"In 1770, Mr. Revere published an engraved print, representing the massacre in King-street, on the memorable FIFTH OF MARCH, and in 1774, another, of an historical character, representing the landing of the British troops in Boston. Copies of all these, though extremely rare, are still extant. A lithographic fac-simile of the print first mentioned, has been recently republished.

" In 1775, he engraved the plates, made the press, and printed the bills, of the paper-money, ordered by the provincial congress of Massachusetts, then in session at Watertown. He was sent by this congress to Philadelphia to obtain information respecting the manufacture of gunpowder. The only powder-mill, then in the colonies, was in the vicinity of Philadelphia. The proprietor refused to let Revere take any drawing or specification whatever, or any memorandum of the manufacture, but consented to show him the mill in full operation. His mechanical skill was now brought into action. With the slight information thus obtained, he was able, on his return, to construct a mill, which was soon put in operation, and with complete success."*

The following extracts from his letter to the corresponding secretary of the Massachusett's Historical Society, will be found interesting :

"Dear Sir,—In the fall of 1774 and winter of 1775, I was one of upwards of thirty, chiefly mechanics, who formed ourselves into a committee for the purpose of watching the movements of the British soldiers, and gaining every intelligence of the movements of the tories. We held our meetings at the Green Dragon tavern. We were so careful that our meetings should be kept secret, that every time we met, every person swore upon the bible, that they would not discover any of our transactions, but to Messrs. HANCOCK, ADAMS, Doctors WARREN, CHURCH, and one or two more.

" In the winter, towards the spring, we frequently took turns, two and two, to watch the soldiers, by patrolling the streets all night. The Saturday night preceding the 19th of April, about twelve o'clock at night, the boats belonging to the transports were all launched, and carried under the sterns of the men of war. (They had been previously hauled

* These memoirs of Hurd and Revere, I presume to be from the pen of the venerable and learned Doctor Waterhouse of Cambridge, Massachusetts, from whom much valuable matter will be found in these pages.

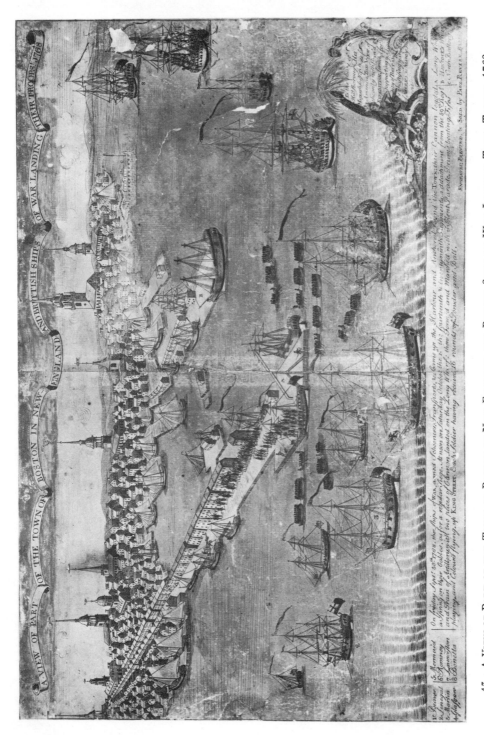

43 A VIEW OF PART OF THE TOWN OF BOSTON IN NEW ENGLAND AND BRITISH SHIPS OF WAR LANDING THEIR TROOPS, 1768.
Engraving by Paul Revere. *Courtesy Prints Division, New York Public Library, Emmet Collection.*

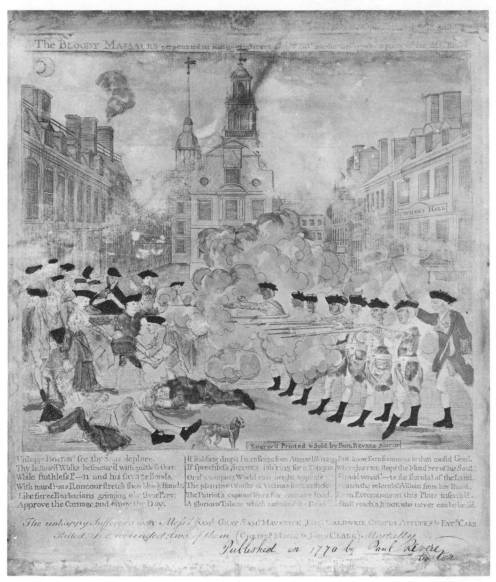

44 BLOODY MASSACRE AT BOSTON, 1770. Engraving by Paul Revere after Henry Pelham. *Courtesy Library of Congress.*

up and repaired.) We likewise found that the grenadiers and light infantry were all taken off duty.

"From these movements we expected something serious was to be transacted. On Tuesday evening, the 18th, it was observed, that a number of soldiers were marching towards the bottom of the common. About ten o'clock, Dr. Warren sent in great haste for me, and begged that I would immediately set off for Lexington, where Messrs. Hancock and Adams were, and acquaint them of the movement, and that it was thought they were the object. When I got to Dr. Warren's house, I found he had sent an express by land to Lexington—a Mr. William Dawes. The Sunday before, by desire of Dr. Warren, I had been to Lexington, to Messrs. Hancock and Adams, who were at the Rev. Mr. Clark's. I returned at night through Charlestown; there I agreed with a Colonel Conant, and some other gentlemen, that if the British went out by water, we would show two lanterns in the north church steeple; and if by land one as a signal; for we were apprehensive it would be difficult to cross the Charles river, or get over Boston neck. I left Dr. Warren, called upon a friend, and desired him to make the signals. I then went home, took my boots and surtout, went to the north part of the town, where I had kept a boat; two friends rowed me across Charles river, a little to the eastward where the Somerset man-of-war lay. It was then young flood, the ship was winding, and the moon was rising. They landed me on the Charlestown side. When I got into town, I met Colonel Conant, and several others; they said they had seen our signals. I told them what was acting, and went to get me a horse. I got a horse of Deacon Larkin. While the horse was preparing, Richard Devons, Esq. who was one of the Committee of Safety, came to me, and told me, that he came down the road from Lexington, after sundown, that evening; that he met ten British officers, all well mounted, and armed, going up the road.

"I set off upon a very good horse; it was then about eleven o'clock, and very pleasant. After I had passed Charlestown neck, and got nearly opposite where Mark was hung in chains, I saw two men on horseback, under a tree. When I got near them, I discovered they were British officers. One tried to get ahead of me, and the other to take me. I turned my horse very quick, and galloped towards Charlestown neck, and then pushed for the Medford road. The one who chased me, endeavouring to cut me off, got into a clay pond, near where the new tavern is now built. I got clear of him, and went through

Medford, over the bridge, and up to Menotomy. In Medford,
I awoke the captain of the minute men ; and after that, I
alarmed almost every house, till I got to Lexington. I found
Messrs. Hancock and Adams at the Rev. Mr.Clark's ; I told
them my errand, and inquired for Mr. Dawes ; they said he
had not been there. I related the story of the two officers, and
supposed that he must have been stopped, as he ought to have
been there before me. After I had been there about half an
hour, Mr. Dawes came ; we refreshed ourselves, and set off
for Concord, to secure the stores, &c. there. We were over-
taken by a young Dr. Prescot, whom we found to be a high
son of liberty. I told them of the ten officers that Mr. Devons
met, and that it was probable we might be stopped before we
got to Concord ; for I supposed that after night, they divided
themselves, and that two of them had fixed themselves in such
passages, as were most likely to stop any intelligence going to
Concord. I likewise mentioned, that we had better alarm all
the inhabitants till we got to Concord ; the young Doctor
much approved of it, and said he would stop with either of us,
for the people between that and Concord knew him, and
would give the more credit to what we said. We had got
nearly half way : Mr. Dawes and the Doctor stopped to alarm
the people of a house : I was about one hundred rods ahead,
when I saw two men in nearly the same situation as those
officers were, near Charlestown. I called for the Doctor and
Mr. Dawes to come up ; in an instant I was surrounded by
four ;—they had placed themselves in a straight road, that
inclined each way ; they had taken down a pair of bars on the
north side of the road, and two of them were under a tree in
the pasture. The Doctor being foremost, he came up ; and
we tried to get past them ; but they being armed with pistols
and swords, they forced us into the pasture ;—the Doctor
jumped his horse over a low stone wall, and got to Concord.
I observed a wood at a small distance, and made for that.
When I got there, out started six officers, on horseback, and
ordered me to dismount ;—one of them who appeared to have
the command, examined me, where I came from, and what my
name was ? I told him. He asked me if I was an express ?
I answered in the affirmative. He demanded what time I left
Boston ? I told him, and that I had alarmed the country all
the way up. He immediately rode towards those who stop-
ped us, when all five of them came down upon a full gallop ;
one of them, whom I afterwards found to be a Major

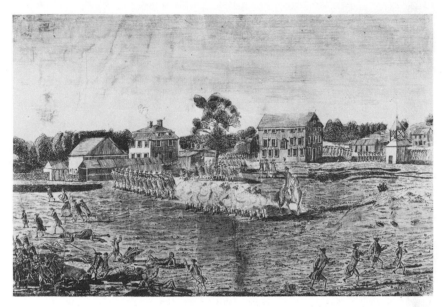

45A THE BATTLE OF LEXINGTON, 1775. Engraving by Amos Doolittle after the painting by Ralph Earl. *Courtesy Prints Division, New York Public Library, Stokes Collection.*

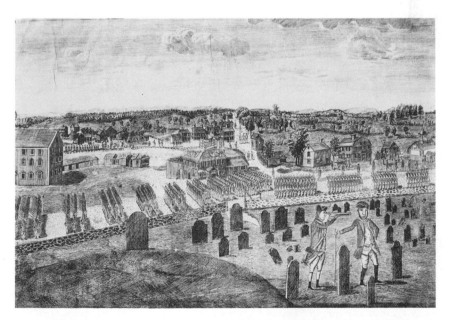

45B A VIEW OF THE TOWN OF CONCORD, 1775. Engraving by Amos Doolittle after the painting by Ralph Earl. *Courtesy Prints Division, New York Public Library, Stokes Collection.*

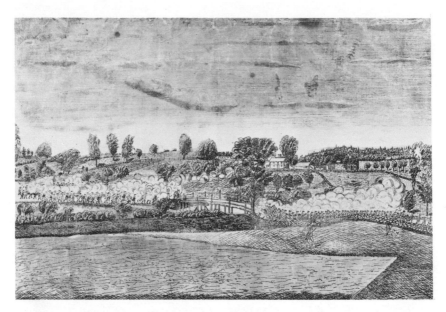

46A THE ENGAGEMENT AT THE NORTH BRIDGE IN CONCORD, 1775. Engraving by Amos Doolittle after the painting by Ralph Earl. *Courtesy Prints Division, New York Public Library, Stokes Collection.*

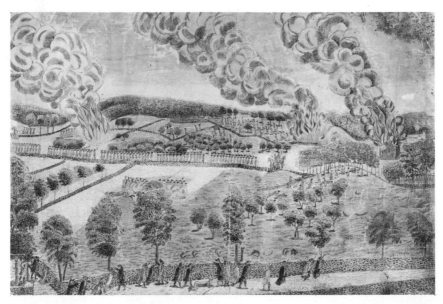

46B A VIEW OF THE SOUTH PART OF LEXINGTON, 1775. Engraving by Amos Doolittle after the painting by Ralph Earl. *Courtesy Prints Division, New York Public Library, Stokes Collection.*

Mitchel, of the 5th regiment, clapped his pistol to my head, called me by name, and told me he was going to ask me some questions, and if I did not give him true answers, he would blow my brains out. He then asked me similar questions to those above. He then ordered me to mount my horse, after searching me for arms. He then ordered them to advance and to lead me in front. When we got to the road, they turned down towards Lexington. When we had got about one mile, the major rode up to the officer that was leading me, and told him to give me to the sergeant. As soon as he took me, the major ordered him, if I attempted to run, or any body insulted them, to blow my brains out. We rode till we got near Lexington meeting-house, when the militia fired a volley of guns, which appeared to alarm them very much. The major inquired of me how far it was to Cambridge, and if there were any other road? After some consultation, the major rode up to the sergeant, and asked if his horse was tired? He answered him, he was—(He was a sergeant of grenadiers, and had a small horse)—then, said he, take that man's horse. I dismounted, and the sergeant mounted my horse, when they all rode towards Lexington meeting-house. I went across the burying-ground, and some pastures, and came to the Rev. Mr. Clark's house, where I found Messrs. Hancock and Adams. I told them of my treatment, and they concluded to go from that house towards Woburn. I went with them, and a Mr. Lowell, who was a clerk to Mr. Hancock. When we got to the house where they intended to stop, Mr. Lowell and myself returned to Mr. Clark's, to find what was going on. When we got there, an elderly man came in; he said he had just come from the tavern, that a man had come from Boston, who said there were no British troops coming. Mr. Lowell and myself went towards the tavern, when we met a man on a full gallop, who told us the troops were coming up the rocks. We afterwards met another, who said they were close by. Mr. Lowell asked me to go to the tavern with him, to get a trunk of papers belonging to Mr. Hancock. We went up chamber; and while we were getting the trunk, we saw the British very near, upon a full march. We hurried towards Mr. Clark's house. In our way, we passed through the militia. There were about fifty. When we had got about one hundred yards from the meeting-house, the British troops appeared on both sides of the meeting-house. In their front was an officer on horseback. They made a short halt; *when I saw, and heard, a gun fired*, which appeared to be a pistol. Then I could distinguish two guns,

and then a continual roar of musketry; when we made off with the trunk."

" After the British evacuated Boston," says the writer of the memoir in the New-England Magazine, "a regiment of artillery was raised for the defence of the state. In this regiment he was appointed a major, and afterwards a lieutenant-colonel, and remained in the service until the peace. During all this period, he might be said to hold the sword in one hand, and the implements of mechanical trades in the other, and all of them subservient to the great cause of American liberty. Whenever any thing new or ingenious in the mechanical line was wanted for the public good, he was looked to for the consummation of the design. When the British left Boston, they broke the trunnions of the cannon at Castle William, (Fort Independence,) and Washington called on Revere to render them useful—in which he succeeded by means of a newly contrived carriage.

" After the peace he resumed his business as a goldsmith. Subsequently he erected an air-furnace, in which he cast church bells and brass cannon. Soon after this time a new era commenced in ship building. Hitherto all vessels had been fastened with iron. It was found that copper sheathing, which preserved the bottoms of vessels from worms, in the course of a few years destroyed the iron bolts and spikes; and copper bolts and spikes were at length substituted for iron. This engaged his attention, and after repeated trials he succeeded in manufacturing the article to his satisfaction. He then erected extensive works at Canton, in the county of Norfolk, about sixteen miles from Boston, for the rolling of copper as well as for the casting of brass guns and bells, which business is still continued by his successors—an incorporated company bearing his name.

" Colonel Revere was the first President of the Massachusetts' Charitable Mechanic Association, which was instituted in 1795 —a society, which has embraced the principal mechanics of all professions in Boston, and which is prominent among the variety of benevolent and useful institutions which dignify and embellish the metropolis of Massachusetts. At the time of his death he was connected with many other philanthropic associations, in all of which he was a munificent and useful member. By an uncommonly long life of industry and economy, he had been able to obtain a competency in the way of property, and to educate a large family of children, many of whom are living to participate in one of the purest and most affectionate gratifications that a child can enjoy—the contemplation of the character of an upright, patriotic and virtuous father.

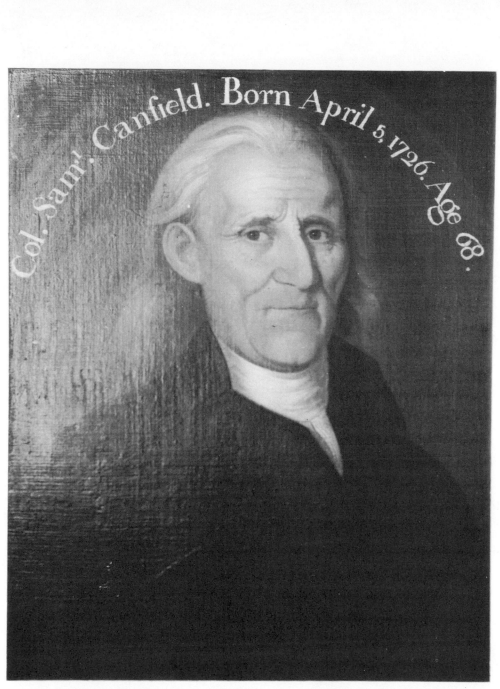

47　COLONEL SAMUEL CANFIELD, *c.* 1794. Painting by Richard Jennys, Jr. *Courtesy Litchfield Historical Society.*

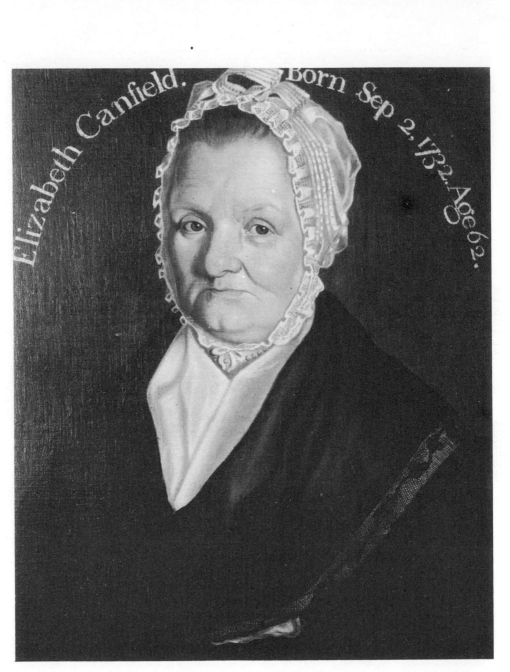

48 ELIZABETH CANFIELD, c. 1794. Painting by Richard Jennys, Jr. *Courtesy Litchfield Historical Society.*

For our notice of

AMOS DOOLITTLE—1771,

we are principally indebted to Barber's History and Antiquities of New-Haven, published in 1831. We remember some of the works of Mr. Doolittle from the year 1777, but to Mr. Barber's book we are indebted for the following advertisement and note.

" This day published, and to be sold at the store of Mr. James Lockwood, near the College in New-Haven, four different views of tbe Battle of Lexington, Concord, &c. on the 19th of April, 1775.

" Plate I. The Battle of Lexington,

 II. A view of the town of Concord, with the ministerial terial troops destroying the stores.

 III. The Battle of the North Bridge, in Concord.

 IV. The south part of Lexington, where the first detachment were joined by Lord Percy.

" The above four plates are neatly engraved on copper from original paintings taken on the spot.

" Price six shillings per set for the plain ones, or eight shillings coloured. December 13th, 1775.

" *Note.*—The above prints were drawn by Mr. Earl, a portrait-painter, and engraved by Mr. Amos Doolittle. Mr. Earl and Mr. Doolittle were both members of the Governor's Guard who went on to Cambridge, and the scene of action, soon after it took place, under command of Arnold. It is believed that these prints are the *first* historical engravings ever executed in America.* Mr. Doolittle is living, and still pursues the business of engraving in this place, and from him the above information is obtained ; he also was in the engagement with the British troops at the time they entered New-Haven."

In another page we find it stated that Mr. Doolittle, having returned from the scene of action at Hotchkisstown, to attend to a sick wife, threw his musket under the bed, and awaited the arrival of the enemy. Fortunately for him he had a guest in an English lady, who, when the British troops arrived, stepped out and asked a guard for the protection of the house, asserting that she was an Englishwoman, and had a son in the British army. The guard was granted ; and when the musket

* It will be seen by the preceding biography, that Paul Revere designed and published historical subjects before him. If Mr. Earl painted these subjects, as is expressly said in Mr. Doolittle's advertisement, where the phrase "original paintings" is used, we must consider Mr. Earl as our first historical painter in point of time. Revere, though he designed his picture of the Massacre, was not a painter.

was discovered, the same protectress said that every man was obliged by law to have arms in his house, but Mr. Doolittle was a friend of King George. This saved him from the prison ships of New-York.

In an addition to Mr. Barber's work it is stated that Mr. Doolittle died January 31, 1832, aged 78 years. There is an engraving, (copied from one 18 inches by 12, which was executed by Mr. Amos Doolittle of New-Haven, in 1775,) showing the town of Lexington and the English troops commanded by Major Pitcairn, firing on the militia. " This print is supposed to be the first regular historical print ever published in America." This we have shown to be a mistake. " Mr. Doolittle's engraving was copied from a *drawing* by Mr. Earl, a portrait-painter." " Mr. Earl's drawing was made on the spot. The engraving was Mr. Doolittle's first attempt at the art, which he pursued for more than half a century."

James Smither, ?–1797.

SMITHERS—1773,

originally a gun engraver, and employed in the tower of London, came to Philadelphia in the year 1773. He undertook all kinds of engraving, and probably stood high in public opinion; he was the best, for he stood alone. To him we may owe the caricatures of the times, some of the wits of the day assisting in the designs. He engraved the blocks for the continental money, and afterwards imitated them for the British. How great must have been his love of his native country! He engraved a large ground plan of the city of Philadelphia, on three plates, which Lawson says, "I bought for thirty dollars, when copper was scarce, and cut them up for small plates." He was the master of Trenchard.

Probably Richard Jennys, Jr., *fl. c.* 1766–c. 1799.

JENNINGS—1774,

is the name of an engraver, who is supposed to have come from England about the beginning of the insurrectionary movements in Boston, and retired again immediately to be out of the way of trouble. All we know of him, is from our friend Buckingham, who says he engraved a head of Nathaniel Hurd, from a likeness painted by Copley. It was in mezzotinto. Probably the first mezzotinto scraped in America. While in this country he resided altogether in Boston.

Henry Dawkins, *fl. c.* 1753–c. 1786.

HENRY DAWKINS—1774,

was the first engraver I find noticed as working in New-York, and he was probably from England. Originally an orna-

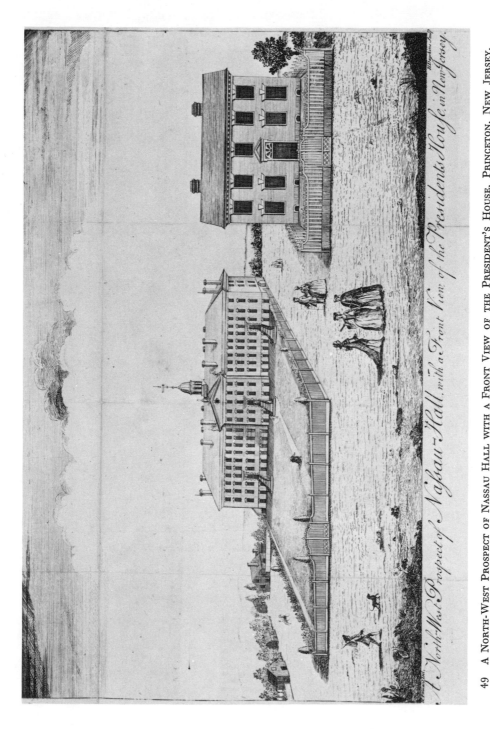

A North-West Prospect of Nassau-Hall, with a Front View of the Presidents House, in New Jersey.

49 A North-West Prospect of Nassau Hall with a Front View of the President's House, Princeton, New Jersey, 1763. Engraving by Henry Dawkins after the painting by W. Tennant. *Courtesy Library of Congress.*

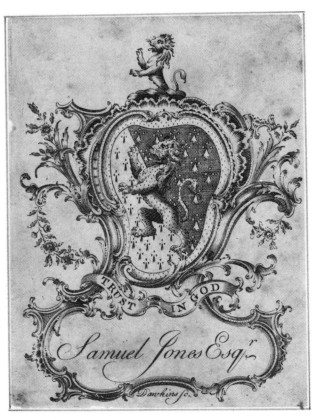

50 COAT OF ARMS. Engraving by Henry Dawkins. *Courtesy Dover Archives.*

menter of buttons, and other metallic substances. On his arrival in America, he worked at any thing that offered, suiting himself to the poverty of the arts at the time.

My friend Alexander Anderson, the first who attempted engraving on wood in America, and who had, in fact, to invent the art for himself, tells me that he has seen ornamented shop bills, and coats of arms for books, engraved by Dawkins previous to 1775. Mr. Anderson adds, " engravings for letter press, had been executed on type-metal in various parts of this country, long before the revolution. Dr. Franklin, if I recollect aright, cut the ornaments for his ' Poor Richard' almanacs in this way." I cannot venture, however, to include Benjamin Franklin among American engravers. That Dawkins would think himself skillful enough to engrave portraits for the colonists I do not doubt.

He is probably the engraver of a very poor portrait of the Rev. Mr. Ogilvie, deposited by G. C. Verplanck, Esq. with the Historical Society of New-York.

ABRAHAM GODWIN—1783.

Abraham Godwin, 1763–1835.

This gentleman, now seventy-one years of age, was a soldier of the revolution, and is now a general of the militia of his native state, New-Jersey. After the war of the revolution, having always a propensity to drawing, he devoted himself to the arts, by choosing the profession of an engraver. Long retired to his native village, his painting and engraving has been for amusement, and in his old age, he enjoys the confidence and respect of his fellow-citizens in that town, of which his father had in youth been one of the earliest *settlers;* now a flourishing as well as extremely interesting place—Patterson.

Mr. Godwin's grandfather was an Englishman, and settled in New Jersey, where the father of the engraver was born in 1724; in manhood he took up his residence at the falls of the Passaic; since (in 1793) called Patterson; and there Abraham Godwin was born in July 1763, and received the same baptismal name as his parent, who in his old age engaged actively in the cause of his country's liberty.

Mr. Godwin was destined for the law; and in 1776 was placed with his brother, an attorney at Fish-kill, in the state of New-York. The lawyer, however, entered the army; and his pupil, as soon as possible, followed his example.

Having when quite a youth seen the operation of engraving he was so delighted with it, that he procured a rude graver, by aid of a blacksmith, and made the first essays on the silver plate of his friends.

The war being over, he married, and then gave his bond to a person of the name of Billings for two months instruction in engraving, but soon found that he could use the graver better than his master, who did not deserve the name of engraver.

Mr. Godwin was employed in engraving the decorations of certificates for various societies, and some of the plates for Brown's Family Bible, published by Hodge, Allen, and Campbell, in New-York.

Retired to his native place, Mr. Godwin has served as captain, judge-advocate, major, colonel, and lastly, brigadier-general of militia, which office he fills in a green old age, to the satisfaction of his countrymen.

PETER R. MAVERICK—1783.

Peter Rushton Maverick,
1755–1811.

Was originally a silver-smith. He is sometimes called Peter Maverick the first, as his son and grandson, both named Peter, have followed his profession. He etched and engraved for many years in New-York. In 1787—8, he taught me the theory and practice of etching, and in his work-shop I etched a frontispiece for a dramatic trifle then published. He had his press in his work-shop. The plates in the bible above mentioned are the best specimens of his art; but, by being the teacher of his son Peter, and of Francis Kearney, he aided materially in the progress of American engraving.

WILLIAM ROLLINSON—1789.

William Rollinson, 1762–1842.

This worthy man, and very estimable citizen is a native of England, born in the year 1760. He was in youth brought up to the business of chaser of fancy buttons, and came to New York with a view of pursuing the same, but soon found that little or nothing of the kind was practised or sought after here. He had not long after his arrival, some work in the way of his original employment, the remembrance of which gratifies the sturdy old gentleman to this day. General Knox, first secretary of war, under the federal government, employed Mr. Rollinson to chase the arms of the United States upon a set of gilt buttons for the coat which was worn by General Washington, on the memorable day of his inauguration as president.

Soon after, General Knox called to make payment, but the young Englishman had caught the spirit of the country of his choice, and would receive no compensation; declaring that he was more than paid by having had the honour of working for such a man on such an occasion. Shortly after, the chiefs of the Creek Indians, with McGillevray at their head, arrived at New-York, then the seat of the federal government, and silver arm-bands, and medals were required for these sons of the

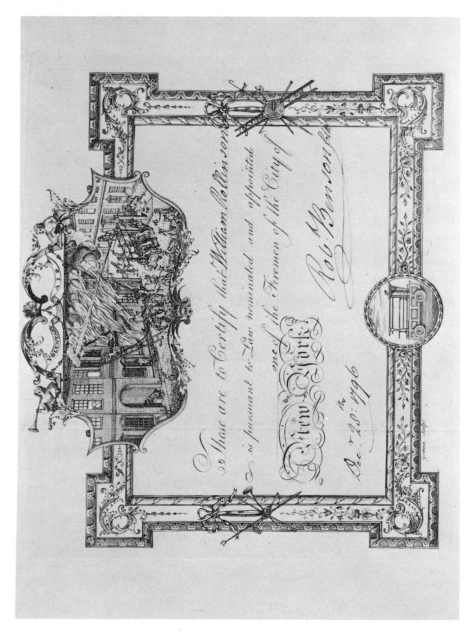

51 FIREMAN'S CERTIFICATE WITH A VIEW OF FIRE FIGHTING IN NEW YORK CITY, c. 1787. Engraving by Abraham Godwin.
Courtesy Museum of the City of New York.

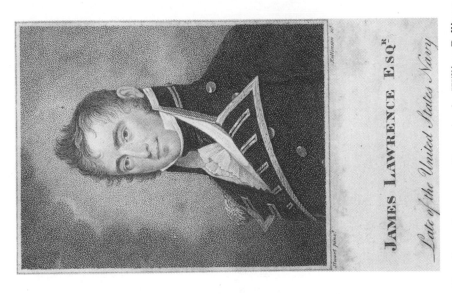

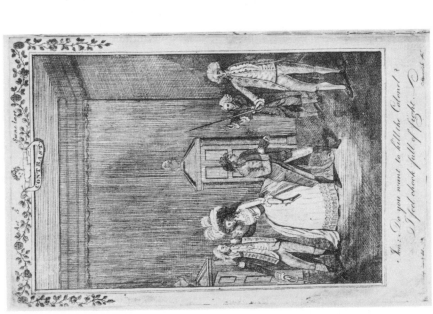

52A SCENE FROM "THE CONTRAST" BY ROYALL TAYLOR, 1787. Engraving by Peter Rushton Maverick after William Dunlap. Courtesy Harvard University Theater Collection.

52B JAMES LAWRENCE. Engraving by William Rollinson after the painting by Gilbert Stuart. Courtesy Dover Archives.

forest, as presents from the United States. These decorations required ornamenting. and General Knox remunerated the button-chaser, by giving him many of them to engrave.

Mr. Rollinson found employment in working for silversmiths, until 1791, when he made his first attempt at copperplate engraving, without any previous knowledge of the profession, or having even seen an engraver at work. This essay was a small profile portrait of General Washington done in the stippling manner.

Through the friendship of Messrs. Elias Hicks and John C. Ludlow, Mr. Rollinson was recommended to the publishers of Brown's Family Bible, mentioned above, for which work he engraved several plates, and found employment with the few book publishers of that day. This practice had given Mr. Rollinson facility with the graver, and about this time, i. e. 1800, Mr. Archibald Robertson having painted a portrait of General Alexander Hamilton, Mr. Rollinson boldly undertook an engraving from it, 18 inches by 14; he had no knowledge of *rebiting* and other processes used by those brought up to the profession, but had perseverance and ingenuity to surmount all difficulties, and finally invented a method of making a background by means of a rolette inserted in a ruling machine. When he commenced this engraving, it was intended to be done at leisure hours, and for practice, but when the plate was about half done, General Hamilton lost his life in a duel with Colonel Burr. The friends of Hamilton were solicitous for a print of him, and the engraver was urged to finish the plate with all expedition. An impression being taken from the engraving in its unfinished state, and the likeness acknowledged, the work was completed, and published by Messrs. Rollinson and Robertson, in 1805, and met with a good sale.

In 1812, Mr. Rollinson invented a machine to rule waved lines, for engraving margins to bank notes. Mr. W. S. Leney, an English artist from London, (a good stipple engraver,) joined Mr. Rollinson in producing a specimen note, which being approved, produced many orders from different parts of the United States. This invention of Mr. Rollinson was a great improvement in bank note engraving, and caused a great sensation among engravers at the time. Mr. Rollinson, now in the 74th year of his age is full of life and strength, and continues to work with unabated ardour and improved skill. In the 70th year of his age, he executed a vignette for the Messrs. Carvils, for an edition of Horace, by professor Anthon, which is a proof of increasing knowledge in the art he professes. At the age of 74, his portrait has been painted by Mr. Agate, an excellent likeness. which might indicate a man of fifty.

CHAPTER IX.

The three Parissiens—L. Kilbrunn—Abraham Delanoy, junr.—Gilbert Stuart's father and the snuff-mill—Cosmo Alexander—Gilbert carried to Scotland—Hard usage and return—His taste for music—Goes to London—Various adventures—Introduced to Mr. West—Desultory anecdotes.

Otto Parisen, 1723–1811; Philip Parisen, son of Otto, ?–1822; William D. Parisen, son of Philip, 1800–1832; J. Parisen (or Parrisen), *fl. c.* 1821–*c.* 1828, probably the brother of William, painted the portrait of Samuel Latham Mitchill.

PARISSIENS.

I remember well three generations of Parissiens or Parisans, all professing to be painters, and all residing in New-York. The first came from France, and was literally, as seen by me, " a little old Frenchman." This was Otto Parissien, or Parissien the first. The phrase " little old Frenchman" is so common in English books, that we of America naturalize it, with a thousand prejudices derived from the same source. But Parissien the first was a model of the *idea*. He was a silversmith, and kept a shop of that precious ware ; he worked ornaments in hair ; and he made monstrous miniature pictures. Genius is hereditary, let democrats say what they will, at least the genius of mediocrity—and yet the three Parissiens improved in regular gradation on the soil of America. The son of the " little old Frenchman" became an American almost of ordinary size, and painted miniatures with a little resemblance to human nature, at the same time working in hair and silver. This was Parissien the second. He died, as is the custom in all countries, and was succeeded by Parissien the third, who arrived at the full height of ordinary Americans, and renouncing the hair-work and the silver tea-pots and milk-jugs, devoted himself to drawing and painting ; but notwithstanding that he attained to cleverness in drawing with chalks, his painting, though beyond comparison better than his predecessors, still bore the family likeness. He even went so far as to paint a full length of my old friend Dr. Mitchill, which was exhibited in the gallery of the American Academy of Fine Arts in the old alms house, and it was generally admired for its rigid portliness and inveterate pertinacity of attitude. But the hereditary propensity to mingle employments descended to Parissien the third, with the hereditary mediocrity of the family. He mixed the business of money-broker with his painting, and both failed. He died in the prime of life, and the race of Parissiens became extinct.

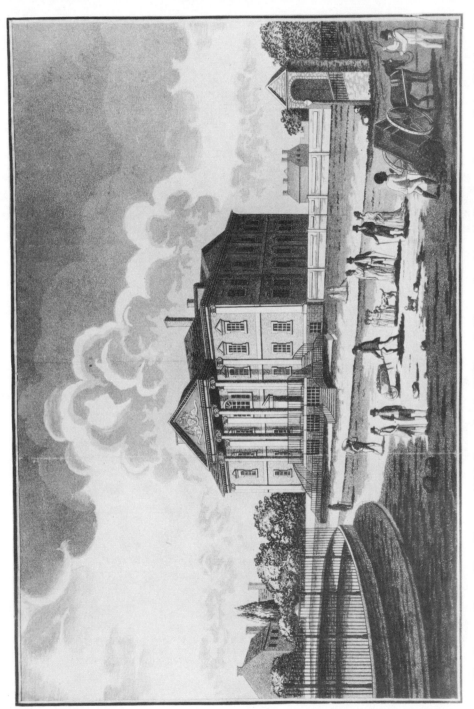

53 CUSTOM HOUSE, NEW YORK, c. 1796. Engraving by William Rollinson after his own drawing. *Courtesy Prints Division, New York Public Library, Stokes Collection.*

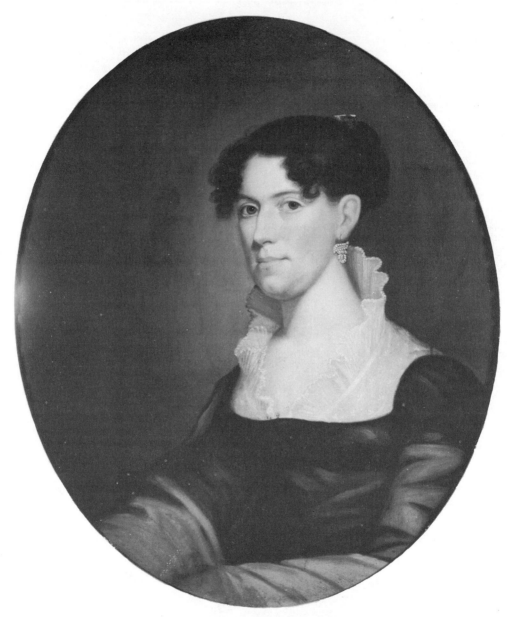

54 HANNAH FRANKLIN CLINTON. Painting attributed to Philip Parisen. *Courtesy Museum of the City of New York.*

L. KILBRUNN—1772.

Who this gentleman was, I know not, but presume he was from England. He painted portraits in New-York in 1761, although I place him later, as supposing he may have continued to 1772.

In the family mansion of James Beekman, Esq. among many portraits of his ancestors, are two by L. Kilbrunn, dated 1761, half-lengths, size of life, one of Dr. William Beekman, a graduate of Leyden, and who practised physic, in New-York; the other of his wife. The Doctor's head is well painted, full of nature, the colours softened skilfully, and the picture in good preservation; the other has merit, but is not so good— all the hands are bad. I owe the discovery of this artist to my friend Doctor Francis.

ABRAHAM DELANOY, Jun.—1772.

Born in New-York, probably in 1740. He visited England about 1766, and was instructed for a short time by B. West. Mr. Depeyster, son in law of Mr. John Beekman, has a head of West, painted by Delanoy at this period; it is marked, "Portrait of Benjamin West, the celebrated limner of Philadelphia, painted by his friend Abraham Delanoy, junior, limner." Mr. John Beekman has several family portraits painted by Delanoy, in 1767: and Mr. James Beekman others, executed near the same period.— I remember Delanoy from 1780 to 1783, in "the sear and yellow leaf" both of life and fortune. He was consumptive, poor, and his only employment sign-painting. He told me of his visit to London, and showed a picture he then copied from one of Mr. West's, it was "Cupid complaining to his mother of a sting from a bee." I saw then his own portrait, and those of his wife and children, by himself. I painted a likeness of Admiral Hood, from recollection, for him on a sign—my first production in oil.

Delanoy was a man of mild manners, awkward address, and unprepossessing appearance. I presume he died about 1786.

GILBERT C. STUART—1773.

Having arrived at that period which is made memorable in the history of American arts, by the commencement of the career in portrait-painting of one who has yet no rival, we, in accordance with our plan, give here a biographical notice of Gilbert Charles Stuart, born in 1754.

As M. Stuart dropped the middle name of "Charles," we

will give our reasons for restoring it to him. He was thus baptized, and it marks the attachment of his father to the worthless dynasty so long adhered to by the Scotch. He bore the three names until after manhood. Dr. Waterhouse, his friend and schoolfellow, in a letter before us, dated 27th of May, 1833, says, " I have cut from one of Stuart's letters his signature of G. C. Stuart, i. e. Gilbert Charles Stuart. I have some doubt whether his widow and children ever knew that he had the middle name of Charles." When writing his name on his own portrait, in 1778, he omitted the " C." The inscription is " G. Stuart, Pictor, se ipso pinxit, A. D. 1778, ætatis sua 24."

His name was frequently written and printed " Stewart ;" and Heath, on the pirated engraving from the artist's celebrated portrait of Washington, calls him " Gabriel." Stuart jestingly said, " men will make an angel of me in spite of myself."

The above quoted inscription from his portrait, is the only authority we have for the time of his birth. That fixes it in 1754. This picture is in the possession of Doctor Benjamin Waterhouse, and is extremely valuable both as the only portrait he ever painted of himself, and as a monument of his early skill.

The name of Stuart will long be dear to those who had the pleasure of his intimacy. His colloquial powers were of the first order, and made him the delight of all who were thrown in his way ; whether exercised to draw forth character and expression from his sitters, or in the quiet of a *tete-a-tete*, or to " set the table in a roar," while the wine circulated, as was but too much the custom of the time and the man.

Still dearer is the name of Stuart to every American artist, many of whom remember with gratitude the lessons derived from his conversation and practice, and all feel the influence of that instruction which is derived from studying his works.

Although our greatest portrait-painter is but recently deceased, already the place of his nativity is disputed, and contending towns claim the honour of producing this extraordinary genius ; we will relate his own testimony on the subject, although no man can be a competent witness in the case.

A few years before his death, two artists of Philadelphia visited Mr. Stuart at his residence in Boston. These gentlemen, Messrs. Longacre and Neagle, had made the journey for the sole purpose of seeing and deriving instruction from the veteran. While sitting with him on one occasion, Mr. Neagle asked him for a pinch of snuff from his ample box, out of which

he was profusely supplying his own nostrils. " I will give it to you," said Stuart, " but I advise you not to take it. Snuff-taking is a pernicious, vile, dirty habit, and, like all bad habits, to be carefully avoided." " Your practice contradicts your precept, Mr. Stuart." " Sir, *I* can't help it. Shall I tell you a story? You were neither of you ever in England—so I must describe an English stage-coach of my time. It was a large vehicle of the coach kind, with a railing around the top to secure outside passengers, and a basket behind for baggage, and such travellers as could not be elsewhere accommodated. In such a carriage, full within, loaded on the top, and an additional *unfortunate* stowed with the stuff in the basket, I happened to be travelling in a dark night, when coachee contrived to overturn us all—or, as they say in New-York, dump us—in a ditch. We scrambled up, felt our legs and arms to be convinced that they were not broken, and finding, on examination, that inside and outside passengers were tolerably whole, (on the whole,) some one thought of the poor devil who was shut up with the baggage in the basket. He was found apparently senseless, and his neck twisted awry. One of the passengers, who had heard that any dislocation might be remedied, if promptly attended to, seized on the corpse, with a determination to untwist the man's neck, and set his head straight on his shoulders. Accordingly, with an iron grasp he clutched him by the head, and began pulling and twisting by main force. He appeared to have succeeded miraculously in restoring life; for the dead man no sooner experienced the first wrench, than he roared vociferously, ' Let me alone! let me alone! I'm not hurt!—I was born so!' Gentlemen," added Stuart, "I was born so;" and, taking an enormous pinch of snuff, " I was born in a snuff-mill."

A plain statement, for which we are indebted to his friend Doctor Waterhouse, will account for the painter's being born in the state of Rhode-Island, and explain his assertion of being born in a snuff-mill.

Between the years 1746 and '50, there came over from Great Britain, to these colonies, a number of Scotch gentlemen, who had not the appearance of what is generally understood by the term emigrant, nor yet were they merchants nor seemed to be men of fortune. They came not in companies, but dropped in quietly, one after the other. Their unassuming appearance, retired habits, bordering on the reserve, seemed to place them above the common class of British travellers. Their mode of life was snug, discreet and respectable, yet clannish. Some settled in Philadelphia, some in Perth-Amboy, some in New-York, but a greater proportion

sat down at that pleasant and healthy spot Rhode-Island, called by Callender, its first historiographer, " The garden of America," afterwards less favourably known as the great slave-market for the Southern colonies.

We have seen, in our notice of Smybert, that that this Garden of America was the residence of Dean Berkeley, the friend of Oglethorpe, and that there he composed his " Minute Philosopher." " The rural descriptions which frequently occur in it ;" the remark is from G. C. Verplanck ; " are, it is said, exquisite pictures of those delightful landscapes, which presented themselves to his eye at the time he was writing."

Several of these Scotch emigrants or visiters, were professional men ; among them was Dr. Thomas Moffat, a learned physician of the Boerhaavean school, but however learned, his dress and manners were so illsuited to the plainness, in both, of the inhabitants of Rhode-Island, who were principally quakers, that he could not make his way among them as a practitioner, and therefore, he looked round for some other mode of genteel subsistence, and he lit upon that of cultivating tobacco, and making snuff, to supply the place of the great quantity that was every year imported from Glasgow ; but he could find no man in the country who he thought was able to make him a snuff mill. He therefore wrote to Scotland and obtained a competent mill-wright, by the name of Gilbert Stuart.

Doctor Moffat selected for his mill-seat, a proper stream in that part of the colony of Rhode-Island and Providence plantations, which bore and still bears the Indian name of Narraganset, once occupied by the warlike tribe of the Pequots, made familiar to us by the intensely interesting romance of our great novelist, James Fennimore Cooper, under the title of " The last of the Mohegans."

There Gilbert Stuart, the father of the great painter, erected the first snuff-mill in New England, and manufactured that strange article of luxury. He soon after built a house and married a very handsome woman, daughter of a substantial yeoman, the cultivator of his own soil, by name Anthony. Of this happy couple was born Gilbert Charles Stuart. The middle name, indicative of the jacobite principles of his father, was early dropped by the son, and never used in his days of notoriety—indeed, but for the signatures of letters addressed by him to his friend Waterhouse, in youth, we should have no evidence that he ever bore more than the famous name of Gilbert Stuart. The father of the painter was remarkable for his ingenuity, and his quiet, inoffensive life. His mother was

a well-informed woman, and capable of instructing her son. She had three children: James, Ann, and Gilbert. James died when yet a child; Ann married, and is the mother of Gilbert Stuart Newton.

Doctor Benjamin Waterhouse, in a manuscript memoir before us, says, that he "from several people imbibed the idea that the child Gilbert betrayed very early signs of genius, and the only reason for doubting it is the fact that his talents continued bright over three score years and ten: witness his portrait of the venerable President Adams, and that of his son John Quincy Adams, late President of these United States, in both of which Mr. Stuart far exceeded any other of his portraits. Vandyke himself might have been proud of either, especially that of the elder Adams." We continue to quote from Dr. Waterhouse.

"The manufactory of snuff from New-England tobacco succeeded, and was as good as that imported from Glasgow, but the scheme for supplying the colonies with that indispensable article failed, for want of glass bottles to contain it; and for which the learned Doctor Moffat substituted beeves' bladders, which effectually destroyed the business, and compelled Mr. Gilbert Stuart to remove from Narraganset to the town of Newport, the capital of the colony of Rhode-Island."

If this is the origin of the custom of packing snuff in bladders, (a custom, which, though it did not succeed at Narraganset, is nevertheless continued elsewhere to the present time,) our pages will be valued hereafter for matter relevant to more arts than those called fine; and we may hope to have our name descending to posterity with those of Waterhouse and Moffat, preserved in a bladder of New-England snuff.

"There," continues the doctor, "the writer of this memoir first became attached to the school-boy Gilbert Stuart." The Doctor was about the same age, and says that Stuart was "a very capable, self-willed boy, who, perhaps on that account, was indulged in every thing, being an only son; handsome and forward, and habituated at home to have his own way in every thing, with little or no control from the easy, good-natured father. He was about thirteen years old when he began to copy pictures," 1767, "and at length attempted likenesses in black lead, in which he succeeded," so far as to discourage the attempts of his school-fellow, Waterhouse.

"About the year 1772," the Dr. proceeds, "a Scotch gentleman, named Cosmo Alexander, between 50 and 60 years of age, arrived at Newport; of delicate health and prepossessing manners, apparently above the mere trade of a painter, he pro-

bably travelled for the benefit of his country and his own health. As the political sky was at that time overcast with many appearances of a storm, our countrymen noticed several genteel travellers from Britain, who seemed to be gentlemen of leisure and observation, and mostly Scotchmen." (Does the Doctor mean to insinuate that these Scotch gentlemen, and among them Alexander, who was " above the mere trade of a painter" and " travelled for the benefit of his country," were spies ?) " Mr. Alexander associated almost exclusively with the gentlemen from Scotland, and was said by them to paint for his amusement." To paint for money would be degradation :— not so to write—to plead—to physic, or to kill. " Be that as it may, he soon opened a painting room, well provided with cameras and optical glasses for taking prospective views. He soon put upon canvas the Hunters, the Keiths, the Fergusons, the Grants and the Hamiltons, and this interest led to the recommendation of the youth Gilbert Stuart, to the notice and patronage of Mr. Alexander, who, being pleased with his talents, gave him lessons in the grammar of the art—I mean drawing—and the groundwork of the palette. After spending the summer in Rhode-Island, he went to South Carolina, and thence to Scotland, taking young Stuart with him. Mr. Alexander died not long after his arrival at Edinburgh, leaving his pupil to the care of Sir George Chambers, who, it seems, did not long survive his friend Alexander. After these sad disappointments our young artist fell into the hands of— I know not whom, nor do I regret never hearing him named, as he treated Stuart harshly, and put him on board a collier, bound to Nova Scotia, whence he got on, not without suffering, to Rhode-Island. What his treatment was I never could learn ; I only know that it required a few weeks to equip him with suitable clothing to appear in the streets, or to allow any one of his former friends, save the writer, to know of his return home. Suffice it to say, that it was such as neither Gilbert Stuart, father, or son, ever thought proper to mention. It is probable the youth worked for his passage to America."

If Stuart went on this first unfortunate voyage to Europe with Alexander, in the winter of 1772, he was of course 18 years of age, and we cannot well assign less than a year for the events which took place before he arrived again at Newport.

It appears that he soon resumed his study of drawing and practice of painting. Waterhouse says, "Mr. Stuart was fully aware of the great importance of the art of drawing with anatomical exactness, and took vast pains to attain it." The Doc-

55A SAMUEL JOHNSON. Painting attributed to Lawrence Kilburn. *Courtesy Columbia University, Columbiana Collection.*

55B GARRET ABEEL. Painting by Lawrence Kilburn. *Courtesy The New-York Historical Society.*

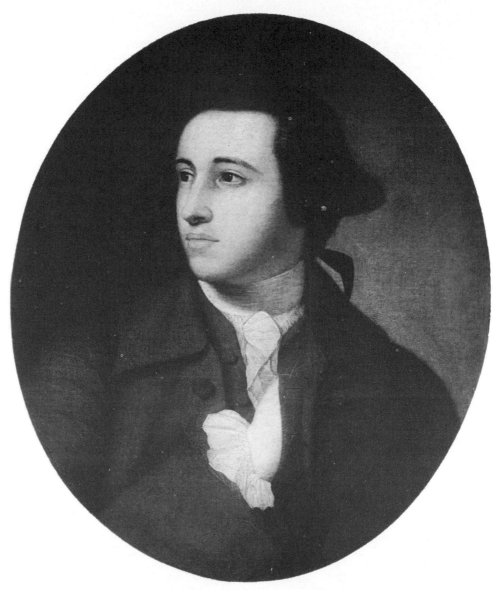

56 BENJAMIN WEST, 1766. Painting by Abraham Delanoy. *Courtesy The New-York Historical Society*.

tor, who was likewise making efforts to draw, in conjunction with Stuart, prevailed on a "strong muscled blacksmith," for half a dollar an evening, to exhibit his person for their study.

Stuart now commenced portrait-painter in form. His mother's brother, Mr. Joseph Anthony, was then a thriving merchant in Philadelphia. He is well known in that city, and has been since the days of banking, the president of one of those institutions. This gentleman, visiting his native colony and his sister, was struck with admiration on entering the painting room of his nephew, by seeing a likeness of his mother, (the young painter's grandmother,) who died when Gilbert was a boy of ten or twelve years of age. He was now about nineteen, and had within the last year been buffeted with no gentle hands from the quiet abode of his parents in the north, to the southern colony of Carolina, thence to Scotland, to Nova Scotia in a collier, and through privations and hardships to Newport again. But the image of his mother's parent, who had probably caressed him with a grandmother's fondness when a child, had been present with him in his wanderings, and one of the first efforts of his incipient art was to perpetuate that image on his canvas. This faculty, the result of strong observation on a strong mind, was one of the distinguishing characteristics of Mr. Stuart, and we shall have occasion to mention extraordinary proofs of it in the sequel.

The effect which this testimony of the young man's affection for his parent, and of his skill as a painter, was such as to interest Mr. Anthony warmly in his behalf. "He was proud," says Waterhouse, "of patronizing his ingenious nephew, after a circumstance which greatly surprised and affected" him. Mr. Anthony employed the young painter to make portraits of himself, his wife, and two children. "Another gentleman," Doctor Waterhouse says in continuation, "of opulence, followed his (Anthony's) example, and several others sat for their single portraits, so that our aspiring artist had as much business as he could turn his hands to; and the buoyancy of his spirits kept pace with his good fortune. He never had, however, that evenness of spirits which marked and dignified the characters of our countrymen Benjamin West and John Singleton Copley. With Stuart it was either high tide or low tide. In London he would sometimes lay a bed for weeks, waiting for the tide to lead him on to fortune. While Copley and West had the industry of ants before they attained the treasure of bees. There was a caprice in Mr. Stuart's character as provoking to his best friends and nearest connexions, as it was unaccountable to the public. A committee of the Redwood

library, of Newport, waited upon him to (engage him to) paint a full-length portrait of its generous founder, *Abraham Red-wood*, then living next door to the painter, for which the young artist would have had a generous reward, but all that his parents and the rest of his friends could say, he declined it in sullen silence, and by so doing turned the popular tide in some degree against him. Whether any of the committee bargained with him in the spirit and style of a mechanic, I never knew; but it is certain he never would hear the subject mentioned if he could check it. This occurrence cooled the zeal of many of his friends."

The doctor's assertion, that he " would have had a generous reward," is gratuitous, as is proved by his suggestion, that " one of the committee" (or perhaps the whole committee) might have " bargained with him as with a mechanic." Or might not Stuart, a youth of 19 or 20, feel that he could not paint a full length, for a public place especially. Might he not have declined to do that, the attempt at which would perplex, and the result disgrace? If such were his motives, he was wise to preserve silence—for his friends would not have understood them.

Ardent as Stuart's love of painting was, we have the authority of his early friend for saying that music divided his affections so equally with her sister, that it was difficult to say which was " the ruling passion."

" Stuart," says the doctor, " became enamoured with music, in which he made remarkable progress without any other master than his own superior genius." " I was willing to believe that he was *au fait* in the science of sweet sounds, but I did not always feel them so sweetly as he did."

The young painter not only became a performer on various instruments, but ventured likewise to compose. The biographer of this early portion of his life, says, " once he attempted to enrapture me, by a newly studied classical composition. I exerted all the kind attention I could muster up for the occasion, until his sharp eye detected by my physiognomy, that I did not much relish it. He coloured, sprang up in a rage, and striding back and forth the floor, vociferated, " you have no more taste for music than a jack-ass! and it is all owing to your stupid quaker education.' To which I replied, ' 'tis very likely, Gibby, and that education has led me to relish silence more than all the passionate noise uttered from instrumental or vocal organs.' Stuart's reply to this, with a laugh, was, ' a good hit, Ben!—but really I wish you had more taste for music.' ' I wish so too, Stuart,' said his friend, ' but I am de-

termined not to admire more in a picture than what I actually
see within its frame; nor affect raptures for music I do not
feel.' "

" On going to England," continues the Doctor, " in the
beginning of March, 1775, I left Gilbert Stuart, according to
his own account, in a manner disconsolate, for, beside me, he
had no associate with whom he could expatiate and dispute
upon painting and music."

Stuart, probably finding that his business of portrait-paint-
ing failed in consequence of the preparations for war, then
making in the colonies, found means to follow his friend
Waterhouse. We have been told that he was assisted by some
of the inhabitants of Newport. It will be seen that he did not
go from home well provided, except with talent, to meet the
expenses incident to a residence in the English metropolis.
He has told the writer that he embarked from the port of Nor-
folk, in Virginia, with the localities of which place, and with its
older inhabitants, he was well acquainted. He went thither
from the port of Boston, after hostilities had commenced
between the veterans of England and the Yankee yeomen.
Doctor Waterhouse says, " Mr. Stuart was shut up in Boston,
when the first blood was spilt at Lexington, in our contest
with Great Britain, April the 19th, 1775, and escaped from it
about ten days before the Battle of Bunker-hill, and arrived
in London the latter end of November following, when he
found I was gone to Edinburgh, and he without an acquaint-
ance." From this we may infer that Stuart relied upon Water-
house principally for introduction, and perhaps support, until
he could obtain employment. As he escaped from the town of
Boston on the 7th of June, 1775, ten days before the fight on
Breed's hill, and reached London the last of November, even
the tardy movement of ships over the Atlantic at that period,
allows us to suppose that the young man past some weeks at
Norfolk.

Mr. Trumbull, who was the fellow-student of Stuart, under
West, and in some sort, the pupil of Stuart, who had preceded
him in the art, and ever far outstripped him in portraiture, gave
the following anecdote to Mr. James Herring, which we copy
from his manuscript.

" Trumbull was told by the lady of a British officer, that
the night before he (Stuart) left Newport, he spent most part
of the night under the window of a friend of hers, playing on
the flute, (he played very well on the flute, and we spent many
an evening together playing duets—he took lessons too in

London of a German, who belonged to the king's band.—T. She afterwards married a British officer."

His friend Waterhouse continues, "When I returned from Edinburgh to London in the summer of 1776, I found Mr. Stuart in lodging in York-buildings, with but one picture on his easel, and that was a family group for Mr. Alexander Grant, a Scotch gentleman to whom he brought letters, and who had paid him for it in advance. It remained long in his lodgings, and I am not sure that it ever was finished." Not being sure—we ought to conclude that it was finished and delivered to the owner.

During this period we presume to fix the time for an adventure, which Mr. Stuart, in his old age, often mentioned. His father's business was broken up by the events of the war in America; the friend upon whom he relied had left London; he found himself poor and unknown in that desert, a populous metropolis, without money, experience or prudence—it was then that his knowledge of music, practical and theoretical, stood him in stead, and gave him the means of subsistence in a manner as extraordinary as his character and actions were eccentric. To Mr. Charles Fraser, of Charleston, and Mr. Thomas Sully, of Philadelphia, he related the following circumstances nearly in the same words.

While destitute of the means whereby to support himself, or pay his landlord for board and lodging, already due, walking the streets without any definite object in view, he passed by a church in Foster-lane; he observed that the door was open, and several persons going in. At the same time, the sound of an organ struck his ear, ever alive to the " concord of sweet sounds," and he approached the door, at first only to gratify his sense of harmony. Before venturing to enter a temple devoted to the worship of the benevolent Giver of good to all, he had to consider the cost as the pew-woman would expect her fee. He therefore, after indulging himself with the sounds which issued from the door, as a hungry pauper snuffs the savours from a cook's shop, asked of a person who was entering to the feast, if any thing particular was going on within ; and was told that the vestry were sitting as judges of several candidates for the situation of organist, the former incumbent having recently died. The trial was then going on—Stuart entered the church, kept clear of the pew-woman, and placed himself near the judges, when being encouraged, as he said, by a look of good nature in one of the vestry-men's jolly countenance, and by the consciousness, that he could produce better tones from the instrument than any he had heard that day, he addressed the man with the inviting face, and asked if he, a

stranger, might try his skill and become a candidate for the vacant place. He was answered in the affirmative, and he had the pleasure to find that the time he had employed in making himself a musician, had not been thrown away even in the most worldly acceptation of the words. His performance was preferred to that of his rivals, and after due inquiries and a reference, (doubtless to Mr. Grant, to whom alone he had brought letters,) by which his fitness for the station was ascertained, he was engaged as the organist of the church, at a salary of thirty pounds a year. He was thus relieved from his present necessities, and enabled to pursue his studies as a painter. "When" said Mr. Fraser, "Mr. Stuart related this anecdote to me, he was sitting in his parlour, and as if to prove that he did not neglect the talent that had been so friendly to him in his youth, and in the days of extreme necessity, he took his seat at a small organ in the room, and played several old fashioned tunes with much feeling and execution. Mr. Sully related this anecdote of Stuart's early life nearly in the same words, and praised his execution on an organized piano-forte very highly. Mr. Sully's taste and knowledge of music render his approbation high authority as to Stuart's skill on this instrument.

Doctor Waterhouse justly observes, that " Stuart's acknowledged advancement in the theory and practice of music was a fresh evidence of his vigorous intellect and various talents, which constitutes genius. He certainly had that peculiar structure of the brain or mind which gives an aptitude to excel in every thing to which he chose to direct his strong faculties." On the return of this friend to London, he had the pleasure of procuring several sitters for the young painter; but could with difficulty keep the eccentric genius in a straight course or within legitimate limits. We will let the doctor tell this portion of Stuart's story in his own way.

" As I was at that time ' walking the hospitals,' as they call it, I took up my quarters in Gracechurch-street, to be near St. Thomas's and Guy's Hospitals, which was about three miles from Stuart's lodgings, an inconvenience and grievance to us both as we could not see each other every day. Therefore measures were taken to procure him lodgings between the houses of my two cousins, Mrs. Freeman and Mrs. Chorley, nieces of my kinsman and patron Dr. Fothergill. This was the best I could do for my friend; but it was not the most favoured location for a professor of one of the *fine arts*, seeing, the quakers are distinguished more for their attachment to the *plain arts*. Yet we made out amongst us to keep Stuart even with his landlord and washer-woman, which was doing better than he

had done. Dr. Fothergill directed him to paint my portrait
for him, which I considered as a delicate mode of giving the
young American artist ten guineas, for no one ever knew what
became of it after it was carried to Harpur-street. Doctor
William Curtis, author of the splendid *Flora Londinensis* sat
for his portrait, and so did two beautiful young ladies, sisters ;
one with dark hair, as the tragic muse, the other with reddish
hair and light blue eyes, as the comic muse; and yet both
daughters of parents remarkable for walking by the strictest
rules of the sect in which they were distinguished leaders.
The celebrated Doctor Lettsom was easily persuaded to sit or
rather stand for his full-length picture for the royal exhibition—
nevertheless Stuart was very poor and in debt. Of my allow-
ance of pocket-money he always had two thirds, and more than
once the other third. He never finished Doctor Lettsom's
portrait, and was of course deprived of that opportunity of
exhibiting the picture of a well-known physician and philan-
thropist."

This reminds us of his declining to paint the full-length of Mr.
Redwood, in Newport. Is it not probable that Stuart found
that even yet he could not paint a full-length that would be re-
ceived at Somerset-house, or if received, contribute to his repu-
tation ? His friend proceeds :

"I devised another plan to benefit him. Dr. George For-
dyce, a very learned Scotch physician, whose medical and che-
mical lectures, I every morning attended in Essex-street, dur-
ing between two and three years, was a philosophical physi-
cian much admired by his pupils. I proposed to my fellow-
students to procure a fine engraving of our favourite teacher.
The proposal took at once, and I was authorized to have the
portrait taken by my friend and companion, Gilbert Charles
Stuart, and they each one paid me their half-guinea subscrip-
tion, and I was unwise enough to let my needy friend have
the greater part of it before he commenced the painting, which
I never could induce him even to begin. This was a source
of inexpressible unhappiness and mortification, which at length
brought on me a fever, the only dangerous disease I ever en-
countered. After my recovery I had to refund the money,
when I had not a farthing of my own, but what came from the
thoughtful bounty of my most excellent kinsman, Dr. Fother-
gill, who would never afterwards see Gilbert Charles Stuart.
Twice before this I took him out of a sponging-house by pay-
iug the demands for which he was confined."

It appears that all this could not shake the friendship or
break the cords which attached the student of medicine to his

imprudent countryman ; for he goes on to say, " Stuart and I agreed to devote one day in the week to viewing pictures, wherever we could get admittance. We used Maitland's description of London for a guide. We found nothing equal to the collection at the Queen's Palace or Buckingham House. We made it a point also to walk together through all the narrow lanes of London, and having a pocket map, we marked such streets and lanes as we passed through with a red lead pencil, and our map was full two thirds streaked over with red when we received some solemn cautions and advice to desist from our too curious rambles. We were told by some who knew better than we did, that we run a risk of bodily injury, or the loss of our hats and watches, if not our lives, when we gave up the project. We had, however, pursued it once a week for more than two years, and never experienced other than verbal abuse, chiefly from women, and saw a great deal of that dirty, monstrous, overgrown city, containing, to appearance, no other people than the natives of Britain and Ireland, and a few Jews, not laughing and humming a song like the populace of Paris, but, wearing a stern, anxious, discontented phiz."

" In the summer of 1776," the young student of medicine has told us that he returned from Edinburgh to London, and supposing these rambles to commence soon after, the two years brings us late in 1778, in which year Stuart painted his own portrait for Waterhouse, at the age of 24, which is said to be a picture of extraordinary merit. All this time the young painter had never been introduced to his countryman, West. There appears to be no reason for this neglect on Stuart's part. This source of instruction was accessible to all; and particularly to Americans. His doors were ever open, and his advice ever freely given.

In a letter before us it appears that Dr. Waterhouse enjoyed the acquaintance of Mr. West, " from the year 1775," he says, " My introduction to that interesting painter, was through the friendly attention of his own father." Yet late in the year 1778, Gilbert Stuart was unknown to Benjamin West, though residing with Waterhouse in London. Doctor Waterhouse thinks that after this long delay, *he* was the means of introducing Stuart to Mr. West, but we prefer the following account from Mr. Sully, not doubting in the least the accuracy of the doctor's statement, that he "called upon Mr. West, and laid open to him his (Stuart's) situation, when that worthy man saw into it at once, and sent him three or four guineas," and that two days afterward he sent his servant into the city to ask

Mr. Stuart to come to him, when he employed him in copying." But we believe the introduction to have taken place prior to Waterhouse's visit, although probably a very few days.

When Mr. Sully returned home from England, West gave him a letter to his old friend Mr. Wharton, then a governor of the Pennsylvania hospital, respecting a place for the reception of the great picture of the " Healing in the Temple," and Wharton, in conversation on the subject of paintings and painters, told Sully that he introduced Stuart to West, and related the circumstance thus :

" I was with several other Americans dining with West, when a servant announced a person as wanting to speak to him. ' I am engaged ;' but, after a pause, he added, ' Who is he ?' ' He says, sir, that he is from America.' That was enough. West left the table immediately, and on returning, said, ' Wharton, there is a young man in the next room, who says he is known in *our* city, go you and see what you can make of him.' I went out and saw a handsome youth in a fashionable green coat, and I at once told him that I was sent to see what I could make of him. ' You are known in Philadelphia ?' ' Yes sir.' ' Your name is Stuart ?' ' Yes.' ' Have you no letters for Mr. West ?' ' No sir.' ' Who do you know in Philadelphia ?' ' Joseph Anthony is my uncle.' ' That's enough—come in,' and I carried him in, and he received a hearty welcome."

Such appears to be the authentic account of Stuart's introduction to the man from whose instruction he derived the most important advantages from that time forward ; whose character he always justly appreciated, but whose example he could not, or would not follow.

It appears from this, that notwithstanding Stuart's poverty at this time, he was well dressed. Waterhouse says that he lived in the house of a tailor. It appears that Stuart painted more than one picture of Waterhouse. " I was often to him," says the Doctor, " what Rembrandt's mother was to that wonderful Dutchman, an object at hand on which to exercise a ready pencil. I once prevailed on him to try his pencil on a canvass of a three- quarter size, representing me with both hands clasping my right knee, thrown over my left one, and looking steadfastly on a human skull placed on a polished mahohany table.' " As this is all we hear of this picture it was probably left unfinished and destroyed.

Of his friend Gilbert's epistolary habits, the Doctor gives the following account. He says, on one occasion " Mr. Stuart sent me the following letter : ' Friend Benjamin, by no means disappoint me, but be at my lodgings precisely at three

o'clock, to go to the Queen's Palace. Yours, G. Stuart. Saturday afternoon.' " There was no date of the month or year, but I think it was in the summer of 1778. In one of his letters, written to me while at Edinburgh, in the latter end of the year 1775, or the beginning of '76, he writes thus in a P. S. ' I don't know the day of the month or even what month, and I have no one to ask at present, but the day of the week is Tuesday, I believe.' I question if Mr. Stuart ever wrote a line to either father, mother or sister, after he went to England. The first letter he wrote to me while at Edinburgh, was a few days after his arrival in London, in which he says, ' Your father was at our house just before I left home, when he said Gilbert and Ben are so knit together like *David and Jonathan*, that if they heard from one, they would also hear from the other.' But in this he was mistaken ; Gilbert Stuart's parents never had a single line from him, and I doubt if there be in existence a single letter in his remaining family, or any where else, except four of his letters in my possession. How often have I entreated him to write to his mother ! He was in this respect a strange character. Strongly attached to his parents, yet he was too indolent—or too something else, to write them a letter when he knew that Rhode-Island was first a British post, and then a French one ; and that his parents and sister found it expedient to quit Newport for the British port of Halifax, in Nova Scotia ; and when there were numerous opportunities every week to that country, he never wrote a line to them."

Soon after Stuart's introduction to Mr. West, Doctor Waterhouse went to Leyden to finish his studies, and they did not meet again until many years after both had returned to America.

From Mr. John Trumbull we have the next notice of Stuart in point of time. Mr. Trumbull after studying in Boston for some years, occupying the room which had been Smybert's, and in which many of his pictures still remained, made his way through France to London, with letters to Mr. West, in August, 1780. He found Stuart at Mr. West's house in Newman-street, and thus described his appearance. "He was dressed in an old black coat with one half torn off the hip and pinned up, and looked more like a poor beggar than a painter." Such is the description taken down by Mr. Herring from the mouth of Mr. Trumbull. Mr. Herring's manuscript note from Mr. Trumbull proceeds thus, " He, (Stuart) was wretchedly poor while in London, and on one occasion when he was sick, Trumbull called to see him ; he found him in bed and ap-

parently very ill. Sometime afterwards he asked Trumbull if he had any idea what was the matter with him. On being told that he had not, he stated that it was hunger! that he had eaten nothing in a week but a sea-biscuit."

Our readers will recollect that this beggarly appearance and absolute starvation, was after Stuart had been received as a pupil by Benjamin West, and employed by him in copying for him, and otherwise assisting his labours.

The above account of Stuart's situation in London, in the year 1780, having been submitted to Doctor Waterhouse, he wrote on it, "I had introduced him to the family of Doctor Fothergill's nieces, Mrs. Freeman and Mrs. Chorley, and they extended towards him every kind act of hospitality and friendship, and would have never withheld assistance had they known he wanted for any thing, so long as I was in the way of knowing any thing about them or him in London. How he stood with them after I left London for Leyden, I cannot say, but they both remembered him in their letters to me."

The following is from Mr. Trumbull, through Mr. Herring. "He, (Stuart,) never could exercise the patience necessary to correct drawing. When a scholar of Mr. West's, his friend and instructor observed to his son Raphael, Trumbull and Stuart, 'You ought to go to the academy to study drawing; but as you would not like to go there without being able to draw better than you now do—if you will only attend I will keep a little academy, and give you instructions every evening.' This proposition was embraced with pleasure, and accordingly the course commenced. Trumbull and young West applied themselves with diligence, and became adepts. Stuart soon made his paper black all over, lost his patience, and gave it up." So far Trumbull. Another anecdote respecting Stuart's drawing is, that Fuseli on seeing some of his drawings, said, 'If this is the best you can do, you had better go and make shoes.'"

These anecdotes being submitted by Mr. Herring to Doctor Waterhouse, he writes on the paper—"S. was patient and even laborious in his drawings, and Mr. F. had he the eye of a true painter, must have seen real genius in his early drawings."

As Fuseli has been here introduced, we will quote from Mr. Allston an anecdote connected both with him and our present subject. Mr. Allston had been previously giving his opinion of the character of the Swiss artist, and he concludes thus: "Before I leave Fuseli, I must tell you a whimsical anecdote which I had from Stuart. S. was one day at Raphael Smith's

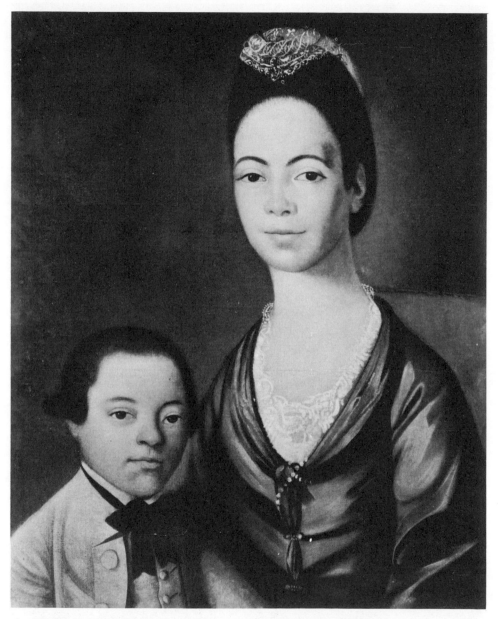

57 Mrs. Aaron Lopez and Her Son Joshua. Painting by Gilbert Stuart. *Courtesy Detroit Institute of Fine Arts.*

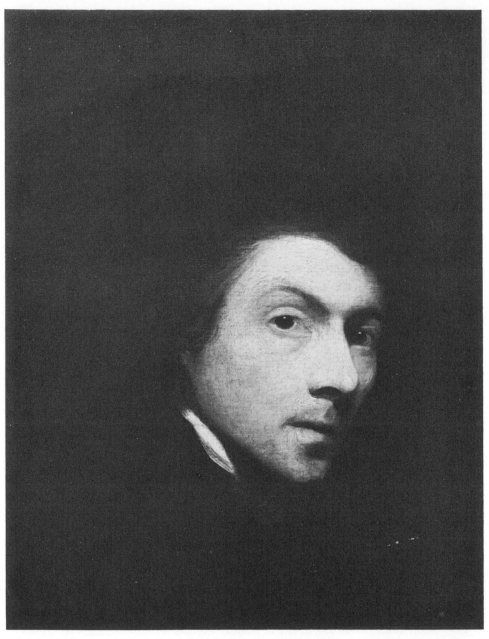

58 SELF-PORTRAIT AT 24, 1778. Painting by Gilbert Stuart. *Courtesy Redwood Library and Athenæum*

the engraver, when Fuseli, to whom Stuart was then unknown, came in, who, having some private business, was taken into another room. 'I know that you are a great physiognomist, Mr. Fuseli,' said Smith. 'Well, what if I am?' 'Pray did you observe the gentleman I was talking with just now?' 'I saw the man; what then?' 'Why I wish to know if you think he can paint?' 'Umph, I don't know but he might—*he has a coot leg*.' Poor Stuart! that same leg, which I well remember to have been a finely formed one, became the subject of a characteristic joke with him but a few weeks before he died. I asked 'how he was?' He was then very much emaciated. 'Ah' said he, 'you can judge;' and he drew up his pantaloons. 'You see how much I am *out of drawing*.'

"He was a much better scholar than I had supposed he was," said Mr. Trumbull, speaking of Stuart, as he knew him in London. "He once undertook to paint my portrait, and I sat every day for a week, and then he left off without finishing it, saying, he 'could make nothing of my damn'd sallow face.' But during the time, in his conversation he observed, that he had not only read, but remembered what he had read. In speaking of the character of man, 'Linnæus is right', said he, 'Plato and Diogenes call man a biped without feathers; that's a shallow definition. Franklin's is better—a tool-making animal; but Linnæus' is the best—homo, animal mendax, rapax, pugnax.'"

It was our impression that Stuart received his education in Scotland, having been sent thither by his father for that purpose; but the testimony of Doctor Waterhouse, as above given, shows that his knowledge of classical literature was obtained in Newport, when he was the doctor's school-fellow.

We have seen that the young painter was received as a pupil by Mr. West, in the summer of 1778, and at the age of 24. At this age he had painted his own portrait, to the great excellence of which Doctor Waterhouse bears ample testimony. He says, "It is painted in his freest manner, with a Rubens' hat;" and in another passage, says that Stuart in his best days said he need not be ashamed of it. Thus qualified and thus situated, Stuart's friend Waterhouse left him, and did not again see him until the evening of his life. We have now to seek for other sources of information respecting the subject of our memoir.

To Mr. Charles Fraser of Charleston, South Carolina, we are indebted for communications made with a frankness which adds to their value. He says Mr. Stuart told him, "that on application to Mr. West to receive him as a pupil, he was welcomed with true benevolence, encouraged, and taken into

the family; that nothing could exceed the attention of that artist to him; they were, said he, paternal." Two years after this, when Mr. Trumbull saw him at work in Mr. West's house, in an old torn coat, and looking like a beggar, we can only suppose that Stuart, like many others, had put on an old coat while at work to save a new one.

Of this period of his life he has often spoken to the writer. On one occasion, as I stood by his esel and admired the magic of his pencil, he amused me and my companion, whose portrait he was painting, by the following anecdote of himself and his old master :—

"Mr. West treated me very cavalierly on one occasion, but I had my revenge. It was the custom, whenever a new Governor-General was sent out to India, that he should be complimented by a present of his majesty's portrait, and Mr. West being the king's painter, was called upon on all such occasions. So, when Lord —— was about to sail for his government, the usual order was received for his majesty's likeness. My old master, who was busily employed upon one of his *ten-acre* pictures, in company with prophets and apostles, thought he would turn over the king to me. He never could paint a portrait. 'Stuart,' said he, 'it is a pity to make his majesty sit again for his picture; there is the portrait of him that you painted, let me have it for Lord —— : I will retouch it, and it will do well enough.' '*Well enough!* very pretty,' thought I, 'you might be civil when you ask a favor.' So I *thought*, but I *said*, 'Very well, sir.' So the picture was carried down to his room, and at it he went. I saw he was puzzled. He worked at it all that day. The next morning, 'Stuart,' said he, 'have you got your palette set?' 'Yes, sir.' 'Well, you can soon set another, let me have the one you prepared for yourself; I can't satisfy myself with that head.' I gave him my palette, and he worked the greater part of that day. In the afternoon I went into his room, and he was hard at it. I saw that he had got up to the knees in mud. 'Stuart,' says he, 'I don't know how it is, but you have a way of managing your tints unlike every body else,—here,—take the palette and finish the head.' 'I can't, sir.' 'You can't?' 'I can't indeed, sir, as it is, but let it stand till to-morrow morning and get dry, and I will go over it with all my heart.' The picture was to go away the day after the morrow, so he made me promise to do it early next morning. You know he never came down into the painting-room, at the bottom of the gallery, until about ten o'clock. I went into his room bright and early, and by half-past nine I had finished the head. That done, *Rafe* and I

began to fence ; I with my maul-stick and he with his father's. I had just driven Rafe up to the wall, with his back to one of his father's best pictures, when the old gentleman, as neat as a lad of wax, with his hair powdered, his white silk stockings, and yellow morocco slippers, popped into the room, looking as if he had stepped out of a bandbox. We had made so much noise that we did not hear him come down the gallery or open the door. 'There you dog,' says I to Rafe, 'there I have you ! and nothing but your background *relieves* you !' The old gentleman could not help smiling at my technical joke, but soon looking very stern, ' Mr. Stuart,' said he, ' is this the way you use me ?' 'Why, what's the matter, sir? I have neither hurt the boy nor the background.' ' Sir, when you knew I had promised that the picture of his majesty should be finished to-day, ready to be sent away to-morrow, thus to be neglecting me and your promise ! How can you answer it to me or to yourself ?' ' Sir,' said I, 'do not condemn me without examining the esel. I have finished the picture, please to look at it.' He did so ; complimented me highly ; and I had ample revenge for his ' It will do well enough.' "

The following anecdote, told under nearly the same circumstances, refers to a later date, as Trumbull is made an actor in the scene :—

" I used very often to provoke my good old master, though heaven knows, without intending it. You remember the color closet at the bottom of his painting room. One day Trumbull and I came into his room, and little suspecting that he was within hearing, I began to lecture on his pictures, and particularly upon one then on his esel. I was a giddy foolish fellow then. He had begun a portrait of a child, and he had a way of making curly hair by a flourish of his brush, thus, like a figure of three. ' Here, Trumbull,' said I, ' do you want to learn how to paint hair ? There it is, my boy ! Our master figures out a head of hair like a sum in arithmetic. Let us see,—we may tell how many guineas he is to have for this head by simple addition,—three and three make six, and three are nine, and three are twelve—' How much the sum would have amounted to I can't tell, for just then in stalked the master, with palette-knife and palette, and put to flight my calculations. ' Very well, Mr. Stuart,' said he,—he always *mistered* me when he was angry, as a man's wife calls him *my dear* when she wishes him at the devil.—' Very well, Mr. Stuart! very well, indeed !' You may believe that I looked foolish enough, and he gave me a pretty sharp lecture without

my making any reply. When the head was finished there were no *figures of three in the hair.*"

Before Stuart left the roof of his benefactor and teacher, he painted a full-length of his friend and master, which attracted great attention and elicited just admiration. It was exhibited at Somerset House, and the young painter could not resist the pleasure afforded by frequent visits to the exhibition-rooms, and frequent glances—who can blame him?—at the object of admiration. It happened that as he stood, surrounded by artists and students, near his master's portrait, the original came into the rooms and joined the group. West praised the picture, and addressing himself to his pupil, said, "You have done well, Stuart, very well, now all you have to do—is to go home and *do better.*"

"Stuart did not," says Mr. Fraser, "describe the course of study recommended by Mr. West, but mentioned an occasional exercise that he required of his pupils for giving them facility and accuracy of execution; which was the faithful representation of some object or other, casually presented to the eye—such as a piece of drapery thrown carelessly over a chair—Stuart's successful performance of one of these tasks attracted the notice and approbation of an eminent artist, which he said were very flattering to him. Stuart had at this time a room for painting, appropriated to himself under his master's roof. One day a gentleman entered, and after looking around the room, seated himself behind the young painter, who was at work at his esel. The artist felt somewhat embarrassed, but Mr. West soon after coming in, introduced the stranger as Mr. Dance. Mr. West left the room, but Mr. Dance remained and entered into conversation with Stuart, who ventured to ask his opinion of his work, which was a portrait. Dance replied, 'Young gentleman, you have done every thing that need be done, your work is very correct!' The young painter was of course delighted with the approbation of the veteran, especially as he knew the reputation of Dance for skill, correctness of eye, and blunt candour. Mr. Dance was one of those who petitioned the king in 1768. He was thought worthy to be the third on the list, his name being placed between Zucarelli and Wilson. Stuart spoke of him with great sensibility, and said, that while he was yet studying with Mr. West, Dance said to him, 'You are strong enough to stand alone—take rooms—those who would be unwilling to sit to Mr. West's pupil, will be glad to sit to Mr. Stuart.' "

Mr. Neagle, of Philadelphia, gives us the following anecdote as received from the artist. "When studying at Somerset-

house, in the school of the antique, it was proposed by his fellow-students, that each one present should disclose his intentions, as to what walk in art, and what master he would follow. The proposal was agreed to. One said he preferred the gigantic Michael Angelo. Another would follow in the steps of the gentle, but divine Raphael, the prince of painters; and catch, if possible, his art of composition, his expression and profound knowledge of human passion. A third wished to emulate the glow and sunshine of Titian's colouring. Another had determined to keep Rembrandt in his eye, and like him eclipse all other painters in the chiaro scuro. Each was enthusiastic in the praise of his favourite school or master. Stuart's opinion being demanded, he said, that he had gone on so far in merely copying what he saw before him, and perhaps he had not a proper and sufficiently elevated notion of the art. But after all he had heard them say, he could not but adhere to his old opinion on the subject. 'For my own part,' said he, 'I will not follow any master. I wish to find out what nature is for myself, and see her with *my own eyes.* This appears to me the true road to excellence. Nature may be seen through different mediums. Rembrandt saw with a different eye from Raphael, yet they are both excellent, but for dissimilar qualities. They had nothing in common, but both followed nature. Neither followed in the steps of a master. I will do, in that, as they did, and only study nature.' While he was speaking, Gainsborough accidentally came in, unobserved by him, and as soon as he ceased, though unknown to the speaker, stepped up to him, and patting him on the shoulder, said, 'That's right, my lad; adhere to that, and you'll be an artist.'"

The lesson is very good, but it is far from being new. We are told by Pliny, that Eupompus gave the same to Lysippus. Nature is to be imitated, and not the artist, who has become such by imitating her. Study the original and not the copy.

"He related to a friend of mine," says Mr. Fraser, "a little incident that occurred while he was with Mr. West, which is sufficiently interesting to be introduced in this part of my little memoir. Dr. Johnson called one morning on Mr. West to converse with him on American affairs. After some time, Mr. West said that he had a young American living with him from whom he might derive some information, and introduced Stuart. The conversation continued, (Stuart being thus invited to take a part in it,)—when the doctor observed to Mr. West, that the young man spoke very good English—and turning to Stuart, rudely asked him where he had learned it. Stuart very promptly replied, 'Sir, I can better tell you

where I did not learn it—it was not from your dictionary.'
Johnson seemed aware of his own abruptness, and was not
offended."

While Trumbull and Stuart were together as pupils of Mr.
West, Stuart being the senior student, and more advanced in
the art, Trumbull frequently submitted his works to him for
the benefit of his remarks. Stuart told Mr. Sully, from whom
we derive the anecdote, that on one occasion he was excessively
puzzled by the drawing, "and after turning it this way and
that, I observed, 'Why, Trumbull, this looks as if it was drawn
by a man with but one eye.' Trumbull appeared much hurt,
and said, 'I take it very unkindly, sir, that you should make
the remark.' I couldn't tell what he meant, and asked him.
'I presume, sir,' he answered, 'that you know I have lost
the sight of one eye, and any allusion to it, in this manner, is
illiberal.' Now I never suspected it, and only the oddness of
the drawing suggested the thing." We have heard from
Stuart's companions in Boston, the same story, in nearly the
same words, and when he told it to them, he went into a long
dissertation on optics to prove that a man, with but the sight
of one eye, could not possibly draw truly. This notion Sully
thought perfectly idle, and only one of Stuart's whims, who
could lecture most eloquently on any subject, from the ana-
tomy of a man, to the economy of his shoe-tie.

We have thought proper to relate such particulars as have
come to our knowledge, and such anecdotes told of the great
portrait-painter, as are immediately connected with his residence
under Mr. West's roof, before following him to his indepen-
dent establishment. He uniformly said, that nothing could
exceed the attention of that distinguished artist to him. And
when West saw that he was fitted for the field—armed and
prepared to contend with the best and the highest—he advised
him to commence his professional career, and pointed out the
road to fame and fortune.

We are obliged to Mr. Charles Fraser for the following, as
communicated to him by Mr. Stuart, and with it begin ano-
ther chapter.

CHAPTER X.

Stuart commences his independent professional career in London—Skating anecdote—Baretti's criticism—Dukes and lords praise his skill—Paints Sir Joshua Reynolds' portrait—Johnson's reply respecting Burke's having aided Sir Joshua in his lectures—Tom, Towzer, and the mutton-pie—Anecdote related by Judge Hopkinson of Lord Mulgrave, and his brother, General Phipps —Practice of demanding half-price at the first sitting for a portrait—Anecdote related by Doctor Waterhouse of Stuart and his travelling companions—Extract from a letter of Mrs. Hopner's—Doctor Waterhouse's testimony, to Stuart's colloquial powers.

" Mr. Stuart," it is Mr. Fraser speaks, "in pursuance of Mr. West's advice, now commenced painting as a professional artist. The first picture that brought him into notice, before he left West's house, was the portrait of a Mr. Grant, a Scotch gentleman, who had applied to him for a full-length. Stuart said that he felt great diffidence in undertaking a whole length; but that there must be a beginning, and a day was accordingly appointed for Mr. Grant to sit. On entering the artist's room, he regretted the appointment, on account of the excessive coldness of the weather, and observed to Stuart, that the day was better suited for skating than sitting for one's portrait. To this the painter assented, and they both sallied out to their morning's amusement. Stuart said that early practice had made him very expert in skating. His celerity and activity accordingly attracted crowds on the Serpentine river—which was the scene of their sport. His companion, although a well-made and graceful man, was not as active as himself; and there being a crack in the ice, which made it dangerous to continue their amusement, he told Mr. Grant to hold the skirt of his coat, and follow him off the field. They returned to Mr. Stuart's rooms, where it occurred to him to paint Mr. Grant in the attitude of skating, with the appendage of a winter scene, in the back ground. He consented, and the picture was immediately commenced. During the progress of it, Baretti, the Italian lexicographer, called upon Mr. West, one day, and coming through mistake into Mr. Stuart's room, where the portrait was, then nearly finished, he exclaimed, ' What a charming picture! who but that great artist, West, could have painted such a one !' Stuart said nothing, and as Mr. West was not at home, Baretti called again, and coming into the same room, found Stuart at work upon the very portrait; ' What, young man, does Mr. West permit you to touch his pictures ?' was the salutation. Stuart replied that the painting was altogether his own; ' Why,' said Baretti, forgetting his former observation, ' it is almost as good as Mr. West can paint.'

"This picture was exhibited at Somerset House, and attracted so much notice, that Stuart said he was afraid to go to the academy to meet the looks, and answer the inquiries of the multitude. Mr. Grant went one day to the exhibition, dressed as his portrait represented him; the original was immediately recognized, when the crowd followed him so closely that he was compelled to make his retreat, for every one was exclaiming, 'That is he, there is the gentleman.' Mr. West now told Stuart that he might venture to take rooms. Returning one morning from the exhibition, he stopped at Sir Joshua Reynolds' residence; whilst he was looking at his pictures, (and here he told me that he had always derived improvement from studying the works of that artist,) the Duke of Rutland walked in, and passed from the outer-room, in which Stuart was, into the next one, where Sir Joshua was painting; the door was left open, and Sir Joshua being hard of hearing, the Duke spoke so loud, that he was overheard, and said to Sir Joshua, 'I wish you to go to the exhibition with me, for there is a portrait there which you must see, every body is enchanted with it.' Sir Joshua inquired who it was painted by? 'A young man by the name of Stuart.' Stuart said that he did not remain to hear more. From that time he was never at a loss for employment. He spoke of another nobleman who he painted, and all his family. Mr. West was so pleased with the portrait of one of the daughters, that he introduced her, from Stuart's picture, into his piece, of James II. landing in England. He painted Sir Joshua Reynolds' portrait, but Sir Joshua said, if that was like him, he did not know his own appearance; which remark was certainly not made in the spirit of his usual courtesy. This picture was painted about 1784, and was afterwards in the possession of Alderman Boydell. He spoke very respectfully of Sir Joshua, but thought there was more poetry than truth in his works. He was present one day in a large company with Dr. Johnson, where some person ventured to tell the sage, that the public had charged *him*, as well as Mr. Burke, with assisting Sir Joshua in the composition of his lectures. The Doctor appeared indignant, and replied, 'Sir Joshua Reynolds, sir, would as soon get me to paint for him as to write for him.'"

It is difficult to account for the very different style of Stuart's painting, from that of the master under whom he studied, and whose works were daily before him, and occasionally copied by him. The pupil had directed his attention to portrait, and the master delighted in the higher branch of the art. West, doubtless, saw that Stuart was the better portrait-painter;

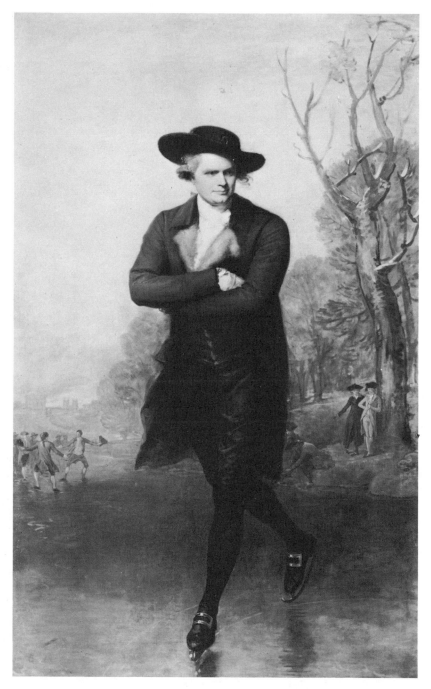

59 THE SKATER (William Grant of Congalton), 1781–1782. Painting by Gilbert
Stuart. *Courtesy National Gallery of Art, Washington, D.C., Andrew Mellon
Collection.*

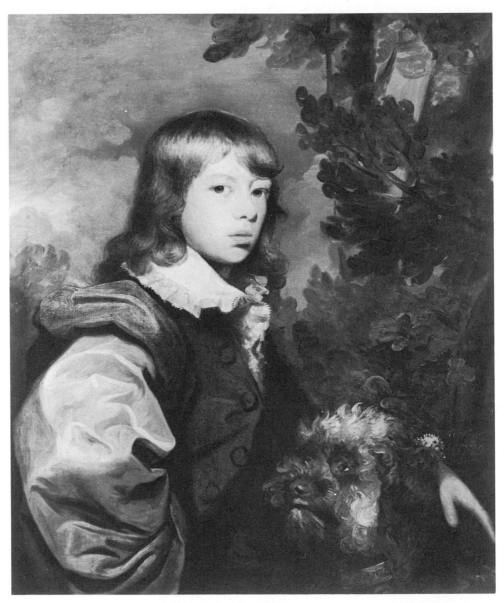

60 JAMES WARD, 1779. Painting by Gilbert Stuart. *Courtesy The Minneapolis Institute of the Arts, William Hood Dunwoody Fund.*

and we know that when he saw the superiority of another, he readily acknowledged it. When applied to for instruction by an artist, now in this city, he readily gave it, but said, " if you wish to study portrait-painting, go to Sir Joshua." Stuart spoke freely of his own superiority as a portrait-painter, and used to say, half-joke half-earnest, that " no man ever painted history if he could obtain employment in portraits." In connection with this difference of opinion and of style, I will mention the following circumstance which took place about 1786, on occasion of a visit to his old master's house and gallery, in Newman-street. Trumbull was painting on a portrait and the writer literally *lending him a hand*, by sitting for it. Stuart came in and his opinion was asked, as to the colouring, which he gave very much in these words, " Pretty well, pretty well, but more like our master's flesh than Nature's. When Benny teaches the boys, he says, ' yellow and white there,' and he makes a streak, ' red and white there,' another streak, ' blue-black and white there,' another streak, ' brown and red there, for a warm shadow,' another streak, ' red and yellow there,' another streak. But Nature does not colour in streaks. Look at my hand ; see how the colours are mottled and mingled, yet all is clear as silver."

This *was* and *is* true, and yet Mr. West's theory is likewise true, however paradoxical it may appear. Mr. West, perhaps, made too great a distinction between the colouring appropriate to historical painting, and that best suited to portrait.

This anecdote we permitted to be published, and it called forth the animadversion of a literary gentleman who professes both love for and knowledge of the art of painting. We, however, repeat it for several reasons. First, because it is true—as is every circumstance we publish which is given as from our own personal knowledge. Every fact we so state defies contradiction or controversy. Secondly, it leads to a consideration of the systems of managing colours so very opposite by great painters. Stuart, in after life, as will be seen in these pages, gave the same lesson in different words, to a young painter, that he gave to Trumbull in 1785 or '6. Mr. West's theory was true to a certain extent, and a good lesson for beginners. Mr. West adopted what he considered an historical style of colouring, and the consequence is, that now it is called quakerlike. Assuredly Stuart's theory for colouring flesh is the best ; and we can see no reason why flesh, in a great historical composition, should not be made as true to nature as in a portrait. It is not to be supposed that Mr. West practised in the manner given as a first lesson to a pupil, to the

extent implied by the words, but that such was his first lesson
at the time of which we speak, *we know*. Of the colouring of
Stuart and of Trumbull there are so many examples before
the public that we need not give an opinion. They are as
unlike as possible.

In the early period of Stuart's career as an independent por-
trait-painter, he had for his attendant a wild boy, the son of a
poor widow, whose time was full as much taken up by play,
with another of the painter's household, a fine Newfoundland
dog, as by attendance upon his master. The boy and dog
were inseparable ; and when Tom went an errand Towzer
must accompany him. Tom was a terrible truant, and played
so many tricks that Stuart again and again threatened to turn
him off, but as often Tom found some way to keep his hold on
his eccentric master. One day, as story-tellers say, Tom
staid when sent of an errand until Stuart, out of patience,
posted off to the boy's mother, determined to dismiss him ; but
on his entering the old woman *began first.* " Oh, Mr. Stuart,
Tom has been here." " So I supposed." " Oh, Mr. Stuart,
the dog!" "He has been here, too : well, well, he shall not
come again ; but Tom must come home to you. I will not
keep him!" " Oh, Mr. Stuart, it was the dog did it." " Did
what?" " Look, sir ! look there ! the dog overset my mut-
ton pie—broke the dish—greased the floor, and eat the mut-
ton !" " I'm glad of it ! you encourage the boy to come here,
and here I will send him !" "It was the dog, sir, eat the mut-
ton." "Well, the boy may come and eat your mutton, I dismiss
him ! I'll have no more to do with him !" The mother en-
treated—insisted that it was the dog's fault—told over and
again the story of the pie, until Stuart, no longer hearing her,
conceived the plan of a trick upon Tom, with a prospect of a
joke, founded upon the dog's dinner of mutton-pie. " Well,
well, say no more : here's something for the pie, and to buy a
dish. I will try Tom again, provided you never let him know
that I came here to-day, or that I learned from you any thing
of the dog and the pie." The promise was given of course,
and Stuart hastened home as full of his anticipated trick to
try Tom, as any child with a new rattle. Tom found his
master at his esel where he had left him, and was prepared
with a story to account for his delay, in which neither his mo-
ther, nor Towzer, nor the mutton made parts. "Very well,
sir," said the painter, " bring in dinner ; I shall know all
about it by-and-by." Stuart sat down to *his* mutton, and
Towzer took his place by his side, as usual ; while Tom, as
usual, stood in attendance. " Well, Towzer, your mouth

don't water for your share. Where have you been ? Whisper."
And he put his ear to Towzer's mouth, who wagged his tail in
reply. " I thought so. With Tom to his mother's ?" " Bow-
wow." " And have you had your dinner ?" " Bow." " I
thought so. What have you been eating ? Put your mouth
nearer sir." " Bow-wow !" " Mutton-pie—very pretty—
you and Tom have eat Mrs. Jenkins's mutton-pie, ha ?"
" Bow-wow." " He lies, sir, I didn't touch it ; he broke mo-
ther's dish and eat all the mutton !" From that moment Tom
thought if he wished to deceive his master, he must leave Tow-
zer at home, but rather on the whole concluded that what with
the dog, the devil, and the painter, he had no chance for suc-
cessful lying.

The following anecdote was related to us by Judge Hop-
kinson. Lord Mulgrave, whose name was *Phipps,* employed
Stuart to paint the portrait of his brother, General Phipps,
previous to his going abroad. On seeing the picture, which
he did not until it was finished, Mulgrave exclaimed, " What
is this ?—this is very strange !" and stood gazing at the por-
trait. "I have painted your brother as I saw him," said the
artist. " I see insanity in that face," was the brother's remark.
The general went to India, and the first account his brother
had of him was that of suicide from insanity. He went mad
and cut his throat. It is thus that the real portrait-painter
dives into the recesses of his sitters' mind, and displays strength
or weakness upon the surface of his canvas. The mechanic
makes a map of a man.

The following was told by Stuart to Mr. Sully. " While I
was in good practice, and some repute in London, a stranger
called upon me and finding me engaged with a sitter, begged
permission to look at my pictures, which was readily accorded,
and he passed some time in my exhibition room. From his
shabby black dress and respectful politeness, I concluded him
to be some poet or author from Grub-street, and made up my
mind that the chief purpose of the visit was to prepare some
article as a puff for the next periodical. A few days after this
I received a polite invitation to breakfast, from the Earl of
————. And you may judge of my surprise, when I found in
my host the supposed Grub-street scribbler. After breakfast
the earl complimented me, and expressed his satisfaction with
what he had seen at my rooms, and requested me to receive a
commission from him, to paint a list of characters, whose names
I should find on the paper he then handed to me, the which he
intended should decorate a new gallery he was constructing
on his grounds. The list contained the names of the most dis-

tinguished personages of the day, in the political and literary world, and seldom has so splendid a denouement followed so unpromising a beginning."

On the subject of the prices he had for portraits in London, we will repeat an anecdote, told by Stuart to Mr. Fraser. A gentleman called upon the painter, with the intention of sitting for his portrait, and having been told five guineas for a head, half in advance, he retired, applied elsewhere, and had two portraits painted, but not satisfied, he returned to Mr. Stuart after a lapse of two years, and found that his price was now thirty guineas a head. Upon being informed of this he remonstrated with the artist, wishing to convince him that he was bound to paint him at the first mentioned price. He was, however, obliged to submit as well to the terms, as to the mortification of paying for two sets of portraits.

Mr. Stuart had his full share of the best business in London, and prices equal to any, except Sir Joshua Reynolds, and Gainsborough. Respecting the practice of demanding half the price at the first sitting, he told Mr. Fraser, that, "Lord St. Vincent, the Duke of Northumberland, and Colonel Barre, came unexpectedly one morning into my room, locked the door and then explained the intention of their visit." This was shortly after his setting up his independent esel. "They understood," said Stuart, "that I was under pecuniary embarrassments, and offered me assistance, which I declined. They then said they would sit for their portraits. Of course I was ready to serve them. They then advised that I should make it a rule that half-price must be paid at the first sitting. They insisted on setting the example, and I followed the practice ever after this delicate mode of showing their friendship.

"On the subject of demanding half-price at the first sittings," Mr. Fraser says, "he told me the following anecdote. A man of distinction having applied to him to paint his portrait, a day was appointed, and the first sitting taken. On the gentleman's preparing to leave the room, the painter told him that it was his custom to demand half-price at the first sitting: against this the sitter warmly remonstrated, hoping that Mr. Stuart had no doubt of his intention to pay for the picture when finished. The artist replied, that he had adopted it as a rule, and must continue to observe it, for if it was departed from in one instance, offence might be justly taken by those who had previously complied with it. This conversation ended with the retreat of the gentleman—he not being prepared for the required ceremony—and he never returned to sit, or to pay."

At an earlier period of our artist's life, and probably before

his introduction to Mr. West, must have happened the adventure I introduce here, as related by Doctor Waterhouse. "He was travelling in England in a stage-coach, with some gentlemen, who were strangers to him, but all sociable, and full of spirits. And after dinner, with conversation animated and various, in which Stuart, it seems, was conspicuous; for his conversation was at all times animated and various, (and not the less so after dinner,) upon any topic that cast up, especially upon subjects that called forth nice discrimination, correct judgment, and rapid thought, apt phrases, ludicrous images, and Burke-like power of expressing them.

" After blazing away in his dramatic manner, his companions were very desirous to know *who* and *what* he was, for whatever Doctor Franklin may have said a century ago of the *question-asking propensity* of his countrymen, I never noticed so much of that kind of travelling curiosity in New-England as in Britain. On the contrary, I am certain that we in the United States are remarkably free from that sort of travelling importunateness. To the round-about question, to find out his calling or profession, Mr. Stuart answered with a grave face, and serious tone, that he sometimes dressed gentlemen's and ladies' hair, (at that time the high craped pomatumed hair was all the fashion.)—'You are a hair-dresser then?' 'What!' said he, 'do you take me for a barber?' 'I beg your pardon sir, but I inferred it from what you said. If I mistook you, may I take the liberty to ask what you are then?' 'Why I sometimes brush a gentleman's coat, or hat, and sometimes adjust a cravat.' ' O, you are a valet then, to some nobleman?' "A valet! Indeed, sir, I am not. I am not a servant—to be sure I make coats and waistcoats for gentlemen.' 'Oh! you are a tailor!' ' Tailor! do I look like a tailor?' ' I'll assure you, I never handled a goose, other than a roasted one.' By this time they were all in a roar. 'What the devil are you then?' said one. 'I'll tell you,' said Stuart. 'Be assured all I have said is literally true. I dress hair, brush hats and coats, adjust a cravat, and make coats, waistcoats, and breeches, and likewise boots and shoes *at your service*.' 'Oho! a boot and shoe-maker after all!' ' Guess again, gentlemen, I never handled boot or shoe but for my own feet and legs; yet all I have told you is true.' ' We may as well give up guessing.' After checking his laughter, and pumping up a fresh flow of spirits by a large pinch of snuff, he said to them very gravely, ' Now, gentlemen, I will not play the fool with you any longer, but will tell you, upon my honour as a gentleman, my *bona fide* profession. I get my bread by making

faces.' He then screwed his countenance, and twisted the lineaments of his visage, in a manner such as Samuel Foote or Charles Mathews might have envied. When his companions, after loud peals of laughter, had composed themselves, each took credit to himself for having, ' all the while suspected that the gentleman belonged to the theatre,' and they all knew that he must be a comedian by profession ; when to their utter surprise, he assured them that he never was on the stage, and very rarely saw the inside of a play-house, or any similar place of amusement. They now all looked at each other with astonishment.

" Before parting, Stuart said to his companions, ' Gentlemen, you will find that all I have said of my various employments, is comprised in these few words : I am a portrait-painter. If you will call at John Palmer's, York-Buildings, London, where I shall be ready and willing to brush you a coat or hat, dress your hair, a la-mode, supply you, if in need, with a wig of any fashion or dimensions, accommodate you with boots or shoes, give you ruffles or cravats, and make faces for you.' "

" While taking a parting glass at the inn, they begged leave to inquire of their pleasant companion, in what part of England he was born ; he told them he was not born in England, Wales, Ireland, or Scotland. Here was another puzzle for John Bull. ' Where then ?' ' I was born at Narraganset.' ' Where's that ?' " Six miles from Pottawoone, and ten miles from Poppasquash, and about four miles west of Connonicut, and not far from the spot where the famous battle with the warlike Pequots was fought.' ' In what part of the East Indies is that, sir ?' ' East Indies, my dear sir ! it is in the state of Rhode-Island, between Massachusetts and Connecticut river.' This was all Greek to his companions, and he left them to study a new lesson of geography, affording another instance of the ignorance of islanders, respecting men of genius, whose vernacular tongue is the same with that of Bacon, Newton, and Locke, Shakspeare, Milton, and Pope."

The good Doctor might have added, that probably these same travelling gentlemen knew as little of the names last mentioned, as of Narraganset, Connonicut, Massachusetts, or Poppasquash. He has added, in reference to the Pequots, " This terrible battle with the last of the Mohegans, was fought about two hundred years ago, a mile or two from the spot where our great portrait-painter was born. That brave tribe of Indians never recovered from their cruel defeat. Mr. Stuart visited the battle-ground a few years before his last

illness, and expressed his satisfaction, that his fellow-country-men, the *Pequots*, were among the bravest of the sons of the new world."

From a letter before me, written by Mrs. Hopner, I can state the date of Stuart's first establishment, after leaving West, and setting up for himself. The letter is dated June 3d, 1782: "To-day the exhibition closes. If Hopner should be as successful next year as he has been this, he will have established a reputation. Stuart has taken a house, I am told, of £150 a year, rent, in Berner's street, and is going to set up as a great man."

Stuart had that tact which induces men to accommodate their conversation, even in the moment of excitement to those in whose company they are thrown. Doctor Waterhouse has given this testimony to his colloquial powers. "In conversation and confabulation he was inferior to no man amongst us. He made a point to keep those talking who were sitting to him for their portraits, each in their own way, free and easy. This called up all his resources of judgment. To military men he spoke of battles by sea and land; with the statesman, on Hume's and Gibbon's history; with the lawyer, on jurisprudence or remarkable criminal trials; with the merchant in his way; with the man of leisure, in his way; and with the ladies, in all ways. When putting the rich farmer on the canvas, he would go along with him from seed to harvest time,—he would descant on the nice points of a horse—ox—cow—sheep or pig, and surprise him with his just remarks in the progress of making cheese and butter, or astonish him with his profound knowledge of manures, or the food of plants. As to national character, and individual character, few men could say more to the purpose, as far as history and acute personal observation would carry him. He had wit at will. Always ample, sometimes redundant."

From the consideration of the *finer*, we will take a glance at the *grosser* material, which the artist employed to represent mind, as well as body, on his pannel or his canvas. And first his palette.

A painter's palette is either the piece of wood with a hole in it for his thumb and a convenient recess for his brushes, or it is the colours with which this utensil is furnished, or such pigments as his knowledge and taste induce him to use. The word *taste* probably indicates the origin of the name given to this necessary piece of limning furniture, and to the tints, with which the artist covers it.

Stuart's palette, (in the sense we have first used the word,) was a small oval. Showing it on one occasion to the writer, he said, that he valued it highly as having belonged to Dance, and still more, that it was a present from that excellent artist.

Speaking on the same subject to Mr. Charles Fraser, Stuart said, that a short time after he had taken rooms, in London, subsequent to leaving Mr. West, when he was commencing his successful career as a portrait-painter, Mr. Dance (whose approbation and advice we have above mentioned,) called upon him and communicated his intention of retiring into the country, at the same time inviting him to come to his house, and take such articles in the way of his profession as would be serviceable to him—that as he was just commencing, he would find ready at his hands many things that he would have occasion for. Stuart happening to call in the absence of his friend, merely took a *palette* and a few pencils. Mr. Dance, a day or two before the sale of his furniture, inquired of his servant if Mr. Stuart had been there? And being informed that he had, and of the moderation he had shown in availing himself of the offer made, immediately sent him a mass of material for his painting room, not only in the highest degree useful, but far more costly than his finances could have afforded at that time. The palette, Mr. Dance afterward informed him, was the one formerly possessed and used by Hudson.

"Mr. Stuart," says Mr. Fraser, "made this exhibition of his palette doubly interesting, by a short dissertation on the use of it, describing the colours employed by him for portrait-painting, with their several gradations. This was done at my request with a readiness and freedom characteristic of great liberality and kindness."*

* In the year 1813, the writer, who as a youth had known Stuart in London, from 1784 to 1787, visited Boston, and renewed his acquaintance with the great portrait-painter. On one occasion, having shown him a miniature he had recently painted, Stuart advised him to paint in oil, adding, "You painted in oil when in London." "Yes, but after having abandoned the pencil for twenty years, I found it easier to make an essay with water colours on ivory, and *in little* than to paint portraits in large with oil. I do not know how to set a palette." "It is very simple," said he. "I will show you in five minutes," and he pointed out on his own palette the unmingled colours, and their tints as mixed with white or each other; first, and nearest the thumb, pure white, then yellow, vermilion, black and blue. Then followed yellow and white in gradation; vermilion and white in gradations; black and yellow— black and vermilion; black, vermilion, and white in several gradations; black and white; and, blue and white. "And for finishing, add lake to your palette, and asphaltum." Later in life, when he lived on Fort-hill, Boston, he gave me another setting of the palette. This was in 1822. I passed the morning with him, and sat for the hands of Mr. Perkins's picture, for the Atheneum, of which he was the munificent endower. The palette Stuart then worked with, as he pointed it out to me, was Antwerp blue— Krem's white—vermilion—stone-oker—lake—Vandyke brown, mixed with one-

We have followed Mr. Stuart's eccentric course until we have brought him to the highest seat a portrait-painter wishes to fill—that of a fashionable and leading artist in the great metropolis, where portrait-painting has been carried to its highest perfection. In 1784, and the years immediately succeeding, I saw the half-lengths, and full-lengths of Stuart occupying the best lights, and most conspicuous places at the annual exhibitions of the Royal Academy.

From the commencement of his independent establishment as a portrait-painter in London, success attended him; but he was a stranger to prudence. He lived in splendour, and was the gayest of the gay. As he has said of himself, he was a great beau. I cannot assert, but feel perfectly convinced that pecuniary difficulties induced him to leave London for Dublin, to which latter city, his daughter, Miss Ann Stewart, in a letter to Mr. James Herring, says he was invited by the Duke of Rutland, and that on the day he arrived, the duke was buried.

There is every reason to suppose that Stuart's total want of prudence, or extreme negligence and extravagance, had placed him in that situation, which induces men

> " To do such deeds, as make the prosperous man
> Lift up his hands, and wonder who could do them !"

The following was told to the writer by Joel Barlow, who with his wife, were intimate with Mr. and Mrs. West, and re-

third burnt umber—ivory black. The tints he mixed were white and yellow—vermilion and white—white, yellow, and vermilion—vermilion and lake—(each deeper than the other,) then blue and white—black and yellow—black, vermilion and lake. Asphaltum in finishing. Let us here add, that Reynolds recommended for the first and second sittings of a portrait, only white, yellow, vermilion, and black, for the flesh. This, of course, was after he had been reconciled to vermilion, and dismissed the lake and yellow, which he once substituted for it.

When I asked Stuart if he used madder-lake, his reply was, " I should be madder if I did." This was merely to play upon the word, for like many I have known the jack-o'lantern of a pun, or a witticism, would draw him from the straight and firm path. " Good woman, I saw a man go in your cellar—the door is open." " What does he want there?—the impudent fellow." The good dame runs to her cellar, and finds the vegetable she had bought for pickling. " Mr. Stuart, this is the greatest likeness I ever saw." " Draw aside that curtain, and you will see a greater." " There's no picture here !" " But there's a grater." In the same spirit, he would make himself the hero of a story, purely imaginary, for the sake of a quibble, a point, or a pun. Such is the following, " When I first came to England, my clothing was half a century behind the fashion, and I was told, ' Now you are in England, you must dress yourself as the English do." " Next morning I presented myself with my stockings drawn over my shoes, and my waistcoat over my coat. Then the cry was, ' Boy, are you mad ?' ' You told me to dress as the English do, and they always say,—put on your shoes and stockings —put on your coat and waistcoat—so I have followed the direction." He has even told this as happening in Mr. West's house. Such are the wanderings of wit. But of a departure from truth for any purpose of injuring the character of another, we never heard Gilbert Stuart accused : men of supposed honour have done it—yet truth is indispensable to honour.

ceived the anecdote from them. As it is my maxim, that biography should be truth, and every man who calls public attention to himself, should be truly represented, and thus abide the reward of his actions; *that* which comes to the writer's knowledge respecting the subject whose life and character is under consideration, and is probable from circumstances connected with the individual, known to be true, should be laid before the public, the authority for the related circumstance being given. When biography is mere eulogium, it must be, generally speaking, falsehood ; unless the subject is more than mortal. It was in the year 1806, in the city of Washington, that, when with Mr. and Mrs. Barlow at their lodgings, he showed me the proof impressions of the plates, which Robert Fulton had procured to be engraved for the Columbiad. Conversation on pictures, led to painters, and Barlow gave the following from Mr. West. He said that Stuart, professing great esteem and much gratitude towards Mr. and Mrs. West, (which no doubt he felt,) painted a very fine portrait of the former, and presented it to the latter. The picture was much admired and highly valued. Not long before leaving England, Stuart borrowed the picture from Mrs. West, to make some suggested alterations, and it was sent to him. The reader may judge of Mr. West's surprise, when he saw this picture at Alderman Boydell's, and was told that Stuart had sold it to him. West claimed his property, and Boydell lost his money. From London, Stuart, as we have seen, went to Dublin, and it is probable that English claims followed him to the capital of Ireland. It was currently said, but I can give no voucher except probability, that, being lodged in jail by some of his creditors, he there set up his esel, and was followed by those who wanted portraits from his hand. He began the pictures of a great many nobles, and men of wealth and fashion, received half price at the first sitting, accumulated enough to enfranchise himself, and left the Irish lordships and gentry imprisoned in effigy. We will suppose, that having thus liberated himself, and there being no law that would justify the jailer in holding the half-finished peers in prison, the painter fulfilled his engagement more at his ease at his own house, and in the bosom of his own family ; and it is probable that the Irish gentlemen laughed heartily at the trick, and willingly paid the remainder of the price. It is likewise probable that when Stuart borrowed the full-length of West, he borrowed it only to improve it ; and when he sold it to Boydell that he meant to replace it with another—this is no excuse, for no circumstance or intention can excuse falsehood.

Previous to leaving England, Mr. Stuart married the

daughter of Doctor Coates. This event according to Miss Stuart, took place in 1786. She says, he arrived in Dublin in 1788, and notwithstanding the loss of his friendly inviter, he met with great success, "painted most of the *nobility*, and lived in a good deal of splendour. The love for his own country, and his admiration of General Washington, and the very great desire he had to paint his portrait, was his *only* inducement to turn his back on his good fortune in Europe."

In the London Magazine, it is said, that Stuart made a sketch of the celebrated Mr. Henderson, in the character of Iago, which was engraved by Bartolozzi.

CHAPTER XI.

Mr. Stuart returns to America in 1793—sets up his esel in New-York—removes to Philadelphia—Great portrait of Washington—Mr. Neagle's communication respecting the original Washington portrait—Winstanley and his Washingtons —Anecdotes of similar impositions—History of the Landsdown Washington, and Heath's vile print from it—Jealousy of other artists on seeing Stuart's success with the portrait of Washington.

In the year 1793 Mr. Stuart embarked for his return to his native country, and had for his companion an Irish gentleman of the name of Robertson, a miniature painter elsewhere noticed in these pages. It is well known that Stuart's passions and appetites were of the kind said to be uncontrollable—that is, they were indulged when present danger or inconvenience did not forbid—as is the case with all men who plead temper as an excuse for folly. On the passage from Dublin to New-York, he frequently quarrelled with Robertson, and when under the influence of the devil who steals men's brains if permitted to enter their mouths, he insulted the Hibernian grossly. To stop this, Robertson left the dinner-table, after receiving his share of the wine, and what he thought an undue share of hard words, and going to his trunk returned with a brace of pistols loaded and primed, and insisted upon an apology or a shot across the table. The devil was put to flight, and returning reason, the captain's good offices, and the peace-maker "if," restored harmony for the rest of the voyage.

Stuart landed at and took up his abode for some months in New-York. Here he favoured the renowned, the rich, and the fashionable, by exercising his skill for their gratification; and gave present eclat and a *short-lived immortality* in exchange for a portion of their wealth. He opened an *attelier* in Stone-street, near William-street, where all who admired the art or

wished to avail themselves of the artist's talents, daily resort-
ed. It appeared to the writer as if he had never seen portraits
before, so decidedly was form and mind conveyed to the can-
vas; and yet Stuart's portraits were incomparably better, ten,
twenty, and thirty years after. Many of his portraits were
copied in miniature by Walter Robertson, who had come to
America with him, and who, to distinguish him from the art-
ists of the same patronymic appellation, was called Irish Rob-
ertson. Some of this gentleman's celebrity was owing to the
accuracy of Stuart's portraits; for the ignorant in the art
transfer without hesitation the merit of the original painter to
the copyist.

In New-York, as elsewhere, the talents and acquirements
of Mr. Stuart introduced him to the intimate society of all who
were distinguished by office, rank or attainment; and his ob-
serving mind and powerful memory treasured up events, cha-
racters and anecdotes, which rendered his conversation an in-
exhaustible fund of amusement and information to his sitters,
and his companions. Of the many fine portraits he painted at
this time we remember more particularly those of the Pollock
and Yates family; Sir John Temple, and some of his family;
the Hon. John Jay; General Matthew Clarkson; John R.
Murray, and Colonel Giles.

From New-York the artist proceeded to Philadelphia, for
the purpose, so near his heart, of painting a portrait of Wash-
ington. In this he succeeded fully: but this is an event in his
life on which we must enlarge in proportion to its interest
with us and all Americans. It is needless to say that the art-
ist's pencil was kept in constant employ in the city of Penn
and its neighbourhood. He attracted the same attention, and
rendered the same services, enriching individuals by his gra-
phic skill with pictures beyond price, and his country by models
for future painters to study. He left us the features of those
who have achieved immortality for themselves, and made
known others who would but for his art have slept in their me-
rited obscurity.

Mr. Stuart took to Philadelphia a letter from the Hon. John
Jay to the first president of the United States, the illustrious
Washington. The reader will recollect that congress had
before 1794, removed from New-York, and that Philadelphia
was at this time the seat of federal government. Stuart had
long been familiar with the aristocracy of Europe, the artificial
great, the hereditary lords of the land, and rulers of the des-
tinies of nations; but it appears from the following account
of his first introduction to Washington, as given in conversa-

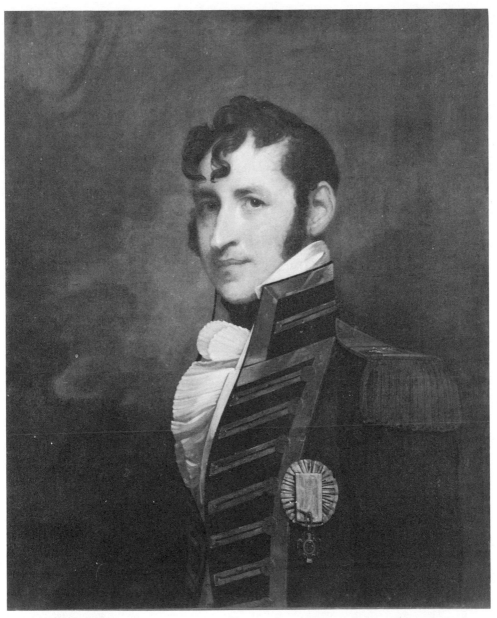

61 STEPHEN DECATUR. Painting by Gilbert Stuart. *Courtesy Independence National Historical Park.*

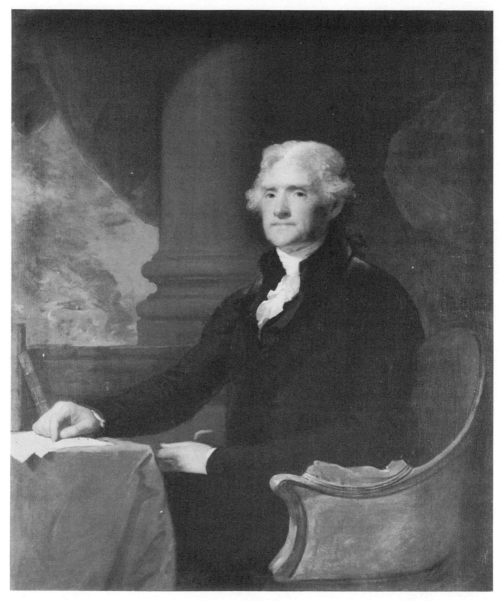

62 THOMAS JEFFERSON. Painting by Gilbert Stuart. *Courtesy Bowdoin College Museum of Art.*

tion with an eminent artist of our country, that, although at his ease with dukes and princes, Stuart was awed into a loss of his self-possession in the presence of him, who was ennobled by his actions, and placed in authority by the gratitude of his fellow-citizens, and their confidence in his wisdom and virtues.

Soon after his arrival in Philadelphia Mr. Stuart called on the president, and left Mr. Jay's letter and his own card. Some short time after, having passed a day in the country, upon his return he found a note from Mr. Dandridge, the private secretary, inviting him to pass that evening with the president. He went accordingly, and on entering a large room, (which he did carelessly, believing it to be an anti-chamber,) he did not distinguish one person from another of the company he found there. But the president, from a dis-tant corner of the room, left a group of gentlemen, with whom he had been conversing, came up to Mr. Stuart and addressed him by name, (probably some one who knew Stuart pointed him out to the president,) and, finding his guest much embar-rassed, he entered into easy conversation with him until he recovered himself. The president then introduced him to the company. This incident I give from the artist to whom Stuart related the circumstance.

In this year, 1794, Stuart painted his first portrait of Wash-ington. Not satisfied with the expression, he destroyed it, and the president consented to sit again. In the second por-trait he was eminently successful. He painted it on a three-quarter canvas, but only finished the head. When last I saw this, the only faithful portrait of the father of our country, it hung, without frame, on the door of the artist's painting-room, at his house on Fort-hill, Boston. This beautiful image of the mind, as well as features of Washington, was offered to the state of Massachusetts, by the artist, for one thousand dollars, which they refused to give. Those entrusted with our national government passed by the opportunity of doing honour to themselves during the life of a man they could not honour, and the only portrait of Washington was left neglected in the painter's work-shop, until the Boston Atheneum purchased it of his widow. It now (together with its companion the por-trait of Mrs. Washington) adorns one of the rooms of that in-stitution.

Stuart has said that he found more difficulty attending the attempt to express the character of Washington on his canvas than in any of his efforts before or since. It is known that by his colloquial powers, he could draw out the minds of his sitters upon that surface he was tasked to represent ; and such

was always his aim. But Washington's mind was busied
within. During the sitting for the first mentioned portrait,
Stuart could not find a subject, although he tried many, that
could elicit the expression he knew must accord with such
features and such a man. He was more fortunate in the second
attempt, and probably not only had more self-possession, but
had inspired his sitter with more confidence in him, and a
greater disposition to familiar conversation.

During his residence at Philadelphia, Mr. Stuart painted
the full-length of the president, for Lord Lansdown. It has
been said that his lordship was indebted to the persuasions of
Mrs. Bingham, of Philadelphia, for this favour. This picture
is in England, and is the original of that vile engraving from
the *attelier* of Heath, which is unfortunately spread through-
out our country, a libel upon Stuart and Washington. Our
fellow-citizen Durand, is now employed in engraving from the
inestimable portrait possessed by the Boston Atheneum, and
the citizens of the United States will have an opportunity of
knowing from his print, when published, how they have been
misled in their ideas of the countenance of the man they most
revere.

Germantown was the painter's place of residence at the
period Washington retired from office, and he rode out and
visited him at that place—a spot so well known to the hero
during his military career. When the president took his
leave, he told Stuart that he would sit to him again at any
time he wished. None but those who know how much this
great man had undergone from the solicitations of painters,
can truly appreciate the value of this compliment to the artist.

The following communication relative to the portraits of
General and Mrs. Washington, is from the pen of Mr. Neagle.
After saying that as well as he could remember, Stuart rela-
ted the circumstances nearly in these words, he proceeds:
" Mrs. Washington called often to see the general's portrait,
and was desirous to possess the painting." (This was the
original picture of which the head only was finished, and from
which Stuart made his copies.) " One day she called with
her husband, and begged to know when she might have it.
The general himself never pressed it, but on this occasion, as
he and his lady were about to retire, he returned to Mr. Stuart
and said he saw plainly of what advantage the picture was to
the painter, (who had been constantly employed in copying
it, and Stuart had said he could not work so well from
another ;) he therefore begged the artist to retain the painting
at his pleasure. Mr. Stuart told me one day when we were

before this original portrait, that he never could make a copy of it to satisfy himself, and that at last, having made so many, he worked mechanically and with little interest. The last one I believe ever made by him, was for Mr. Robert Gilmor, of Baltimore. I asked him if he ever intended to finish the coat and back-ground of the original picture? To this he replied, 'No: and as this is the only legacy I can leave to my family, I will let it remain untouched.'" (Meaning that it would be, as is true, more valuable as it came from his hand in the presence of the sitter, than it would be if painted upon at this late period; for by *painting upon*, it would be more or less altered.)

"Mr. Stuart" (we again copy Mr. Neagle,) "considered that every painter held an inherent copy-right in his own works, and that they should not be copied without the consent of the artist. A copy made of an artist's picture while he lived, and without his consent, he called '*pirating*.' A portrait-painter of the name of Parker had applied to the Pennsylvania academy for the privilege to copy Stuart's full-length of Washington, which is on the walls of that institution; but as the picture belonged to the estate of Mrs. Bingham, the application was refused by Mr. Hopkinson, the president of the academy. Mr. Sully was consulted, and he thought that Mr. Stuart's permission should first be obtained. When I arrived in Boston, (in 1825,) Mr. Stuart had just received a letter from Mr. Parker, and handed it to me to read aloud to him. It was an application to him for the opportunity of copying the full-length Washington, but it was couched in terms that offended the painter. He made some severe remarks upon the writer; among other things he said, 'If I am not much mistaken, this man has not the essentially requisite feelings for a good artist.' His reply he entrusted to me for Mr. Hopkinson, the president of the academy. *It was a denial.* He said, 'I am pleased that Mr. Hopkinson has referred the question to me, it is what I would expect from him. My answer will be found in a number of the Spectator, mentioning it, and my feelings understood, by referring to that paper: the only difference is, that Addison speaks of pirating the works of an author. Substitute for *author* the word *painter*.' One Sunday morning Mr. Stuart opened the Spectator while Mr. George Brimmer, Mr. Isaac P. Davis and myself were with him, and had this paper read aloud."

With a knowledge of such feelings and opinions, the reader may judge of the painter's reception of a proposal made in the following manner: "When I lived at Germantown," said

Stuart, "a little, pert young man called on me, and addressed me thus,—'You are Mr. Stuart, sir, the great painter!' 'My name is Stuart, sir.'" Those who remember Mr. Stuart's athletic figure, quiet manner, sarcastic humour, and uncommon face, can alone imagine the picture he would have made as the intruder proceeded:—"'My name is Winstanley, sir; you must have heard of me.' 'Not that I recollect, sir,' 'No! Well, Mr. Stuart, I have been copying your full-length of Washington; I have made a number of copies; I have now six that I have brought on to Philadelphia; I have got a room in the state-house, and I have put them up; but before I show them to the public, and offer them for sale, I have a proposal to make to you.' 'Go on, sir.' 'It would enhance their value, you know, if I could say that you had given them the last touch. Now, sir, all you have to do is to ride to town, and give each of them a tap, you know, with your riding-switch —just thus, you know.'"

Stuart, who had been feeding his capacious nostrils with Scotch snuff, shut the box, and deliberately placed it on the table. Winstanley proceeded, "'And we will share the amount of the sale.' 'Did you ever hear that I was a swindler?' 'Sir! —Oh, you mistake. You know—' The painter rose to his full height. 'You will please to walk down stairs, sir, very quickly, or I shall throw you out at the window.'" The genius would have added another "you know;" but seeing that the action was likely to be suited to the word, he took the hint, and preferred the stairs.

Stuart continued the story of Winstanley and his Washingtons, by saying, that one of these pirated copies was the cause of his being employed to paint the full-length of Washington, which adorns Faneuil-hall: a picture which, in my opinion, speaking from recollection, is the best portrait of the hero, with the exception of the head purchased by the Atheneum, ever painted. If so, Boston possesses in her public buildings, the two most perfect representations of the father of his country that are in existence. Stuart told our friend Fraser that he painted this picture in nine days. Certainly, it is in one sense, a nine days' wonder. The circumstances which led to it he thus narrated, after telling the anecdote of Winstanley's visit to Germantown.

"One of these full-length Washingtons, which only wanted a magic touch from my finger, my maul-stick, or my riding-whip, was brought to Boston by the manufacturer, who likewise brought letters of introduction to our great men, and among others to Mr. ———, a rich merchant and devoted

federalist, it being then warm party times. In this gentleman's family and society the little Englishman made himself agreeable to such a degree, that he borrowed five hundred dollars of the merchant, offering as security my full-length portrait of Washington painted by himself, as you may suppose; but that could not be seen by the connoisseur of the counting-house. The money was lent, the picture received as security, and the swindler never seen more. After a time the precious deposit was offered for sale, as Stuart's Washington. The real connoisseurs laughed, and the merchant found he was bit. It would not do for the Boston market, so he sent it by one of his *argosies* to foreign parts, but it returned again and again unsold, and, like some other travellers, unimproved. It would not pass for Stuart's Washington with any one but himself. At length, he determined to show his patriotism and present it to the town, which was done in all due form. In the mean time I had removed to this place, (Boston.) The picture had been put up in Faneuil-hall. A town meeting had been called on political affairs, and federalists and democrats were arrayed in bitter hostility in the hall, when one of the democratic orators seized on the opportunity for attacking his opponents, by exposing the mock generosity of the federal merchant, and to the great amusement of the audience, told the story of the picture, exposed its worthlessness, and related its adventures. The effect was electrical, and spread through the town. The connoisseur was pointed at and almost hooted by the boys. What was to be done? His friends suggested his defence, ' He had been deceived, he thought it a real Simon-pure. There was no crime in not being a judge of painting, and to show his generosity, he must apply to Stuart to paint a Washington for the town.' This was a bitter pill. ' How much would it cost?' ' Six hundred dollars perhaps.' ' Five and six are eleven.' ' Something must be done, and quickly.' ' But how can I call on Mr. Stuart after this affair—he may insult me.' ' We will negotiate the matter.' I was called upon by Mr. ———'s friends, and to the proposal answered, ' Certainly, gentlemen.' ' Will you do it immediately?' ' Immediately.' ' The price?' ' Six hundred dollars.' It was agreed upon, and in a few weeks the picture took its place in the Town-house, and the merchant paid me in uncurrent bank-notes, which I had to send to a broker to be exchanged, I paying the discount.' " This we give as a Stuart story. All we vouch for is, that he told it without reserve.

Another of Winstanley's surreptitious full-length Washingtons long disgraced the president's house at the city of Wash-

ington. The story is worth telling, and belongs to our subject.

It is well known that the first full-length of his illustrious subject which the great artist painted, was sent to Lord Lansdown. The second was painted for Mr. Gardner Baker, of New-York, for his museum. The third for Mr. Constable—which is now at Mr. Pierpont's, at Brooklyn.

Mr. Baker in the course of business became the debtor of Mr. Wm. Laing, who, in process of time, received the second picture in payment. Mr. Laing being in the metropolis when the president's house was being furnished, suggested the appropriateness of such a picture as he possessed, for such a place, and eventually sold the portrait to the committee who directed the business. Unfortunately only knowing Winstanley as a painter, he sent to him a commission for packing up and shipping the original Stuart. Winstanley received it, and packed up one of his copies instead, which was unsuspectingly received and put up in the palace. This cheat was not discovered until after Stuart removed to the city of Washington, when he at a glance, saw that the picture was not from his pencil and disclaimed it. In the meantime the rogue had returned home with his prize, and Mr. Laing, after making every effort to regain the picture, refunded the money. A similar trick was played by a Frenchman, in respect to one of the first portraits Stuart painted on his return to America. The picture was that of Doctor Johnson, president of Columbia college, which having been left with one of his sons, this Frenchman, known to the son as a painter, solicited the loan of this very fine portrait as a study. Mr. Johnson complied, and the picture was detained for a long time ; at length a copy was sent which deceived Mr. Johnson, and the swindler kept the original. Fortunately for the family and for justice, Mr. David Longworth, a liberal publisher and friend of the arts, discovered that the original Stuart remained with the Frenchman, who had removed to Boston, and after some difficulty succeeded, probably by threats, in gaining possession of the picture, and sent it to Doctor Johnson, with a letter congratulating him on the recovery.*

These anecdotes will remind the reader (who reads such things,) of the story told by Roscoe in his Catalogue published in 1816, of an imposition practised by one of the Medici upon the Duke of Mantua, who had obtained from the pope, Clement VII., a gift of Raffeale's portrait of Leo X., then at Florence,

* This anecdote comes from Wm. S. Johnson, Esq., a grandson of the venerated Doctor.

and ordered it to be sent to Mantua. The Florentine Medici instead of so doing, sent for Andrea del Sarto, and employed him to make a copy, which done, he held the original and sent the copy to the amateur duke. The story of the deception is worth attention, and will be found as above, and in the Life of Roscoe by his son. Here it was not the painter that was the rogue, but the proprietor; and another dissimilarity is, that the copy was pronounced as good as the original.

In connection with the portrait of Washington, and in elucidation of the character of Mr. Stuart, we here mention another circumstance. After the painter removed to Boston, the Pennsylvania Academy of Fine Arts appropriated fifteen hundred dollars for a portrait of the hero. Mr. Hopkinson, the president, wrote to Mr. Stuart to engage the picture at that price, expecting, of course, an exertion of his utmost skill—and the artist never answered the letter.

The following is the history of the picture of Washington, painted for Lord Lansdown, and the print published from it by Heath, as given by the painter to Mr. Neagle. "The marquis gave Mr. Stuart a commission to paint for him a full length, to be sent to London. When the picture was nearly finished, Mr. Bingham, a rich man of Philadelphia, waited upon Mr. Stuart, and begged as a favour, that he might be allowed the honour of paying for the picture, and presenting it to the marquis. Mr. Stuart, after taking time for deliberation, consented. He said that he gave his consent, thinking that the marquis would be gratified by the compliment, but he requested Mr. Bingham to secure a copy-right for him. When the picture arrived in England it attracted general attention, and Mr. Heath, the engraver, was not slow to perceive the advantage that might accrue to himself by publishing a print from it; which he did, with the consent of the marquis, who observed at the time, that Mr. Stuart would be highly gratified by having his work copied by an artist of such distinguished ability."

Accordingly the engraving was announced in London, with the usual puffs; stating that the picture is in the possession of the Marquis of Lansdown; is "the production of that very excellent portrait-painter *Gabriel* Stuartt, a native of America," and an eléve of Benjamin West, Esq. To introduce the eulogium on the engraving, of this execrable libel, on the countenance of Washington, so different from Stuart's pictures, praise is first lavished on the painter. "His pencil has a freedom that is unaffected; his colouring is clear without glare, and chaste without monotony; his style of

composition is animated, yet simple, and he has the happy
facility of embodying the mind, as strongly as he identifies
the person.' After much more, ' puff direct' goes on to say,
" The engraving of this portrait is the work of that very
excellent artist, Mr. James Heath, historical engraver to the
king, and one of the six associate engravers to the royal
academy." The conclusion of the advertisement announces
" that Mr. Heath is joint proprietor of this portrait, with the
Messrs. Boydell and Thompson." Those who know how
tenacious Sir Thomas Lawrence, and other English painters
are, of their right in their pictures, and the sums demanded
for permission to engrave them, may judge of the feelings of
Stuart, when he saw himself excluded from this partnership in
his property. Mr. Neagle proceeds thus :

" Mr. Bingham had not made it a condition with the marquis
that a copy-right should be secured for the benefit of the
painter ; indeed he never mentioned Mr. Stuart's wish, intend-
ing by the next vessel, to beg this provision for the painter's
benefit, as an after thought, which would not appear to lessen
the value of the present. But this proved too late for poor
Stuart. When the next vessel arrived, Heath had made his
copy under the sanction of the owner, and his design was
already on the copper. The matter, however, was never
broached to Stuart, and he told me that the first he knew of it
was in Mr. Dobson's book-store, in Second-street, Philadel-
phia. He was unknown to Mr. Dobson, but was in the habit
of frequenting the store and purchasing books, paper, and
pencils. On one occasion, when calling as usual, Mr. Dob-
son having just received a box of these finished engravings, for
sale on commission, opened it, and showed Stuart an impres-
sion from Mr. Heath's plate ; this was the first intimation he
had of the unwelcome fact, that his prospects of advantage
from a copy-right were annihilated, and the fruits of his
labours snatched from him by one who had no share in his
enterprise, or claims whatever upon that which he had invent-
ed and executed. He was unable to answer Mr. Dobson's
questions respecting the merit of the engraving and the
prospects of sale ; but when he recovered himself, he replied,
' Sir, the work is as infamous in its execution as the motive
that led to it.' ' What,' said Dobson, ' have you the feel-
ings of an American ? What! Do you not respect the man
here represented, nor the talents of the American painter who
executed the original picture ? What would Mr. Stuart
say if he heard you speak thus ?' ' It has been my custom,'
replied Stuart, ' to speak the language of plainness and

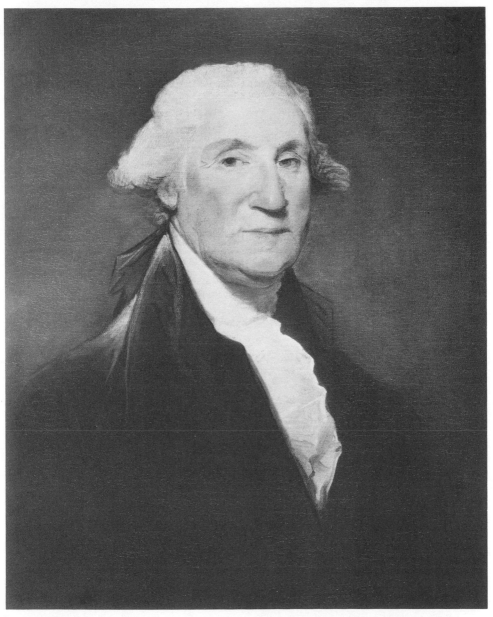

63 GEORGE WASHINGTON (Vaughn Portrait), 1795. Painting by Gilbert Stuart.
Courtesy National Gallery of Art, Washington, D.C., Andrew Mellon Collection.

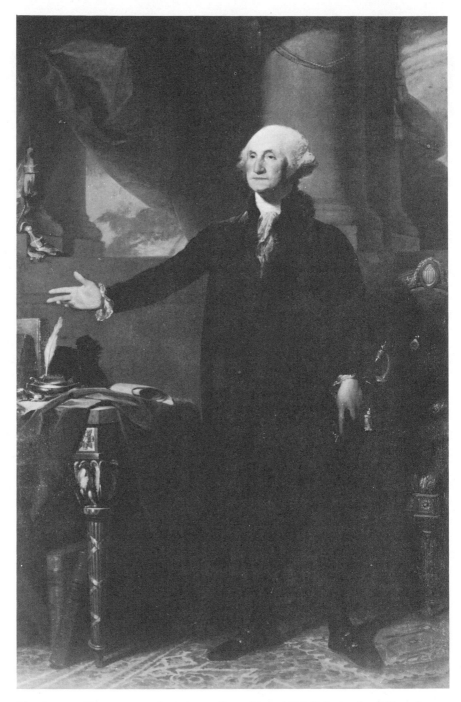

64 GEORGE WASHINGTON (Lansdowne Portrait), *c.* 1796. Painting by Gilbert Stuart. *Courtesy The Pennsylvania Academy of the Fine Arts.*

truth, whenever the character and fortune of any man are thus jeopardized. By this act, the family of the painter is ruined. My name is Stuart. I am the painter, and have a right to speak.' He then related the whole transaction to Mr. Dobson, who returned the prints to the box, nailed it up, and was never known to sell, or offer for sale, one of those engravings, (and as I understood Mr. Stuart,) or any other engraved head of Washington, from his work.

" Mr. Stuart waited upon Mr. Bingham, by advice, to obtain justice, but in vain. They quarrelled, and the painter left unfinished painting that he had commenced for the Bingham family. I saw one beautifully painted head of Mrs. Bingham, on a *kit cat* lead coloured canvass with nothing but the head finished. The rest was untouched."

Such is Mr. Stuart's history of Heath's print of Washington. That " the work is infamous," as it respects the representation of Stuart's picture or Washington's physiognomy, is most true, and " true 'tis pity, and pity 'tis, 'tis true :" this, and other vile libels upon the countenance of the father of his country are spread over the land, leaving such impressions as will make those who see the original portrait by Gilbert Stuart think they look upon the face of a stranger.

The success of Stuart's Washington, and the generally received opinion that he alone had represented the hero truly on canvas, was a sore mortification to those painters who had preceded him. We have seen the president of an academy, when surrounded by the directors, stand before a full-length Washington, by Stuart, and after pointing out to these gentlemen, all worthy physicians, lawyers, or merchants, what he considered, or called, the defects, he has literally to show his contempt, drawn the stick he held in his hand, here and there over the surface, and concluded by saying, " It is like a little old French marquis more than Washington." On another occasion, when sitting to a young artist for his portrait, the subject of Stuart's picture of the first president being introduced, he gave this version of the story. " Mr. Stuart's conversation could not interest General Washington— he had no topic fitted for his character—the president did not relish his manners. When he sat to me he was at his ease." This was to confirm the previously advanced opinion, that Stuart's picture of Washington did not represent the hero's character.

On this subject we quote the opinion of a greater artist. Charles R. Leslie says, after praising Stuart's portrait of Alderman Boydell, and the full-length of Washington, painted

for the Marquis Lansdown, "How fortunate it was that a painter existed in the time of Washington, who could hand him down to us looking like a gentleman."

Charles Wilson Peale had repeatedly painted him, and was mortified to find his efforts forgotten or despised. Stuart has asserted, that it was at his request that General Washington, after sitting to him, consented to sit once more to Mr. Peale, and related the result somewhat in this manner to Mr. Neagle. "I looked in to see how the old gentleman was getting on with the picture, and to my astonishment, I found the general surrounded by the whole family. They were peeling him, sir. As I went away I met Mrs Washington, 'Madam,' said I, 'the general's in a perilous situation.' 'How, sir?' 'He is beset, madam,—no less than five upon him at once ; one aims at his eye—another at his nose—another is busy with his hair—his mouth is attacked by a fourth—and the fifth has him by the button ; in short, madam, there are five painters at him, and you who know how much he has suffered when only attended by one, can judge of the horrors of his situation.' "

We learn from Mr. David Edwin, the well known engraver, and son of the celebrated comedian, long the delight of London, that during the yellow fever, which afflicted Philadelphia, in 1798, he and Mr. Trott, the miniature-painter, were neighbours to Mr. Stuart, near the Falls of the Schuylkill. Edwin was at the time engraving from the painter's portraits. "When I carried him a proof of Judge Shippen's picture," says the engraver, "he had a sitter with him, and the print was sent in. He came out to me, and expressed his gratification on seeing the result of my labour. "You may consider it," said he, "the greatest compliment I ever paid you, when I leave my sitter to tell you how much I am pleased with this head.' When looking at a print from my engraving, of his portrait of Judge McKean, "I will make this look like his son," said he, and taking some chalks, he removed the wig of the judge, and with a few scratches over the face, produced a likeness, when before there was no apparent similarity."

As in times to come this immortal work may be quoted to prove that American judges wore wigs, we will add that in 1798 they only wore them as other old gentlemen did, to cover baldness. As judges' wigs were never worn in the U. S.

Judge Hopkinson has communicated the following anecdote of our artist during his residence in the vicinity of Philadelphia. Contemporary with our great portrait-painter in the

city of Penn, was a great wine merchant, and it is well known that before his return to his native country, Stuart had contracted an unfortunate habit which rendered the dealers in wine very important personages in his estimation. It happened that Mr. Wager's taste for pictures was almost as strong as the painter's taste for Madeira, and he was willing to indulge Stuart's natural palette in exchange for the products of his artificial. Mr. Wager had three portraits painted, value, per bill, three hundred dollars. When the painter and the wine merchant balanced accounts, the dealer in paint and immortality was debtor, per bill, two hundred dollars.

Stuart was an enemy to academies for teaching the fine arts. Fuseli has said, " Academies are symptoms of art in distress." Stuart said they raised up a multitude of *mediocre* artists to the injury of art and its professors. We think he was wrong in his sweeping condemnation, and shall give our opinions and reasons for them in the course of this work. That the number of painters is increased is certain, but the most meritorious take the lead, and are greater in merit in proportion to the number they precede. Stuart pettishly has said, " By-and-by you will not by chance kick your foot against a dog-kennel, but out will start a portrait-painter." Fuseli, after the above sarcasm on academies, was for many years the keeper of that over which West presided, and, in his old age, when criticising the work of Harlowe, after witnessing his ineffectual attempts to draw an arm, exclaimed, " It is a pity you never attended the Antique Academy." So much for the learned keeper's opinion respecting academies. The office of a keeper of an Academy of Design or of the Fine Arts is of the first importance to the institution, and highly honourable ; the keeper is the *teacher*. Where an academy is merely such in name, the keeper may be found, and usually is, some trustworthy mechanic, who never thought of a picture but as something made valuable by a frame. Academies whose members are patrons, not artists, and whose keepers are carpenters instead of painters, are indeed " symptoms of art in distress."

After the foundation of the city of Washington, and the removal of congress to that place, Mr. Stuart followed, taking up his abode where the officers and representatives of the people congregate. At what precise period he removed from Germantown to Washington we do not know. He resided there until 1805, and then removed to Boston, in which city and its suburbs he continued until his final removal by death. While at the seat of government, which was probably from 1800 to 1805, he associated intimately with all the leading

and distinguished men of the time, and painted the portraits of the greater number, as well as those of the reigning belles, residing or visiting the metropolis of the nation, as he had before done at New-York and Philadelphia. In 1806 he boarded and painted at Chapotin's hotel, Broad-street, Boston. I there saw him both in the painting room and at the dinner-table. His mornings were passed in the first and too much of the remainder of the day at the second. His family were not with him.

It was at this time that he again met his early friend Doctor Waterhouse, after a separation of near thirty years. The Doctor writes, " After spending the night at my house, he got up early in the morning, and went into the room where hung this head," (the portrait already mentioned by the Doctor in these words, " The only head of his own, painted by himself, was done for me, and is now in my possession. On the back of it is written, in his own hand, *G. Stuart, Pictor, se ipso pinxit, A. D.* 1778. *Ætatis sua* 24.") " when I heard him talking to it thus : ' Gibby, you needn't be ashamed of that— there is the perfection of the art or I know nothing of the matter.' And after I made my appearance, he said to me, ' I should like to see A. B. or C. attempt to copy it.' I remarked that most people took it for a very old picture. He replied, ' Yes, I suppose so ; I *olified* it on purpose that they should think so,'—punning on the Latin word *oleum*-oil."

This was written by Doctor Waterhouse in 1833, after an interval of more than twenty years, and although Stuart, like Reynolds, might have been surprised to find that his improvement during many years of practice had not been so great as he had thought before he examined his early work, yet we can hardly think that he saw in a picture painted in 1778, " the perfection of the art," and must conclude that his venerable friend has forgotten the precise expression made use of.

Mr. Stuart often expressed a wish to visit New-York, but from the time that he set up his esel at Chapotin's, to the day of his death, his longest journey, I believe, was his visit to Narraganset, the place of his birth. In 1813, I passed many hours with him at his house in Roxbury, adjoining Boston-Neck, and in 1822 I saw him apparently not in so good circumstances and much afflicted with gout, on Fort-hill. I always found him cheerful and ready to impart knowledge from the store his observation had gained and his extraordinary memory retained. It was at this time that I sat to him for the hands of Mr. Perkins' portrait, now in the Atheneum at Boston, to which institution he had been a munificent donor, and had

died after the head of this portrait was finished. It was no task to sit to Stuart; his conversation rendered it a pleasure.

If we judge by the portrait of the Hon. John Quincy Adams, the last head he painted, his powers of mind were undiminished to the last, and his eye free from the dimness of age. This picture was begun as a full-length, but death arrested the hand of the artist after he had completed the likeness of the face; and proved, that, at the age of seventy-four, he painted better than in the meridian of life. This picture has been finished; that is, the person and accessories painted, by that eminent and highly gifted artist, Mr. Thos. Sully; who, as he has said, would have thought it little less than sacrilege to have touched the head.

Mr. Stuart died in the month of July, 1828, in the seventy-fifth year of his age; and was buried in the cemetry of the episcopal church, which he attended during his residence in Boston.

With the most brilliant talents, and, through life, the admiration of every one who approached him or saw his works, Gilbert Stuart died poor. His friends, and the friends of the fine arts in Boston, caused an exhibition to be made of such of his works as could be collected, and the proceeds were appropriated to his family. How many, without a hundredth part of his talents, have passed through life by their own efforts, not only without embarrassment from poverty, but in affluence, merely by following the dictates of prudence; while of Stuart, the delight of his friends and the boast of his country, we are obliged to say, as was said of another professor of the fine arts, "poorly, poor man, he lived! poorly, poor man, he died!"

It has been said that Mr. Stuart, before removing to Boston, made an attempt to provide for his family, by purchasing a farm in Pennsylvania, near Pottsville, and paid part of the money; but did not complete the payments, and finally lost the whole. Of this we can gain no accurate information.

Mr. Stuart married the daughter of Doctor Coates, while residing in London, in 1786. By this marriage he had thirteen children, two born in England. Of these children two were sons, and the eldest son inherited much of his father's talent for painting. Both the sons died early. Several daughters are living. The youngest, Miss Jane Stuart, will be mentioned in another part of this work.

We shall conclude this article by miscellaneous observations, facts, and anecdotes, relative to the subject of it.

When the celebrated George Frederick Cooke was playing

at Boston, Stuart painted his portrait for an admirer of the
tragedian ; and it happened that the last sitting was appointed
for a day immediately following one of the actor's long sit-
tings for another purpose. He began the sitting in full glee,
under the influence of some brandy toddy ; " and Stuart, al-
ways full of anecdote, which he happily applies to keep alive
the attention of his *patients*, and elicit the peculiarities of their
character, exerted himself to keep up the animation which
sparkled in George Frederick's eyes ; but after a short time,
his endeavours were in vain. His eloquence failed ; and the
subject of his attention dropped his chin upon his breast, and
slept as comfortably as though he had gone to church. Stuart
had tried to rouse him by—" a little more up, if you please—
a little more this way—" but finding all in vain, he very deli-
berately put down pencil and pallette and took out his snuff-box.
The painter having made this appeal to his nose, got up—took
another pinch—looked at Cooke—shrugged his shoulders—
walked to the fire place, and then continued to apply the stim-
ulating dust in most immoderate quantities, like the represen-
tative of Sir Fretful, in the Critic. Cooke at last awoke ; and
addressing himself to the chair Stuart had left vacant, protested
that he believed he had been asleep. " I beg pardon, Mr.
Stuart, I will be more attentive." Stuart, who stood behind
him, gave no other answer, but—" The picture's finished,
Sir."

There were many points in which these two eccentric men
of genius resembled each other ; but Stuart was much supe-
rior in general information, in wit and in repartee. They
were both fond of telling a story, and not sparing in embel-
lishment. It has been remarked, that it is more from a care-
lessness about truth, a want of due respect for its importance,
than from intentional misrepresentation, that there is so much
falsehood in the world. This carelessness, and the habit of
talking to endeavour to call forth the character of his sitters,
caused in Mr. Stuart a laxity in his statement of incidents that
was at once amusing, curious, puzzling, and lamentable. Yet
this carelessness, censurable as it is, does not debase character
so much as intentional and premeditated falsehood. The
first renders us doubtful respecting assertions made relative to
events or persons, and fixes a character of levity on the man
who habitually practises it. The other belongs to the system-
atic man of deceit, who misrepresents for purposes of self exal-
tation, or for the injury of others, and marks a mind addicted
to turpitude ; from the possessor of which we shrink as from a

venomous reptile. Mr. Stuart had none of the latter character.

Of Mr. Stuart's power or faculty of recollection the following circumstance has been published. When he resided in Dublin, which must have been about 1788-9, a young lad, afterwards, during a long life, a citizen of Philadelphia, was an apprentice in a book store, nearly opposite the house, in Pill-lane, where the painter lodged. This citizen's portrait was painted in Philadelphia, a few years since, by Mr. John Neagle; who shortly afterwards making a visit to Boston, for the purpose of seeing Mr. Stuart, (a pilgrimage many a painter has made) took the portrait with him, as a specimen of his talents. When presented to Stuart he gazed at it for a while, and then pronounced the name of the person for whom it was painted, declaring that he had known him in Pill-lane, Dublin. The citizen in question was in Boston not long before the painter's death, and went with Mr. O. C. Greenleaf to see Mr Stuart, requesting his companion not to mention his name. As soon as he entered the room Mr Stuart came up to him familiarly, shook him by the hand, accosted him by name, and told him that he had recognised his portrait as that of his former acquaintance of Pill-lane.

His powers of recollection were further exemplified in the case of a gentleman of Charleston, South Carolina, whose portrait he had formerly painted. After an absence of at least twenty-five years, the gentleman called on him in Boston, and was shown up to the room in which he was painting. He knocked, and was invited to walk in. On opening the door, finding that the artist was engaged he was retiring, when Stuart addressed him by name, as if he had recently seen him, and insisted on his coming in.

Of the rapidity with which he caught the form, and recognised a person before known, Mr. Edwin mentioned this instance. "I entered Boston in the evening, in a stage-coach, and next day visited Mr. Stuart, 'I knew you were in Boston,' said he. 'I only came last evening, sir, and this is the first time I have been out.' 'I saw you—you came to town, like a criminal going to the gallows—back foremost.' I had been sitting on the front seat."

On this occasion, Mr. Edwin mentioned Stuart's well known aversion to Jarvis; the latter had arrived at the same time with Edwin, and wished to call on Stuart, but Edwin avoided going with him. "When I saw Stuart a second time, I remarked, that he had had a visit from Mr. Jarvis: 'Yes,' said he, 'and he came to see me *in his buffs*. He had buff gloves—

buff jacket—buff waistcoat and trowsers—and buff shoes.' I mentioned this remark to Jarvis, and when he called on Stuart again, he wore black. I told Stuart, that I repeated his description of the buffs, and reminded him of the second call, in black. He jumped up, and clapt his hands, laughing heartily: 'So! I caused him to put his buff in mourning.' "

Another time that Jarvis had called on Stuart, he made his appearance in a short coatee with large pockets, and the old man described him as "all inexpressibles and pockets." Instances were mentioned of Stuart's power of painting likenesses from memory. He had so painted his own grand-mother, and several others with great success. This was owing to his observation of expression and character, rather than feature. "You have Hull's likeness here," said he to Edwin, looking on the engraving from his portrait of the naval commander. "He always looks as if the sun was shining in his face, and he half shuts his eyes as he gazes at him."

The English ambassador, known in this country by the appellation of Copenhagen Jackson, told Judge Hopkinson, that when he was about leaving England for America, he called on Mr. West, and asked him to recommend a portrait-painter. Telling him that he was going abroad. "Where are you going?" "To the United States." "Then, sir, you will find the best portrait-painter in the world, and his name is Gilbert Stuart." Mr. Jackson visited Stuart, and told him the words of his old master. "I saw the portraits he painted for him," said Mr. Hopkinson, "and they were admirable likenesses of the ambassador and his wife."

It is remembered by many that Stuart generally produced a likeness on the pannel or canvas, before *painting in* the eyes, his theory being, that on the nose, more than any other feature, likeness depended. On one occasion, when a pert coxcomb had been sitting to him, the painter gave notice that the sitting was ended, and the dandy exclaimed on looking at the canvas, "Why—it has no eyes!" Stuart replied, "It is not nine days old yet." We presume our readers need not be reminded that nine days must elapse from the birth of a puppy, before he opens his eyes.

Mr. David Edwin engraved many portraits from the works of Stuart, and had much intercourse with him. In a letter before us he says, " Mr. Stuart has been thought by many to have been harsh and repulsive in his manners: to me he never appeared so; and many of those who thought they had cause to complain, have possibly brought his ill temper on themselves by want of manners, or some other cause. Perhaps he prac-

tised too often the advice which he said had been given him by Lord Thurlow, who on one occasion said to him, " If any man speaks disrespectfully of either you or your art, give him battle, my boy ! Give him battle !" This system might undoubtedly appear sometimes " harsh and repulsive ;" and perhaps his nephew Stuart Newton found it so, for I have been told that his bitter expressions of dislike to his uncle, originated from a repulse of this kind. Newton had been receiving Stuart's instruction in painting, and on one occasion, under the influence of high animal spirits, and little observant of the present humour of his instructor, he abruptly entered Stuart's room, and flourishing his pencil, cried, " Now, old gentleman ! I'll teach you to paint !" This joke came unseasonably it seems, and the reply was, " You'll teach me to paint, will you ? and I'll teach you manners !" and not happening to have the gout at the time, he kicked the youth out of his room.

Of the painter's inveterate habit of snuffing we have already spoken. Mr. Edwin relates the following instance of the slavery to which his nose subjected him. Having engaged to dine with him, the engraver went early and found that he had not returned from his morning's walk. By and by in came Stuart, apparently in a state of great agitation, and passing his guest without speaking, or even noticing him, went to a closet and took out a bundle. Edwin was fearful that he had offended him unknowingly, and sat rather uneasily, observing his motions. He took from the bundle some tobacco, a grater, (probably the identical grater which occasionally was stationed behind the curtain to help the master to a pun instead of a pinch,) and a sieve. His nerves were so agitated that with difficulty he manufactured the precious article, which he had inhaled with his first breath—but succeeding, he hastily took a large dose ; his uncommon tremor seemed suddenly to forsake him, and greeting his guest cordially, he exclaimed, " What a wonderful effect a pinch of snuff has upon a man's spirits."

He had forgotten to replenish his snuff-box before going out and was so enslaved by habit, that he could not even recognise an acquaintance, in his own house, until the appetite was satisfied.

Another pinch of snuff. The writer on occasion of one of his visits to Boston, had a sea-captain, an elderly man, of some humour, for a companion, who was, like Stuart, a slave to snuff, and like him had most capacious nostrils. The sailor invariably applied the stimulating dust to his right nostril. Seeing at length that his companion observed this, he

remarked, "You see, sir, I have always a nostril in reserve. When the right becomes callous after a few weeks usage, I apply for comfort to the left; which having had time to regain its sense of feeling, enjoys the *blackguard*, until the right comes to its senses. When I visited Stuart, I told him of the sailor's practice. "Thank you!" said he, "it's a great discovery. Strange that I should not have made it myself when I have been voyaging all my life in these channels."

Stuart once asked a painter, who had met with a painter's difficulties, "how he got on in the world?" "Oh," said the other, "so, so! hard work—but I shall get through." "Did you ever hear of any body that did not?" was the rejoinder.

Of the merits of his pictures, when collected for exhibition, after his death, we have heard some speak disparagingly.— These pictures are mostly heads. Now a gallery of heads, many of them portraits of persons unknown, and many of those who have been long since forgotten, must ever be an uninteresting exhibition to most. Some of these pictures were said to be positively bad. I am free to say, that I never saw a picture by Stuart that did not show a skill in handling, and a mind in dictating, far above mediocrity. His best pictures are beyond all praise. An impudent pretender to criticism has said, that "Stuart painted bad pictures enough to damn any other man." This was said because it had point and was bold; but it is as false as the author is ignorant of the art he criticised. Others again have said, Stuart's females were always poor, compared to his portraits of men. I doubt that, and remember some truly splendid. Mr. Isaac P. Davis has two heads on one canvas that may defy competition. I have seen unfinished and carelessly finished, and slovenly pictures, by Stuart, but I never saw a bad one: His last portraits, or those painted in Boston, are his best.

In corroboration of my opinion respecting the merit of Stuart's works, after his removal to Boston, I here insert an anecdote related by Mr. Sully. Mr. Allston, at Sully's request, accompanied him to the house of Mrs. Gibbs, where Allston's fine picture of Elijah was to be seen. After looking at this, Miss Gibbs invited them into another room, to see a portrait of her father by Stuart. Sully says, he almost started at first sight of it: and after he had examined it Allston asked, "Well, what is your opinion?" The reply was, "I may commit myself and expose my ignorance; but, in my opinion, I never saw a Rembrandt, Rubens, Vandyke, or Titian, equal to it. What say you?" "I say, that all combined could not have equalled it."

Mr. Neagle says, speaking of this same portrait, " There was a portrait, by Stuart, that Mr. Allston regretted that I could not see ' the house of the owner,' being at the time shut up. He spoke of it, not only as the best American portrait, but said, that ' Vandyke, Reynolds, and Rubens, combined, could not have produced so admirable a work. Mr. Sully has described it as a portrait of a man of middle age, looking out. His hair was dark, but becoming silvery, and the grey and dark hairs were mingled. Mr. Sully told me, *it was a living man, looking directly at you.*"

We extract the following from Mr. Neagle's manuscript notes.—" When I knew him, he carried two boxes of snuff, each nearly as large round as the top of a small hat. I remember he offered me a pinch of each: and when I asked him what was the difference, he replied, ' One box is common and one superior ; the first is for common, every day acquaintance, the second for paticular friends ; therefore, take you a pinch of the best.' This was his humour, and I never felt so much ease in the company of any superior man as in his, nor ever received so much improvement in conversation on the arts from any other. I have drank wine and taken snuff with him ; and I must agree with David Edwin, that those who smarted under his resentment, must have brought it on by their own imprudence or presumption. I shall never forget his kindness to me. His family appeared to fear him. He had an odd way of addressing his wife. He called her Tom several times in my presence. I have often remarked, that Mr. Stuart made use of fewer technicals than any other artist with whom I ever conversed. Mr. Edwin has made the same observation. While criticising a half finished engraving, he would not talk of *breadth, drawing, proportion,* or the like ; but would say of a portrait, ' this man's eyes appear as if he was looking at the sun.' Instead of saying, make a back ground *neutral,* he would say, ' Make nothing of it.' His feelings were sore on the subject of the Washington portrait, by Rembrandt Peale. He imagined there was much quackery in that affair. In answer to a question I put to him on that picture, and the certificate, he said, ' Si qui decipientur decipiuntur.' He did not appear to me to be happy, yet was always ready to converse, had a fund of anecdote, and was then cheerful. He was particularly eloquent on the subject of arts and artists ; and when he wished he could wield the weapons of satire and ridicule with peculiar force, seize the strong point of character, placing it so dexterously in the light he wished, that the impression was irresistible and not easily ef-

faced. His plan with his sitters was, to keep up an agreeable but gentle conversation, keeping his mind free and fixed on his work. He commenced his pictures faint, like the reflexions in a dull glass, and strengthened as the work progressed, making the parts all more determined, with colour, light, and shade. Mr. Stuart, at the time I visited him, had suffered from paralysis : the left side of his face was contracted, and he called my attention to this fact when I was about to commence his portrait ; and advised me, for the sake of perspective representation, in such cases, to place the withered side farthest from the eye. His hands shook at times so violently, that I wondered how he could place his brush where his mind directed. He laughed at the portrait of himself painted by C. W. Peale, and placed by him in his museum at Philadelphia : he said it was an awkward clown. He had been solicited repeatedly by letter, and verbally, in this country and in Europe, to sit for his portrait. Frothingham asked him, and he admired Frothingham ; yet he never sat to him. —That he should have honoured me, an humble artist and a stranger, by not only sitting for one portrait entire, but by sitting for the completion of a copy, is singular. My portrait is the last ever painted of this distinguished artist. I presented it to Mr. Stuart's friend, Isaac P. Davis, Esq. and it is now I think, the property of the Boston Athenæum. He said he never could make a finished drawing on paper. I asked why he and Mr Allston did not get up an Academy of Arts in Boston : he said that men of wealth and pretension generally interfered, to the detriment of arts and artists.

"The following dialogue passed between us, as nearly as I can remember the phraseology : it was when my portrait of Mr. Stuart was in progress, in the summer of 1825. He had stepped out of the painting room, (it was at his own house) and in the mean time, as a preparation for his sitting, I placed alongside of my unfinished portrait one painted by him of Mr. Quincey, the mayor of Boston, with a view of aiding me somewhat in the colouring. When he returned and was seated before me, he pointed to the portrait of the mayor, and asked, 'What is that?' 'One of your portraits.' 'Oh, my boy, you should not do that!' said he. 'I beg your pardon, Mr. Stuart, I should have obtained your permission before I made this use of it; but I have placed it so carefully that it cannot suffer the least injury.' 'It is not on that account,' said he, 'that I speak : I have every confidence in your care : but why do you place it there?' 'That I might devote my mind to a high standard of art,' I replied, 'in order the

more successfully to understand the natural model before me.'
' But,' said he, ' does my face look like Mr. Quincey's?'
' No, sir, not at all in the expression, nor can I say that the
colouring is even like ; but there is a certain air of truth in
the colouring of your work which gives me an insight into
the complexion and effect of nature ; and I was in hopes of
catching something from the work of the master without imi-
tating it.' ' As you have heretofore,' said Mr. Stuart, ' had
reasons at command for your practice, tell me what suggested
this method.' ' Some parts of the lectures of Sir Joshua
Reynolds,' which I repeated to him. ' I knew it,' said he ;
and added, ' Reynolds was a good painter, but he has done
incalculable mischief to the rising generation by many of his
remarks, however excellent he was in other respects as a writer
on art. You may elevate your mind as much as you can ;
but, while you have nature before you as a model, paint what
you see, and look with your own eyes. However you may
estimate my works,' continued the veteran, ' depend upon it
they are very imperfect ; and the works of the best artists have
some striking faults.'

" He told me that he thought Titian's works were not
by any means so well blended when they left the esel, as
the moderns infer from their present effect. He considered
that Rubens had a fair perception of colour, and had stu-
died well the works of the great Venetian, and that he must
have discovered more tinting, or *separate tints*, or distinct-
ness, than others did, and that, as time mellowed and incorpo-
rated the tints, he (Rubens,) resolved not only to keep his
colours still more distinct against the ravages of time, but to
follow his own impetuous disposition with spirited touches.
Mr. Stuart condemned the practice of mixing a colour on a
knife, and comparing it with whatever was to be imitated.—
' Good flesh colouring,' he said, ' partook of all colours,
not mixed, so as to be combined in one tint, but shining
through each other, like the blood through the natural skin.'
Vandyke he much admired, for the intelligence of his heads
and his freedom. He spoke well of Gainsborough's flesh, and
his *dragging* manner of tinting ; but could not endure Cop-
ley's laboured flesh, which he compared to tanned leather.' "

We copy these reminiscences of the conversation of Mr.
Stuart, and consider them valuable. What is said of flesh
" partaking of all colours," will remind the reader of Stuart's
remarks on West's mode of teaching, as given in a preceding
page, when he was speaking to Trumbull. Mr. Copley's

manner was not always like " tanned leather" in his flesh: some of his pictures deserve the censure—but our opinion of his works is already given.

We all know that Mr. Stuart sometimes neglected the draperies of his pictures, leaving them in a most slovenly style of unfinish. " I was with him one day," said Mr. Trott, " when he pointed to the portrait of a gentleman, saying, ' That picture has just been returned to me, with the grievous complaint that the muslin of the cravat is too coarse. Now, sir,' he continued, with increasing indignation, ' I am determined to buy a piece of the finest texture, have it glued on the part that offends their exquisite judgment, and send it back again.' "

On one occasion (probably more than one) his sense of propriety was tortured by the want of taste in the dress and decoration of a sitter. This is the common fate of portrait painters. A mantua-maker of Boston had drawn a great prize in the lottery; and imagining that wealth made a fine lady of her, determined that at least her appearance should be fine, and decorated herself with all the choice trumpery of her own shop, the glittering gew-gaws of the jewellers, and, with the addition of hair powder and rouge, presented herself to the great portrait painter for immortalization. There were times and humours in which he would have refused the task; but he consented to share the prize, and painted the accumulation of trinket and trifle, as if determined to raise a monument to folly. " There," said he to a friend, pointing to the picture, " is what I have all my painting life been endeavouring to avoid, —vanity and bad taste."

Stuart, before drawing in a portrait, observed which side of the face gave the best outline of the nose, and chose *that* as the side nearest the spectator's eye. He always asserted, that likeness depended more upon the nose than any other feature; and often related a real or imaginary conversation, in which Chas. Fox, Lord A—, Lord B—, and Lord C—, with himself, were the interlocutors. He would give the arguments of one for the mouth, another, (Fox) for the brow, most for the eyes; and concluded by convincing them, and the person to whom he addressed himself, that the nose was the key feature of portraiture, by putting his thumb under his large and flexible proboscis, and turning it up, so as to display the ample nostrils, he would exclaim, " Who would know my portrait with such a nose as this?"

When asked why he did not put his name or initials, to mark his pictures, he said, " I mark them all over."

In a letter before us Mr. Sargent says, "Stuart, you may remember was very fond of story-telling, and like all other story tellers was very apt to repeat them; but the climax of this sort of thing was his repeating stories to others, who had told them originally to him. I once told him a story that was very interesting and original, at which he laughed immoderately, and on meeting me the next morning, he said he had a good thing to tell me—what was my surprise when he told me my own story! Knowing his peculiar temper, I let it pass, and we both laughed heartily—but we were laughing with very different views of the subject."

Doctor Waterhouse says, that the task of writing Stuart's biography was expected from him even before the painter's death, "which induced his widow, when it happened, to express her uneasiness, and to beg of me not to do it." This was in consequence of some real or supposed difference between the friends in the decline of life. The Doctor in a letter before us says, "Gilbert Stuart and I *never quarrelled;* I withdrew from him and his hot-headed companions, when *nullification* reigned in New-England." And again, "Stuart vindicated me at the dinner and supper tables of the *Essex junto,* or *nullifiers* of that day, amidst their insults and toasts, until the getting up of the Hartford Convention, when I took my stand against it, and when the current in its favour ran so strong that Stuart thought it for his interest to yield to it while I opposed it with all my might; of course, Gilbert and I found ourselves on opposite banks of the river."

In another letter, the same writer says, "It should be borne in mind, that he had been on the stage as a most eminent head painter, nearly sixty years, and that he had painted all the presidents of the United States, the present one excepted, (1833) and most of the distinguished characters of the revolution, and that Sir Joshua Reynolds himself sat to him, and that, take him altogether, he was one of the most extraordinary men our country has produced. When I quitted England, and entered the University of Leyden, I received no letter from Stuart; only verbal messages and kind wishes. During my residence at that seat of science, he married and went over to Ireland, and I never saw him afterwards, till he called upon me here in Cambridge, in, I think, 1802," (1805.) "and then I found him a much altered man. He had, it seemed, relished Irish society, particularly their conviviality." "He would sometimes spend several days together at my house, and remain as long as his snuff lasted, and then nothing could detain him from Boston."

On another occasion, Doctor Waterhouse writes, " My knowledge of him was during his struggles up the hill of fame, and not when he had surmounted it, and sat down with his bottle to enjoy the scene below him." " His prosperity did not operate upon him as it operated on the judicious and strictly moral Benjamin West." " I shall say, that after 1778 Mr. Stuart came into notice as a portrait painter in London, and painted several distinguished characters, and was for a time in the high road to fame and fortune, and would have secured both, had he duly estimated, like West and Reynolds, the great value of his art, and wisely appreciated the short lived gratification of a man of wit and pleasure in London, that whirlpool of dissipation, which has engulfed many a bright genius before the time of Gilbert C. Stuart." Again he says, " He was a man of genius and a gentleman. He saw the great merit of an artist without envy. He never appeared to damn with faint praise. When merit was mistaken, he was silent, and when praise was richly deserved, he gave it liberally. There are a thousand anecdotes, good, bad, and indifferent, many of them unworthy of his powerful mind." We have given one from the Doctor, and leave the reader to class it—we give another. " A gentleman of an estimable character, and of no small consequence in his own eyes, and in the eyes of the public, employed our artist to paint his portrait, and that of his wife, who when he married her was a very rich widow, born the other side of the Atlantic. This worthy woman was very homely, while the husband was handsome, and of a noble figure. The painter, as usual, made the best of the lady, but could not make her so handsome as the husband wished, and preserve the likeness. He expressed in polite terms his dissatisfaction, and wished him to try over again. The painter did so, and sacrificed as much of the likeness to good looks, as he possibly could, or ought. Still the complaisant husband was uneasy, and the painter was teazed from one month's end to another to alter it. At length he began to fret, and to pacify him Stuart told him that it was a common remark, that wives were very rarely, if ever, pleased with pictures of their husbands, unless they were living ones. On the other side, husbands were as seldom pleased with the paintings of their beloved wives, and gave him a very plausible reason for it. Once they unluckily both got out of temper at the same time, and snapped out their frettings accordingly. At last the painter's patience, which had been some time threadbare, broke out, when he jumped up, laid down his palette, took a large pinch of snuff, and walking rapidly up and down the room, exclaimed, ' What a —— business is this of a portrait-

painter—you bring him a *potatoe*, and expect he will paint you a peach.'

One of the most unequivocal testimonies to the truth of Stuart's portrait of Washington is, that when Vanderlyn was employed by congress to paint a full-length of the hero for the nation, it was stipulated that he should copy the countenance from Stuart's original picture in the possession of the Boston Athenæum.

Immediately upon hearing of the decease of our great portrait-painter, the artists of Philadelphia met, and published a number of resolutions expressive of their regret.

I will close this biographical notice of Gilbert Stuart, by an extract from a letter dated Oct. 15, 1833, from Mr. Allston, and another from the publication he mentions. "I became acquainted with Stuart after my return from Italy, and saw much of him both before, and since my last visit to Europe. Of the character of our intercourse you can form an opinion from these few lines, extracted from an obituary notice of him I wrote (published in the Boston Daily Advertiser, a few days after his decease;) his uniform kindness, and the unbroken friendship with which he honoured the writer of this, will never be forgotten. To this I may add, that I learned much from him in my art." The obituary notice was as follows :

During the last week the remains of Gilbert Stuart, Esq. were consigned to the tomb. He was born in the state of Rhode-Island in the year 1754. Soon after coming of age he went to England, where he became the pupil of Mr. West, the late distinguished president of the Royal Academy. Stuart there rose to eminence ; nor was it a slight distinction that his claims were acknowledged even during the life of Sir Joshua Reynolds. His high reputation as a portrait-painter, as well in Ireland as in England, having thus introduced him to a large acquaintance among the higher classes of society, both fortune and fame attended his progress ; insomuch that, had he chosen to remain in England, they would doubtless have rewarded him with their highest gifts. But, admired and patronized as he was, he chose to return to his native country. He was impelled to this step, as he often declared, by a desire to give to Americans a faithful portrait of Washington, and thus in some measure to associate his own with the name of the father of his country. And well is his ambition justified in the sublime head he has left us : a nobler personification of wisdom and goodness, reposing in the majesty of a serene conscience, is not to be found on canvas. He returned to America in the year 1793, and resided chiefly in Philadelphia

and Washington, in the practice of his profession, till about the year 1805, when he removed to Boston, where he remained to the time of his death. During the last ten years of his life he had to struggle with many infirmities; yet such was the vigour of his mind, that it seemed to triumph over the decays of nature, and to give to some of his last productions all the truth and splendour of his prime.

Gilbert Stuart was not only one of the first painters of his time, but must have been admitted by all who had an opportunity of knowing him, to have been, even out of his art, an extraordinary man; one who would have found distinction easy in any other profession or walk of life. His mind was of a strong and original cast, his perceptions as clear as they were just, and in the power of illustration he has rarely been equalled. On almost every subject, more especially on such as were connected with his art, his conversation was marked by wisdom and knowledge; while the uncommon precision and elegance of his language seemed ever to receive an additional grace from his manner, which was that of a well bred gentleman.

The narrations and anecdotes with which his knowledge of men and of the world had stored his memory, and which he often gave with great beauty and dramatic effect, were not unfrequently employed by Mr. Stuart in a way, and with an address peculiar to himself. From this store it was his custom to draw largely while occupied with his sitters—apparently for their amusement; but his object was rather, by thus banishing all restraint, to call forth if possible some involuntary traits of the natural character. But these glimpses of character, mixed as they are in all men with so much that belongs to their age and associates, would have been of little use to an ordinary observer; for the faculty of distinguishing between the accidental and the permanent, in other words, between the conventional expression which arises from *manners*, and that more subtle indication of the individual mind, is indeed no common one: and by no one with whom we are acquainted, was this faculty possessed in so remarkable a degree. It was this which enabled him to animate his canvas—not with the appearance of mere general life—but with that peculiar, distinctive life which separates the humblest individual from his kind. He seemed to dive into the thoughts of men—for they were made to rise, and to speak on the surface. Were other evidences wanting, this talent alone were sufficient to establish his claims as a man of genius; since it is the privilege of genius alone to measure at once the highest and the lowest.

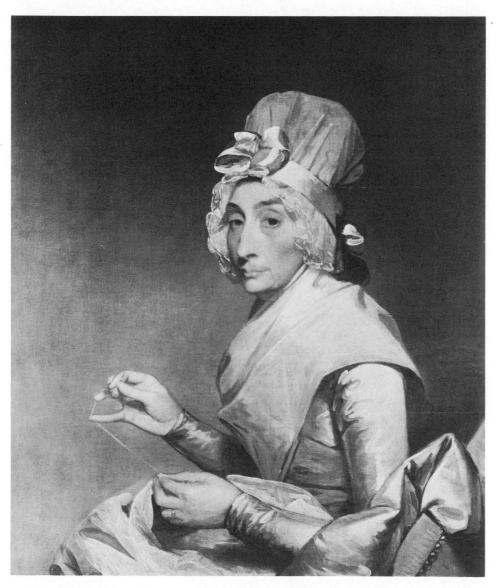

65 MRS. RICHARD YATES, *c.* 1793. Painting by Gilbert Stuart. *Courtesy National Gallery of Art, Washington, D.C., Andrew Mellon Collection.*

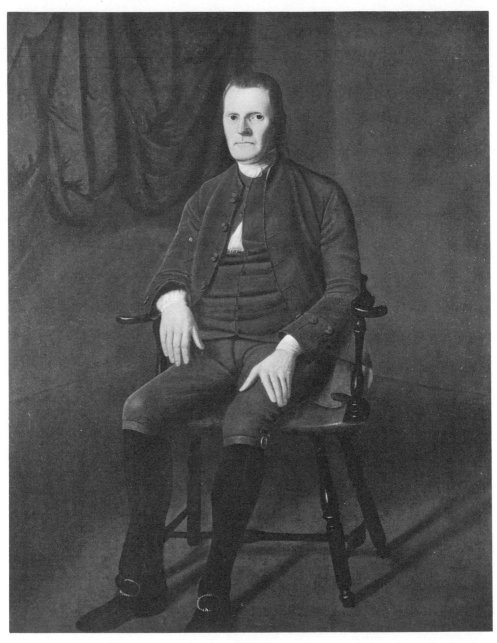

66 ROGER SHERMAN, c. 1775–1777. Painting by Ralph Earl. *Courtesy Yale University Art Gallery, gift of Roger Sherman White.*

In his happier efforts no one ever surpassed him in embody-
ing (if we may so speak) these transient apparitions of the
soul. Of this not the least admirable instance is his portrait
(painted within the last four years) of the late President
Adams; whose then bodily tenement seemed rather to present
the image of some dilapidated castle, than that of the habita-
tion of the "unbroken mind:" but not such is the picture;
called forth as from its crumbling recesses, the living tenant
is there—still ennobling the ruin, and upholding it, as it were
by the strength of his own life. In this venerable ruin will
the unbending patriot and the gifted artist speak to posterity
of the first glorious century of our Republic.

In a word, Gilbert Stuart was, in its widest sense, a *philo-
sopher* in his art; he thoroughly understood its principles; as
his works bear witness—whether as to the harmony of colours,
or of lines, or of light and shadow—showing that exquisite
sense of *a whole*, which only a man of genius can realize and
embody.

We cannot close this brief notice without a passing record of
his generous bearing towards his professional brethren. He
never suffered the manliness of his nature to darken with the
least shadow of jealousy, but where praise was due, he gave
it freely, and gave too with a grace which showed that, lov-
ing excellence for its own sake, he had a pleasure in praising.
To the younger artists he was uniformly kind and indulgent,
and most liberal of his advice; which no one ever properly
asked but he received, and in a manner no less courteous
than impressive. The unbroken kindness and friendship with
which he honoured the writer of this imperfect sketch will
never be forgotten.

In the world of art, Mr. Stuart has left a void that will not
soon be filled. And well may his country say, "a great man
has passed from amongst us:" but Gilbert Stuart has be-
queathed her what is paramount to *power*—since no power
can command it—the rich inheritance of his fame.

EARLE—1775.

Ralph Earl, 1751–1801.

In the year 1775 Mr. Earle painted portraits in Connec-
ticut. I remember seeing two full-lengths of the Rev.
Timothy Dwight and his wife, painted in 1777, as Earle
thought, in the manner of Copley. They showed some ta-
lent, but the shadows were black as charcoal or ink. In the
year 1775, Earle, as one of the governor's guard of militia,
was marched to Cambridge, and soon afterwards to Lexing-
ton, where he made drawings of the scenery, and subsequently
composed the first historical pictures, perhaps, ever attempted

in America, which were engraved by his companion, in arms, Mr. Amos Doolittle. Mr. Earle studied under the direction of Mr. West, immediately after the independence of his country was established, and returned home in 1786. He painted many portraits in New-York, and more in Connecticut. The time of his death is unknown to us. He had considerable merit—a breadth of light and shadow—facility of handling, and truth in likeness, but he prevented improvement and destroyed himself by habitual intemperance.

Alexander Campbell, *fl. c.* 1775–*c.* 1776. Probably a fictitious name.

CAMPBELL—1776.

In a letter from General Washington to Col. Jos. Reed, he thanks him for a picture sent by him to Mrs. Washington, and meant as a portrait of the general, which was painted by a Mr. Campbell, who Washington says he never saw. The letter is dated from Cambridge, in 1776, the writer says the painter has " made a very formidable figure of the Commander in chief."

CHAPTER XII.

History of miniature-painting—John Ramage—James Peale—W. Williams—Mather Brown—Thomas Spence Duché—Bishop Seabury's portrait—Robert Fulton—Thomas Coram.

This department of art, from its reduced scale, and consequent minuteness, does not fill the eye, or dazzle the imagination, so as to come in competition with the higher order of historic composition, or even with the portraits of Titian, or Vandyke, and other masters who painted in the large or life size, and had the grandeur, which depends so much upon an opportunity of giving vigour of style and breadth of effect.

It nevertheless possesses many advantages for the objects of portraiture, peculiarly its own; and is equally susceptible of truth in resemblance, and beauty of execution with works executed of a large size. In composition, colour, light, and shadow, it is governed by the same principles as other departments of the art, and is capable of carrying them to as great a degree of perfection.

The early history of miniature-painting is extremely obscure, and so completely confounded with the history of the art in general, as to make it a matter of great difficulty to separate it.*

* For this brief history of the art, I am indebted to T. S. Cummings, Esq. N. A.

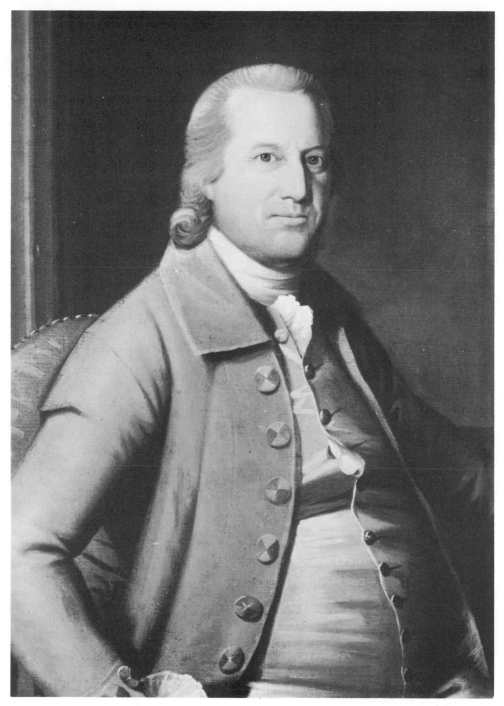

67 OLIVER WOLCOTT. Painting by Ralph Earl. *Courtesy Connecticut State Library.*

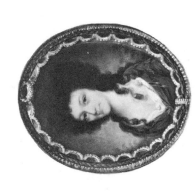

68A GULIAN LUDLOW. Miniature by John Ramage. Courtesy The Metropolitan Museum of Art, Rogers Fund.

68B MRS. GULIAN LUDLOW (Maria Ludlow Ludlow). Miniature by John Ramage. Courtesy The Metropolitan Museum of Art, Rogers Fund.

A consecutive notice of the practitioners of miniature painting would be more than our limits would admit. A sketch of its *progress* is all I can promise.

The first mention made of miniature painters in the annals of legitimate painting, and distinct from illuminators, appears to be of painters in *oil*, of what are now called cabinet pictures; for such a title is given to John De Laer, a painter in the Dutch school, of landscape and figures. He is, by the historians, called the first miniature painter of his time.

This definition of miniature-painting is wide of our present purpose, as I shall confine my remarks to those only who painted in water-colours and on vellum, paper or ivory; that is, in what is now called miniature-painting.

The earliest artist, coming within this limit is Giotto, an illuminator of manuscript; which practice was in great repute as early as the eleventh century, and continued so to the end of the thirteenth. Giotto may be considered the founder of miniature painting, or at least it received so much improvement from his pencil, as to entitle him to the credit of the invention. Baldinucci, states that Giotto executed a series of histories from the old testament, in miniature, and speaks of it as a work of most exquisite minuteness and finish.

I believe the general practice of that day extended no farther than neat outlining, filled up with vermilion, or red lead. Brightness of colour and gilding, were the chief objects aimed at by the illuminators of manuscripts, and they frequently succeeded in producing the most dazzling effects.

The introduction of the art of printing destroyed the fetters that limited knowledge to the rich only; and of course destroyed this expensive mode of book making. What resource the miniature painters of that period had I know not. I shall therefore confine myself to the mere notice of the practice of illuminating, and pass on to the latter part of the sixteenth, and beginning of the seventeenth century, a time when we find miniature-painting in great repute for the purpose of portraiture.

Sir Balthasar Gerbier, a miniature painter of Antwerp, visited England in 1613, and was one of the most popular painters of his day. He was principal painter in small to Charles the First, by whom he was knighted, and he was also employed by the court in many important missions. He was sent to Flanders to negotiate privately a treaty with Spain, the very treaty (remarks Walpole,) in which Rubens was commissioned on the part of the Infanta, and for which end that great painter visited England.

Of the English miniature painters of this period, none rank-
ed higher than Hilliard and Oliver; " the first native artists,"
says Walpole, " who have any claims to distinction." Hilliard
painted Mary, Queen of Scots, which procured him universal
fame, and he was soon after appointed principal painter *in
small* to Queen Elizabeth, whose picture he also painted. His
works are celebrated for their elaborate finish, and their force
and truth.

About this time also flourished Cooper, called the Vandyke
of his time in miniature. That sycophantic coxcomb Pepys
quaintly calls him " the *great* limner in *little*." His pencil was
generally confined to a head only; and *so far* he was consi-
dered to surpass all others. His most famous production is the
miniature portrait of Oliver Cromwell.

" This miniature," says Walpole, " enlarged by a magnify-
ing glass, will compare with any of Vandyke's portraits," and
he believes that Vandyke would appear less great by the com-
parison.

This celebrated picture (as well, I believe, as all the minia-
tures of this period,) is painted wholly with opaque colours.

The exact time of the introduction of the use of transparent
colours, as now practised, is difficult to ascertain. The drape-
ries are at present only executed in opaque pigments, though
the French school still retain them for their back-grounds, as
well as draperies.

The merit of first painting miniatures in transparent colours
is accorded by some to Jeremiah Myers, an English artist. I
cheerfully award him all praise for the introduction of a prac-
tice which contributes so much to give *aeriel* tranparency,
tone, and at the same time *depth and richness* to this interest-
ing department of art.

As this work is only a record of American artists, or such
as practised their art in America, I conclude this sketch of
the history of miniature-painting, by a notice of the first minia-
ture-painter of whom I have knowledge, and who now suc-
ceeds in chronological arrangement.

John Ramage, *c.* 1748–1802. ## JOHN RAMAGE—1775.

This was an Irish gentleman, who painted miniatures in Bos-
ton and married there. He left it with the British troops, and
was as early as 1777 established in William-street, New-York,
and continued to paint all the military heroes or beaux of the
garrison, and all the belles of the place. He did not accompany
the army when it left our shores, but continued the best artist in
his branch for many years after. Mr. Ramage occasionally

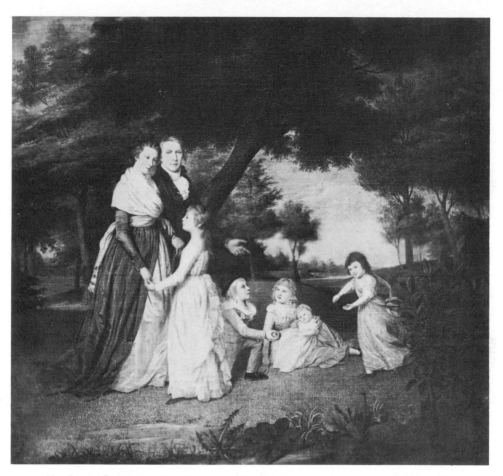

69 JAMES PEALE AND HIS FAMILY, 1795. Painting by James Peale. *Courtesy The Pennsylvania Academy of the Fine Arts.*

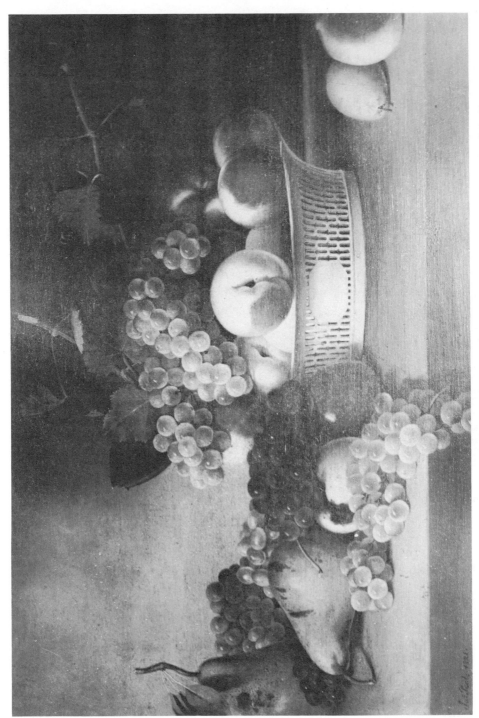

70 STILL LIFE WITH BOWL OF FRUIT. Painting by James Peale. *Courtesy The Pennsylvania Academy of the Fine Arts.*

painted in crayons or pastil, the size of life. His miniatures were in the line style, as opposed to the dotted. I admired them much in the days of youth, and my opinion of their merit is confirmed, by seeing some of them recently. Mr. Ramage was a handsome man of the middle size, with an intelligent countenance and lively eye. He dressed fashionably, and according to the time, beauishly. A scarlet coat with mother-of-pearl buttons—a white silk waistcoat embroidered with coloured flowers—black satin breeches and paste knee-buckles—white silk stockings—large silver buckles in his shoes—a small cocked-hat, covering the upper portion of his well-powdered locks, leaving the curls at the ears displayed—a gold-headed cane and gold snuff-box, completed his costume. When the writer returned from Europe in 1787, Mr. Ramage introduced to him a second wife ; but he was changed, and evidently declining through fast living.

JAMES PEALE—1775,

who had been taught by his brother Charles Wilson, painted during the war of the revolution, and long after in Philadelphia, and south of it. His principal work was miniature, but he painted portraits in oil we believe as late as 1812. We never saw any of them, and their reputation was never high. Mr. James Peale left several children who became artists, as did those of his brother Charles, also.

WILLIAM WILLIAMS—1778,

next claims our attention. He was a native of New-York. He painted portraits in crayon or pastil, and when I knew him lived with his widowed mother in the extreme suburbs of the city, east of the Collect, where Mott-street is now built. In the year 1780 he appeared five-and-twenty years of age. His pictures were flat, with that degree of likeness which entices certain employers. He attempted nothing below the head and shoulders. Still, there was sufficient skill in the management of his pastils, to excite a curiosity in respect to his teacher. He may have received instruction from Copley, who painted on crayon pictures in New-York in 1773, or he may have taken lessons from Ramage at a later period. My father made an arrangement with Williams to teach me, but after two or three visits the teacher was not to be found, or if found, was unfit for service either from ebriety or its effects. He was at this time an officer in the militia, as enrolled by the British.

Williams left New-York with the refugees or loyalists, and settled in Halifax, if such a man could be settled. In the

year 1814, the writer being then in the paymaster's department, Williams presented himself for settlement of his accounts, as a quarter-master of sea-fencibles in the U. S. service. He was old and almost blind, but told me that he could paint better than any man in America. This is the last I know of William Williams, whose crayons, though not his instructions, led to my practising in that style.

Mather Brown, 1761–1831.

MATHER BROWN—1779.

Mr. Brown about this year painted in London. In the year 1785 he appeared to have full employment, and painted much (especially theatrical performers,) on speculation. He had several large pictures in the exhibition at Somerset-house, figures the size of life, representing Mr. and Mrs. Pope, in Beverley and wife in the Gamester ; and Mrs. Martyr, in the page of the Follies of a Day, and other like compositions. They were hung in the outer room at Somerset-house, and not in the saloon of honour.

Brown was not highly esteemed as a painter. He had disgusted Stuart by some meanness of conduct, but could not easily be repulsed from his house. As the great portrait-painter, then in the blaze of popularity, stood looking out from his front window, he saw Mather Brown pass, look at him and apply to the knocker of his door. " Say I am not at home," was the order to the servant. " Mr. Stuart is not at home sir." " Yes he is—I saw him at the window." " Yes sir, and he saw you, and he says he is not at home."

Brown was born in America about the year 1763, and his first name, Mather, marks him as from Massachusetts. He was one of the many who called themselves the pupils of Benjamin West, and undoubtedly received his instruction. His father was probably a loyalist of Boston, and left America at the commencement of the contest for liberty.

Mr. Allston says, " I am pretty sure that Mather Brown was a native of Boston. I have heard that he was the son of a celebrated clock-maker—the maker of the ' old south' clock in Boston, which is said to be an uncommon piece of mechanism. Leslie must be mistaken as to my having any anecdotes of Mather Brown. If I ever had any, they have entirely escaped from my mind : I have not the slightest recollection of one, except (if it may be called an anecdote,) my meeting him once at Mr. West's in a *cap-a-pie suit of brown*, even to stockings, wig and complexion. He must, I think, have held a respectable rank as an artist, as I remember that he lived in either Cavendish or Manchester-square. But for myself, I

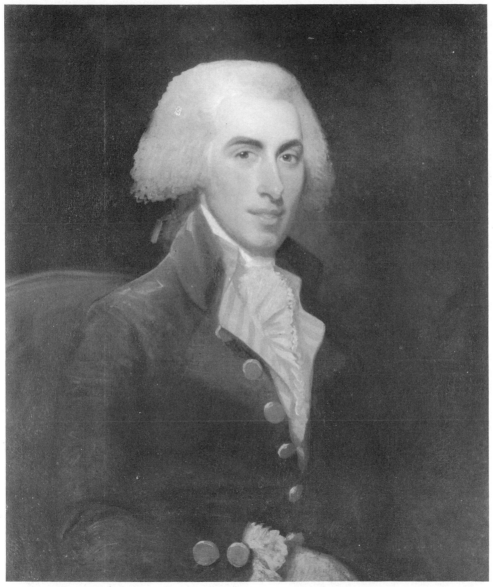

71 CHARLES BULFINCH. Painting by Mather Brown. *Courtesy Fogg Art Museum, Harvard University, gift of Francis V. Bulfinch.*

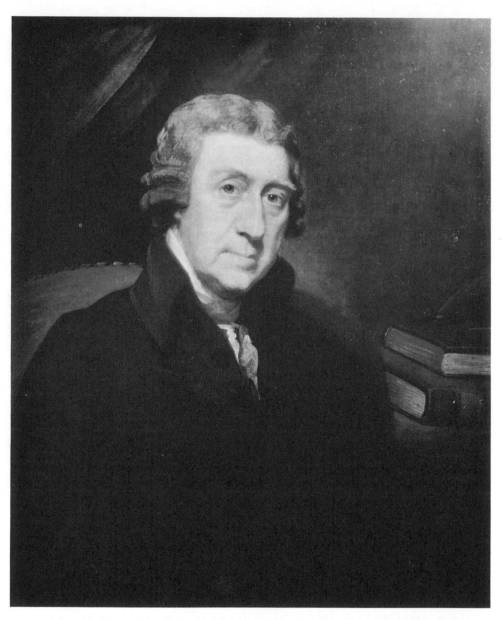

72 Thomas Dawson. Painting by Mather Brown. *Courtesy National Gallery of Art, Washington, D.C., Andrew Mellon Collection.*

have not sufficient recollection of his pictures, to express any opinion on the subject."

In a letter from a person in London to his friend in Boston, dated March 6th, 1789, are these words : "Your countryman Mather Brown, is well, and in the highest state of success. He now rents a house of £120 a year, and keeps a servant in livery, and is appointed portrait-painter to his royal highness the Duke of York. He has a great run of business, and has not only painted a great many of our nobility, but also the Prince of Wales."

In answer to a question put to Mr. Leslie, he says "I was once in Mather Brown's rooms, and a more melancholy display of imbecility I never witnessed. Imagine two large rooms crowded with pictures, great and small, historical and portrait—in some places several files deep. I thought of Gay's lines :

> 'In dusty piles his pictures lay,
> For no one sent the second pay.'

And in all this waste of canvas not one single idea, nor any one beauty of art. He seemed to possess facility, but nothing else. Those of his canvasses that looked most like pictures, exhibited a feeble imitation of the manner of West, but wholly destitute of any one principle of his master.

He told me that when a boy, he was the playfellow of Raphael West and young Copley, (now Lord Lyndhurst,) and that he and Ralph had often, while bathing, given the chancellor in embryo a ducking in the Serpentine river."

Another loyalist's son was a cotemporary pupil and painter with Mather Brown.

THOS. SPENCE DUCHÉ.

Thomas Spence Duché, Jr., 1763–1790.

He was born in Philadelphia, probably about 1766. His father (who as a boy was a schoolmate of Benjamin West,) at the time of colonial opposition to Britain, was well known as a tory clergyman, and removed from the land of rebellion.

The grandfather of the painter was a protestant refugee from France, and crossed the Atlantic with William Penn.— During the voyage Penn borrowed twenty pounds of the Frenchman ; and when they arrived in Pennsylvania, offered him, as payment, a square in his city of Philadelphia, meaning thereby to show his friendship. Duché, however, very courteously refused, saying, he "would rather have the money." "Blockhead !" said Penn, "thou shalt have the money; but canst thou not see that this will be a great city in a little time?" Duché afterwards frankly acknowledged

that he had proved himself a blockhead, when he saw the square he had refused, as an equivalent for twenty pounds, sold for as many thousands.

Watson, the antiquary, of Pennsylvania, says, " that an aged woman, who gained a subsistence by selling cakes, remembered that her grandfather had received the ground now occupied by the Bank of the United States in Philadelphia, together with half the square, for his services as chain-bearer, in surveying the site of the intended city. She had lived to see the Bank erected on a part of it, bought for that purpose with one hundred thousand dollars !"

But we have lost sight of Duché the painter, who, as a Pennsylvanian and the son of an old school-fellow, had peculiar claims on the attention and instruction of Benjamin West ; but, as we have seen, the benevolence of West was not confined within narrow limits.

We know very little of the subject of this memoir. His picture of Bishop Seabury, the first of the three episcopal clergymen who, for the purpose of being raised to the episcopacy, and thereby be enabled to build up and sustain the church, without further reference to the hierarchy of England, were sent to England soon after the peace of 1783, is well known from Sharpe's engraving from it. The original picture is now at Washington College, Hartford, Connecticut.

The three gentlemen abovementioned were, White of Pennsylvania, Provost of New York, and Seabury of Connecticut. Mr. Duché likewise painted the portrait of Bishop Provost, now in possession of the family of the late Cadwallader Colden, Esq. The engraving, by Sharpe, of Bishop Seabury, is dedicated to Benj. West, by his grateful friend and pupil.

Duché, the clergyman, preached at a chapel on the Surry side of the Thames, near Blackfriars' Bridge, and it was fashionable to go to hear him. An American lady, very pretty, but very pale,when not assisted by art, said, " We heard Parson Duché yesterday : and I saw his son too, a fine, handsome young man." " Ah ! did you ? he paints." " Is it possible ?" " Well, I thought his colour unnatural." Thus conscience not only makes cowards, but suspicious cowards of us all.

Robert Fulton, 1765–1815.

ROBERT FULTON—1782,

Was guilty of painting poor portraits in Philadelphia, in the year 1782, and is therefore our next subject. The parents of this gentleman were of Irish origin : the father, a native of Kilkenny ; the mother, a Pennsylvanian, by name Smith, and descended from Hibernian emigrants. Robert was the oldest

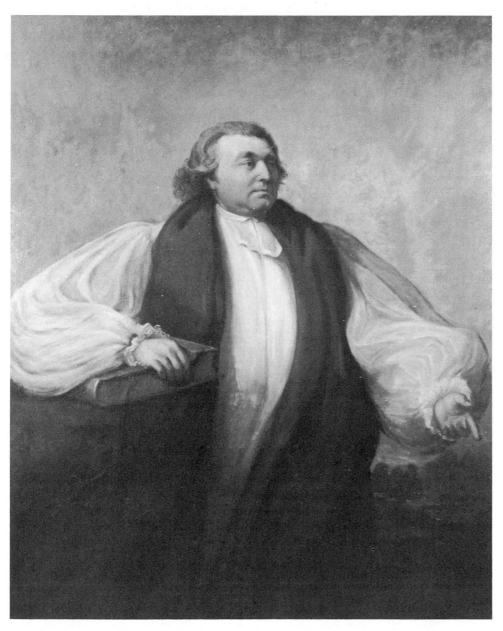

73 SAMUEL SEABURY. Painting by Thomas Spence Duché, Jr. *Courtesy Trinity College Library*.

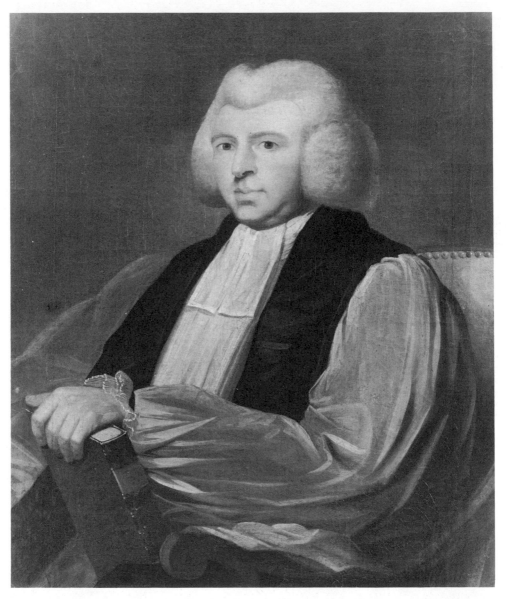

74 SAMUEL PROVOOST. Painting by Thomas Spence Duché, Jr. *Courtesy The New-York Historical Society.*

of two sons : he had three sisters, two older than himself. He
was born in Little Britain, in the county of Lancaster, Penn-
sylvania, in 1765, and showed early indications of his attach-
ment to mechanics ; but was, as a youth, still more devoted to
the pencil. He commenced the painting of portraits and land-
scapes, as a profession, at the age of seventeen ; that is, in the
year 1782 ; and continued so employed until 1785. During
this period Charles Wilson Peale was the principal painter in
that city, until Pine's arrival ; and doubtless Fulton did not
neglect the instruction to be derived from them and their pic-
tures.*

Robert Fulton, at the age of 21, had, by his industry and
frugality, enabled himself to purchase a little farm in Penn-
sylvania, on which he established his mother ; and soon after
crossed the Atlantic, to seek instruction from Benjamin West.
That Mr. West justly appreciated the character of his young
countryman, is attested by his presenting him with two pic-
tures ; one representing the great painter, with his wife's por-
trait on his esel ; and the other, Fulton's own portrait.

Mr. Fulton, perhaps by invitation, practised as a portrait
painter in Devonshire, and here appears to have revived his
attachment to mechanics. Canal navigation attracted his at-
tention, as he here became acquainted with the Duke of Bridg-
water, and they became united by their mutual love of science.
Lord Stanhope and Fulton were attracted to each other by
similar propensities. In 1793 was published a print, engraved
by Sherwin, from a picture, by Fulton, of Louis XVI. in prison,
taking leave of his family. The only copy I have seen is pos-
sessed by my friend Dr. Francis : it is now a curiosity. As
early as 1793, Fulton's mind was engaged in projects to im-
prove inland navigation. In 1794 he obtained a patent for a
double inclined plane, and other patents, from the British gov-
ernment. For eighteen months he resided in Birmingham,
and improved his knowledge of mechanics in that great work-
shop.

In 1795 he published several essays, which elicited the com-
pliments and recommendations of Sir John Sinclair and the
Board of Agriculture. The profession of a painter was aban-
doned, and his knowledge of the art of design applied to
drawings on the subjects which now engaged his mind.

* " Robert Fulton," says Edward Everitt, " was a porrrait painter in Penn-
sylvania, without friends or fortune." A school-fellow of Fulton says, " Robert
Fulton was a school-boy in Lancaster, Pennsylvania ; his mother then a widow.
He borrowed paints and brushes of another, and soon excelled, but neglected his
books. He was sent to Philadelphia, to a silversmith ; but not liking, he went
to London."

In the year 1797 Mr. Fulton had apartments in the same Parisian hotel with Joel Barlow; and a friendship was then formed between these two eminently gifted and amiable individuals which was only broken by death. When Mr. Barlow established himself in a style befitting his public station, in a hotel appropriated to himself and lady, he invited Fulton to make one of his family. Here he resided seven years, during which he studied the modern languages and the higher branches of science. During this time Fulton also projected a panorama, in imitation of Barker. It had some success, and is said to have been the first seen in Paris. But his mind was occupied with other projects, particularly the explosion of gunpowder under water. His torpedoes were offered to the French and Dutch governments; and when Bonaparte became first consul, he appointed a commission to examine Fulton's plans and assist in making experiments.

When chancellor Livingston arrived in Paris, the intimacy between him and Fulton commenced, which led to the fulfilment of his destinies, by the accomplishment of steam navigation.

If the failure of Mr. Fulton's schemes for the destruction of ships of war, by torpedoes, fixed his attention upon navigating vessels by steam, we may congratulate the world that the conflicting nations of Europe, to whom with perfect indifference he seems to have offered his projects and services, for the destruction of their enemies, did not accept of them. If, as we believe, the views of Mr. Fulton were to banish naval warfare from the world, perhaps that change which will take place in defensive warfare, by the use of the steam frigate, such as Fulton built at New-York, in harbours and on coasts, may go far to answer the same end.

In 1801 Mr. Fulton repaired to Brest, to make experiments with the plunging boat he had constructed the preceding winter. This, as he says, had many imperfections, natural to a first machine of such complicated combinations. Added to this, it had suffered much injury from rust, in consequence of his having been obliged to use iron instead of brass or copper, for bolts and arbours.

Notwithstanding these disadvantages, he engaged in a course of experiments with the machine, which required no less courage than energy and perseverance. Of his proceedings, he made a report to the committee appointed by the French executive; from which report we learn the following interesting facts:

On the 3d July, 1801, he embarked with three companions

on board his plunging boat in the harbour of **Brest**, and descended in it to the depth of five, ten, fifteen, and so to twenty-five feet; but he did not attempt to go lower, because he found that his imperfect machine would not bear the pressure of a greater depth. He remained below the surface one hour. During this time they were in utter darkness. Afterwards he descended with candles; but finding a great disadvantage from their consumption of vital air, he caused previously to his next experiment, a small window of thick glass to be made near the bow of his boat, and he again descended with her on the 24th of July, 1801. He found that he received from his window, or rather aperture covered with glass, for it was no more than an inch and a half in diameter, sufficient light to enable him to count the minutes on his watch. Having satisfied himself that he could have sufficient light when under water; that he could do without a supply of fresh air for a considerable time; that he could descend to any depth, and rise to the surface with facility; his next object was to try her movements, as well on the surface as beneath it. On the 26th of July, he weighed his anchor and hoisted his sails: his boat had one mast, a mainsail, and jib. There was only a light breeze, and therefore she did not move on the surface at more than the rate of two miles an hour; but it was found that she would tack and steer, and sail on a wind or before it, as well as any common sailing boat. He then struck her mast and sails; to do which, and perfectly to prepare the boat for plunging, required about two minutes. Having plunged to a certain depth, he placed two men at the engine, which was intended to give her progressive motion, and one at the helm, while he, with a barometer before him, governed the machine, which kept her balanced between the upper and lower waters. He found that with the exertion of one hand only, he could keep her at any depth he pleased. The propelling engine was then put in motion, and he found upon coming to the surface, that he had, in about seven minutes, made a progress of four hundred meters, or above five hundred yards. He then again plunged, turned her round while under water, and returned to near the place he began to move from. He repeated his experiments several days successively, until he became familiar with the operation of the machinery, and the movements of the boat. He found that she was as obedient to her helm under water, as any boat could be on the surface; and that the magnetic needle traversed as well in the one situation as the other.

" On the 7th of August, Mr. **Fulton** again descended with

store of atmospheric air, compressed into a copper globe of a cubic foot capacity, into which, two hundred atmospheres were forced. Thus prepared he descended with three companions to the depth of about five feet. At the expiration of an hour and forty minutes, he began to take small supplies of *pure* air from his reservoir, and did so as he found occasion, for four hours and twenty minutes. At the expiration of this time he came to the surface, without having experienced any inconvenience from having been so long under water.

" Mr. Fulton was highly satisfied with the success of these experiments; it determined him to attempt to try the effects of these inventions on the English ships, which were then blockading the coast of France, and were daily near the harbour of Brest.

" His boat at this time he called the submarine boat, or the plunging boat; he afterwards gave it the name of the Nautilus; connected with this machine, were what he then called submarine bombs, to which he has since given the name of torpedoes. This invention preceded the Nautilus. It was, indeed, his desire of discovering the means of applying his torpedoes, that turned his thoughts to a submarine boat. Satisfied with the performance of his boat, his next object was to make some experiments with the torpedoes. A small shallop was anchored in the roads, with a bomb containing about twenty pounds of powder; he approached to within about two hundred yards of the anchored vessel, struck her with the torpedo and blew her into atoms. A column of water and fragments was blown from eighty to one hundred feet in the air. This experiment was made in the presence of the prefect of the department, Admiral Villaret, and a multitude of spectators.

" The experimental boat of Mr. Livingston and Mr. Fulton, was completed early in the spring of 1808: they were on the point of making an experiment with her, when one morning as Mr. Fulton was rising from a bed, in which anxiety had given him but little rest, a messenger from the boat, whose precipitation and apparent consternation, announced that he was the bearer of bad tidings, presented himself to him, and exclaimed in accents of despair, " Oh, sir, the boat has broken in pieces, and gone to the bottom." Mr. Fulton, who himself related the anecdote, declared that this news created a despondency which he had never felt on any other occasion; but this was only a momentary sensation. Upon examination, he found that the boat had been too weakly framed to bear the great weight of the machinery, and that in consequence of an agitation of the river by the wind the preceding

night, what the messenger had represented had literally happened. The boat had broken in two, and the weight of her machinery had carried her fragments to the bottom. It appeared to him, as he said, that the fruits of so many months' labour, and so much expense, were annihilated; and an opportunity of demonstrating the efficacy of his plan was denied him at the moment he had promised it should be displayed. His disappointment and feelings may easily be imagined; but they did not check his perseverance. On the very day that this misfortune happened, he commenced repairing it. He did not sit down idly to repine at misfortunes which his manly exertions might remedy, or waste, in fruitless lamentations, a moment of that time in which the accident might be repaired. Without returning to his lodgings, he immediately began to labour with his own hands to raise the boat, and worked for four and twenty hours incessantly, without allowing himself rest, or taking refreshment; an imprudence, which, as he always supposed, had a permanent bad effect on his constitution, and to which he imputed much of his subsequent bad health.

" The accident did the machinery very little injury; but they were obliged to build the boat almost entirely new; she was completed in July: her length was sixty-six feet, and she was eight feet wide. Early in August, Mr. Fulton addressed a letter to the French national institute, inviting them to witness a trial of his boat, which was made in their presence, and in the presence of a great multitude of the Parisians. The experiment was entirely satisfactory to Mr. Fulton, though the boat did not move altogether with as much speed as he expected. But he imputed her moving so slowly to the extremely defective fabrication of the machinery, and to imperfections which were to be expected in the first experiment with so complicated a machine; but which he saw might be easily remedied."

Mr. Fulton returned home in 1806, and renewed his efforts to prove that he could destroy vessels by invisible means, and the next year he made an experiment upon a hulk, anchored in New-York harbour for the purpose. The owner of the hulk having consented, the experiment was fully successful. In 1810, the United States made an appropriation for trying the effect of torpedoes and other submarine explosions. The experiments were made upon the sloop of war Argus, Capt. Lawrence, but as she did not consent, the experiment failed. Mr. Fulton's friends still thought, or said, that the experiments would be successful. Commodore Rogers thought and reported them altogether impracticable.

We all know that Fulton was not the first who propelled a boat by steam, but we know that we owe to him those inventions which remedied the failures of former experimenters, and, in fact, by his genius and skill, created the steam-boat. Fulton was assisted by friends, with advice and funds; but Fulton's was the mind and the perseverance which gave to the world a mode of conveyance for speed, ease, and certainty so powerful in its influence on travelling and commerce, as to have advanced civilization on its destined progress beyond any former gift bestowed on man, printing excepted. He thus writes to his friend Joel Barlow: "New-York, Aug. 2, 1807. My dear friend, my steam-boat voyage to Albany and back, has turned out rather more favourable than I had calculated. The distance from New-York to Albany is 150 miles; I ran it up in thirty-two hours, and down in thirty hours, the latter is five miles an hour. I had a light breeze against me the whole way going and coming, so that no use was made of my sails, and the voyage has been performed wholly by the power of the steam engine. I overtook many sloops and schooners, beating to windward, and passed them as if they had been at anchor.

"The power of propelling boats by steam is now fully proved. The morning I left New-York, there was not perhaps thirty persons who believed that the boat would move one mile an hour, or be of the least utility; and while we were putting off from the wharf, which was crowded with spectators, I heard a number of sarcastic remarks. This is the way you know, in which ignorant men compliment what they call philosophers and projectors.

"Having employed much time, and money, and zeal, in accomplishing this work, it gave me, as it will you, great pleasure to see it so fully answer my expectations. It will give a cheap and quick conveyance to merchandise on the Mississippi and Missouri, and other great rivers, which are now laying open their treasures to the enterprise of our countrymen. And although the prospect of personal emolument has been some inducement to me, yet I feel infinitely more pleasure in reflecting with you on the immense advantage my country will derive from the invention."

Thus the first voyage, and that perfectly successful, was made in thirty-two hours from New-York to Albany. In consequence of this first voyage it is now made in nine.

Surely the discoverer enjoys a pleasure greater and purer than any other human being can enjoy. We mean the discoverer who has just views of the great advantages which will

result from the successful termination of his researches. Not to mention many others—let us reflect upon the pure and intense joy of Columbus, when he landed on St. Salvador—of Franklin, when he succeeded in drawing the lightning, innocuous, from the thunder cloud—of Worcester, when convinced of the power of steam—and of Fulton, when he saw, felt, knew, that he could triumph over winds and tides, by machinery of his own invention—when he heard the acclamations of the scoffers, and received the praises of the wise.

"He published his work, entitled 'Torpedo War, or Submarine Explosions.' He adopted as a motto for his publication, his favourite sentiment, "The liberty of the seas will be the happiness of the earth." He addressed it to the President of the United States, and to the members of both houses of congress: It contained a description of the experiments he had made, of his engines as he had improved them, and of the manner in which they might be used. He expressed the most sanguine expectations as to the effects they would produce, when they had attained the improvements, of which he believed them capable, and had the advantage of practice, by which gunnery, and other modes of warfare, had been brought to their present perfection." Fulton's ideas respecting submarine guns, led to the invention of the steam frigate.

" He communicated to Mr. Jefferson an account of his experiments on submarine firing, with drawings of his various plans. Mr. Jefferson expressed himself much pleased with this novel mode of maritime warfare, and assured Mr. Fulton that he would recommend it to the attention of government.

"It is curious to observe how Mr. Fulton's projects grew one out of another.

"The submarine guns gave rise to the steam man-of-war.

"It having been suggested, by a distinguished naval officer before alluded to, that in approaching an enemy so near as was necessary to give effect to submarine cannon, the vessel if she was rigged in the ordinary way, would be liable to be entangled with her adversary; to meet this objection, Mr. Fulton proposed to move the vessel by steam. His reflections on this project, and what he saw of the performance of so large a vessel as the Fulton, her speed, and the facility with which she was managed, led him to conceive, that a vessel of war might be constructed, in which, to all the advantages possessed by those now in use, might be added the very important ones which she would derive from being propelled by steam, as well as by the winds."

The character of Mr. Fulton is elucidated by an incident given thus in Colden's life of him :—

"We must all remember how long, and how successfully, Redheffer had deluded the Pennsylvanians by his perpetual motion.

"Many men of ingenuity, learning, and science had seen the machine: some had written on the subject; not a few of these were his zealous advocates; and others, though they were afraid to admit that he had made a discovery which violated what were believed to be the established laws of nature, appeared also afraid to deny what the incessant motion of his wheels and weights seemed to prove. These contrived ingenious theories, which were hardly less wonderful than the perpetual motion itself. They supposed that Redheffer had discovered a means of developing gradually some hidden power, which though it could not give motion to his machine for ever, would keep it going for some period, which they did not pretend to determine.

"One of these perpetual motions commenced its career in this city* in eighteen hundred and thirteen. Mr. Fulton was a perfect unbeliever in Redheffer's discovery, and although hundreds were daily paying their dollar to see the wonder, Mr. Fulton could not be prevailed upon for some time to follow the crowd. After a few days, however, he was induced by some of his friends to visit the machine. It was in an isolated house in the suburbs of the city.

"In a very short time after Mr. Fulton had entered the room in which it was exhibited, he exclaimed, 'Why, this is a crank motion.' His ear enabled him to distingish that the machine was moved by a crank, which always gives an unequal power, and therefore an unequal velocity in the course of each revolution: and a nice and practised ear may perceive that the sound is not uniform. If the machine had been kept in motion by what was its ostensible moving power, it must have had an equable rotary motion, and the sound would have been always the same.

"After some little conversation with the show-man, Mr. Fulton did not hesitate to declare, that the machine was an imposition, and to tell the gentleman that he was an impostor.

"Notwithstanding the anger and bluster which these charges excited, he assured the company that the thing was a cheat, and that if they would support him in the attempt, he would detect it at the risk of paying any penalty if he failed.

"Having obtained the assent of all who were present, he began by knocking away some very thin little pieces of lath,

* New-York.

which appeared to be no part of the machinery, but to go from the frame of the machine to the wall of the room, merely to keep the corner posts of the machine steady.

" It was found that a catgut string was led through one of these laths and the frame of the machine, to the head of the upright shaft of a principal wheel: that the catgut was conducted through the wall, and along the floors of the second story to a back cock-loft, at a distance of a number of yards from the room which contained the machine, and there was found the moving power. This was a poor old wretch with an immense beard, and all the appearance of having suffered a long imprisonment; who, when they broke in upon him, was unconscious of what had happened below, and who, while he was seated on a stool, gnawing a crust, was with one hand turning a crank.

" The proprietor of the perpetual motion soon disappeared. The mob demolished his machine, the destruction of which immediately put a stop to that which had been, for so long a time, and to so much profit, exhibited in Philadelphia."

In the year 1806, Mr. Fulton married Miss Harriet Livingston, daughter of Walter Livingston, Esq. One son and three daughters were the fruit of his marriage. In 1815, Mr. Fulton was examined as a witness in a steam-boat cause, at Trenton.

" When he was crossing the Hudson to return to his house and family, the river was very full of ice, which occasioned his being several hours on the water in a very severe day. Mr. Fulton had not a constitution to encounter such exposure, and upon his return he found himself much indisposed from the effects of it. He had at that time great anxiety about the steam-frigate, and, after confining himself for a few days, when he was convalescent, he went to give his superintendence to the artificers employed about her: he forgot his debilitated state of health in the interest he took in what was doing on the frigate, and was a long time, in a bad day, exposed to the weather on her decks. He soon found the effects of this imprudence. His indisposition returned upon him with such violence as to confine him to his bed. His disorder increased, and on the twenty-fourth day of February, eighteen hundred and fifteen, terminated his valuable life.

" It was not known that Mr. Fulton's illness was dangerous, till a very short time before his death, which was unexpected by his friends, and still more so by the community. As soon as it was known, all means were taken to testify, publicly, the universal regret at his loss, and respect for his memory. The

newspapers that announced the event, had those marks of mourning, which are usual in our country when they notice the death of public characters. The corporation of our city, the different literary institutions, and other societies, assembled, and passed resolutions expressing their estimation of his worth, and regret at his loss. They also determined to attend his funeral, and that the members should wear badges of mourning for a certain time.

"As soon as the legislature, which was then in session at Albany, heard of the death of Mr. Fulton, they expressed their participation in the general sentiment, by resolving that the members of both houses should wear mourning for some weeks.

"This is the only instance, we believe, of such public testimonials of regret, esteem, and respect, being offered on the death of a private citizen, who never held any office, and was only distinguished by his virtues, his genius, and the employment of his talents.

"He was buried on the twenty-fifth day of February, eighteen hundred and fifteen. His corpse was attended from his last residence, (No. 1 State-street,) by all the officers of the national and state governments, then in the city, by the magistracy, the common council, a number of societies, and a greater number of citizens than have been collected on any similar occasion. From the time the procession began to move, till it arrived at Trinity Church, minute guns were fired from the steam-frigate and the West Battery. His body, in a leaden coffin, covered with plain mahogany, on which is a metal plate engraved with his name and age, is deposited in a vault belonging to the Livingston family."

As a painter Mr. Fulton does not rank high. Probably his best picture is the portrait of his friend Barlow. We owe to him the splendid edition of Barlow's Columbiad. Mr. Colden says:

"The elegant plates which adorn that work were executed under the superintendence and advice of Mr. Fulton. He paid about five thousand dollars for the paintings, the plates and letter-press; which gave him a property in the publication. He relinquished, by his will, all his right to the widow of Mr. Barlow, with the reservation of fifty of the proof and embellished copies of the work. It was printed in Philadelphia, in quarto, and published in eighteen hundred and seven; it is dedicated by Mr. Barlow to Mr. Fulton, in such terms as evince the strong attachment which subsisted between these men of genius. The original paintings, from which the prints of the

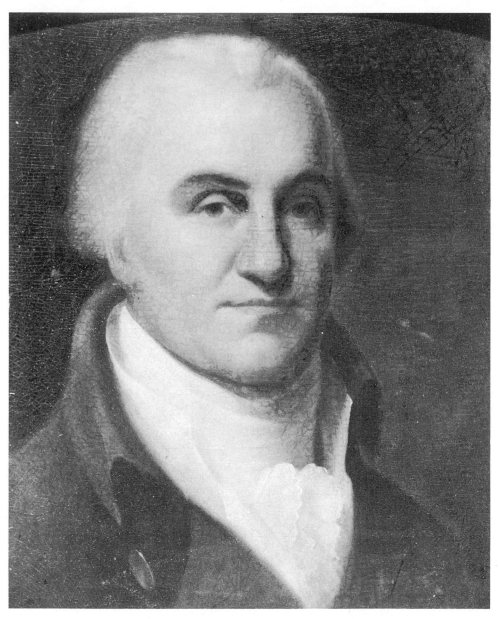

75 Joel Barlow. Painting by Robert Fulton. *Courtesy Samuel L. M. Barlow.*
Photograph Frick Art Reference Library.

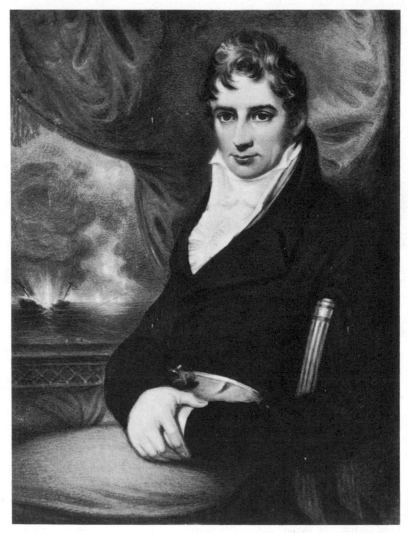

76 SELF-PORTRAIT. Miniature by Robert Fulton after the painting by Benjamin West. *Courtesy The New-York Historical Society.*

Columbiad were engraved, form a part of the handsome collection which Mr. Fulton has left to his family."

We owe to him the introduction into this country of the pictures painted by his friend and master West, from Lear and Hamlet, for Boydell's Shakspeare. The Lear cost him two hundred and five guineas, and the Ophelia one hundred and twenty-five at Boydell's sale. At the same time he purchased a fine picture by Raphael West, from " As you like it." We have copied from Mr. Colden's book the prices at which he says Fulton purchased the Lear and the Ophelia, but instead of the sale of the pictures of the Royal Academy, we substitute Boydell's sale, for the Royal Academy never had a sale of pictures. West's pictures were painted for Boydell, and his great project failing, the government allowed his pictures to be disposed of by a lottery. Whether Fulton was an adventurer in this lottery, or purchased of the owner of a prize, we know not. That he did not purchase of the Royal Academy is certain, or at any sale of their pictures. My impression is that he was an adventurer in the lottery, and gained these paintings as a prize. The inaccuracy of one part of Mr. Colden's statement renders further inaccuracy probable.

He endeavoured to persuade his countrymen to purchase such pictures of West's as were at the artist's disposal, and he wrote to the citizens of Philadelphia thus :

" I now have the pleasure to offer you a catalogue of the select works of Mr. West, and with it to present you the most extraordinary opportunity that ever was offered to the lovers of science. The catalogue referred to is a list of all Mr. West's productions, portraits excepted. No city ever had such a collection of admired works from the pencil of one man ; and that man is your fellow-citizen. The price set on the collection is fifteen thousand pounds sterling ; a sum inconsiderable when compared with the objects in view, and the advantages to be derived from it."

Mr Fulton was six feet in height, slender in his form, easy and graceful in his deportment. His countenance was animated, and his eyes and forehead betokened genius and unconquerable ardour. He was a kind father, a fast friend, an enlightened philosopher, and a good republican. The arts of America are indebted to him much—but the science and happiness of the world more.

THOMAS CORAM—1780.

Thomas Coram, 1757–1811.

Of Charleston, South Carolina, assisted the progress of the fine arts, and claims a place here. We find this gentleman

mentioned by Ramsay, as having exceeded " what could have been expected from his slender opportunity of improvement."

He presented to the Orphan Asylum a picture after a design of Mr. West, from the passage, " Suffer little children," &c. From Mr. Fraser, our very valuable correspondent, we learn, that Thomas Coram was a native of Bristol, England; and nearly related to the philanthropist of the name, to whose benevolent exertions the Foundling Hospital, in London, is indebted for its existence.

Thomas, the subject of our notice, was born in 1756, and was brought to America when six years of age. His early pursuits were mercantile; but from these he was alienated by the attractions of the pencil and graver, to which, while yet a young man, he devoted himself exclusively. Mr. Coram must have been among the earliest who attempted engraving in this country.

" He was," says Mr. Fraser, " truly a self-taught artist; seeking information from books, practice, and the conversation of artists who occasionally visited Charleston; but from Mr. Bembridge his instruction was chiefly derived.

The phrase " self-taught" must mean, as far as taught previous to Mr. Bembridge's instructions; and even before that, it must be received with qualifications. " His industry," says Mr. Fraser, " which was extraordinary, was the more laudable as it was not prompted by encouragement or competition, but proceeded from an ardent devotion to the art." Sincerely attached to the interests of his adopted country, he volunteered to take arms in their support, and served as a private soldier.

His drawings are characterized, by Mr. Fraser, as possessing " neatness and correctness; and in his oil paintings there was a harmony of colouring and felicity of execution rarely surpassed by those who have had more extensive opportunities of study and observation. His reading embraced almost every subject connected with his favourite art: he delighted in the history of it, and the biography of eminent painters; and of both it was his habit to collect and transcribe such anecdotes and passages as were striking and useful."

He was a benevolent man, and died, regretted, at Charleston, the second of May, 1810, aged 54.

CHAPTER XIII.

Autobiography of the Author—General Reflections—My parents—My birth and education—Thomas Bartow—first visit to New York—School education interrupted by the invasion of the British—Piscatawa and scene of war—Winter of 1776-7, at Perth Amboy—removal to New York—Copy prints and begin to paint portraits—Peace of 1783—first sight of Washington—paint his portrait at head quarters—a pig chace—Joseph Wright—preparation for London and arrival there—first visit to Mr. West—neglect of study and its consequences.

THE writer of this work began to paint portraits, so called, in 1782; and therefore

WILLIAM DUNLAP—1782,

William Dunlap, 1766–1839.

follows in the chain.

As I have endeavoured, by the examples of West and Copley, to show the road to eminence which a painter ought to follow, and shall hereafter exhibit Trumbull, Sully, Allston, Morse, Leslie, and others, as examples of industry, when students, my desire is to exhibit my own conduct when placed in that situation, and *its results*—as a beacon to be avoided by all. I would wish to show, that *that* conduct was caused by the want of good, and the abundance of bad education: not as an excuse for folly, but to render its excess, in my instance, probable in the eyes of the reader. In my history of the American Theatre, I believe I proved, to my readers' satisfaction, that I was not qualified to be the director of a playhouse: and I now intend to show the causes that, at the age of twenty-three, and after a long residence in London, left me ignorant of anatomy, perspective, drawing, and colouring, and returned me home a most incapable painter. I can speak of myself now, at the age of sixty-nine, as of *another*, better known than *any other* could be known. If it were not for this *intimate* knowledge, one might almost doubt one's identity. I am so dissimilar to what I was, that I can with difficulty realize *sameness*. I am *not* what I was; but the knowledge of what I was produces the conviction of identity.

At at an advanced age I look back upon a long life with the persuasion that what is called misfortune, in common parlance, is caused generally by our own folly, ignorance, mistakes or vices. Even that health, which is necessary to the enjoyment of the good showered upon us by the benevolent Creator of the universe, when lost, is frequently lost from the same causes. Natural decay and death are to be considered as the termination of a free gift, in itself an assurance of infinite goodness in the giver. A well spent life must be a life of happiness, and a preparation for the will of the Creator hereafter. But a well spent life depends upon education—the knowledge of good and evil—truth and falsehood—and their

influences. Inasmuch as man obeys the great law of love to
God and his neighbour, he is happy. Undue self-preference
causes misery. If the events I record tend to strengthen the
many proofs of these truths, I shall leave an important lesson
to my fellow creatures.

I was born in the city of Perth-Amboy and province of
New-Jersey. My father, Samuel Dunlap, was a native of the
north of Ireland, and son of a merchant of Londonderry. In
early youth he was devoted to the army, and bore the colours
of the 47th regiment, " Wolfe's own," on the plain of Abra-
ham. He was borne wounded from the field on which his
commander triumphed and died. After the French war,
Samuel Dunlap, then a lieutenant in the 47th regiment, and
stationed at Perth-Amboy, married Margaret Sargent of that
place, and retired from the profession of a soldier, to the quiet
of a country town and country store. The 19th of February,
1766, is registered as the date of my birth, and being an only
child, the anniversary of the important day was duly celebra-
ted by my indulgent parents. Education I had none, accord-
ing to the usual acceptation of the word, owing to circum-
stances to be mentioned ; and much of what is to the child
most essential education, was essentially bad. Holding negroes
in slavery was in those days the common practice, and the
voices of those who protested against the evil were not heard.
Every house in my native place where any servants were to be
seen, swarmed with black slaves—*every house save one*, here-
after to be mentioned. My father's kitchen had several fami-
lies of them of all ages, and all born in the family of my
mother except one, who was called a new-negro, and had his
face tattooed—his language was scarcely intelligible though he
had been long in the country, and was an old man. These blacks
indulged me of course, and I sought the kitchen as the place
where I found playmates, (being an only child,) and the place
where I found amusement suited to, and forming my taste, in
the mirth and games of the negroes, and the variety of visiters
of the black race who frequented the place. This may be
considered as my first school. Such is the school of many a
one even now, in those states where the evil of slavery con-
tinues. The infant is taught to tyrannize—the boy is taught
to despise labour--the mind of the child is contaminated by
hearing and seeing that which perhaps is not understood at
the time, but remains with the memory. This medley of
kitchen associates was increased during a part of the war of
our revolution by soldiers, who found their mess-fare improved

by visiting the negroes, and by servants of officers billetted on the house.

Happily from very early infancy I had another school and another teacher, as also the usual instructions of a good mother. I owe my love of pictures and of books to one on whose memory and character I must dwell, and of whose house and household I must give a description, for *they* made a part of *him*, and are intimately connected with me.

Perth-Amboy is regularly laid out in squares, and in the centre-square of the city, the metropolis of the province, stood the market-house of brick, shaded on all sides by locust trees, the centre of a square through which pass Market and High-streets. On the corner of Market-street stood the house of Thomas Bartow, almost surrounded by the fruit-trees of his garden. He was a small thin old man, with straight gray hair hanging in comely guise on each side of his pale face. His appearance was truly venerable. He was feeble from age and lame from rheumatism. His countenance, ever mild, was towards me kind and cheerful. Whether with his books by the blazing hickory fire of winter, or in his garden amidst vines and fruit-trees in summer, I was always welcome. Over the snows I accompanied him in his one-horse sleigh; and in the more genial seasons old sorrel dragged us over the same roads through the adjoining villages of Woodbridge and Rahway. It must have been the delight he took in watching the growth of the mental faculties, which caused this benevolent old man to devote so much attention to a child, and doubtless, he felt gratified by the attachment of the child, and the preference given to his company, his books, and his tuition over the enticing gambols of those who from age might be supposed, and frequently were, more congenial associates. It is not irrelevant to dwell upon my visits to this good old gentleman. The happy hours passed with him in his garden, or in walking with him, or in our rides might be omitted, but when I found him on *that* Sunday morning when the parson, a regimental chaplain, who was engaged to bestow his spare time on the episcopalians at Woodbridge and Amboy, was absent from the latter place, when I was received and placed by the side of the old gentleman at the stand or table where he sat with his books, when, after going up stairs to the book-closet and bringing down such volumes as struck my fancy, I received his explanations of the pictures or the pages; if these visits were passed over I should omit the record of the happiest moments of childhood, and of hours which expanded my intellect, and laid the foundation of my love for books and pictures.

Patiently he turned over the pages of Homer and Virgil in the translations of Pope and Dryden, and of Milton's poems, and explained the pictures, until I was familiar with the stories of Troy and Latium—of heaven and of hell, as poets tell them. Nor was history strange to me, especially that of Rome. Thus was commenced a love of reading which has been my blessing. My friend's library was small, but, as I now know, well chosen. Besides the books I have mentioned, and many others, it contained the Universal History, condemned by Warburton and praised by Gibbon.

I should not do justice to my early friend if I did not notice peculiarities in his conduct and household, probably little thought of by me at the time, but making their due impression. His was the only house where slavery did not exist. His servants alone in the place were white. An elderly woman and a sturdy youth composed the establishment. The first kept all within as neat as herself, the second was gardener, hostler and general out-door minister—and he sawed wood for the fires—at every other house the axe was used for cutting. I never remember to have seen the old gentleman within any house but his own, nor had he visiters except on business, for he was an agent for the lands of the original proprietors of the province. He read the bible, but he never went to church.

That event by which I, in common with the world, have gained so much, the rebellion of 1775, was the cause of my losing this my earliest companion and friend. He retired to Bethlehem, in Pennsylvania, and there died about five years after. I followed him towards the Raritan on which he was to embark, and lingered until he desired me to return home. I was then nine years of age, and my friend perhaps seventy. For years I saw him vividly in my dreams, and awoke, like Caliban, with the disposition to weep for a renewal of my dreams. Mr. Bartow retired from the approach of scenes in which age prohibited his becoming an actor.

Among the earliest pictures that I remember were some on oil-cloth, without frames, representing huntsmen, horses and dogs. They made a deep impression on me, and I recollect them still with pleasure. This must have been in 1772, or earlier; and when I saw Heard's hounds from Woodbridge enter Amboy, surrounding the black huntsman with his scarlet coat, black jockey-cap and gold tassel, broad leather belt and hunting-horn, he appeared to me a most dignified and venerable personage.

The records of the time will show the date, probably 1774, at which the 47th regiment was removed from Perth-Amboy

to New-York and thence to Boston, to be cut up by Prescott and the Yankees at Bunker's-hill. It was after that removal that my father took me with him in the small packet sloop, which was the mode of communication, on the summer-day's voyage to New-York. The first visit to the great city was of course all wonder to me. I remember that preparations for hostilities were making. Horsemen's helmets, swords and belts, with other equipments, were displayed at the shop-doors and windows. In a walk taken with my father *out of town,* on the new road, he was attracted by preparations for supplying the city with water from the *Collect* or fresh-water pond, (a project of good old Christopher Collis;) and entering among some mounds of earth on the east of the road, and where Franklin-street now is, we saw a company of gentlemen practising, with an instructor, the small-sword salute.

I learned my letters of the school-mistress—was then turned over to master M'Norton and learned to spell, perhaps read—commenced more regular instruction with an English gentleman; read Anson's voyage, and had the mysteries of grammar put in my hand; but they went no further. The British troops appeared on Staten Island, opposite Amboy—the militia of the villages poured into the place half-armed and unarmed—Doctor Franklin and others met the English commissioners at Billop's house on Staten Island—my father removed his family to Piscatawa, on the banks of the Raritan, and from 1775 to 1777, when he removed to New-York, I heard not the word school. The summer of 1776 was passed at Piscatawa, in a retired spot, about a mile from the village and post-road. The lessons of my friend Bartow were now useful to me; I read Pope's Homer, which I found in my father's house, and other books I borrowed from a gentleman who resided two miles up the river. I read Shakspeare, certainly without understanding all I read. My father gave me lessons in writing and arithmetic, but my time was principally occupied in swimming and fishing in the creeks of the Raritan, rambling the fields and woods—sailing boats on a mill-pond—visiting the miller—and in short in the delights of liberty and idleness—no, not idleness, for this was as busy a summer as I remember. The Declaration of Independence caused a sensation which I distinctly remember, but my sports and rambles had more interest for *me.*

The English troops marched through Piscatawa without opposition, and plundered the houses. I witnessed this scene. The men of the village had retired on the approach of the enemy. Some women and children were left. I heard their

lamentations as the soldiers carried off their furniture, scatter-
ed the feathers of beds to the winds, and piled up looking-
glasses, with frying-pans in the same heap, by the road side.
The soldier would place a female camp-follower as a guard
upon the spoil, while he returned to add to the treasure. Perth-
Amboy being now in the possession of the British, my father
returned with his family to his house, and I saw in my native
town, particularly after the affairs of Princeton and Trenton,
all the varieties and abominations of a crowded camp and
garrison. An army who had so recently passed in triumph
from the sea to the banks of the Delaware, and chosen their
winter-quarters at their pleasure, were now driven in and
crowded upon a point of land washed by the Atlantic, and de-
fended by the guns of the ships which had borne them to the
shore as the chastisers of rebellion.

I have elsewhere compared the scenes I now witnessed to
the dramatic scenes of *Wallenstein's Lager.* Here were cen-
tered, in addition to those cantoned at the place, all those
drawn in from the Delaware, Princeton and Brunswick; and
the flower and pick of the army, English, Scotch, and Ger-
man, who had at this time been brought in from Rhode Island.
Here was to be seen a party of the 42d Highlanders, in na-
tional costume, and there a regiment of Hessians, their dress
and arms a perfect contrast to the first. The slaves of Ans-
pach and Waldeck were there—the first sombre as night, the
second gaudy as noon. Here dashed by a party of the 17th
Dragoons, and there scampered a party of *Yagers.* The trim,
neat and graceful English grenadier, the careless and half
savage Highlander, with his flowing robes and naked knees,
and the immovably stiff German, could hardly be taken for parts
of one army. Here might be seen soldiers driving in cattle,
and others guarding wagons loaded with household furniture,
instead of the hay and oats they had been sent for.

The landing of the grenadiers and light infantry from the
ships which transported the troops from Rhode Island; their
proud march into the hostile neighbourhood, to gather the
produce of the farmer for the garrison; the sound of the mus-
quetry, which soon rolled back upon us; the return of the
disabled veterans, who could retrace their steps; and the
heavy march of the discomfitted troops, with their wagons of
groaning wounded, in the evening, are all impressed on my
mind as pictures of the evils and the soul-stirring scenes of
war.

These lessons, and others more disgusting—the flogging
of English heroes, and thumping and caning of German;

the brutal licentiousness, which even my tender years could not avoid seeing in all around, and the increased disorders among my father's negroes, from mingling with the servants of officers,—were my sources of instruction in the winter of 1776–7. In the spring of 1777 my father removed to New-York. Perhaps it was at this time of removal that many things which I should now highly value were lost. It is to me incomprehensible, that books and other articles, which are remembered as being in existence at a distant time, vanish, and leave no trace behind them. I used to play with my father's sword, gorget and sash ; *when* they disappeared, I know not. Of books, I remember a work from the French, called " La Belle Assemblée," " Bartram Montfichet," an imitation of Tristram Shandy, the " Fortunate Country Maid," the " Fool of Quality," a great favourite ; the two spirits, one good and one evil, united in the same body, made a lasting impression on me; and although I know the idea is not original with Brooke, I cannot but admire him for the use he made of it ;— " Sir Launcelot Greaves," a " Life of Swift," and others ; but I most regret a small volume, in a black leather cover, and printed in old English characters, giving an account of the sufferings of Elizabeth under the tyranny of her sister Mary. These and many more would give me delight to see now. Some very valuable books remain with me to this time—Pope's " Homer," Taylor's " Life of Christ," folio edition, with plates, which afterwards served for me to copy in Indian ink, " Anson's Voyage," Butler's " Hudibras," with plates by Hogarth, and a few others, in possession of the family at that time. But the mystery is how these things vanish from the possession of an orderly family.

In New-York I was sent to Latin-school, and Mr. Leslie heard me say the grammar by rote ; but I was removed from him, I know not why, and attended an English-school, where, with a good old quaker, I might have acquired a common education, but another and a final interruption to my school instruction occurred. Andrew Elliot, Esq. at this time resided at his country-seat, on the New-road, in a mansion long after known as the " Sailor's Snug Harbour." It had so happened that at the time my friend Bartow left Amboy, Elliot removed his family to that place, to await the movements of the British army, and on their taking possession of New-York returned home again. While at Amboy, his boys became my playmates, and the intimacy was renewed under the banner of Great Britain. In June, 1778, by invitation, I dined with his large family of youngsters, and in the afternoon we all engaged in

throwing chips of wood at each other in the wood-yard. In this sport my right eye was cut longitudinally, by a heavier piece of firewood than was in the general use of the combatants, and, deprived of its use, I was led into the house, accompanied by all my affrighted associates. A carriage was prepared, and I was delivered to my distressed parents. After many weeks of confinement to my bed, and more to the house, I slowly regained health; but never the sight of the organ. By degrees I recovered the full use of the remaining eye, but the accident prevented all further regular schooling.

Books and pictures became the companions of my leisure, and I had as much time to bestow on them as I pleased. I had acquired the use of Indian-ink, and became attached to copying prints. I was encouraged by admiration—good engravings were lent to me, and by degress my copies might almost pass for the original prints. My eye became satisfied with light and shadow, and the excitement of colour was not necessary to my pleasure; indeed, I believe that either from nature or the above accident, I did not possess a painter's eye for colour; but I was now devoted to painting as a profession, and I did not suspect any deficiency.

Seeing that I aspired to be a painter, and talked of West and Copley, and read books on the art, my father looked out for an instructor for me. Mr. Ramage, the miniature painter, was in reality the only artist in New-York, but he was full of employment and declined teaching.

A painter of the name of Delanoy lived in Maiden-lane, and certainly had no inconsiderable knowledge of colours and the mechanical part of the art. He said he had visited London, and been instructed by Mr. West, and he showed a picture copied from West, of Cupid stung by a bee, and complaining to his mother: he had in his house a family picture of himself, wife and children—whether completed or not, I do not remember—the heads were all turned one way, and the shadowed side relieved by dim spots of light in the back ground; and yet my memory tells me that the faces were cleverly painted. Mr. Delanoy's occupation, at this time, was sign-painting, and his poverty did not tempt to become a painter, yet I believe that he might have taught me much of the management of oil colours, and by so doing have materially altered my course when I went to England. Why he was not employed to teach me I do not know. His manners were not prepossessing, though mild; I can remember that I had not confidence in his pretension, at that time, though since confirmed.

The next in degree was William Williams, he undertook the task ; I went to his rooms in the suburbs, now Mott-street, and he placed a drawing book before me, such as I had possessed for years : after a few visits the teacher was not to be found. I examined his portraits—tried his crayons, and soon procuring a set, commenced painting portraits, beginning with my father's. From painting my relations I proceeded to painting my young companions, and, having applications from strangers, I fixed my price at three guineas a-head. I thus commenced portrait-painter in the year 1782, by no means looking to it for subsistence, but living as the only and indulged child of my parents, with them, and doing as it seemed best unto me. Thus passed life to the age of seventeen. I was now at the period of full animal enjoyment—the world was a wilderness of roses ; still, although all was delight, I longed for change. Books did not at that period attract me as they had done. I gained an imperfect knowledge of French. I had no check on my wishes, but I longed to leave home. Six years I had been shut up in a garrison town, and *that* added to the common desire every youth feels for roving.

I was released by the preliminary treaty of peace, and in the summer of 1783 returned to the place of my nativity for a few days. I visited other portions of my native state, now no longer a dependent province. I passed some time at Princeton and Rocky-hill. I mingled with the defenders of the country who had followed Washington at Trenton and Princeton. I visited Philadelphia for the first time. I saw and admired Peale's gallery of pictures, for then I admired every thing. After a few days I returned to Rocky-hill, and soon after to New-York. I was again indulged with an excursion to Princeton and Rocky-hill, in the autumn of the same year, when both places had become of importance, the first by the presence of congress, the second as the head quarters of their general. I was now introduced to men and scenes which would have been interesting at any period of life, but which to a boy on the verge of manhood, and assuming to be man, one new to the world, and to whom the world was dressed in rainbow colours, were calculated to make impressions, which, at the distance of half a century, are like the glowing pictures of the artificial *camera obscura*, when every object is illuminated by a summer's sun.

Congress had left Philadelphia in consequence of mutinous symptoms in the Pennsylvania troops. The triumphant rulers of the republic held their sittings in Princeton College, and

their triumphant general occupied the house of Mr. Berrian, at Rocky-hill, a short walk from the rustic mansion of Mr. John Van Horne, whose guest I was.

Before I left Princeton for Rocky-hill, I saw, for the first time, the man of whom all men spoke—whom all wished to see. It was accidental. It was a picture. No painter could have grouped a company of military horsemen better, or selected a back-ground better suited for effect. As I walked on the road leading from Princeton to Trenton, alone, for I ever loved solitary rambles, ascending a hill suddenly appeared a brilliant troop of cavaliers, mounting and gaining the summit in my front. The clear autumnal sky behind them equally relieved the dark blue uniforms, the buff facings, and glittering military appendages. All were gallantly mounted—all were tall and graceful, but one towered above the rest, and I doubted not an instant that I saw the beloved hero. I lifted my hat as I saw that his eye was turned to me, and instantly every hat was raised and every eye was fixed on me. They passed on, and I turned and gazed as at a passing vision. I had seen him. Although all my life used to the " pride, pomp and circumstance of glorious war"—to the gay and gallant Englishman, the tartan'd Scot, and the embroidered German of every military grade; I still think the old blue and buff of Washington and his aids, their cocked hats worn side-long, with the union cockade, their whole equipment as seen at that moment, was the most martial of any thing I ever saw.

A few days after this incident I took up my abode at Mr. John Van Horne's, by invitation, within a short distance of the head quarters of the commander-in-chief. He frequently called, when returning from his ride, and passed an hour with Mrs. Van Horne and the ladies of the family, or with the farmer, if at home. I was of course introduced to him. I had brought with me materials for crayon painting, and commenced the portraits of Mr. and Mrs. Van Horne; these were admired far beyond their merits, and shown to all visiters. I had with me a flute and some music books. One morning as I copied notes and tried them, the general and his *suite* passed through the hall, and I heard him say, " The love of music and painting are frequently found united in the same person." The remark is common-place, but it was delightful to me at the time.

The assertion that this great man never laughed must have arisen from his habitual, perhaps his natural reservedness. He had from early youth been conversant with public men and

employed in public affairs—in affairs of life and death. He was not an austere man either in appearance or manners, but was unaffectedly dignified and habitually polite. But I remember, during my opportunity of observing his deportment, two instances of unrestrained laughter. The first and most moderate was at a *bon mot*, or anecdote, from Judge Peters, then a member of congress, and dining with the general; the second was on witnessing a scene in front of Mr. Van Horne's house, which was, as I recollect it, sufficiently laugh-provoking. Mr. John Van Horne was a man of uncommon size and strength and bulky withal. His hospitable board required, that day, as it often did, a roasting pig in addition to the many other substantial dishes which a succession of guests, civil and military, put in requisition. A black boy had been ordered to catch the young porker, and was in full but unavailing chase, when the master and myself arrived from a walk. "Pooh! you awkward cur," said the good-natured yeoman, as he directed Cato or Plato (for all the slaves were heathen philosophers in those days) to exert his limbs—but all in vain—the pig did not choose to be cooked. "Stand away," said Van Horne, and throwing off his coat and hat he undertook the chase, determined to run down the pig. His guests and his negroes stood laughing at his exertions and the pig's manifold escapes. Shouts and laughter at length proclaimed the success of the *chasseur*, and while he held the pig up in triumph, the big drops coursing each other from forehead to chin, over his mahogany face, glowing with the effect of exercise, amidst the squealing of the victim, the stentorian voice of Van Horne was heard, "I'll show ye how to run down a pig!" and, as he spoke, he looked up in the face of Washington, who, with his suite, had trotted their horses into the court-yard unheard amidst the din of the chase and the shouts of triumphant success. The ludicrous expression of surprise at being so caught, with his attempts to speak to his heroic visiter, while the pig redoubled his efforts to escape by kicking and squeaking, produced as hearty a burst of laughter from the dignified Washington as any that shook the sides of the most vulgar spectator of the scene.

But to return to the young painter. The portraits of Mr. and Mrs. Van Horne elicited praise, and I was delighted by the approbation of General Washington—doubtless the mere wish to encourage youth. My friend Van Horne requested him to sit to me and he complied. This was a triumphant moment for a boy of seventeen; and it must be remembered that Washington had not then been " hackneyed to the touches

of painter's pencil,"—(see his letter to Francis Hopkinson in Pine's life in this work,)—I say a triumphant moment, but it was one of anxiety, fear and trembling.

My visits were now frequent to head quarters. The only military in the neighbourhood were the general's suite and a captain's guard, whose tents were on the green before the Berrian house, and the captain's marqué nearly in front. The soldiers were New-England yeomen's sons, none older than twenty; their commander was Captain Howe, in after times long a resident of New-York. I was astonished when the simple Yankee sentinels, deceived by my fine clothes, saluted me as I passed daily to and fro; but Captain Howe's praise of my portrait of the general appeared to me as a thing of course, though surely he was as much deceived as his soldiers. I was quite at home in every respect at head quarters; to breakfast and dine day after day with the general and Mrs. Washington, and members of congress, and noticed as the young painter, was delicious. The general's portrait led to the sitting of the lady. I made what were thought likenesses, and presented them to Mr. and Mrs. Van Horne, taking copies for myself.

Mr. Joseph Wright, son of the celebrated Mrs. Patience Wright, and a pupil of Mr. West's as a painter, arrived at head quarters from Paris, bearing letters from Dr. Franklin, which entitled him to sittings from the general and Mrs. Washington. I thought at the time these portraits were very like.

The time for returning home arrived. I took leave of my friends at Rocky-hill, and soon after saw Washington enter New-York with two or three regiments, and attended by the citizens on horseback and on foot, who went out to meet him and accompany his triumphal entry; while the English fleet slowly sailed from the no longer hostile harbour. This was the ever memorable 25th of November, 1783. It had now been decided that I should go to London in the spring, and the winter was passed in painting and in making preparations for the voyage.

My first portrait in oil was made for the assistance of a sign-painter, probably in the year 1782. Delanoy had undertaken to paint a head of Sir Samuel Hood, one of the lions of that day, and found himself puzzled to make a likeness that the sailors would acknowledge. In this dilemma the artist came to me. I took his palette, and with a bold brush dashed in the red face and hair, long nose, and little grey eyes of the naval hero. The sign swung amidst the acclamations of the Jack tars. A more inveterate likeness did not exist in Charles Surface's col-

lection, and yet I have recognised my first oil portrait, somewhat improved, in the British portrait gallery, under the title of Lord Hood.

Now, in preparation for my departure, with a palette presented to me by a lady, and such oil colours as my friend Delanoy could furnish, I painted my second oil picture, a full-length figure of Washington. The canvas was prepared by myself; and was suspended by cords, but without stretching frame. I placed my hero on the field of battle at Princeton. I did not take the liberty to throw off his hat, or omit the black and white cockade; but in full uniform, booted and spurred, he stood most heroically alone—for the figures in the back-ground I had thrown to a most convenient distance.—*There* was General Mercer, dying in precisely the same attitude that West had adopted for Wolfe—two authors may think alike—a few soldiers, with a great deal of smoke, completed the picture.

The education which prepared me for entering the labyrinth of London, alone and unguided, at the age of eighteen, ought to be before the reader. The winter previous to my voyage I had attended an evening school for French, and gained a superficial knowledge of the language: and, from the dancing school of William Hulet, who, with his sons, accomplished several generations of New Yorkers, I carried the reputation of one learned in that valuable mystery—it was more than my French master could say for my grammar.

Another branch of my education will throw further light on my fitness for self-government in London. I had been introduced to the billiard tables of New York, not as a gambler, but an idler, and of course profited by the company I found at such places. During the winter previous to my departure my evenings were divided between a billiard room on Crane Wharf and sleigh rides out of town, with cards and dancing.

The May of 1784 arrived, and on the 4th I embarked in the good ship Betsy, Thomas Watson commander; taking with me my copy from the print of the youth rescued from the shark, and my great picture of Washington at Princeton, as my credentials to Benjamin West, who had consented to receive me. I had, previously to the Shark picture, made a copy of the Death of Wolfe, in Indian ink, of the size of Woolett's engraving, which would certainly have been the more acceptable specimen to have carried to the author of the original; but I had, in the simplicity of my heart, preferred the copy from Copley, because I had done it better.

To cross the Atlantic was not, in 1784, as now, an everyday business, and performed by every body. Heretofore, go-

ing from America to England was called going home—that
time had nearly passed away—but I did not feel that I was
going to a land of strangers. We entered the Thames about
the middle of June, and anchored off Gravesend, at which
place I first touched European ground. At Tower-hill, the
next day, I entered London. Having procured London-made
clothes, and sent forward my recommendatory pictures, Capt.
Effingham Lawrence, my father's friend, and an American,
accompanied me to Newman-street, and guided me through
a long gallery hung with sketches and designs—and then
through a lofty anti-chamber, filled with gigantic paintings,
to the inner painting room of the artist; where he sat at
work upon an esel-picture for the Empress of Russia. It
was the beautiful composition of Lear and Cordelia.

The painter received his friend Lawrence cordially. The
sea captain and the artist were both quakers by birth and early
education, and both had abandoned the language, manners,
and costume of the sect ; and the powdered hair, side curls,
and silk stockings of that day gave no indications of quaker-
ism. After my first introduction, Mr. West led us back to the
room we had passed through, and where my specimens were
deposited. He first examined the drawing in Indian ink. I
stood on trial, and awaited sentence. "This is very well."—
I felt that all was safe. "But it only indicates a talent for
engraving." I sunk from summer heat to freezing point.—
My friend seized the painting and unrolled it on the floor.
The artist smiled—the thermometer rose. "This shows some
talent for composition." He appeared pleased ; and looking
at the distant figures, smiled to see an awkward imitation of
his own General Wolfe, dressed in blue, to represent the death
of General Mercer ; and the Yankees playing the part of the
British grenadiers, and driving red coats before them. I was
encouraged. My friend was directed to No. 84, Charlotte-
street, Rathbone-place, where rooms had been engaged for
me. Mr. West offered his casts for my practice when I should
be ready to draw. Before leaving the house of the great
painter, it may be supposed that I gazed, with all the wonder
of ignorance and the enthusiasm of youth, upon the paintings
then in the rooms, which were many of them for the King's
chapel, Windsor. The one most impressive was, Moses re-
ceiving the law.

I was now left master of my own actions, and of two rooms
in the house of Robert Davy, Esq. I was put in possession
of a painting room on the first floor, or second story, and a
furnished bed-chamber immediately over it : and for these,

and for my board, fire, &c. I was to pay a guinea a week.—
After seeing the lions of the Tower, and of other parts of London, I sat down to draw in black and white chalks from the bust of Cicero; and having mastered that, in every point of view, I drew from the Fighting Gladiator, (so called)—and my drawing gained me permission to enter the Academy at Somerset House. I know not why—perhaps, because I was too timid to ask Mr. West to introduce me, or too bashful and awkward to introduce myself; but I never made use of the permission.

I had an awe of distinguished men that caused many weaknesses in my conduct; a bashfulness that required encouraging, at the same time that I was first of the boldest among my companions—but so it was; I went with my portfolio, port-crayon, chalks and paper, and delivered them to the porter, made some excuse for not going in, and walked off; I never entered the school or saw my portfolio again.

This monomania (it was little less) was encouraged by the consciousness of the deficiency of my education and knowledge upon all subjects.

The drawings above-mentioned, and a few pictures in oil, executed under the direction of Mr. Davy, who taught me to set a palette as he had been taught in Rome, were all the records that remained of my exertions to become a painter, which the year 1784 produced.

Wright Post, a youth of New-York, born on the same day with myself, had been sent to study surgery with the then celebrated Sheldon. Post attended to his studies assiduously, but found leisure to join me in my idleness. With him and other young men, this invaluable portion of my life was worse than wasted. The next summer Mr. West and family were at Windsor. Mr. Davy and his family in Devonshire. And when my companion, Post, was not with me on some party of pleasure he supped with me at Charlotte-street, where I was willing at my own charge to make up in the evening for the eternal mutton of my landlord's dinner-table.

At the time I left my portfolio at Somerset House, (a wet autumnal evening,) I suffered from what terminated in an abcess, and confined me to my bed or bed-chamber during the winter. Post was my physician, and passed much of his time in my company, as did my townsman Andrew Smyth, and Raphael West. Sheldon at length attended to me at the request of his pupil and not too soon. Health at length returned, and in May I attended the first exhibition I had seen at Somerset House. Thus passed a year in London—lost to all

improvement except what I have above-mentioned, and some desultory reading during my illness.

In the summer of 1785 I copied Mr. West's picture of " The Choice of Hercules," and painted a few portraits of my friends. The return of health brought an overflow of animal spirits. The theatres—Vauxhall—parties on foot to Richmond-hill and on horseback to Windsor, and every dissipation suggested by my companions or myself, was eagerly entered into. I look back with astonishment at the activity of my idleness, and the thoughtlessness of consequences with which I acted. The number of my companions increased, and the long absence from home of the father of one of them, afforded an opportunity to the son, left master of the house, (which had no mistress,) to assemble us for mirth and midnight revelry. Raphael West came in for his share of this, and his derelictions were probably scored up to my account where nothing appeared on the credit side.

Every source of information was neglected. I thought only of the present, and that was full of delight to my empty mind. I seldom saw Mr. West except when invited to dine, which was generally when he had Americans recently arrived at his table. He saw no proofs of my industry, and heard no good reports from Mr. Davy. I was often with Raphael, his son, who painted a very little—played on the fiddle or hautboy a great deal, and amused himself in the room sometimes occupied by Trumbull, at the commencement of the gallery. My visits were of little advantage to myself, and none to my friend Rafe. Ben, Mr. West's second son, was at school. Trumbull was awfully above me and my companion, and I only accidentally met him; sometimes in the small painting-room above-noticed, and sometimes in the rooms beyond the gallery or Mr. West's rooms, where I first saw the beautiful pictures of the Battle of Bunker's-hill and Death of Montgomery. I received neither advice nor instruction from him.

It was probably during this summer of 1785 that I received one of the few lessons which I put myself in the way of receiving from my ostensible master. I presume that I carried something for his inspection which I had painted. I would willingly think so; and probably he found it deficient in keeping. My monomania prevented me from asking questions. He was at work in the room where I had first seen him, and his subject at this time was a landscape; a scene in Windsor-forest, with the figures of the king and his suite on horseback hunting in the distance, and a frightened sow and pigs near the foreground. He elucidated the doctrine of light and

shadow by drawing a circle on an unoccupied canvas, and touching in the light with white chalk, the shadow by black, and leaving the cloth for the half-tint and reflexes. He then pointed to a head in the room to show that this theory was there in practice, and turning to the landscape said, that even the masses of foliage on the oak-tree there represented were painted on the same principle. All this has long been familiar to every artist, and that this lesson was thought necessary is perhaps a proof of the little progress I had made in the rudiments of the art I professed to study. Yet I had a better eye for form than for colour. I was discouraged by finding that I did not perceive the beauty or the effect of colours as others appeared to do. Whether this was a natural defect, or connected with the loss of the sight of an eye, I cannot determine.

The return of full health to a youth of nineteen may be said to come as a torrent of delight, without using the language of figures which poetry deals in. It was in my case absolutely intoxicating, and brought with it no particle of the precious wisdom which experience might be supposed to mingle in the stream. The enjoyment of the present was never interrupted by the remembrance of the past or anticipation of the future. How the blessing of health which I every day exposed was preserved, I know not—certainly by no prudence on my part.

It has been said that the contemplation of the solar system and the infinite multitude of stars beyond, each of which is the centre of a similar system having its planets revolving around it, filled with myriads of intelligent beings—and the whole revolving around *one centre*, gives the clearest notion of God that our limited faculties can conceive; the creator, upholder, director and ultimate perfecter of the whole; but perhaps if we turn our observation within and contemplate the wonderful machine, man—the adaptation of the parts to the whole—the connection of mind and matter—the incomprehensibility of the spirit which we feel, yet cannot obtain a definite knowledge of—perhaps, if we study man, a mere atom in the universe, we shall come to the same result; a knowledge of God strengthening the previously attained notions of his infinite goodness; but certainly the contemplation of both must lead to a confirmation of that religion which teaches love to God and to our neighbour. Yet how difficult has been the attainment of this knowledge and how prone has man been to forget his Creator, or to turn the religion of love into the idolatry of fear.

Reader, this is not without connection with the subject be-

fore us. The uneducated youth is as blind as the savage : he sees in the wonders which surround him no more than the idolater sees of God. So to me the wonders of art with which I was surrounded communicated no instruction, because of the lack of previous education. If I caught a glimpse of their perfections, it was only to fill me with dismay.

Many a day was wasted in walking to the New-York Coffee-house, near the Royal Exchange, under pretence of looking for letters from home. The morning lounged away, I dined at the Cock eating-house, where the master with a white apron waited upon me to know if all was satisfactory, and then, (the business of the day over,) rolled away in his coach to his country seat. Dining and port wine over, there was " no use in going home," the theatres stood midway ; and when the play was over, I might rest from a lost day, and not dream that I had been doing wrong or neglecting right. Many a day was spent in pedestrian expeditions to Richmond-hill, Hampton Court and Greenwich ; or in rides to more distant places around the metropolis. Sometimes it was an excuse that pictures were to be seen—but I looked upon pictures without the necessary knowledge that would have made them instructive.

Captain Lawrence and Mr. West, it appears, did not feel themselves authorized to control and advise me ; and my connection with these worthy men became merely that of occasional visits, and frequent invitations to their tables. I prevailed on Lawrence to permit me to paint a group of his beautiful boys, but I undertook more than I could accomplish—it was never finished.

After being two years with Mr. Davy, I, with the thoughtlessness which characterized my actions, left Charlotte-street, Rathbone-place, without consulting Mr. West, and removed to a furnished first-floor in Broad-street, Soho. Davy was not backward in communicating my change to West, and I presume, in assigning motives unfavourable. West recommended the apartment I abandoned to Fulton. My new establishment was elegant, and increased my expenses. I breakfasted in the house and for dinner, made one of a *mess*, principally half-pay officers, who had served in America. This eating and drinking club was established at a porter house in Oxford-street. The man's name was Ensworth, and by adding a letter, an eccentric old gentleman, who occasionally visited the place, designated the house *end's worth*. He was a humorist, and used sometimes to amuse the young men by a pretence of telling their fortunes or giving oracular advice from his interpretation of the individual's name. The landlord's

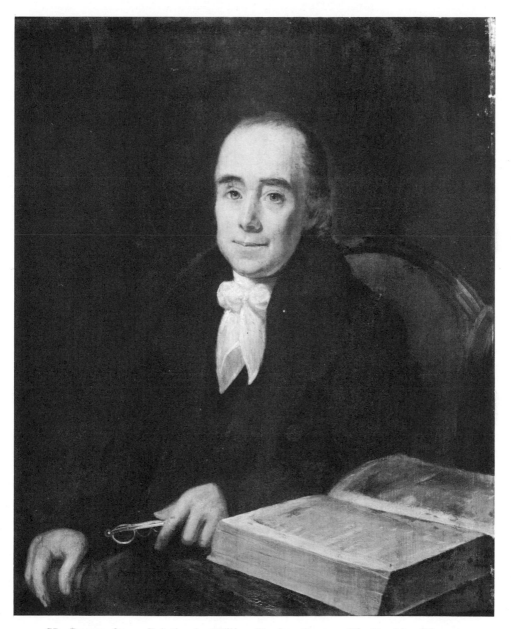

77 ROBERT SNOW. Painting by William Dunlap. *Courtesy The Brooklyn Museum.*

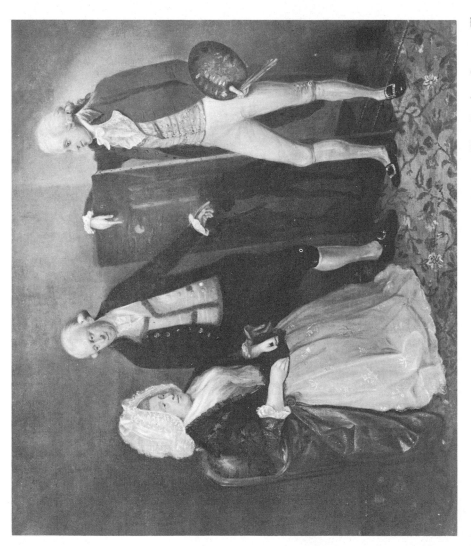

78 THE ARTIST SHOWING HIS FIRST PAINTING TO HIS PARENTS. Painting by William Dunlap. *Courtesy The New-York Historical Society.*

name, he would say, was a warning to all not to visit his house
or any one similar. The places where character, fortune, and
worth must end. " And what is your name, sir?" " Dunlap."
"Very well, sir, take warning; *Done—cease—stop—forbear—*
that is the first part. *Lap*—a mode of drinking—cease
drinking." And thus more or less happily he would proceed
through the company.

During this period of my life had I any character? I was
a favourite with my companions—I was always full of life and
gaity; and moved by a desire to please. I was by them sup-
posed to possess humour or wit. I had some little knowledge
of music, and could sing to satisfy my associates; but I did
nothing to satisfy the man who had it in his power to serve
me. My follies and my faults were reported, and exaggerated
to Mr. West, and as he saw no appearances of the better self,
which resided in me, (for there was a better self,) he left me to
my fate.

The members of the mess agreed to pay Ensworth one shil-
ling, cash, for each dinner at which they were present. A
course of meat was followed by a dessert of pudding or pies,
and each man was allowed a pint of porter as table drink.
However, scarcely a day passed but brandy-punch followed
the dessert, and sometimes wine. Those who know what the
mess-room of officers generally is, may suppose that the warn-
ing of the old man—" cease drinking," might sometimes be of
service.

At my new establishment I painted several portraits and
composed some historical pieces, one of which I will mention
(the only one which attained something like finish,) the subject
was from Hoole's Ariosto. I had attempted to represent Ferau
gazing with horror upon the ghost, who rises from the water
with the helmet in his right hand, and points to it with his
left. Lieutenant Spencer, of the Queen's Rangers, (one of our
mess,) had been my model, and stood for *Ferau*, and a very
fine figure he was; but Spencer had attempted to figure on the
stage, had failed, and his attitude was strained—his expression
exaggerated, (as might be expected from a bad actor,) and my
Ferau partook of his faults more than his beauty. The steel
armour of Ferau had received a touch from my friend Raphael
West. The ghost I had studied from the looking-glass.
When I showed this picture to Mr. West, I unexpectedly heard
him say to one present, " That figure is very good," and
turning towards him, was upon the point of saying, " Rafe
helped me with the armour," when to my surprise I found that
he pointed to the ghost, for which I had been my own model.

On this same occasion I showed the great painter a portrait I had painted. It was freely touched, well coloured, and full of expression—better than any thing I had done by far. He gave it due praise, but observed, "You have made the two sides of the figure alike—each has the same sweeping swell—he looks like a rolling pin." I might have said truly that it was characteristic—but I took the lesson in silence, and made no defence, although I knew that my subject was in fact "like a rolling pin." Silence, in this instance, may have been commendable; but my habit of silence, in presence of those whom I considered my superiors, was very detrimental to me. The person who asks for information gains it. The questioner may be at times irksome, but that is for want of tact. He should be a judicious questioner and a good listener. I stood in the presence of the artist and wondered at his skill, but I stood silent, abashed, hesitating—and withdrew unenlightened;—discouraged by the consciousness of ignorance and the monomoniacal want of courage to elicit the information I eagerly desired. Let every student be apprised that those who can best inform him, are most willing to do so.

CHAPTER XIV.

Among the collections of paintings which I have said I visited with little or no improvement, was that at Burleigh House, near Stamford, in Lincolnshire. I had an acquaintance engaged in mercantile business of the name of Linton, a man older than myself, attached to me for qualities compatible with my thoughtless career, (though himself a man of thought) perhaps for inexhaustible good spirits, frankness and unweariable cheerfulness. His father had been a clergyman of Stamford, and his widowed mother, with two sisters, resided there. He was about to visit them and proposed that I should accompany him. It suited me exactly. Each with a small trifle of baggage proceeded to the stage-coach, and on

being told that it was full, mounted to the top, (although it was to be a night ride) and with the guard, armed at all points, for our *companion de voyage,* dashed off on the road for Scotland. We arrived shortly after daylight at Stamford, and were received with all the warmth belonging to the English character in that respectable class of English society to which my friend belonged—he, as the only son and brother, and I, as his friend. We soon saw the lions of the place, and I found that I was a lion. The next day was Sunday, and my friend said, " It is already buzzed abroad that I have brought down an American with me, and when we go to church, the people will expect to see a black or a copper-coloured Indian at least; I was, at that time, as fair as West was when Cardinal Albani asked if the young American was as fair as he, an old olive-coloured Italian, was. We went to church, and I presume the good folks thought it was an impudent attempt at imposition to pass me off for an American. How could it be otherwise with those who had been taught by the most sanctioned journals of their country, that " an American's first plaything is a rattlesnake's tail?"

We staid a few delightful days at Stamford. I saw the pictures at the castle—Madonnas and Bambinos, and Magdalens, and Crucifixions, but I believe all did not advance me one step in my profession.

My view of the collection of painting at Blenheim House was seen in company of my friend Samuel Latham Mitchill, who, having returned from Edinburgh an M. D., proposed a visit to Oxford and its neighbourhood. On this occasion I took with me a blank-book and kept a journal which I still possess, and which is somewhat of a curiosity. One of the most interesting anecdotes of this pedestrian tour I published in a former work, from memory, the journal being at the time lost. I will give some extracts from this manuscript :—

" After securing a passage for our trunk in the stage for Friday, Doctor Mitchill and myself commenced our foot expedition on Thursday morning, November 16th, 1786, at eleven o'clock ; and proceeding on our way, passed Kensington Gravel Pits, and stopped at Norcoat to refresh ourselves with a glass of ale." I will remark, that we set out in the rain, with great coats on and boots, and often literally waded through the mud.

On the 17th, before breakfast, we pursued our walk through rain and mud, and rested at Stoken Church. The next day we had an adventure, which I always considered remarkable, in the chapter of accidents. " We had not proceeded many

miles, when an aged man attracted our attention. He carried nought but a staff: his garments were wretchedly tattered: his shoes worn out, and falling from his feet, seemed, like their owner, to have suffered much from the ravages of time, but more from hard service. He did not address us at meeting; Mitchill, the interrogator, stopped him. After the usual salutation we began our inquiries; and he told us that he was a soldier, returning from Shropshire to London, for some papers he had lost, which entitled him to seven pounds a year, the reward of his faithful services. I asked him where he had served.—" In America—under Wolfe—I saw him fall—I received this wound in my cheek that day—lay your finger in it, sir." I then felt interested in the tale of this veteran, and with earnestness demanded what regiment he belonged to.— " The forty-seventh, sir," said he. " What officers do you know of that corps?" He mentioned the names of several of his old commanders. I asked him if he remembered an officer of the name of Dunlap. " Mr. Dunlap," said he, " certainly I do; he was my lieutenant—to be sure I remember him." " And where were you after the French war? Were you in New Jersey, at Perth Amboy?" " I was not quartered at Perth Amboy, sir, but at Brunswick, with that part of the regiment. We were removed to New York, and then to Boston. I was at Lexington and Bunker-hill, and I was taken with Burgoyne at Saratoga." While he spoke his countenance was enlightened, and he seemed to feel himself again a soldier. " Suppose that I am the son of that Lieut. Dunlap?" " Are you?" he cried. And upon my assuring him that I was, he seized my hand with an honest ardour; and if he could have afforded a tear, I believe it would have started. " And after all your toils—after all your services—how has your country provided for you?" " Why, well," said he " seven pounds a year are enough for me in my native village: but having lost my certificates, I am now without a halfpenny to buy food or procure me lodgings on my way to London. See!" said he, searching his rags, " see what I have lived on these two days!" and he produced a half-eaten, uncooked turnip. " All I have eaten these two days is half of this turnip." As we stood mute he thought we doubted his word, and added, " May I be damned if I lie!" Our soldiers swore terribly in Flanders.

As we were within sight of a tavern, we turned him back with us; and I had the pleasure, while breakfasting, to afford a good meal to my father's old companion in arms; and on parting, gave him wherewithal to make his journey comfort-

able to the War-office. The old man said he was then sixty-
six years of age : and when he left us, he took us each by the
hand and blessed us. Turning to us, at a few paces distance,
he said, " If ever you see your father, perhaps he may remem-
ber old Wainwright."

Between the hours of one and two we gained sight of the
University from Shotover-hill. My journal is barren of all
interest respecting Oxford : probably no journalizing tourist
ever visited the place more ignorant than the author.

On the 22d we walked to Blenheim, and I saw the Duke
of Marlborough's collection of pictures with some pleasure
and little profit. The house, furniture, park, &c. were objects
of admiration. We walked about Woodstock, and then, cud-
gel in hand, returned to the Angel inn, Oxford. The next
day we departed for London, having sent our trunk on before
us. Though humble pedestrians, we passed through a lane
of expectant waiters, chamber-maids, cooks, scullions, &c. as
great as if we had been travellers with coach and six. We
changed our route in returning, and stopped a day and a night
at Windsor ; and next day, after early breakfast, attended the
King's chapel—saw the royal family—and at nine, leaving
the Castle, arrived in Oxford-street, London, at two P. M.
and dined with the *mess* at four.

Except the journeys to Stamford and Oxford, I saw nothing
of the interior of England. Parties of pleasure to Windsor,
Richmond, Hampton Court, Greenwich, Woolwich, either
on horseback or on foot, were frequent ; and I passed a few
delightful days at the residence at the Rev. Mr. Moore, where
the widow and family of Mr. John Smyth were on a visit.
Mrs. Smyth was of the family of the rector of North Cray,
and both relatives to the afterwards celebrated Sir John
Moore. At this delightful place I heard, for the only time,
the notes of the nightingale. I painted and presented to Mrs.
Smyth several portraits, two originals and two copies, of her
relatives, one from Opie.

This life of unprofitable idleness was terminated by a sum-
mons to return home, brought by Captain Watson, who in-
formed me that my passage was paid, and he should sail in
August. I made preparations for embarkation ; my pictures
(poor things!) were packed, and with prepared cloths, co-
lours, &c., were shipped. Thus ended a residence in London
of sufficient length to have made a man of abilities feebler than
mine a painter. But my character was at first mistaken—I
was discouraged and led astray, and gave up the pursuit of
my profession for the pursuits which youth, health, and a dis-

position to please and be pleased, presented to me. In August, 1787, I embarked to return home with the same ship and captain that brought me all alive with the best dispositions to improve myself, to the metropolis of Britain, in June, 1784.

After a passage of seven weeks, we arrived in the beginning of October. The weather had permitted me to set up my esel in the cabin, and I painted two portraits of our captain during the voyage. When the pilot came on board, I was called up from over the bows, where, in jacket and trowsers, I was assisting a sailor to paint the figure-head of the good ship Betsy. I heard that my parents were well, and we were soon cheered by the beauties of the bay of New-York, and a view of the city, with old Fort George towering in front. Before landing, we were boarded by a boat, and I was greeted by my father and my friend Wright Post. I soon found myself in my mother's arms, and surrounded by the black faces, white teeth, and staring eyes of the negroes of the family.

In due time, my pictures, canvasses, colours, &c., were landed. I was installed as a portrait-painter in my father's house, and had sitters; but I felt my own ignorance, and felt the superiority of Joseph Wright, who was my next door neighbour, and painting with but little success as to emolument. By degrees my employers became fewer, my efforts were unsatisfactory to myself. I sought a refuge in literature, and after a year or two abandoned painting, and joined my father in mercantile business.

It was on an evening of this winter, that, sitting by the fire, and conversing with an English gentleman on the subject of pictures, he asked me if I had any idea of a picture which should represent all surrounding objects as they appear in nature when we turn and look from a central spot? I answered, "Yes. It has been familiar with me from childhood, though I do not think I have ever before spoken of it. Often when standing on an eminence, and looking around me on the bright and glorious objects, here a landscape, there a bay and shipping—a city glittering in light—all the tints of a sky from the setting sun to the sober colours of the opposite horizon—I have imagined myself surrounded by an upright circular canvass, and depicting the scene just as nature displayed it, and I have regretted that I could not make the experiment." " *That's it!*" was his unintelligible exclamation. He then told me, as a thing yet unknown, that an artist in Edinburgh had conceived the plan, made the drawings, and was executing

such a picture ; that he had helped him with funds, and by that means became acquainted with the fact. This was the first time I ever heard of a panorama, a species of picture then unknown to the world.

It was my good fortune, soon after my return, to become a member of a literary society formed by young men for mutual instruction and improvement. My friend Samuel L. Mitchill, Noah Webster, (then editing a magazine in New-York,) and others afterwards known in American literature, were members. This led to a more regular course of study than I had ever known. I sought assiduously to gain knowledge, but unfortunately could not be content without exposing my ignorance by writing and publishing. I even planned an epic poem, on the story of Aristomenes, and wrote some hundred verses : fortunately this was not published. I was likewise drawn into some societies called convivial ; and as I had been a member of a *Buck's* lodge in London, so at home I became a *Black Friar* and a *Mason ;* but happily I was withdrawn from this course by marriage with Elizabeth, the youngest daughter of Benjamin Woolsey, deceased, and Anne his second wife, the daughter of Doctor Muirson. Beside the inestimable blessing of a good wife through a long and checkered life, I obtained the advantage of connexion with her relatives, her brothers, her sisters and their husbands and friends. I derived much advantage intellectually from the society of the Rev. Timothy Dwight, afterwards president of Yale college, who had married my wife's sister, and at whose house on Greenfield Hill I passed some of my happiest hours. I was now rescued from inevitable destruction. I had lost the opportunity of becoming a painter, but I might become a useful and happy man. It will be observed, however, that I had no education or habits fitting me for any definite pursuit. My character was fast changing, and the monomania I have complained of was vanishing, until by degrees I learned to appreciate myself and others with some degree of justice.

From the year 1789 to 1805 the events of my life have no connexion with the arts of design. I was for several years an active member of the Abolition Society of New-York—a trustee of the African school—and twice represented the society (in conjunction with other members) in the conventions held in Philadelphia, congress then holding their sessions in that city. I remember with pleasure, that, as chairman of a committee, I drew up a memorial which produced from congress one of the most efficient acts against the slave-trade, and under a commission I afterwards procured testimony which

caused the condemnation of one of those infernal instruments
of torture, a slave-ship. During this time I painted some
small sketchy likenesses of my friends C. B. Brown, Elihu
H. Smith, and a few others. My father died, and I liberated
the family slaves, retaining some as hired servants. I was
engaged in mercantile journeys. I visited Boston as a mer-
chant, and Philadelphia several times on mercantile business,
and twice as a delegate to the convention for promoting the
abolition of slavery. I engaged in theatrical speculations,
and became bankrupt in 1805.

My summers had been passed at Perth Amboy, writing for
my theatre, and traversing hills, dales, and woods, with
my dog and my gun. I have attributed, in an early part
of this autobiography, the misfortunes of men to their own
misconduct. Sickness is a great misfortune, and I have
experienced much of it; generally to be traced to excess
or folly of some kind. During the period above-mentioned,
I passed days in what are called field sports, and often under
the burning sun of July and August, and my just reward was
bilious fevers—in some instances to the extreme of illness con-
sistent with recovery. I can remember distinctly the causes
of many severe attacks of illness at that period and since, to
the present time.

Some of the particulars of the portion of my life above-men-
tioned I have published as connected with the History of the
American Theatre. Deprived of property, and a debtor to
the United States as a security for the marshal of New-Jersey,
who was a defaulter, I abandoned New-York, and took refuge
with my family in the house of my mother, at my native town
of Perth Amboy.

I now turned my attention to miniature-painting, and found
that I could make what were acknowledged likenesses. I was
in earnest, and although deficient even in the knowledge ne-
cessary to prepare ivory for the reception of colour, I im-
proved.

It was necessary to make exertion to procure money for my
family, and I determined to try Albany, where I yet had never
been, as a place in which work might be obtained. In a sloop,
after a tedious passage, I reached Hudson; where I found P.
Irving, and accepted his invitation to take part of his gig, visit
William P. Van Ness, and proceed together to Albany. After
two days passed at Van Ness's, we, keeping the east side of
the river, crossed the ferry to the old Dutch city in the evening
of the third. Here I found my friend Judge Kent, and be-
came acquainted with Gideon Fairman, then commencing his
career as an engraver. I took lodging at a boarding-house;

put some miniatures in a jeweller's window; consulted Fairman as to prospects, and waited the result. Kent was very attentive to me, and took me to the neighbouring villages of Troy, Lansingburgh and Waterford—then very poor places (as well as Albany) in comparison with the present time. We rode to the Cohoes and I was at home in his family; but my board was accumulating, no application for a miniature was made, and while I had yet a few dollars it was necessary to make another move. I determined on Boston, and after a most pleasant and picturesque ride, was put down at a stage-house, near the old market, late in the evening. I immediately sallied forth to find an eligible place for board and lodging, and in State-street, almost the only house still open, entered a hotel, and agreed for six dollars a week with Mr. Thayer, (a new landlord glad to receive a customer,) and removing my trunk I established myself, having money enough left to pay one week's board—and no more. I found next morning that Mrs. Thayer was the daughter of Mrs. Brown, with whom I had boarded many weeks in former and more prosperous days.

The next morning, with miniatures in my pocket, I visited Cornhill, and found myself at home among the booksellers, who had dealt in my plays and were glad to see the author. With one of these, Mr. West, an amiable man, I left several miniatures with my address, and returned to my hotel to await my fortune. In a few hours, while reading the papers, I heard an inquiry for the miniature painter, and was greeted with the question, " Can you paint my likeness, sir?" Most joyful sounds! " Certainly sir." An appointment was made for the next morning, and I felt the first fifteen dollars (the price I had fixed on) already in my pocket. I had from that time forward constant employment, and sent with delight a part of my profits home.

My former Boston acquaintance had mostly vanished, but I received calls and invitations from Josiah Quincy, Colonel David Humphreys, Andrew Allen the British consul, and from Powel, now manager of the theatre. Cooper, Bernard and others sat for their pictures. I worked in the forenoon—dined out generally—and, when not engaged, visited the Federal-street theatre—made free to me.

There were at this time two good miniature painters in Boston—Field and Malbone; the latter at the very pinnacle of perfection in the art for drawing, colouring, truth, and above all, taste. I met Field at Andrew Allen's, but never became acquainted with him. With Malbone it was different.

I showed him my work, and he exclaimed with surprise, "I wonder you do so well when your ivory is not prepared." He made an appointment for the purpose of showing me the mode of preparation, which he did one morning after we had passed the evening at Allen's, at a great dinner party. "They told me that I might drink champagne without fear of headache," said the amiable Malbone, then already in the fangs of consumption, "but I can hardly see, and my head is splitting."

Gilbert C. Stuart was then boarding and painting at Chapotin's hotel. His family were not with him. T. A. Cooper and his family were at the same house. I renewed my acquaintance with Stuart, began in London, and once before renewed in New-York. I did not see much of him at this time. His mornings were employed at his esel, and his afternoons at the dinner-table.

I returned to my family at Perth-Amboy, but judging it necessary to see the secretary of the treasury respecting the debt incurred by the marshal, I proceeded to the city of Washington, taking my painting apparatus with me, and stopping at Philadelphia and Baltimore on my way. At Philadelphia my friend C. B. Brown, now a married man and settled near his brothers and his venerable parents, gave me a home and a repetition of the pleasures I had enjoyed in his society at my house. Conrad was at this time the Philadelphia publisher, and my friend was regularly an author by profession and in his employ. I have a memorandum of a literary dinner at Conrad's, which, written at the time, has some claim to attention. "January 14, 1806. I dined on Saturday at Conrad's, with a party of *literati*. Fessenden the author of Tractoration, Denny, Mr. John Vaughan, member of the Philosophical Society of this place; Doctor Chapman, one of the founders of the Edinburgh Review. Fessenden is a huge, heavy fellow, as big as Colonel Humphreys, with features as heavy as his person, and an address rather awkward; but his conversation, setting aside Yankeeisms, is agreeable, and evinces an amiable disposition. He is a mechanical as well as poetical genius, and when in England was concerned in erecting floating mills upon the Thames, similar to those used in France and Germany. Denny is a small neat man, an entire contrast in appearance to the foregoing. He appears to be about forty-five years of age, and is well bespattered with gray hairs. Though a Massachusetts man, he has freed his conversation from Yankeeisms, and speaks with as much facility as he writes. He is polite in his address, attentive to the etiquette of society, and studious to suit his conversation to those

with him, as well as to elicit the sparks that might otherwise remain dormant—with all this I confess that I did not hear those brilliant things which I expected from the mouth of the editor of the Portfolio."

If any person in 1834 will look over the numbers of this popular and celebrated journal, as published in Philadelphia in 1801, he must be astonished that a work breathing the highest degree of ultra-toryism, attachment and servile subserviency to England, and admiration of her political institutions, with, of course, bitter enmity to all that is fundamentally American, or that is the true source of her prosperity, could be extensively circulated and popular. Its literary merit is great, but the feelings of a great party among us must have been such as are now incomprehensible.

I copy this account of the dinner party *as the impression made at the time.* I can add, from memory, that this, the only bookseller's dinner I ever partook of, was not very interesting. I was of course a cipher. Brown, who when tete-a-tete with me would pour forth streams of copious eloquence by the hour, was here as silent as myself.

I painted some miniatures, and early in January 1806, proceeded to Baltimore with funds undiminished.

Groomrich, elsewhere mentioned, was painting at Baltimore, and beside his own landscapes showed me some clever pictures to which he had affixed great names. I now first heard the name of Guy, of Baltimore.

I put up at the Fountain Hotel, and found employment for some weeks. I at length reached the great city, then rather a desolate place, crude and unfinished. Here I found many of my friends as members of congress, and among them Samuel L. Mitchill, with whom I now rambled on the banks of the Potomac as we had done on those of the Thames, and with undiminished good will. I settled my business with Mr. Gallatin, who instructed me in the measures necessary to be taken with the district attorney of New-Jersey, and put me at rest respecting the debt of the late marshal. I was introduced to Mr. Jefferson by Mitchill, and copied in miniature his portrait by Stuart, lent me by Mrs. Madison.

The good old Vice-President, George Clinton, received me as an old acquaintance, but I saw little of public men. Among the old friends I saw at Washington, I must not omit Joel Barlow and his amiable wife; and of those from whom I received civilities, Mr. Thornton of the patent office.

I passed some days at the house of Mr. Love, at Georgetown, who insisted on my staying with him while painting his wife's miniature. I left Washington late in March, and stop-

ped for a short time with my friend Brown and his amiable wife on my return. I again visited them about the beginning of April, and passed three weeks with them : I then returned to my family at Perth Amboy, and devoted myself to painting and gardening.

My mother's house stood on the main street of the town, and an acre lot extended westward to a street without houses. During my supposed prosperity as lessee of the New-York theatre, I had planted this garden with choice fruit, besides setting out orchards and otherwise improving a farm on the rising ground about a mile from the city, where I had planned and enjoyed an air-castle ; the latter had passed away, and I was contentedly working in my mother's garden, when a gentleman approached from the house, whom I soon recognised as my friend T. A. Cooper. He rapidly informed me that he had taken the New-York theatre on conditions of a rebuilding of the interior—that he was on his way to Philadelphia to make engagements—that he wished me to assist him as general superintendant of his theatrical concerns and manager in his absence—made me such an offer as to yearly emolument, to commence that day, as I could not reject, and proposed getting into a carriage in waiting and proceeding to Philadelphia immediately. It did not take long to change dress, dine or lunch, and I was no longer a painter, but all my mind absorbed in theatrical affairs.

My situation in the theatre became disagreeable, not owing to any acts of Mr. Cooper, and in the year 1812, after a sacrifice of another six years, I relinquished it and again commenced miniature-painter, taking an apartment in Tryon-row, which had been occupied by Bass Otis. My family had remained at Perth Amboy as their permanent residence ; my success as a miniature-painter at this time determined me to remove them to New-York, and I took a house in Fulton-street in despite of the war then existing with Great Britain. My business declined and I commenced author again, by publishing the Memoirs of George Frederick Cooke, and commencing a magazine under the title of "The Recorder," in both works being assisted by my son. I was applied to by Mr. Elijah Brown to write a biography of my friend C. B. Brown, which I did, encumbered by a selection made by Paul Allen, of Baltimore, which being in part printed was to be retained, by agreement.

My magazine was a source of trouble and was running me in debt. I took my painting materials and proceeded to Boston with a double view of aiding the periodical, and gaining

something by my pencil. I stopped a few days with my brothers-in-law, president Dwight and Wm. W. Woolsey at New-Haven, and painted some miniatures there and at Hartford, where I passed some very pleasant days in August with my friends Theodore Dwight, Doctor Cogswell and Mr. Scarborough. I visited my excellent friend Richard Alsop, at Middleton, and took from him letters to Benjamin Pollard and F. J. Oliver of Boston, the son-in-law of Mr. Alsop. This gentleman's acquaintance ripened into a friendship to me invaluable. On my way to Boston I passed a few days at Providence, but finding no employment for an itinerant painter, I pushed on and arrived at the Exchange Coffee-house in the evening of August 26th. The next day I took up my abode at the boarding-house of Mrs. Brown in State-street, with whom, at the same house, I had boarded at three different periods, twenty-two years, seventeen years, and seven years before the present visit. On the 28th I had a portrait begun (miniature,) and in the afternoon a second sitting.

In the society of Mr. Oliver, his friends and relatives, my leisure hours were happily passed. Stuart at this time had his family with him and lived at Roxbury, where I visited him on the 2d of September, and was received cordially. My journal says, " he has begun the full-length of Hull for our corporation, and is to begin Bainbridge soon. He says Decatur and Lawrence are not bespoke of him." The Corporation of New-York have none of his pictures.

I showed him the miniatures I had painted at New-Haven, and he made his remarks freely, but strongly urged me to paint in oil. I took his advice on my return to New-York.

Finding no encouragement for the " Recorder," I wrote to my son to offer the work and subscribers to James Eastburn, of New-York, but he declined and the magazine failed.

On the 25th of October, (having until that time found employment in painting miniatures, and delightful society, principally with F. J. Oliver, W. Heard and B. Pollard and their connections,) I took my friend Alsop's wife under my charge and returned to Hartford.

While I was in Boston I received letters from P. Irving, Esq., informing me that he had agreed with Miller of London to publish my life of Cooke and divide the profit; but before I left it, I learned that John Howard Payne, having found a copy in a ship from New-York, with a view to serve me, sold it to Colbourne, who got out an edition before, (or on the same day) with Miller's, and the two publishers agreed to make the best for themselves, and sink me.

After my return home I commenced painting portraits in oil, and with a success beyond my expectation. In the year 1814, when sitting at my esel, I heard a knock at my street-door and opened it myself, when, to my surprise, I saw an orderly-sergeant, who delivered a message from the commander-in-chief of the third military district, requesting to see Mr. Dunlap immediately. The surprise of a man who had had no connection with the political affairs of the times (except expressing his opinion and giving his vote, or with the military except lamenting disasters and rejoicing in the triumphs of the army and navy,) may be imagined at receiving such a message ; and curiosity alone was sufficient to carry me in a short time to head-quarters. Daniel D. Tompkins was then commander of the district for the United States. I had seen him as a judge, and as governor of the state, but had no acquaintance with him, further than returning a salute from him in public which showed that he knew me, although I had never exchanged words with him. I found him surrounded by officers and applicants, at a table covered with papers. He broke off and saluted me with the smile of an old friend. " Mr. Dunlap, I have to apologize for not thinking of you sooner, if it will suit you to enter the service, the best thing I can now offer you is the office of Assistant paymaster-general of the militia of the state, in the service of the United States ; walk into the next room and the paymaster-general" (to whom he then introduced me,) " will explain the duties, pay and emoluments, and I shall be happy if the office suits you." After a short interview with the paymaster-general, in which he told me what steps must be taken previous to exercising and receiving the emoluments of office, I returned through the room in which Tompkins still was, thanked him, accepted the office and retired. Washington Irving was then one of the commander-in-chief's aids, and of course, a lieutenant-colonel, and I suspect that it was in consequence of his mentioning me to Tompkins that I received this military appointment. Be that as it may, the manner of the General was in the highest degree friendly, and his friendship continued till death.

I was thus again removed from pencil and palette, and until 1816, or rather 1817, for it was late in the fall of 16 before my office expired, I was engaged in affairs foreign to the Arts of Design. So that at the age of fifty-one I became permanently a painter.

Although in a history of the Arts of Design it is not necessary to depict the scenes and characters I met with while paying off militia from Montauk point to Lake Erie, yet as

connected with my life in character of an artist, I ought to mention that I practised more than ever I had done before sketching scenes from nature in water-colours, and making faithful portraits of places which appeared worthy of my attention. A habit of early rising and pedestrian exercise gave me time and opportunity to visit and make drawings of spots within several miles of the place at which I was to labour in my vocation of paymaster during the remainder of the day. My last payments were made amidst the ruins of Buffalo, and being free for a time, I left my trunk at the only tavern in the place, and that not half built, and with my portfolio under my left arm, containing a change of linen with materials for drawing, and my artist's three-legged stool, resembling a club, in my right hand, I departed from Buffalo to visit Fort Erie and all the wonders of the Niagara as a pedestrian.

The artist's portable seat consists of three pieces of tough wood, the smaller ends pointed with iron and the larger ends bound together by a strong iron ring, which, when slipped down, permits the smaller ends to expand and form legs to the seat and the thicker likewise to expand for the reception of a small piece of sail-cloth with loops, which is carried in the pocket; this forms the seat, and secures the whole, making a three-legged stool. When not in use as such, the ring keeps the three sticks firmly together as a short heavy club, in which state, as it was generally seen, it was an object of curiosity and speculation which afforded me no little amusement. Crossing at Black-rock I visited the ruins of Fort Erie, and then at my leisure walked towards the Falls. I took shelter from rain at a miserable tavern, where I passed the night, during part of which a set of ruffians poured out their vituperations on Yankees, as they stimulated their passions with whiskey. The next day, after stopping to make many sketches, I reached the cottage of Forsyth, near the great cataract. I remained four days at the Falls, and made drawings which I carefully coloured in the open air, on the banks and on the table-rock. This wonder of nature is an exhausted theme. I will only remark that I saw it in 1815, and before the artificial additions and conveniencies were added, which now exist.

I walked down the Canada side of the Niagara and returned on the American side, all then either in ruins or rising from the effects of the war. Through rain and mud I reached Buffalo, and found the tavern so occupied by Governor Tompkins and his suite, that my trunk was deposited within the liquor bar, and *there* alone, surrounded by boors, I found a

place to change my clothes. While in the act, Tompkins, hearing I was in the house, left the dinner-table to seek me, and found me putting on my shirt. I slept that night amidst shavings and fleas in an unfinished garret, and next day departed for home.

I was, as Doctor Franklin has expressed it, at this time, "a young man of fifty." I was young and active in reality, and capable of as much fatigue as at the age of thirty. I had never been in the western portion of the state of New-York ; and although I knew that towns and villages had succeeded to the forest and the wigwam, when I actually saw the progress of civilization, the scenes of activity and prosperity, of cultivation, fertility and riches, day after day a succession of surprises and of pleasures heretofore unknown, filled my mind with delight. The remaining tribes of the Six Nations were objects of curiosity to me ; and I had frequent intercourse with Webster and Parish, the Indian interpreters, men yet in the prime of life, who, when children, had been carried off by the savages, adopted by them, and as young men, had roamed with them through the wilderness which I was now traversing as a paradise.

I saw a great deal of the population of the state, from the Dutch inhabitants on the Mohawk, to the New England men further west from Utica to Buffalo, but I saw them under circumstances which exhibited them to disadvantage. They congregated at the paymaster's call, and on receiving at a public house small sums of money (for most of them had only been out a short time) they were too much disposed to spend it in drunkenness, and in many instances quarrelling and blows followed. I could communicate many facts respecting the militia, and much that interested me relative to the remains of the Iroquois, but that the subjects would be out of place in this work, and other subjects demand the space.

In 1816 I was travelling under orders on Long Island, and then north to St. Regis, on the St. Lawrence. My mission to St. Regis was on business with that tribe of Indians ; and if I might in this memoir give my experience of this people at this time, and in 1815 when I visited the Onandagas, with Webster the interpreter, (a white man, stolen when a child and educated as an Indian.) I could state some facts curious and elucidative of the character of a race fast passing away.

In the autumn I returned home and resumed the profession of painter, much less qualified for it than in 1814, for in that year I painted one of my best portraits, which is now with the widow of the subject, (J. J. Holland, Esq.) at Vice

Chancellor McCoun's, for whom I have in much later days painted a child's picture, on which I would willingly rest my reputation as an artist. In a sick chamber, and in aiding to re-establish what is called the American Academy of Fine Arts, many months now passed away. I was elected a director and keeper, had a salary of 200 dollars a year and rooms for painting assigned to me, and painted in the year 1817 and 1818 many portraits.

My business in New-York failing in October 1819, I determined to try Virginia for the winter, and leaving a provision with my family, took 150 dollars with me and letters to Richmond.

I dined with my friend T. A. Cooper, at his house at Bristol, and took letters from him to Virginia and north Carolina. At Philadelphia I stopped a day or two with Sully, who always instructs me. He was, at this time, painting his great picture of the crossing of the Delaware, and occupied the Philosophical Hall adjoining the state house. He told me that he had not had a portrait to paint for Philadelphia since May last. Such are the fluctuations in an artist's fortunes. In conjunction with a frame-maker, Mr. Earle, he had built and opened an exhibition gallery, with little profit. Among the pictures were Leslie's Death of Rutland, Ward's Anaconda, Horse and Indian, and a landscape by Gainsborough. S. F. B. Morse was at this time painting oil portraits successfully at Charleston, S. C. and C. Fraser, miniatures. Trott was in Philadelphia at this time, but doing nothing, and was about visiting Savannah and Charleston.

I now, for the first time, saw Mr. West's picture of "Healing in the Temple." My first sensation was disappointment. My admiration followed; but the principal figure then and since, appeared very deficient. I saw Allston's "Dead man revived," at the Pennsylvania Academy, and could not but prefer much of it to the "Healing in the Temple."

Oct. 20th.—Embark for Newcastle—cross to Frenchtown, and again embark in a steam-boat for Baltimore and arrive at Baltimore before day-light next morning. At 7 A. M. embarked in steam-boat for Norfolk, touched at Annapolis and went ashore, and on the morning of the 22d landed at Norfolk.

I was now in a new region, and all appeared strange to me. The immense numbers of negroes was very striking. After a time Norfolk appeared to me, in many points, to resemble the place of my birth at the time of my childhood—no doubt the black slave-servants made a principal feature in this like-

ness; but the roads and walks, the want of cultivation in the surrounding country, and the hospitable manners of the inhabitants added to the resemblance. Norfolk had been long on the decline, and Richmond had the ascendant. I knew no one in the place and had not brought a letter. I took up my quarters at the steam-boat hotel, intending to proceed immediately up James River; but my landlord, Matthew Glenn, finding my plans and intentions from conversation with me, engaged me to paint two portraits of his daughters; his own portrait followed, and I remained in Norfolk fully employed until the last of April 1820.

I soon found some acquaintance here from the north. Mr. Crawley was settled here as a drawing-master and portrait-painter. I found myself at home in Norfolk, and my ease as well as profit was most materially owing to Thomas Williamson, Esq., cashier of the branch bank of Virginia, whose hospitable house was literally a home, though I continued to board at my hotel. Mr. Williamson has remained steadily to this day (1834) my firm and beloved friend.

When it was evident that I should be from home the winter, I wrote to Alexander Robertson, and enclosed my resignation as keeper of the American Academy. He was elected keeper and secretary, without salary. Mr. Trumbull had procured a law that the keeper should never be chosen from the directory. Mr. Joshua Shaw, landscape-painter, passed a few days at Norfolk. My reading this winter, 1819-20, was not of much profit, except diligent study of Adam Clark's edition of the Bible and notes.

On the 24th of April 1820, I left Norfolk on my way home, having promised to return the next winter. If I were to name those from whom I had received attention and hospitality, I should include all the enlightened part of the population.

At Baltimore, on my homeward journey, I found three portrait-painters. Rembrandt Peale, who was living there, and had a museum and gallery—Sully and Eickholtz visiters. The latter painting good hard likenesses at thirty dollars the head, had most of the business. I found Peale much inferior to my preconceived opinion of him, and far below Sully in merit.

The 27th April, 1820, I passed in Philadelphia: visited West's picture again, and Allston's, and saw no reason to change the opinion I had formed at my last visit. On the 28th I arrived at home, and found my family well. I was now an itinerant portrait painter. In New York little or nothing

to do. I had received a handsome sum of money at Norfolk ;
but my expenses, and my family expenses at home, soon ren-
dered it necessary to look out for more ; and I determined to
try Lower Canada, (new ground to me) and return in time to
take my wife to Norfolk in the autumn, where Williamson was
to have a painting room built for me. Accordingly, in the
afternoon of August 9th, 1820, I proceeded by steam to Alba-
ny, and by stage to Lake Champlain. Passed the lake, and
on landing, on the 13th, at St. John's, found myself in a foreign
country ; as we rode on to La Prairie it being Sunday, we
met the French peasants coming from church in the costume
of Normandy, as their fathers left it.

At Montreal I found employment until the 9th of October,
when I judged it best to seek home ; but curiosity, the desire
to see Quebec, and visit the plains of Abraham, where my
father fought by the side of Wolfe—to see those places which
had been made so familiar to me in infancy, when, sitting on
his knee he told me of battles on the ice and marches with
snow shoes, and all the stirring events of war, so fascinating
to the child and so repulsive to the " thinking, understanding
man."

It would be superfluous to describe a place so well known
and oft visited as Montreal ; but I should do injustice to my
readers, and to my friends found or made there, if I did not
copy some passages from my journal. I had taken a letter
from Dr. Mitchill, which introduced me to Dr. Paine, now
a practitioner in New York, but then a young physician in this
foreign country : through him I had the kind offices of Mr.
Cunningham, bookseller and librarian, and the society of Mr.
and Mrs. Barrett. " Walk with Dr. Paine round the moun-
tain by the north, and over part of it, my friend botanizing,
while I enjoyed his conversation and the beautiful scenery.—
This walk reminded me of days long past, when I studied
botany, and traversed the fields and rocks of Manhattan with
Dr. E. H. Smith.

" The whole island of Montreal is a plain, except this hill,
which gives it name. It is all capable of the highest cultiva-
tion, and a great part is in that state : farms, orchards, villa-
ges, and glittering spires, appear in every direction. We
took shrub and water, with cakes and bread, at a small Cana-
dian public-house ; and were served by a neat, polite, and
pretty landlady." As a contrast to this neat and comfortable
auberge, I mention one more truly Canadian. Being out on
a pedestrian excursion, with a companion, " after a walk of
ten miles we sought food and refreshment at a tavern of lar-

ger size and more prepossessing appearance than common. The keeper agreed to give us (having nothing else) some bread, eggs, and brandy. The brandy came first, and proved to be miserable rum. The landlady brought in six eggs in a soup-plate and one large pewter spoon : she then went out and brought in part of a loaf of sour brown bread grasped in one hand and a saucer with salt in the other, and with the spoon she ground the salt from coarse to fine in the saucer. We saw before us our dinner, its condiments, and its furniture : no plates, no knives ; six eggs to be managed as we could with one large spoon. Nothing more was to be had ; and, much amused by the specimen of Canadian tavern keeping, we soon dispatched the eggs, and departed as hungry as we came. This was not a hovel, but a good looking house, with a large sign, several apartments decorated with pictures of saints, virgins, and abundance of crucifixes, and immediately opposite the village church."

At the Mansion-house hotel, splendidly kept by an Englishman, I became acquainted with a very intelligent Scotch gentleman, Mr. Wm. Thomson, attached to the commissariat. —He had been with the army on the continent, of Europe, was well acquainted with books, men, and pictures, and drew correctly himself. He favoured me with the reading of a journal kept by him in France and Holland, with many excellent sketches. To him I am indebted for the subjoined memorandum of the prices at which casts from the Elgin marbles may be obtained in London.*

* Casts of the following plasters, from the Elgin Marbles, may be purchased in London for the prices annexed.

	£	s	d
Large Trunk, unknown (meaning the trunk of the human body)	4	4	0
2 small Trunks, bas relief ; Temple of Victory	0	5	0
2 Arms do. from Frieze	0	5	0
3 Horses' Heads from do.	0	7	6
Part of large Trunk, supposed to be Jupiter	3	3	0
Fragment of Head	0	5	0
Female Arm, from one of the large groups	0	10	0
Bas relief of Male Trunk, from Frieze	1	7	0
Arm of Metops	1	3	0
Three small Fragments	0	3	0
Bas Relief	0	5	6
Four Bas Reliefs of Frieze, at £1 10	10	0	0
High relief Figure, fighting with Centaur	7	7	0
Large Female Arm	0	10	0
Mask of Bacchus	0	5	0
Four Fragments, from high relief Metops	1	10	0
Large Female Arm	0	10	0
Three large Bas Relief Friezes of Horsemen	12	12	0
Young Theseus, from high relief	2	12	6
Leg of Metops	0	7	0
Bas Relief of Frieze	1	10	0
High Relief of Centaur	7	7	0

The governor, Lord Dalhousie, one of Wellington's generals, with his aid, visited my painting room. He is a plain gentlemanly soldier. He spoke of himself as a stranger in the country; and, after some pleasant chat, said he should be glad to see me at Quebec, and I must call upon him; adding, " but I shall not be there until the end of the month." The next day he departed, amidst drums, trumpets, and peals of cannon, to visit Upper Canada.

The convents, churches, &c. were visited of course, and I by invitation breakfasted with Mr. M'Gilvary at his very pleasant house on the road to La Chine. " He has a fine head of himself by Stuart, which he finds fault with, because the drapery is slighted, and a beautiful portrait of his brother by Shee."

I find the following comparison between Norfolk and Montreal in my journal. " They have two similar customs; they sweep their chimneys by pulling a rope up and down with brush-wood attached to it—and they bring their country produce to market in one horse-carts, which are arranged in order on the market-square. In both places the inhabitants are supplied with water by carting in casks, as in former times at New-York; but how different are the two places in many respects: the cold, close, cautious, inhospitable manners of the motley and jarring population here, contrast as strongly with the free, open, warm-hearted Virginians, as the solid prison like hybernacles, the stone-houses, with their deep retiring windows, and doors, and iron window-shutters do, with the light ever-open habitations of the children of the south. But then here is no slave population! O, what a paradise would Virginia be, if it had, instead of its negroes, the intelligent population of the middle states, or even the hardy ignorant French peasants of Canada, for in Virginia they would not remain as they now do, *French peasants.*"

	£	s.	d.
Fragment of Metops	0	7	0
Bas Relief of Horse's Head	0	7	0
Two small Bas Reliefs, from Temple of Victory	1	4	0
Large Arm, supposed to be of Neptune	0	12	0
Large Figure of Neptune	10	10	0
Dead Figure, from high relief	2	12	6
Large piece of Breasts, from female group	2	12	0
Theseus	10	10	0
Horses' Head, large	3	3	0
Sterling	85	15	6

Packing cases for the above cost £. 30

I made several excursions in the neighbourhood of Montreal, and passed one day at Leney's cottage, who, giving up his profession of engraver, was cultivating a farm near the banks of the St. Lawrence. I was hospitably entertained at La Chine by Col. Finlay and his family. On Monday the 9th of October, I embarked in the steamboat Telegraph for Quebec. After a very stormy passage down the river, with torrents of rain, which form water-falls from the precipitous banks of the river, we arrived at the very picturesque and famous city of Quebec. I had never before the true idea of a fortified town, and this is a second Gibraltar. The lofty rock of Cape Diamond frowning on the lower town; the tiers on tiers of guns mounted in every direction, with the irregularity of streets as you mount to the upper town, all fortress and garnished with cannon, so unlike any thing I have ever seen, baffles my poor talent at description. The river, a magnificent sheet of water lies far below, and above all, is the Castle, and Government-house on Cape Diamond. I arrived on Wednesday; on Thursday I saw the town, and walked over the plains of Abraham; and on Friday, a cold day, and part of the time snowing, I walked to the Falls of Montmorency, made sketches with benumbed fingers, enjoyed scenery of the most superb kind, almost atoning for starvation from cold and hunger, (for I could not obtain a piece of bread that I could eat) and got back to the hotel at Quebec to a dinner and the warmth of a fire that reminded me of my distance from home.

I remained after my return but a few days at Montreal, and then pressed my homeward journey; arriving on the 24th of October, after pleasant travelling with summer-like weather.

Leaving our son and daughter to keep house in New-York, myself and wife proceeded on our promised visit to Norfolk the 13th of November, 1820. We passed some very pleasant days with the family of Charles Chauncey, Esq. of Philadelphia— stopped a day at Baltimore, and on Tuesday the 21st of November, found our friend Williamson ready to conduct us from the steamboat to his hospitable mansion at Norfolk.

Previous to this time I had painted a great many portraits, and (never satisfied) my style and palette were ever changing. I did my best always, but much depended on my sitters. The best head I had painted was my friend John Joseph Holland, who felt and sat like an artist, and my own head painted with great care and study from a mirror. I had likewise painted since resuming the oil brush, an historic or scripture-piece on a cloth eight feet by five. The subject was the young Saviour with the Doctors in the Temple, and parts of this were good;

the boy's head was truly fine. This picture was rolled on a cylinder made of unseasoned wood, and being packed up was left unopened for many months—on taking it from the packing-case, it fell into pieces and was lost entirely.

After staying a few days with Mr. and Mrs. Williamson, we removed to a boarding-house, very pleasantly situated in Granby-street, but I had to wait some days before my new rooms were ready for me; that accomplished, I put up my pictures and commenced painting. My exhibition-room contained sixty pictures of my own painting; the principal being the picture above mentioned. I hired a person to attend it, and printed catalogues in due form.

This winter passed pleasantly; my wife owing much of her enjoyment to Mr. and Mrs. Williamson's attentions; and in the latter part of May she accompanied Mrs. Williamson to their country-seat at Ferryville, near the shores of the bay, and on the banks of an inlet, where I passed many days in rambling, and in fishing excursions with my friend.

I painted many portraits during this second residence in Norfolk, and made a sketch 36 inches by 30, as a model for an intended great picture, to be called "Christ Rejected." This I composed according to the printed descriptions of Mr. West's picture of that name. I made use of the parts of figures he had published, composing, as far as I could, to suit them, the principal groups and figures. The following is an extract from my scanty journal, dated February 19, 1821.

"Monday.—A fine clear day. I am this day fifty-five years of age; this is the second birth day in Norfolk; but since the last what a variety of scenes have I passed through! I yesterday answered a letter from my amiable friend Doctor Paine, of Montreal, which revived the events of last fall, and may perhaps lead me again to Canada. But in all—thy will be done, O God! And may I remember that if I truly wish thy will to be done, I shall strive to do thy will; and that thy will is truth and love."

We left Norfolk and returned home the last of June, 1821, taking with us Master John Williamson, the second son of our friends. To paint a great picture, now occupied all my thoughts. I purchased of my friend Sully a cloth 18 feet by 12, which he had imported from England—but where to put up a canvas of that size, and have a proper light on the work? The sailor's song says—

> "How little do you landsmen know,
> What we poor sailors feel," &c.

And the painter may say how little do mankind know of, or care for, the difficulties which attend the poor painter in his progress. He has neither money nor credit to procure a proper room for his work, and has perhaps to show his picture to the public without having seen it during the painting. " But it is his own choice." May be not. He is striving to attract notice, that he may gain bread for a family. " There is a pretty good effect in the picture—that's a good figure, he stole that from Correggio—why didn't the fellow," &c. &c. This is all to be expected, and is sure to meet the painter's work when exhibited; but it is likewise certain that a good picture will be duly appreciated by the public, and meet its reward in praise, if not by a purchaser.

Not being able to put up my canvas in a proper place, I raised it in the garret of the house I occupied in Leonard-street, with conflicting lights all below the centre of the cloth, and thus proceeded with my work through a hot summer, sometimes discouraged, but generally pleased to see effects produced, which I had thought beyond my power. In November, I took down the canvas, and packed it for the purpose of transportation to Norfolk, where I purposed to pass a third winter, and knew I had a better place than my garret to work on the picture, as well as better prospect of lucrative employment while finishing it. It was accordingly shipped, and on the 22d of November 1821, with my young friend John Williamson, I embarked again for Virginia by the way of Philadelphia. At Philadelphia I saw my friend Sully and family, and of course his beautiful copy of the Capuchin Chapel—West's picture—the pictures of the Academy, &c. At Baltimore, I visited Rembrandt Peale's Museum and Gallery. He had just finished his picture of " A mother attracting her infant from a precipice." It did not please me as a composition. I think the subject better for the page than the canvas. We arrived on the 27th.

After some days recreation with Williamson at Ferryville, living upon the best oysters and hoe-cake in the world, I got up my 18 by 12 cloth, and worked assiduously at it through the winter, except at intervals when employed on portraits or otherwise. I boarded at a new hotel kept by Major Cooper; having remained with my friend Williamson until January 8th, 1822, during the preparations for opening the new house.

I had become acquainted at Williamson's with a very fine young man of the name of Douthat, who had married a lovely woman, and was settled on a fine plantation up James River, near the house of his father-in-law Mr. Lewis, the proprietor

of Wyanoke, famous in early Virginia history. I had promised
Douthat to visit Westover, the name of his residence. In
the beginning of February Williamson went up to Douthat's.
On the 11th of February my young friend John Williamson
called to show me a letter from his father, saying, that Mr.
Douthat was much disappointed at my not coming—had pre-
pared a room for me, and engaged several portraits for me to
paint; thus joining profit to the pleasure of visiting the hospi-
table planters of James River. Williamson pressed my coming
up immediately, and I made my arrangements for so doing.

On the 15th I went up the river in a good steamboat,
passed James Island, where all that remains of the old James-
town is a ruined belfry of a church; about sun-set passed
Wyanoke, where the English made their second attempt at set-
tlement, and after dark, arrived opposite Westover, the third
place attempted. The whites chose an island, and two Pres-
que isles, as affording easier defence against the savages.
Douthat came off in his boat, and escorted me to his splendid
mansion. I here found my friends Mr. and Mrs. Williamson,
and the warmest welcome from Mr. and Mrs. Douthat. The
next day we proceeded by water to Wyanoke, the plantation
of Mr. Lewis. This place, so well known in our early history
as the second spot selected by the English for their settlement,
is nearly surrounded by the waters of James River. At the
time of my visit it formed a model for a well cultivated Virginia
plantation, as worked by slave labour, under a wise and humane
master. I have remarked in my journal, that "I should not
have known Virginia if I had not come up James River," for
Norfolk; and the neighbourhood is by nature a part of North
Carolina, and although my friend Williamson's plantation at
Ferryville, (once the site of a town, with a church long aban-
doned, and a Court-house where Patrick Henry was heard,
and where now a part of the plantation negroes reside) al-
though Ferryville was a source of delight to me and many
more, its master's chief occupation being in Norfolk, and the
soil very poor, it did not represent the seat of a Virginia plan-
ter. At Wyanoke all was in high cultivation and perfect
order. The overseer was intelligent, and was directed by the
master. The house servants, though occupying a building
separate from the mansion, as is the case on the plantations,
and even in many instances in the towns of Virginia, were or-
derly and fully employed in the duties imposed by the owner's
hospitality. I had lived well all my life, (except with old
Bobby Davy in London,) and certainly the luxuries of Nor-
folk, and the good cheer at my friend Williamson's did not

mislead me in my estimate of the living at Wyanoke and
Westover, but I could not avoid looking with surprise at the
well covered table, especially at breakfast, where the varieties
of hot breads of the finest kind exceeded any thing I had met
with. Indian-corn bread in three or four shapes, all excellent ;
buck-wheat cakes ; cakes of different kinds made of the best
wheat flour in the world, and loaf bread of the same, all hot
and all as perfect in the cooking as the material ; and all this
as accompaniment to the fish, flesh, and fowl, and the usual
liquid beverage of the breakfast table.

Westover, the third station selected by the English colo-
nists, is like Wyanoke, a *presque isle*. The estate had been
recently purchased by Mr. Robert Douthat. The house had
originally been the most splendid probably on the river, and
was still a magnificent mansion. In the garden is a marble
monumental ornament, with sculptured urns, shields, and coats
of arms ; and an inscription, commemorating the Hon. Wm.
Byrd, former owner of this and other great estates in Virginia.
He died in 1744. Having been educated in England, he en-
joyed the friendship of the great of that day, and was, after
his return, president of his Majesty's council for the colony.
He inherited his estates from his father, who lies buried, with
others of the family, in a large walled cemetery on the estate.
The son of the president of the council was likewise educated
in England, or *at home ;* is said to have been an accomplished
gentleman, one consequence of his *home-bred* education : ano-
ther was, that he became famous for losing 10,000 guineas on
one cast of the die ; and the result is, that the fourth genera-
tion are in comparative poverty, and have sold the estate and
palace to one who begins a new dynasty, and calls America
his home.

Discerning men have expressed astonishment at the servile
adulation which Americans pay to the customs and opinions
of England. It is an evil which has been planted in our courts
of justice ; but, with wigs and gowns, is giving way to com-
mon sense and the democratic principle ; yet it shows itself
mischievously even in our legislative councils, although our
constitution of government is opposed to monarchy and aris-
tocracy : but is it to be wondered at, when we recollect that
men yet live who were taught in infancy to reverence the king
next to God, and to obey him implicitly and " all in authority
under him ;" and that, up to this day, we look to England
for our books, and fear to praise (almost to read) one of na-
tive growth, until some hireling English or Scotch reviewer
has stamped it with the seal of his approbation ?

At the time when the elder Mr. Byrd built his palace at Westover, not only a man's opinions, but the bricks and stone and wood work of an American gentleman's house were imported from England : and if the colonists had not resisted the usurpations of the Euglish aristocracy, we might at this time have sent our cotton and wool, our leather and fur, as well as our thoughts to that country, to be worked over before we were permitted to use them.

There was more costly magnificence in and about the house at Westover than I had seen any where in our country ; but all had become dilapidated, and was under the repairing hand of the present possessor. The wall which surrounded the house was entered through gates of lofty iron rail-work : the brick pillars were ornamented with eagles, globes, vases, and other well-executed sculptures, all brought from *home*.— The house is large and heavy, with spacious hall and staircase. The rooms high and wainscotted, from the floors to the richly decorated ceilings. All the sculptured work, and, in fact, every other part, if well wrought, was, at that time, necessarily imported. The situation of the house was well chosen ; commanding extensive views of the superb river, the opposite shores, and the surrounding plantation. The buildings on the Westover estate, beside the mansion-house, consist of fourteen brick houses, and several framed ones of wood. The dwelling place for the dead has been judiciously walled in, at a due distance from that of the living who are to rest there, and out of sight. I visited it one cold morning, and copied some of the inscriptions. It is not an uninteresting fact to Americans, that the first husband of Mrs. Washington (Mr. Curtis,) had been intended, by his father, as the husband of one of this Byrd family ; Col. Byrd, of Westover, being, at that time, " from his influence and vast possessions, almost a Count Palatine of Virginia."

At Wyanoke was a son of Chief Justice Marshall, and his wife, a daughter of Mr. Lewis, with occasionally other visiters. I remained among these hospitable and excellent people, sometimes at Douthat's and sometimes at Lewis's, until the 7th of March, and painted several portraits. On that day I embarked for Richmond, and had the good fortune to find General Taylor, of Norfolk, on board, who, on our arrival, next morning, at Richmond, pointed out some of the principal edifices. I then rambled over the city, and up the banks of James' river to the canal, from whence the view of the rapids, the water, and the town, is strikingly beautiful. I visited the museum, the capitol, and examined Houdon's statue of

Washington, which I did not and could not admire. Of the artist and his work I shall speak hereafter. I called on Mr. Peticolas, and introduced myself to him. Of him and his paintings hereafter. I visited some ladies I had become acquainted with at Norfolk, and, refusing invitations, dined as I had breakfasted, at a hotel. Notwithstanding all the agreeables at the hospitable mansions I had come from, I felt like a prisoner escaped from confinement. It was not so with me at Williamson's—he made me at home—his house was " mine inn," and he paid me for using it.

I visited Bishop Moore without seeing him—and the church built where the theatre was burned; I saw its monument, inscribed with the names of forty-nine women and twenty men, who perished on the occasion. My visit to Richmond was too hurried to allow of describing its beauties, and most readers will be glad of it. On Sunday, the 10th of March, I embarked, and arrived late at night at Norfolk; seeing nothing on the passage that excited my feelings, except a brig loaded with negroes for New Orleans!

Sully's copy of the Capuchin Chapel was brought to Norfolk, and I did my duty towards it. It received in two weeks exhibition upwards of two hundred dollars. I now worked assiduously at my " Christ Rejected," and before I left Norfolk exhibited it in what I then thought a finished state. I printed a descriptive pamphlet, in which I pointed out all the figures borrowed from West. During its exhibition I painted several portraits. I visited my old friends Mr. and Mrs. Irwin, at Fort Monroe.

It is hazardous for a man to visit Virginia, the temptations to indulging appetite are so great. Yet excess is as seldom seen at Norfolk as at the northern cities. I must mention three temptations peculiar to the country: toddy just before dinner; and in summer mint juleps before breakfast, the fresh mint spread over the top of the bowl, and the ice and sugar disguising the fiery poison; and last, not least, egg-nog in the winter, a Christmas custom.

On the 3d of June, 1822, I left Norfolk, I presume for the last time, though it is as a home to me. I gave Williamson a portrait of myself, and the original sketch of the " Christ Rejected," in which, as I remember, the Magdalen is abominably bad, poor thing! and I had no power to make her better. I engaged a young Irishman of the name of Doherty, who aspired to be a painter, to take charge of the " Christ Rejected," and shipped it by way of Baltimore for Philadelphia, where I had engaged Sully and Earle's gallery at ten

dollars the week. My other pictures I shipped by sea to New-York. At Baltimore I saw for the first time Gruin's very fine picture of the "Descent from the Cross," presented to the Roman Cathedral by the king of France. At Philadelphia I left directions for Doherty respecting the exhibition of my picture, and proceeded home, where happily I found all well. Of works of art I found the only thing new to be pleased with, Lawrence's great full-length of West, a perfect likeness in the face, but far too large and tall for truth. The composition perfect. For this portrait, Sir Thomas Lawrence received from a number of gentlemen of New-York two thousand dollars; but his English and Scotch biographers make a present of it from this great and generous man to the American Academy of Fine Arts, in return for making him a member of that illustrious body. Such is biography. Cunningham adds, "The Academy of Florence, having heard that Lawrence had painted one of his finest portraits as a present to the American Society," (here the biographer stumbled on the right name, ' society,') " instantly elected him a member of the first class; but Sir Thomas, probably penetrating the motive of their kindness, sent nothing." This motive, assigned to the Academy of Florence, is probably as groundless a fabrication as Sir Thomas's generosity to America. We are glad to have so fine a picture of our great countryman, by so great a painter as his successor ; but it was bargained for, the price fixed by the painter, and paid for by those who subscribed the money. The bills and receipts are vouchers against romance in the shape of biography.

Rembrant Peale was now in a large house in Broadway, at a rent of nine hundred dollars; this lasted one year. He had been in New-York from 1st May, and had begun one head. On the 9th of June I was again in Philadelphia, to see to putting up my picture, and working on it before opening it for exhibition. I could see its faults better than at Norfolk ; but in a good light and room I was surprised at its effect, and encouraged by seeing that, with all its imperfections, it was a powerful picture, with some good parts, far beyond my expectations ; for I knew my deficiencies well—better than any one. As Doherty was new to the business of exhibiting pictures, I remained some days, amusing myself principally by walking on the banks of the two rivers that enrich and beautify the city.

I had reason to be gratified by the impression made upon the public, and the surprise it excited among the artists. Sully, my friend, talked with me of its faults, and how to

amend them. " But you have a precious line of light upon those soldiers' heads." " Oh !" cried Robinson, an English miniature painter, and pretty clever, " throw shadow over those soldiers' heads, sir, such a light destroys that part of your picture." For my own part, I never see the picture without wondering, that, with my defective drawing, (and, I may add, colouring,) I could produce a painting with the merit it possesses. I had, after taking up the pencil when beyond the middle of life, tried to remedy my deficiencies ; and it may be an argument for industry and determined application, that so late and with so many interruptions, I should have succeeded as far as I have.

I had an opportunity, during this visit, to see my former friends, the mother of Charles B. Brown, one brother, and the widow of another. His widow was out, and I did not see her while in the place. A Mr. Street, a young man, carried me to see his pictures, and seemed delighted with them.

CHAPTER XV.

Visit to Boston—Journey to Portland and return home—Pass the summer of 1823 at Utica—The Lunch--Exhibit my picture of "Christ Rejected" in New-York with success——A winter visit to Washington, D. C.—Paint more large pictures—Albany—Trott and Tisdale--Journey to Buffalo—Letter from G. C. Verplanck—Contrasted modes of treatment experienced by my agents when exhibiting my pictures--Picture of Calvary--History of the American Theatre—Visit to Vermont—Second visit to Vermont—Illness—Doctor Woodward—Publish my History of American Theatre--Receive a high compliment in a benefit at the theatre I once conducted, got up by my fellow-citizens.

On the 22d of June I sent my picture by sea, Doherty attending it, to Boston, having engaged a very fine room for its exhibition, and I returned home, little the better as yet in cash by my experiment. I again visited Boston, and in July, 1822, I put up my picture in Doggett's great room, a noble place, soon afterward appropriated to other purposes ; and although I had my vanity gratified, I experienced that very warm weather is unpropitious to exhibitions. My old friend Stuart seemed surprised at the effort I had made, and pointed out some faults—Heaven knows there were enough of them. Jarvis and his pupil Henry Inman came to Boston to seek employment, but did little. Henry's beautiful little water-coloured likenesses were a source of some profit. Jarvis, in a very friendly way, pointed out an error in the neck and head of the Magdalen, and observed, " Henry noticed it." I subsequently endeavoured to remedy the defect. In Mr. John

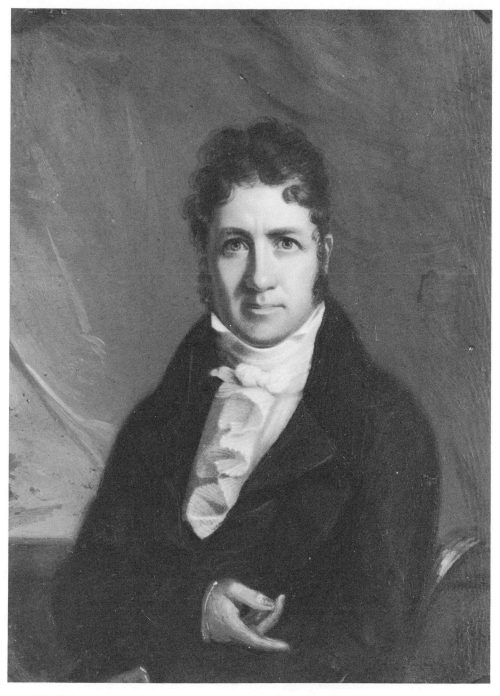

79 THOMAS ABTHORPE COOPER. Painting attributed to William Dunlap. *Courtesy The New-York Historical Society.*

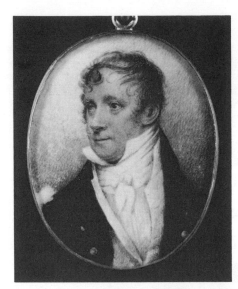

80B SELF-PORTRAIT. Miniature by William Dunlap. *Courtesy Yale University Art Gallery.*

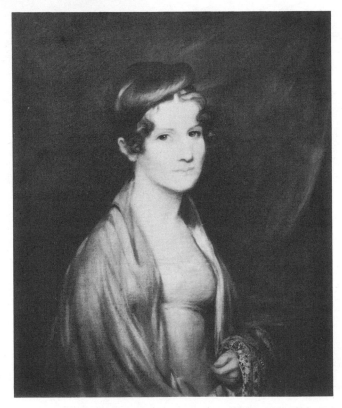

80A MRS. THOMAS ABTHORPE COOPER. Painting by William Dunlap. *Courtesy The Cleveland Museum of Art, J. H. Wade Fund.*

Doggett I found a most friendly man. My friends, Francis J. Oliver, Mr. Heard, Mr. Pollard, and others, were still, as ever, *my friends.* Sereno E. Dwight, the son of Dr. Dwight, was now a preacher established in Boston. I had some portraits to do, and passed an agreeable summer. In New-York an alarm prevailed of yellow fever, but no apprehensions were entertained in the quarter where my family resided. Still my experiment in great historical painting yielded little profit. Again I shipped my picture further east, to Portland; and here the tide of fortune turned. This place yielded, over all expenses, between two and three hundred dollars in two weeks.

On hearing of this success, I passed rapidly by land on to Portland, for the purpose of stopping at all the towns, and securing rooms for exhibition. I obtained public buildings, court-houses, and churches, free of charge. After one day at Portland, I returned by land to Boston again, after having given Doherty a plan of operations for the winter. I visited Newport on my way home, and arrived safely, and with money in my pocket, to my family, and again set up my esel for portraits; but I was now represented as being employed in historical compositions, and for that reason I had few calls for portraits. Perhaps stronger reasons existed—younger candidates and better painters were in the market. I this winter, that of 1822–3, painted a sketch for another great picture of the size of the first. The subject chosen was " The Bearing of the Cross," in which I introduced a crowd of figures attending upon the victim; but they are not " figures to let," but the characters of the evangelists, most of whom had appeared in the " Christ Rejected." Barabbas, now at liberty, occupies one corner—the principal figure is sinking under the cross— the centurion is ordering the seizure of Simon the Cyrenian, &c. I was encouraged to proceed with this study by the success of the " Christ Rejected," from which I received flattering accounts and comfortable remittances of cash. At Portsmouth a sermon was preached, recommending attention to the picture, and the selectmen advised its exhibition on a Sunday evening. My visits to the eastern towns had facilitated my agent's operations, and he was successful.

In the spring of 1823 I was invited by James Hackett, then keeping a store at Utica, to come to that place, with assurances of his engaging some work for my pencil; and early in April I proceeded, after a short stop at Albany, from whence I took some letters from Samuel M. Hopkins and Stephen Van Rensselaer to gentlemen in Utica, and arrived

by stage in due time at Bagg's hotel. In 1815 I had boarded
for weeks at this house, then acting as paymaster, and had
seen with astonishment the growing town on a spot where in
1787, Governor George Clinton made his treaty in the wilder-
ness with the Six Nations. Even in 1815 a rich population
and flourishing villages surrounded Utica, and extended west
to Lake Erie, through the thriving towns of Geneva, Canan-
daigua and Batavia to Buffalo, (then in ruins as burnt by the
English ;) but now eight years had increased Utica to a city,
and its public buildings, court-house, banks, churches and
hotels, filled me with almost as much surprise as I felt on my
first visit. Mr. Hackett, since so well known as a comedian,
received me cordially, and I found old acquaintances in James
and Walter Cochran, and made lasting friends in J. H. Loth-
rop, Esq., cashier of the bank of Ontario, E. Wetmore, (since
his son-in-law,) Mr. Walker and his son Thomas, and in short
during a spring and summer's residence became as much at
home in Utica as I had been at Norfolk. I painted a number
of portraits. I left Utica for four days to visit Saratoga, and
contract with a builder for an edifice sufficient for the exhibi-
tion of the " Christ Rejected." I left the stage on the post-
road and walked to Balston, where having slept, I walked to
Saratoga springs before early breakfast, accomplished my busi-
ness and proceeded on foot to Schenectady—next day returned
by stage to Utica. In July my wife met me in Albany at Samuel
M. Hopkins', and returned with me to Utica, where we took
board with Mrs. Skinner, a sister of my late friend Dr. E. H.
Smith. Weir was in Albany exhibiting his picture of Paul at
Athens without success. Sir Thomas Lawrence's West was sent
to Philadelphia and exhibited with a loss of more than $100 ;
Sully's Capuchin Chapel lost by its exhibition at Saratoga
springs, as did my " Christ Rejected ;" the last, fifty dollars.

It may be supposed that having some taste for the pictu-
resque and more for rambling, I did not omit the opportunity
neighbourhood gave me of visiting Trenton Falls, to which
place I rode once and once walked, stopping a day in clamber-
ing rocks and making sketches. The village of Trenton I
had visited as a paymaster in 1815. I now found with one of
its inhabitants a good portrait by Copley.

The last of August my wife left me to return home, and
about the middle of September Doherty arrived with my pic-
ture, which was put up for exhibition in the court-house. The
exhibition in Utica yielded in three weeks $184 75, giving a
profit after paying the expenses and transportation to Utica,
of $124 75.

My friend Dr. M. Payne had removed from Montreal to Geneva, and requested me to send on the picture to that place. I accordingly directed a building to be erected for it, and in the mean time sent it to Auburn. On the 18th of October 1823, I left my friends of Utica and arrived at my house in New-York on the 21st.

In December I took a painting-room at the corner of Nassau and Pine streets, but sitters were shy. " The Christ Rejected" was still successful, and I employed a part of the winter of 1823-4, in painting a scene from James Fennimore Cooper's Spy. I had recently become acquainted with him, and acquaintance has ripened into friendship.

On the 23d of February 1824, I purchased a large unprepared cloth, intended as a floor-cloth, and having access to the garret of the house in which I had my *attelier*, I nailed it to the floor, and gave it several coats of white lead, which being dry, I proceeded to outline the " Bearing of the Cross" from the sketch previously made. So *high* and so *low* was the commencement of this my second *big* picture.

This winter I became a member of a club which called itself the Lunch—members admitted by ballot, one black-ball excluding the candidate. Of the members I recollect G. C. Verplank, J. F. Cooper, Halleck, Anthony Bleeker, Charles King, James Renwick, James Kent, J. Griscom, Brevoort, Bryant and Morse, as of my acquaintance before and since.

About the beginning of May I hired a building with an entrance from Broadway, and prepared it for my picture, which now approached New-York, and on the 21st opened it for exhibition. The attention paid to it so far exceeded my expectation, that I was encouraged to proceed with the Bearing of the Cross. The receipts were in fourteen weeks $650. Mr. Trumbull's fourth picture for the government was exhibiting part of the time, and his friend Stone of the Commercial Advertiser, who represented it as a wonder, said it did not pay the room rent. The American Academy had its exhibition during May and June.

In the mean time I had put up my second picture in my garret in Leonard-street, but on removing the Christ Rejected from Broadway, I put the Bearing of the Cross up in its place, as a far better light to paint on it. I exhibited it in this place, but not with the success of the first. The Christ Rejected was exhibited in the gallery of the American Academy of Fine Arts on shares, and yielded me profit.

In November I visited Philadelphia, where Trumbull's Resignation of Washington was exhibiting free of rent in the

state-house, and yielding no profit. My errand at this time was to find a place for putting up the Bearing of the Cross, which was done by engaging Sully and Earle's gallery on shares.

To paint exhibition pictures and show them was the business of my life at this time; and from Philadelphia the "Bearing of the Cross" was sent with Doherty to Washington; to which place I went, partly to make arrangements for the picture at Baltimore, and partly to settle my paymaster's accounts—the treasury having made me defaulter to the amount of some thousand dollars; but on investigation the debt was brought down to *one* dollar, and that proceeded from an error in addition.

I found at Gadsby's Hotel Causici the sculptor, and in the capitol Rembrandt Peale's painting of Washington on horseback, with Lafayette, &c. at Yorktown—the worst of his pictures. I visited the capitol with Messrs. Cambreleng and Van Rensselaer. I saw Trumbull's picture of the Surrender of Burgoyne for the first time, having been at Norfolk when he exhibited it. I found it better than the Resignation, but can say no more in its praise. The whole set were in bad odour. C. B. King agreed to exhibit my picture in his gallery. I visited my friend Major Vandeventer, at Georgetown, and the place brought vivid reminiscences of the year 1807. I had formerly painted pictures of the major and his wife; but his picture did not satisfy, and I now took the opportunity of painting another for him, and staid some days with his most amiable and exemplary family.

A distinguished member of congress told me that the Custis's, the relatives of Washington, had told him that they did not consider Peale's certificate-picture like the general at any period of his life, yet, he continued, "they signed Peale's certificate, stating that it is the true and only likeness of Washington." He then mentioned a distinguished senator, whose name was appended to the same certificate, who told him that it was not a likeness in his opinion. On his reminding him of his signature, the reply was, "I could not deny the man." So much for certificates and for the love of truth! This conversation passed as we stood before Peale's picture of "Washington at Yorktown," which was, as it deserved, condemned. The dishonourable and immoral practice of certifying to falsehoods, or to that of which we are ignorant, is not confined to America. I found at Washington a Scotchman who told the Yankees that he could cure all diseases by a steam bath impregnated with herbs. He knew each person's disease by smelling the pa-

tient; that he had left four agents to cure the people at home, and had come with one assistant to cure us. He was furnished with due certificates signed by the lords and commons of England, and at their head the name of the Duke of York.

I called with my friend Vandeventer on General Jackson, and was pleased with my reception and his manners. My friend, James Fennimore Cooper, visited Washington at this time, and I had the pleasure of his company, and that of some of his former naval associates on my return. I think he will remember the story of the Irish sportsman rabbit hunting, who, seeing a donkey looking over a hedge swore he had found the father of all rabbits. On this journey, February 1825, I became acquainted with Robert Gilmor, Esq. of Baltimore, and saw his choice collection of pictures. On the sixteenth I arrived, after a very fatiguing journey, at my house, and found my family well; but in a few days was confined to my bed by illness for ten days, and to my chamber many more—a lamentable beginning of the fifty-ninth year of my age.

My next exertion as an artist was the composition of a third picture, connected with the crucifixion, which I called " Calvary." This winter and spring I finished the sketch in oil, thirty inches by twenty-five—probably my best composition.

Before transferring it to the large canvas, I painted from nature the principal figures and groups separately. I had none of that facility which attends the adept in drawing, and now felt the penalty—one of the penalties of my idleness and folly when I had the Royal Academy of England at my command, and the advice of the best historical painter of the age always ready for my instruction—and both neglected. I now, and for some years before, studied the casts from the antique and improved, but my drawing remained deficient. I had neglected " the spring of life," and it never returns.

When studying the casts in the gallery of the American Academy of Fine Arts, I was very much struck by the deficiency apparent in those of Canova when compared with the antique. I was mortified to see that the man who was called the greatest genius the modern world had produced as a sculptor, was in my estimation a pigmy; and I felt, until some years after, when I saw the Mercury of Thorwaldsden in the gallery of the National Academy of Design, that it was in vain for a modern to emulate the statuary of antiquity.

In April I made a journey to Baltimore—received my Bearing of the Cross from Rubens Peale, and had it transported to Philadelphia, where it was put up in Sully & Earl's gallery—

it proved an unprofitable exhibition ; but I passed the first week of May very pleasantly with Sully and other friends.

From the 23d to the 28th of May I made a pleasant excursion to New-London and Norwich, to direct a young man in the mode of exhibiting my " Christ Rejected" in those places and further east. Returning home, I found some portrait-painting awaiting me, and continued my studies for " the Calvary." Warned by the bad effect of my floor-cloth experiment (for I never got a good surface for the " Bearing of the Cross,") I had a cloth prepared at McCauley's manufactory, Philadelphia, which proved satisfactory. I likewise ordered a canvas, twenty feet by ten, having determined to make a picture from the etched outline of West's " Death on the Pale Horse," taking, as my guide, the printed description ; and in the summer of 1825 was busily employed in studies for the " Calvary" and in painting the above-named picture.

Having determined to finish my " Death on the Pale Horse" before the " Calvary," I exerted myself for that purpose, and making an arrangement with the directors of the American Academy of Fine Arts for the use of the gallery at twenty-five dollars a week, I opened the picture to the public in two months and twenty-six days from the commencement of the outline. This exhibition was successful, and my picture was only taken down to make way for David's " Coronation of Bonaparte."

In November I became acquainted with the person and paintings of Mr. T. Cole, since so well known as the celebrated landscape-painter. I did the best I could to make the public acquainted with the extraordinary merit of his pictures even then, and it is among the few of my good deeds. He has proved more than I anticipated, and I have been repaid by his friendship and gratified by his success. Mr. Trumbull attracted my attention to Mr. Cole, by the most liberal praises of his painting, and expressions of surprise at the taste and skill he had manifested.

In January 1826, I had the bearing of the cross on exhibition at Charleston, the Death on the Pale Horse at Norfolk, and the Christ Rejected at Washington.

It may be amusing to my readers to see a specimen of the literary talent of one of my agents, an honest old man, who was indebted to his native country, England, for his education. It is a letter dated Pitsburg, (meaning Petersburg in Virginia) March 15th, 1826.

" The proceeds of the painting was 110 dollars in Richmond—it wos very bad weather all the time—I Cold not Geat

the Church in Pitsburge, it wos sold to the Freemasons for a Log, and it wos Poold all to Peasses in the in Side, I have a Ball Room in the sentre of the Town, it is a much better Plass. I open'd on Mounday Eavning at 6 o'clock, at seven it began to rain. I receive $1 50 ; Tuesday $17 50 Wensday $16 25 Thursday at 1 o'clock $6 25" the time he closed his epistle " I leave year on sunday for Norfork 25—P. S. I pay $1 50 Per Day four the room—Your Humbel Sarvent——"

This, beside being a literary curiosity, will give the reader some notions of the mode of exhibiting from town to town, and the contingencies upon which profit depends. It may be supposed that the eloquence of this showman did not add to the attraction of my picture ; but I have known some of the tribe, who, by management and an oily tongue, have made money for their employers and *for themselves.*

In February I had recurrence of abscess with attendant illness, an evil which has occurred at intervals, and in my mind is traced to that I have recorded of my early days in London. On the 19th I find in my journal, " I this day complete the sixtieth year of my age ; physically worse—am I morally better? As a man, I hope I am a little improved ; as an artist, more. My health worse, my fortune a little better by the increase of income from the works of my pencil."

I was this winter anxiously employed in painting on the " Calvary," in an apartment granted to me by the corporation of the city.

At this time the National Academy of Design was created, composed of and governed by artists only. I became an active member, being elected an academician. In the spring I continued to paint studies from nature, for the " Calvary," and likewise painted several portraits. In the month of May the National Academy of Design opened their first annual exhibition, which has increased in interest yearly.

About this time I sent my picture of " Christ Rejected" to the *far West*, and it produced profit and compliments ; but it likewise produced a letter which I will lay before the reader, as a proof of the effect which a picture may produce in exciting ambition, and of the kind of stuff ambition may be made of. " Urbana, Ohio, Champaign county, Dec. 30th, 1826. Mr. William Dunlap, I write my respects to you through the influence of the gentleman that had your painting through this country. I informed him that I was an artist of that kind also ; am in low circumstances ; am 20 years old, and have a great genius for historical painting ; and he informed me to write to you, informing you on the subject of painting. He

told me that I ought to make some specimens of my work, and if it would justify, I could go to the National Academy of Fine Arts. I wish you to write to me on the subject if you please. The citizens of this place thinks, with tuition, I would make a superior to any artist they had ever saw. I went 40 miles to see your painting, and it creates a new feeling in me. Nothing more at present, but remain your humble servant. H. H."

I saw two pictures in the possession of Mr. Saml. Maverick, said to be Hogarth's; one of them has a drummer which would not dishonour the great painter. These pictures were brought to this country by Mr. Charles Caton, himself a painter of merit, and were painted by him. The latter part of this month I passed at Albany, having taken my "Death on the Pale Horse" thither, and being enabled, by the politeness of Mr. Stevenson the mayor, Doctor Beck, Mr. Gansevoort, and other gentlemen, to have it exhibited in the great hall of the academy, where the effect was far beyond what I had seen from it elsewhere. Mr. Croswell advised and assisted me in the most friendly manner in the accomplishment of my object.

I resided at this time with my good friend Cruttenden, and the conversations at his table were oft-times amusing. We had with us a rough judge from one of the western counties, who was particularly annoyed by a young man of New-York, of rather much pretensions to multifarious knowledge. Upon the dandy's talking, with a dictatorial air, of Belzoni and the *Orrery* that he had discovered in an Egyptian pyramid, the old man lost all patience and broke out with "Belzoni is not so ignorant as to talk of an *Orrery* in an Egyptian pyramid. No, sir, you will not find the word in his writings. The word is modern—a name given to a modern invention, in honour to Lord Orrery. You mean, if you mean any thing, the Zodiac." The young man walked off, and the judge supposing him to be an Albanian, turned to me, "You must not expect any thing from this stupid place. There are not three men in it that ever thought. I'll tell you an anecdote.— At a time of yellow fever in New-York, two miniature painters, Trott and Tisdale, came to this city; they took a room and painted some heads. This was about the year '96. It was a novelty, and the gentlemen of Albany visited the painters and were pleased with them; and on occasion of a ball they were getting up, they sent them tickets of invitation. But before the ball took place they had time to reflect and consult; and the result was, that a note was written to the

painters to say that the gentlemen of Albany must recall the invitation, as, according to the rules, no mechanics could be admitted." I insert this freely, because of the known intelligence of the inhabitants of a city where our legislature convenes, our highest courts sit, and many of our judges and first men reside, who are accustomed to think and act with propriety. "Sir," he continued, "I saw both the notes myself,"which were probably from shop-keepers or their clerks, whose knowledge might not rise higher in the scale than such notes indicate.

From Albany, where I received profit from my exhibition, and pleasure from my friends, I proceeded to Troy, and had the picture exhibited with profit ; and thence to Utica, where I found a man apparently equal to the charge of my picture ; which was exhibited profitably, and sent on westward. In Utica I found great change—enormous growth—some of my friends gone from thence, and some removed by death ; but Lothrop and his charming family, with many others, still ready to add to my pleasure and welfare. I painted at this time several portraits.

At Syracuse, a new place, I had my picture put up in an unfinished church, where it did but little, and I sent it on to Auburn and passed on to Geneva. After a few days I went to Canandaigua and to Rochester. I will copy a passage from my journal—"When I saw Utica in 1815, I was astonished ; in 1823 I admired its growth and again in 1826. Syracuse, Auburn, and Geneva, are all causes of admiration from their prosperity, as is Canandaigua, but all sink into insignificance in comparison with Rochester, when the time of its first settlement is considered. In 1815 it was unknown: now the canal, bridges, churches, court house, hotels, all upon a great scale, excite my astonishment anew at the wonders of the west." I viewed the Falls of the Genesee River, and soon after embarked in the canal-boat, and passed many flourishing villages to Lockport, where the excavations for the canal are of a magnitude to excite the surprise of the untravelled. The canal brought me into Tonawanta Creek, where another scene of a milder aspect is presented, and I soon saw the great Niagara. One of my pictures was on exhibition at Buffalo, and I ordered it on to Detroit. In the towns I had passed I made arrangements for the picture of "Death on the Pale Horse," which was to follow.

Buffalo, which I had left in 1815 a desolated village, I now found a large and thriving town, with splendid hotels, large churches, a theatre, a noble court-house, showing enterprise

and prosperity ; while steam-boats and other vessels indicate the commerce of the inland sea. Rain induced me to return without visiting again the Falls of Niagara : I have ever regretted the omission. In the canal-boat I retraced my way home. I landed at a village called Lyons, slept and proceeded by stage to Geneva, thence to Auburn, and at Syracuse embarked on the canal for Utica, where I arrived on the 21st of October. A manuscript was here lent me, which I read with interest, written on the Bible and New Testament, by John Q. Adams, as instructions to his son, by this indefatigable man. Extract, respecting the latter :—" If it be objected, that the principle of benevolence towards our enemies, and forgiveness of injuries, may be found, not only in the books of the Old Testament, but even in some of the heathen writers, and particularly in the Discourses of Socrates, I answer, that the same may be said of the immortality of the soul, and of the rewards and punishments of a future state. The doctrine was not more of a discovery than the precept. But the connection with each other, the authority with which they were taught, and the miracles by which they were enforced, belong exclusively to the mission of Christ."

At Utica I again was employed to paint several portraits ; receiving, as usual, the kind attentions of my friends, and indulging my propensity to ramble about the neighbourhood. —On the 4th of November I left Utica, and on the 8th was happy with my family.

During this winter of 1826-7 I painted on my picture of Calvary, but had part of my time occupied by an engagement with the managers of the Bowery Theatre to write occasionally for them. As the subject of filling the vacant pannels of the Rotunda, at Washington, was at this time agitated in Congress, I wrote to G. C. Verplanck on the subject. The following is an answer to my letter.—" Washington, Jan. 29, 1827. Dear sir, I do not know, at this moment, how I can be useful in furthering your views. The whole subject of decorating, as well as finishing the capitol, is now in the hands of a committee, to which I do not belong. General Van Rensselaer is the chairman. I understand that they are very anxious to press the completion of the building ; and Mr. Bulfinch, the architect, complains much of the precipitancy. If so, probably they will recommend so large an appropriation to the architect as to leave little for other artists. As soon as they make their report I will send you a copy.

" Besides the four vacancies in the Rotunda, I have been urging the propriety of placing some works of art connected

with the history, or at least with the scenery of the country, in the large room of the President's house, which is now filling up. Its size, (80 or 90 feet by 50) its height, &c. fit it admirably for the purpose ; and it would be honourable to the nation to apply it thus, instead of filling it merely with mirrors, curtains, and chandeliers, like a tavern ball room, or at best, a city drawing room on a large scale. I am, &c."

' A member of the senate wrote to me—" Col. Trumbull is here, and has been all winter seeking to be employed to fill the vacant pannels." About this time the letters written by Trumbull to the President (for which see his biography) were published by the directors of the American Academy, and the originals, by unanimous vote, deposited in the archives.

During the winter and spring of 1826-7 I not only painted on my " Calvary," but put up and painted on the " Bearing of the Cross," and finished several portraits ; one of which, Thomas Eddy, was for the governors of the New-York Hospital ; who afterwards ordered a copy, to place in the Asylum for the Insane, an institution owing its being to Mr. Eddy.— Several copies of this portrait were ordered.

I experienced, during the winter of 1827-8, a great diminution of profit from my exhibition pictures, which were travelling east and west. The incidents attending them would fill a volume. At one place a picture would be put up in a church, and a sermon preached in recommendation of it : in another, the people would be told from the pulpit to avoid it, as blasphemous ; and in another the agent is seized for violating the law taxing puppet-shows, after permission given to exhibit ; and when he is on his way to another town, he is brought back by constables, like a criminal, and obliged to pay the tax, and their charges for making him a prisoner.— Here the agent of a picture would be encouraged by the first people of the place, and treated by the clergy as if he were a saint ; and there received as a mountebank, and insulted by a mob. Such is the variety of our manners, and the various degrees of refinement in our population. On the whole, the reception of my pictures was honourable to me and to my countrymen.

In February 1828, I was introduced to Horatio Greenough, who will occupy a distinguished page in this work. About this time I painted, and gave to James Hackett a full length, about 17 inches by 12, of himself as Jonathan. In April I wasted some time in studying lithography and making experiments—I say wasted, because I did not succeed.

On the 5th of May, 1828, I opened for exhibition my long

wrought on picture of "Calvary." I will indulge myself by extracts from an essay which appeared in the Mirror, written by a stranger to me, recently from South Carolina.

"This picture is eighteen by fourteen feet. The subject is the moment before the crucifixion of Jesus, and the preparations for the sacrifice. How far this great and truly poetical design has been brought into life and being on the canvas, it is for the spectator to feel and judge. The first impression on the eye is the living mass, the amphitheatre of figures, that surrounds the base of the mount, and gradually ascends, thickens, and fades into distant perspective. The eye then retraces its progress, and pauses on more distinct and separate impressions, dwelling with delight on the beautiful grouping, and classically correct costume of the multitude assembled to witness the death of the great Author of Christianity.

"But it is not true, that 'the eye of the spectator is *first attracted to the principal figure*—that of the Redeemer—who stands near the top of the mount.' Had this 'attraction' existed; had this effect been produced : the picture would have been more complete in its *epic* purpose. On the contrary, ' the eye is attracted,' instantly, and instinctively, to the groups in the fore-ground ; the striking and passionate attitudes of the first followers of Jesus ; and the expression of ecclesiastical persecution against the *reformer*, which burns among the priests and pharisees. The 'principal' figures are, therefore, the multitude ; and Jesus, in the back ground, is but auxiliary to the great effects.

"The four figures on the left, consisting of Mary the mother, Mary Magdalen, Mary the daughter of Cleophas, and John, compose a group of the deepest interest. Abstract them from the picture, and, in themselves, they constitute an eloquent commentary on the subject. The strong expression of grief, the grace of form, the *intellectual* beauty which distinguishes the females we have never seen exceeded.

"The high priest, in the next group, ought, perhaps, to be placed nearer his victim; but it is a classical and finished figure.

"On the right, the harmony of this beautiful picture is *sustained* with equal, if not superior effect. The female whose exquisite neck is presented to the spectator, and the wife of Pilate ' in costly robes,' are beautifully delineated. We then ascend the hill, pass on from object to object, from the pharisee disputing with Joseph, to Peter and Barabbas ; Simon supporting the cross, the Roman soldier, women, and other spectators fill this portion of the picture. On the extreme right is seen a

female with two lovely girls. The Asiatic guards which occupy this division of the foreground, are also in strict and classical accordance."

The reader must not think that I consider this praise as just. Although the picture is my best composition and most finished, it is, in my opinion at present, very defective. Writers who describe pictures are generally ignorant of true merit, and partial in their criticisms or eulogiums.

I had at this period commenced my History of the American Theatre, which eventually yielded me some remuneration, both from the publishers here and in England, but of course occupied much of my time ; and I had before this learned that time was my only property, and the proper use of it the only support of my family.

My income was at this time very low. I had contracted debts to support me while painting my last large picture. I sold to Mr. Eickholtz of Philadelphia, my lay figure which was one of the best, and purchased for me from the maker in Paris.

In June I went to Philadelphia to make arrangements for exhibiting " the Calvary" in that city, which was done in the Pennsylvania Academy of Fine Arts, through the liberality of the Hon. Joseph Hopkinson, president of that institution. It was exhibited during the months of October and November 1828, occupying—the more the pity ! though for a short time, the place of Allston's great picture. The profit was little. I had in the mean time an exhibition open in New-York, which yielded something, and I painted a few portraits. In October the Bearing of the Cross was sent on a tour to the west. In the winter the " Calvary" was exhibited in Baltimore, but none of these efforts were successful to any extent. I received something from successful dramas at the Bowery Theatre, and painted during the winter, principally after the commencement of 1829, several portraits. From my journal I extract an entry, not made for the public eye :—

"Thursday, 19th of February, 1829—I am this day 63 years of age, active, and I think stronger than a year ago. I believe I am improving as an artist. As a man, I hope I am— but it is little ! May God receive my thanks for his blessings, and may his will be done !"

In March my " Calvary" was exhibiting in Washington with praise and profit. I painted a portrait of Samuel S. Conant, which led to a visit of some profit and much pleasure in a region new to me—Vermont. About this time the Common Council notified all the occupants of the old Almshouse to vacate on, or before first of August next. A

very pleasant Club was formed, of which I remained a member until it expired, like all mortal things. It was called the Sketch Club. The members met at each other's houses, sketched and conversed principally on art, took refreshments, and unfortunately, sometimes suppers. The National Academicians were most of them members, as were many of my literary friends.

In July I had a severe recurrence of the disease which has pursued me through life. In the latter part of the same month I received an invitation from Samuel S. Conant, (at that time at his father's in Vermont, disabled by a lameness, which some years after caused his death,) to come and paint eight portraits of his father's family at Brandon. In August I received a definite invitation and agreement for eight portraits from John Conant and sons. In this month I made a tour to Albany—Troy—Saratoga—to prepare the way for the exhibition of "Calvary," returned to Albany, and staid at my friend Samuel M. Hopkins', most pleasantly with his amiable family, while I painted several portraits at the Academy Hall. My friend Cruttenden engaged two fancy pictures to be painted at New-York.

I stopped on my way to Brandon at Castleton, a very pleasant village, and became acquainted with Doctor Lewis Beck, brother to my friend Doctor Beck of Albany, and with Doctor Woodward, afterwards of vital importance to me. Passing through Rutland, I reached Brandon, and took up my residence with the hospitable family of the elder Mr. Conant.

Vermont, a rough country and newly settled, is a perfect contrast to Virginia. A black face is not to be seen in Brandon. Every man works and all prosper. John Conant, like every other father of a family in the state, came from the old New-England States. The country was settled and obtained its independent self-government in despite of its neighbour, New-York. Mr. Conant was a first settler at Brandon, built his own house with his own hands, (and a very good one it is,) and by prudence and industry established a manufactory of iron ware, and a family of children, together forming riches that princes might envy. I remained with this worthy family until the 21st of October, when ice, and the snow on the mountain, warned me to seek home. Painting, and rambling over hills and by the side of Otter Creek, a river that falls into Lake Champlain, with reading, (for I found books and readers here,) filled up my time agreeably, and I took leave of my Brandon friends with an impression of deep esteem. Mr. Chauncey Conant conveyed me over the Hubbard-town hills to Castleton, and pointed out on the way one of the spots made

memorable by a skirmish between a foraging party from Burgoyne's army and the Vermontese militia. At Castleton he left me, and I proceeded by stage to Albany, suffering severely from cold on the way.

At New York I found Mr. West's youngest son, Benjamin, with his father's " Christ Rejected." As I had been fully persuaded that England would never permit that great work to be carried across the Atlantic, I had, as I have stated, made use of the etchings of figures published from it, and always avowed the obligation. On seeing the picture, I put out all the figures borrowed, and introduced others of my own, worse. I lost the Barabbas, but I gained by a group of the Virgin and others, which now occupies his place. I admired Mr. West's noble picture, the principal figure of which I think one of the finest I ever beheld : yet, strange as it may appear, I frankly avow, that my picture, with all its faults, rose in my estimation. It must not be supposed that I was, or am, so blind as to compare my drawing, touch, colouring, or finishing, to West's : beside that all the originality of the subject is his. But I found that my grouping and disposition of the light and shade, the attitude of Christ, and the situation of Pilate, the executioner and others, were as different as if I had never read a description of his picture.

This winter I painted two pictures for my friend Cruttenden, and a few portraits. Among others, one of my best efforts, a child returning from school, for the Hon. William M'Coun, vice chancellor ; and a female study, which I called the Historic Muse, bought in 1833, by H. C. Beach, Esq. This, Sully said, was my best picture.

I received rather more than of late from my travelling pictures ; and on the 19th of Feb. 1830, I find in my journal,— " I am to-day 64 years of age—active, and enjoying generally comfortable health."

In March was exhibited a collection of the best pictures from old masters which America had seen. The gallery of the American Academy of Fine Arts was hired by a man of the name of Abrams, who fitted it up admirably for the occasion. This man (as I was informed by an intelligent English gentleman, an amateur painter) was a picture dealer and cleaner in London ; and having, in conjunction with another dealer, of the name of Wilmot, collected a number of good pictures, under various pretences, they concerted the scheme of flying with them to New York. Here they were stopped, and Abrams imprisoned. Wilmot, under the name of Ward, escaped the catchpoles, and embarked for Liverpool in the

same vessel with my informant; and contrived, by cards and betting with the passengers, to gain upwards of three hundred guineas. On his arrival he was recognised before he could reach the great hiding place, London, and seized by those he had defrauded. Abrams made some compromise, by which he was permitted to exhibit the pictures for the benefit of the proprietors; and he did it adroitly, with an impudence worthy of a picture dealer.

Mr. Morse, the President of the National Academy of Design, having gone to Italy, I, as vice president, exerted myself for the institution: and on returning from a council meeting, in the evening, my wife put in my hand a letter which she, by accidentally answering a knock at the door, had received from a man who gave it and hastily departed. That no hand writing might be recognised, the whole was in imitation of printed letters. A note of the Bank of America for one hundred dollars was enclosed. The letter was as follows:—

" Wm. Dunlap, Esq.

 " My dear Dunlap—During the high wind on Sunday the enclosed 100 dollar bill was blown up here from your BANK NOTE WORLD. As we have every thing here without money and without price, several of your old friends thought it best to send it down to you. I accordingly inclose it, hoping you will receive it as coming from ABOVE.

 " Your friend before and after death,

 " CHAS. B. BROWN."

I never have had suspicion or hint of the author or authors of this delicate communication; but I hope, if any of the parties see this book, they will accept my thanks and assurances, that the God-send was appropriated as it was intended.

On the 1st of April I visited Philadelphia, to solicit pictures for the exhibition of the National Academy. I of course saw all the painters and obtained a number of pictures. I called to see Mr. and Mrs. Darley, and found them in the house where I had passed so many happy hours with Charles Brockden Brown, his wife, children and friends.

Shortly after returning home I received an invitation to come to Castleton, Vermont, and paint ten portraits, which occasioned my going to that pleasant village again, and passing the summer with Solomon Foote, Esq. principal of the high school, then just opened.

My friend S. S. Conant was at this time at Clarendon Springs, in the hope of help for his lameness. I visited him on the 4th of July; and passing the night there, walked next day to Rutland. In the evening I walked to West Rutland, and sleeping there, returned by day-break in the stage to Cas-

tleton, where I entered the High School, (the door on the latch, as is the case all through the place) and went to bed without the knowledge of the family.

In August, by invitation I went to Rutland, and painted some portraits. I remember the place and its pleasant walks with pleasure; and with still more, General Williams and his family. Having an invitation from Mr. Ira Smith, of Orwell, and knowing it was near a landing place on Lake Champlain, from which I could readily embark, by steam-boat, for Whitehall, I proceeded thither and painted several portraits: but my old enemy, my chronic disease, which had given me warnings of late, came upon me with deadly force, and I was confined to my bed, with nurses and sitters-up, for sixteen days. Far from my family and among strangers, in a country tavern, my situation would appear hard; but I found kind people, a most kind nurse in the sister of the landlady, Adeline Wilson, to whom and to Doctor Woodward, of Castleton, who came to me and directed the practice of a younger physician, Dr. Gale, I shall with life, retain gratitude. My situation was such, that it was suggested I should send for my wife; but Woodward told me not to do it, as it would give her anxiety and trouble, cause unnecessary expense, and that, although I was a very sick man, I should be up again in about the time, at which it really so occurred. I wrote to my wife only to inform her of my convalescence. In October I was able to finish the portraits begun and two more, making eight, (one a present to my landlord) and on the 21st of October I commenced my homeward journey, and soon was happily in the midst of my family.

During the winter of 1830–1, I painted a few portraits, and a hasty picture of the " Attack on the Louvre," in the Parisian revolution of July 1830. It was exhibited, but without success. I wrote and delivered lectures on historical composition in painting to the students of the National Academy. On the anniversary of my birth I wrote: " February 19th, 1831—I am this day sixty-five years of age. I am in health, having no return of my disease since the attack at Orwell, in September last. I hope *I am better ;* and I am thankful to God for great blessings. Richer I am not, but hope supports me. I labour daily, rising between six and seven." I painted on the Louvre and some portraits during the winter, and on the 21st of April delivered an address to the students on distributing premiums, which was published by the academy. It made some impression, and prompted letters to me from various parts of the Union and from Europe, particularly a very welcome one from J. Fennimore Cooper, from Paris. In the summer

of 1831 I painted some portraits, and repainted a great part of the Bearing of the Cross.

Few persons who have lived to old age have experienced so many and so violent attacks of disease. During that period of my life which is not introduced in this work, when I was engaged for many years in directing the New-York theatre and writing plays, I passed my summers at my native place, Perth Amboy, and seldom a year passed without illness; sometimes bilious fever or remittents, and more than once with extreme danger to life.

From the 25th of June to the 9th of July 1831, I was in great distress from a recurrence of my chronic complaint: on the 1st of July my friend Dr. McLean brought Dr. Mott to me, who performed *that* which in my case Post had declared impossible. From that time I recovered, and, to dismiss the subject, I remained in good health until the autumn of 1833, when I was much distressed and continued so until February 1834, in which month Dr. Mott performed the operation of lithotomy, which was attended with difficulties very unusual; and I write at this moment, June 1834, under the afflictions of pain and weakness caused by the disease. My friends, Francis and McLean, have watched over me with the attention of affectionate brothers, and to them and the skilful operator I must remain grateful for life and a portion of health and ease, as long as life is lent me. But even their skill and attention would have availed little but for unwearied nursing of my wife and daughter. I have had, and have, many blessings; but those flowing from my family are the most precious.

In August 1831 I was strong enough to paint several portraits, and a project was agitated of publishing a quarterly review of fine arts in every part of the world—to that project, perhaps, it being given up, is owing the present work. At this time a number of Ward's pictures were sent to New-York for exhibition—a cattle piece and several others very good; but the adventure sunk a great sum of money. Mr. West's "Christ's Rejected" was put up for exhibition after having been eminently successful throughout the Union; but a repetition did not answer in New-York. Nothing but novelty attracts our people.

Having had an invitation to come to Burlington, Vermont, when at Castleton, I, finding myself pressed for money, left home on the 8th of September, and after a few hours spent with my friends in Albany, passed on the old track to Whitehall, and up the lake to the very pretty town I aimed at. As a second string to my bow, I ordered on my picture of "Calvary."

But all would not do at promising Burlington. I had no pic-
tures to paint, and the exhibition yielded very little ; however,
during its exhibition, I crossed the lake to the rough and un-
promising Plattsburg, where I found warm friends, portraits to
paint, and, having removed my picture thither, a profitable
exhibition.

I put up at a tavern and was well treated, but my home was
at Dr. Samuel Beaumont's. His wife was Miss Charlotte
Taylor and my townswoman, and he has acted like a son or
brother. I remained at Plattsburg until November 2d ; then
embarked on my return voyage with impressions of esteem for
many left behind me, and none more than for Moss Kent,
Esq. brother to my old friend the ex-chancellor. On the 6th
of November I found myself at home with my family.

Mr. Gouverneur Kemble had for some time past the collection
of pictures bought in Spain by the late Richard Meade, Esq.
exhibited at Clinton Hall, but with loss. Doctor Hosack has
supported the American Academy of Fine Arts, by erecting a
very convenient building in Barclay-street, with good rooms
for exhibition and for the casts.

This winter of 1831–2, I was requested to give two lectures
on the fine arts, in the Clinton Hall lecture room, for the bene-
fit of the Mercantile Library Association. I complied. This
addressing large assemblies of people was a new business to me ;
and it is rather late at sixty-five or sixty-six years of age to be-
gin to play the orator. I believe that I did not essentially fail
in what was expected from me. I at this time lectured to the
students of the National Academy. My prospects as to re-
ceipts and the necessary means of living were this winter very
gloomy, and my lecturing suggested the notion of putting up
all my pictures in the Clinton gallery and lecturing on them.
I carried this into effect and gained by the exertion. My his-
tory of the American Theatre was now nearly ready for pub-
lication. Towards spring I had some portraits to paint at ge-
nerous prices.

In the month of April 1832, I removed all my pictures to a
gallery, the corner of Anthony-street, Broadway, and had a
painting room adjoining. The profits of exhibition were to
be shared with the owner of the building, but there were none,
owing principally to the prevalence of Asiatic cholera, and
partly to the improper occupation of the lower part of the
house. During the summer I attended daily at this place,
although the neighbourhood was the seat of disease. Happily
I had removed my family from that region to a distant and
more airy situation in the Sixth Avenue.

In October, about the time of publishing my History of the American Theatre, I visited Albany for a few days, and on my return for the first time stopt at West Point, but was disappointed in my views (which were to see the old and new objects worthy of attention) by incessant hard rain. I returned home, and in a few days went to Philadelphia. It happened to be election time, and I find this entry in my journal: " Sunday, October 14th—My inn is thronged with what are called politicians; men who gamble by betting on elections, and men seeking—or seeking *to keep*—offices. Swearing, drinking and wagering was the order of the day. It is a melancholy and degrading picture." On the 16th I returned home.

In November, my History of the American Theatre having been published, I received letters of compliment from every part of the United States, and published proposals for the work I now write on.

About the last of December, Mr. Gimbrede the teacher of drawing at West Point died, and my friends urged an application in my favour as his successor. The answer was that Mr. Leslie was appointed. Mr. Leslie accepted the appointment, and acted upon it for a short time.

Tuesday, 19th of February 1833. I entered my 68th year of age. I find this entry in my journal.

"My health generally good; my activity little impaired. My pecuniary circumstances better. My blessings many, but my thankfulness not adequately strong—but I am thankful, and hope to be more and more so."

The 27th in the evening I received the following:—

" New-York, February 27, 1833.

Dear Sir:—At a Meeting of the Committee of the citizens of New-York, friendly to literature and the drama, held this evening at the Shakspeare Hotel, it was unanimously resolved that ten tickets, seats secured in Box No. 16, be presented to you and the members of your family, for the benefit to take place at the Park to-morrow evening.

" We are with sentiments of esteem and great respect,
"Yours, DAVID HOSACK,
" CHARLES KING, *Sec.* *Chairman.*
" To William Dunlap, Esq."

I returned an answer in the most respectful manner thanking the committee, but declining being present at what was called a festival in my honour.

On the 5th of March I received the following from the hands of my good young friend, William Sidney M'Coun.

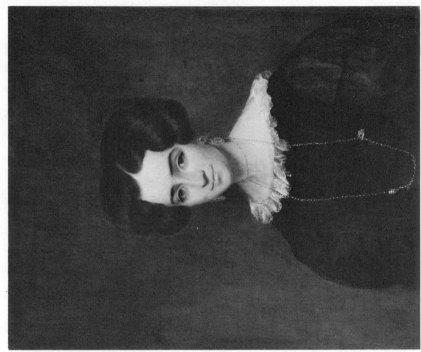

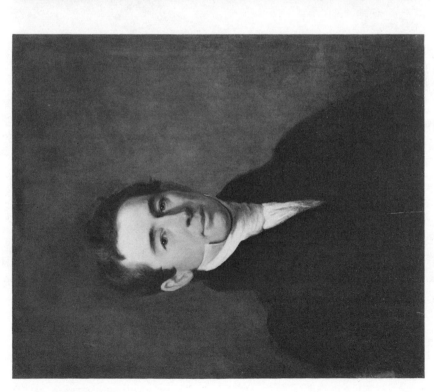

81A JOHN ADAMS CONANT, 1829. Painting by William
Dunlap. *Courtesy The Metropolitan Museum of
Art, gift of John A. Church.*

81B MRS. JOHN ADAMS CONANT (Caroline D. Holton),
1829. Painting by William Dunlap. *Courtesy The
Metropolitan Museum of Art, gift of John A. Church.*

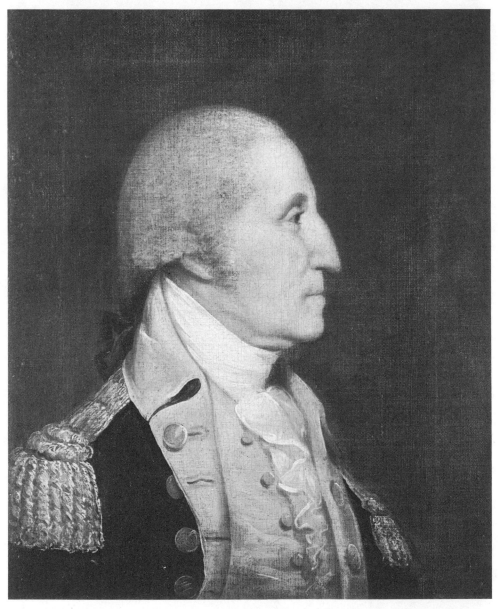

82 GEORGE WASHINGTON, AGE 58. Painting by Joseph Wright. *Courtesy The Cleveland
Museum of Art, Hinman B. Hurlbut Collection.*

" New-York, March 5, 1833.

" Dear Sir :—It has become my pleasing duty as the chairman of the committee, appointed by the citizens of New-York, who were convened to express their deep sense of the services rendered by you to the promotion of the fine arts, and the dramatic literature of our country, to inform you that a benefit has been appropriated, in which many of your fellow-citizens have had an opportunity of expressing their estimate of those services, and bearing their testimony to your character as a private citizen. For the proceeds I refer you to the Hon. Wm. T. M'Coun, Treasurer.

" Allow me, in the name of the committee, to congratulate you upon the success that has attended their efforts, and to add their fervent wishes that the evening of your life may be as happy as the former part of it has been usefully and honourably employed in the advancement of the cause of virtue.

" Accept, dear sir,

" The expression of my personal regard and respect.

" DAVID HOSACK,

" William Dunlap, Esq." *Chairman.*"

I returned an answer very inadequate to my feelings.

The net proceeds of this most flattering compliment as paid to me by the treasurer, the Hon. William T. M'Coun, Vice-Chancellor, was $2517 54. In addition to the above names, George P. Morris, Charles King, Doctors McLean and Francis, William S. M'Coun, William C. Bryant, and many other personal friends, with still more of my fellow-citizens personally unknown to me, together with members of the dramatic corps, zealously aided this most honourable testimony and opportune gift ; a gift which has enabled me to labour on the present work, and supported me under the afflicting disease I have before mentioned. If this autobiography appears to others as it does to me, of undue length, it must be attributed to my knowing more, *(not of myself,)* but of the incidents occurring to me, than I know of those which influence the conduct of other men.

CHAPTER XVI.

Place of Mr. Wright's birth—Carried to England by his mother—Returns to America in 1783—Letter from Washington—Residence in New-York—Removes to Philadelphia—Death by yellow fever—William Rush—Robert Edge Pine— Edward Savage—Trenchard—M. Houdon—His great reputation in Europe— Death—J. P. Malcolm—John Dixey.

Joseph Wright, 1756–1793.

JOSEPH WRIGHT—1783.

This gentleman was the son of Joseph Wright, of Borden-town, New-Jersey, and Patience Lovell of the same place, so celebrated afterwards as Mrs. Wright the modeller in wax. The subject of this memoir was born at Bordentown, on the 16th of July, 1756. After the death of his father, his mother about the year 1772, carried him with other children to London; she became famous for her modelling in wax, and was enabled to give Joseph a good education. He was in his efforts to become a painter, aided by Benjamin West, and by Hopner, who married his sister.

In a letter from Mrs. Hopner to her mother in 1781, who was then in Paris, and very successful in her wax modelling, she requests her not to write to Joseph in such style as will encourage him to think that she will make a fortune for him; for she says, Joe is inclined enough already to be idle, and that he receives the money from the wax-work exhibition, and spends it at pleasure. Joseph, however, before he left England had made himself a good portrait painter, and had painted a likeness of the Prince of Wales, afterwards George the Fourth.

In the winter of 1782, Joseph was placed by his mother under the protection of Benjamin Franklin in Paris, and the following letter from William Temple Franklin, a protegé of his grandfather, shows in some measure how the young painter was employed in the French Capital.

"A Monsieur, Monsieur Wright,
 "Hotel de York,
"Rue Jacob—Fauxbourg, St. Germains: *Passy, Feb.* 28, 1782.

"Dear Sir:—Inclosed are the directions of the ladies to whom I think you will do well to carry, and show your performance. The former, Madame de Chauminot, will, I doubt not, employ you in taking her likeness, providing you are disposed and not exorbitant in your price. The time for waiting upon these ladies will be in the morning, from half past twelve to two. The sooner you go the better.

"I am, my dear sir, yours sincerely,
 "W. T. FRANKLIN."
"Mr. Wright."

A passage in a letter from his mother to him, dated in this same year, August 16th, no doubt alludes to the result of the application advised by the above. " I am sorry for your sake that the Duchess forgot the character of her station, or her own character, in the affair of the two guineas. But I am so well acquainted with the world, that I am not disappointed. My dear son, *silence, patience, prudence,* industry, will put you above all those mean and little minds, and teach you how to act when *you* become great."

In the autumn (October) of 1802, Joseph departed by sea from Nantz, and went, or was driven by stress of weather to port St. Andrew's, in Spain. He was shipwrecked probably on the coast of Spain. In a ten weeks voyage he reached Boston, and wrote almost despondingly to his mother, having his journey south to New-Jersey to perform, and being destitute of money. He had letters, however, both to Boston and Rhode Island, and found his way to Bordentown, I presume without difficulty. In the autumn I met him at head quarters at Rocky Hill, near Princeton, to which place he brought a letter from Doctor Franklin to Washington. This was in October, 1783. At this time and place Mr. Wright painted both the General and Mrs. Washington, as I likewise attempted to do. Wright's pictures I then thought very like. He afterwards drew a profile of Washington and etched it, and it is very like.

Congress then sitting at Princeton, Mr. Wright was employed to take a mould in plaster of Paris, from which a cast might be made of the general's features, to be sent to some European sculptor, as a guide for a marble bust or statue. The general submitted to the irksome task of laying on his back, with his face covered with the wet plaster. What a situation for a hero! When the mask or mould was hardened, the artist took it off, but in his anxiety and trepidation, probably hurrying to release the general from thraldom, he let it fall and it was dashed to pieces on the floor. Washington would not carry his desire to comply with the wishes of congress so far as to undergo another prostration, and the affair of a sculptured resemblance was deferred until Franklin brought out Houdon.

In 1784, and probably in the winter of 1783, Mr. Wright was in Philadelphia, and there received the following letter from General Washington after his retirement:

<div align="center">" Mount Vernon, 10th Jan. 1784.</div>

Sir,—When you have finished my portrait, which is intended for the Count de Solms, I will thank you for handing it to

Mr. Robert Morris, who will forward it to the Count de Bruhl, (minister from his electoral highness of Saxe, at the court of London,) as the channel pointed out for the conveyance of it.

" As the Count de Solms proposes to honour it with a place in his collection of military characters, I am persuaded you will not be deficient in point of execution.

" Be so good as to forward the cost of it to me, and I will remit you the money. Let it (after Mr. Morris has seen it) be carefully packed to prevent injury.

<div align="center">

"With great esteem, I am, sir,

" Your most obedient servant,

" GEO. WASHINGTON."

</div>

Mr. WRIGHT.

I copy the above from the original letter, in the possession of Mr. Wright's children.

How long Mr. Wright remained in Philadelphia, at that time, I know not. In 1787 he resided in Queen (now Pearl) street, New-York, where he for some years practised his profession, having married Miss Vandervoort, the niece of the martyr to liberty and his country, Colonel Ledyard, who was murdered at Croton, near New London, by the British officer to whom he had presented his sword on surrendering the Fort he had defended.

Mr. Wright removed from New-York about the time congress did, and to the same place, Philadelphia. His children have a picture painted by him in Philadelphia, representing in small full-lengths, himself, wife and three children. It was left unfinished, but the heads are very well painted. Among other distinguished men, Mr. Wright painted the portrait of Mr. Madison. I have before me a note from Mr. Madison to the painter, containing an apology for not sitting at an appointed time, and fixing another time if agreeable to Mr. Wright. He was a modeller in clay and practised dye-sinking, which last gained him the appointment, shortly before his death, of dye-sinker to the mint.* The yellow fever of 1793 deprived his country of his abilities, he and his wife dying within a few days of each other, in the prime of life. His children (besides the portrait in the group above-mentioned, which is too tall, but otherwise somewhat like) have a chalk drawing of his head, done from the mirror, which is more like,

* I have before me a design for a *cent*, made by Mr. Wright, and dated 1792. It represents an eagle standing on the half of a globe, and holding in his beak a shield with the thirteen stripes. The reverse had been drawn on the same piece of paper, and afterwards cut out.

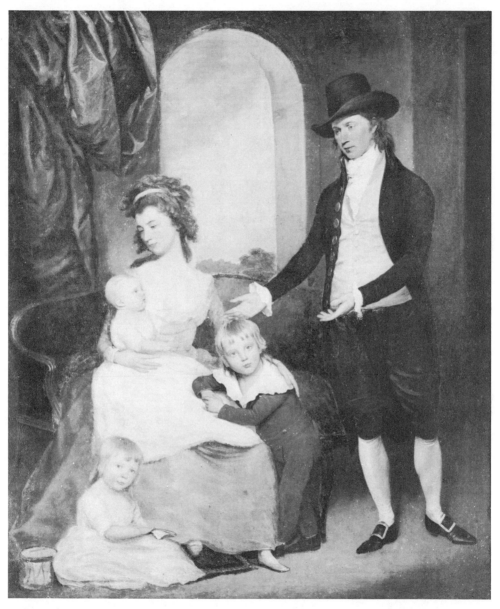

83 THE WRIGHT FAMILY. Painting by Joseph Wright. *Courtesy The Pennsylvania Academy of the Fine Arts.*

84 WATER NYMPH AND BITTERN. Carved statue by William Rush. *Courtesy Commissioners of Fairmount Park, Philadelphia Museum of Art.*

and very skillfully drawn. There is likewise a head of him modelled in clay by Mr. W. Rush, of Philadelphia, who, I am told, said that Wright taught him to model.

While Mr. Wright lived in New-York he accidentally saw a very venerable Jewish gentleman of the name of Simpson, who wore his grey beard long, and was remarkably handsome. His complexion did not indicate his descent from Abraham, it was a clear red and white. Wright with the enthusiasm of an artist, and with an eccentricity peculiarly his own, stepped up to the door of the house, at the window of which the patriarch sat, and knocking, was admitted. He introduced himself to the family, and begged the old gentleman to sit for his portrait, expressing his admiration of his picturesque appearance. The request was complied with, and at the distance of five-and-forty years, I recollect with pleasure the beautiful representation he made of the venerable Israelite. I am told that Mr. Simpson, the grandson, living at *Yonkers,* possesses this picture in perfect preservation.

WILLIAM RUSH—1783.

William Rush, 1756–1833.

This intelligent and very pleasant old gentleman (for such he was when I knew him) was born in Philadelphia in the year 1757. He commenced modelling in clay about the period at which I introduce him to the reader. His performances are all in wood and clay—he never worked any in marble. The first figure he carved was at about the third year of his apprenticeship, which far outstripped his master.

My correspondent says, " His time would never permit, or he would have attempted marble. He used to say it was immaterial what the substance was, the artist must see distinctly the figure in the block, and removing the surface was merely mechanical. When in a hurry he used to hire a wood-chopper, and stand by and give directions where to cut, by this means he facilitated work with little labour to himself. The crucifixes in the St. Augustine and St. Mary's Catholic churches, the Water Nymph at "Fair Mount," the figures in front of the theatre, with the statue of Washington in the State House, are his works in Philadelphia. It was always a source of regret that he had so little time spared him from his occupation in ship-carving where he succeeded so admirably, especially in his Indian figures. He died January 17th, 1833, aged 76."

Mr. Rush was a coadjutor in 1789, with Charles Wilson Peale and others, in attempting to institute an Academy of Fine Arts in Philadelphia.

In 1812 Mr. Rush exhibited several busts and figures at the Pennsylvania Academy of Fine Arts: these were the bust of Linnæus—bust of William Bartram—bust of Rev. H. Muhlenburg—figures of Exhortation, Praise, and a Cherubim.

Mr. Rush was observing in his study of the human figure, " When I see my boys bungling in the carving a hand, I tell them look at your own hands—place them in the same position—imitate them and you must be right. You always have the model *at hand*." These were nearly his words in a conversation with me some years ago.

<div style="margin-left:0">

Robert Edge Pine,
c. 1730-1788.

</div>

ROBERT EDGE PINE—1783,

Came to America in the year 1783, upon a speculation similar to that which John Trumbull happily commenced a short time after. Pine's very rational scheme was, to paint portraits of the heroes and patriots of the American Revolution, and combine them in historical pictures of the great events which had made the United States an independent nation.

Mr. Pine had proved himself an historical painter in England by several compositions of merit, some of which are rendered familiar to the world by good engravings. Why Allen Cunningham has not enrolled him in his list of eminent British painters must be left to conjecture : that he is more entitled to such distinction than Sir George Beaumont, is evident from Cunningham's own showing, in the biography of the accomplished, liberal, and amiable knight. He was established in London as early as 1761-2. Mortimer, after leaving Hudson, with whom he had studied a short time, became a student with Pine.

I learn from " Edwards' Anecdotes of Painters," that " Mr. Pine was born in London. He was the son of Mr. John Pine the engraver, who executed and published the elegant edition of Horace, the whole of which is engraved. Robert Edge Pine chiefly practised as a portrait painter, and was considered as among the best colourists of his time. He resided several years in St. Martin's-lane, in the large mansion opposite to New-street, Covent Garden.

"In the year 1760 he produced a picture, as candidate for the premium then offered by the Society for the Encouragement of Arts, &c. for the best historical picture painted in oil colours; the figures to be as large as life, and the subject to be taken from English history. Mr. Pine selected the Surrender of Calais,* and obtained the first prize of one hundred guineas.

* The point of time represented in the picture is the approach of Eustace de St. Pierre with his five townsmen to Edward III. while his Queen Philippa kneels and intercedes for them.

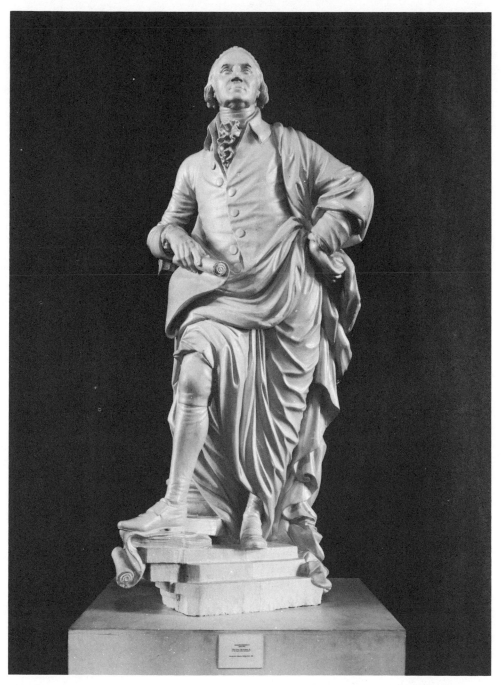

85 GEORGE WASHINGTON. Carved statue by William Rush. *Courtesy National Park Service.*

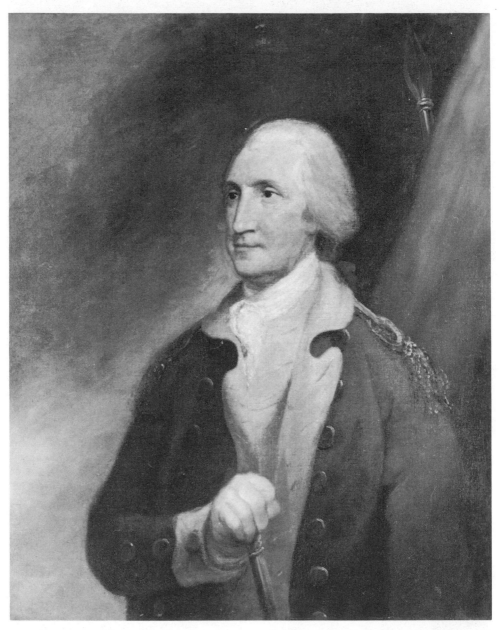

86 GEORGE WASHINGTON. Painting by Robert Edge Pine. *Courtesy Independence National Historical Park.*

—This was the first time that the Society offered this liberal stimulus to the exertions of the British artists.

"In 1762, he again offered a picture, as candidate for the similar premium, and obtained the first prize; the subject, "Canute on the sea-shore, reproving his courtiers for their flattery." At the same time his former pupil, Mr. Mortimer, obtained the second premium. West arrived in London in 1763, and took precedence of all the English historical painters.

"In the year 1772, upon the death of his brother Simon, Pine went to Bath, and staid there till 1779. He returned to London in the early part of 1782, and made an exhibition at the Great Room, Spring Gardens, of a collection of pictures painted by himself; the subjects taken from various scenes in Shakespeare; but the exhibition did not answer his expectations. It must be observed, that whatever merit those works might possess in their colouring and composition, his drawing in general was feeble in the extreme, as may be seen by the prints which were engraved after some of the pictures.

"The peace of 1783 opened a new field for Pine; and as he did not meet with that employment he wished for in London, he quitted England and went to America.*

"The following may be considered among his best pictures:—A whole-length portrait of his late Majesty George II. painted from memory.—A whole-length portrait of the late Duke of Northumberland, in the committee room of the Middlesex Hospital, in which his grace is represented as laying the first stone of that building. His picture of the Surrender of Calais is in the Town-hall of Newbury. It was bought of the artist by the corporation; and the print which was engraved from it, is dedicated to them by Mr. Pine."

He took up his abode in Philadelphia, having brought his family with him, and resided at the corner of High and Sixth streets. The following is part of a letter relative to him, from the Hon. Joseph Hopkinson, of Philadelphia, received May 6th, 1833.—

" I remember his arrival in this country; he brought letters of introduction to my father, whose portrait was the first he painted in America. It is now in my possession, and is a very fine one: it bears the date of 1785, and is now as fresh in colour as it was on the day it was painted. Pine came to

* Mr. Pine's turn of mind and political feelings may be seen by his painting several of the popular patriots of the day, from which prints were engraved and published. Among others is one of John Wilkes, Esq. with the following inscription:—"Patricius Pine humanarum figurarum pictor pinxit."

this country in the preceding year. His particular object was, to paint the distinguished persons and events of our Revolution; but we were too young to give encouragement or patronage to historical pictures—and he took to portraits; which his wife also painted, and taught the art in this city. Robert Morris, who patronized him, built a house in Eighth-street, now standing, suitable to his objects. He died here, I think, of an apoplexy, but do not find in what year. He brought a high reputation here—was king's painter; and I have seen engravings from several of his pictures, particularly of Garrick. I remember a large picture in his gallery, of *Medea* murdering her children, and several others, some from Shakespeare.— Prospero and Miranda, in the Tempest, I particularly recollect. Many of his pictures are scattered about in Virginia, where he went occasionally to paint portraits. He was a very small man—morbidly irritable. His wife and daughters were also very diminutive; they were indeed a family of pigmies. After his death his family went back to Europe, and his pictures were sold by public sale. Many of them were bought and taken to Boston by a person whose name I forget, (I think it was Bowen) who kept a museum there. This, I think, was about the year 1793; and of course his death was antecedent to that time, but how long I cannot say, His widow and daughters kept a school after his death. I believe he died before my father, which was in the spring of 1791, and that the school was not opened till after his death. This is all the information now in my recollection. I think, by making some inquiry I may collect something more; in which ase I will communicate it to you.

" Yours, &c. Jos. Hopkinson.

" P. S. He brought with him a plaster cast of the Venus de Medicis, which was kept *shut up in a case*, and only shown to persons who particularly wished to see it; as the manners of our country, *at that time*, would not tolerate a public exhibition of such a figure. This fact shows our progress in civilization and the arts."

Our people now flock to see the naked display of a Parisian hired model for the painter's study, and an English prostitute in the most voluptuous attitude, without a shade of covering, enticing the man to sin; a perfect Venus and Adonis, under the names of Adam and Eve, and called " a moral picture."

The paintings mentioned by Judge Hopkinson, as being removed to Boston, were all destroyed by fire, in a conflagra-

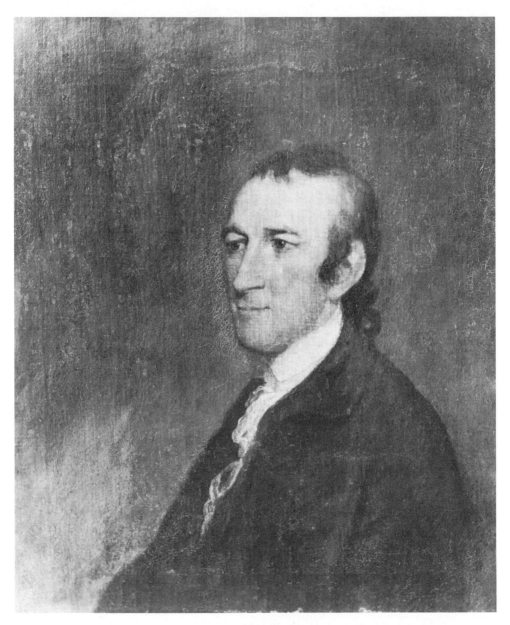

87 THOMAS STONE. Painting by Robert Edge Pine. *Courtesy Enoch Pratt Free Library.*

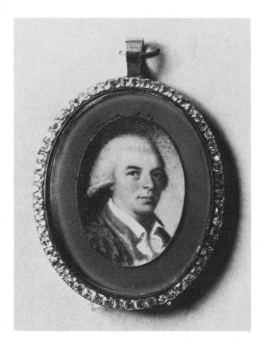

88 SELF-PORTRAIT. Miniature by Edward Savage. *Courtesy Worcester Art Museum.*

tion of Bowen's Museum : but they had the honour, with Smybert's copy of Cardinal Bentivoglio, of giving the first lessons in colouring to the greatest colourist this country has produced. Mr. Allston has said, " In the colouring of figures the pictures of Pine, in the Columbian Museum in Boston, were my first masters. Pine had certainly, as far as I can recollect, considerable merit in colour."

The world can now form an estimate of the talents and acquirements of Pine only from the engravings published of his works, and the portraits of eminent men of our country still remaining among us. The former place him in a high rank, though not the highest, among modern artists, for composition ; and the latter give him a still superior station among the portrait painters. The portraits of Francis Hopkinson, in the possession of his son, and of Doctor Johnson, President of Columbia College, in the collection of his grandson, Gulian C. Verplanck, are specimens of talent for the delineation of character of a high order ; and for colouring, much beyond any of the artists, his cotemporaries in this country, Stuart alone excepted.

Robert Gilmor, Esq. of Baltimore, in answer to inquiries respecting our early artists, says, " Chas. W. Peale and Robt. Edge Pine were the earliest painters I recollect in Baltimore, and there are numbers of portraits by both here. Mrs. Caton has the Carroll Family, by Pine, painted at Annapolis ; in which full-lengths of C. Carroll of Carrollton, his son Charles, herself and her sister, Mrs. Harper, are painted. Mr. Patterson and Mr. Robert Smith have large family groups, by Pine also.

The Hon. Francis Hopkinson, whose portrait Pine had painted with perfect success,* wrote to General Washington, explaining the design Pine had in view of collecting portraits for historical pictures of the events of the Revolution, and requesting the general to forward the wishes of the artist, by sitting to him : and Washington wrote the following letter to Hopkinson, in reply :—

" Mount Vernon, 16th May, 1785.

" Dear sir—' In for a penny in for a pound' is an old adage. I am so hacknied to the touches of the painter's pencil, that I am now altogether at their beck, and sit like Patience on a monument, whilst they delineate the features of my face. It is

* An engraving from this portrait, by Heath, (or rather, from a copy of it sent to England) is in Delaplaine's gallery of portraits of eminent men, but the character is lost.

a proof, among many others, of what habit and custom may effect. At first I was impatient at the request, and as restive under the operation as a colt is of the saddle. The next time I submitted very reluctantly, but with fewer flounces : now, no dray moves more readily to the drill, than I to the painter's chair. It may easily be conceived, therefore, that I yielded a ready acquiescence to your request and to the views of Mr. Pine.*

"Letters from England recommendatory of this gentleman came to my hands previous to his arrival in America—not only as an artist of acknowledged eminence, but as one who has discovered a friendly disposition towards this country—for which it seems he had been marked.

"It gave me pleasure to hear from you—I shall always feel an interest in your happiness—and with Mrs. Washington's compliments and best wishes, joined to my own, for Mrs. Hopkinson and yourself,

"I am, dear sir,
"Your obedient and affectionate humble servant,
"GEORGE WASHINGTON."

It would appear by the following notification, that Mr. Pine was dead before the 18th of April, 1789.

"Kingston, Jamaica, April 18, 1789.

"A very capital painting representing the quarter-deck of the Formidable, on the memorable 12th of April, 1782, with whole-length figures, large as life, of Lord Rodney, Sir Charles Douglas, Lord Cranston, and other British worthies, was exhibited to the British Club, and a handsome subscription immediately commenced to purchase it. This piece is the production of an American artist, Mr. Pine, lately deceased. The price is 200 guineas."

Therefore we see that Mr. Pine was denied time to make the collection of portraits necessary for his great undertaking. This agrees with the Hon. Judge Hopkinson's supposition that he died before 1791, the date of the decease of the Hon. Francis Hopkinson.

Edwards says, that he died in 1790, leaving a widow and some daughters, who returned to England.

* The portrait painted at this time of Washington, by Mr. Pine, (or a copy of it by his hand) was found many years after in Canada, and purchased by Henry Brevoort, Esq.

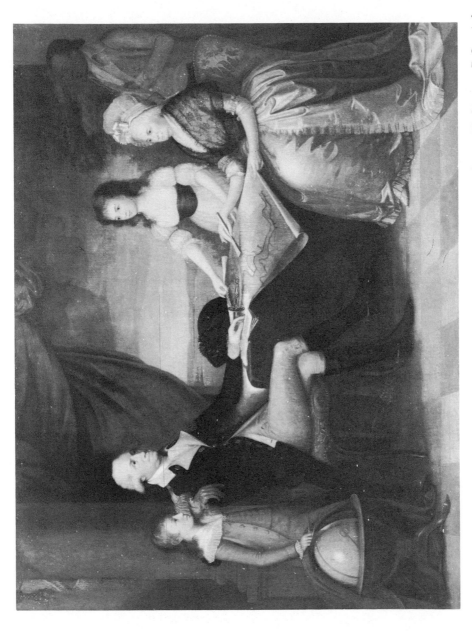

89 THE WASHINGTON FAMILY. Painting by Edward Savage. *Courtesy National Gallery of Art, Washington, D.C., Andrew Mellon Collection.*

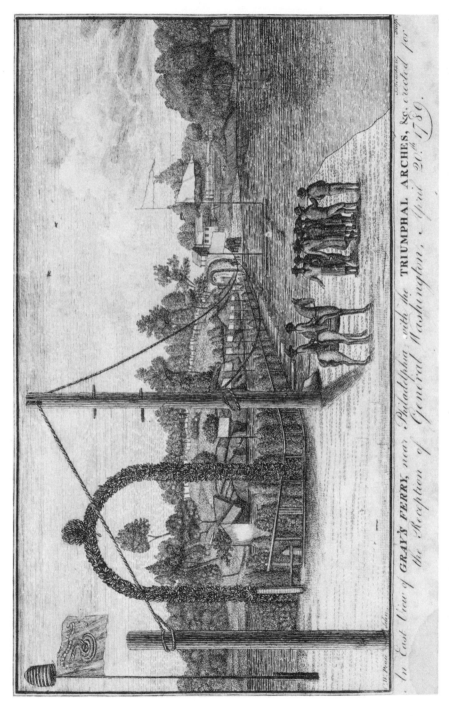

90 An East View of Gray's Ferry, Philadelphia, 1789. Engraving by James Trenchard after Charles Willson Peale. *Courtesy Library of Congress.*

EDWARD SAVAGE—1784.

Edward Savage, 1761–1817.

Mr. Savage, I believe, was a native of one of the New-England states. He was painting in New-York in 1789; and had previously been living in Philadelphia. He would not be worth notice as an artist but as connected with others. He removed to Philadelphia, and there painted and pretended to engrave. The father of John Wesley Jarvis, put the boy, his son, to Savage, to learn engraving; and Savage, removing again to New-York, Jarvis, as his apprentice, came with him, as did David Edwin, the celebrated engraver, whom he engaged in his employ. This was in 1798. Savage published prints from his own wretched pictures, mended and engraved by Edwin, but inscribed with Savage's name as engraver. Edwin, being asked why he did not put his name to his work, by one who knew Savage could do nothing with the tool or graver, replied, " I do not wish the credit which is to be derived from pictures of Mr. Savage's composition." " I soon found," said Jarvis, " that I could paint better than my master, and engrave ten times better."

After Jarvis left him, he had as pupils Charles B. King and John Crawley. He had a kind of museum and picture-gallery in Greenwich-street, in a building once used as a circus. He published the " Washington Family," engraved by Edwin, who made it tolerable, and perhaps Jarvis helped. Jarvis has said, " I assisted in engraving it—I printed it, and carried it about for sale." Before he engaged Edwin he had visited London, and brought out a man whom he engaged to engrave for him at half a guinea a week, Savage paying his passage. This is similar to some of the early engagements made by managers with actors, who found, after their arrival in America, that their weekly salary would not pay their board and lodging.

TRENCHARD—1785,

James Trenchard, 1747–?.

Engraved in Philadelphia about this time. He was a pupil of Smithers. " He tried," says Lawson, " to make designs and engravings for a magazine, but they were poor scratchy things, as were all the rest of his works." He was the master of Thakara and Valance, and taught what he knew to his son Edward Trenchard, hereafter mentioned.

Jean Antoine Houdon,
1741-1828.

M. HOUDON—1785.

M. Houdon was born at Versailles in 1741. The celebrated sculptors of France immediately preceding him were Coisevoix, Vancléve, Lepautre, Legros, the two Coustons, and Bouchardon. The works of these masters, placed under the eyes of the young man, had their influence in forming his taste, even without his being conscious of the aid he received from them. These masters were in fact the only instructors of Houdon until he had, by his untutored efforts, gained admission into the academy ; and he continued his studies without placing himself under the formal direction of any professor. By his diligence he progressively advanced to skill, until he gained the great prize for sculpture in 1760, at the age of nineteen.

Pigale, the successor of Bouchardon, encouraged the young man by his advice, but we see by the opposite mode in which these artists afterwards treated the same subject, (the statue of Voltaire) that the younger had a genius which would not submit to copy the errors of his friend's style. He struck out a path for himself and followed it.

Houdon had the advantage of a ten year's residence in Rome ; and left in the porch of the church of the Chartreux the beautiful statue of St. Bruno, in marble, the product of his chisel. This statue is said to be the perfect representation of humility, in the costume of the pious Cenobite. Pope Clement the fourteenth said of it, " It would speak, if the rules of the order had not enjoined silence."

On returning to France M. Houdon introduced a style, which, although not of the highest order, avoided the servility of imitation, and was free from the constraint of those leading-strings of art which have been called the Academic manner.

His Morpheus gained him the honours of the academy, and he shortly after presented to all students of the arts of design his invaluable anatomical statue—" l'écorché." This is a work for which he deserves our gratitude, inasmuch as it could not add to his fame, and he could only be remunerated for his labour by the pleasure of being useful to others.

M. Houdon had now no rival in France ; and his fame had reached America. He was invited to the United States for the purpose of executing a likeness of Washington in marble, and chiseling a statue of the hero of our revolution, a work which had been long contemplated. I have already noticed the attempt made by Mr. Joseph Wright, in 1783, to take a masque or mould in plaster of Paris, from which a cast

might have been made as a guide to some sculptor, in the formation of a statue, and the accidental failure of Wright's effort.

M. Quatrieme de Quincy says, in his "Notice Historique sur la vie et les ouvrages de M. Houdon," which I have freely used, "The United States invited him to execute the statue of Washington." This is not fact. The State of Virginia had resolved to have such a statue, and Benjamin Franklin and Thomas Jefferson agreed with the sculptor to cross the Atlantic for the purpose of making a bust, preparatory to executing the statue for the state-house at Richmond. Mr. Jefferson was probably authorized by his native state to engage an artist for the purpose.

The same writer says, "Conducted to America by Franklin, he resided some time at Philadelphia, where he was lodged in the house of Washington himself." This is likewise erroneous, General Washington having retired to his house at Mount Vernon, at which place M. Houdon executed his bust, and took the measurement of the hero's person, to give perfect accuracy to the proportions of the statue ; which was done in the presence of Mr. Madison. For the proof of this see the letters in the note.*

Philadelphia, September 20, 1785.

Dear Sir—I am just arrived from a country where the reputation of General Washington runs very high, and where every body wishes to see him in person ; but being told that it is not likely he will ever favour them with a visit, they hope at least for a sight of his perfect resemblance, by means of their principal statuary, M. Houdon, whom Mr. Jefferson and myself agreed with to come over for the purpose of taking a bust, in order to make the intended statue for the state of Virginia. He is here, but the materials and instruments he sent down the Seine from Paris, not being arrived at Havre when we sailed, he was obliged to leave them, and is now busied in supplying himself here. As soon as that is done he proposes to wait on you in Virginia, as he understands there is no prospect of your coming hither, which would indeed make me very happy : as it would give me the opportunity of congratulating with you personally on the final success of your long and painful labours in the service of our country, which have laid us all under eternal obligations.

With the greatest and most sincere esteem and respect,

I am, dear sir, your most obedient and most humble servant,

B. FRANKLIN.

[ANSWER TO THE FOREGOING.]

Mount Vernon, September 26, 1785.

I had just written, and was about to put into the hands of Mr. Taylor, (a gentleman in the department of the secretary for foreign affairs,) the inclosed letter, when I had the honour to receive your favour of the 20th instant.

I have a grateful sense of the partiality of the French nation towards me ; and I feel very sensibly for the indulgent expression of your letter, which does me great honour.

It is true, as the author goes on to say, that " he took the likeness of Washington *en buste*, and brought it home with him, to serve in the execution of the statue in marble," destined for the capitol in the city of Richmond, " where it may be seen."

In the diary of Governeur Morris, as published by the Rev. Jared Sparks, is the following insertion. " June 5th, (1789,) Go to M. Houdon's. He has been waiting for me a long time. I stand for his statue of General Washington, being the humble employment of a manikin. This is literally taking the advice of St. Paul, to be all things to all men,—promise M. Houdon to attend next Tuesday, at half-past eight, to have my bust taken, which he desires *to please himself*, for this is the answer to my question, what he wants with my bust ?"

I have seen the statue of Washington in the capitol at Richmond. It is not so good a likeness as Ceracchi's bust in marble, size of life, or Stuart's original head of Washington. The statue is in the modern costume. The general has his full military dress, as worn in the war of our liberation. Of what use the person of Governeur Morris could be to the artist I cannot conceive, as there was no likeness in form or manner between him and the hero, except that both were tall men. And the measurements above-mentioned, which Mr. Madison told Mr. Durand (at the time *that* artist went to Virginia for the purpose of painting his excellent head of that great man) he saw the sculptor make at Mount Vernon, would certainly not agree with the proportions of Mr. Morris.

On his return to Paris, M. Houdon produced a statue of Diana, a copy of which was made in bronze. The original, in marble, was ordered by the Empress Catharine, of Russia, for the Hermitage. It is said that this Diana is more like one of the followers of Venus than the goddess of Chastity. M. de Quincy, with great *naivete*, wonders that the artist should so represent Diana. He forgets that the statue was destined

When it suits Mr. Houdon to come hither, I will accommodate him in the best manner I am able, and shall endeavour to render his stay as agreeable as I can.

It would give me infinite pleasure to see you. At this place I dare not look for it, although to entertain you under my own roof would be doubly gratifying. When, or whether ever, I shall have the satisfaction of seeing you at Philadelphia is uncertain, as retirement from the walks of public life has not been so productive of that leisure and ease as might have been expected.

With very great esteem and respect,

I am, dear sir, your most obedient humble servant,

GEORGE WASHINGTON.

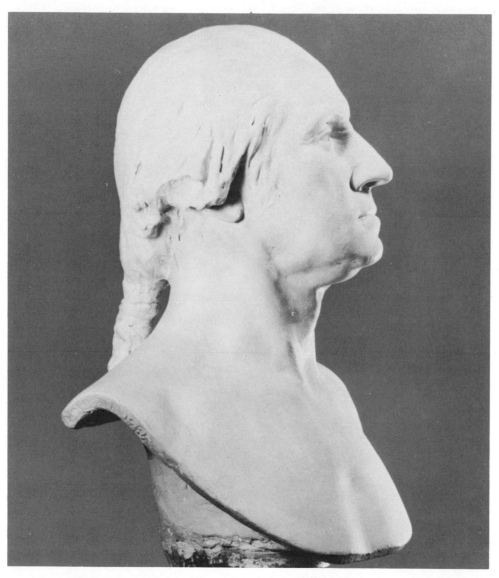

91 GEORGE WASHINGTON. Sculpture by Jean Antoine Houdon. *Courtesy Mount Vernon Ladies' Association.*

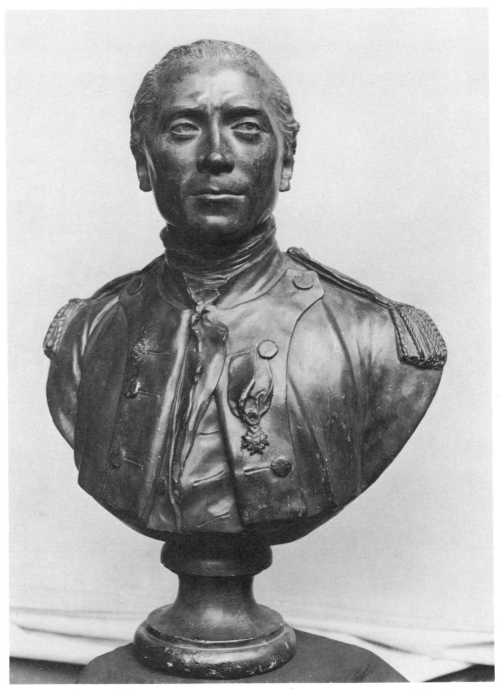

92 JOHN PAUL JONES. Sculpture by Jean Antoine Houdon. *Courtesy The Pennsylvania Academy of the Fine Arts.*

for Catharine of Russia. That she should order a Diana is the wonder.*

M. Houdon gained great credit by his representation of Voltaire. Pigale had been employed to execute a statue of the poet and philosopher; and gave him in all the nudity of the Greek statuary, and all the detailed decrepitude of old age. The result was a figure fit for the anatomical school. Houdon's statue is sitting, and the drapery flowing and befitting a philosopher. It has the air of the antique, and is a true portrait of the man. The costume might be termed ideal, but accorded strictly with his character, at the same time avoiding the dress of the court or the street. Gulian C. Verplanck and Washington Allston saw this great effort of Houdon's genius at the same time. Allston stood silent before it for some minutes, and then exclaimed, " A living statue !"

The statue called *la Frileuse*, gained M. Houdon great popularity, and principally by the charm of simplicity. It is the personification of cold, or winter. This simplicity was not the characteristic of Houdon's style in portraiture. He produced likeness by too great attention to detail. Among the many portraits from his chisel may be mentioned Voltaire, Franklin, Gluck, Washington, Rousseau, D'Alembert, Buffon, Gerbier, Sacchini, Barthélemi, and Mirabeau.

The revolution was inimical to the arts. Heads were *taken off* by a more summary process than those of the painter or sculptor; and the artist who had been favoured by monarchs and nobles, became the object of suspicion when licentiousness had supplanted liberty, and was preparing the way for renewed despotism. Houdon, during that reaction whose cause was the insolence of tyranny and the baseness of slavish submission—during the tumult caused by the reins of government falling into the hands of those who had been rendered

* One of the questions long agitated in relation to portraits of modern personages is, (or has been,) whether the costume of the time should be adopted, or every modern be made to assume the habiliments of Greece and Rome. As it respects painting, the question has been decided both by ridicule and argument. The alderman or cheesemonger in cuirass or toga, and their wives as nymphs or shepherdesses have been laughed from the esel and the canvas. But it was and is contended that a warrior or statesman may be disguised or appear in masquerade when he appears in marble, provided the face is unmasked. I believe that a skillful artist may dispose of any costume so as to exhibit characteristic grace, and think that every portrait, whether in marble or painted—whether on a round or flat surface—should represent the truth, and convey to posterity not only the features and expression of the individual, but the costume of the age. The choice may be of a winter or summer dress—an in-door or out-door—a morning gown for a student, or a hunting dress for a sportsman. A cloak or veil will sufficiently destroy the too familiar or the too stiff—the point is however yet undecided.

brutal by the usurpation of kings and courtiers—during the hurly-burly of revolutions and insurrections, amused himself by finishing a statue of one of holy mother church's saints, which had been long neglected in his *attelier*. The old regime of despotic church and despotic state government, had been too closely connected, and too oppressive, to allow of separation now that the once oppressed were the masters. The artist was denounced. He was accused of devoting his talents to the cause of oppression. No distinction could be allowed between religion and the hierarchy; and the hierarchy was as odious as the aristocracy or the monarchy. Happily the pleader who defended Houdon, bethought himself of turning the statue into a representative of Philosophy; denied its holy character; and saved the head of the artist by convincing the judges that he had no religion, and his marble saint no sanctity. The statue was pronounced to be Philosophy, the enemy of priestcraft and tyranny; and Houdon had only to undergo the fear of death as a reward for his industry and skill.

A new generation of artists sprung up with the new generation of mushroom kings, princes, dukes, and other nobles; and Houdon was found too old to contend with the aspirants of the colossal empire. He was however remembered; but it was only to afford him an honourable retreat in his old age. He was employed to model subjects intended for the colossal column of *Boulogne-sur-mer*, and his work was never applied as designed.

When the hideous despotism of Bonaparte was overthrown by a combination of meaner tyrants, aided by injured and suffering humanity, Houdon had withdrawn from public life. He had played his part on the stage, and had retired full of years and honours. He was a member of the legion of honour, and of the Royal Academy of Fine Arts. He had been an active professor, and assisted still at the sittings of the academy, without taking frequent part in debate or deliberation; and terminated a long and honourable career at the age of eighty-eight, on the 16th of July, 1828.*

* The London artists tell an anecdote of M. Houdon, illustrative of the supercilious feelings and manners of French, Italian, and other continental professors of the fine arts in the last century. Houdon and Flaxman were at Rome at the same time, and some years afterward Houdon being asked if he remembered a great English sculptor of the name of Flaxman, replied, "Flaxman? Flaxman? No." "Why you were at the same time students in Rome, you certainly must remember so remarkable and excellent an artist—an English sculptor." "Oh! Flaxman—ah!—a little man with a hump on his back—an Englishman—the English *do* make very good—penknives and razors."

JAMES PELLER MALCOLM, F. S. A.—1787.

James Peller Malcolm, 1767–1815.

This artist made his first efforts as a painter in Philadelphia, about the year 1787—8. We shall draw our information respecting this gentleman principally from a memoir, written by himself in 1805. His grandfather, Malcolm, he says "went from Scotland to St. Christophers or St. Kitts, where all his numerous family became extinct, except my father, a merchant, who died in Philadelphia when under 30 years of age, and when I was but two years old."

His maternal grand-parents, the Pellers, were natives of Bristol ; "whence James Peller, his great grandfather, went in the same ship with William Penn to the banks of the Delaware, and there hutted with him and other adventurers of the voyage ; returned with him, and again went finally, conveying his family." William Penn was not under the necessity of hutting. This is a trifle perhaps, but truth is not to be trifled with.

Mr. Malcolm says, " The house in which Mr. Peller resided was built by him about 1689 ; and there all my immediate relatives of this branch were born ; nor was it taken down till about 1793, after we had sold it."

James Peller Malcolm was born in Philadelphia, in the month of August 1767, and baptized in St. Peter's Church, by the Rev. Jacob Duché, elsewhere mentioned by me. Young Malcolm was admitted at the quaker school ; but as the enemies of his country approached Philadelphia, he was removed to Pottstown, and there received his education. He returned to Philadelphia in 1784. "During the period in which I received my education," he says, " I felt the strongest impulses to drawing and painting ; and employed every leisure moment I could command in those fascinating pursuits. Mr. Bembridge, a relation and a brother student of Mr. West, who had spent several years at Rome, flattered me with his approbation and advised an immediate voyage to Great Britain."

We stop to say that we do not think Mr. Bembridge was related to Mr. West, that he was not a " brother student," is certain. This error is excusable in Mr. Malcolm, who knew they were both Pennsylvanians, and both had studied in Rome.

Mr. Malcolm visited England " immediately after he was of age." Of course some time in the year 1788–9. He continues, "After I had studied at the Royal Academy three years, and received many hints relating to the art from the late Mr.

Wright of Derby, and Mr. West, I began to perceive that no
encouragement was offered to the liberal branches of history
and landscape, and therefore desisted from the pursuit. My
subsequent efforts in engraving are the result of *self-taught*
knowledge."

I have expressed my opinion of the words self-taught.
Here is a gentleman who from the mature age of 21 or 22,
studies drawing in the best school in Europe for three years—
mingles with artists, and sees all the best paintings and en-
gravings, yet when he commences working on copper, instead
of paper and canvas, considers his knowledge as proceeding
from himself.

There is reason to believe that Mr. Malcolm, after his dis-
appointment in England, returned to Philadelphia, and that
then his maternal property, the Peller-house, was sold. Alex-
ander Lawson says, "There was a young lad of the name of
Malcolm, about '92 'or 3, who drew and engraved an inside
view of Christ Church, and some other things without any in-
structions, scratchy and poor, but indicating talent. He went
to England, where he became an architectural draughtsman."
See how the word scratchy agrees with Malcolm's taste as to
engraving. Speaking of his works, he says, " Which I value
only in proportion as they are approved by the admirer and
judge of nature, rejecting the gloss of mere lines without a
particle of true drawing." The works of Mr. Malcolm, as we
see them in the Gentleman's Magazine, as late as 1815, show
this want of attention to lines and are scratchy.

Mr. Malcolm's mother accompanied him to England, and
her property having been exhausted for his education, he, by
his industry as a writer and engraver, maintained her, and a
wife and family, until he sunk " under a complication of disor-
ders, originating in a white swelling of the knee, which from
its first attack deprived him of the use of his limb." He died on
the 5th of April, 1815.

I believe Mr. Malcolm was a better man than artist. He
continued his literary exertions through sickness and pain, and
on completing a copious index for Mr. Nichols, he thus ad-
dressed him, " The Almighty has been so merciful to me, as
to enable me to complete your index ; and thus have been ful-
filled your benevolent intentions towards me and my family.
Surely never was an index completed under equal continuance
of pain ; but it was a kind of refuge and solace against afflic-
tion ; and often has it turned aside the severest pangs."

Mr. Malcolm published plates to illustrate the environs of
London, the designs by himself: letters between literary men

Christ Church, Philadelphia

93 CHRIST CHURCH, PHILADELPHIA. Engraving by James Peller Malcolm after his own drawing. *Courtesy Dover Archives.*

94　CHERUB'S HEAD ON THE ALEXANDER HAMILTON MEMORIAL TABLET. Sculpture by John Dixey. *Courtesy Corporation of Trinity Church.*

illustrative of Granger's Biographical History of England, 1808. Excursions in Kent, Gloucestershire, &c., &c., with 24 plates, 1807. Second edition, 1813. Londininium redevivum, 4 vols. 4to, 1802–7, with 47 plates. Anecdotes of the manners and customs of London, from the Roman invasion to the eighteenth century, 1808–11, with forty-five plates. Miscellaneous anecdotes illustrative of the manners and history of Europe, during the reigns of Charles II., James II., William III. and Queen Anne, 1811, with five plates. History of the art of caricaturing, 1813, with 31 plates, 4to. His works for the Gentleman's Magazine were many, and for Nichol's History of Leicestershire he laboured as a draughtsman and engraver for nearly twenty years. He likewise designed and engraved many architectural views for various individuals and societies. Thus he laboured to the age of forty-seven, and left his family dependent upon the charity of the British public.

JOHN DIXEY—1789.

John Dixey, c. 1762–1820.

Mr. Dixey, an artist educated in London, is among our earlier sculptors—among the pioneers who have aided the progress of art, and by their efforts contributed to exalt our national character.

John Dixey was born in the city of Dublin, but left the metropolis of Ireland at an early age for London. He was a student of the Royal Academy, and both his assiduity and talent must have been apparent, as I am informed that his name was on the list of those who were selected from the students to be sent to Italy for finishing their education. But other prospects opening to him, he left England for America, and arrived in 1789.

My informant says, " He was elected vice-president of the Pennsylvania Academy of Fine Arts in 1810 or 12," from which we know that he was at that time a resident of that city, although he lived many years in New-York ; he continues, " and exhibited, I think, on that occasion, a model in bas-relief of Hercules chaining the Hydra."

The models he executed were the fruits of his leisure hours, made at such intervals as he could spare from the pursuits which the state of the arts in this country, at that time, compelled him to resort to. He wished to revive the too much neglected art of sculpture, and his models were generally done at a considerable pecuniary sacrifice. His death occurred in 1820. Besides Hercules and the Hydra, Mr. Dixey executed in 1818, a model of Ganymede, and the next year he carved in wood the Adoration of the wise men of the

East. The Cherub's head in marble, on the Hamilton monument, is from his chisel, and the Figures of Justice on the city-hall of New-York, and the state house at Albany are his design and execution.

The talents and acquirements of Mr. Dixey, for many years previous to his death, were principally directed to the ornamental and decorative embellishment of public and private edifices. In the graceful and almost endless variety in which flowers are susceptible of being grouped, intermingled with the fanciful heads of men and animals, his chisel ever displayed both taste and ability.

Mr. Dixey married in America and left two sons, who, as American artists, will be hereafter mentioned.

———

CHAPTER XVII.

Egyptian architecture—adopted and improved by Greece—Orders—Roman architecture—Arabian—Gothic—Modern—American—City of Washington—Major L'Enfant.

A history of ARCHITECTURE in a work like this must necessarily be exceedingly brief, my object being the progress of the art in our own country; but a rapid view of its rise and progress in other countries, until Europeans colonized America, appears desirable, as an introduction to what I can record conformably to my general plan.

To Mr. A. J. Davis, and to the splendid library of Mr. J. Town, I am indebted for information and opportunities which might have led to more valuable results.

I adopt the opinion which gives the highest antiquity to the architecture of Egypt. That country of wonders furnished the leading principles of that style which has been diffused throughout the world, and is now acknowledged the standard of the art—*the three orders of Greece.*

The Egyptian style is colossal. It is simple, solid, and gigantically sublime. In its decorations the vegetable products of their country were imitated with truth and taste. The early people of Egypt appear to have been assiduous cultivators of science and art. The wonders of their temples and other buildings have been, until of late, unknown; and the work of discovery begun by Pocock and Norden, continued by the French savans, and yet in progress, fills the mind with astonishment and ardent anticipation.

The excavated temples and other stupendous monuments of Indian and Persian architecture, are immediately derived

from Egypt. The conquests of Osiris and Sesostris carried
the arts and religion of Egypt to Hindoostan. The ruins of
Persepolis may be traced to the same original. In all, the
huge block, the heavy column, the colossal statue, the enor-
mous animals supporting immense piles of stone, the extent
of the buildings, and their suitableness to resist time, mark the
genius of the same people. Every where are seen hierogly-
phics, zodiacs, celestial planispheres, sphynxes, lions, and
other animals, with beautifully executed bas-reliefs, all replete
with knowledge, which time has locked up from modern research,
but with a key that will be discovered, and reward the philoso-
phers of a day close at hand. We may hope that what has for
ages been viewed with stupid wonder by the barbarian, or
with delight by the man of taste, as beautiful decoration, will
unfold hereafter sublimer views of the attributes of the Creator
of the universe, than have generally been supposed to have
existed among that great people, and precepts for the govern-
ment of his creatures, mingled with the records of a nation,
from which the successive generations of mankind have receiv-
ed the genius of science, yet slowly unfolding.

To Denon, Belzoni, and Champolion, we are indebted for
much of what we know of the pyramids, the obelisks, the temples,
statues, bas-reliefs, and hieroglyphics of Egypt. I proceed to
trace the elegance and proportions of Grecian architecture to
their originals in the country of the Pharaohs.

The Egyptian column, always heavy, sometimes repre-
sented the trunk of a tree—sometimes bundles of reeds—or
the whole plant of the papyrus—bound together at different dis-
tances, and ornamented at the base with palm-leaves. Hence
the flutings and the astragals of the Greeks. Both capitals and
shafts of the Grecian columns may be traced to the Egyptians.
The Ionic volute is to be seen. The peristyles supported by
human figures, as in the Parian and Persian peristyles of the
Athenians, are of Egyptian invention, as well as many other
ornamental or fundamental portions of the art.

But *that* susceptibility to the beauty of form which charac-
terized ancient Greece, gave elegance, simplicity, and propor-
tion to its architecture which more than compensates for the
enormous masses of the Egyptian, and by its sculpture added
decorations, which are the wonder of mankind to this day.
Greece borrowed science and art from Egypt, and brought
the latter to a state of perfection from which men have only
wandered to return with renewed admiration.

It must be borne in mind, that it is principally to the Asiatic
Greeks, or the colonies from Grecia proper, that we owe the

arts borrowed from Egypt, and the improvement on them. The names of Doric and Ionian show from whence these improvements in architecture came, and the improvements borrowed by the colonists from their African neighbours, stimulated the artists of the mother country, until, under Pericles and Phidias, the acmé of Grecian skill and architectural greatness was established.

The Doric, Ionic, and Corinthian are acknowledged the universal standard of taste in the art.*

The Doric is the oldest of the three great orders, and was invented by the Asiatic Dorians, borrowing from Egypt in part. Prior to the days of Alexander, it prevailed throughout Greece. Its characteristics are the short thick column, fluted, as seen in the ruins of Paestum and elsewhere. The capital is composed of the abacus, or square flat slab ; and the ovolo, the lower member, resting on the capital. The whole column is five and a half or six modules in height ; the capital being half a module. The entablature is one fourth of the whole column in height, and divided into twenty-four parts ; six is given to the cornice, eight to the frieze, and ten to the architrave. The cornice is the most simple of the three orders, a thick heavy corona, under which are placed carved mutules, in imitation of roofing rafters.

The spiral volute particularly distinguishes the Ionic order, the invention of the Ionians of Asia Minor. This ornament is borrowed from Egypt. The Ionic is a medium between the massy Doric and the slender Corinthian. The order is distinguished by a lighter and more ornamental entablature than the Doric, a more slender column with the spiral volute, the abacus of the capital is scooped, the whole is supported by an echinus, cut into eggs, and bordered by a beaded astragal.

* *A few technical terms.*

A module is the lower diameter of a column ; when divided into 60 parts, is the architectonic scale.

The façade is the front of a building, generally ornamented with a projecting portico, surmounted by a pediment.

A pediment consists of a tympanum and a cornice. The first is the interior area, usually ornamented.

Intercolumniations are the spaces between the pillars, which spaces are from one module and a half in width to four modules.

The entablature and column are the distinguishing features of an order. The first consists of cornice, frieze and architrave ; the second, of capital, shaft and base.

The architrave (epistyle) is the part which rests on the columns, and represents the main beam of primitive temples.

The frieze is the centre division, and rests on the architrave, and the cornice crowns the whole and supports the roof.

The capital, shaft and base of a column are too well known to need explanation.

The column of this order has a base supported on a square plinth.

The proportions of the Ionic column are, a height of eight modules, of which the base occupies thirty lines ; the capital twenty, and the shaft seven and a half modules. The best specimens of the Ionic are the temples of Minerva Polias, at Priene and Athens, and of Jupiter Erectheus at Athens.

The Corinthian order, more ornamented and in greater favour with the Roman conquerors of Greece, did not supersede the Ionic in Grecian estimation. Its bell-shaped capital is borrowed from Egypt, and decorated with the leaves of the acanthus. The ruins of Balbec and Palmyra, remains of Roman grandeur, give specimens of the Corinthian temple. The column is nine and three quarter modules, of which the capital occupies one, the base twenty lines, and the shaft eight modules. The entablature is one-fifth of the height of the whole column, and is divided into an architrave of thirty-six lines, a frieze of thirty-three lines, and a cornice of thirty-nine.

When two or three orders are employed in one edifice, the heaviest should form the base, and the lighter surmount it.

Another style of architecture adopted by the Greeks is composed of male and female figures, occupying the place of columns, and made to support a heavy Doric entablature. The male figures represent Persians, and commemorate conquests over them, and the female Careans—the latter are called Caryatides. The invention is founded on a barbarous system of moral feeling, and we are happy to say that even among the ancients it did not much prevail. Specimens are found in the Pandroseam at Athens. The artists of modern Italy, in many instances, adopted them.

The Grecian temples and theatres gave scope for the exercise of the exalted taste displayed by the nation in architecture and sculpture. I have said enough to lead the reader on for our purpose, and I hope enough to stimulate him to the study of those who will satisfy the thirst I wish to create.

The Roman architecture is built on that of Etruria, and finished after the models of the Greek. The arch, unknown to the Egyptians, may have originated with the Etruscans, but the Romans brought it to perfection, and bestowed on architecture an inestimable gift.

In other respects Roman architecture only combined the Grecian orders with variations, which are now justly rejected. Rome, however, invented what are called the Tuscan and Composite orders. The first is the simplest of all the orders, and most solid. Its column is only five modules in height—

the shaft is four: the base thirty lines, and the capital the same. This order may support even the Doric.

The great architectural remains of the Romans, peculiarly their own, are the cloacæ, circuses, acqueducts, columns, amphitheatres, and baths.

With the overthrow of the Roman empire, architecture, as a fine art, vanished; and it is only in more extensive works that its decline and revival can be recorded. The Goths robbed the beautiful specimens of art to form castles and strongholds—the Lombards followed, even more rude than their predecessors—Christianity raised churches, and, even in the dark ages, infused some life into architectural science. Then followed the Arabian, Saracenic, and Moorish architecture. And the Arabians, imbibing science and taste from the nations they subdued, produced a fanciful style of architecture, combined with great skill, taste, and science, from the models of antiquity; and kept distinct from the temples of Pagan or Christian, equally abominations in their eyes. They adopted the Roman arch. They invented the pointed arch, and the sacred or horse-shoe arch. The Turks are the only Mohammedans who have adopted Christian architecture, which is attributable to their conquest of Constantinople.

Specimens of Mohammedan architecture are to be seen in many parts of the world, but the most worthy of admiration are the mosques of Benares and Lucknow.

For the Norman architecture we must refer to others; only remarking that they adopted the cross for the form of their churches, and the tower or steeple as an ornament: but the Gothic, into which it passed in the eleventh and twelfth century, as it is still imitated, we must pause upon.

The Gothic style differs from all others. By whom invented is yet in dispute. A plausible conjecture is, that it arose in Spain during the struggles of the Goths and Moors. In the twelfth century it was adopted in France. The doors, like the Norman, were deeply recessed, and three were adopted as typical of the trinity. The windows were narrow, and terminated with the sharp arch—columns were clustered pillars encircled with fasces—the capitals formed of flowers or delicate foliage—projecting buttresses and the spire were introduced.—Little turrets and parapets were adopted from the castles.

By degrees this style improved in magnificence, with the rule of the clergy. The doors were enlarged, and surmounted with triangular pediments, and ornamented with sculptures. The windows were enlarged and ornamented with pillars, whose tracery imitated the most beatiful flowers. The columns

became more delicate and elevated. The crocket or *crochet* was introduced at the angles of spires, tabernacles, canopies, and turrets. Buttresses were made more projecting and ornamented with tablets and niches. The 14th century increased this gorgeous style, and statues evince the improvement of sculpture. The vaulting of the naves and aisles became more complex and rich in ornament. The specimens of this best style are the Church of St. Owen, that of St. Sepulchre, and St. Stephen at Rouen, Paris and Caen.

To this succeeded the Florid style, and this is the period of decline. This style, in the 15th century, degenerated into false taste and fantastic refinement. By degrees every species of architecture was combined with the *Gothic*, and finally the Gothic gave way to a pure taste in the revival of the Antique or Grecian style. As in sculpture so in architecture, the Greeks are our models and our masters.

We have not at all times (when speaking of Greece) been sensible of the obligations which Greece proper owed to her colonies. Not only the two most perfect orders of architecture, the Doric and Ionic, were invented by the colonists, but the history of Heroditus, and the poems of Homer, were bestowed by the colonies on the mother country and the world.

English writers tell us that in the land of our forefathers architecture has declined since the days of Inigo Jones and Sir Christopher Wren, and they complain of the want of invention and taste, and even common sense in their late architects. They complain of abortive attempts at Roman, Grecian and Gothic architecture—of ornaments so misapplied as to become ludicrous, and of monuments which are only monuments of absurdity.

Let us now come home, hoping that our brief sketch may elucidate the rise and progress of this inestimable art in our own country. Public architecture seems principally connected with our subject, but the effect of domestic architecture upon the moral feelings and character of mankind, renders it a subject not to be disregarded by us. This is beautifully illustrated by T. Dwight, D. D., president of Yale College, in the 2d volume of his travels through the eastern and middle states.

The learned and amiable president has enforced the utility of the fine arts, and shown how intimately utility and the most refined and ennobling pleasure are connected. Roscoe has beautifully said, "Utility and pleasure are bound together in an indissoluble

chain. And what the Author of nature has joined let no man put asunder." These reflections are applicable to other fine arts as well as architecture. Dugald Stewart has said, " A man of benevolence, whose mind is tinctured with philosophy, will view all the different improvements in arts, in commerce, and in science, as co-operating to promote the union, the happiness, and the virtue of mankind."

Before speaking of such architects as have imprinted their names on our public works, in hopes of a *short-lived immortality*, I will republish a " few remarks respecting the city of Washington, the capitol, and those who have contributed, by their talents, wealth, or industry, to raise" the metropolis of the United States.

" The design for the capitol was made by Dr. Thornton, who received the premium for the same. He was a scholar and a gentleman—full of talent and eccentricity—a quaker by profession, a painter, a poet, and a horse-racer—well acquainted with the mechanic arts—at the head of the patent office, and was one of the original projectors (with John Fitch) of steamboats, and the author of an excellent treatise on language, called ' Cadmus.' He was ' a man of infinite humour'— humane and generous, yet fond of field sports—his company was a complete antidote to dullness.

"The north wing of the capitol was chiefly built by Mr. George Hadfield. He was a man of uncommon talents, and was selected by Colonel Trumbull, in London, under the authority of the commissioners for laying out the city, to superintend the building of the capitol; but, unfortunately, a dispute arose between him and them, which ended in his leaving the public employment, by which we were deprived of his eminent talents. He gave the plan of the public offices, the City Hall, Custis's Mansion, Commodore Porter's, Gadsby's Hotel, (when Weightman's buildings,) Fuller's Hotel, the United States Bank, Van Ness' Mausoleum, &c. He died 1826.

" Mr. Latrobe built the south wing, and gave the final plan for finishing the capitol. He also was a man of brilliant talents. He died some years ago in New-Orleans. Mr. Chas. Bulfinch erected the rotunda, improved the design of the eastern front, and finished the building.

" Mr. G. Blagden was the chief builder—a worthy man and an excellent workman. He was killed three or four years ago by the falling in of some earth at the capitol.

" Mr. Lenthall, the clerk of the works, was killed by the falling of an arch over the room of the supreme court some years before Mr. B.

" Mr. Lenox was the chief carpenter, and the late Mr. Andre the chief sculptor. They were both distinguished men, and the public spirit of the former (lately deceased) has contributed much to the embellishment of the city by good buildings.

" The trees and shrubs around the capitol, and other public places, were chiefly planted by our friend, Mr. John Foy. In this business he has shown much skill, and his labours have been attended with complete success. In after ages, when the old and the young shall take shelter from the heat under their shade, they will bless the memory of the honest Irishman who planted them.

" The great Chesapeake and Ohio canal owes its first sugges-tion to the sagacious mind of Washington ; but it received its impetus and beginning, its noble dimensions, and admirable execution, from the enlightened and indefatigable Mercer.

" The *conveying of the pure water* from the source of Tiber creek to the capitol, in pipes, is the suggestion of the Colum-bian Institute, a committee of which took the levels for that purpose about four years ago, by which it was ascertained that the source of the water was about thirty feet above the base of the capitol ; that sixty-five gallons of pure spring water per minute could be delivered ; and recommended, in a petition to congress, that the water be brought into a reservoir in the capitol square, and afterwards thrown up in a *jet* in the Botanic garden. This work is in a state of forwardness, but the main reservoir, it is feared, (as mentioned by Mr. F.) is in too low a situation, and is too near the capitol. By placing it in the east or upper side of the square, all the grounds might have been irrigated, which would have given them a green and beautiful appearance in the heat of summer.

" As to the *enlargement* of the grounds around the capitol, as suggested by Mr. F. and others, my opposition is founded on preserving the original plan of the city entire—a plan beau-tifully consistent in all its parts. And a serious question may one day arise, whether the plan of the city can be altered to the injury of private property.

" During the administrations of Presidents Washington and Adams, the plan of the city was laid out, and the capitol, president's house, two of the executive offices, and navy-yard were commenced, and carried on to a considerable extent.

" Mr. Jefferson adopted Mr. Latrobe's plan of the hall of representatives and senate chamber, and caused Pennsylvania avenue to be opened and planted with trees. Owing to the restrictions on commerce and the late war, little was done in Mr. Madison's administration for the benefit of the city, except

by friendly feelings, &c. In Mr. Monroe's administration two new executive offices were built, the president's house nearly finished, the north entrance of the square in which it stands ornamented with a handsome gateway and iron railing, both wings of the capitol restored, the centre building commenced, and the capitol nearly completed ; the square surrounded with an iron railing, and trees and shrubs planted.

" During the administration of Mr. J. Q. Adams, the east front and the rotunda of the capitol were finished, the west partially altered, a penitentiary erected, the general post-office enlarged, and a new patent office and city post-office erected.

" The present aspect and future prospects of the city are encouraging ; and it is hoped that the present administration of General Jackson will leave further marks of its munificence to the metropolis."

Pierre Charles L'Enfant,
1754–1825.

MAJOR L'ENFANT—1789.

This gentleman was a native of France, and the first I know of him is his being employed to rebuild, after a design of his own, the old New-York City Hall in Wall-street, fronting Broad-street ; making therefrom the Federal Hall of that day. The new building was for the accommodation of congress ; and in the balcony, upon which the senate chamber opened, the first president of the United States was inaugurated. A ceremony which I witnessed, and which for its simplicity, the persons concerned in it, the effect produced upon my country and the world, in giving stability to the federal constitution, by calling George Washington to administer its blessings, remains on my mind unrivalled by any scene witnessed, through a long life, either in Europe or America.

This building gave way, as perhaps it ought, to utility and the convenience of the citizen. It projected into Wall-street, and the foot passage was under the balcony made sacred by the above-mentioned inauguration. It likewise projected into Nassau-street. The late custom house was upon a part of the site of Federal Hall, as Major L'Enfant's building was called ; and the great custom house now erecting has likewise its foundation on a small part of the same building.

When congress removed to Philadelphia, Major L'Enfant accompanied them. Whether any public building in that city was designed by him, I know not ; but many will remember the enormous house began by him for Robert Morris, the great financier of the revolution, the foundation of which exhausted a fortune, and which, being discontinued, is now

the site of a large square, or block of elegant houses, accommodating numerous families of wealthy citizens.

The name of L'Enfant is not only associated with the inauguration of our first president, but with a permanent monument to his name in the city of Washington. It is well known that Washington himself fixed upon the site of this city as the seat of government of the United States, and Major L'Enfant had the honour of designing the plan.

I republish from an anonymous writer the following:—

" When the present generation shall have passed away, and mixed with those beyond the flood; when party strife shall have ceased and be forgotten, it is to be hoped that the future historian of our city will do justice to the memory of *all* those who have struggled through so many difficulties to make what was lately a morass and forest, the abode of reptiles, wild beasts, and savages, a suitable habitation for legislators, ambassadors, presidents, ministers, and strangers of distinction. In that day, when *our* eyes shall be closed, and others shall look with delight on the majestic Potomac's placid stream, covered with the riches of the east and the west, the beautiful surrounding heights (now covered with woods) studded with elegant villas; the grand canal pouring into the city the produce of the west; when all private jealousies shall have entirely ceased, and the character of every man who has contributed to the rise and progress of our city shall be estimated by the good he has done—the names of Washington, John Adams, Jefferson, Madison, Monroe, J. Q. Adams, and Jackson, &c. will be recorded as the great patrons of the city; those of Carroll, Burns, Young, &c, the liberal donors; Major L'Enfant, for his genius in planning the city; Ellicott, Roberdeau, and the Kings, in laying it out; Thornton, Hadfield, Hallett, Latrobe, and Hoban, for their ingenious and chaste designs; and Blagden, Brown, Lenox, and Andre, for their good execution. To the enlightened efforts of Judge Thompson, of Pennsylvania, (now no more,) when he was in congress, we owe the erection of the penitentiary, and the consequent humane code of criminal laws, which was afterward carried through by the profound jurisconsult, the lamented Doddridge, and his liberal coadjutors. To Major Eaton, also, when he was in the senate, the city is indebted for his steady friendship; and to General Chambers, for his successful exertions in effecting various valuable appropriations for its benefit. There are others of both houses of congress who might be mentioned with gratitude; and among the patriots who have contributed to the useful institutions of the city, may be ranked

a number now living, of our own citizens, whose names may hereafter be recorded as its benefactors.

"The plan of the city was made by Major L'Enfant, a French officer of great talents and of singular habits; who was too proud to receive such a compensation for his services as his friends and President Monroe thought just, (because less than what he claimed,) yet accepted an eleemosynary support from Mr. Digges and others, till his death. The site of the capitol, as well as that of the city, was selected by General Washington himself."

Major L'Enfant was of ordinary appearance, except that he had an abstracted manner and carriage in public. It appears that he had the irritability belonging to ambition, but which is falsely made appropriate to genius; and that he thought himself wronged. That he died poor is too certain.

———

CHAPTER XVIII.

Mr. Trumbull's parentage—education—enters Harvard college—copies Smybert's Cardinal Bentivoglio—first visit to Copley—enters the army to avoid the pulpit—stationed as an adjutant at Roxbury—becomes one of Washington's family—appointed a major of brigade—Gates and Schuyler—Mr. Trumbull, deputy adjutant general—goes to Rhode Island, and resigns his commission, March, 1777—studies painting in Boston until 1779—goes to London in 1780—studies with West—is arrested as a spy.

John Trumbull, 1756–1843.

JOHN TRUMBULL—1789.

It will be seen, by the following pages, that this gentleman made his first effort at historical composition in the year 1774, and at the age of eighteen. But as I take the time of each artist's *professional* exertions, *in this country*, as the period for introducing his biography in my work, I must date that of Mr. Trumbull from 1789, the time at which he returned from his second visit to Europe, and appeared professionally in America. This painter was emphatically well-born; and we shall see that he reaped, as is generally the case, through life, the advantages resulting from the accident.

The many biographical sketches which have been given to the world of Mr. Trumbull afford me ample materials for my work, when combined with my own personal knowledge and the printed documents published with his name as author.— But I shall principally rely upon a narrative communicated by Mr. Trumbull to Mr. James Herring, secretary of the American Academy of Fine Arts, of which Mr. Trumbull is

95 PLAN FOR THE CITY OF WASHINGTON, 1791. Plan by Pierre Charles L'Enfant. *Courtesy Library of Congress.*

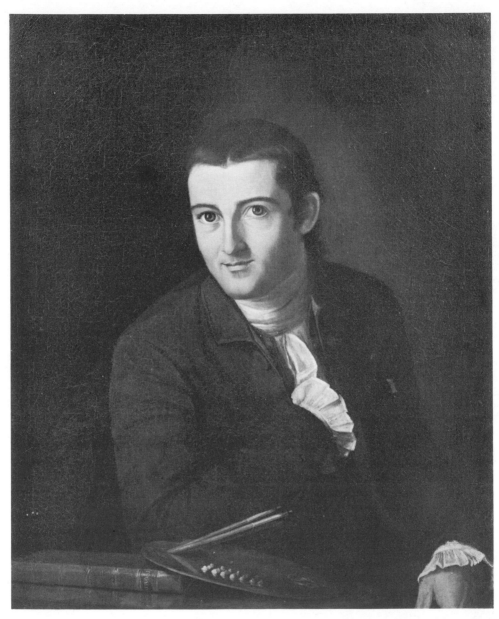

96 SELF-PORTRAIT. Painting by John Trumbull. *Courtesy Museum of Fine Arts, Boston, bequest of George Nixon Black.*

president, for the purpose of publication. This narrative I shall accompany with such remarks as may be suggested by it, and facts within my own knowledge.

The narrative says of the painter's ancestors :—"Two brothers first settled in Massachusetts about 1630. One or both of them removed to what is now Enfield, Connecticut. John Trumbull (the subject of the narrative) was born in Lebanon, Connecticut, on the 6th of June, 1756. He was the son of Jonathan Trumbull, first governor of the *state* of Connecticut of that name." I presume this alludes to the painter's brother Jonathan, who was afterwards governor of the state : his father was first governor of Connecticut as an independent state, and had the additional honour of guiding her through the storms of the Revolution.

The narrative proceeds :—" His mother's name was Faith Robinson, the fifth in descent from the famous John Robinson, often called the father of the Pilgrims, who died in Holland, but whose son came into this country in the spring of 1621. The painter's ancestors resided in the county of Springfield, Massachusetts, until 1690, when his grandfather removed to Lebanon. The little boy had a feeble infancy, but recovered when about three years old.

In the National Portrait Gallery Mr. Herring says, " The carelessness or ignorance of the family physician had nearly consigned our infant genius to a life of idiocy or an early grave. After being afflicted with convulsions nine months, it was discovered that the bones of his skull had been allowed to remain lapped over each other from his birth : but by skilful applications and maternal care they were adjusted ; and, as we have heard him express it with filial veneration, " he owed his life a second time to his mother."

" At Lebanon he went to school to Nathan Tisdale, who kept one of the best schools of that or any other period, and whose reputation brought to his school youth from the southern colonies and from the West Indies. He received, under the tuition of this gentleman, an excellent education, and entered the junior class at Harvard in January, 1771 or 2, and graduated in 1793, " at the age of seventeen. This early entrance at college was, as he considers, one of the misfortunes of his life : he found himself a better scholar than those with whom he was associated, and he became idle ; but, by way of amusement, he frequently visited a French family in the neighbourhood which had been banished from Acadie, a respectable family in humble life, from whom he obtained a sufficient knowledge of the French language to read and write it. He

ransacked the college library for books on the arts : among others he found Brook Taylor's ' Jesuit's Perspective made easy.' This work he studied thoroughly, and copied all the diagrams : he also copied a picture which the college possessed of an irruption of Mount Vesuvius, painted by some Italian ; and copied a copy of Vandyke, the head of Cardinal Bentivoglio, and Nicholas Coypell's Rebecca at the Well.— He copied them in oil. He got his colours from a house-painter."

The advantages flowing from being well-born gave to young Trumbull one of the best educations the country could furnish. These advantages are no trifles, however they may be sneered at by those who become leaders in the world's affairs by their own energies, unassisted by wealth or ancestry. In the year 1773, and at the early age of seventeen, he had graduated at college, and had received instruction from the works of Smybert and Copley in that career he wished to pursue. The head of Cardinal Bentivoglio, here mentioned, is the same which Allston says first gave him an idea of colouring. The amanuensis proceeds :—

" He got, before he went to college, a book called the Handmaid to the Arts. He had somewhere picked up the title page, and requested his brother-in-law to send to London for the book. Copley was then in Boston, and young Trumbull's first visit to that distinguished artist happened to be made at a time when he was entertaining his friends, shortly after his marriage. He was dressed on the occasion in a suit of crimson velvet and gold buttons ; and the elegance of his style and his high repute, impressed the future artist with grand ideas of the life of a painter."

The works of Smybert, Blackburn and Copley, at Boston, so immediately under the eye of the young man, doubtless strengthened his desire to become a painter ; and on his return to Lebanon he made his first attempt at composition.— The narrative proceeds thus :—

" After leaving college he painted the Battle of Cannæ, which shows the bent of his mind, being particularly struck with the character of Paulus Emilius. This picture is now at Yale College. He painted several other pictures ; among them one of Brutus condemning his sons. What has become of that is unknown. Very soon after, all other subjects were absorbed in the stirring incidents of the times."

" His father wished him to be a clergyman ; he did not like it—his object was to be a painter. He hoped, that by being active in the political commotion of the time he should get

clear of being a clergyman. He obtained a book on military
tactics ; he was made an adjutant of militia before he had ever
seen a regimental line formed ; and a few days before the re-
view was to take place, the battle of Lexington took place ;
and his mock adjutancy became a real one of the first Con-
necticut regiment which was stationed at Roxbury, under
General Spencer."

Boston and its environs had become the seat of warfare,
and the good old Governor Jonathan Trumbull was not back-
ward in forwarding troops to the scene of conflict, in support
of his country's rights. Thus we see that the young painter,
glad to escape from the threatened prospect of a pulpit, at the
age of nineteen was enrolled as an adjutant, and marched to
join the undisciplined forces which were assembling round the
head quarters of General Gage.

On the 17th of June, 1775, was fought the memorable bat-
tle of Breed's-hill, (commonly called Bunker's Hill,) at which
time the young adjutant was stationed with his regiment at
Roxbury. In the catalogue of his painting, which he publish-
ed in 1831, after describing his beautiful small picture called
" The Battle of Bunker's Hill," he says, " The artist was on
that day, adjutant of the first regiment of the Connecticut
troops, stationed at Roxbury, and saw the action from that
point." This he repeats in 1832 in the catalogue written for
Yale College, where the picture is deposited.

A foreigner, or a person not intimately acquainted with the
topography of the town of Boston, and the neighbouring vil-
lages, might suppose that the painter meant to say, that he
saw the battle he shows us in his admirable picture. This he
could not mean. Roxbury is to the south of Boston, and the
scene of action on the north. From Roxbury to Breed's-hill
is three, or perhaps four miles ; the town of Boston, (the tri-
mountain town,) with its three hills, then towering undimi-
nished, in mid-way between. Boston-neck is on the south,
and part of the waters of the bay on the north of the elevated
ground on which the town stands. The British ships of war
added the smoke of their guns to that of the combatants, and
of the burning village of Charlestown. And all these enter-
vened between the painter and the battle. The inhabitants of
the *north* side of Boston might see the landing of the British
troops, and some of the movements on the hill, but a person at
Roxbury, or at any point south of Boston-neck, could only
know that a battle was being fought, by the noise of guns,
and the clouds of smoke proceeding from the combatants,

the ships, the floating batteries, and the conflagration of Charlestown.

In July, General Washington arrived at Cambridge, and took command of the troops which were beleaguering Boston. Mr. Herring thus continues his narrative as dictated by Mr. Trumbull :—

" There," that is with the army, " his drawing became first of use to him. General Washington was desirous to obtain a draft of the enemy's works, and hearing that Trumbull could draw, he was requested to draw a plan of their works, but before he had proceeded far, a deserter came—the man could draw a little himself, and he completed a rude plan which confirmed Trumbull so far as he had gone, but rendered another unnecessary, (whose information assisted him to complete the plan to the satisfaction of the commander-in-chief, and probably led) to his appointment of aid to him—but it showed the correctness of his drawing—he had gone near enough to count every gun and ascertain their situation exactly."

Previously to having seen this (rather confused) account of the immediate causes, which transferred the young adjutant to the family of the general, we had supposed that it was a compliment paid by Washington, to Governor Trumbull, but it seems not.

"In August 1775," continues the narrative, " he was appointed aid to the commander-in-chief, and after serving in that capacity some two or three months, he was appointed major of brigade, and in that situation he became more particularly known to the adjutant-general Gates, whose observation of the accuracy of the returns rendered by Trumbull, induced him the year following to offer him the office of adjutant-general of the Northern Department under his command, and which he accepted."*

It might have been supposed that the amanuensis misunderstood Mr. Trumbull as to the appointment of adjutant-general, *only* that Mr. Trumbull, in a letter published January 7th, 1830, in the New-York American, addressed to the Hon. M. Wilde, says the same thing in the following words : " In July 1776, I was appointed adjutant-general of the Northern Department with the rank of colonel, under the command of General Gates." Now, General Schuyler was the commander of the Northern Department until August 1777, which was four months after Mr. Trumbull had resigned his commission

* Gates was appointed a major-general in May 1776, and in June following, to the command of the *army in Canada.* He never was appointed to command the army of the north. For the aids of the commander in chief at this time, see Washington's letters.

of deputy-adjutant-general, as we shall see hereafter, and retired from military life.*

The narrative proceeds thus : " He then went with the army to New-York, stopping a day or two with his father, which was the only leave of absence he had while in the service. Left New-York on the 20th of June 1776, with General Gates, at which date his rank of colonel and adjutant-general was presumed to have commenced. He was ten days getting to Albany in a sloop. Gates was at this time expected to have proceeded to Canada, but he met the army driven out, and thus caused some confusion in the command."

There is an interlineation after the word Canada of these words, " At that time probably the Northern Department." Not so. Gates, who was a presuming and assuming man, and the enemy of Washington and Schuyler, showed his disposition so plainly on his appointment to command in Canada, that congress passed a resolution " that they had no design to invest him with a superior command to Schuyler, while the troops were within the bounds of the States." Mr. Sparks says, " the instructions of General Gates were too explicit to raise a doubt in any other mind than his own." Though congress decided against his pretensions, there was a New England party in that body and elsewhere, who encouraged him in his intrigues to overthrow Schuyler and Washington.

General Philip Schuyler was commander of the Northern Department from July 1775 to August 1777, four or five months after Mr. Trumbull retired to private life. General Schuyler did at one moment tender his resignation to congress, but it was several months after the date of Mr. Trumbull's voy-

* For the time of Mr. Trumbull's resignation, and at which congress accepted his commission of deputy-adjutant-general, the reader may see the minutes of congress, March 1777. For the time during which General Schuyler held the command of the Northern Department, see Chancellor Kent's discourse before the Historical Society, 1826. General Schuyler held the command of the Northern Department when Burgoyne's advance induced Sinclair to evacuate Ticonderoga, and Schuyler met that news on the upper Hudson, while using the utmost diligence and judgment to oppose the enemy ; likewise see Marshall's Washington, Vol. III. p. 247. It will be seen hereafter that Mr. Trumbull had acted in the adjutant-general's department without a commission, and that on receiving it he enclosed it in a letter, the receipt of which is acknowledged on the minutes of congress, of March 1777, as a letter enclosing the commission of John Trumbull, deputy-adjutant-general, which commission, we shall see, was sent back by him, not because it was deficient in rank, but because it was dated in September, 1776, whereas he thought it ought to have been dated in June. I further remark that the British were driven from Boston in March 1776, and took possession of New-York in September, and that Mr. Trumbull tells Mr. Wilde that he was appointed adjutant-general of the *Northern Departmen* with the rank of colonel, in July 1776.

age to Albany with Gates. Congress " declared that they
would not dispense with his services during the then situation
of affairs, and they directed the president to request him to
continue in his command." (See Kent and Marshall.) Schuy-
ler had been treated unceremoniously according to military eti-
quette; but his object was to serve his country, not himself
alone: he made allowances for the confusion caused by the
public danger, and continued in his command. As early
as September 1775, he had proceeded as far as *Isle au
Noix* with intent to enter Canada, but was obliged, by severe
illness, to leave the expedition to Montgomery. While that
officer was employed in Canada, Schuyler was called to oppose
the tories under Johnson; and in January 1776, he was
ordered, by congress, to have the St. Lawrence explored and
to fortify Ticonderoga. In February he was ordered to
repair to New-York, and in March to establish his head quar-
ters in Albany and superintend the supplies for Canada; and
these orders were renewed April and May 1776. (See Journals
of congress, vols. I. and II.) " He gave life and vigour to
every branch of the service." (See Kent,) On the 17th of June,
he was ordered to clear Wood-Creek, and to build armed ves-
sels for the mastery of the lakes. " There can be no doubt,"
says Kent, " that the northern frontier, in the campaign of
of 1776, was indebted for its extraordinary quiet and security,
to the ceaseless activity of General Schuyler. General Sulli-
van had the command of the Northern or Canadian army, and
on the 18th of June 1776, received orders from General
Schuyler to embark on Lake Champlain for Crown Point.
General Gates at this time was ordered to take command of
the Northern or Canadian army, (see Marshall), that is, of the
forces that had been commanded by Sullivan under the orders
of Schuyler. At the close of that year Schuyler was further in-
structed to build a floating battery on the lake, and a fort on
Mount Independence, and also to strengthen the works at Fort
Stanwix." In the campaign of 1777, Schuyler made all the
dispositions to receive Burgoyne, and was only superseded in
consequence of Sinclair's evacuation of Ticonderoga, and that
senseless, popular clamour which induced the appointment of
Gates, in August 1777, long after Mr. Trumbull's retirement
from military life. When superseded by Gates and robbed of
his well-earned laurels, General Schuyler still continued to
serve his country. The Baroness Reidesel's account of his
behaviour, at the capture of Burgoyne, is one of the most beau-
tiful passages of history. There may be readers who will
think I " travel out of the record" in this brief sketch of the

services of Phillip Schuyler ; but I am perfectly satisfied that I could not have given Mr. Trumbull's narrative without this explanatory comment, and left the fair fame of a distinguished patriot unsullied by doubts, as far as that narrative concerns the affairs of the northern department.

The amanuensis of Mr. Trumbull proceeds :—" He," that is, Mr. Trumbull, " proceeded to Ticonderoga. He was the first person who reconnoitered Mount Independence :" a post which, as we have seen, Congress had ordered, near the close of this year, General Schuyler to fortify ; " which he," Trumbull, " soon after explored, with General Wayne, which led to its occupation. While he was impressed with the belief that the whole position of the army, both at Ticonderoga and Mount Independence, was commanded by a height situated nearly at an equal distance from both those points, being elevated about 500 feet higher than either of them, and at the distance of about a mile, well known as Mount Defiance. He mentioned his observation at the dinner table. He ventured to advance an opinion, that their entire position was commanded by that hill ; but they universally laughed at the idea : the general opinion was, that it was too distant, even if an enemy were there. Finding argument useless, he proposed settling the question by experiment. As the commanding officer of artillery was proving guns at the most remote part of Mount Independence, he, the next morning, caused the experiment to be made with a double-shotted gun. The shot reached near the summit of the hill, which of course confirmed his opinion. In the afternoon the experiment was repeated, in the presence of the officers, with a six-pounder, from the glacis of the old French fort : the shot reached nearly to the summit. Several of the officers afterwards ascended the hill, and, when there, it was the unanimous opinion, that there would be no difficulty in ascending with a yoke of oxen, and, of course, getting cannon to the summit. Two memoirs were drawn up : one setting forth the expense and force necessary to maintain the post as then occupied ; for which it was shown ten thousand men and one hundred pieces of cannon were necessary : the other was grounded on the proposition to abandon the whole, and establish another post on the summit of Mount Defiance, with a force of five hundred men.

" This suggestion of the *adjutant general* was not acted upon ; and the consequence was, that the next campaign Gen. St. Clair was left to defend the original lines with 3000 men, and the first movement of the British force was to take possession of Mount Defiance ; from which, according to their ac-

count, they could observe every movement of the Americans within their lines. The abandonment of the entire position became immediately necessary ; and St. Clair deserved great praise for his well conducted retreat, by which the army was saved from capture, and became the nucleus of that force which afterwards prostrated the British power in the northern department."

As St. Clair's retreat, and all the events last-mentioned, took place after Mr. Trumbull had resigned, gone home, and was pursuing his studies in Boston, we are as well qualified to speak of them as far as facts are concerned, as he can be if we use an equal degree of industry in the investigation.

The people of the United States have been habituated to surround with a halo every head presented to their view as that of a soldier of the Revolution. The feeling is natural, and has its origin in our *better* nature. But it appears to me high time to pass the grain through the sieve and separate it from the chaff which has heretofore claimed equal weight. It is time and high time that we should discriminate, and teach our children to discriminate, between the mercenary and selfish, who took up arms to serve themselves, and the real patriotic soldier of the Revolution. There are people who cry " Huzza for the revolutionary soldier !" when the name of Gates is mentioned, with as much well meant good will as when that of Schuyler or Washington meets their ears, (the men whom he endeavoured to undermine and disgrace) or that of Green, who saved the south from the effects of his imbecility.

Washington, speaking of his army at Cambridge, says,—" Such a dearth of public spirit, and such a want of virtue! such stock-jobbing, and felicity at all the low arts to obtain advantages in this great change of military arrangement, I never saw before, and pray God's mercy that I may never see again." And again " such a mercenary spirit pervades the whole, that I should not be surprised at any disaster that might happen." Yet these blasted and worthless shoots are bound up in the same sheaf with the wholesome ears from which we derive our bread. Men who only thought of their own promotion and emolument are confounded with the gallant Prescott and his companions at Breed's Hill—with a Whitcomb, who, having a regiment, and being omitted in the new-modelling of the army, encouraged his men to enlist anew, by offering to join the ranks with them—with Brewer, who, being appointed to Whitcomb's command, insisted upon resigning it to him and taking an inferior station—with the many glorious names who served for honour and their country's good.

It may be my task, in these pages, to state facts which will militate against the preconceived opinions formed of individuals; but I shall do it conscientiously, that the self exalter may not occupy the ground which should be kept clear for the man of real worth.

The judgment which pointed out the importance of Mount Defiance is highly creditable to the young officer; but there appears to be no cause for censuring General Schuyler. It appears, that long after the memorials Mr. Trumbull mentions, General Schuyler was acting under the immediate orders of Congress, in strengthening Mount Independence, a part of the position which was thought untenable. I do not know by whom these memorials were drawn up or signed, or to whom transmitted. I know that if Burgoyne had been stopped on Lake Champlain, as Provost was in 1814, he could have saved his army by retreat, and that the surrender at Saratoga would not have taken place. And I am perfectly convinced, (in the year 1834) that if Philip Schuyler had not been superseded, Burgoyne must have surrendered to him, and that without any convention. I now return to Mr. Trumbull's narrative, and to the summer of 1776, one year or more before Schuyler was superseded by Gates.

"In the mean time the adjutant general," meaning Mr. Trumbull, "had remained without a commission. This rendered his situation peculiarly painful; and what rendered it more so was, that other and inferior officers did receive commissions, giving them rank equal to his own."

Here there is a break in the MSS. with a memorandum referring Mr. Herring to one of the catalogues published by Mr. Trumbull. This points to a passage respecting Gates' command of the northern department, which we have already commented upon; and goes on to the defeat of the American flotilla, which, as we have seen, was constructed by Schuyler, under the immediate orders of Congress, and which was entrusted to the command of Arnold. The British, commanded by Carleton, broke through this impediment, and having reconnoitered Ticonderoga, in October, 1776, retired to winter quarters.

"Thus," says Mr. Trumbull, "terminated that campaign, and the principal part of the disposable force moved down to Albany, about the 20th of November;" where, as we have seen, General Schuyler had been ordered by Congress to establish his head quarters, as commander of the northern department. "General Gates received orders from the commander in chief to join him with all his disposable force be-

hind the Delaware. He moved of course by the route of Eso-
pus, Hurley, the Minisink, Sussex Court House, Easton, Beth-
lehem, and joined Washington at Newtown, Pennsylvania, a
few days before the battle of Trenton. News was at that time
received that the British had landed at Newport, Rhode
Island, with a considerable force. General Arnold was or-
dered to proceed to Rhode Island to assume the command of
the militia to oppose them; and Trumbull was ordered to pro-
ceed with him as *adjutant general.* The head quarters were
established at Providence for the winter; and there, in the
month of March, Colonel Trumbull received his commission,
as adjutant general, with the rank of Colonel; but dated in
the month of September instead of the month of June."

I have already shown that this commission was that of deputy
adjutant general by reference to the journals of Congress. In
a manuscript memoir in Mr. Trumbull's handwriting, given
for publication in 1817, and now in possession of Robert Gil-
mor, Esq., he speaks of himself as in the inferior capacity. In
his letter to Mr. Wilde, he calls himself adjutant general, and
the next year, in a memoir appended to a catalogue of his pic-
tures, published in 1831, he says his appointment was deputy
adjutant general, yet in 1833, when dictating to Mr. Herring,
he claims the full rank. I have quoted the passage from the
minutes of Congress, which settles this point. After mention-
ing the receipt of the commission, the narrative proceeds:

" By whatever accident or cause is unknown, but this added
to the chagrin and vexation of the officer commissioned, and
within an hour he returned it under cover to the president of
Congress, accompanied with a letter, perhaps too concise and
laconic, stating the impossibility of serving, unless the date
was altered, to correspond with the date of his actual service.
A correspondence of some length ensued, which terminated
after some weeks, in the acceptance of the resignation, and
thus his military career terminated."

As the commission was received in Rhode Island during
March, and the resignation accepted in the same month, the
above mentioned correspondence could not have been of much
length or duration. Although to this abandonment of military
life, we are indebted for one of our most distinguished artists,
I cannot but think that the young gentleman made a great mis-
take even upon the narrow calculation of self-interest. Before
the age of twenty-one he had been advanced from the grade of
adjutant of a regiment, to that of deputy adjutant general, and
appears to have been doing the duty as principal at the post to
which he was assigned, yet for a difference of dates from June

or July 20th, (for he has stated both as the date of appointment) and some day in September, he abandoned the cause of his country, at the time that "tried men's souls," and gave up prospects, as fair as any young man of the period could have, of being an honourable agent in the great events which followed.

"He then," continues his amanuensis, "returned to Lebanon, (to the object of his first love, he said,) and afterward went to Boston to profit by studying the works of Copley and others, where he remained until 1779, occupying the room which had been built by Smybert, in which remained many of his works.* He there became acquainted with Mr. John Temple, afterwards first consul general of Great Britain to the United States, who was connected with the families of Grenville and Temple, and by marriage with the family of Governor Bowdoin in the United States, through him he ascertained the possibility of his going in safety to London, to study his profession under Mr. West. In May 1780, he embarked for France, and after a short stay at Paris he found his way to London, in August, by the way of Ostend. He was kindly received by Mr. West, to whom he had a letter of introduction from Doctor Franklin, and from whom he received the most liberal instruction.

"Mr. West asked Trumbull if he brought any specimen of his work, and being answered in the negative, told him to copy some one of his pictures and bring it to him. 'Go into that room, where you will find Mr. Stuart painting, and choose something to copy.' Trumbull selected one, (by an old master,) the copy of which is with him still. West asked him if he knew what he had chosen, he said, no. West told him, adding, 'You have made a good choice; if you can copy that, I shall think well of you.' " The picture was Raphael's "Madonna della sedia." This anecdote is given from Mr. Herring, but is not in the MS. narrative, which proceeds thus:—"There he pursued his studies uninterruptedly for about three months, to the middle of November. At that time the news of the death of Major André was received, and oc-

* I am sorry to see in a work written by Mr. Trumbull, and published in 1832, such assertions as the following respecting the motives which induced him to study painting. "Ardently anticipating the vast consequences of the revolution, and the future greatness of his country; and having a natural taste for drawing, in which he had already made some progress, Colonel Trumbull resolved to cultivate that talent, with the hope of thus binding his name to the great events of the time, by becoming the graphic historiographer of them and of his early comrades. With this view he devoted himself to the study of the art of painting, first in America, and afterwards in Europe."

casioned a violent irritation in the public mind. It was his misfortune to lodge in the same house with another American gentleman, who had been an officer, against whom a warrant had been issued to apprehend him for high treason. Instructions had been given to the officer who was to execute the warrant, to arrest, ad interim, the painter, and secure his papers, in expectation of finding something of importance. The following day he was examined before the principal magistrates of the police, and in the course of the examination something occurred which wounded his military pride, and called forth an address to this effect: —' Gentlemen, you are rude. You appear to be more in the habit of examining pickpockets and highwaymen than gentlemen. I will cut this examination short, gentlemen, by telling you who I am, and what I am. I am the son of him you call the rebel governor of Connecticut, and I have been an aid-de-camp to him you call the rebel General Washington. I know that in saying this I put my life in your hands. You will treat me as you please—remembering, that as you treat me, so will those gentlemen whom I have named treat your countrymen who are their prisoners, and in their power.' "

Mr. Trumbull ought to have known, that if his life was in danger, it was not as a prisoner of war, but as a spy; and that the circumstance of his being the son of Governor Trumbull, and having been in the army, could not be kept from the knowledge of those who had arrested him: so that what he avowed did not put his *life in the hands* of the police magistrates; and his threat was utterly ineffective and irrelevant. The narration proceeds:—" This, perhaps imprudent, declaration had, however, a good effect. He was treated with greater civility. He was, however, confined, and remained in confinement until the month of June following, more than eight months."

CHAPTER XIX.

Mr. West's conduct on the arrest of Trumbull—pictures painted during his confinement—Release and return to America—Embarks for England again in 1783, and resumes his studies with West—1786, Pictures of Bunker's Hill and Montgomery—Picture of the "Sortie"—Goes to Paris, 1787--Paints the beautiful heads for the "Surrender of Cornwallis"—Returns to America in 1789—Pictures painted from 1789 to 1793.

MR. TRUMBULL was arrested on the 19th of November, and released the June following. Some other particulars, connected with the arrest and examination, were communicated

to Mr. Herring, which are not noticed in the manuscript. Difficulties occurred at the police respecting a place of confinement, the prisons of London having been destroyed by the rioters in June 1780, and a message being sent to the secretary of state's office, Trumbull had the choice of the place left to himself.

However much Mr. Trumbull may have regretted the resignation of his commission of deputy adjutant general, he probably now regretted still more that he had taken up his abode in the capital of Great Britain, while those with whom he had been engaged were struggling for life and liberty against that mighty power. I remember distinctly all the circumstances of this incident, as detailed to several listeners by Mr. Trumbull many years ago. He then attributed his arrest to Thompson, afterward Count Rumford, saying that this man had applied for a commission in the rebel army before Boston, and had been refused—that afterward he joined the English, and was, at the time of Trumbull's arrest, in the secretary of state's office. He gave formal notice to the secretary of state, that John Trumbull, son to the governor of Connecticut, and known to have served in the rebel army, was in London. It is well known that Thompson was afterward under-secretary of state; that he procured an appointment for himself as colonel of a regiment of horse to be raised in America; and that he came to this country, and staid long enough to secure the emoluments appertaining to his appointment, serving with his regiment in the south. Although Mr. Trumbull had received assurances previous to leaving Boston that he would not be molested, this formal information could not be passed over, and he was arrested. This was in November, 1780; and Mr. Trumbull stated, that the irritation caused in England by the recent execution of the spy, Major Andre, and the circumstance that the young painter had served in the adjutant general's department of the rebel army, caused alarm to his friends; and caused Mr. West, immediately on hearing of the arrest, to wait upon the king, and represent the facts of his pupil's former and present situation; the long time which had intervened between his quitting the rebel army and his coming to England; and his present entire devotedness to the study of the fine arts. Finally, by pledging himself for the young man's good disposition, the benevolent Benjamin obtained the king's assurance that no farther interruption to the studies of the young painter should take place than what the forms of office required, and that at all events his personal safety should be fully attended to; and at the worst—his life be perfectly safe. I give this

from memory—but in the anecdote told of Thompson, and the statement of his agency in the arrest, I cannot be mistaken. I might have forgotten it—I could not have invented it; and I am certain that West's application to George the third was not attributed to selfish motives at the time I first heard of it.

Another account of this affair may be found in Stuart's "Three Years' Residence in America," where, after stating that the painter "was apprehended and *sent to the tower*, on the ground that he was a spy," the author gives the following in the words of Trumbull:

"I was arrested at twelve o'clock at night of the 19th of November, in London, on suspicion of high treason. I was then principally occupied in studying the art of painting under Mr. West. Mr. West well knew that his attachment to his native country gave offence to some individuals who were about the king's person. He therefore went the next morning early to Buckingham House, and requested an audience of the king. It was granted; and he proceeded to state the origin and nature of his acquaintance with me, concluding that, whatever might have been my conduct in America, he could conscientiously state to his majesty, that since my arrival in London the principal part of almost every day had been passed under his eye, in the assiduous study of his profession, leaving little or no time for any pursuit hostile to the interests of Great Britain. The king, after a moment's hesitation, made this answer: 'Mr. West, I have known you long—I have confided in you—I have never known you to mislead me—I therefore repose implicit confidence in the representation. This young gentleman must in the meantime suffer great anxiety. He is in the power of the laws, and I cannot at present interfere. But go to him, and assure him from me, that in the worst possible legal result, he has my royal word that his life is safe.' Mr. West came to me with this message immediately; and you may well believe that it softened essentially the rigour of an imprisonment of eight months."

Here the motive ascribed to Mr. West's prompt interference is *self*. To screen himself from any injury that might be done him by the "individuals about the king's person." I had hoped that this might have been a mistake of Mr. Stuart's, but the narrative as given to Mr. Herring for publication confirms the suggestion :—"On hearing this adventure the apprehensions of Mr. West were aroused; for he well knew that he had enemies about the person of the king, and therefore hastened to the palace and asked an audience, which was granted. He proceeded to state to the king his personal

knowledge of the conduct of Trumbull while in London.—
After listening to him patiently, the king replied, ' West, I
have known you long, and I don't know that I have received
any incorrect information from you on any subject; I there-
fore fully believe all that you have said to me on the present
occasion. I sincerely regret the situation of the young man;
but I cannot do any thing to assist him. He is in the power
of the law, and I cannot interfere. Are his parents living?'
To which Mr. West answered that his father was. ' Then I
most sincerely pity him,' said the king. After a moment's
pause, he continued, ' Go immediately to Mr. Trumbull, and
give him my royal assurance that in the worst possible event
of the law, his life will be safe.' The assurance of course
softened in a great degree the rigours of a winter's confine-
ment, and enabled him to proceed with his studies."

It was during this confinement that Mr. Trumbull, among
other pictures, copied that beautiful *copy* of the " St. Jerome,"
which is mentioned in the life of West as being executed by
him from the exquisite original of Corregio, at Parma. Mr.
Trumbull's is perhaps equal to his master's, and certainly one
of the gems of the art.

There is something, to me, inexpressibly beautiful in the tes-
timony borne to West's character, and to the force of truth
from the lips of one whose lips were unaccustomed to false-
hood. This interview between George the third and his his-
torical painter, is highly honourable to both; and the account
of it from the lips or pen of West would have been a treasure.

" In June," proceeds the narrative, " at which time a turn
had taken place in the affairs of the two countries, and the
government began to relax their severity; Trumbull was ad-
mitted to bail by a special order of the king in council, on
condition of quitting the kingdom within thirty days, and not
to return during the war. His securities were West and Cop-
ley." Did not Mr. West procure this order?

" Crossed," says the narrative, " over to Ostend, thence to
Amsterdam, and embarked. Temple accompanied him to
Ostend, and sailed for Boston, where he arrived in about 30
days; and Trumbull in about 50 landed at Corunna in Spain.
Had sailed for Philadelphia, but fell short of water and provi-
sions, and put back to Corunna. Finding an American ship
there bound to Bilboa, took passage in her, and arrived in the
beginning of December, and arrived at ————, in the
middle of January, whence he found his way home. Fatigue,
vexation and disappointment, brought on a fit of illness which
confined him to his father's the principal part of the ensuing

summer.　At the close of the summer again visited the army then at Verplanck's point, and entered into an arrangement with his brother and others, who were contracting for supplying the army with provisions, and passed the winter at New-Windsor as store-keeper.

"In the spring of 1783 the news arrived of the preliminaries of peace having been arranged.　He was then at Lebanon. Conversation with his father, who was desirous to have him make choice of a profession, wished the law—leading profes sion in a republican government—gratify ambition, &c.— reply—'So far as I understand the law, it is rendered necessary by the vices of mankind.　A lawyer must be distinguished for his acuteness and skill in extricating rogues from the consequences of their villany; and as I view the life of a lawyer it must be passed in the midst of all the wretchedness and meanness of—" &c.—then went on to give an idea of an artist's life—enlarged on the honours and rewards bestowed by the ancients, particularly the Athenians, and in modern times referred to Copley and West.　'My son, you have made an excellent argument, but its operation is against yourself, and only serves to satisfy me that in the profession of the law you might take a respectable stand; and in your case you have omitted one point as the lawyers call it.'　'What is that, sir?'　'That Connecticut is not Athens.'　He then bowed and left the room, and never afterwards interfered in the choice of life.

"In January, 1783, he (the painter) embarked from Portsmouth, New-Hampshire, and in January, 1784, landed in Portsmouth, England, and immediately proceeded to London, where he was again kindly received by Mr. West, pursued his studies indefatigably, and in 1785 had made such progress as to copy for Mr. West his celebrated picture of the Battle of La Hogue.　The first original composition of his own was painted immediately afterward, and he chose for his subject Priam bearing back to his palace the body of Hector—the figures about ten inches in height.　The picture is now in the possession of the widow of Mr. Gore, to whom it was presented, at Waltham, near Boston, and is devised to Harvard college, where he, 'the painter,' was educated."

In June, 1784, the writer found Mr. Trumbull the established successor of Gilbert Stuart in West's apartments.　The picture of Priam with his son's corse was in miniature oil, a style in which Mr. Trumbull was afterwards unrivalled as an historical painter.　The figures were of a size similar, or nearly so, to those in his "Bunker Hill" and "Death of Montgomery." Another original picture, painted by Mr. Trumbull, was a full-

length figure of a soldier of the king's horse guards, for which one of Mr. West's hired models, who belonged to that corps, furnished person, costume, and horse. The figure was of a greater size than that in which Mr. Trumbull best succeeded.

In the year 1786, Mr. Trumbull finished his picture of the Battle of Bunker's Hill. I saw this beautiful picture in various stages of its progress, and when finished, in the painting-rooms of Mr. West. The similarity of the subject leads to a comparison with two pictures previously painted by Mr. Trumbull's countrymen, and both familiar to him—the " Death of Wolfe," by West, and the " Death of Major Pierson," by Copley ; and however masterly the picture of the younger painter, it fails in the comparison. Neither is it equal to his next picture, the " Death of Montgomery." " The Death of Wolfe" was produced by West at an early age, when thrown upon his own resources, in his own painting-room, without an adviser or instructor, and adventuring upon what was then a new species of historical composition—an heroic action or subject in modern costume. West has therefore not only the merit of producing by far the best picture, but of originating a new style. Another great advantage possessed by the " Death of Wolfe," is that the painter has represented the triumph of his heroes, whereas Trumbull chooses for his picture the moment of the overthrow of his countrymen, and the triumph of their enemies. The death of Doctor Warren, however amiable, accomplished, and intelligent he may have been, is an incident of minor consequence compared with the repeated defeats of the veterans of Great Britain, by Prescott, Putnam, and the brave undisciplined Yankee yeomen their associates, before the hill was carried by reinforcements sent from Boston. Surely one of these moments of triumph might have been chosen by an American painter for his picture. *Then* Prescott, Warren, and Putnam would have been the heroes, instead of Small, Howe, and Clinton. Then, instead of Major Small (who is in fact the hero of the piece) arresting the bayonet of an English grenadier who is about to stab a dying man, we might have seen the gallant and chivalrous action of Putnam striking up the musket of his neighbour when levelled with deadly aim at this same Major Small, (once his companion in arms,) when retreating from the murderous fire which his soldiers would not face.

The imitative spirit is shown in the modern-dressed historical compositions which followed West's " Death of Wolfe ;" he has a dying man in the centre of his composition, and the dying Major Pierson, Doctor Warren, General Montgomery, &c. &c., follow in the train. But see the enormous difference

in the interest and character of the dying men. Wolfe died triumphant, surrounded by his friends in the moment of victory, knowing that France had lost America by the successful efforts of his genius—that the chain which extended from the Gulf of St. Lawrence to that of Mexico, encircling the English colonies with links of French bayonets and Indian tomahawks, was broken and annihilated for ever. But the dying men of the other pictures are nothing more than—dying men.

It is well known that the story of Bunker Hill, as told by Mr. Trumbull, was and is particularly objected to by many of the inhabitants of Boston and its neighbourhood. It has been called " The triumph of British valour and humanity;" and the painter has been censured for taking Major Small's version of the affair, rather than that of the Americans concerned in it. We have before us several letters, written by a venerable gentleman, of high standing in our literary world, from which we extract a few passages on the subject. After censuring the costume of Prescott, and his situation in the picture, (he is represented as a feeble old man, with a slouched hat and plain coat and under-clothes, more like a quaker than a soldier, and placed in a situation little corresponding with command) he says : " The whole picture is apocryphal from beginning to end, and unworthy of the gentleman I much esteem. Besides, General Dearborn, one of our delegation in congress, has in manuscript the life of his father, Major General Dearborn, who I have heard again and again contradict all the leading points of that picture." " Bunker Hill is two and a half miles from the table on which I am now writing, and I know the circumstances of that eventful battle better than the painter of it."

The composition, colouring, and touch of Mr. Trumbull's " Bunker Hill," are admirable. The drawing and attitudes of the figures, likewise admirable, are inferior to his next picture, of the same miniature size, the " Death of Montgomery, at Quebec." In this the grouping is better than that of the Bunker Hill. The figures are accurately drawn, and the attitudes finely diversified. The *chiara scuro* is perfect. But I cannot help feeling that it is the commemoration of another triumph of Britain over America. I must farther remark that the truth of history is violated in misrepresenting the spot where Montgomery and his brave companions fell. When a man becomes a " graphic historiographer," he has a duty to fulfil that cannot be dispensed with. If the historian or the " graphic historiographer" cannot tell the whole truth, he must not at least violate the known truth.

These two beautiful little pictures were carried to the city of Washington in 1816–17, (as we shall hereafter notice,) and shown to the members of congress, as inducements to employ the painter in patriotic works for the capitol: but although their merits gained employment for the artist, the senators and representatives saw at once that such subjects were not fitted for the decoration of the rotunda. Had the Battle of Bunker's Hill represented the true point of time—the triumph of our militia and their gallant leaders over the disciplined veterans of Britain, there can be no doubt that the picture would have been copied for the nation.

The fourth and last historical composition which Mr. Trumbull finished while under the eye of West, was another triumph of the arms of Great Britain over her enemies. The Sortie from Gibraltar is perhaps the best of Mr. Trumbull's works.

Mr. Trumbull had proved that he could succeed in historical composition on the miniature scale, which was best suited for the purposes of the engraver. The American revolution had terminated happily for the cause of justice and humanity. It was popular on the continent of Europe. The immense traffic in prints which had been established by England, presented a field for the accumulation of wealth. To paint a series of pictures on subjects connected with the American revolution, was obviously a speculation worthy of attention. Pine, an English artist, had already gone to America for the purpose. It could not escape the attention of Mr. Trumbull's mind that he would have advantages over every rival. To paint the events of the struggle for freedom in America, and by a copartnership with European engravers spread prints of the size of the original pictures, was a feasible project, offering both fame and fortune. No man could better advise in the execution of such a plan than West, who had long circulated prints from his pictures wherever art or literature were known. Under such circumstances, and with such views, Mr. Trumbull made his arrangements for carrying into effect a project, of which every artist must lament the failure.

Let us now recur to the narrative. Mr. Trumbull says: "The success of this picture," the Priam and Hector, "induced him to commence a project which had long been floating in his mind, of painting a series of pictures of the principal scenes of the revolution. He began with the 'Battle of Bunker Hill,' which was composed and finished in the early part of the year 1786. In the three subsequent months of the same year, the 'Death of Montgomery before Quebec,' was composed and painted. The pictures met with general approbation, not only

in London, but in Paris, Berlin, Dresden, and other parts of the continent. They were as soon as possible placed in the hands of eminent engravers, for the purpose of being" published from the press. " Among others, they were seen by Mr. John Adams, then in London, and Mr. Jefferson in Paris, to whom the project was communicated of painting a series of national pictures, which was highly approved, and by their concurrence the subjects were chosen, (several of which have been since executed,) and he proceeded to arrange and adjust the composition of those subjects.

" Finding that the painting of Bunker Hill had given offence in London, and being desirous to conciliate, he determined to paint one subject from British history, and selected the Sortie of the Garrison of Gibraltar. Of this the first study was made in oil, twelve by sixteen inches, and was presented to Mr. West, (figures carefully finished,) as an acknowledgment for his kindness. Then a second picture was painted, twenty by thirty, carefully and laboriously finished, with the intention of having it engraved. This picture was sold to Sir Francis Baring for five hundred guineas, who contracted for the purchase of a series of pictures of American subjects at the same price, subject to the contingency of the higher powers. He found that the possession of the pictures proposed would give offence in a very high quarter, and therefore retracted. Having engaged Mr. Sharpe, the first engraver of the age, to engrave the picture, he was tenacious of rendering the composition as perfect as in his power, he therefore rejected that picture, and began another six feet by nine. This picture occupied the principal part of the year 1788, and was finished in the spring of 1789, when it was exhibited by itself in Spring Garden, London, and received great applanse. This picture was engraved by Sharpe, and has since been purchased by the Athenæum of Boston, where it now is."

The reason given by Mr. Trumbull for choosing this subject, " must give us pause." " The painting of Bunker Hill had given offence in London, and being very desirous to conciliate," he painted a third victory of the English over their enemies, to appease them for having painted the two which preceded it. *Who* had been offended by the triumphs of Howe and Carlton over Prescott and Montgomery, that were to be conciliated by the triumph of Elliot over the French and Spanish, allies of America? But so it is—and this conciliatory painting, after being offered for years to the conciliated people, is finally purchased by the citizens of Boston. That it *is so*, is matter of congratulation to Americans.

We see that Mr. Trumbull painted his subject three times—the first given to Mr. West, very small—the second sold to Baring, and the third and largest now in Boston. If, after painting these pictures, Mr. Trumbull had been lost to the world, there would have been just reason to exclaim, as it respects his reputation for painting, "Now to die, were now to be most happy;" for certainly the world would have said, "Had he lived, he would have been the greatest artist of his age." The world would have lost many beautifully painted miniature heads, and pictures of merit by this consummation—all we mean to say is, that Mr. Trumbull's reputation as a painter has not been enhanced by any thing he has done since the " Sortie."

In 1787 Mr. Trumbull was in Paris ; and in the house of Mr. Jefferson, our minister to France, he painted the portrait of that eminent statesman and patriot, and likewise the portraits of the French officers who assisted Washington in the capture of Cornwallis at Yorktown. We now return to the narrative :

"In the mean time the present constitution of the United States had been framed, and the first session of congress was appointed to be held in New-York in December, 1789 ; the time had therefore arrived for proceeding with the American pictures. (He had already obtained the portrait of Mr. Adams in London, and Mr. Jefferson sat to him for his in Paris.) Sailed for America, and arrived in New-York, November, 1789, and proceeded to paint as many of the heads of the signers of ' The Declaration of Independence' as were present, and of General Washington at Trenton and Princeton."

These portraits, of such persons as had been in congress at the signing of the declaration of independence, or had afterwards signed it,* and of Washington, for the pictures of the Battles of Trenton and Princeton, are among the most admirable miniatures in oil that ever were painted. The same may be said of the portraits in the small picture of the " Surrender of Cornwallis."

Mr. Trumbull at this period published a prospectus of his intended work, and solicited subscriptions for the prints of Bunker Hill and Quebec. He obtained nearly three hundred subscribers, at six guineas, for the two prints, and half the

* Mr. Trumbull, in a work published by him in 1832, says, that Adams and Jefferson advised him to introduce the portraits of those who afterwards signed, *as if present* at the time of the important resolution ; that is, to violate historical truth.

money paid at the time of subscription. In May, 1794, he returned to England, as secretary to Mr. Jay, and was announced by that gentleman to the English ministry as Colonel Trumbull. In 1796 he received the appointment of agent for impressed seamen; but Mr. Jay having concluded a treaty with Great Britain, by which commissioners were to be appointed to carry into effect an article respecting illegal captures, Mr. Trumbull was chosen as a fifth by the four commissioners who had been chosen by the two governments, and he accepted *that* as preferable to the first. Between 1794 and 1796, it will be seen that Mr. Trumbull was engaged in mercantile speculation. But I am anticipating his own narrative, to which I now return:

" In the summer of 1790 he painted the full-length portrait, in the council-room, City Hall, New York, of General Washington, size of life; and in 1791, that of Governor George Clinton, in the same room."

These two large full-lengths are in a style totally different from that Mr. Trumbull afterwards adopted; and the last-mentioned is, in my opinion, the best large-sized picture he ever painted. It represents the revolutionary governor in his capacity of general, defending Fort Montgomery, on the Hudson : it is strikingly like, with an heroic and historical expression, and the distant figures are beautifully touched in.

" In 1792 he painted another full-length portrait of Washington for the city of Charleston, with a horse; and in the back-ground a view of that city. At the same time he painted another, which is now at the college at New Haven, to which it was presented by the state society of the Cincinnati. This latter portrait is regarded, by the artist, as the finest portrait of *General* Washington in existence. It represents him at the most critical moment of his life, on the evening before the battle of Princeton, meditating his retreat before a superior enemy. At the time this picture was painting, Signor Ceracchi executed a bust, of which there is a colossal cast in the collection of the American Academy of the Fine Arts. The best evidence that can be given of the correctness of both these productions of art is to be found in the close resemblance they bear to each other, although executed by different hands and in materials so dissimilar."

The reader will remark, that Mr. Trumbull emphasises the word " General." This refers to Stuart's portrait, which was painted a short time after, and is presumed to represent President Washington. But Washington was president when Trumbull painted his portrait, and when Ceracchi sculptured

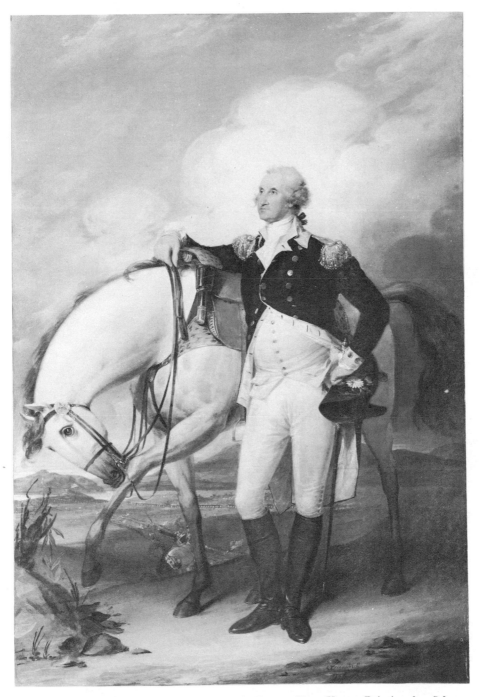

97　GEORGE WASHINGTON AT VERPLANCK'S POINT, NEW YORK. Painting by John
Trumbull. *Courtesy Henry Francis du Pont Winterthur Museum.*

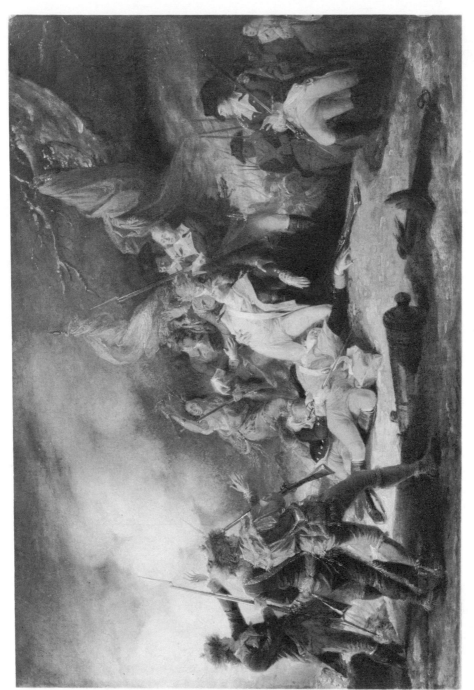

98 DEATH OF GENERAL MONTGOMERY IN THE ATTACK ON QUEBEC, DECEMBER 31, 1775; 1786. Painting by John Trumbull. *Courtesy Yale University Art Gallery.*

his bust. Let it be further remarked, that the original bust of Washington, by Ceracchi, is not colossal. It is the size of life, is very unlike the colossal, and is in the collection of the late Richard Mead, Esq. This last mentioned is very similar to Stuart's original picture, and very like the heroic original, but totally unlike the picture at Yale College; which, as a picture, has much merit, and was painted in Mr. Trumbull's best days.

The narrative proceeds:—" A few other portraits were painted about this time ; but the years '91, '92, and '93, were principally spent in paining original portraits for the historical pictures. In the accomplishment of his great design he travelled from New Hampshire to Charleston, in South Carolina. The head of General Lincoln, at the surrender of York Town, was painted in Boston. Edward Rutledge, —— Hayward, and William Washington, were painted in Charleston. The heads painted at this period are in the small set of pictures now at New Haven. They are the originals of the whole work, and were all painted from the living men—persevering in the object of obtaining authentic portraits."

━━

CHAPTER XX.

Mr. Trumbull returns to England as secretary to Mr. Jay—engages in commerce and speculation—appointment as a fifth, by the four commissioners under Jay's treaty—Travels in Germany and France—marriage—return to America, 1804—exhibits a number of fine pictures—his style of painting changed for the worse—returns to London in 1809—paints historical pictures unsuccessfully—charges against Mr. West.

" Difficulties had existed between the late belligerents ever since the war, and they were of the most embasrassing character. Mr. Jay was appointed minister to Great Britain, for the purpose of bringing these subjects of mutual complaints and grievances to an end," negotiating a treaty of amity and commerce, &c. " and Mr. Jay appointed him his secretary. This afforded T. an opportunity of attending to the finishing of his three large copper-plates, which were at that time engraving in London, Copenhagen, (struck out) " and at Stutgard, in Germany, and at an expense of upwards of 3000 guineas."*

* In 1833 these plates are said to be in the possession of Illman and Pilbro, engravers, at New York. Pilbro says, he bought them of some one in London, within a year, and this person purchased them of another, who found them at a pawnbroker's.

" The result of that negotiation is well known to have terminated in a treaty, signed on the 19th of November, 1794. The manner in which Mr. Jay conducted the negotiation rendered the duties of the secretary merely nominal. After the signing of the treaty Trumbull went to Paris; and he saw, from the condition of the continent, that all hope of profit from the sale of engravings was at at end. His calculation had been on a more extensive demand on the continent of Europe than elsewhere for American historical pictures. The war had overwhelmed all Europe, and painters and paintings were not in demand. In consequence of which he gave up his professional pursuits and embarked in commerce, until August, 1796, when he returned to England."

At this period, as Mr. Trumbull expressed it to Mr. Herring, " he made some lucky hits in the French funds." We have reason to believe, that at this time he purchased many valuable pictures by the old masters, some of which he afterwards brought to America.

The narrative proceeds to say, that " he was appointed one of the commissioners under the treaty ; for the execution of the seventh article. This placed him in a new and difficult situation. The British commissioners, Sir John Nichol and John Anstey, Esq. were two of their most eminent civil lawyers, and the two Americans, Mr. Gore and Mr. Pinkney were likewise eminent lawyers : it was easy to foresee that these gentlemen would frequently differ with respect to the rights of the two countries, and it would remain with the fifth commissioner to decide." It might appear, from this statement of Mr. Trumbull, that he was appointed by the government of the United States, as well as Mr. Gore and Mr. Pinkney, but it was not so ; the appointment was by some agreement between the British and American commissioners conferred upon him.*

" An arduous duty for a man who had not been educated for the legal profession. It placed him under the necessity of going through a course of reading on the law of nations and maritime law.

" They were met at the threshold by a most important question. What cases were to come before them ? and what their

* In the letter of Mr. Trumbull to Mr. Wilde, speaking of this commission, he says, " The commission was composed of five members, Mr. Gore and Mr. Pinkney on the part of the United States ; Dr. Nichols and Dr. Swabey, (two of the most eminent civilians) on the part of Great Britain ; and I was the fifth commissioner, representing both nations." And he says, " all questions where the commissioners appointed by England and the United States did not agree, were decided by the fifth commissioner."

powers? On these points the commissioners of both nations were in direct opposition, 'when' says Mr. Trumbull, 'I proposed to Sir John Nichols this question, 'Have you any objection to leave this to the dicision of the lord chancellor? To which he replied, 'None in the world,' I rejoined ' neither have I, Sir John.' An audience of the lord chancellor was requested and the time appointed.

" When all the commissioners attended and the question was proposed to him by Sir John Nichols—to which the chancellor immediately replied, 'Sir John, the American gentlemen are right. The parties who framed this treaty, in appointing this commission, intended to create a court with powers paramount to the courts of either nation, in order that the subjects of both might there find impartial decisions, conformable to justice, equity, and the law of nations. You, gentlemen, are vested with powers, such as have rarely been given to any court upon earth; I hope you will use them carefully and wisely.' Multitudes of complaints were made by the subjects of both nations, and were carefully examined and decrees made on each separate case on its own merits. The commission was not concluded until the beginning of the year 1804. The number of cases examined amounted to between three and four hundred, and the amount awarded to be paid by the British government exceeded ten millions of dollars. The awards against the United States amounted to about half a million. In all cases of importance written opinions were recorded; one copy of which is in the hands of Colonel Trumbull. The principles laid down and acted upon in those opinions, will hereafter form an important part of the maritime law of nations, and have already been of value to many individuals in the settlement of claims against Russia and other governments."

I have an interesting account of Mr. Trumbull's visit to the European continent during the period he was enjoying the honours and emoluments of a commissioner under the treaty negotiated by Mr. Jay; a part of the following was given to me in manuscript by Mr. Herring as written under Mr. Trumbull's dictation and part communicated from memory. The last being the first in order, I shall give it first.

" During the existence of the commission and previous to the year 1800, Mr. Trumbull took advantage of one of the adjournments with which the commissioners indulged themselves when wishing to recover from the fatigues of debates 'in which the parties differed continually,' to visit the continent: and as the adjournment was for some months, he resolved to

travel to Stutgard, where his picture of 'Bunker Hill' was in the hands of the engraver. He first proceeded to Paris, desirous, among other things, to procure passports from the French government. Upon applying he was put off from time to time, and at length upon receiving a hint that he was in danger in consequence of some suspicions entertained by the police, he decamped for Amsterdam, having the good fortune to find a vessel ready to sail and a captain willing to take him. At Amsterdam he applied to the French ambassador for passports to Stutgard, and obtained them. This enabled him to visit that and other places, and to take possession of his painting and the engraved plate.

" Germany being at that time the seat of war, our artist met with various adventures, one of which is particularly interesting. He arrived in his carriage at the only inn belonging to a village on the Rhine, which was in the possession of a division of the French army. The inn was fully occupied by officers, and there was no bed for the traveller. Boniface, however recollected that an aid of the general, who had his quarters in the house had been recently sent off, and perhaps might be absent for the night. He was willing to accommodate the traveller, but must first have permission from the general. Accordingly he was sent to inquire of, and receive commands from his excellency. He returned with an orderly sergeant, and a message from the general, who wished to see the applicant for his aid's bed. On being introduced, he was questioned as to his country. 'America.' 'From what part?' Connecticut.' 'And the town?' 'Lebanon.' 'Ha! You must know then my old friend Governor Trumbull?' 'I am his son.'

" The general was rejoiced to meet on the banks of the Rhine, the son of one whose hospitality he had enjoyed in another hemisphere, and the traveller found himself in excellent quarters, and among friends. The commander of this division of the French army, was one of those officers who had accompanied Rochambeau and learned his first lesson of republicanism in the native country of the painter.

" The artist returned to France with his pictures, and as he could not proceed to England without permission, and the time of the adjourned meeting of the commissioners was fast approaching, he addressed a letter from Calais to Talleyrand, requesting a passport. He received no answer, and proceeded to Paris." His difficulties in that city I transcribe from the manuscript, which begins abruptly:

"From a Frenchman whom he had known in Boston, who expressed great pleasure at seeing him in Paris, and after some conversation, asked, if he had seen the minister?' 'What

minister ?' 'Citizen Talleyrand, certainly.' 'I sent letters to him from Calais to which he made no reply, and should have thought it impertinent to have called upon him under those circumstances.' 'O, you are very much mistaken—he will be very happy to see you—he wishes to see you very much—I have seen him this morning—he would be very happy to see you.'

"So, Colonel Trumbull called upon the minister, and was very politely received, and invited to dine; and he did dine that day with him. He sat next to Lucien Bonaparte, and near to Madame de Stael, who was very prompt to make inquiries, and launched at once into political subjects. Talleyrand, however, interrupted her by observing, 'This is no place, madam, to talk politics.'

"The time was approaching when it was necessary for the commissioner to be in London, and he accordingly applied for a pass at the *bureau de police;* but he was put off. He called again but could not succeed. Being puzzled with this unexpected difficulty, he went to Mr. Pinkney and told him of it, but was assured that he could not help him, and that it was not unlikely that in twenty-four hours they would meet in the Temple.

"Trumbull at last made up his mind to call again on Talleyrand, to take leave, and, if he found a convenient opportunity, to obtain his aid in procuring a passport. Talleyrand at once took him into his private bureau, and began to talk on the subject of the difficulties between the nations, and particularly of the money demanded of the American deputies, and attributed the high tone of the American government to British influence. Trumbull observed, 'Mr. Talleyrand, you have been in America, and know our constitution as well as I do, and you must know that these gentlemen can do no less than they have been instructed to do by their government.'

"Talleyrand fiercely thumped his fist upon the table, and exclaimed, 'But they must.' Whether in the ardour of his thoughts he had forgotten his diplomatic caution, or had acted a part for the purpose of having it communicated to the American commissioners, can only be judged by those who know the character of the minister, and they will not hesitate to admit, as most probable, that he had made his calculations for effect. The strange turn which had been given to the conversation, and its rough termination, cut off all hope of Talleyrand's interference in the obtaining a passport; he accordingly applied again to the police office, and was told if he would ascend the grand staircase, and turn into a low door on

the left, he would there find a person who would do his business.

"He went as directed, and entered a room in which was seated a little, thin, sharp old Frenchman, who was alone and writing. 'We shall meet in the Temple within twenty-four hours,' flashed on his mind. 'I shall be caught by this old spider.'

"'What does the citizen want?' Trumbull informed him. 'What is your name?' 'John Trumbull.' 'Ah, you are very well known here.' He then went on with his writing, and paid no further attention to the application. And when Trumbull became satisfied with waiting, he retired—unmolested.

"The time appointed for the meeting of the commissioners in London was drawing nigh, and if he was detained, another would be selected *by lot* in his place. What could he do? Who did he know, of all in Paris, who would have an influence with the powers in the ascendant? 'David the painter—the very man!' He took a carriage and called on him, and was received with great cordiality, and asked about his great work—how the engravings progressed. He told him that Bunker-hill was finished, and he had been to get the plate and picture, and had them in Paris, and that he was anxious to proceed to London, but did not appear to be as well known as he formerly was, concluding by asking David to assist him in procuring a passport.

"David requested him to take a carriage, and bring his picture immediately. He did so: and David accompanied him to the police office taking the picture along with them. On entering the office the same persons were there as before, and a whispering was observed among them, and looks of wonder that citizen David should lean on the arm of that man who could not get a passport. 'Which is the secertary's office?' demanded David, with authority. He was shown to it. He then introduced Colonel Trumbull, as a friend; vouched for him as a republican as good as himself; told his profession and his business in Paris; and requested that a passport might be furnished. The secretary promised to have it done immediately, and after a moment wished the minister to be informed, and his consent obtained. They were then ushered into the apartment of the minister, (*of police,*) and the picture produced. 'This gentleman,' said David, 'saw the battle of Bunker-hill and has painted it. I saw the picture ten years ago. He has been to have it engraved.'

" The minister was very polite ; authorized the passport; but added, that ' he was almost tempted to use his power to prevent it, that he might detain so excellent an artist in the country.' Mixing up with his unwilling consent the smoothest flattery.

" No sooner was his passport ready than he took post horses and away with speed lest another change should detain him. On arriving at *St. Dennis,* while changing horses, a motley crowd assembled around the carriage, and amongst them was a man distinguished by a military uniform and peculiar figure, being upwards of six feet one or two inches, in height, thin, and of a Don Quixote appearance, with a sword almost as long as himself dragging along the pavement in a brass scabbard. This figure approached the carriage and looking in, inquired, ' Is the citizen alone ?' Trumbull's first thought was, ' I am entrapped !' "

After some inquiries and answers, which Mr. Herring repeated verbally, the narrative proceeds, " ' Is the citizen English ?' ' No, I am an American.' ' The carriage is English ?' ' Yes, I have been residing some time in England, and brought the carriage from that country.' "

" These inquiries and answers at last led to the singular question by the stranger if he ' might be permitted to take the vacant seat as far as Chantilly ?' The request, of course, was granted. When the horses were ready they proceeded, and the *militaire* asked a number of questions as—where his fellow-traveller had been, and of the persons he had seen in his route. On Trumbull mentioning a certain officer, the soldier exclaimed, ' Ah, he was a fool ! I was a private in his regiment. I now command it.' It was Trumbull's intention to have proceeded beyond Chantilly ; but his companion told him it would be unsafe. ' Wait until morning, and I will give you an escort through.' "

Here the manuscript fails me, but Mr. Herring terminated the adventure thus : " The painter concluding that he was a prisoner, complied with the suggestions of his companion as with commands, and awaited the result. The next morning at daybreak an escort of horse was ready and thus attended he proceeded. Having passed through the part which had been described as unsafe, to the traveller's surprise his guard left him to pursue his way at his pleasure. Still the fear of detention was not removed, and on his arrival at Calais, finding that the packet had just entered the harbour from Dover, so great was the fear of French republicanism which haunted the American commissioner, that he induced the captain, by an

offer of one hundred guineas, immediately to return and land him on that shore where alone his safety could be assured."

If we look attentively at this narrative of difficulties, it will be seen that Trumbull did not ask Talleyrand for a passport—that he did not wait for an answer from the little old Frenchman at the police office—in short, that he had been imagining difficulties which had no existence. It appears further, that as soon as David applied for it, the permission was given. Notwithstanding which, the little old Frenchman and the French officer, six feet two in height, haunted his imagination as emissaries of tyranny, though both harmless—the first let him depart unmolested ; the second gave him an escort to render his journey safe.

We have seen that the business which occupied the commissioners was concluded in the beginning of the year 1804. In the meantime an event had taken place which usually has the most important bearing on the life of man. During the existence of this commission Mr Trumbull was married.

All I find in Mr. Herring's manuscript are these words, at the top of a page : " He was married in 1800-1. There is every reason to suppose that Mr. Trumbull meant to make England his home. His wife was an Englishwoman, and his only son an officer in the English army ; but Mr. Trumbull returned to the United States, bringing Mrs. Trumbull with him, in June 1804.

In the month of June 1794, Mr. Trumbull had landed in England as secretary to Mr. Jay, and in a residence of ten years painted many portraits the size of life, assuming a style altogether different and much less happy than that he had formerly adopted.

Among the works of this period which have remained with the painter are portraits of Messrs Gore and King ; portrait of a lady ; St. John and Lamb ; the " Madonna *au Corset Rouge*," from Raphael ; Infant Saviour and St. John ; and a Holy Family.

On the occasion of this visit of 1804 to his native country, the painter brought a large collection of pictures, which had been, as is understood, thrown into the Parisian market as things of little or at least diminished value by the stormy waves of the French revolution ; and were purchased by the artist in his visits to that capital. These pictures were placed on exhibition in the room afterwards occupied as a saloon in the Park theatre New-York ; but notwithstanding their great beauty and intrinsic merit, they did not attract sufficient attention to pay the charges of exhibiting, although the manager of the theatre gave the room rent free. This was the first public

exhibition of original pictures by the old masters of Europe which had been made in America, and in many respects it has not been exceeded since. The artist at the same time exhibited as part of the collections his own fine picture of the Sortie from Gibraltar, which is now in the Boston Athenæum.

After a trial of the want of taste in New-York, at that period, these pictures were repacked, and stored away until their owner returned again to London. They then followed him.

Mr. Trumbull, soon after his arrival in 1804, established himself in a large house, corner of Pine-street and Broadway, as portrait-painter, in his second style. He stood alone in the northern and eastern division of the United States. Jarvis and Sully, though pofessing to paint, were tyros and unknown. Stuart was at the seat of government. Our wealthy citizens had their portraits painted, and the corporation of New-York had their governors and mayors immortalized by Mr. Trumbull.

An auctioneer, once upon a time, had a variety of articles which he exposed for sale, perhaps in Wall-street, and among the rest some sheep. He dwelt at length, and with many flourishes, upon the invaluable bargains he offered, far below their value, and concluded his eloquent harangue with, " As to the sheep, gentlemen, they will speak for themselves."

So I would willingly say of the pictures painted during the painter's present visit to America, if my readers could all have the opportunity of appreciating their dumb eloquence. Some of these portraits of the head-size are speaking likenesses; but of the generality, and of the whole-lengths, they are wonderful proofs of the possibility of the same hand painting at one period beautiful faces and figures, worthy of the admiration of the amateur and artist, and while yet in the vigour of life, at the age of 48, producing pictures devoid of most things valuable in the art, and contrasts to his former work. Perhaps the worst of these pictures is the portrait of John Jay.

This could not last. Jarvis and Sully were rising. Stuart moved north. Applications for portraits became "few and far between," and in 1808, Mr. Trumbull again returned to England, loudly complaining of the taste, manners, and institutions of America. That he now intended to make England his permanant place of residence we presume.

In 1809, Mr. Trumbull was established in handsome style in Argyle-street, London, and had some share of the portrait-painting of the time, but not enough, and he again devoted himself to historical composition.

In respect to this portion of Mr. Trumbull's life, that is from 1804, all we find in the manuscript, dictated to Mr. Herring, is: " 1808, the embarrassments of commerce affected the class of citizens by whom, in this country," America, " the fine arts are chiefly supported, and he determined to seek abroad that employment which he could not obtain at home. Accordingly," (he returned to London and remained abroad until 1816,) " during his residence in England he painted a number of pictures, with the hope of attracting some attention, but," says he, " every thing American was unpopular. The war of 1812 was unpopular, and he failed completely. At the close of the war he returned to New-York."

Now, during this same period, Washington Allston, and Charles R. Leslie, were likewise in London, and painting ; and the reader has only to turn to the accounts these gentlemen give of the encouragement afforded to their efforts by Englishmen, and he will conclude that the true reason of failure is not given. Allston expressly says, " England has never made any distinction between our artists and her own."

When Mr. Trumbull returned to England in 1808, he carried with him several studies which he had made of the Falls of Niagara, with a view to have a panorama of that great scene painted by Barker, that species of exhibition being at the time fashionable and profitable in London.

I have heard Mr. Trumbull say, speaking of Mr. West, " For thirty years he was more than a father to me." Yet it is well known that after the failure of his prospects as an historic painter in London, and the rejection by Barker of his proposals for a joint concern in a panorama of Niagara, he spoke of Mr. West in a style of bitterness little according with the first mentioned fact of paternal protection. That West secretly influenced public opinion against the efforts of the man he had made a painter, is so diametrically opposite to the uniform character and conduct of that benevolent and pure man, that the assertion, when I heard it made, astonished and disgusted me. He further charged his old master with influencing Barker to reject his views of Niagara. If the rival merits of the pupil could cause the master to fear his overshadowing popularity as an historical painter, still we are to look for a motive that might influence his conduct in thwarting the plans of a project as a designer of panoramas.

Mr. Trumbull's account of this transaction (as related by a highly respectable gentleman) is as follows: Mr. West, as was asserted, was overheard, at the theatre, in conversation with Barker, giving his opinion that the views painted by

Trumbull were not fitted for a panorama, and discouraging
the acceptance of his proposals. Barker, having rejected the
plan, and this *overheard conversation* being reported to the dis-
appointed painter, he repaired to Newman-street, and finding
the old man, as usual, at his esel, opened his battery of re-
proaches, and told the story of the overheard dialogue.

The old gentleman continued his work until the complain-
ant had finished—made a pause, and then mildly said, "All
the difference from the truth in what you have stated, is, that
I urged the plan, and the objections were made by Barker."
But this did not satisfy—perhaps only irritated the disappointed
man.* It is to be remarked that this is Mr. Trumbull's own
version of the story. In connexion with the anecdote, it may
be well to quote the words of another pupil of West. Wash-
ington Allston says, "He was a man overflowing with the milk
of human kindness. If he had enemies, I doubt if he owed
them to any other cause than this rare virtue."

From this time until a subscription was filled for a picture
of West by Lawrence, proposed by Mr. Waldo in New-York,
Mr. Trumbull spoke of West in terms of enmity. He was ap-
pointed to write the letter requesting the sittings, and he did
it in the style of friendship.

It was not until after Mr. Trumbull's final return to the
United States in 1816, that I had the most distant notion that
he could feel enmity to his former teacher. Standing before
a cast from Chantry's bust of West, I remarked, with a feeling
of delight, " How like it is !" " Yes," was the reply ; " it has
precisely his jesuitical expression." These few words let in a
flood of light upon the hearer. They pierced like an arrow,
and like a barbed arrow they remained fixed.

When afterwards I heard of the disappointed expectations of
the artist, on presenting his master with the small study for
his picture of the " Sortie,"—that " it had not been exhibited
and displayed as it might have been," and that the pupil ex-
pected the master to have relinquished his mantle, and covered
him therewith ; I had still more light shed upon me. Whe-
ther it was expected that West should ascend to heaven before
his time to accommodate his grateful protegée, I know not ;
but I do know, that long after this period of disappointed ex-
pectation, the greatest and best works of the great painter

* This passage has been submitted to the gentleman who originally related it,
and he confirms the whole, adding, that by the pause before speaking, it was insi-
nuated that West took time to fabricate an answer, and that the answer was a
falsehood.

were completed, and other pupils had arisen, much more able to sustain the " mantle," when he should be called from the cold world where his old age needed it.

But I must return to that portion of the artist's life, which passed between his return to England in 1808, and his last visit to America in 1816. During this eight years' residence in England, he made strenuous efforts to attract popular attention. But his style had changed since his happy state of pupillage under West. As we have seen in his own words, " he failed completely." Besides two elaborately finished pictures from scripture subjects, which were exhibited at the British Institution, in the hope of prize or sale, the artist seized a moment of Russian popularity, and displayed " Peter the Great at Narva." When Scott's poems occupied public attention, he painted Ellen Douglass, her father, lover, and the old harper, which, although on the small scale, approached in nothing else to his first pictures. The Knighting of De Wilton was painted ; and the picture of " Lamderg and Gelchossa."

But the two scripture pictures above noticed seem to have engrossed a great portion of his time, study, and labour. The subjects are, " The Woman taken in Adultery," and " Suffer little children to come unto me," both now (1834) at New-Haven. Both were painted on a small scale, and then enlarged to life size. These are the best pictures painted by the artist at this period, and far superior to his more recent works.

" The Woman taken in Adultery" is the best of the two. The figure of Christ is the best large historical figure by this painter, and is in many respects better than the Saviour in West's great painting of " The Healing in the Temple." For the distribution of the figures, the painter has judiciously followed the recommendation of old Richardson, where he points out the best mode of arranging the subject. The second picture, " Suffer little children," &c., is apparently more laboured than the first ; and is devoid of its aerial perspective. But the most striking defect is the palpable imitation of the Magdalen in Correggio's " St. Jerome," which the artist had copied (from West's copy) in the winter of 1800–1, and the utter failure in the attempt.

CHAPTER XX.

Final return to America in 1816—Successful application to congress—Four pictures for the capitol—Unsuccessful application to congress—Letter to Mr. Wilde—Copies—Extraordinary deterioration—Trumbull Gallery at New-Haven.

In 1816 Mr. Trumbull returned to America, after having passed, for the second time in the enemy's country, a period of warfare successfully terminated by his fellow-citizens. The change which had taken place in the state of the arts during the last absence of the artist, rendered his prospects as a portrait-painter sufficiently gloomy. In addition to Stuart, who had all the applications from the rich and the celebrated to the east, Sully was in high and deserved reputation, commanding the demand for portraits in Philadelphia and its neighbour-hood, and Jarvis was full of orders for private and public individuals in New-York. Vanderlyn had likewise returned from the continent of Europe, and the admirers of the fine arts looked with mingled delight and admiration on his "Marius" and "Ariadne." And although Allston had not yet arrived, the fame of his success had preceded him, and he soon followed his great picture of the "Dead man revived by the bones of the prophet." Besides these prominent men, a number of younger artists were coming forward, many of whom soon displayed skill, which threw the waning talents of Mr. Trumbull in the shade.

The pictures brought home by Mr. Trumbull attracted attention to him as an historical painter, and he now judiciously determined, as the capitol at Washington was rebuilding, and the nation animated by recent triumphs, to make an effort for employment in commemorating the heroes of the revolution, by exhibiting his early pictures at the seat of government.

A preparatory step was the revival of the American Academy of Fine Arts at New-York, the consequence of which was his election as its president, and a nominal sale of several of his pictures to the institution over which he presided.

I was among the first and warmest in recommending the application to congress. I looked with delight on the miniatures painted in 1786–7–8 and 9, and anticipated more delight from the same when enlarged and rendered more powerful by the charm of magnitude. Members of congress seemed to calculate upon the same scale, and of the vast increase in difficulty between the small and the great, and the possibility of deterioration in an artist's abilities, while in possession of his physical powers, I was as ignorant as any member of congress.

Mr. Trumbull proceeded to Washington during the session of 1816–17; and the fine compositions of " Bunker Hill," and " Montgomery," with the admirable miniature portraits of the signers of the declaration of July 4th, and the heroes who terminated the revolution at York Town, procured an order for four pictures, for the rotunda of the capitol, the architect of which made his design to accommodate eight, each 18 feet by 12. Appropriations were made for the payment of thirty-two thousand dollars, or eight thousand dollars for each, a part paid in advance, as I understand, and the remainder in due time. This magnificent national encouragement of the fine arts, and tribute of gratitude to the sages and warriors of the revolution, met the full approbation of every portion of the republic.

But although the paintings of " Bunker Hill" and " Montgomery's Defeat," contributed by their excellence to facilitate the order for four pictures, congress did not choose to ornament their halls with the triumphs of their enemies and rejected those subjects. They chose what is called the " Declaration of Independence," " The Surrender of Burgoyne," " The Surrender of Cornwallis," and " The Resignation of Washington," when his great work was accomplished.

As the " Declaration" and " The Surrender of Cornwallis," were composed, and the heads finished on the small scale, the painter began the series, by the large picture of the first subject, which, when finished, he exhibited in New-York, and then in all the principal cities of the Union; this gave an opportunity to the citizens of seeing their picture without the expense of a journey to Washington.

Public expectation was perhaps never raised so high respecting a picture, as in this case: and although the painter had only to copy his own beautiful original of former days, a disappointment was felt and loudly expressed. Faults which escaped detection in the miniature, were glaring when magnified—the touch and the colouring were not there—attitudes which appeared constrained in the original, were awkward in the copy—many of the likenesses had vanished. The arrangement of the whole appeared tame and unskilful—and people asked, " What is the point of time?"—" It is not the declaration,"—" No, it is the bringing in of the declaration by the committee." It was then found that men who were present at the scene were omitted; and men not present, or who had not even then taken a seat in congress, were represented as actors in the great deliberative drama. Men said, " Is history thus

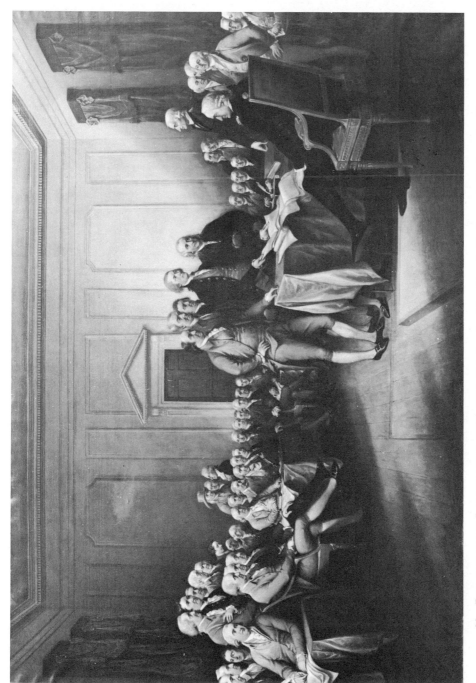

99 DECLARATION OF INDEPENDENCE, 1786–1790. Painting by John Trumbull. *Courtesy Wadsworth Atheneum.*

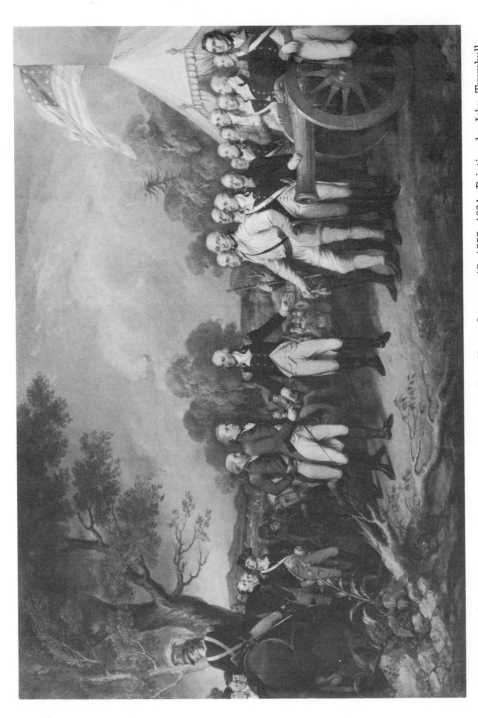

100 SURRENDER OF GENERAL BURGOYNE AT SARATOGA, NEW YORK, OCTOBER 17, 1777; 1824. Painting by John Trumbull, *Courtesy Architect of the Capitol.*

to be falsified, and is this record to be placed in the capitol to contradict the minutes of congress and the truth ?"

However, these murmurs died away. The painter received several thousand dollars by exhibiting his picture before he delivered it at Washington, and it was received and paid for. It retains enough of the original to make it valuable for like- nesses of some distinguished men, and proved by far the best of the series which had been ordered by the government.

In the second picture of this series, which had likewise been partly finished about 1790, in its original beautiful miniature form, the painter again violated truth, by introducing Lord Cornwallis in the scene of the surrender ; and finding that so gross a violation of known fact was objected to, he gave the figure another name, and in his catalogue says, generally, " the principal officers of the British army."

On another occasion, when a person who had witnessed the inauguration of the first president described the scene to Mr. Trumbull, " Here stood Washington, in a suit of brown Am- erican broad cloth; there stood Chancellor Livingston, pre- pared to administer the oath prescribed by the constitution ; and here stood Mr. Otis, supporting the Bible." The painter remarked, " I would place a more important personage in that situation." Thus the truth of history is to be sacrificed to effect or flattery.

Horace Walpole has said, " I prefer portraits really inter- esting, not only to landscape painting, but to history. A landscape is, we will say, an exquisite distribution of light and shade, wood, water, and buildings. It is excellent—we pass on, and it leaves not one trace in the memory. In historical painting there may be *sublime deception*, but it not only al- ways falls short of the idea, but it is always *false*. Thus it has the greatest blemish incidental to history. It is commonly false in the costume, always in the grouping and attitudes, which the painter, if not present, cannot possibly delineate as they were. Call it fabulous painting, I have no objection.— But a real portrait, we know, is truth itself; and it calls up so many collateral ideas, as to fill an intelligent mind more than any other species." Now, although Mr. Trumbull did not, and could not, see any of the scenes represented by him, he had the advantage of seeing the costumes of the persons, and of painting the portraits of many of the men, although some years after the transactions. He had an opportunity of knowing, from Mr. Jefferson, Mr. Adams, and others, and from the minutes of Congress, who were present when the committee brought in the Declaration ; and Count Rocham-

beau, or other French officers in Paris, and Washington and his officers, could have told him every minutiæ of the surrender at York Town. The pictures should have been portraits of the *events*, as faithful as of the *faces* of the men. That the painter should fail in copying the features he had put on canvas in early life, is only to be lamented ; but just disappointment was excited and expressed when men found that the walls of the Rotunda were to contradict the records of history.

The second picture of the series was finished and was carried the same round for exhibition, but with somewhat diminished profit. Still, I believe, thousands were added to the thousands paid for it by the national government.

So far the artist had had his early painted models to guide him, but no further. The " Surrender of Burgoyne" is altogether the work of his declining years, except as he had made beautiful miniature portraits of many of the officers present, when he had his original powers, and was fresh from his studies with West. It is a lamentable falling off, even from his two immediately preceding it. It was exhibited as the others, but with less profit.

The last was another fresh composition, still worse in the conception and execution. Several female figures are introduced, as witnesses of the resignation of that commission under which the hero had fought the battles of his country : but instead of adding grace and beauty to the scene, they are prominent in deformity.

Let not foreigners, or men of after days, take these pictures, because of their situation, as a standard by which to measure the arts of design in our country at the time they were painted. It was my duty to show the causes which led to the employment of their painter, and I have faithfully done so. The government judged of the painter's ability from what he had done in early life. They looked for improvement rather than deterioration. The progress of the arts had been great, and good painters existed ; but the advantage of having the portraits of the men of other days in his possession, and the exhibition of compositions made near thirty years before, under the eye of West, very naturally induced the statesmen of 1817 to accept with joy the proposals of Mr. Trumbull. I have mentioned American artists existing at this time, whose works will give the true standard of the art of painting at the period of painting the four great pictures which are now (1834) in the capitol.

It is necessary to mention, that before the place designed for their reception was prepared, they were deposited in some

lower apartments and occasionally seen ; and that some ruffian, to express his disappointment or malice, cut through the canvas of one of them with a sharp instrument. The author of this atrocity was never discovered. When the Rotunda was finished, the painter, with the concurrence of government, repaired to Washington, to see his pictures put up and retouch them. In this service he attended for a considerable portion of one session of Congress, urging his suit for the filling of the remaining pannels, at the same time making a small picture of the Resignation of Washington ; and unfortunately painting on other small pictures, particularly the original miniature Battle of Princeton. When the sum to be appropriated to this service was in question, the painter was offered the wages of a member of Congress. He replied, "I am not a member of Congress, and never expect to be. I am a painter.—In New York my price for a portrait, of head-size, is one hundred dollars ; and one such picture occupies one week. I expect to be paid one hundred dollars a week for the time I have attended here."

I do not pretend to give the exact words, but such substantially is the fact, as related to me by a member of Congress then and there present, who gave the painter credit for the answer and his adroit management. It is unnecessary to add that the demand was paid.

That the painter demanded, in New York, one hundred dollars for a head or bust-size portrait is true ; and true that he might paint one a week—but the deduction from the premises may be doubted.

When Mr. Trumbull first applied for the painting of the designs for the Rotunda, his application was for eight pictures, the number which would fill it. It will be evident at once, from what I have said, that I consider it a most fortunate circumstance that this contract was made for four only. The artist has repeatedly made application for the honour of filling the remaining four pannels ; and on every renewed effort our journals have teemed with enumerations of his superior claims to all other artists in America for such patriotic employment. One publication intended for this purpose came avowedly from himself, and, in justice to his character, will be inserted.—(The letters to the President of the United States, as published with the resolution of the directors of the American Academy of the Fine Arts.)

In the year 1830 I attended a meeting called by the opposers of Mr. Jackson's administration, respecting the rights of the Indians. I was told that Col. Willet was to preside. I

found Mr. Trumbull in his place : the veteran, who had served with honour through the revolutionary contest, could not be had. Shortly after this meeting Mr. Wilde, in Congress, said, " The painter had better keep to his palette," or words to that effect. And in the American, New-York, 20th Jan. 1830, Mr. Trumbull indignantly spurns at the title. I publish the letter to Wilde, and the introductory letter to the Editor.

New-York, 20th January, 1830.

To the Editor of the American,

May I beg the favour of you to publish in your paper the following copy of a letter which I have thought it my duty to address to the Hon. Mr. Wilde, in congress, the original of which I sent to him by the mail two days ago, and which I now wish to make public in consequence of the publicity of his attack.

After having devoted ten of the best years of my life, in very early youth and in middle age, to the active services of my country; and having employed the intervals of military and political occupations in acquiring an elegant art, for the very purpose of preserving through its means the memory of the great events and illustrious men of the revolution; I did hope to enjoy some repose during the fragment of a life which can remain to a man who has passed its ordinary limits. It appears cruel as towards me, and disgraceful to themselves, that so many men in congress should have continued to teaze me with a repetition of paltry personal squibs. They may rest assured that, however painful the task may be, yet, so long as my intellect and my hands are spared to me, I shall never fail to return an answer.

Yours truly,　　JOHN TRUMBULL."

New-York, January 16, 1830.

Hon. Mr. Wilde, in congress,

Sir,—In the newspapers of this day, I observe a sketch of the debate which took place in the House of Representatives on the 11th instant, on the subject of the memorial from this city, relating to the Cherokee Indians, and which was signed by me as chairman of the meeting. I am very much obliged to you for the favourable terms in which you speak of me as an artist; but when you recommended to " the painter to stick to his palette," you perhaps were not aware that I had not been always, nor merely, *a painter.*

You might not know, that in August, 1775, I was appointed an Aid-de-camp of General Washington ; and that I am the eldest of the few survivors who ever had that honour.

You might not know, that in July, 1776, I was appointed Adjutant General of the Northern Department, with the rank of Colonel, under the command of General Gates ; and that, of course, I am now one of the oldest surviving colonels of the revolutionary army.*

You might not know that, in 1794, I attended Mr. Jay, as his secretary, in his very important, though unpopular embassy s to England.

And probably you do not know the triumphant resul of the 7th article of the Treaty then negotiated by him, relating to the subject of " irregular or illegal captures."

The papers relating to that subject were deposited, by the American commissioners, in the department of state, in 1804. It did not suit the policy of the government, at that time, to give publicity to a result which was so favourable to the commercial part of the nation, and so honourable to Mr. Jay : and as those papers perished when Washiugton was burnt, it is probable that you are not accurately acquainted with the facts. I beg leave to state them to you.

The commission to which was referred the subject of " irregular or illegal captures," was composed of five members :— Mr. Gore and Mr. Pinkney, on the part of the United States ; Dr. Nichol and Dr. Swabey, (two of her most eminent civilians) on the part of Great Britain ; and I was the fifth commissioner, representing both nations. This commission was clothed with authority paramount to all courts of prize of both nations. It was very natural for the two commissioners of each party to think their own government generally right ; and such was the fact on all important questions—of course, all such questions remained to be decided, and were decided, by the fifth commissioner.

In very many cases, the decisions of the courts of both nations were over-ruled by us and reversed; and the government of Great Britain actually and faithfully paid, under our awards, to citizens of the United States, *more than ten millions of dollars.*

It is not to be supposed that I hazarded such a course in such society, during seven years, in the city of London, and supported my decisions by written opinions, without having devoted some time to the study of the law of nations.

* The preceding pages render any comment unnecessary upon these assertions.

If you had known these facts, perhaps you would not have thought it so extraordinary that " the painter should now risk an opinion on a question which he regards as one strictly of international law.

I reason thus :—By the Constitution of the United States, treaties are the supreme law of the land, obligatory not merely on all the individuals, but on all the States which compose the nation.

The power of making treaties is vested *exclusively* in the President and Senate.

Many treaties have been made between the Presidents and Senates of the United States and the Cherokee nation.

A treaty can be annulled only by the consent of both the contracting parties, or by the violent and lawless conductof one.

The Cherokee nation, one of the parties in this case,f ar from giving their consent to a dissolution of existing treaties, earnestly insist upon their fulfilment.

Therefore, the present attempt to set aside these treaties, by any act of the government of the United States, or by their supineness or connivance, does appear to me to be a direct and most unfair appeal to the law of the strongest—a principle which I am very reluctant to see acted upon by the government of my country, in this or any case.

Thus thinking, and presuming that I am a free citizen of a free country, I cannot be persuaded that I have acted improperly in expressing my opinion on this important subject to the representatives of the nation : and I presume that every gentleman who took part in the memorial in question will most cordially subscribe to these opinions.

Permit me to add, for the information of Mr. Thompson, and whomsoever it may concern, that the meeting, of which I had the high honour to act as chairman, was not held in a grog-shop, butin the most spacious hall in this city, which was literally filled by the most respectable of its inhabitants.

I am, &c. &c.

JOHN TRUMBULL.

After the completion of the large picture of the Declaration, the artist employed the first American engraver for talent, to give more extended circulation to that composition by his burin. He engaged A. B. Durand, Esq., after having failed in a negotiation with a celebrated Italian engraver, of the name of Gondolfi. Mr. Trumbull applied to Heath, of London also, who demanded a price equal to $6000. Mr. Durand agreed to engrave it for $3000. He was then a young man,

and justly thought that the work gave him an opportunity of coming before the public, in connection with a popular subject, and that although it would exhaust at least three years of his time, he had better accept an inadequate compensation for the exertion of his talents, and gain, as he had reason to expect, an addition to his fame as an engraver. In 1829, Mr. Trumbull said, that in 1790 he got 270 subscribers for his two prints of " Bunker Hill" and " Montgomery," in the United States, at three guineas for each print, and in 1819, he could only obtain the same number for his print of the " Declaration of Independence." From this he inferred that as the population increases, the taste for the fine arts decreases. Fortunately for Americans the plate was engraved from the small original picture, and the engraver has preserved the real portraits of the eminent men introduced. We speak without hesitation on this point, having known most of the originals. Mr. Durand likewise corrected the drawing of several parts of the picture, by consent, and with the approbation of the painter.

The perseverance with which Mr. Trumbull pursued his plan of painting *more* great pictures for the government, not only to fill the four remaining pannels of the rotunda, but to fill the president's house, and the engines he set at work with even more assiduity than when he made his successful application to congress, are subjects of admiration. Presenting himself at the seat of government, he again, as at the former period, procured what is called his biography, to be circulated *there* and elsewhere in the newspapers. In December 1826, the National Intelligencer announces that the four great pictures are in their places in the capitol—that Col. Trumbull is at Washington—that his powers are undiminished, and promises his biography. On the 29th of December 1826, there appeared in the New-York Times, " Biographical notices of Colonel Trumbull, author of those paintings of subjects from the History of the Revolution, which are now placed in the great hall of the capitol of Washington." The writer then praises the pictures, but acknowledges that " since they have been removed to the seat of government" they " have been bitterly criticised." After going through the military and civil services of *Colonel* Trumbull, the biographer eulogizes the *four pictures* in which " this nation," he says, " possesses a work which no other people have yet possessed." He then proceeds : " We are happy to hear, from the proceedings of the House of Representatives, that there is an intention to fill the remaining vacant spaces in the Grand Hall with other paintings of revo-

lutionary events, and hope sincerely that the importance will be felt, of employing the few remaining years of this *veteran soldier* and artist in this work. *No one else devoted his youth to the necessary studies. No one else has given years of thought and labour to the preservation of the memory of the great events of that distant day. He alone appears to have made it the study of a long life;* and strange will it appear to other nations, and to posterity, if under such circumstances, half of this magnificent room should be filled with *imaginary scenes delineated by men who have no personal knowledge of the events,* and who have hitherto scarcely given the dream of an idle hour to the subject." So are mankind deceived by bold assertions, without any foundation in truth.

Mr. Trumbull's best pictures are "imaginary scenes;" they could be no other. His only advantage over better painters, of 1826, was that he had collected portraits of many men, (after he returned from England, and the Federal Government was established) who had served their country in the field and the council. He has great merit in so doing, and has reaped the advantage.

This biography of 1826, must be taken in connection with the following letters addressed by Mr. Trumbull to the president of the United States, on the 25th and 28th of December, 1826, four days before the " Biographical notices" appeared in the Times at New-York.

"Washington, 25th December, 1826.

" *To the President of the United States.*

" Sir,—I beg permission to submit to your consideration the following plan for the permanent encouragement of the fine arts in the United States : public protection has already been extended, in a very effectual manner, to various branches of the public industry employed in manufactures of different kinds ; and I wish to call the attention of the government to the fine arts, which, although hitherto overlooked, may, I trust, be rendered a valuable, as well as an honourable branch of the national prosperity, by very simple and unexpensive means.

" I would propose that whenever an event, political, naval, or military, shall occur, which shall be regarded by the government as of sufficient importance to be recorded as matter of history, the most eminent painter of the time, be ordered to paint a picture of the same, to be placed in some of the national buildings—that an artist of secondary talent be employed to make a copy of the same, which shall be given to

the minister, admiral, or general under whose direction or command the event shall have taken place, as a testimony of the approbation and gratitude of the nation.

"It appears to me that this would operate as a powerful stimulus to the ambition and exertions of the national servants in their various departments, as well as an effectual encouragement to artists, and an honourable mode of exciting their unremitting endeavours to attain to the highest possible degrees of eminence.

"I would next propose, that the most distinguished engraver of the day should be employed to engrave a copperplate from the painting so executed, and that one thousand impressions, first printed from this plate, be reserved by government for the purpose hereafter designated ; the remaining impressions which may be printed, to be sold, and the proceeds applied to a fund destined to defray the expense of the plan.

"This part of the plan is founded on the experience of individuals who have pursued the business of publishing and selling engravings, many of whom, after paying the painter, the engraver, the paper-maker, the printer, and all the various expenses of publication, have acquired considerable fortunes in reward of their enterprise and exertions.

"This was particularly instanced by the late Alderman Boydell, of London, who, (himself an engraver,) in the beginning of the reign of George III. found England paying annually to France and other nations, for this article of ornamental furniture, engravings, near $200,000, and lived to see (in consequence of a judicious encouragement of the fine arts by the sovereign and his own individual exertions,) England receiving from France and other nations, a balance considerably exceeding that sum, making a difference in favour of England of more than $400,000 a year. Reasoning on this experience, it is manifest that this nation may be probably indemnified for the entire expense of the project, by the sale of those impressions which may be taken from the plates after the first thousand, which would remain to be diposed of as follows :—

"Every minister of the United States, going abroad on a mission, should be furnished with one (or a set) of these reserved engravings, as an article of his outfit; they should be handsomely framed and hung in the most public and elegant apartments of his foreign residence—not so much for the purpose of ornament, as of showing the people among whom he resided, at once an historical record of important events and an evidence of our advance, not only in political, naval,

and military greatness, but also in those arts of peace which embellish and adorn even greatness itself.

" Every minister of a foreign nation returning home from a residence among us, should also receive one (or a set) of those prints, in a handsome port-folio; and the same compliment might occasionally be paid to foreigners of distinction, visiting the country from motives of curiosity or a desire of improvement, in the discretion of government.

" An historical record of memorable events, and a monumental tribute of gratitude and respect to the distinguished servants of the nation, would thus be preserved in a series of paintings of unquestionable authenticity; the principal works adorning the public edifices and placing before the eyes of posterity the glorious examples of the past, and thus urging them to that emulation which may render the future yet more glorious; the smaller works in possession of the immediate descendants of those who had thus received the thanks of the country, decorating private houses with the proud evidence of individual service and of national gratitude, and thus kindling all the talent and energy of succeeding generations to elevate, if possible, at least not to diminish the honour of the name and nation; while the engravings in a more portable, more multiplied and less expensive form would disseminate through the world evidence of the greatness and gratitude of the United States.

" Talent for all the elegant arts abounds in this country, and nothing is wanting to carry their votaries to the highest rank of modern or even ancient attainment, but encouragement and cultivation; and although all cannot hope to rise or be sustained in the most elevated rank, still the less successful competitors would become eminently useful by turning their abilities to the aid of manufactures. It is the overflowing of the schools and the academies of France which has given to the manufacture of porcelain at Sevres, and of or-molu time-pieces and ornaments in Paris, that high pre-eminence over the rival attempts of other nations, which drives them almost entirely from the markets of elegance, and thus becomes the source of very considerable wealth to France.

" The history of the United States already abounds in admirable subjects for the pencil and the chisel, which should not be suffered to sink into oblivion : the last war especially, is full of them, and it seems to me that this is the proper field for the present and rising artists to cultivate; the field is not only fertile and extensive, but is hitherto untouched, and seems to solicit their patriotic labours and to chide their delay.

They are cotemporaries and familiar with the actors and the scenes they are called to commemorate, and can therefore fulfil the duty with enthusiasm, a knowledge of facts, and a degree of absolute authenticity, which ensures success and would give real value to their works. Nor should it be forgotten, that the stream of time is continually, though silently, bearing away from our view, objects, circumstances and eminent forms, which memory can never recall.

" The public buildings offer fine situations for the display of works of this nature, not only in various apartments of the capitol, but in the house of the president, where the great room now furnishing, would with more propriety and economy be enriched by subjects of national history, executed by our own artists, than loaded with expensive mirrors and all the frivolous and perishable finery of fashionable upholstery.

" By giving, in such way as I have here taken the liberty to suggest, a right direction and suitable encouragement to the fine arts, they may be rendered essentially subservient to the highest moral purposes of human society, and be redeemed from the disgraceful and false imputation under which they have long been oppressed, of being only the base and flattering instruments of royal and aristocratic luxury and vice.

" I do not pretend to originality, sir, in submitting to you these ideas ; Athens in ancient times, and Venice, in the best days of that republic, acted on these principles to a certain extent. All civilized nations have made the arts useful auxiliaries of history, by the means of medals; and it is even said, that this very system was proposed to Louis the XVI. of France and approved by him, but prevented from being carried into effect, by the long train of succeeding calamities. I have only attempted to adapt the general idea to the circumstances of our country and times, and I cannot but believe, that not only artists and manufacturers would derive great advantage from the adoption of some such plan, but that the honour and the essential interests of the nation would thereby be eminently advanced.

　　" With very great respect,
　　　" I have the honour to be, sir,
　　　　" Your most faithful servant,
　　　　　" JOHN TRUMBULL."

" Washington, 28th December, 1826.

" *To the President of the United States.*

" Sir,—Permit me to place before you an estimate of the expense which would be incurred by the government of the United States, in carrying into effect the plan for the permanent encouragement of the fine arts, which I had the honour of submitting to you in a letter dated the 25th instant. Taking for the purpose a single event for commemoration, with which it would perhaps be proper to commence.

The United States Dr. for a painting to be placed in the large room of the president's house ; the size not to exceed 6 by 9 feet, nor smaller than 4 by 6 feet, with figures half the size of life,	$2,500
For a copy of the same half the dimensions, to be given to whomsoever,	500
For an engraved copperplate from the same, in size 14 by 21 inches,	2,500
For paper and printing two thousand impressions at 50 cents, one thousand to be retained, and one thousand for sale,	1,000
	$6,500

The United States Cr. by proceeds of sale of one thousand impressions at 10 dollars, $10,000
Deduct the usual commission on sales, 25 per cent. $2,500
For possible losses and damage, 1,000
 ——— $3,500
 ——— $6,500

" The above statement is founded on my own personal knowledge and experience ; and thence it is demonstrated, that if only one thousand impressions of the plate should be sold, the account would be balanced, with no other expense to the nation than the interest of 6,500 dollars, during the interval between paying the several articles of charge and the receipt of the proceeds of the sale of prints. And you will permit me to add, that one thousand impressions are a small number to sell of good works published by individuals ; and that a greater number would probably be sold of a work published under the orders and authority of the nation, and thus bearing the stamp of perfect authenticity.

" I have stated the price of the principal picture at that sum, which I should have been delighted to receive for a similar work at the time when I painted the Battle of Bunker's Hill, in 1786, and which I believe would be satisfactory at this time to distinguished artists, in Paris or London, and I have fixed the price of the copy by the same rule. I should have been happy to have received that sum in 1675, for a copy I then

made for Mr. West, of his celebrated picture of the Battle of La Hogue.

" The price at which I have estimated the engraving of a copperplate, 14 inches by 21 in size, is suggested by that which I paid to Mr. Durand for engraving the Declaration of Independence, 3000 dollars. The size of that plate is 20 by 30 inches, nearly one-third larger than that proposed in my estimate. I presume that 2,500 dollars for the smaller plate proposed would command the first abilities in the country.

" The price of printing, in like manner, is estimated by my own experience : each sheet of the Declaration, on grand eagle paper, cost me nearly 75 cents for paper and printing. That is much larger, and of course the labour and expense of printing is much greater, than is requisite for the contemplated purpose.

" I propose pictures of moderate dimensions, as being best suited to the apartments in the President's house, or the committee rooms of the capitol : and I propose copper-plates smaller than that of the Declaration ; because the sale of that print is impeded by the necessity of large and expensive frames and glasses, or portfolios for their preservation. Should it be thought more consistent with the dignity of a national work to adopt a larger size for the copper-plate, a corresponding larger sum must be paid to the engraver : but, as in that case it would be proper to increase the price of the impressions sold, no difference unfavourable to the plan would arise, in respect to my estimate.

" I have allowed one thousand dollars for *possible* loss or damage on the sale of the prints ; but loss to that extent is by no means *probable*, and any saving on that article of the estimate would go in diminution of interest. So that it appears, that with very little expense, beyond the mere *patronage of government*, the fine arts may be stimulated and encouraged, the national edifices decorated, authentic monuments of national history preserved, elegant and attractive rewards bestowed on the meritorious servants of the public, and the national glory essentially advanced.

" With great respect I have the honour to be,
" Sir, your most faithful servant,

" JNO. TRUMBULL."

These letters, and the biographical notices pointing out " the most eminent painter of the time," did not produce the

intended effect. Mr. Trumbull returned from attending con-
gress, and in April, 1827, as the minutes of the Academy over
which he presides inform us, " read copies of two letters
proposing a plan for the permanent encouragement of the fine
arts, by the national government, &c. &c., *and requested* that
these copies (in his own handwriting) might be deposited
among the archives of the academy." Whereupon, the board
of directors, consisting of fifteen persons, of whom three were
artists, including the president, resolved that five hundred co-
pies of these letters should be printed and distributed for the
benefit of the fine arts; which was accordingly done. In
these letters, the price which Mr. Trumbull fixed as a remune-
ration to the first engraver in the United States, is founded on
that which he gave Mr. A. Durand, that is, three thousand
dollars. It is well known that Mr. Durand agreed to take
that sum, merely as a young man's first step to celebrity, as
the engraver of a popular subject, and that Heath demanded
six thousand; so that the president, perhaps, notwithstanding
the prospect of making cheap presents to distinguished indivi-
duals, might have been led into an unprofitable speculation.
I will remark on the passage in these letters which asserts that
works having been ordered by the nation, bear " the stamp of
perfect authenticity," that it appears to be meant as an answer
to those who have asserted from their own knowledge, that,
although the author's pictures were ordered by congress, they
did not represent the truth of history.

About the time of completing the last of the series of pic-
tures for the capital, Mr. Trumbull became a widower, and
soon after gave up the house in which he had painted those
great works, (the north corner of Park-place and Church-
street,) and failing in his efforts to procure an order for more
pictures from government, he employed his pencil in painting
portraits of many of his friends, gratuitously, and in making
copies from the works of older artists, with, generally, varia-
tions to please his own taste.

On Monday, June 14, 1824, Mr. Trumbull opened for ex-
hibition his last picture for the government, the Resignation
of Washington. It was exhibited six weeks; and the Com-
mercial Advertiser told the world that " its exhibition had not
paid room rent." Mr. Trumbull then went with his picture
to Albany, intending, as I understood, to travel with it until
he placed it in Washington. This is a sad contrast to the
profit which his first picture for congress gave from exhibition.

I have mentioned his admirable copies made in London,
when under the roof of West. It is a curious and singular

fact, that as the talent of this artist declined for original composition, so his powers for copying failed; and both appear to have decayed simultaneously. The number of Madonnas and holy families from his pencil is a proof of his praiseworthy perseverance, and of an utter blindness to the change which his judgment had undergone. I have seen exhibited, in the same place, the exquisite copies of the St. Jerome of Correggio and the Madonna of Raphael, with the holy family, painted as his academical gift to the institution over which he presides —and I defy the annals of painting to show a greater contrast.

A more unfortunate employment of the artist has been, after an interval of almost half a century, to complete, as he calls it, those pictures begun in 1787 or 8, or 1790, by painting in figures and heads which had been omitted. In every instance the recent touch is a blot, and the works injured by his misapplied industry.

Fortunately, the miniature original of the " Declaration" had very few heads to be finished. The battles of Princeton and Trenton had more to fill up, and consequently have suffered more.

We now return to the manuscript dictated by Mr. Trumbull to Mr. Herring for publication, and partly published in Longacre and Herring's " National Portrait Gallery." " At the close of the war he returned to New-York. In 1816 he was engaged by the government to paint the four large pictures now in the rotunda of the capitol at Washington, on which he was occupied seven years. Since which he has been principally employed in the ordinary pursuits of an artist's life ; and though now at an advanced age, is still pursuing his design of completing his series of copies of his national pictures on a uniform scale of six feet by nine. Finding the government not likely to order the complete series, nor any individual desirous to possess them, he has, within the last year, given the entire set of the original paintings to Yale College ; and a building has been erected by the president and fellows of that institution for their preservation."

I think it is due to the president and fellows, and the institution generally, to say that this gift was, and is a bargain, by which the artist receives fifteen hundred dollars annually during life, either from the receipts of the exhibition or otherwise.

The building cost $4000, and there are two galleries, one appropriated to Mr. Trumbull's paintings exclusively, the other containing Smybert's Berkeley family, (which I found

far superior to my recollection of it; the dean, the amanuensis, and the artist, are finely painted,) and a number of portraits, some good, and some good for nothing. The galleries are both well designed, and the pictures show to the best advantage.*

* I will here give the titles of the Trumbull pictures, from the catalogue drawn up by the artist, with such remarks as are suggested by a recent visit in August 1834:—

No. 1. "Preparation for the Entombment of the Saviour," painted 1827. This is a copy with intended amendments.

No. 2. "The Battle of Bunker's Hill," painted in Mr. West's house in 1786. A perfect contrast to No. 1, both in drawing and colouring, and full of excellence and beauty. It is much injured by the cracking of the paint, and has been repaired by the artist. This is a jewel.

No. 3. "The Death of Gen. Montgomery," painted immediately after No. 2, in the same place, and under the same eye, and even more perfect. A brighter jewel, but injured after the same manner.

No. 4. "Battle of Princeton." An instructive sketch.

No. 5. "The Declaration of Independence." The heads painted in 1787-9, and very beautiful, but the composition not so good as the two last, and much of the drawing very inferior. Still the greater number of the heads renders it very valuable.

No. 6. "Capture of the Hessians at Trenton." All that is good in this picture was painted in 1789 and shortly after. What is good is very good, but unfortunately the artist undertook, in after life, to finish it, and every touch is a blot. To look at the hands and compare them to the heads, excites astonishment. Washington's head and Smith's are jewels—the hands are very bad.

No. 7. "Copy of Correggio's St. Jerome." This is a jewel; but I think copied from West's copy. This was painted when the artist was a pupil of West's, in 1781.

No. 8. Copy of Raphael's "Madonna della Sedia," "painted," says Mr. Trumbull, "in London, in the house and under the eye of Mr. West."

No. 9. "Madonna au Corset Rouge," copied in 1801.

No. 10. "Death of General Mercer at the Battle of Princeton." I presume from the excellence of this composition, as I saw it in 1790, that it was designed under Mr. West's roof and eye—if not very shortly after. The artist has, as he calls it, "accomplished his original purpose;" but it is not so—he has accomplished the destruction of his sketch. The heads of Washington and some few near him, have all the merit of Mr. Trumbull's miniature heads of that time, (1787-8-9, &c.) but the foreground figures are all comparatively bad.

No. 11. "Surrender of General Burgoyne." This is a copy in miniature from the large picture at Washington; and both being the work of late years, both are, compared with former work, very poor. Let any one of common sense, or sight, compare this with the artist's work done in West's house, London, or soon after, and the contrast will strike beyond previous conception.

No. 12. "The Death of Paulus Emilius," painted at Lebanon, 1774. Mere boy's work.

No. 13. "Surrender of Lord Cornwallis." Most of the heads painted in 1787-8-9. They are exquisitely beautiful miniatures. See the head of Rochambeau. The head of Washington has been finished lately.

No. 14. "Resignation of General Washington," copied from the large picture at Washington.

No. 15. "Our Saviour Bearing the Cross, &c." This is a match for No. 1.

No. 16. "Our Saviour with Little Children," painted in London, 1812. I

Mr. Herring's manuscript concludes thus, after mentioning the gift to Yale College, and the building erected to preserve the paintings—" in which they will be united by a number of pictures, by the most distinguished painters of various periods—Trumbull gallery."

No American painter has ever received from government such patronage as Mr. Trumbull; and in the decline of life he receives, as a reward for his military services, a pension, which, though not adequate to his merits, may, when added to the income from his pictures at Yale College, afford those comforts and enjoyments which old age so much requires to smooth the passage to the tomb.

have spoken so fully of this picture and "The Woman taken in Adultery," that I pass them over here.

No. 17. "Peter the Great at Narva," painted 1811. A picture of no merit.

No. 19. "St. John and Lamb," has much beauty, and was painted in 1800.

No. 20. "Portrait of General Washington," painted in Philadelphia, 1793. Without merit of any kind.

No. 21. "Knighting of De Wilton," painted in London, 1810. A laboured picture of little merit, except armour and drapery painting.

No. 22. "Portrait of Alexander Hamilton." Not like.

No. 23. "Holy Family," composed in London, 1802—finished in America, 1806. Beautifully painted, but without originality of thought.

No. 24. "President Dwight." Not a good portrait or picture, compared to the artist's early works.

No. 25. "General Washington," a full length, painted in 1792. This is, in many respects, a fine picture, and painted in the artist's best days.

No. 26. "The Revolutionary Governor of Connecticut, Jonathan Trumbull," father of the artist. I presume a good portrait.

No. 27. "Infant Saviour and St. John," painted in London, 1801. Beautifully executed, but without originality.

No. 28. "Portrait of the Hon. Rufus King." A poor portrait, although painted in 1800.

No. 29. "Lamderg and Gelchossa," painted 1809. A laboured picture without merit.

No. 30. "Portrait of Mr. Gore," painted 1800.

No. 31. "Maternal Tenderness," painted 1809.

No. 32 to No. 42. Miniatures in oil, painted in the artist's best days, from 1790 to 1792, and only rivaled by the exquisitely beautiful heads painted in the small historical pictures from 1786 to 1792. These are studies for the artist.

No. 43. Five heads. Oil miniatures, painted 1827, in imitation of the former happy style, but forming a perfect contrast.

Mr. Trumbull unfortunately believed, that in 1827 his sight and his judgment enabled him to paint as in 1786 or 1792, and in consequence has injured the small historical pictures of that period to a lamentable degree. Let the student admire and profit by the early works of this artist; but beware of the opinion that there is any thing to imitate in the later efforts of his pencil: let him look at the hands in the Death of Montgomery and those of later date, and he must understand me.

CHAPTER XXI.

William Winstanley— S. King—Mr. S. King gives instruction to Mr. Allston and Miss Hall—Archibald Robertson—Born near Aberdeen—Studies drawing at Edinburgh, 1782, with Weir and Raeburn—Studies in London—Determines to visit America—Opinion of that country—Disappointed—The Wallace box—Mr. Robertson paints the President and Mrs. Washington—Guiseppe Ceracchi—Employed by the Pope in conjunction with Canova—Visits England—Visits America—Intended monument—Bust of Washington—Returns to Europe—Attempts to assassinate Bonaparte—Uncertainty of the mode of his death—Benjamin Trott—Jeremiah Paul.

William Winstanley, *fl. c.* 1793–*c.* 1801.

WILLIAM WINSTANLEY—1790.

THIS young man was understood to have come to New-York on some business connected with the Episcopal church.

He was of a good family in England, and had received a gentlemanly education. At his first arrival he was well received among our first and best citizens, and was intimate at the house of Bishop Benjamin Moore. He became well known to the public in 1795, by painting and exhibiting a panorama of London, as seen from the Albion Mills, Blackfriar's Bridge. This was the first picture of the kind ever seen in America, and was exhibited in Greenwich-street, New-York.

In another part of this work it is stated that a friend of mine furnished the money either in part or the whole, to enable Barker to get up the first panorama ever executed, which was of Edinburgh. Barker afterward painted the panorama of London, and had it engraved and published in six prints of 24 inches each. These prints were brought to America by Mr. Laing, the brother-in-law of my friend, and were, through Mr. Alexander Robertson, lent to Winstanley. The reader may see in the biography of Stuart, how Mr. Laing was repaid. These panoramic prints brought him to the knowledge of Winstanley, as a painter, and having sold to General Henry Lee an original full-length of Washington, by Stuart, he sent it to Winstanley as understanding the best mode of packing it, as it was purchased for the President's house at the seat of government. Winstanley immediately copied it, and sent the copy to General Lee, keeping the original; by and from which to manufacture more Stuarts, and finally Mr. Laing lost the amount of the original picture.

Winstanley painted portraits, landscapes—any thing—and in 1801, this swindling genius, as appears by a puff direct in Denny's Portfolio, announced the publication of eight prints by subscription, select views, to be engraved in London from oil paintings by Mr. Winstanley, " an artist of genius and reputation, whose landscapes in oil are greatly admired by the connoisseurs."

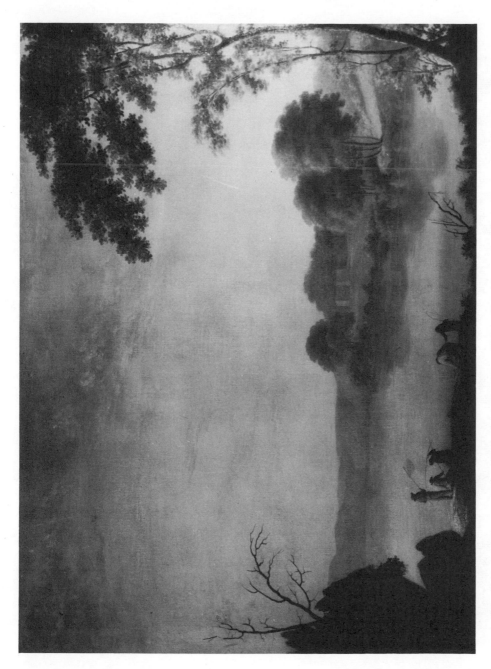

101　EVENING, HUDSON RIVER. Painting by William Winstanley. *Courtesy Mount Vernon Ladies' Association.*

102 MORNING, HUDSON RIVER. Painting by William Winstanley. *Courtesy Mount Vernon Ladies' Association.*

It was probably at this period that he borrowed the five hundred dollars from the Boston merchant, and gave him as security an original Stuart painted by himself. This is the last notice I have of William Winstanley.

S. KING—1790.

Samuel King, 1748/49–1819.

This gentleman, although he painted portraits for many years in Newport, Rhode Island, might perhaps have escaped my notice, if a great painter had not mentioned him as one who encouraged the efforts of design in his schooldays. He had not that skill which would entitle him to historical notice, but if he stimulated in any degree the genius of Allston, he deserves immortality. He was an able and ingenious man, and has contributed his mite to the progress of American art, by giving instruction to Washington Allston, and imparting some knowledge of the rudiments of the art to Miss Anne Hall, one of our most excellent miniature painters, and a National Academician.

Mr. King painted professionally in 1790, and when Allston returned an accomplished artist in 1809, he had the pleasure of reminding the good old man of the kindness he had, as a child, received from him.

ARCHIBALD ROBERTSON—1791.

Archibald Robertson, 1765–1835.

Archibald Robertson arrived at New-York on the 2d of October 1791. He was born in the village of Monymusk, eighteen miles from Aberdeen, Scotland, in 1765. His father was an architect and draftsman, and practised the art at that place. Two brothers, Alexander and Andrew, are likewise artists. the latter has long been, if not the best, equal to the first miniature-painter in the metropolis of Great Britain.

Archibald showed an early disposition for the fine arts. I have seen designs of Mr. Robertson's for historical compositions which evince good knowledge of drawing, chiara scura, and expression. One from Shakspeare, of Falstaff and his companions, has much of these qualities and pleased me most. Lord Archibald Grant encouraged his attempts at drawing, and after he had completed his education at Marshall college, Aberdeen, Grant invited him to Edinburgh to study the arts of design, and thither he went in 1782. At that time there was no academy of fine arts in that city, and Archibald associated himself with Weir and Raeburn, then like himself students of painting, to form a school for mutual improvement. Raeburn was about the same age with Robertson and afterwards attained that eminence as a portrait-painter which gained him the appellation of the Reynolds of Scotland.

Robertson, Raeburn, Watson, and Weir had as associates some engravers of Edinburgh, and they obtained permission from the manager of the theatre to occupy the green room for their school on such evenings as it was not in use, which were three in the week. Runciman, who was the teacher of the drawing school of the college, lent them casts and directed their operations. He is well known among painters for his pictures from Ossian and other works, which place him almost on a level with Barry and Mortimer, at least in the minds of his countrymen, who speak of Barry, Mortimer and Runciman as the pride of Ireland, England and Scotland. The college drawing school was a free school. The associates studied from the life, and hired a porter as their model. It was a school of mutual instruction. Raeburn is well known to fame. George Watson is now his successor in Edinburgh. He was the youngest of the associates. Before going to Edinburgh the young painter had received instructions from Peacock in miniature, Nesbit in water colour drawing, and Wales in oil.

Having passed two years in Edinburgh he returned to his own climate to restore his impaired health, which accomplished, after practising his art in Aberdeen and Edinburgh, he, in 1788, went to London. He carried among other letters one to Sir Robert Strange. The engraver was not home when he called, but his wife, a Scotchwoman, received her young countryman very cordially and went with him to Newman-street to introduce him to Benjamin West. The great historical painter was found at his (chevalet de peintre) or esel, working upon one of the pictures commemorative of the order of the garter. West received the young man with that amenity which characterized him, and continued his occupation while conversing with his visiter, as was his wont. He asked Robertson what were his views in respect to the art. Whether he intended to pursue historical or portrait painting, and being informed that the latter was his object he recommended application to Reynolds, saying, " I seldom paint portraits, and when I do, I neither please myself nor my employers."

Robertson was delighted with the urbanity of the painter, astonished by the facility and rapidity with which he was executing the work on his esel, and determined to follow his advice by seeking an introduction to the great portrait-painter.

To Sir Joshua he was introduced by Sir William Chambers the architect, and was received as he could wish. Reynolds was then the president of the Royal Academy and pointed out to him the steps necessary for his introduction to that school ;

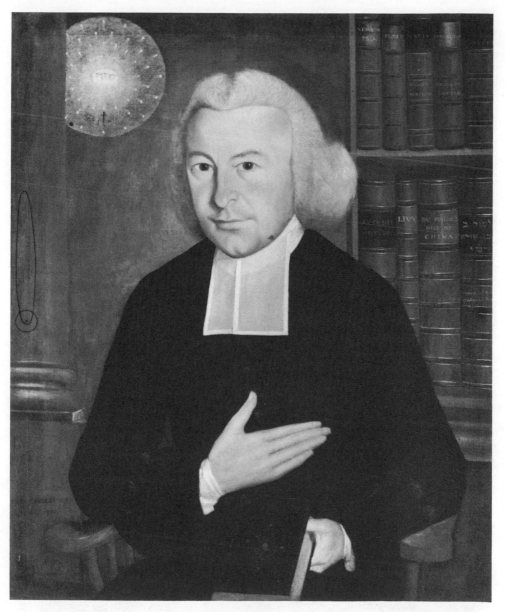

103 EZRA STILES. Painting by Samuel King. *Courtesy Yale University Art Gallery,*
bequest of Dr. Charles C. Foote.

104 HAYMARKET THEATRE, BOSTON. Wash drawing by Archibald Robertson. *Courtesy Library of Congress.*

the first of which is to make a drawing from the plaster figure
for presentation to the counsel or keeper. We need not say
that in Europe an academy is composed of those who can
teach the arts or sciences it is instituted to promote. Robert-
son said he had no plaster figure to draw from, and the artist
directed him to choose one from those in his *studio* and make use
of it. The young Scot chose the crouching Venus and
triumphantly bore the goddess to his own chamber, eager to
devote himself to the study of beauty and the *antique*.

His drawing gained him admission to the schools of Somer-
set House. He studied the portraits of Reynolds and copied
several of them in miniature. Returning to Scotland he ex-
ercised his profession at Aberdeen successfully, until he was so-
licited by Dr. Kemp, of Columbia College, New-York, (through
the medium of the venerable Dr. Gordon of Kings College,
Aberdeen,) to come and settle in America. The advice of his
friends and his own inclinations determined him to visit the
terra incognita. Not until he had made up his mind for this
voyage of discovery did he make any inquiries respecting the
country or its inhabitants, or indeed think any thing about it.
It was a land of savages where some Europeans had fled from
oppression or poverty or debts, and others had transported
Africans, and convicted felons, in chains. The information
the young painter received was such as to induce him to be-
lieve that except in the sea-ports the country was a wilderness,
and the inhabitants wild beasts and Indians. He thought him-
self fortunate in meeting a lady whose husband had been
taken prisoner with Burgoyne, and had with the captured
army been marched from Saratoga to Virginia. She was
at New-York, doubtless expecting to receive her husband
in that British garrison, after he should have marched in
triumph from Canada, and assisted in dividing the eastern
states from their brethren of the union. She was disappoint-
ed; and now solicited and obtained permission to pass through
the tract of country which separated her from the place of her
husband's captivity. She unwittingly confirmed Robertson in
the opinion that America was a country of savages, for she
told him that having been fortunate enough to carry from the
city a large stock of needles and pins, she found them of
greater use to her than money, they being so eagerly desired
by the inhabitants she encountered in the course of her jour-
ney. This would of course remind the young man of the
avidity with which the savages, discovered by Cooke, sought
for like articles, and even beads and nails, and confirmed him
in the notion that all beyond the precincts of the cities was a
land of wild beasts and wild men.

The reader will observe the manner in which this fact, (the avidity with which pins and needles were sought for,) told without explanation, might operate. The lady knew the cause doubtless of the high price set upon needles and pins, by the people among whom she journeyed from New-York to Virginia. The people of America had, before the era of their emancipation from the bonds of a foreign parliament, been prohibited the exercise of ingenuity or skill in most articles of manufacture, or had, from the sparse nature of the population, been induced to depend upon Great Britain for the products of her manufactories; and being, at the time she spoke of, cut off from all foreign commerce by the armies and fleets of England, they were literally put to their shifts to make a shirt, and unable, in some instances, to pin a garment except with thorns, unless supplied by some visiter like herself, or by smugglers and illegal traffickers with New-York or other garrisons of their enemy. She only reported the fact without comment or explanatory facts, and the young painter drew his own conclusions. When he arrived at New-York in 1791, he expected to find some whites, but was utterly astonished on landing to see the same forms and complexions he had left behind on the other side the Atlantic, except here and there the face of an African. It is probable that he did not see an Indian for years after his arrival, and then as much of a raree-show to his adopted countrymen as to himself.

In the month of December following his arrival in the United States, he went to Philadelphia, then the seat of government, to deliver to Washington the celebrated box made of the wood of the oak tree that sheltered Wallace after the Battle of Falkirk. This token of regard for the character of the president, had been committed to the charge of Mr. Robertson by his friend the Earl of Buchan.

We extract the following from the Atlantic Magazine:

"Philadelphia, January 4. On Friday morning was presented to the president of the United States, a box, elegantly mounted with silver, and made of the celebrated Oak Tree that sheltered the Washington of Scotland, the brave and patriotic Sir William Wallace, after his defeat at the battle of Falkirk, in the beginning of the fourteenth century, by Edward the First. This magnificent and truly characteristical present is from the Earl of Buchan, by the hand of Mr. Archibald Robertson, a Scots gentleman, and portrait-painter, who arrived in America some months ago. The box was presented to Lord Buchan by the Goldsmith's Com-

pany at Edinburgh, from whom his lordship requested, and obtained leave, to make it over to a man whom he deemed more deserving of it than himself, and the only man in the world to whom he thought it justly due. We hear farther, that Lord Buchan has, by letter, requested of the president, that, on the event of his decease, he will consign the box to that man, in this country, who shall appear, in his judgment, to merit it best, upon the same considerations that induced him to send it to the present possessor.

" The inscription, upon a silver plate, on the inside of the lid, is as follows :—Presented by the goldsmiths of Edinburgh, to David Stuart Erskine, Earl of Buchan, with the freedom of their corporation, by their deacon—A.D. 1790.

" The following is the letter which accompanied the box that was presented to General George Washington, by Mr. Robertson, from Lord Buchan.

" Dryburgh-Abbey, June 28th, 1791.

" Sir—I had the honour to receive your excellency's letter relating to the advertisement of Doctor Anderson's periodical publication, in the Gazette of the United States : which attention to my recommendation I feel very sensibly, and return you my grateful acknowledgments.

" In the 21st number of that Literary Miscellany, I inserted a monitory paper respecting America, which, I flatter myself, may, if attended to on the other side of the Atlantic, be productive of good consequences.

" To use your own emphatic words, 'may that Almighty Being who rules over the universe, who presides in the councils of nations, and whose providential aid can supply every human defect,' consecrate to the liberties and happiness of the American people, a government instituted by themselves for public and private security, upon the basis of law and equal administration of justice, preserving to every individual as much civil and political freedom as is consistent with the safety of the nation : and may He be pleased to continue your life and strength as long as you can be in any way useful to your country !

" I have entrusted this sheet inclosed in a box made of the oak that sheltered our great Sir William Wallace,* after the

* Sir William Wallace, at first a private gentleman, unsuccessfully attempted a revolution in Scotland, nearly on the same grounds with that more recently accomplished in America, to expel the English and their adherents, who had usurped the government. Having gained a victory over the forces of Edward the First, at Stirling, he was soon after attacked by Edward at the head of 80,000 foot and 7000 horse ; whereas the whole force of Sir William did not exceed

battle of Falkirk, to Mr. Robertson, of Aberdeen, a painter, with the hope of his having the honour of delivering it into your hands ; recommending him as an able artist, seeking for fortune and fame in the New World. This box was presented to me by the goldsmith's company at Edinburgh, to whom, feeling my own unworthiness to receive this magnificently significant present, I requested and obtained leave to make it over to the man in the world to whom I thought it most justly due ; into your hands I commit it, requesting of you to pass it, in the event of your decease, to the man* in your own country, who shall appear to your judgment to merit it best, upon the same considerations that have induced me to send it to your Excellency.

> " I am, with the highest esteem, sir,
> " Your Excellency's most obedient
> " And obliged humble servant,
> " BUCHAN."

" General Washington,
 President of the United States of America."

" P. S.—I beg your Excellency will have the goodnes to send me your portrait, that I may place it among those I most honour, and I would wish it from the pencil of Mr. Robertson. I beg leave to recommend him to your countenance, as he has been mentioned to me favourably by my worthy friend, Professor Ogilvie, of King's College, Aberdeen."

Mr. Robertson says that, although " accustomed to intimate intercourse with those of the highest rank and station in his native country," his embarrassment on being introduced " to the American hero," was so obvious, that Washington entered into familiar conversation, with a view to putting his guest at his ease, and introduced him to Mrs. Washington, whose urbanity and ceaseless cheerfulness fully accomplished the general's intention.

Previous to sitting for his portrait, in compliance with Lord Buchan's request,† the president invited the artist to a family dinner, which he thus describes in a memorandum before us :

30,000 foot ; and the main division of his army was tampered with by a traitor, and rendered of no use to the patriotic army. Not long after the battle of Falkirk, Sir William was made prisoner by some of Edward's partisans, carried to England and beheaded.

* The general, with great wisdom, has desired the box to be returned to his lordship with this answer, " That it is not for General Washington to point out the worthiest citizen of the United States."

† See Cunningham's character of this *noble*-man, as quoted by me in this work, p 123.

" The dinner at three o'clock was plain, but suitable for a family in genteel circumstances. There was nothing specially remarkable at the table, but that the general and Mrs. Washington sat side by side, he on the right of his lady; the gentlemen on his right hand and the ladies on his left. It being on Saturday the first course was mostly of eastern cod and fresh fish. A few glasses of wine were drank during dinner, with other beverage, the whole closed with a few glasses of sparkling champagne, in about three quarters of an hour, when the general and Colonel Lear retired, leaving the ladies in high glee about Lord Buchan and the Wallace box."

The president sat to Mr. Robertson for a miniature, as did Mrs. Washington. From the miniature of Washington a larger picture was painted by the artist for Lord Buchan, "in oil, and of a size corresponding to those of the collection of portraits of the most celebrated worthies of liberal principles and in useful literature, in the possession of his lordship at Dryburgh Abbey, near Melross, on the borders of Scotland."

To conclude the history of the Wallace box, we give Washington's answer to Lord Buchan, and an extract from the hero's will.

Philadelphia May 1, 1792.

" My Lord—I should have had the honour of acknowledging sooner the receipt of your letter of the 28th of June last, had I not concluded to defer doing it till I could announce to you the transmission of my portrait, which has just been finished by Mr. Robertson, (of New-York,) who has also undertaken to forward it. The manner of the execution of it does no discredit, I am told, to the artist; of whose skill favourable mention had been made to me. I was farther induced to entrust the execution to Mr. Robertson, from his having informed me that he had drawn others for your lordship, and knew the size which best suited your collection.

" I accept, with sensibility and with satisfaction, the significant present of the box which accompanied your lordship's letter.

" In yielding the tribute due from every lover of mankind to the patriotic and heroic virtues of which it is commemorative, I estimate as I ought the additional value which it derives from the hand that sent it, and my obligation for the sentiments that induced the transfer.

" I will, however, ask that you will exempt me from compliance with the request relating to its eventual destination.

" In an attempt to execute your wish in this particular, I should feel embarrassment from a just comparison of relative

pretensions, and fear to risk injustice by so marked a preference. With sentiments of the truest esteem and consideration, I remain your lordship's most obedient servant,

"G. WASHINGTON."

"Earl of Buchan."

Extract from the will :

" To the Earl of Buchan I re-commit 'The box made of the oak that sheltered the brave Sir William Wallace after the Battle of Falkirk,' presented to me by his lordship in terms too flattering for me to repeat, with a request 'to pass it, on the event of my decease, to the man in my country who should appear to merit it best, upon the same conditions that have induced him to send it to me.' Whether easy or not to select the man who might comport with his lordship's opinion in this respect, is not for me to say ; but conceiving that no disposition of this valuable curiosity can be more eligible than the re-commitment of it to his own cabinet, agreeably to the original design of the Goldsmith's Company of Edinburgh, who presented it to him, and, at his request, consented that it should be transferred to me, I do give and bequeath the same to his lordship ; and in case of his decease, to his heir, with my grateful thanks for the distinguished honour of presenting it to me, and more especially for the favourable sentiments with which he accompanied it."

Mr. Robertson sent his picture to Europe by Col. Lear, and received the thanks of the earl of Buchan. From 1792 to 1821, Mr. Robertson exercised his profession in New-York, and likewise taught drawing and painting in water colours. He married Miss Abrams, (an only child, and understood to be a fortune,) and is surrounded by a numerous family. Good fortune and prudence going hand in hand, he retired from business at the last-mentioned period.

In 1802, he was one who assisted, with his advice, in the project of forming an academy of fine arts, and about the same time published an elementary book on drawing.

In 1816, when a second attempt was made to establish an academy of the fine arts, and an association was chartered under the title of the American Academy, Mr. Robertson was elected a director. The association consisted principally of lawyers, merchants, and physicians, with a few artists, and Mr. Trumbull was elected president. Mr. Robertson joined with another artist in recommending the establishment of schools, but the president overruled the measure, and defeated it by his influence with the board of directors, who being

105 New York from Long Island, 1794. Watercolor by Archibald Robertson. *Courtesy Columbia University.*

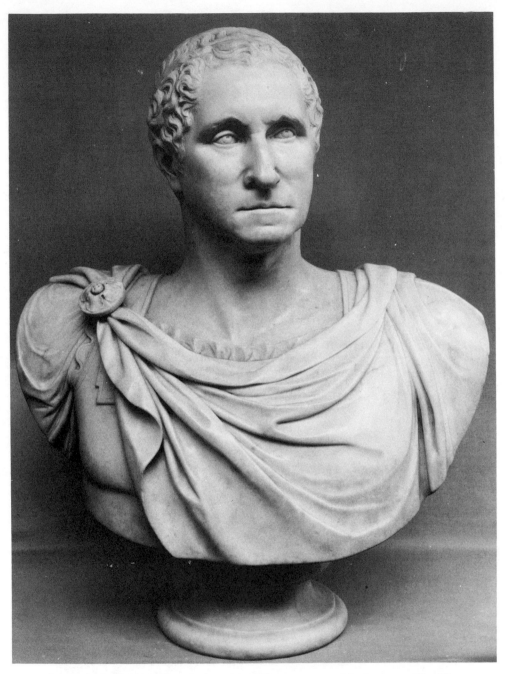

106 GEORGE WASHINGTON. Sculpture by Giuseppe Ceracchi. *Courtesy The Metro-politan Museum of Art, bequest of John R. Cadwalader.*

mostly not artists, were governed by his opinions, and the institution became merely a society for the exhibition of pictures, and so continues to this day.

Mr. Robertson found oil painting injurious to his health, and confined himself to water colours and crayons. Several portraits of this description, painted soon after his marriage, we have seen with pleasure; and he had great facility in the management of water colours on ivory. His exertions in his profession advanced the arts of design, and he is entitled to the gratitude of the country as one of those who forwarded the progress of the fine arts.

As an architect, though never professionally such, he has shown his skill on several occasions by plans for public buildings. He was among those who presented designs for the city hall of New-York. Mr. Robertson enjoys health and affluence, the reward of prudence and temperance; and at an advanced age retains his love for science and the arts, united to an activity of body and mind, giving him power to advance their interests.

GIUSEPPE CERACCHI—1791.

Giuseppe Ceracchi (or Ceracci), 1751–1802.

This great sculptor and enthusiastic republican was born at Rome about the year 1740. He was employed by the Pope, in conjunction with Canova, in designing and executing sculpture for the Pantheon. Louis Simond, in his travels in Italy, speaks of the monumental busts of the great artists of Italy, with which the Pantheon is decorated, as having been executed by " Canova and Ceracchi."

He left Italy on a visit to England, and arrived in London in the year 1772. He was well received by Sir Joshua Reynolds, then President of the Royal Academy, whose bust he executed in marble with great success and credit. He was the instructor, in modelling and sculpture, of the Hon. Anna Seymour Damer; who executed many works in marble, of sufficient merit to draw forth the praises of Horace Walpole, who compares her (and makes her equal) to the authors of the antique busts which have come down to us. Ceracchi executed a full-length figure of Mrs. Damer, " as the Muse of Sculpture;" in which, says Walpole, " he has happily preserved the graceful lightness of her form and her air."

The author of the Life of Nollekins says, (vol. II. p. 119. London edition, 1828)—" During the time I was under the tuition of Mr. Nollekins, Signor Giuseppe Ceracchi, a Roman, often visited the studio. He came to England in 1773,

with letters of recommendation from Nulty, a sculptor at Rome; was employed by Carlini ; and when he first exhibited at the Royal Academy, his residence was stated to be at that artist's house, in King-square court, now Carlisle-street, Soho-square.

" Mr. R. Adam, the architect, employed Ceracchi to model a basso-relievo, fourteen feet in length by six feet in height, of the Sacrifice of Bacchus, consisting of twenty figures, in Adams's composition,—a mixture of cement with oil, which is now called mastic, and similar to that used on the columns of the Theatre in the Hay-market, for the back front of the house of Mr. Desenfans, in Portland-road ; at whose decease it was sold by auction to the proprietors of Coade's artificial stone manufactory, in that part of the New Road called Tottenham Court ; and it is very tastefully modelled.

" The bust of Sir Joshua Reynolds, sold by the figure-casters, Mr. Northcote informs me, was also modelled by Ceracchi. Baretti, in his ' Guide through the Royal Academy,' when describing the Strand-front of Somerset House, thus speaks of him :—' The two figures nearest the centre were made by Signor Carlini : the two at the extremities, by Signor Ceracchi, an Italian sculptor, who resided some time in London, whose abilities the architect (Sir William Chambers) wished to encourage and keep among us ; but the little employment found in England for sculptors, however excellent, frustrated his intentions.' Ceracchi had, when I was taken to see him, very extensive premises, at No. 76, Margaret-street, Cavendish-square. He was a short thin man, with a piercing black eye, and a very blue beard. He was the Hon. Lady Damer's master in sculpture, as that lady declared to me herself.*

" Ceracchi, highly gifted as he certainly was, met so little encouragement in this country, that, after disposing of his property in Margaret-street, he quitted England for Rome ; where he continued to practise, as a sculptor, until the breaking out of the French Revolution,† when he became so violent a partisan, and so desperate, that he was condemned to death, as the leader of the conspirators connected with the infernal machine contrivance ; and was guillotined at Paris in 1801. —Ceracchi continued so frantic to the last, that he actually built himself a car, in which he was drawn to the place of execution in the habit of a Roman Emperor. David, the French

* He modelled a statue of his pupil, which, since the decease of Lord Fred. Campbell, has been carved in marble, and placed in the hall of the British Museum.

† This is erroneous, as will be seen.

painter, with whom Ceracchi had lived in intimacy, was called to speak to his character ; but he declared he knew nothing of him beyond his fame as a sculptor."

An ardent lover of the rights of man, Ceracchi conceived the design of erecting a monument to Liberty in the United States of America, and for this purpose crossed the Atlantic. In 1791 he arrived in Philadelphia, and prepared the model of a great work, designed to be one hundred feet in height, of statuary marble, and the cost was estimated at thirty thousand dollars.

The Congress, then sitting in Philadelphia, did not feel themselves authorized to expend the money of their constituents in erecting a monument of this description, and the sculptor was disappointed in respect to the government encouragement he had relied upon. He had, in the mean time, become acquainted with the first men of the United States, and had executed a bust, in marble, representing, with truth and characteristic dignity, the likeness of that great and good man, Washington. This beautiful piece of art and faithful portraiture, which is (with the exception of Gilbert Stuart's original painting, now in the Athenæum at Boston) the only true portrait of our hero, was purchased of Ceracchi by the Spanish ambassador for one thousand dollars, and sent to Spain, where it having been rejected by ' the Prince of the Peace,' for whom the ambassador intended it as a present, (but who probably thought such a bust as little suited to his cabinet as that of Brutus or Socrates would be) this excellent piece of art remained with the ambassador, and after his death, with his widow ; of whom Richard Mead, Esq. of Philadelphia, with true taste and patriotism, repurchased it, for the same sum received by Ceracchi, and sent it back to its native land.

General Washington not having the power, except in his private capacity, to forward Ceracchi's great plan of the monument, but admiring the model, and wishing to serve the man, advised him to try to obtain a subscription by private individuals, the amount of which should cover the expense. He accompanied this advice with a letter recommending the artist and the intended monument, and placed his name at the commencement of the subscription list. I give the whole of this letter and plan in the subjoined note.*

* Sir,—Herewith you will receive the description of a monument proposed to be erected to the American revolution, and the plan by which the means for the undertaking are to be provided.

The ardent sculptor was too impatient to await the success of this plan to raise the necessary fund, and returned poor and disappointed to Europe, in (I believe) 1795.

Those who truly admire the great event which established the liberty of this country, and who wish to see the blessing cherished by all who may be heirs to it, will need no exhortation to contribute their reasonable aid to a work which is so well calculated to blend with the glory of the present, a lesson to future generations.

Among the means employed by the wisest and most virtuous people for nourishing and perpetuating the spirit of freedom and patriotism, monumental representations are known to be amongst the most ancient, and perhaps, not the least influential. And as it is the happiness of this country to enjoy an occasion, more glorious and more auspicious to it, than has been the lot of any other, there ought to be felt a pride, as well as satisfaction, in commemorating it, by a spectacle as unrivalled as the occasion itself. Should the plan, now offered, be successful, this object will be fully attained; for it may, without hazard, be affirmed, that no similar work of equal magnitude and merit, can be boasted by the nations most distinguished for their munificent zeal in rendering the fine arts auxiliaries to the cause of liberty.

Although it was deemed proper to provide for an eventual assumption of the monument and the expense by the government of the United States; yet it was necessary, both as an immediate and a certain resource, to appeal to the patriotic liberality of individuals. In one view it may be particularly desirable that the monument should be founded on voluntary and diffusive contributions. The event to which it is dedicated, the emblems of which it is composed, and the effect which it is meant to produce, have all an intimate relation to the rights and happiness of the people. Let it be commenced then, not through the organ of the government as a political act, but in a mode which will best testify the sentiments which spontaneously glow in the breasts of republican citizens.

The artist contemplated for the work is Mr. Ceracchi, of Rome; who, influenced by admiration for the revolution, and by a desire of distinguishing himself as the instrument of erecting a monument worthy of so great a subject, came to the city of Philadelphia in 1791, with a design to prosecute the undertaking, if sufficient means could be found. Since that period he has prepared the model, of which the description is annexed. The model of itself evinces the capacity, genius and taste of the author, and concurs with other proofs of his distinguished qualifications, to inspire a wish that he could be enabled to execute his plan. The material of the monument is to be statuary marble; its height one hundred feet; its circumference three hundred feet; the height of the principal figure fifteen feet, and the others of various proportional dimensions. It is computed that ten years will be required to complete it.

A hope is entertained that the public spirit of the citizens of the United States, seconded by a taste for the fine arts, will induce them not to suffer to escape so fair an opportunity of raising a lasting monument to the glory of their country; and that a sufficient number will be found ready to furnish, by subscriptions, the necessary sums. The confidence which is placed in your personal disposition to forward the commendable design, has pointed you out, among a few others, for soliciting and receiving the subscriptions, and is the apology for imposing the task upon you.

A description of the monument consecrated to liberty:

The goddess of liberty is represented descending in a car drawn by four horses, darting through a volume of clouds, which conceals the summit of a rainbow. Her form is at once expressive of dignity and grace. In her right hand she brandishes a flaming dart, which, by dispelling the mists of Error, illuminates the universe; her left is extended in the attitude of calling upon the people of America to listen to her voice. A simple *pileus* covers her head; her hair plays unconfined over her shoulders; her bent brow expresses the energy of her cha-

During the time Ceracchi remained in this country, he modelled and chiseled many busts of distinguished gentlemen connected with the revolution, some of which I can par-

racter; her lips appear partly open, whilst her awful voice echoes through the vault of heaven, in favour of the rights of man. Her drapery is simple; she is attired in an ancient *chlamys*, one end of which is confined under her zone, the rest floats carelessly in the wind; the *cothurnus* covers her feet.

Saturn is her charioteer, emblematical of the return of the golden age; he has just checked the horses, upon his arrival on the American shore. Immediately as the car lights upon the summit of a lofty rock, various groups are seen issuing from compartments at its base, to hail the descent of the goddess, by whose beneficent influence they are at once animated into exertion.

The first compartment is consecrated to poetry and history. Apollo, attired in the characteristic dress of that deity, is seated with his lyre in his hand, and his countenance glowing with the sublimity of his song. Clio is employed in recording the hymns with which Apollo salutes the arrival of the goddess of freedom; while the INDEPENDENT STATES, which are blessed by their influence, appear upon a globe which is placed beside her.

In the second compartment, Philosophy, without whose assistance liberty would soon be obscured by ignorance, is represented as presiding at this memorable epoch. He appears in the character of a venerable sage, with a grave and majestic aspect. On his head he wears the *modius*, an ornament given to Jupiter by the Egyptians, as a symbol of perfect wisdom. The fasces are in his hand. He is seated, dressed in the consular habit, and leaning upon the altar of Justice. As the inflexible friend of Truth, he is seen tearing off from a female figure, who stands near him in the character of Policy, the false veil which has so long concealed the science of government. Anxiety appears painted on the countenance of Policy; her head is shaded by a small pair of wings; her right arm supports a roll of geographical charts; and a robe of exquisite thinness, gives an additional appearance of velocity to her motion. The gigantic figure below (designed to represent National Valor) rises at the voice of Liberty to combat the oppressors of his country. He eagerly seizes on his arms, which lie near him, and prepares to abandon the tranquil occupations of agriculture for the hazards and tumults of war. His form is muscular and robust; his mantle is thrown carelessly over him; the disorder of his hair, and the fierceness of his countenance inspire Despotism with terror.

The adjoining group represents Neptune seated between two rivers; he appears exhorting Mercury (who stands near him) to take American commerce under his protection, and to increase the glory of the American flag.

At the powerful voice of liberty NATURE, whose simplicity had been forced to give way to the introduction of the meretricious refinements of *art*, appears starting to life, burst from the bosom of the earth, and seems about to resume her ancient dignity. A dewy mantle, studded with stars, is supported by her right hand; with her left she is employed in expressing streams of water from her flowing ringlets, allegorically emblematic of the source of rivers.

The last group represents Minerva, the patroness of the arts and sciences. In order to designate the country to which they owe their origin, she is seated on a fragment of an Egyptian obelisk, and holds the *papyrus* in her left hand. Near her stands Genius, with a flambeau in one hand, and a butterfly, the emblem of immortality, in the other—expressive of the grand principles of fire and animation. His countenance is fixed in an attitude of silent attention, whilst the goddess commands him to inspire, with his divine influence, the bosom of the children of Freedom. Behind, is a figure designed to represent Fame, with her appropriate emblem. A pair of ample pinions shades her shoulders; she holds her trumpet in her left hand; and, with her right, points to the Declaration of Independence, which is inscribed upon a massy column.

ticularize; and first the admirable marble bust of Hamilton, in the possession of that great man's family—the bust of Jefferson, deposited at Monticello—that of George Clinton, the revolutionary governor of New-York—another of Egbert Benson—one in terra cotta of Paul Jones, and another of John Jay. The artist took to Paris, with the model of the intended monument, many other models in clay—some of distinguished men—but in his wreck all have been lost, and no trace of them remains. This unfortunate, or imprudent and

Articles of subscription towards erecting a monument to the American revolution.

I. Thirty dollars to be the amount of subscription for one year.

II. Each person, at discretion, to subscribe for one year, or for any greater number of years, not exceeding ten.

III. Where the subscription of any person shall be for one year, the whole sum to be immediately paid; where it shall be for more than one year, the amount of one year's subscription to be immediately paid; and an equal sum on the first Monday in January in each succeeding year, during the term for which the subscription shall be made; unless the subscriber shall prefer to make greater or earlier payments.

IV. The monies subscribed and paid shall be deposited in the Bank of the United States, to the credit of " The subscribers towards erecting a monument to the American revolution," and shall be subject to the disposition of the secretaries of state, of the treasury, and of war, the attorney-general, and the treasurer of the United States, for the time being; who, or any three of whom, being met together, are hereby empowered, by majority of voices of those met, to apply the said monies to the purpose of erecting the said monument, in such manner as shall appear to them proper.

V. The work shall not be begun until the sum of thirty thousand dollars shall have been subscribed and paid; and in case it should happen that the said sum should not be subscribed in one year from the date thereof, the monies which shall have been subscribed and paid shall revert to the subscribers, whom the said managers shall cause to be reimbursed.

VI. Subscriptions may be received by and paid to any person who may have a copy of this paper, certified by the managers and persons named in the fourth article.

VII. The United States may, at any time within six calendar months after the monument shall be completed, become proprietors thereof, or, at any time sooner, may become proprietors of so much thereof as shall have been executed by making effectual provision for reimbursing the subscribers, or their lawful representatives, the sums which shall have been advanced by them, towards carrying on the work.

VIII. The monument shall be erected or placed at the permanent seat of the government of the United States.

IX. The said managers, if they shall judge it necessary, may convene the subscribers, (giving six months notice of the time and place of meeting, in one or more gazettes or newspapers,) who may convene in person, or by proxy, or attorney, and shall be entitled each to one vote for each yearly subscription, which he or she shall have subscribed and paid.

X. Those whose names are subscribed hereto, severally engage to pay, according to the tenor of the third article hereof, thirty dollars for each year of the number of years set against their respective names.

Dated, this fourteenth day of February, in the year one thousand seven hundred and ninety-five.

With great consideration we are, sir, your very obedient servants.

Philadelphia, February 14, 1795.

misled man of talents, when oppressed by poverty, and disappointed in his hopes of assistance from the government of the United States, or of adequate employment from our citizens, made several unjustifiable efforts to relieve himself from pecuniary embarrassment. He requested sittings from distinguished individuals, who, thinking to do him service, sacrificed their time to what they thought his wish to possess their portraits, and he, having finished their busts in marble, demanded large sums, as though he had been employed, or the work ordered. In this manner it is said that Alexander Hamilton's invaluable likeness was executed, and that eminent statesman and soldier yielded to the unexpected demand.

I find, in Dr. Hosack's "Medical Essays," an account of another attempt of this nature recorded. In vol. 1st, p. 202, the doctor, in a biographical memoir of Hugh Williamson, M. D., says :—

" Joseph Ceracchi, an Italian statuary of great celebrity in his profession, finding the turbulent state of Europe unfavourabe to the exercise of his art, had come to this country. This gentleman exercised his talents in erecting honorary memorials of some of our most distinguished public men.

" He, at that time also, as appears by a correspondence in my possession, applied to Dr. Williamson, then a member of congress, for permission to perpetuate in marble, the bust of the *American Cato*, as Mr. Ceracchi was pleased to denominate him. I beg leave to read the originals :

" Mr. Ceracchi requests the favour of Mr. Williamson to sit for his bust, not on account of getting Mr. Williamson's influence in favour of the National Monument ; this is a subject too worthy to be recommended ; but merely on account of his distinguished character—that will produce honour to the artist, and may give to posterity the expressive features of the American Cato."

" To this note Dr. Williamson replied in his appropriate caustic style :

" Mr. Hugh Williamson is much obliged to Mr. Ceracchi for the polite offer of taking his bust. Mr. Williamson could not possibly suppose that Mr. Ceracchi had offered such a compliment by way of a bribe ; for the man in his public station who could accept of a bribe, or betray his trust, ought never to have his likeness made, except from a block of *wood*.

" Mr. Williamson, in the mean time, cannot avail himself of Mr. Ceracchi's services, as he believes that posterity will not be solicitous to know what were the features of his face. He hopes, nevertheless, for the sake of his children, that posterity

will do him the jnstice to believe that his conduct was upright, and that he was uniformly influenced by a regard to the happiness of his fellow-citizens, and those who shall come after them."

Ceracchi became a citizen of the French republic, and not brooking Bonaparte's successful schemes for the overthrow of all liberty, and establishment of his despotism, the sculptor entered into a conspiracy for the destruction of the First Consul, before he should have rivetted the chains already forged for the nation.

It has been repeatedly asserted that he was concerned in the infamous attempt to murder by the justly denominated *infernal* machine, but it was not so. He had entered into a conspiracy with Georges and others, and he was either to assassinate the tyrant when sitting to him for his bust, or to aid others in doing it. So far had he been deceived and blinded by his fierce passion for what he justly considered the prime blessing of man, political liberty, that he had persuaded himself that it was justifiable, or meritorious, to become a deceiver, a traitor, and a murderer, even in the sanctuary of his own apartment.

One account of this nefarious affair states, that Ceracchi had apartments in the opera house, where he received his sitters and executed his statuary, and that in this place the murder was to have been committed; but the plot being discovered, the artist was tried, convicted, avowed his intention, and justified it to the hearers as he had justified it to himself, and was sentenced to death, but was not guillotined or publicly executed, but removed to some bastile, where he ended life in oblivion—when or where it is not said.

Madame Junot gives another version of the conspiracy to assassinate Bonaparte; and I insert, from her memoirs, the passages relative to this extraordinary affair, and misled man. Junot, at that time commandant of Paris, had endeavoured to persuade his wife and her mother not to go to the opera on the 11th of October, he knowing that the first consul was to be there, and that the conspirators intended *there* to murder him. The ladies, however, persisted in going, of course not knowing Junot's motives, which he would not divulge. Junot left them.

"When he returned to the box, his countenance, which all day had been serious, and even melancholy, had resumed in a moment its gaiety and openness, relieved of all the clouds which had veiled it. He leaned towards my mother and said, very low, not to be heard in the next box, 'Look at the first consul, remark him well.'

"'Why would you have me affect to fix my eyes on him?' said my mother, 'it would be ridiculous.'

"'No, no, it is quite natural. Look at him with your glass; then I will ask the same favour from Mademoiselle Laurette.' I took the opera glass from my brother, and looked at him in my turn.

"'Well,' said the general, 'what do you observe?'

"'Truly,' I replied, 'I have seen an admirable countenance; for I can conceive nothing superior to the strength in repose, and greatness in quiescence, which it indicates.'

"'You find its expression, then, calm and tranquil?'

"'Perfectly. But why do you ask the question?' said I, much astonished at the tone of emotion with which the general had put the question.

"He had no time to answer: one of the aids-de-camp came to the little window of the box to call him out. This time he was absent longer; and on his return wore an air of joy: his eyes were directed towards the box of the first consul, with an expression which I could not understand. The first consul was then buttoning on the gray coat which he wore over the uniform of the guards, the dress which he then always wore, and was preparing to leave the box. As soon as this was perceived, the acclamations were renewed, as vehemently as on his entrance. At this moment Junot, no longer able to conquer his emotion, leaned upon the back of my chair, and burst into tears. 'Calm yourself,' said I, leaning towards him to conceal him from my mother, who would certainly have exercised her wit upon the subject: 'calm yourself, I entreat you. How can a sentiment altogether joyful produce such an effect upon you?' 'Ah!' replied Junot, quite low, but with an expression I shall never forget, 'he has narrowly escaped death! the assassins are this moment arrested.'"

After their return home, Junot informs his wife's mother "that Ceracchi and Aréna, the one actuated by republican fanaticism, the other by vengeance, had taken measures to assassinate Bonaparte.

"We have yet only taken Ceracchi, Aréna, and I believe Demerville. They are just taken, but they were not the only conspirators."

Junot gives the following account of a scene between himself and Fouché on the subject:—

"And what do you think he said upon this resolution of the first consul to go to the opera? He blamed him as I did; but what was the motive? 'Because,' says he, 'it is an am-

bush !' You suppose, no doubt, that this deprecated ambush was for the first consul? No such thing ; it was for those honest rascals, whose necks I would wring as willingly as a sparrow's, and with no more scruple, after what I have learned of them and the honourable functions which I find them exercising. He made an oration, which, I believe, was taken from his collection of homilies ; by which he proposed to prove, that affair might be prevented going to this length. As I had already had a very warm discussion, upon the same subject, with a personage whom the First Consul will know, I hope, some day for what he is, (and the time is happily not far distant) and as I know that this personage and Fouché had been emulating each other in their interference in this affair, I was desirous that my way of thinking should be equally known to both of them. I therefore constrained Fouché to explain himself clearly, and to tell me that it was wrong to lead on these men to the moment of executing their design, since it could be prevented. That was his opinion.

"And thus," said I, " you would replace in society those who have evidently conspired against the chief of the state ; and that not to force him to resign his authority, not to remove him from it, but to murder him—and to murder him for the satisfaction of their own passions. Do you believe that Ceracchi—content to die, if, in sacrificing himself, he can kill the First Consul—putting him to death to glut an inordinate passion, in obedience to a species of monomania—do you believe this madman will be cured by a simple admonition, or by an act of generosity? No : he must kill this man, whom he looks upon as a tyrant, and whom he will never be induced to see in any other light. Or do you believe that Aréna, during so many years the enemy of General Bonaparte, will abjure his hatred against the First Consul, because the latter has taken up the character of Augustus? No : It is his death they desire. Listen to the expression of Ceracchi, in buying a poniard : ' I should like a knife better : the blade is solid and sure, and does not foul the hand.' To leave a determined assassin like this to his blood-thirsty contrivances, what is it but to insure to-morrow the full execution of the project you have averted to-day.

" This is not my first knowledge of the Arénas. The First Consul, who is thoroughly good-hearted, is willing to forget the evil they have always been forward to do him ; but I have not so forgiving a soul. I remember his arrest in the south : I have heard the particulars of the 18th Brumaire, and I am completely acquainted with the circumstances of the present

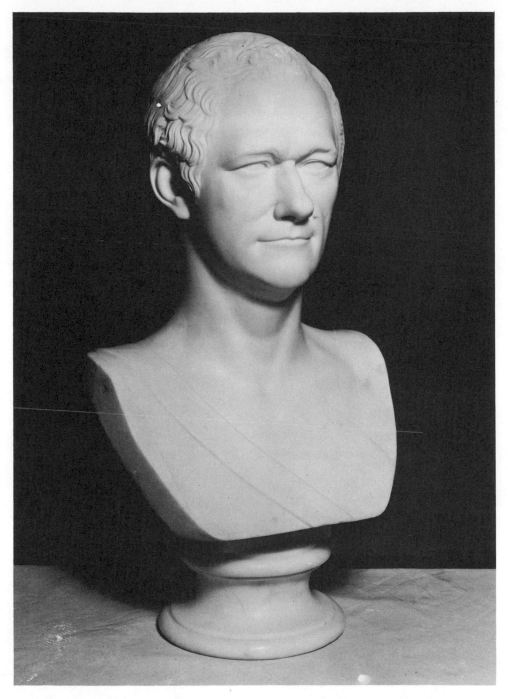

107 ALEXANDER HAMILTON. Sculpture by Giuseppe Ceracchi. *Courtesy The New-York Historical Society*.

108A LEWIS ADAMS, 1828. Miniature by Benjamin Trott. *Courtesy Amherst College, bequest of Herbert L. Pratt.*

108B MR. POINER (John Woods Poinier). Miniature by Benjamin Trott. *Courtesy Museum of Art, Rhode Island School of Design.*

affair. Certainly I tremble to see the First Consul go to face the death which, notwithstanding all our cares, he might encounter : but, on the other hand, I saw but this means of cutting through the net they had cast around him. His existence would be rendered miserable, supposing it was preserved.— There would be daily new conspiracies—a hydra, constantly reviving. When Fouché," continued Junot, " found that I saw through him, notwithstanding his cunning, he had recourse to the sentiments of humanity. He ! Foucèé ! he harangued me in the style of a homily : and all this with that head that one would have supposed he had stolen from a skeleton. Oh ! what a man ! And the First Consul will place faith in his words ! At length we shall see the conclusion of this affair, which he and another called child's play—reason in all things."

" With respect to Ceracchi, nothing you could say of him would surprise me. Permon, who knew him in Italy, introduced him to me at a ball at M. Delanoue's. Since then I have sometimes seen him at Madame Magimelli's, at Anteuil. I acknowledge his exaggerated notions have made me tremble ; while his distaste of life, and his profound melancholy, made him interesting. Albert observed that his heart must have been profoundly wounded by the injuries with which he imagined Italy had to reproach Bonaparte : ' For I have seen him,' said he, ' weep with enthusiasm in only speaking of him.' And when he was required to model his bust, or rather, when he himself requested permission to execute it, he was so much affected in delineating the traits of him whom he believed destined to regenerate the world, that I have heard it asserted by persons who knew the fact, that he was compelled to abandon the task. This man had a soul of fire !" Madame Junot says :—

" I had also seen this Ceracchi, and witnessed some of his ebullitions of enthusiastic republicanism at Madame Magimelli's ; and I confess he had not produced upon my mind the same disagreeable impressions that he had upon my mother's. I pitied him warmly, for it was impossible not to perceive that his excessive sensibility must render him miserable."

Lucien Bonaparte is reported to have said, " How can such strokes be averted ? Jaques, Clement, Ravillac, Damien, Jean Chatel—all these men executed their projects ; because, in forming them, they held their own lives for nothing. If Ceracchi had been alone, as was his original intention, my brother had been no more. But he thought, by taking associates, to make his success more certain. He deceived himself." This is all I can find respecting Ceracchi.

BENJAMIN TROTT—1791.

Mr. Trott is one of the few artists who have shrunk from rendering me that assistance which even a few dates would give in raising, what I hope and believe will be, a monument to the arts of America. I give my own knowledge, and such as flows incidentally from the communications of artists, who have not hesitated to furnish me with materials and help to put them together.

Trott commenced his career, as a portrait painter in miniature, about the year 1791; which will allow us to guess that he was born not far from 1770. In 1793 he painted a good miniature head, and practised successfully in New York when Gilbert Stuart arrived there from Dublin, in company with Walter Robertson. Walter Robertson was a native of Ireland; and I believe Trott first saw the light in or about Boston. Robertson's style was very singular and altogether artificial; all ages and complexions were of the same hue—and yet there was a charm in his colouring that pleased, in despite of taste. Trott's manner was more in the old way and more natural. Robertson was employed very much in copying Stuart's portraits; and with his colouring, and Stuart's characteristic likenesses, he was at the pinnacle of fame for a time. Stuart did not like that another, with another set of colours, should be mounted above him, on his own shoulders; and for that reason, and the more natural colouring of Trott, preferred the latter, assisted him by advice, and recommended him.— Trott's blunt and caustic manner was probably to Stuart's taste.

Notwithstanding Stuart's approbation, Trott longed to be able to imitate the colouring of Walter Robertson; and I remember to have seen in his possession one of the Irishman's miniatures, half obliterated by the Yankee's experiments, who, to dive into the secret, made his way beneath the surface like a mole, and in equal darkness.

He followed or accompanied Stuart when he removed from New-York to Philadelphia; and that city was his head quarters for a great many years. His copies on ivory, with water colours, from Stuart's oil portraits, were good—one from the Washington, extremely beautiful and true.

Who Trott's early instructors were, or whether he had any instructors, other than such as pictures and occasional contact with painters afforded, I know not. He certainly had attained a great portion of skill before he made his appearance in New-York. A well painted miniature is to me a source of

delight, and some of Mr. Trott's are of great beauty. I speak
of the miniatures of the painter in his best days—for the days
of decay generally attend the artist as well as his work.

In 1805 Mr. Trott visited the western world beyond the
mountains, travelling generally on horseback, with the imple-
ments of his art in his saddle-bags. This was a lucrative
journey. He returned to Philadelphia in 1806, at which time
I was there with my friend Charles Brockden Brown ; and I
became somewhat intimate with Trott, and pleased with the
pungency of his remarks and amused by the eccentricity of
his manners. At this time his reputation was at its height,
and he might have commanded more employment than he did,
but he was visited by a most mischievous notion, a disease of
the mind, which occasionally affects painters—this was a firm
conviction, that some vehicle had been discovered for convey-
ing colours to the ivory, which gave force, clearness, and every
good quality ; but that it was kept secret by those who used
it, and gave great advantages to certain colourists. This me-
grim having taken possession of his brain, the consequence
was, that if the time which spent in drawing and practising
with pure water, would have produced the effect he wished,
was wasted in filterings and chemical experiments. He pur-
sued a phantom, as alchymists of old sought the philosopher's
stone—and with the success—to the same encouragement of
irritability of temper, already too sensitive, and the waste of pro-
perty and more precious time. I must however acknowledge,
that by his distillations and filterings he produced some of the
cleanest pigments that ever I used ; and he bestowed upon me
specimens of all the necessary colours for miniature.

In 1806 he justly considered that he had nothing to fear
from my rivalry—he would not have been so liberal towards
Malbone. The fame of this young painter annoyed Trott, for
he had none of that feeling which rejoices at a rival's success,
nor of that self-confidence which perhaps causes the generous
sensation. Malbone proposed an exchange of specimens with
him, probably to show the different manner by which two emi-
nently successful artists arrived at their respective excellence.
But Trott considered and denounced it, as an insidious mode
of comparison with his own : forgetting, that if such an advan-
tage could be taken by one, it was equally in the power of the
other. Though not acknowledged, this jealousy shows a con-
sciousness of inferiority, or at least a fear of the humiliating
truth.

In 1808, Mr. Trott and Mr. Sully were joint tenants of a
house in the metropolis of Pennsylvania, pursuing their re-
spective branches of the art. Mr. Sully, who long knew Trott,

says, that he was in all things extremely sensitive; and in many things generous and truly right minded.

When Sully returned from Europe, in 1810, he again took a house in conjunction with Trott. But during the violence of the opposition made by the associated artists to the Pennsylvania Academy of Fine Arts, Trott, led by Murray, spoke harshly of Sully, because, being a director of the academy, he did not join the association in their opposition.

In 1812 Mr. Trott exhibited, at the Academy, several miniatures of great merit. "The works of this excellent artist," says a writer in the Portfolio, " are justly esteemed for truth and expression. In examining his miniatures, we perceive all the force and effect of the best oil pictures; and it is but fair to remark, that Mr. Trott is purely an American—he has never been either in London or Paris." The same writer compares Trott's miniatures to Stuart's oil paintings : without going so far, I can speak with approbation of two of his portraits, which had extraordinary merit, that of Benjamin Wilcox, Sully's friend, and a friend of the arts ; and a lady in a black laced veil. Very dissimilar in manner, but both very fine.

In 1819, when passing through Philadelphia, I found Trott preparing to go south, Philadelphia had become too cold for him. He went to Charleston, South Carolina, and some one has remarked, that at the same time there were in that city three artists of the names of Trott, Rider and Canter. He returned to Philadelphia, and was generally to be found there until he made a mysterious marriage; and not having the effrontery to announce as " Mrs. Trott," a person whose origin he was ashamed of, he, after suffering for some time, took refuge in New-Jersey, whose laws offered him a release in consequence of a limited term of residence, and he resided for some years in obscurity at Newark.

He did not return to Philadelphia, where his business and reputation had suffered, but removed to New-York; and his miniatures having become poor, and appearing poorer in comparison with those of younger artists, he tried oil portraiture with no success. He painted a few oil-portraits in New-York; but although he had enjoyed intimately the opportunity of studying Stuart, and was an enthusiastic admirer of his manner, nothing could be more unlike Stuart's portraits than those painted by Trott.

After remaining in New-York some years, rather in obscurity, generally shunning his acquaintance, he went to Boston, probably his native place, in the year 1833, after an absence of perhaps more than forty years.

Trott was rather inclined to be caustic in his remarks upon others, (especially artists,) than charitable. He would introduce a bitter remark with a kind of chuckle, and " upon my soul I think," and conclude with a laugh, " I think so, upon my soul I do." If he saw any one in the street approaching, with whom he had a temporary *miff*, or feeling of offended pride, or who for any other cause, or no cause, he wished to avoid, he would turn the first corner or cross the street, and this was so frequent, that any one walking with him would be surprised or amused by the eccentricity of his proceeding: if he had time and opportunity he would say to his companion, " come this way," if not, he would leave him abruptly.

Of the full medium height, thin, with a prepossessing countenance, Mr. Trott had qualities which ought to have led to better results. An early marriage with one whom he could honour and present to his friends, without blushing and without effrontery as his wife, would probably have secured to him respectability and domestic happiness.

JEREMIAH PAUL—1791.

Jeremiah Paul, Jr., ?–1820.

This was one of the unfortunate individuals, who, showing what is called genius in early life, by scratching the lame figures of all God's creatures, or every thing that will receive chalk or ink, are induced to devote themselves to the fine arts, without the means of improvement, or the education necessary to fit them for a liberal profession. They arrive at a certain point of mediocrity, are deserted, and desert themselves.

About the year 1791, Paul commenced portrait-painter, after having copied prints, and even made some enlarged oil pictures from the engravings of West's pictures. I remember Cromwell dissolving the long parliament. " Take away that bauble."

John Wesley Jarvis mentions him thus, in a letter to me : " About 1800, there were four painters in partnership," this was in Philadelphia, " Jeremiah Paul was good," Jarvis must mean compared to the others, " Pratt was pretty good—he was generally useful," he was far superior to Paul. " Clark was a miniature painter—Retter was a sign painter—but they all would occasionally work at any thing, for at that time there were many fire-buckets and flags to be painted. When Stuart painted Washington for Bingham, Paul thought it no disgrace to letter the 'books.' "

When Wertmüller's Danae made a noise in our cities, Paul tried his hand at a naked exhibition figure, which I was induc-

ed to look at, in Philadelphia, but looked at not long. Neither did it answer Paul's purpose. Our ladies and gentlemen only flock *together* to see pictures of naked figures when the subject is scriptural and called moral.

In 1806, I found Paul in Baltimore, painting a few wretched portraits, and apparently prostrated by poverty and intemperance. This is the last I have known of him. He was a man of vulgar appearance and awkward manners.

J. R. Lambdin, Esq. a pupil of T. Sully's and native of Pittsburg, in a letter to me, says that Paul " Visited Pittsburg in 1814, painted many good portraits and better *signs*. From the sight of one of the latter I date my first passion for the profession I pursue : it was a full length copy of Stuart's Washington, and was elevated over the door of a coffee-house, in a diagonal corner opposite my mother's house." Again, " Paul introduced to the admiration of the citizens the exhibition of phantasmagorias, and, *I believe*, painted the first scenery, to the first theatre erected in the west. He died in Missouri about the year 1820."

CHAPTER XXII.

The school for the fine arts—The Columbianum—The New-York Academy of Fine Arts—Pennsylvania Academy.

1791. ACADEMIES (real and nominal) of the fine arts, form an important item in the progress of the arts of design. The first attempt at such an establishment was

THE SCHOOL FOR THE FINE ARTS—1791.

Charles Wilson Peale, in the year above-mentioned, attempted to form an association under this title. Ceracchi, the great sculptor, joined in the scheme, but it proved abortive. Mr. Peale made a second attempt, and called the intended institution

THE COLUMBIANUM—1794.

In this he was rather more successful. He collected a few plaster casts, and even opened a school for the study of the living figure, but could find no model for the students but himself. The first exhibition of paintings, in Philadelphia, was opened this year, in that celebrated hall where the declaration of independence was determined upon and proclaimed.

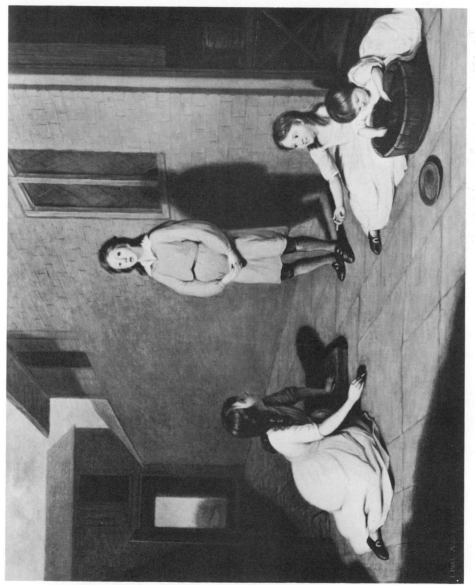

109 CHILDREN PLAYING IN THE STREET, 1795. Painting by Jeremiah Paul. *Courtesy Kennedy Galleries, Inc.*

POUGHKEEPSIE.

110 SKETCH OF POUGHKEEPSIE, 1796. Drawing by Alexander Robertson. *Courtesy The New-York Historical Society.*

The pictures were borrowed from the citizens. This association of artists, of whose names I find only Charles Wilson Peale, Joseph Ceracchi, and William Rush, held their meetings at the house of Mr. Peale. Some other artists, principally foreigners, joined in this plan; but the foreign artists, and Ceracchi at their head, separated from the Columbianum, and after the first exhibition it died. Ten years after Mr. Peale's first attempt, some of the most enlightened citizens of New-York, with a view to raising the character of their countrymen, by increasing their knowledge and taste, associated for the purpose of introducing casts from the antique into the country. These worthy citizens, though none of them artists, called themselves

THE NEW-YORK ACADEMY OF THE FINE ARTS—1801.

At a meeting of these gentlemen, Dec. 3, 1802, Edward Livingston was requested to take the chair, and by ballot the following persons were elected :—Edward Livingston, *president*, Col. Wm. Smith, Dr. Jos. Brown, John B. Prevost, Wm. Cutting, Wm. M. Seton, and Stephen Van Rensselaer, *directors*, Robert L. Livingston, *treasurer*, Dr. Peter Irving, *secretary*. It was resolved to form laws, to apply for an act of incorporation under the title of " The New-York Academy of the Fine Arts," and to extend the shares to five hundred, to be paid by instalments.

*The charter was not obtained until 1808. The words "New-York" were exchanged for " American," and the word " Fine" was omitted. We had then these gentlemen of every profession, but that of an artist, constituted by law an academy of arts. By this charter, dated Feb. 12, 1808, to continue in force twenty-five years, Robert R. Livingston and

* Robert R. Livingston, Esq. when residing in Paris as ambassador from this country, purchased by order of these gentlemen, and sent to New-York, the following plaster casts :—The Apollo Belvidere—Venus of the capitol—Laocoon —Gladiator—Silenus—Grecian cupid—Castor and Pollux—Germanicus—Hermaphrodite—Venus of the bath and Torso of Venus—with the busts of Homer, Demosthenes, Niobe, Euripides, Hippocrates, Artimisia, Cleopatra, Alexander, Bacchus, Roma, Seneca, Augustus, Cicero, Brutus, and Zenophon.
I copy this from a list furnished by John G. Bogert, Esq. When these casts arrived in New-York, a building on the west side of Greenwich-street, which had been erected for a circus or riding school, was hired, and the statuary opened for public exhibition. This did not attract much attention ; and the funds of the society suffering, the casts were packed up and stored. After the charter was granted, the use of the upper part of a building, once intended as a house for the president of the U. S., but occupied as the custom house, was loaned to the *academy*, and the casts removed thither. They were again removed, packed up, and stored, until 1816.

others then being, and such as may become members, are constituted a body coporate, with the usual privileges, their income being limited to $5000 the year: the stock not to consist of more than one thousand shares at $25 the share: the management to be with a president, vice-president, and five directors. The first officers were Robert R. Livingston, *president*, John Trumbull, *vice-president*, Dewitt Clinton, David Hosack, John R. Murray, William Cutting, and Charles Wilkes, *directors*. It will be observed that there was now *one* artist in the association, Mr. Trumbull. The casts and books were removed to the upper story of the custom house, which was granted rent free, and there exhibited for a time, then re-packed and re-stored, sleeping quietly with the association.

In the mean time the importation of casts into New-York, and the name of an academy of arts, produced important effects in the sister city of Philadelphia. We have seen above, that *the artists* of Philadelphia made the first move in the cause of the fine arts; but were too few, and too poor probably, to establish an academy. If they had succeeded, a *real academy* would have been opened, with schools for various branches, and teachers for the schools.

In 1805, Jos. Hopkinson, Esq., stimulated by a view of the casts executed in Paris after the antique, which were in the possession of the New-York academy, and, by his own taste and patriotism, proposed to several gentlemen of Philadelphia the establishment of a similar institution. They undertook it with zeal, and executed it with promptitude. Seeing that the nominal academy of arts was useless, and attributing it to the want of a building for the casts, they erected an elegant and appropriate building, while the necessary measures for procuring plaster casts from Europe were pursued, and in April, 1807, the Pennsylvania Academy of Fine Arts was opened, a charter having been obtained in 1806, and a president and directors elected, among the latter were two artists. On this occasion an address was delivered by Mr. Clymer, the president of the institution. At first, statues and busts alone were thought of for exhibition; but Mr. Robert Fulton, of New-York, having purchased a portion of Alderman Boydel's great Shakspeare Gallery, and other excellent European paintings, placed them with the Pennsylvania academy, for their use and the public gratification. The great attention which these pictures excited, suggested the idea of establishing annual exhibitions for the advantage of the academy and the improvement of public taste.

In May, 1810, a number of artists and amateurs of Philadelphia formed an association, which they denominated " The Society of Artists of the United States." They drew up a constitution, which was signed by sixty persons. They were invited by the members of the Pennsylvania Academy, to hold their meetings in the building erected by those gentlemen, and they accepted the invitation. In six months the society increased to upwards of one hundred, and they proposed an union with the academy, so as to form but one institution; this, however, was found impracticable at the time, and shortly after an arrangement was made, and a written agreement entered into, and signed by five members of each institution, by which, for a consideration of two thousand dollars, proposed as the wish of the society, the members of the society became entitled to " free admission to the academy in like manner with the members thereof;" to the right of using the specimens of art; to " the right of making their annual exhibition in the rooms of the academy for six weeks; during which time the academy also to be open to the inspection of the visitors of the exhibition," and to the most commodious rooms and the use of the property generally for the schools of the society.

On the 6th of May, 1811, the first annual exhibition of the *Society of Artists of the United States*, in conjunction with the directors of the academy, was opened to the public; previously to which an oration was delivered by Jos. Hopkinson, Esq. The receipts of the exhibition, during the stated period of six weeks, amounted to eighteen hundred and sixty dollars. After which, by concurrence of the two associations, the exhibition was continued one week longer, for the benefit of the sufferers by fire in Newburyport, Massachusetts—four hundred and ten dollars was received, and appropriated to this purpose.

On the 8th of May, 1811, an oration was delivered *before the Society of Artists* and the public, by Benjamin H. Latrobe, Esq., and on the fifth of June following, a committee was appointed by the Society of Artists to confer with a committee of the Pennsylvania Academy, on the subject of a more intimate union of the institutions; but a difference of opinion produced a resolution of the society, that it was best to continue a " distinct and independent institution."

Thus it will be seen, that a real Academy for teaching the fine arts, was formed, under the title of " Society of Artists," while the associated patrons of the arts were by law called the Academy. The first exhibition of the " Associated Artists" was made, by agreement, under the roof of the " Pennsylvania

Academy of the Fine Arts," in 1811. This exhibition I attended, but my notes on the subject are very meagre. A Ceres, by Wertmüller, is mentioned with dissatisfaction—a street, by Strickland, the architect—and Views on the Schuylkill, by T. Birch.

The Society of Artists, and the Pennsylvania Academy, both opened schools ; and the consequence of a want of union, between those who held the purse and those who possessed the knowledge, was, that the schools languished and failed. The Society of Artists, after a time, dissolved ; and the Pennsylvania Academy of the Fine Arts became, and has continued, merely an Institution for collecting and exhibiting pictures and statuary. As such it is valuable, and tends to the civilization, refinement, and good taste of the public : but it is an Academy only in name.

In October, 1824, the artists presented some by-laws, which they wished the Academy to adopt. they being willing to cooperate with that institution ; but the Directors insisted on the privilege of rejecting academicians, though elected by that body to fill vacancies ; and that the President, an eminent lawyer, shall judge of the qualifications of an applicant to become a student. This answer stopped all proceedings at that time.

In 1828 the resident artists of Philadelphia appointed Mess. John Neagle and James B. Longacre to draw up a memorial, which was signed by twenty-seven artists, and presented to the Pennsylvania Academy of the Fine Arts, in which they enumerated their grievances. They complain that they have no voice in hanging their works for exhibition—that their works are mingled with those of old masters, and injured by the prejudices of society—that the annual exhibitions are not attended, because the Academy keeps an open exhibition all the year—that the casts intended for the student are made part of the exhibitions—that they have no voice in the appointment of the keeper—that the rooms granted to the use of artists were appropriated by the keeper to his private use—and generally, that although their works must eventually support the Academy, they are treated as ciphers. The Board of Directors appointed a committee to reply to this memorial, and the reply was signed by Jos. Hopkinson, president. The reply tells the artists how much the patrons have done for the arts ; notwithstanding which, " a few artists, of a restless and ambitious temper, and impatient for personal authority and distinction, propagated opinions that artists only should have the government of an Academy of Arts." They say what is

groundless, " that experience was opposed to this theory ;—they insinuate the danger of placing their property under the management of artists. They say that no artist, " in any country, ever received, or expected any other return for the exhibition of his pictures, than the introduction of them to the knowledge of the public, and the fame and emolument he would derive from that knowledge." All this is intended in good faith, but exposes the ignorance of these gentlemen in the history of the arts.

John Trumbull received in New-York from the academy $200 for the use of pictures for one exhibition. The artists of England have and do receive pecuniary emolument and relief from the funds accumulated by the exhibition of their works. But the artists of Philadelphia did not ask any remuneration for exhibiting their works, they asked just consideration, distinction, and honourable treatment. The directors tauntingly tell the artists that having been paid by their employers for their pictures, they are at the disposal of purchasers, and may be borrowed for exhibition without any debt due to the artist. The directors claim the right to elect the teachers, i. e. lawyers, physicians, and merchants elect the competent lecturers and masters in schools of art! The whole reply, though professing to wish to give satisfaction, is very little calculated to produce that effect, and consequently the rejoinder of the artists, signed by order of the resident artists, " John Neagle and James B. Longacre," expresses their diminished hopes in, and expectations from the directors, as their opinions relative to artists and their rights are so opposite to those entertained by the professional artists of Philadelphia. They touch on the subjects in controversy and conclude, " We are not prepared to accede to any terms whatever which will compromise the respect which we owe to ourselves or the obligations we feel to sustain to the utmost of our power the dignity of our profession."

It was the intention of the artists to have an exhibition of their works under their own direction, and they applied for Sully & Earle's gallery, which was offered for half the clear proceeds. This plan fell through, and I believe the affairs of the academy have declined, and artists coldly look on and occasionally exhibit their works in the apartments of the institution.*

<hr />

By an artist of Philadelphia.

* " The Pennsylvania Academy of the Fine Arts" in Philadelphia, Chestnut-street, between Tenth and Eleveth-streets, north side. This institution owes its

In another chapter I shall continue the subject of academies as attempted in New-York.

origin to a few gentlemen of Philadelphia—seven lawyers, one carver, two physicians, one auctioneer, one wine-merchant, and one painter constituted the first board of officers. Incorporated 28th March, 1806. The property was divided into 300 shares, of 50 dollars each. A building was erected on a lot on ground-rent. Within a few years an addition to the academy was erected on the east for the statues, now called the "Antique Gallery." In 1810, a society of arts was formed, called the "*Society of Arts of the United States.*" There was one also called the "*Columbian Society of Arts.*"

The "*Academicians,*" a body of artists, were organized and were attached to the academy on the 13th March 1810. I do not know how long they acted in concert with the academy, but Mr. Edwin, who was one of the original academicians, told me that *diplomas* were promised to them by the board of directors, and that at some public meeting, where ladies were invited, each academician received, with great pomp and ceremony, a paper tied with a pink riband, which were thought to be the diplomas, until they reached home and went to exhibit the honours conferred upon them to their families and friends ; when, lo ! to their disappointment and chagrin, each had a piece of *blank paper !* I believe this was the death blow to all zeal on the part of the artists of that day. This fact I never knew until after I had become an academician.

When the artists complained of the trick played off upon their credulity, they were promised soon "*righty dighty*" ones, but to this day no one has ever been thus honoured by the board.

The first exhibition held in the Pennsylvania Academy was in 1811, since which an exhibition in the spring has been held annually, except 1833. This year no artist was in the board after the death of Mr. Rush, the ship-carver.

By reference to the catalogue of the first exhibition in 1811, I do not find the title P. A. or Pennsylvania Academy. The printed book, however, says they were organized in 1810. The catalogue of the third exhibition in 1813, is in the name of "*Columbian Society of Artists.*"

I find the titles P. A. in the catalogue of the 2d exhibiton in 1812. The duties of the academicians were unattended to for years, and the titles ceased to be printed with catalogues until the year 1824, when several artists were elected by the old academicians and most of these elections were confirmed by the directors. I called the meeting which led to this step at my own house. Mr. Rembrandt Peale being one of the party, and Sully another, it was suggested to re-organize the body of academicians—we did so after our election by the academy, and our first meeting in the academy (as academicians,) was on the evening of October 18, 1824

The artists of Philadelphia themselves are much to blame. They want firmness and consistency, and now they exercise no authority in the academy. Mr. Sully has backed out from the Board of Directors, and so did I before him. I don't think he will ever serve as an officer again. Mr Inman was, the other day, elected a director, and he is the only painter in the board, and whether he will truckle to these aristocratic gentlemen, remains to be seen.

I believe George Murray, the engraver, was the ring-leader in mischief, in the early history of our academy, but this was long before my time ; he died before I had entered as an artist. Mr. Sully can say much of the early history, and he will not say a great deal, I think, in favour of Murray.

CHAPTER XXIII.

Alexander Robertson—Joshua Cantir—M. Belzons—English Earle—John Roberts—his versatility as a mechanic, musician, painter, and engraver—intemperance and death.—Walter Robertson.—R. Field—Adolph Ulric Wertmuller—William Birch—John Valance—James Thackara—Alexander Lawson—Jennings.

ALEXANDER ROBERTSON—1792.

Alexander Robertson, 1772–1841.

This gentleman was born at Monymusk, near Aberdeen, in North Britain, in the year 1768. His father was an architect and draftsman, and his elder and younger brothers, Archibald and Andrew, are both artists. Andrew stands in the first rank of miniature painters in London, and as far as my knowledge extends, is the first *in the rank*. Of Archibald I have spoken above. He arrived in 1791, and finding that America was a land of performance as well as promise, he wrote for Alexander to join him in New-York. Andrew was then a child ; previous to embarking for America, Alexander passed five months in London in the summer of 1792, and took lessons in miniature painting from Shelly. He embarked at Liverpool, and in the autumn met his brother in New-York, where he had some practice as a miniature painter, and had established a drawing school under the title of " the Columbian Academy of painting." Mr. Alexander Robertson associated with his brother in this institution, and afterwards when conducting a similar establishment of his own, has been the teacher of many successive generations in the rudiments of the arts of design. Mr. John Vanderlyn received his early instructions at the " Columbian Academy." In 1816 Mr. Robertson was elected secretary to the American Academy of Fine Arts.

If Mr. Robertson had been no otherwise instrumental in furthering the progress of the arts of design in this country, we owe him much for freely communicating to us a very valuable manuscript treatise on miniature painting, detailing every part of the process, with instructions for each successive sitting. This was written by his brother Andrew for Alexander's use, but through his liberality, has assisted very many of our first artists in that branch of the art.

Mr. Robertson sketches and paints landscape in water colours with great facility. He has been the instructor of many young ladies who are distinguished for talent and skill. Miss Hall stands very prominent among our best painters of miniatures, and was for a time his pupil. Several ladies under

the tuition of Mr. Alexander Robertson, have attained skill in the painting of landscape in oil. A copy from Ruysdaal by Miss Stora, I remember as exciting my surprise and giving me much pleasure.

Mr. Robertson married Miss Provost, a niece of Bishop Provost, and is surrounded by a large and worthy family. He is himself one of the most amiable men of my acquaintance.

Allan Cunningham in his lives of painters, tells us that Raeburn " was elected an honorary member of the Academy of Fine Arts at New-York," and goes on to say, " the secretary, Robertson, says in his intimation to Raeburn of this transatlantic honour, that ' the institution is in a flourishing condition, and the collection of paintings is rapidly increasing. In addition to such pictures as the funds of the society permit it to purchase, the friendly donations of many of the honorary members will enable it to boast of specimens of most of the distinguished artists of the day.' In 1821 he was elected an honorary member of the Academy of Arts of South Carolina. The communication of Cogdel, the secretary, is in a strain more to our liking than that of his brother secretary of New-York : no hint of the donations of works by new members."

Mr. Alexander Robertson is not to be charged with the eleemosynary spirit and hint of this letter. It was the common mode adopted by this nominal academy, to procure presents from persons of distinction, whether artists or not. I do not know that the pope was made a member of this society of physicians, lawyers, and merchants, but his friends Napoleon and Lucien Bonaparte were, and paid the admission fee duly and punctually. Raeburn, simple soul, thinking that he had to deal with a school of artists, took the hint, and sent to New-York a very fine head, the portrait of an American gentleman, at that time in Edinburgh, which is a monument of his talents and liberality, and a model for every student of the art of portraiture.

Mr. Robertson still teaches drawing and painting; and another, and another generation, may profit by his instructions.

Joshua Canter (or Canterson or Cantir), ?–1826.

JOSHUA CANTIR—1792.

This gentleman came to Charleston, South Carolina, in 1792 from Denmark, and became a resident. He had received his education as an artist, under a professor of the aca-

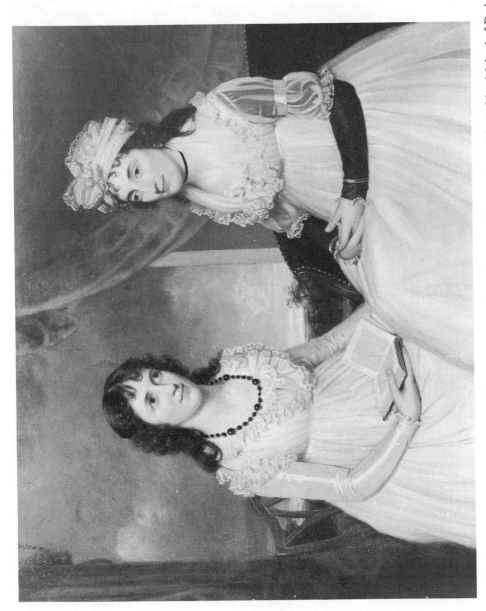

111 Elizabeth Fales Paine and Her Aunt. Painting by James Earl. Courtesy Museum of Art, Rhode Island School of Design.

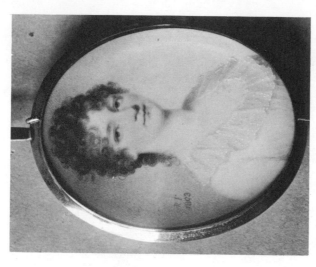

112B Mrs. Thomas Chase, 1803. Miniature by Robert Field. *Courtesy Worcester Art Museum.*

112A Augustus Vallette Van Horne. Miniature by Walter Robertson. *The Metropolitan Museum of Art, gift of Mr. and Mrs. William A. Moore.*

demy at Copenhagen. He painted and taught drawing for many years in Charleston. "He was, says my correspondent, " devotedly attached to the art, and possessed talents, which, under more favouring circumstances, and with that professional competition which he did not find at that time in South Carolina, might have raised him to a higher standing among artists than he actually enjoyed. He died in New-York.

M. BELZONS—1792.

Jean Belzons (or "Zolbius"), *fl. c.* 1792–*c.* 1812.

Was a native of France, and painted miniatures and other portraits in Charleston, South Carolina, in 1792. I should probably never have heard of him, if he had not been the first instructer, for a short time of Thomas Sully, whose sister he had married. M. Belzons had lost his fortune, and been driven to America by the French revolution, the source of so much present misery and future good ; and he employed that skill, which had been attained as a source of amusement, or an elegant accomplishment in France, to the purposes of gaining a reputable subsistence in a foreign country for himself and family.

EARLE—1792.

James Earl, 1761–1796.

An English gentleman painted portraits in Charleston, South Carolina, at the above period. Mr. Sully when a boy saw him ; and when he went to England, visited his widow and gave her an account of him and his death by yellow-fever, after he had embarked his property to return home.

JOHN ROBERTS—1793,

John Roberts, 1768–1803.

Was born in Scotland 1768, and came to America in 1793. Possessed of remarkable talents, and receiving a good education, he turned every advantage to little account either for others or himself by instability, and the want of that prudence which is supposed to be one of the good gifts bestowed upon his countrymen. He was truly eccentric, and probably prided himself too much upon his eccentricity.

He was, (says my informant,) a good mathematician—passionately fond of music, and complete master of most instruments.—A musical club was formed in New-York, where he resided, of which my friend Charles Rhind, our first consul to the Porte, and through whom our treaty of commerce with that power was formed, Benjamin Trott, the distinguished miniature painter and others of my acquaintance were members :

they met in a room adjoining the Methodist meeting-house in John-street, and struggled with all the instruments they could muster to overpower the discords of their neighbours—but inflated minds acting upon inflated lungs, put down the united efforts of fiddles, flutes, clarionets, and trumpets, and they were obliged to give up the contest and remove to another place of meeting.

The ingenuity of Roberts in mechanics was as great as his taste for the fine arts. He made engraving tools, and even invented new to answer the exigencies of his work. His friend Trott had executed a beautiful miniature of Washington from Stuart's portrait of the hero, and Roberts engraved a plate from it, but after he had finished his work to the satisfaction of his friends, he was retouching it, when Trott came in, and some misunderstanding taking place between the engraver and the painter, Roberts deliberately took up a piece of pumice and applying it to the copper obliterated all trace of his work; then taking the miniature, he handed it to its owner, saying, " There, sir—take your picture—I have done with it—and with you." A few impressions, taken as proofs, only exist. He designed and engraved the frontispiece for David Longworth's edition of Telemachus, published in 1797–8.

While he was engraving the Washington from Trott's miniature, he invented a new mode of stippling, produced by instruments devised and executed by himself, and which I have been assured, were " of such exquisite finish and workmanship, that a microscope was necessary to discover the teeth in some of the rollers." He made a printing-press for proving his work. He painted in miniature and drew portraits in crayons; but being engaged in constructing an organ on *a new principle,* and in contriving improvements on the steam engine for propelling boats, he abandoned the fine arts, and would only paint or engrave to procure the very little money he wanted for living and making experiments.

A correspondent says, " In music he was a master on several instruments. He was the founder of the Euterpean Society, (which still exists,) and for several years led the orchestra thereof as first violin. Sometimes he took the clarionet, which he played with uncommon sweetness, at others he would take the flute, and he spent much of his time at the piano-forte and organ, both of which he touched like a master. He was much engaged in mechanics—he invented an economical stove, the patent of which he gave to an iron founder for a single casting, the moulds of which he made himself. He also invented a bellows of singular power, which he used in forging iron

and steel. In his mathematical studies he devised a system of algebra, which he believed would render that science as simple as common arithmetic. He was an optician, and made improvements in preparing glasses or lenses to use in his new style of engraving. He was seized with apoplexy while descending the stairs of his dwelling, fell to the bottom, fractured his skull and died immediately, in the year 1803, at the age of thirty."

The reader may ask where are his works ? Of what utility to science or art, his inventions ? With all his extraordinary powers he brought nothing to perfection. Truth obliges me to say that with a mind so comprehensive, and body fitted to second its dictates, he seems to have forgotten the purposes for which such gifts are bestowed, and the source from whence they came—he abused them—he became intemperate, and it is most probable that the fall which ended his short life, was caused by alcohol rather than apoplexy. The low estimation in which artists were held at that period in our cities, where trade is the source of wealth, and wealth the fountain of honour, was both cause and effect in respect to that conduct I have been obliged to record :—that time is past. Artists know their stand in society, and are now in consequence of that conduct which flows from their knowledge of the dignity and importance of art, looked up to by the best in the land, instead of being looked down upon by those whose merits will only be recorded in their bank books.

EDWARD TRENCHARD—1793.

Edward C. Trenchard, *c.* 1777–1824.

This gentleman was born in Philadelphia, and being the son of an engraver, received his first lessons in the art from his father. Not satisfied with the knowledge to be obtained at that period in America, he visited England, and brought out Gilbert Fox to practise with him, and teach him the art of etching. As I am informed, Mr. Trenchard was afterwards an officer in the navy of the United States.

WALTER ROBERTSON—1793,

Walter Robertson, *c.* 1750–1802.

An Irish gentleman, who came to New-York in the same ship with Gilbert Stuart. The captain of the ship related that Stuart frequently quarrelled with Robertson when the decanter had circulated freely after dinner, and *in his cups* made use of abusive language. Robertson took the following method to keep the peace. He went to his berth, and returned to the cabin with a pair of pistols. " Mr. Stuart, we'll pass over what has gone by ; but the first time you use ungentle-

manly language to me, you will please to take one of these and I'll take the other, and we'll take a pop across the table." It is said the hint was taken, rather than the pop.

Robertson's style was unique; it was very clear and beautiful, but it was not natural. He went to Philadelphia before Stuart, and painted a portrait, in miniature, of Washington; which Field, another miniature painter and engraver, engraved and published, with decorations by Jno. Jas. Barralet. It was altogether a failure; and so little like the General, that one might doubt his sitting for it. His copies from Stuart's oil portraits pleased very much. After painting in New York and Philadelphia he went to the East Indies and there died.—His portrait of Mrs. Washington, engraved for the National Portrait Gallery, is like, and very creditable to him.

Robert Field, *c.* 1769–1819.

R. FIELD—1793.

An English gentleman, who engraved in the dotted style, (or stippling) and painted very good miniatures. Field and Robertson both annoyed Trott. Of Robertson he said, his excellence depended upon the secret he possessed—the chemical composition with which he mixed and used his colours;—of Field, that his work was too much like engraving.

Mr. Field painted more in Boston, Philadelphia, and Baltimore, than in New-York. He was a handseme, stout, gentlemanly man, and a favourite with gentlemen. He went from the United States to Halifax, and I have not heard of him since. I remember two very beautiful female heads by him; one of Mrs. Allen, in Boston, and one of Mrs. Thornton, of Washington. In a preceding biography I have mentioned the head of Washington, engraved by him. This picture has the merit of not representing the General with a wig on, as Heath's engraving does; but the countenance is unlike Washington's. And one remarkable deviation from the General's costume adds to the belief that he did not sit for it—it is painted with a black stock, an article of dress he never wore. I believe, when President, Washington never wore his military dress; when he, as General, wore it, he *always* wore it, but with a white cambrick stock.

Adolph Ulrich Wertmüller,
1751–1811.

ADOLPH ULRIC WERTMULLER—1794.

This artist was introduced to me by Mr. Gahn, the Swedish consul, soon after his arrival in this country; and from Mr. Gahn I have expected a promised notice of him, as he knew him well and came to America with him. I have been disap-

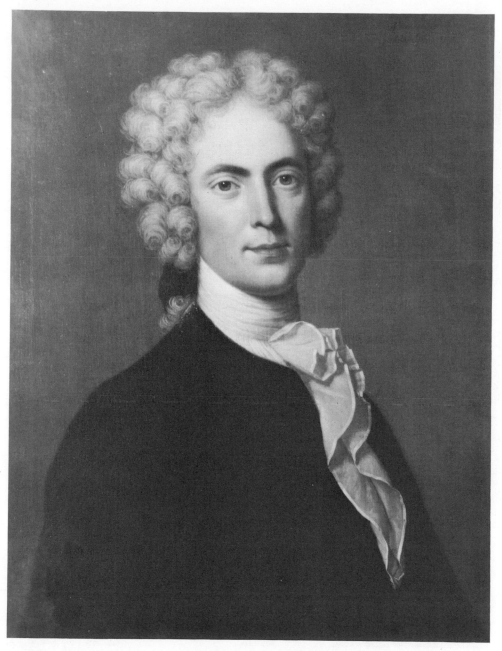

113 ANDREW HAMILTON II. Painting by Adolph Ulrich Wertmüller. *Courtesy The Pennsylvania Academy of the Fine Arts.*

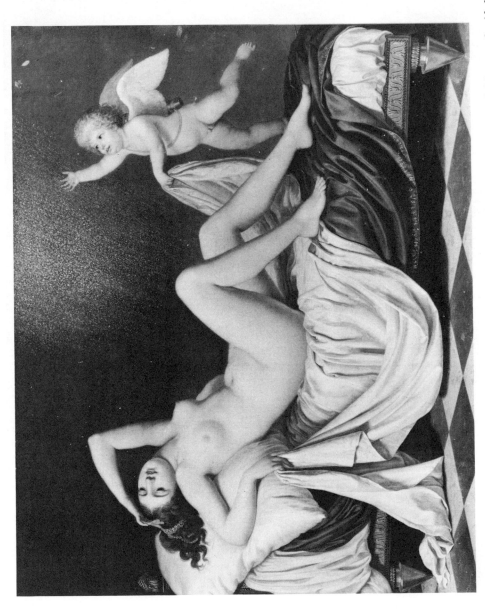

114 Danäe and the Shower of Gold, 1767. Painting by Adolph Ulrich Wertmüller. *Courtesy National Museum, Stockholm.*

pointed, and take my information from the Analectic Magazine of 1815.

" Adolph Ulric Wertmüller was, by birth, a Swede, the son of a respectable apothecary of the city of Stockholm. Having acquired the rudiments of the art of painting at home, he removed to Paris for the purpose of further improvement, where he studied and pursued his profession for several years. He appears to have acquired considerable reputation on the continent of Europe. He was elected a member of the Royal Academies of Sculpture and Painting, at Paris and Stockholm ; and, in addition to these unsubstantial honours, he received a more solid reward, in such a share of public patronage as enabled him to amass a considerable fortune. This he had placed in the French funds, and in the hands of a Paris banker; but, in that general convulsion of all financial and commercial concerns which took place in the early part of the Revolution, he lost the greater part of his fortune. He then determined to escape from the storm which threatened such general destruction, and try his fortunes in another hemisphere. In May, 1794, he landed at Philadelphia. In this country his paintings were admired, he received many attentions, and President Washington sat to him ; but the arts were then strangers among us, and we were not yet rich enough for patronage. He remained here until the autumn of 1796, when he re-embarked for Europe, and returned to Stockholm, where he resided for several years. Misfortune still pursued him ; he lost a large sum by the failure of a great house in Stockholm ; and, in disgust, he again returned to America, and arrived at Philadelphia in 1800. Here he exhibited his large and beautiful picture of Danae, from which he derived a handsome income. About a year after his arrival he married a lady of Swedish descent, who brought him a considerable property. After a few years' residence in the city of Philadelphia, he purchased a farm at Marcus Hook, on the Delaware, and removed thither, where he lived in ease and comfort until his death, in 1812.

" Not long after his death, most of his pictures were sold at auction in Philadelphia. A small copy of his Danae, by his own hand, was sold for five hundred dollars ; and some time after the original picture was sold, in New-York, for fifteen hundred dollars.

" Wertmuller had studied his art with great assiduity and ardour : he copied with accuracy the models before him, and imitated with success the masters on whom he had formed his taste.

" His Danae is his greatest and most splendid production. It is indeed his great work; and for that very reason it is, on every account, to be regretted, that both in the subject and the style of execution it offends alike against pure taste and the morality of the art.

" As in literature, so also in the other productions of cultivated genius, the connection between a corrupted moral taste and an unchaste, false style, is so strong, that, did not frequent experience teach otherwise, one would think it impossible that an artist, who feels the dignity, and aspires to the perfection of the noble art which he loves, could ever stoop to the pollution of that art, and the debasement of his own powers."

This artist painted in New-York, and more in Philadelphia. It is said that William Hamilton, of the Woodlands, employed him to copy the old family pictures, and then destroyed the originals.

William Russel Birch, 1755–1834.

WILLIAM BIRCH—1794,

Came to America in 1794. He was born in Warwick, England. He was an enamel painter, and settled in Philadelphia, where he died. I remember seeing a miniature of Washington, executed by him in enamel; which I thought very beautiful, and very like Trott's copy from Stuart's original picture. My impression is, that it was copied from Trott. Birch could design.

John Vallance, c. 1770–1823.

JOHN VALANCE—1794.

The name of Valance is connected with that of Thackara, as they worked in partnership, as engravers, for many years. Dobson's Encyclopedia bears their marks on many a plate. Alexander Lawson says of him, " he had attempted to copy a head of Franklin, and also one of Howard, with some success. He was certainly the best engraver at this time (1794) in the United States; and had he been placed in a more favourable situation, he would have been a fine artist."

James Thackara, 1767–1848.

JAMES THACKARA—1794.

The partner of the above, but inferior to him as an engraver. He was a long time keeper of the Pennsylvania Academy of Fine Arts; not as the term keeper is used in England, but merely having charge of the property. Mr. Thackara is a respectable citizen.

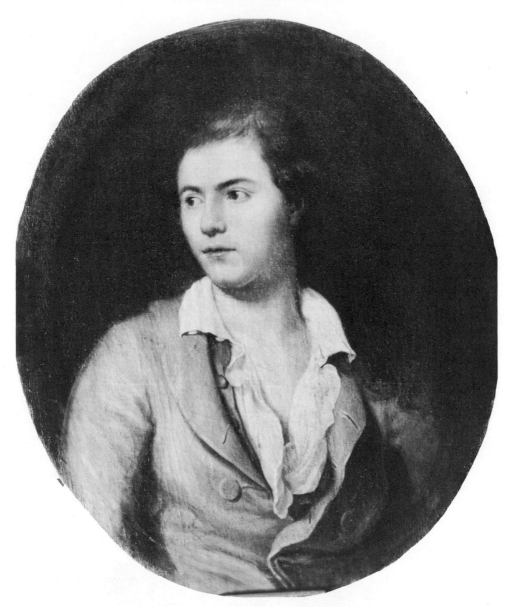

115 SELF-PORTRAIT. Painting by Adolph Ulrich Wertmüller. *Courtesy The Pennsylvania Academy of the Fine Arts.*

116` CAPITOL OF THE UNITED STATES AT WASHINGTON, 1800. Watercolor by William Russel Birch. *Courtesy Library of Congress.*

ALEXANDER LAWSON—1794.

Of this gentleman, my valuable correspondent, Mr. John Neagle, says, he is "the best engraver of birds, in America. He engraved for Wilson's Ornithology."

In a letter to a friend who had requested Mr. Lawson to give him a memorandum respecting his first efforts, and the state of the art of engraving at the period of his arrival in America, he writes:—

"I was born near Lanark in Scotland, in the year 1773. Trifling circumstances gave me very early a love for prints, and my schoolmaster drawing a little, (though he gave me no instruction in it,) increased my fondness; so that my books had as many houses, trees and birds in them as sums. I went to Manchester, in England, when sixteen. A print store was near us, where some of the first prints were kept;—and my intimacy with a bookseller, who showed me all the best works with engravings, caused me to become enthusiastically attached to the art.

"I read all the books on art I could meet with; but they were of little use. My first efforts at engraving were made on smooth half-pennies with the point of my penknife; and at this I became pretty expert. I soon after obtained a graver, which was made by a blacksmith from my description of the instrument, as I understood it to be from a figure I found in a book. We made a clumsy affair of it, and it worked very stiffly; but it was a step forward.

"When in the country, where I often was, I used to amuse myself of an evening in ornamenting the pewter tankard, out of which I drank my ale. A gentleman who called upon me about three years ago, (after I had been thirty-six years in America,) told me that when in the West-riding of Yorkshire, while putting up at an inn, he happened to mention that he was going to the United States, and the landlord immediately brought forward a tankard of my ornamenting, which he said he had preserved carefully ever since I was at his house, and intended so to do as long as he lived."

This is one of the many little incidents which sweeten the cup of life; and I doubt not but the knowledge of the value set upon this early work of his art, gave more pleasure to the artist at the age of threescore than the most flattering reception given to the most perfect production of his graver, when he by dint of study and perseverance, in the land of his adoption, had placed himself at the head of one branch of his profession. It came from afar, associated with the recollections of

55

youth, bright hopes, and his former home. The artist thus proceeds—" I bought a graver at last. I had *points* made for etching, and tried that. I then got a mezzotinto tool, and tried that mode of engraving—I tried every thing, and did nothing well, for want of a little instruction. I was then connected in trade with my brother; but loving art better than trade, and taking different views of political questions from those of my brother, I gave up my share in the business, and in my twentieth year, embarked at Liverpool for Baltimore, where I arrived on the 14th of July, 1794. I staid in that city one week, and then came to Philadelphia, where I have remained ever since. Thackara and Valance were partners when I came to Philadelphia. I engraved with them two years. They thought themselves artists, and that they knew every part of the art; and yet their art consisted in copying, in a dry, stiff manner with the graver, the plates for the Encyclopedia, all their attempts at etching having miscarried. The rest of their time, and that of all others at this period, was employed to engrave card-plates, with a festoon of wretched flowers and bad writing—then there was engraving on type metal—silver plate —watches—door-plates—dog-collars and silver buttons, with an attempt at seal-cutting. Such was the state of engraving in 1794.''

In conversation Mr. Lawson said that while he worked with Thackara and Valance he improved himself by studying drawing. He afterwards worked for Dobson, and engraved the plates for the supplement of the Encyclopedia.

He likewise worked for Barralett, the painter and designer, and afterwards formed a kind of co-partnership with him, but was obliged to quarrel with the eccentric Irishman before he could get any share of profits. Mr. Lawson is a tall, thin man, of large frame, and athletic; full of animation, and inclined to be satirical, but, as I judge, full of good feeling and the love of truth. Krimmell and Wilson he speaks of in rapturous terms of commendation, both as to talents and moral worth. Murray, on the contrary, with great asperity.

Mr. Lawson engraved the Rev. John Blair Linn's plates for his poems, the designs by Barralett. He likewise engraved the plates (and beautiful they are) for the nine volumes of Wilson's Ornithology, and Charles Lucien Bonaparte's four additional volumes. He is one of the many examples of a native of Britain coming to America and making himself an artist.

HIGH STREET, from the Country Market-place PHILADELPHIA.

117 HIGH STREET FROM THE COUNTRY MARKET-PLACE, PHILADELPHIA, 1800. Engraving by William Russell Birch after his own drawing. *Courtesy Library of Congress.*

118 ELECTION DAY AT THE STATE HOUSE. Engraving by Alexander Lawson after the painting by John Lewis Krimmel. *Courtesy Library of Congress.*

JENNINGS—[of Philadelphia]—1794.

Samuel Jennings,
fl. c. 1787–*c.* 1792.

Of this painter all I know is, that he was in London practising *art* about this period. Colonel Sargent in a letter to me, says, "There was a Mr. Jennings, from Philadelphia, in London, to whom I had a letter from Colonel Trumbull. I know not what has become of him, though I had a letter from him some time ago informing me of his success in '*manufacturing old pictures* for the *knowing ones*,' and that it was very curious to hear their observations upon the merits of these works of the old masters." Of course he was an impostor, leading a life of falsehood and deception; and probably ended it at Botany Bay, unless his meritorious knavery exalted him to a higher situation in the country of his adoption.

END OF VOLUME I